THE SOCIAL LIFE OF PAINTING IN ANCIENT ROME AND ON THE BAY OF NAPLES

In this study, Eleanor Winsor Leach offers a new interpretation of Roman painting as found in domestic spaces of the elite Romans of ancient Italy. Because the Roman house fulfilled an important function as the seat of its owner's political power, its mural decoration provides critical evidence for the interrelationship between public and private life. The painted images, Leach contends, reflect the codes of communication embedded in upper-class life, such as the performative theatricality that was expected of those leading public lives, the self-conscious assimilation of Hellenistic culture among aristocrats, and the ambivalent attitudes toward luxury as a coveted sign of power and a symptom of ethical degeneracy. Relying on contemporary literary sources, this book also integrates historical and semantic approaches to an investigation of the visual language through which painting communicates with its viewers. It also offers a fresh perspective on the demography of Pompeii and the relationship between the colony and Rome as reflected in its wall painting.

Eleanor Winsor Leach is Ruth N. Halls Professor of Classical Studies at Indiana University. The author of numerous articles and books on aspects of Roman literature and painting, she has received fellowships from the Guggenheim Foundation, the National Endowment for the Humanities, the American Council for Learned Societies, and the National Humanities Center.

THE SOCIAL LIFE OF PAINTING IN
ANCIENT ROME AND ON
THE BAY OF NAPLES

ELEANOR WINSOR LEACH

Indiana University, Bloomington

CAMBRIDGE UNIVERSITY PRESS
Cambridge, New York, Melbourne, Madrid, Cape Town, Singapore, São Paulo, Delhi

Cambridge University Press
32 Avenue of the Americas, New York, NY 10013-2473, USA

www.cambridge.org
Information on this title: www.cambridge.org/9780521826006

First published 2004
Reprinted 2007

Printed in the United States of America

A catalog record for this publication is available from the British Library.

Library of Congress Cataloging in Publication Data
Leach, Eleanor Winsor.
The social life of painting in Ancient Rome and on the bay of Naples / Eleanor
Winsor Leach
p. cm.
Includes bibliographical references and index.
ISBN 0-521-82600-4
1. Mural painting and decoration, Roman – Italy – Campania – Social aspects.
2. Interior decoration – Rome – Social aspects. 3. Dwellings – Rome.
4. Art and society – Rome. 5. Symbolism in art – Rome.
6. Rome – Social life and customs. I. Title.
ND2575.L43 2004
751.7'3'09377 – dc21 2003055282

ISBN 978-0-521-82600-6 hardback

LRjr.

CONTENTS

CONTENTS

ILLUSTRATIONS

TEXT ILLUSTRATIONS

DAI - Deutsches Archäologisches Institut
MN - Museo Archeologico Nazionale di Napoli
FU - Fototeca Unione (Accademia Americana)
ICCD - Istituto Centrale per il Catalogo e la Documentazione

CHAPTER 4

CONCLUSION

COLOR PLATES

ACKNOWLEDGMENTS

GOETHE DIDN'T MUCH LIKE POMPEII ON FIRST VIEWING. IN SPITE OF ITS "RICHLY detailed frescoes," the "mummified city" left him with a "curious and rather disagreeable impression," but a good local dinner in the pergola of a small inn with a sea view mitigated his distaste, and a second visit converted him to the opinion that "few disasters . . . have given such delight to posterity."[1] Pompei Scavi is addictive. New things are always there to assimilate and familiar things to reconsider. For that reason if for no other, this book might have continued to be *lavoro in corso* for double the already long time it has taken to produce, were it not for the writer's obligations to the several sources that have provided assistance for the work. Foremost are the National Humanities Center and the American Council of Learned Societies whose combined fellowship support during the year 1992–3, augmented by a Research Leave Supplement from Indiana University brought a neglected project back to the computer screen. Before that, however, the incipient stages had been supported by a Summer Faculty Fellowship from Indiana University, whose grants-in-aid-of-research have continued to provide assistance with the purchase of photographs. The two National Endowment for the Humanities Summer Seminars for College Teachers that I had the good fortune to direct at the American Academy in Rome during 1986 and 1989 furnished opportunities to visit both Roman and Campanian sites and museum collections in the company of a custom-selected symposiast fellowship. Particular thanks are owing to the several Superintendants of Antiquities for Pompeii whose accomodation of visiting scholars has made my work possible, especially Dr. Giuseppina Cerulli-Irelli during whose superintendency I conducted much of the work that laid the ground for this study, and the present Superintendant Dr. Pietro Giovanni Guzzo whose remarkable reorganization and revitalization of the site has made the final stages a particular pleasure. Additionally I thank Dr. Antonio Varone for his kind permission to study and include material from houses specifically under his jurisdiction.

Pompeian scholarship in recent years has been lively, and my debts to the many colleagues whose acquaintance I have enjoyed in situ and whose publications I am repeatedly shuffling between my desktop and bookshelves are too numerous to detail in this place. Above all I consider myself fortunate in the long-standing friendship of two of the most seasoned *Pompeianisti*, without whose readiness to exchange information and ideas I can hardly imagine that my own investigations could have been so personally rewarding as they have been. As frequently as I have paid tribute to these *familiares* in the past, their own continuing work on related projects constantly renews dialogue and brings new areas of obligation to the fore. For the many years in which I have benefited from Lawrence Richardson's comprehensive knowledge and scholarly generousity, the dedication might express my appreciation albeit qualified by the wish that the product were as good as his consistent encouragement of the process deserves. My Indiana University colleague James Franklin's book on Pompeian political families, which I had the good fortune to read first in manuscript, will be seen as the source of virtually all my own prosopographical information. Many the pleasant hour

we have spent chatting over the gladiatorial shows and sharing gossip about the lifestyles of the neighbors along the the Via dell' Abbondanza. But neither Larry Richardson nor Jim Franklin should be held responsible for any details of topography or prosopography I have accidentally misrepresented. Among other fellow Pompeianists, Pim Allison's tough-minded archaeological view of artifactual records and their implications for the interpretation of traditionally received wisdom have influenced the kinds of questions I have come to ask and been of particular use in charting the ground of Chapter 6. It is a particular pleasure to thank European friends and colleagues who have provided guidance through their particular preserves: Luciana Jacobelli for a summer morning's leisurely and informative *giro* through the luxurious, and controversially decorated, Suburban baths, to Hélène Eristov for introducing me to the work of her restoration laboratory at the Rotonda de la Villette in Paris; to Agnes Rouveret, Angela Pontrandolfo, and Marina Cipriani for making it possible for me to see the installation of the Tomb of the Magistrates in the Museum at Paestum; and to Daniella Scagliarini-Corlàita and Antonella Coralini for invaluable advice of many kinds.

Given that a person cannot always be in contact with Pompeii, I, like many others, owe particular gratitude to Dr. Ida Baldassare and those who have collaborated with her in the production of the monumental *Pitture e Mosaici* volumes of the Encyclopedia Italiana, whose emergence *seriatim* during the last few years is another particular circumstance that has enabled me to bring this study to completion. Here at Indiana University my pursuit of this bibliographically demanding project would never have been possible without the ministration of acquisitions librarians Nancy Boerner for classical studies and Betty Jo Irvine for fine arts. The magic that these two budgetary wizards have exercized in meeting requests from the Pompeian contingent have put at our disposal one of the strongest collections of work on the ancient city. During my year at the National Humanities Center, Jean Houston, as triangulator of the Research Triangle Libraries, fulfilled daily requests with breathtaking efficiency and Rebecca Vargas tracked obscure journals through the mazes of computer bibliography with elegance and finesse. During the year in North Carolina, I also benefitted from access to archival material in the Library of the Duke University Department of Classical Studies, and I am particularly grateful for Lawrence Richardson's recent assistance in checking my scrambled references to the volumes of Warsher's *Codex Topigraphicus Pompeianus*. At the American academy, where I have worked profitably on numerous occasions, Lucilla Marino, Antonella Bucci, and, recently, Christine Huemer have provided friendly and expert assistance. Likewise at the American Academy, Karin Einaudi, long-time director of the Fototeca Unione, nobly facilitated a large order at a time when the Fototeca, along with the rest of the Academy building, was *in restauro*. During his tenure as Director of the Archivo Fotografico of the German Institute, Dr. Helmut Jung answered innumerable requests, and kindly granted permission to publish the prints. My own photographs, the product of numerous visits to the site, as well as photographs acquired from the Superintendency Archive, are published with the kind permission of Superintendent of Antiquities for Pompei Scavi, Dr. Pietro Giovanni Guzzo. When at last I found an opportunity to pursue the replicas of Roman paintings that Thomas Ashby describes in his 1914 *Papers of the British School in Rome* article to their home in the Eton College Library, Dr. Louisa Connor, Curator of Prints, welcomed me with gracious hospitality and useful information. As a long-standing admirer of Cambridge Editor Beatrice Rehl's handsome books, I am delighted to be able to add my own to her shelf. Working with her, and her assistant Sarah Wood, has been a pleasure. My thanks also are owed to two anonymous press readers for their helpful observations and suggestions, and to Christopher Parslow, as additional reader, for assistance given from Rome. Michie Shaw, Senior Project Manager at TechBooks, has kindly and patiently answered endless questions pertinent to index making, and weathered numerous crises of photographic indecision and substitution. Finally, to come full circle, no memories of Pompeii would be complete without appreciation for the warm friendship of the Sabatino family who for all the years of my sojourns have made the latter-day Villa dei Misteri a welcome and ever more commodious place to return to after dusty days in the Campanian sun.

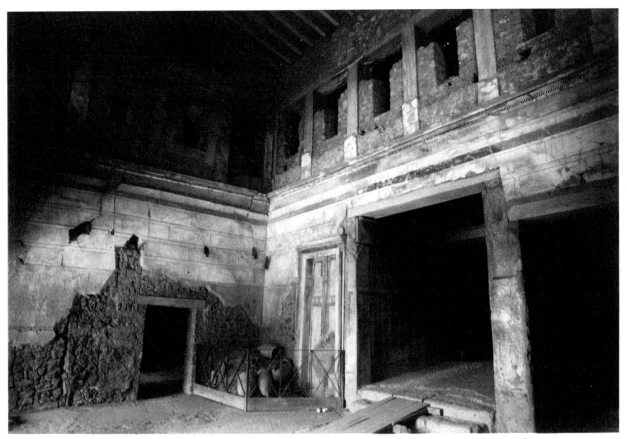

I. House of C. Julius Polybius, magistrate and imperial freedman, *vestibulum*. Author's photograph (su concessione del Ministero per i Beni e le Attività Culturali).

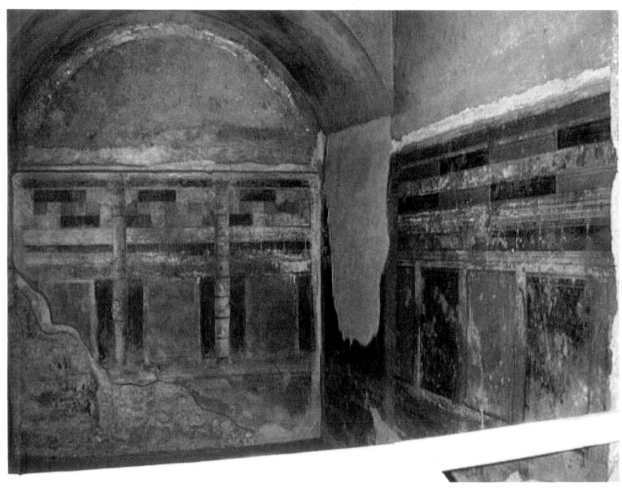

II. Casa delle Nozze d'Argento, *camera* in peristyle. Author's photograph (su concessione del Ministero per i Beni e le Attività Culturali).

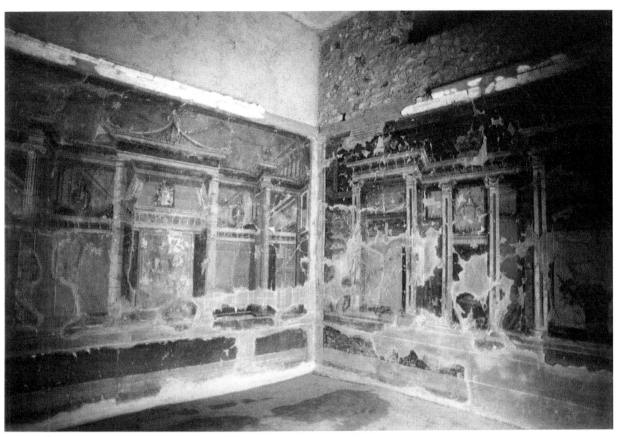

III. Villa Oplontis, Room 23. Author's photograph (su concessione del Ministero per i Beni e le Attività Culturali).

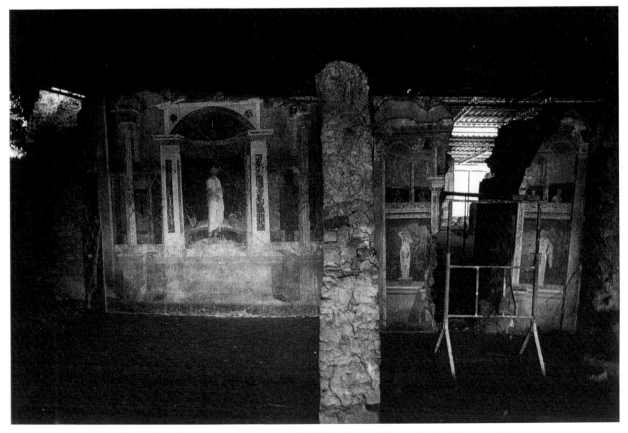

IV. Insula Occidentalis, Region 6.17.41, rooms behind atrium-*tablinum*. Author's photograph (su concessione del Ministero per i Beni e le Attività Culturali).

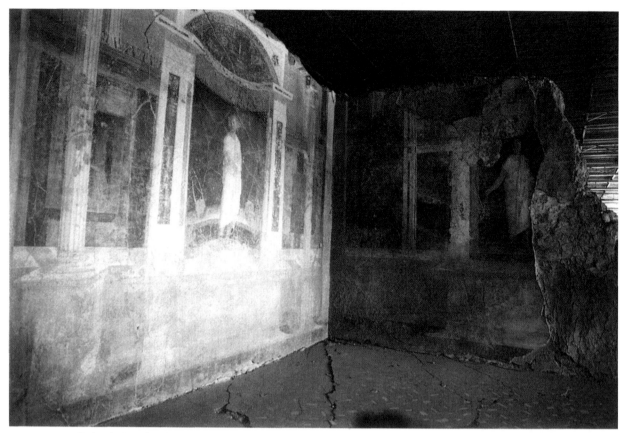

V. Insula Occidentalis, Region 6.17.41, poet reciting in an exedra. Author's photograph (su concessione del Ministero per i Beni e le Attività Culturali).

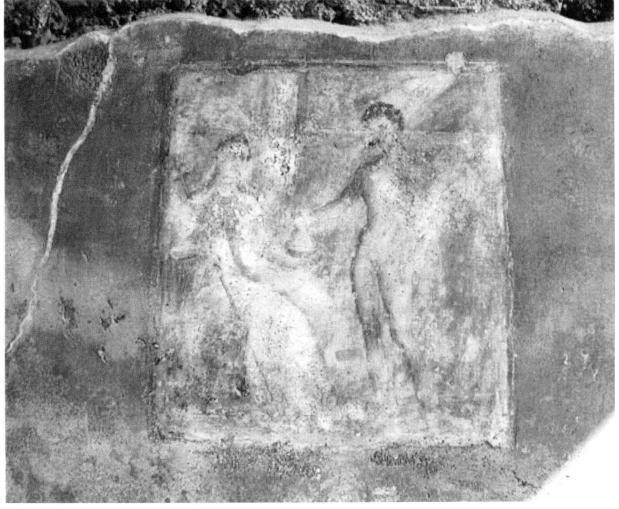

VI. Casa del Meleagro, panel from the entrance way. Mercury gives a purse to Ceres. Author's photograph (su concessione del Ministero per i Beni e le Attività Culturali).

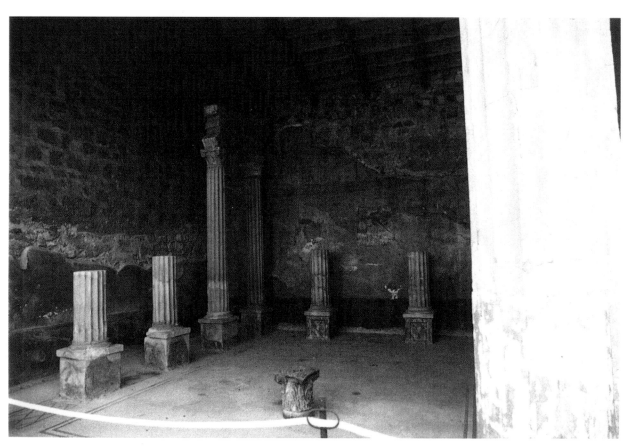

VII. Casa del Meleagro, Corinthian *oecus*. Author's photograph (su concessione del Ministero per i Beni e le Attività Culturali).

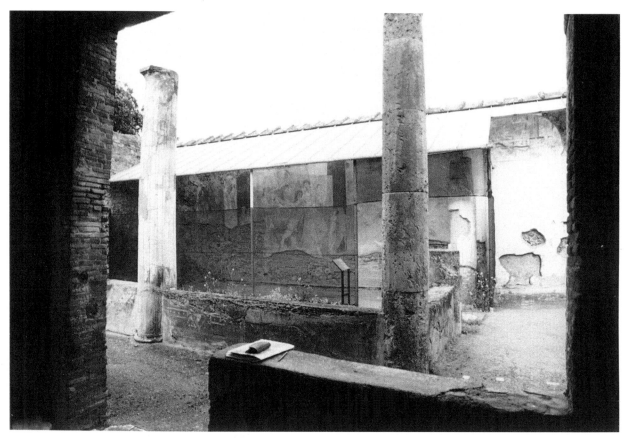

VIII. Casa di Adone Ferito, view of garden. Author's photograph (su concessione del Ministero per i Beni e le Attività Culturali).

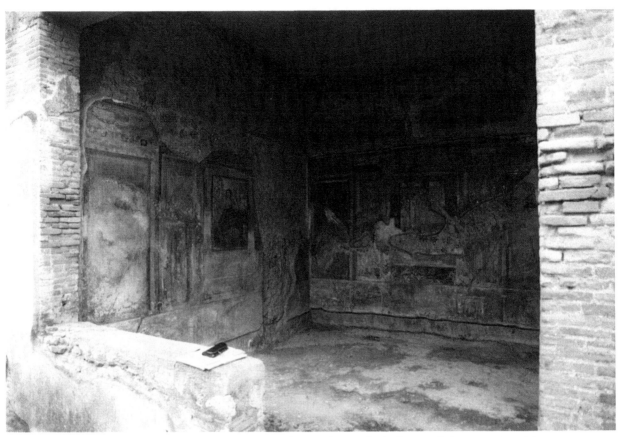

IX. Casa di Adone Ferito, room with view of the garden. Author's photograph (su concessione del Ministero per i Beni e le Attività Culturali).

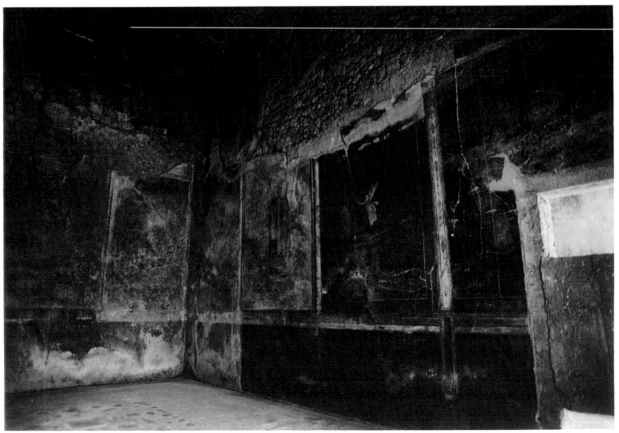

X. House of C. Julius Polybius, late Third Style *pinacotheca* with Punishment of Dirce. Author's photograph (su concessione del Ministero per i Beni e le Attività Culturali).

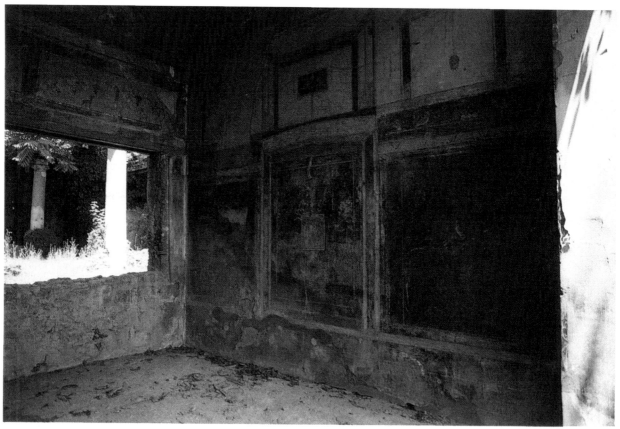

XI. House of Trebius Valens, Third Style *tablinum*. Author's photograph (su concessione del Ministero per i Beni e le Attività Culturali).

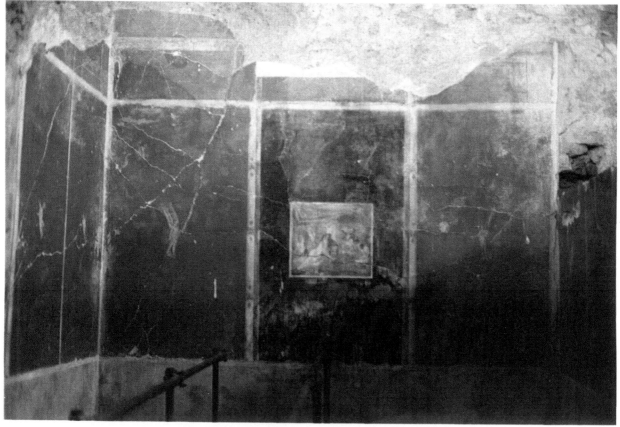

XII. Casa dei Casti Amanti, Third Style symposiast room. Author's photograph (su concessione del Ministero per i Beni e le Attività Culturali).

The World's Common Property

ATE HAS OFTEN PLAYED CAPRICIOUS TRICKS WITH PREDICTIONS, BUT never more perversely than with what the Elder Pliny wrote in his encyclopedic book on natural history during the first century A.D. concerning the survival of paintings in the public and private spheres. He has just mentioned Ludius, a painter of the time of Augustus Caesar who pleased many patrons by his invention of a novel and inexpensive mode of decorating walls inside their houses with villa landscapes. All the same, as Pliny would have it, such pictures sequestered within the domain of private individuals can never achieve the widespread or enduring reputation commanded by great examples of public art (*NH*. 35.118):

> sed nulla gloria artificium est nisi qui tabulas pinxere, eo venerabilior antiquitatis prudentia apparet. non enim parietes excolebant dominis tantum, nec domos uno in loco mansuras quae ex incendiis rapi non possent . . . nondum libebat parietes totos tinguere, omnium eorum ars urbibus excubabat pictorque res communis terrarum erat.
>
> [But the fame of artists is negligible unless they have painted tablets. By this token the wisdom of antiquity deserves our respect all the more. For they did not labor over walls for patrons (owners) merely, nor in houses which would remain stationary and could not be carried out of a fire to safety. Nor yet was it pleasing (to Apelles and Protogenes) to color entire walls. The art of all these stood sentinal out of doors in (their) cities and the painter was the common property of the entire world.]

By assigning greater importance to the public sphere than the private, Pliny here exemplifies a value system that was common to both the Greek and the Roman world. His *gloria* reflects that same craving for immortality that inspired both writers and actors in the political sphere. The famous Greek artists had certainly obeyed this impulse; whether it extended to such personages as Ludius is less certain. With historical accidents intervening, however, no certain traces have survived from the work of the Greek painters whose reputations had become international, nor from any of the works that once adorned the Roman public world, but those very walls that were hidden away in houses have, in a number of situations, survived the accidents of twenty centuries to exhibit a large repertoire of Romano-Campanian painting that has at last become "the common property of the entire world."

For many centuries now the value of this cultural heritage has been recognized while the extent of the known repertoire has been continuously on the increase by virtue of accidental discoveries and systematic excavations alike. Florentine painters working in Rome during the early Renaissance were the first publicists. Venturing into the buried chambers of Emperor Nero's Domus Aurea on the Esquiline, an area whose identity was at that time confused with the Baths of Titus, they came upon strangely configured designs that challenged their previous conceptions of a clean-cut classical style. Calling these motifs "grotesques" (*grotteschi*) from the "grottoes" (*grotte*) in which they found them, the artists integrated new versions of them into the frescoed ceilings and walls of palaces and chapels which they were decorating "in the antique mode."[1]

Investigation of Campanian painting began almost two centuries later but has been steadily pursued since the eighteenth century.[2] Ultimately receiving much more widespread publicity, the designs adapted from this repertoire have found their way into currents of artistic production ranging from stuccoed walls in English country houses to ceramics and furnishings produced for the popular market.[3] Even today the occasional interior designer whose imagination is fired by a glimpse of these paintings incorporates them into a domestic program.[4] More surprisingly, perhaps, certain modernist painters responding to the fragments displayed in New York's Metropolitan Museum of Art have translated Campanian figures and patterns into abstraction. Behind Willem De Kooning's large-eyed female faces the knowing spectator can see the enigmatically fixed gaze of the Boscoreale women, whereas Mark Rothko, initially impressed by the theatricality of the fragments, came to

"recognize himself" in Pompeii, incorporating the large rectangular forms of paintings into his own work.[5]

Given that the majority of us are neither artists nor interior decorators, however, one may ask what else this "common property" is good for. Logically we might expect it to tell us something about the Romans themselves, but there remains the challenge of knowing which questions to ask. The final irony that chance visited upon Pliny's remark is that so many of the sequestered paintings that have survived up to our own day owe their preservation to that same natural cataclysm, the eruption in A.D. 79 of Mount Vesuvius, that caused Pliny's death. Since the eighteenth century, visitors to the buried cities and villas of Campania have experienced a certain voyeuristic frisson in confrontation with the empty but fully decorated houses that seem to provide one of the closest possible approaches to the manner in which life was lived in the Roman world. If Goethe initially found these spaces gloomy,[6] Madame de Stael remarked melodramatically on the emotions inspired by glimpses of private life amid desolation: "Il semble qu'on attende quelqu'un, que le maître soit prêt à venir."[7] With characteristically democratic humor, Mark Twain recorded a similar sensation in the role of unbidden guest. "We lounged through many and many a sumptuous mansion which we could not have entered without a formal invitation in incomprehensible Latin in the olden time when the owners lived there – and we probably wouldn't have got it."[8] In a more objective style of discourse, the American scientist Benjamin Silliman professed that the experience of his 1851 visit had amplified the knowledge gained from ancient literature: "The resurrection of these cities from their forgotten tombs has brought Roman life vividly before us in all their family scenes, and at the period of their greatest power and luxury and glory."[9] Many have echoed this sentiment, yet in the strictest sense, this notion of closeness can be illusory. If there was one point on which Pliny pronounced with fatal accuracy, it was the anonymity of these domestic wall paintings, in which condition, despite their physical durability, they now face the beholder. Paradoxically enough the anonymity that confronts us in Roman painting enforces the effectual silence of an art that originally existed as a mode of communication.

Subjective re-creations tempt the viewer. That the decoration of the individual residence must represent the taste of its owner has often enough, on the analogy of later practice, been assumed.[10] Taste as a mirror of personality was the principle on which Edward Bulwer-Lytton matched fictive inhabitants to houses as

he repopulated the city in *The Last Days of Pompeii*. As an owner for the House of the Tragic Poet, already much celebrated for its paintings of heroic and dramatic subjects, he created a sentimental Athenian expatriate: "Alcibiades without the ambition . . . passionately enamoured of poetry and the drama, which recalled . . . the wit and the heroism of his race." This Glaucus adorns his "fairy mansion . . . with representations of Aeschylus and Homer."[11] Conversely the silly Fulvius, a mediocre Roman poet, is rumored to have decorated his house with pictures so "improper" that he does not show them to women.[12] Amusing as these reconstructions may be, they do not advance our understanding of ancient practices because concepts of taste need interpretation within the larger frame of reference constituted by the cultural system to which they belong. This requirement pertains no less to the house of so celebrated a historical figure as Augustus Caesar than to that of a Pompeian magistrate known to us only as a name that fellow citizens supporting his candidacy for office had painted on a wall. Understanding this system involves not merely a knowledge of the aesthetic options available for selection at any given moment, but also the principles of decorum that the system embodied, the communicative purpose that motivated its deployment, and the way in which this communication was to be validated by its audience.

In this respect Pliny's excursus in the *Natural History* concerning artistic fame provides an apposite introduction to issues that will confront a person hoping to learn something about Roman culture from these paintings, not simply by virtue of the information he gives and the values he expresses, but also because of the silences he underscores. With his emphasis on lasting *gloria* and his distinction between public and private, he perfectly exemplifies Ferdinand Braudel's saying that "the unusual conceals the everyday" in historical sources.[13] Despite his purpose of writing informatively, which he approached with a predilection for detail that surpassed most of his fellow Romans, he could scarcely imagine that inquisitive cast of mind a modern scholar might bring to the past in search of information now lacking because he and his compatriots took it for granted.

The serious challenge for the contemporary student of Romano-Campanian painting is that of reinstating its repertoire within the context of active social use. For this purpose the anonymity Pliny deplored can function as a positive advantage in directing our speculations away from elusive individual personalities toward the social system, thus ensuring our freedom from the kinds of preconception that prejudice investigations of fully attributed art.[14] Confronting the condition of anonymity

produces a sense of interpretive disorientation sufficient to remind us how we need to accept what is currently termed the "foreignness" of the past as a caution against easy familiarity. Keenly aware of the differences between present and past that the empty houses of the Vesuvian cities bring home to us, Bulwer-Lytton attempted to make his reconstruction of Pompeian culture sympathetic to his British contemporaries by choosing, as he put it, "Those aspects most attractive to a modern reader; the customs and superstitions least unfamiliar to him." With considerably greater resources of information to draw upon, scholars of the present day proceed differently. As the social historian Andreau remarked in the conclusions of his book concerning the business activities of the auctioneer-banker L. Caecilius Jucundus, one of the most publicized personalities in Pompeii, "The study itself is to make a person distrust a modern vision of the past. Neither profession nor professional association, individual or economic liberty can be judged in contemporary terms. Ancient institutions and modes of thought must be defined within the workings of the ancient economy."[15]

A similar philosophy pertains to painting. What we must discover as a first step toward reconstructing the functions a culture ascribes to art is not what can be comfortably assimilated to our own predilections and orientation, but what is different and strange and needs explanation within its own context.

PUBLIC AND PRIVATE SPHERES

As a preliminary, it is useful to consider briefly what was the full compass of ancient pictorial production within which domestic mural painting had its place. When Pliny distinguishes painted *tabellae* from painted interior walls, he is scarcely telling the whole story about the use of decoration in his world. The inhabitants of ancient cities were accustomed to seeing painted surfaces all around them occupying a far more conspicuous place in the urban landscape than is generally the case today. Contemporary Mediterranean buildings with painted stucco exteriors may give us some sense of this colorful spectacle, but by no means to the degree present in the ancient world. Romantic Hellenophiles once had difficulty accepting the knowledge that Greek marble sculpture was painted, but these polychrome reliefs and statues were only one element contributing to a gaudy scene. In Rome, where stucco coatings and terra-cotta played an important role in decoration, painting was virtually an aspect of architecture. Houses, shops, public buildings, and tombs were painted on both their exterior

and interior walls. The Roman town or cityscape was one from which many modern spectators, and even dedicated classicists, might have turned in embarrassment, as did Goethe recording his first impressions of "richly detailed frescoes" as witness to "an artistic instinct and a love of art shared by a whole people which even the most ardent art lover today can neither feel nor understand and desire."[16]

When we look from exteriors to interiors, we find both archaeological and literary sources indicating an early origin for the practice of painting, although the frames of reference thus designated do not coincide. On the archaeological side the evidence is fragmentary. Remains of the two-story houses that were built in the Roman forum along the line of the Via Sacra as early as the sixth century show that these had painted plaster.[17] The colors were red, yellow, and blue, but the designs, if there were any, are unknown. The buildings themselves may have been constructed under Etruscan influence; we do not know whether their colored walls should be understood within the same general rationale of decoration in which extant Roman houses participate, because they antedate these by some two or three centuries, yet the common Mediterranean tendency toward visual dramatization encompasses both.[18]

Turning from this fragmentary evidence to the sphere of literary documentation, we find attention focused on a more monumental kind of art. Wanting to establish a specifically indigenous tradition of painting, Pliny assigns its beginnings to an indefinable moment in early Italian history. He speaks of paintings still extant in the temples of Ardea and Lanuvium older than the city of Rome (NH. 35.17). These were figured paintings; those at Lanuvium portrayed mythological heroines, Atalanta and Helen, both nude and reputedly very beautiful. Furthermore they must have been frescoes because the condition of the plaster (tectorii natura) prevented Caligula from taking them off their walls. Some paintings at Caere, Pliny claims (NH. 35.16), were even more ancient; they antedated the coming of the Greek Ekphantos of Corinth, the painter said to have migrated to Italy in company with Damaratos the father of the Tarquin family. Whatever the genesis of these early paintings – and they were as likely to have come about under Greek influence as native Italic[19] – the decoration of temples with figural work would seem to have constituted a tradition, whether continuous or not, that extended into the later Roman Republic.

Opportunities for historical commemorations within the context of temple dedications clearly contributed to the growth of the tradition.[20] Pliny's first notice of a connection between painting and historical events discloses links with personal status. A member of the aristocratic Fabian family acquired the surname Pictor because of his work in the Temple of Salus at Rome (NH. 35.7.19). Tradition remembers these paintings as extensive (Val. Max. 8. 14. 6.) as well as clearly drawn and pleasingly colored (D. H. 16. 3 [6]). Probably they depicted historical events with reference to the military career of C. Junius Bubulcus, a hero of the Samnite Wars, who consecrated the temple vowed in 311 at the battle of Bovianum after he had become censor in 303 B.C. In this instance the prestige of the painter may have outclassed that of the patron, but additional testimony to commemorative representations of triumphing generals within the temples they dedicated leaves the painters unnamed, as when the lexicographer Festus (252) mentions that two persons, T. Papirius Cursor and M. Fulvius Flaccus, dedicators respectively of the Temple of Consus (272 B.C.) and a Temple of Vortumnus (264 B.C.) were shown wearing the triumphal toga (toga picta).[21]

Another set of paintings in the Temple of Hercules in the Forum Boarium is attributed by Pliny to the playwright Pacuvius working under the patronage of L. Aemilius Paulus, father of Scipio Aemilianus. For these we have no corroborating testimony, but they provided Pliny with the occasion for remarking that the fame of the stage made painting itself more lustrous (35.7.20: "clarioremque artem eam Romae fecit gloria scenae"). What he means by "glory of the stage" is scarcely clear, and possibly no more than a reference to Pacuvius' success as a playwright. Eventually, however, the connection between painting and the theatre would assume major importance in the traditions of pictorial imagery. We see this development forecast in another incident Pliny relates concerning the installation of painted decorations of an illusionistically architectural nature on a temporary wooden stage during the early first century B.C. (35.7.23).[22]

To such personally commissioned decorations must be added pictures brought as booty from conquered countries that were exhibited initially in triumphs and then later placed on display. Many of the world-famous monuments Pliny celebrates came to Rome by this route. Although some were in the possession of individual owners, a large number stood in the public sphere. Again the idea of status is paramount, for the donor becomes associated with the donation and gains credit for public benefaction. Thus Cicero (de Officiis 2.21.75) praised L. Mummius, conqueror of Corinth, because he gave his captured ornaments to the state. By adorning Italy, "he made his own house more richly decorated." The inauguration of this practice is popularly assigned to Marcellus' sack of Syracuse in 211.[23]

The *Porticus* of Metellus Macedonicus built in 146 B.C., which was situated along the triumphal route close to the Circus of Flaminius, was probably the first building specifically created for display. Facing the facades of the two temples that the colonnades enclosed was a veritable crowd (*turma*) of equestrian statues brought from Macedonia that Alexander the Great had commissioned from Lysippus representing with recognizable fidelity his companions fallen at the Granicus with himself in their midst (Velleius 1.11.3–4).[24] Although statues comprised the bulk of early imports, there is evidence of painting.[25] From the title of a speech by Cato the Censor *de signis et tabulis*, we may infer that such imports had become familiar by the mid–second century.[26] According to Pliny the first foreign picture to become state property was a representation of Dionysus by Aristides that L. Mummius placed in the Temple of Ceres (35.24). Mummius would never have recognized the value of this painting, it is said, had he not become aware that Attalus of Pergamon craved it for himself.[27] Long before Pliny's time, however, many Romans had come to revere the tradition of famous artists.

Although the exhibition of artistic spoils frequently provokes critical ruminations on the notorious Roman arrogance of conquest, we must recognize the multiple purposes served by display. As Aqnès Rouveret points out, the spoils of conquest functioned no less as a component of public memory than did specifically commissioned monuments.[28] Historian Erich Gruen defends the practice of exhibition on both religious and aesthetic grounds.[29] One should also recognize the common desire to create an international identity on behalf of a city emerging as a world power. In these several capacities such artistic displays became one of the chief vehicles for personal and political statement, serving first the great personalities of the Republic and then Augustus. In some cases, artworks decorated buildings that existed to serve other purposes, such as temples, the Forum, or the Curia, but galleries constructed with exhibition as their primary purpose were increasing in number.[30] The *porticus* of Pompey's theatre was among the most celebrated of such formal display places. It housed a collection composed of paintings and sculpture, several of the former by well-known artists and many of the latter commissioned expressly for the site.[31] As a legacy to the Roman people, Julius Caesar willed his Transtiberine gardens and the statues and paintings with which he had furnished them; Mark Antony carried off the portable objects to properties that he had appropriated (Cicero *Phil.* 2.42.109). Testimony concerning the collection of Asinius Pollio mentions only sculpture,[32] but paintings were installed in other porticoes endowed by

Augustus and members of his family. The *Porticus Argonauticum* in the west colonnade of the Saepta Julia took its name from a painting of Jason and the Argonauts, and the facing *Porticus Meleagri* appears to have derived its name on similar grounds.[33] Even Agrippa's baths housed paintings.

The works selected did not simply display the sponsor's personal taste but might also thematically express his policies or interests.[34] Often a combination of acquired paintings with some expressly commissioned objects effectively served this purpose. As one example of the continuing tradition in Rome, Pliny mentions several paintings that Augustus displayed in the buildings he had given to the state. His tastes seem to have inclined toward the heroic and allegorical – no surprise in view of our other information concerning his high valuation of the moral possibilities of art. One may think that the single objects participated actually in a well-knit system of visual propaganda.

Such material had great influence on the course of Roman art, and we might wish that we knew more about it, especially with what kind of framing and in what relationship to each other such objects were displayed. The highlights Pliny sets forth are presented in such a manner as to reinforce his dichotomy of public and private spheres, yet the decorative faces that these two actually wore within the Roman world may have been closer in real practice than he leads us to assume, with the consequence that public and private are more accurately to be seen as indications of location than of style or subject. In some instances, as we shall see, public painting has apparently created the standards used in private houses; in other cases these would merely appear to share in a common mode. The earliest mural decoration of a public building discovered in Campania, that of the forum basilica in Pompeii, seems to establish a precedent for the treatment of domestic interiors of the same period or shortly thereafter.[35] Later buildings of the forum area that contain traces of painted decoration seem less likely to have been trendsetting than to have participated in the prevailing stylistic current: for instance, the Temple of Jupiter, decorated at the inception of the Roman colony;[36] the building of Eumachia, dating from the late Augustan period;[37] the Temples of Apollo and Isis, both redecorated[38] after the earthquake; or the Macellum, also completely refurbished in the last decade of the city.

One of our best insights into the exposure of art objects within the public sphere is afforded by the contents of a building that was fortuitously the first source of finds for the pioneering excavations at Herculaneum. Mistaken for a temple to Hercules during the initial stages

of exploration, the large structure that has subsequently come to be known as a "basilica" was the civic benefaction of one M. Nonius Balbus, *patronus coloniae*. In a location that bordered on the ancient Forum (still unexcavated) the collonaded enclosure, in which scholars most recently have seen an *Augusteum*, houses a display of portrait sculpture encompassing members of several generations of imperial families.[39] Behind an interior colonnade, the walls were structured into compartments by simulated architectural decoration rich in miniature grotesque motifs: "real and imaginary animals, heads of Medusa, landskips, views of houses.[40] Two large-figured paintings of mythological heroes framed within niches probably imitate famous originals. Additionally there were painted representations of two sculptural groups – Achilles and Chiron, Pan and Olympus – whose originals were on display in the Saepta Julia in Rome.[41] Certain themes emerge from the juxtaposition of figures and subjects within the gallery: the future of the city is adumbrated both by the exploits of the heroes and the nurturing of youth, while allusions both to Augustan monuments and to imperial families, seemingly irrespective of political mutations, enforce the bond between Herculaneum and Imperial Rome.[42]

Across the street from this building was another to which one of Balbus' own freedman had contributed: *Aedes collegii Augustalium*, which furnished the ceremonial quarters for meeting of a civic sodality made up of prosperous freedmen.[43] On the ground floor of this "clubhouse" the social space was oriented around a central shrine decorated with paintings of clear thematic import depicting events in the life of Hercules which showed the eponymous mythological founder of the town as an example of social mobility.[44] The decorative contexts within which these paintings were framed, as with those of the "basilica," are virtually identical with those in houses of the day. The same was true of the corridor walls in the Pompeian Macellum decorated during the Flavian period with a selection of mythological subject panels.[45] Here the interweaving of architectural elements and painting was so rich that the building was for a long time considered a Pantheon dedicated to the Twelve Gods.[46] Clearly during these years the same painters were being employed to execute both public and private commissions between which they made little artistic distinction.

Leaving aside these few extant traces of mural painting in the public world, the survivals from the private sphere are of two kinds: tomb painting and domestic wall painting, both closely connected with the structure of the individual life. Painted tombs in the Etruscan city of Tarquinia date from the sixth century onward. Their topics

are primarily ceremonial and involve human figures. The typical ensemble covering the four walls of a large chamber tomb consists of a banquet representation, along with some manner of performance such as games, dances, sacrifices, or athletic activity, such as hunting or racing. Often these events are staged within vestigial landscapes represented by files of trees, and the interior of the tomb frequently depicts a structure, such as a tent. Presumably these representations perpetuated the events solemnizing the funeral, but they may also have predicated the conditions amid which the deceased might live in the other world.[47] Certainly they signified status.

Such customs might be considered generally Italic. Some Lucanian paintings from the cemeteries around Paestum in southern Italy appear comparable in significance. In spite of the fact that these are closed tombs never intended to be seen after interment, status decorations are frequent; however, their symbolic "language," as Rouveret has called it, is very much the creation of their own cultural environment.[48] Except for the symposiast "Tomb of the Diver," almost certainly painted under Greek influence during the early fifth century, banqueting is never shown. Funeral games, clearly designating the rich and influential members of the community, appear in the burials of both sexes.[49] A figure to represent the deceased person is not uncommon, and often in male burials, especially those dating from the period of the Roman-Samnite Wars, this figure appears as a warrior returning victorious from battle with spoils.[50] In the impressively life-scale, recently excavated paintings of the "Tomb of the Magistrates," this topic assumes a narrative dimension. On one side the warrior receives an honorific greeting in life as he comes home with his weapons and a captive in tow; on the opposite side two horses carry his equipment in a funeral procession, while the scene centered on the rear wall shows his reception after death by a noble ancestor as a worthy continuator of family tradition.[51]

Something of this Italic pictorial tradition might seem to be recapitulated in the funerary monument of a young Pompeian magistrate in the necropolis outside the Porta Vesuviana. The tomb of the aedile C. Vestorius Priscus, who died at age twenty-two, presumably during the period of his office in A.D. 75–6, stands within an enclosure some of whose painted interior walls commemorate his activities as magistrate while others carry depictions of banquets and games referring either to the young man's sponsorship or to his obsequies.[52] The tomb of Vestorius, however, is unusually elaborate among known monuments in Pompeii, the majority of which communicate their messages through exterior relief sculpture. That this was not always the case in Rome is indicated

by a few fragments on the Esquiline of an apparently nationalistic or historical cast. A narrative frieze from an Esquiline tomb pictures incidents in the legendary history of the founding of Rome from Aeneas to Romulus.[53] Another fragment is historical, forming part of what would have been an extensive battle scene. Recent study suggests that the event portrayed is the conferral of an award on the Roman legionary M. Fannius. The Fannii gained political consequence after the third century. The incident portrayed here may have constituted the beginning of the family's rise in status.[54] The military topic suggests another kind of painting that both Pliny and the historians mention: the reportorial account of events in a battle. The implications of this for composition and ethos will be discussed later.

The domestic painting with which this book primarily concerns itself is also employed as a status sign, but in a very different manner. Unlike historical painting or tomb painting, it employs human figures sparsely except when these appear as sculptural images or as personages in mythological narrative. Instead of commemorations and depictions of particular events, it creates backgrounds for the activities of everyday life. Within the structure of the Roman house, painted walls and ceilings figured as an aspect of interior furnishing. Indeed, in the greater number of cases these supplied the only fixed element of furnishing because the Romans furnished their rooms sparsely, and those essential articles used for seating or storage were portable enough to facilitate their transfer from room to room in accordance with seasonal needs. But the effect of painting was comprehensive. With floors, walls, and ceilings coordinated into a coherent ensemble, painting articulated the sense of spatial enclosure within a room and so conferred both an atmosphere and a visual conformation on the spaces of Roman life.[55] Within this frame of reference domestic painting, however anonymous, cannot be considered as private, for it was seldom intended for limited personal contemplation but rather to display itself before the many persons whom the owner received and entertained in this house. Whatever the owner wanted to impress upon these persons concerning his individual preferences and judgments was mediated through a mutually understood code of communication. Thus painting was in the fullest sense an aspect of material culture with a function to fulfill.

The "vocabulary" by which the code delivered its messages involved pictorial imitation, which employed a number of techniques to create illusions of form and depth. This predilection for the persuasively lifelike image emerges corroboratively from written testimony concerning painting. One Augustan Age writer states his convictions unambiguously (Vitruvius *de Architectura* 5.5.2): "a painting is an imitation of an image of something that did or will or can exist." Granted this emphasis on probability, we should, nevertheless, understand that the employment of illusion aimed less at deceiving the beholder – ancient viewers were scarcely so naive – than at soliciting his intelligently critical recognition.[56] Allusion is a more appropriate term than illusion. As one scholar succinctly reformulates, "la théorie de la *mimesis* est un réalisme non de l'art, mais de la connaissance."[57] Yet even this validation of the individual figure is only a first step in cognitive response because the value and meaning of the simulated image is determined not only by its effectiveness in persuasion but also by its participation in a complex system of communications within its larger contextual scheme.

ANCIENT SOURCES

One may safely say that we would be less confident about the aesthetics of mimesis in Roman painting were it not for the insistence of ancient literary sources. Although our impression of ancient art inevitably depends on the character of surviving examples, our understanding of these has always been influenced by the kinds of ancient descriptive writing that has come down to us. In our effort to see paintings as their original audience might have seen them, the articulation of impressions and assumptions supplied by literary evidence, in spite of all practical limitations, remains a valuable source of guidance. The present-day reader should consider it not only for the information it provides but also for its role in the formation of analytical discourse within the art historical field.

To study the communicative function of wall painting, it is necessary to accept its physical remains as a partial "text" to be read in connection with whatever surviving texts of either a literary or a material nature can help us to reconstruct the fabric of everyday life. Especially our present-day perception of the images should be informed by written documents recording ancient social experience. However valuable this evidence may be, it does require interpretation because not only the information but also the points of view it embodies and its mode of presentation are affected by context. Interpretation challenges our conceptions of contemporaneous social life because it involves the identification and tracing of patterns so closely interwoven into this fabric as to be practically indiscernible. For this reason the study of painting is an aspect of social history.

Written source material in four categories is available to assist our consideration of Romano-Campanian

painting. Of these the most formal is ancient art history of which the chapters of the Elder Pliny's *Natural History* already mentioned constitute the chief exemplar. Art history of a kind also occurs in a brief passage in Vitruvius' *Ten Books on Architecture*, published during the Augustan Age. Apart from these directly pertinent and partially descriptive passages, information can be gleaned from historians or orators when their narratives mention customs or events with some bearing on art. The same is true when Cicero or the Younger Pliny mention relevant practical matters in correspondence. Finally ancient poems sometimes contain explicit descriptions of artworks. The tradition of such passages begins with Homer's *Iliad* and is perpetuated both for itself and as a deliberate echo of Homer. All four kinds of writing have their strengths and limitations as evidence.

Art histories and treatises on painting were not infrequently produced in the ancient world; some were written by practicing artists and others by philosophers analyzing the experience and the value of art. Naturally what the philosophers wrote accorded with the general structures of their philosophical systems. For Plato the mimetic aims that bind art to physical reality make it an inferior species of activity, whereas the writings of later philosophers more commonly framed their theories of perception with reference to the principles of their physics. Such, at least, we take to have been the case with the treatise *On Painting* written by the atomistic philosopher Democritus in the late-fifth or early-fourth-century B.C., which is a probable source for remarks on the visual effects of perspectival illusion ostensibly realized in Roman painting.[58] Neither this nor any other of the treatises specifically concerned with art survives in its entirety, but some sense of the information they provided has been transmitted indirectly through excerpts embodied in different contexts.[59] In the Roman world, this material was not only excerpted but also synthesized. The chief work of this kind was produced by Marcus Terentius Varro, a distinguished antiquarian and polymath, who lived during the late Republic. Varro's writing was, in turn, consulted extensively by the Elder Pliny, who is our chief extant source for the history of ancient art.[60]

We must approach Pliny with the understanding that he possessed no special expertise in the subject, save for his cultural legacy as an upper-class Roman, but this in itself is important enough to command attention. As a gentleman scholar he was driven by a passion for acquiring and transmitting knowledge to which he dedicated the greater part of his time. His nephew the Younger Pliny gives an affectionate picture of his uncle's disciplined lifestyle, which incorporated research into vir-

tually every waking activity of the day (*Ep.* 3.5.7–17). His characteristic method was to make extracts from multiple sources and recombine them into encyclopedic wholes. His compendiary *Natural History* was the most ambitious of all his projects: a useful compilation of knowledge intended as much for reference as for reading. Although he dedicates his work to the new emperor, Titus, who was his personal friend, he conceives of his primary audience as the ordinary man who lacks access to sources of knowledge.[61]

Certain conceptual assumptions can be seen to underlie Pliny's expressions of opinion. As several scholars have recently pointed out, the *Natural History* is characterized by its author's consistent scientific interest in the relationship between the natural world and man.[62] The relationship is a precariously balanced history of interactions wherein healthy progress in the creation of a civilized environment easily degenerates into the greedy exploitation of natural resources.[63] The visual arts figure naturally in this treatise because they involve man's employment of natural raw materials: the stones and metals from which sculpture is shaped or buildings adorned and the pigments used for mixing paint. The five chapters of the *Natural History* devoted to sculpture, metalwork, and painting describe the evolution of the arts, the innovative contributions and the works of significant artists, and the status of art in contemporary Rome, which Pliny considered sadly deficient. These five chapters show certain similarities that not only attest to their derivation from common sources but also reflect the ideas and purposes underlying them. These assumptions should be considered as an important influence on the presentation of the material.

The first of these assumptions is the conceptualization of any manner of historical writing as a history of progress. This idea may well have colored some of Pliny's sources. It is a commonly used paradigm of ancient anthropology, particularly associated with Democritus and the Epicurean view of civilized development. As Gombrich points out, the concept of progress has affected our view of the development of naturalism in ancient sculpture.[64] The concept pertains to painting as much as to sculpture and thus forms the basis for a history that commences with rough shadow tracings (35.15) and arrives at an ability to articulate the inner soul. Each individual painter of importance in this history figures as the discoverer or contributor of some particular characteristic to the common resources of art, until this evolutionary pattern reaches its culminating success in perfected naturalism. Following this, we see painters as the creators of individual refinements that make them competitors for honor within their own

contemporary societies. From this period come many of Pliny's often-cited anecdotes concerning the styles and personalities of painters. Because the history, and especially these anecdotes, place a particular emphasis on naturalism, it is often considered as the governing principle of Pliny's own taste. Perhaps this is so, but it is more instructive to understand that the expression of personal taste is not Pliny's chief aim. Rather he shapes a history that often incorporates popular responses into its narrative.

In attempting to systematize the history of painting, Pliny is working on two fronts; on one hand he provides a history of the origins and development of the art that inevitably focuses on Greece; on the other he discusses the fortunes of painting in Rome. Consequently we should be alert to the museological purposes of his account as well as to its prejudices and opinions.[65] Like all of the *Natural History*, the discussion of art aims to be of genuine practical value to readers who will find it most useful when they encounter sample works by an artist. Thus Pliny not only mentions the locations of artworks and the persons responsible for their placement, but also includes details needed to afford viewers an intelligent appreciation of works and their creators. These details range from biography to iconography. Their traditional and derivative character should not be held against them because they are intended to be nothing other than the standard offerings of a guidebook.

Pliny's museological orientation can also illuminate his disparaging remarks on the enforced obscurity of privately owned artworks and on painters who serve a single patron. Consistent with his pronouncements on the limited exposure of wall paintings is his comment that the works of one Fabullus, a painter of the Neronian period are "imprisoned" within the Golden House. These remarks not only distinguish past concepts from present, but also enter into an ongoing Roman moral debate concerning the social responsibility of art collectors. Potentates of the late Republic had become notorious for ornamenting their houses and villas – rural villas in particular – with the works of art they had collected during their foreign governorships and campaigns. "You really must hear," writes young Caelius Rufus to Cicero in 50 B.C., "that censor Appius Claudius is energetically making a wondrous inventory of [everybody's] statues and paintings"(*Fam.* 8.14.4: *de signis et tabulis*). Caelius invites Cicero to get a laugh from the fact that this vicarious washing down of contemporary indulgences is only calling attention to Appius' own venality.[66] Pliny attributes to Marcus Agrippa an oration urging that all paintings and statues should be shared through public display (*NH.* 35.26).[67] As a courtier of Vespasian, an em-

peror who drew heavily on Augustan precedent as the basis for his own politics of reassurance, the Elder Pliny not surprisingly shares in the Augustan spirit. Within the structure of his thought, private patronage is a manner of exploitation with artistic production as the vulnerable resource.[68] Even so he once admits, almost in violation of his civic principles, that the crush of *officia* and *negotia* surrounding artworks in public places are detrimental to serious study, which demands both leisure and silence (36.4.27: "quoniam otiosiorum et in magno loci silentio talis admiratio est").[69]

For a more technical view of wall painting as a feature of Roman life, we should turn to an earlier writer, the architect Vitruvius, author of the *Ten Books on Architecture* [*Libri X de Architectura*]. His own prefatory remarks indicate that he served as a military engineer in Gaul under Julius Caesar (*Praef.* 2). He dedicates his book to Augustus with praise of the *princeps'* current building campaign, which he aims to facilitate by the contribution of definite architectural rules. Vitruvius' "rules" express standards of taste and decorum, not mere mechanics. Nowhere are these standards more in evidence than in that chapter of his discussion of domestic architecture, which deals with the decoration of walls (7.5.1–5). Unlike Pliny, Vitruvius concerns himself with wall paintings as an integral aspect of houses and therefore as an accustomed product of patronage.

Here also we find a short history conforming to the concept of progress, but this one confines itself to Roman phenomena. Vitruvius' chronology of the initial stages is indefinite (7.5.1). Speaking of the initiators of decoration as *antiqui* (men of former days), he neither separates painters from patrons nor locates their positions in historical time. As we shall see, his discussion has proven controversial in its relationship to even the simplest paintings: those of the early period that, as he puts it, imitate pieces of marble in different juxtapositions. After this, as he points out, painters made such progress as to reproduce capitals and projecting cornices, a development that enabled painting to develop a mode of architectural illusionism. Henceforth there came a more varied repertoire and a code of decorum by which the determination of subject patterns or images was in some manner related to the nature or shape of the space to be decorated.

This coordination of spaces and patterns is one of Vitruvius' most intriguing scraps of information, but also among the most problematic. Some of the subjects he lists whose selection might be related to spatial context are landscapes, images of divinities, heroic subjects drawn from ancient epics, and designs imitating the decoration of the stage. All these meet his criterion for nat-

uralistic representation. In his opinion painting should offer recognizable images of actual or possible objects. By this standard he criticizes the decorative fashions of his own period for diverging from natural probability. At this point the architect turns moralist, changing his style of observation from narrative to polemic. To moralize the history of progress is an open invitation to hypothesizing decadence. So he complains that perversities have invaded design; proportions are ignored and nature is violated (7.5.3–5). The logical interrelationship between architecture and painting is no longer respected. Blame sits equally on the painters who indulge wayward fancy in creating such "monstrosities" and the patrons who have made artistic caprice into fashion through their encouragement.

Vitruvius' descriptions of artistic license have universally been taken as a confirmation of his Augustan dates and, by the same token, have corroborated the identification of the Augustan Age as a time when changes began to take place in the pictorial architectonics of the wall. In the historical discussion of painting, Vitruvius' few chapters have drawn no less attention than many celebrated passages of poetry within the history of their genres. Like a talismanic Golden Bough they give access to the realms of painting, but not without controversy concerning their practical points of reference. *Quot homines tot sententiae.* Many of the problems of interpretation taking rise from this text can be seen as the consequences either of a too-literal application or else a too-liberal one that stretches the evidence beyond its implications. In spite of its provocations and limitations, the *de Architectura* is an important visual witness to whose testimony my discussion will again and again have resort. No small part of its value is owing to the fact that its information is not confined to direct observations on painting. Instructions concerning the design and function of houses, while no less traditional in their outlook, embody social as well as personal codes and bear repeated consideration in their relevance to the house as a context for decoration.

The importance of Vitruvius and Pliny to the formation of Roman art historical discourse owes much to the surrounding void in which their sustained discussions exist. As I have noted, one of the conditions that require our constant piecing of scraps and hints to gain knowledge of Roman culture is the infrequency and spareness of descriptive writing in Roman literature. Nonetheless, we find some descriptions of artworks in Roman poetry, particularly epic and lyric. The artworks that epic incorporates belong to a world of heroic culture; they comprise public paintings, tapestries, tore-

utics, decorated shields – all of which play some role in the action of their poetic narratives. Although these roles highlight their fictional status clearly enough to prevent our searching for them among real objects, the continuous literary tradition to which such ekphraseis belong provides a background against which to identify innovations in style and taste that may be likely to reflect that of the author's own time. Beyond this, the rhetoric of literary ekphrasis as a narrative simulation of viewing is no less productive of insights into contemporary habits of experiencing and responding to art than Pliny's or Vitruvius' writings. Whereas the descriptions in epic are fictive, those in elegiac poetry and also in epigrams are more likely to refer to specific objects.

The descriptive epigram, a genre developed in Hellenistic literature, provides considerable insight into the process of viewing through its use of rhetorical techniques that approximate a spectator's interaction between the object and the reader. Many examples accompany dedications particularizing either the object or the place where delivered.[70] Others were composed as tributes either to an artwork or to an artist. Often the work itself, speaking with the voice of a personified subject, addresses the reader with instructions for viewing.[71] Instructions for viewing and interpretive information are even more common in prose versions of ekphrasis such as descriptions in Greek romances or the *Imagines* of Philostratus: a collection of bravura descriptions of the second century A.D. that showcases their author's rhetorical mastery for the declared purpose of teaching young persons what to notice and appreciate in painting. These texts generally adopt an aesthetic of mimesis as they focus the manner in which their execution effects persuasion of the beholder or else his wondering bedazzlement. The subjects have a way of assuming life and action within the text that often transforms the descriptive process into narrative. Although the student of decoration may find it frustrating that such concentrated attention on figurative painting bypasses contexts,[72] iconographical studies have found Philostratus' images particularly valuable in showing some of the classic postures for the representation of mythological subjects.

The chief value that all literary, non–art historical sources possess in common is their ability to show us works of art participating in contexts as they are perceived from contemporary points of view, and sometimes even undergoing active use. In this area, finally, lies the greatest fascination of Roman painting, not merely as an index of that elusive quality called taste, whose definition will always remain somewhat speculative, but also in its reflection of customs and institutions.

RECOVERY AND RECEPTION

Today's repertoire of Roman painting ranges from the moldered ceilings in subterranean vaulted chambers that were once showplaces of Nero's Golden House, known now for four centuries, to walls of Roman provincial houses lovingly reassembled like picture puzzles from small chunks of recently excavated plaster by restorers in laboratories throughout Europe and the Near East.[73] The possibilities of study are partially conditioned by the particular circumstances that have, at one or another period of time, surrounded excavation and publicization. Renaissance artists who first visited the Golden House did little harm save for inscribing their famous names on the ceilings and exposing the buried decorations to the air.[74] They did not see everything because they had no idea what was there to be seen, but also they took nothing away with them except for impressions and a few drawings, some of which, having been published, now comprise our most legible records of the site (Figure 1).[75]

Excavations in the Campanian cities Herculaneum and Pompeii, which began in 1738 and 1748, respectively, followed a quite different agenda. Their earliest stages proceeded amid great secrecy as a royal treasure hunt undertaken for the greater glory of the reigning Bourbon house at Naples.[76] Although the excitement of discovery manifestly surrounded the operation, bursting forth in encomiastic comparisons of anonymous ancient artists with Raphael, still excavators operating under the mandate to furnish a royal museum with objects worthy of his majesty's patronage, treated the actual buildings of Pompeii and Herculaneum with an impatient disregard for history.[77] Winckelmann deplored their carelessness, and Goethe after his first visit to the royal museum at Portici wrote, "It is a thousand pities that the site was not excavated methodically by German miners instead of being casually ransacked as if by brigands."[78] In the quest for objects that motivated the excavations, sculpture was valued above painting. With respect to wall painting, this royal purpose was most readily served by cutting figured panels from their settings to display them as independently framed pictures.[79] Given also the general state of knowledge concerning ancient art, the paintings thus recovered seemed to many less valuable for their own sake than as clues to the nature of lost Greek painting.[80] Readings in Pliny concerning the famous Greek painters were partially responsible for this prejudice, which the art historian Winckelmann did much to perpetuate by incorporating Pompeian painting into his aesthetics as accidental preservations that would be ordinary in comparison with the lost beauty of so many celebrated masterpieces.[81]

A point that the royal treasure hunters failed properly to respect was that figured panels never in any period constituted the total decoration of a Roman ambience. Rather these *tabulae* were framed within elaborately designed settings that structured the visual surface of the wall. The letter of an early traveler to Herculaneum who saw the actual underground context from which the heroic paintings of Hercules, Theseus, Achilles with Chiron, Pan and Olympus had been taken describes their settings:[82]

> The walls are painted in compartments in chiaroscuro, red and yellow. In the middle of the compartments are painted several pictures representing the combats of wild beasts, tigers surrounded with vines, heads of Medusa and Faunus, a winged Mercury with a boy supposed to be Bacchus; landscapes, fictitious and real animals, architecture, sacrifices, houses and other buildings in perspective.

As these settings and countless others crumbled during hasty excavation the indignation of scholarly and artistic onlookers began to be aroused. Letters from the Roman painter Carlo Paderni, sent to the Royal Society of London in 1740, contain one of the forthright notices by an Italian of how "grotesques composed of most elegant masques, figures and animals which, not being copied, are gone to destruction."[83] Because of his protests over the careless treatment of these figures, Paderni initially made himself unwelcome to the authorities, but two decades later when he had mounted into the curatorial position at the Royal Museum, he felt himself confronted by an overabundance of details and gave orders for all duplicate figures to be destroyed.[84] Nevertheless, enough were left standing in place to continue attracting visitors' attention. Recording his Pompeian visit of 1787, Goethe expressed less enthusiasm for the frescoes themselves than for "amusing arabesques in admirable taste" from which, in one instance, he saw "enchanting figures of children and nymphs" evolving. When he mentions how "wild and tame animals emerge out of luxuriant floral wreaths," his precision allows us to recognize the acanthus frieze decorations of the Temple of Isis.[85]

In their similar regard for individual images as components, rather than for entire settings, both Goethe and Paderni reveal attitudes that were typical of their time. Likewise, in the seven volumes of *Le Antichità de Ercolano esposte*, a traveling museum, as it were, of engravings with commentary, produced from 1757 to

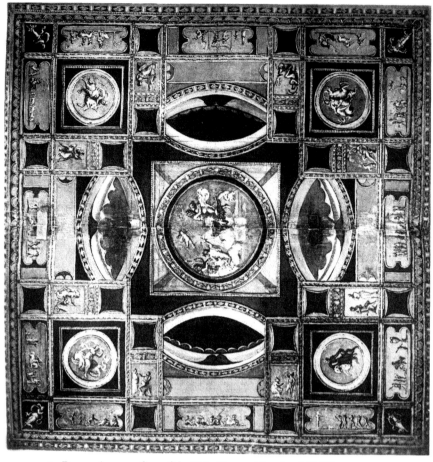

1. Domus Aurea, ceiling of the Volta Dorata. Drawing MDAIR 1935.764.

1779 under royal sponsorship to circulate the glories of Bourbon archaeology among a select European audience, these components were not neglected but rather utilized in the manner of decontextualized body parts to serve as ornamental headers and fillers in page design. In this manner the publications actually exploit the fragmentation that procedures of excavation and selection had produced. In prefacing the initial volume, the editor Ottavio Antonio Bayardi promises examples of "all the various tastes in painting whose memory resides in books." Every volume is to present a selection from each category of paintings.[86] Accordingly we see on one page a frieze of Bacchantes as the accompaniment to a painted tabula, while on other pages such figures as a caryatid, a peacock, a sea-centaur, a bowl of fruit, or a small landscape medallion bound off a segment of text (Figure 2). Medea, having lost her children in traveling from the excavations to the museum, and therefore misidentified as a suicidal Dido, stands framed by two tapestry border strips that seem not to have come from her wall (Figure 3). With greater thematic appropriateness, a small image of Eros driving a swan cart such as

we frequently see in predellae occupies the lower part of a page devoted to the panel painting of Eros delivering Polyphemus a billet-doux from Galatea (Figure 4). On some plates the illusionistic architectural perspectives that the Germans term *durchblicke* were presented as autonomous, free-standing compositions (Figure 5); others, such as the museums of natural curiousities so popular during the era, comprised random collections of decontextualized motifs (Figure 6).

Ultimately, although not until after the Bourbon monarchy had returned from its Napoleonic exile, that same fascination with totality that emerges from traveler's verbal impressions of Pompeii makes its way into visual publication as well. The transfer during the years 1807–22 of collections from the Portici Palace to a new Museo Reale at Naples called for a new form of publication. The sixteen volumes of the *Real Museo Borbonico* published 1824–57 were closer in format to a modern museum catalogue than was *Le Antichità*, but also contained in their comprehensive and detailed account of the Casa del Poeta Tragico one of the first attempts at the systematic exposition of the nature and function of

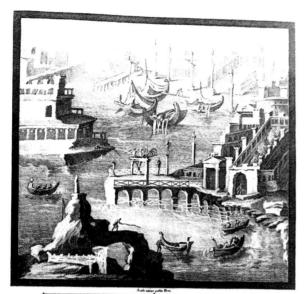

2. Page with landscape panels. *Le pitture antiche d'Ercolano e contorni incise con qualche spiegazione*, p. 173. Vol. I. Naples, 1759.

domestic spaces.[87] At relatively the same time, the discursive presentations of Sir William Gell attempted to recreate the culture of a living Pompeii for an English audience. Illustrations in his popular volumes ranged from reportorial drawings of excavations in progress to atmospheric reconstructions of populated rooms, such as the atrium of the House of the Tragic Poet (Figure 7). Above all the attractiveness of such images as a resource for the composition of new ornamental patterns proved responsible for bringing attention and appreciation back to their full contexts.[88] Goethe's account of his travels had publicized the charms of these fine figures among German audiences. In 1827, forty years after the poet's own sojourn in Campania, he was host to a young German artist, Wilhelm Zahn, who had sought him out in his eagerness to display the results of two years spent tracing and copying newly discovered paintings.[89] Although the subjects stressed in Zahn's own narrative account of the visit are figured panels, all the same his three volume *Die Schönsten Ornamente und merkwürdigsten Gemälde aus Pompei, Herculaneum und Stabiae* included a large number of full-scale walls.[90] In

the preface of the first pair of volumes, he writes of the "lively interest that his collection has inspired on a great number of distinguished artists and amateurs of the arts," and he speaks of the potentially formative influence of ancient taste on modern aesthetics.[91] By the late nineteenth century several designers had published drawings, often partially reconstructed, of some of the most complex and colorful walls.[92] Finally, after the political reorganization of the Italian states into a unified nation in 1862 had sparked an intensified awareness of Pompeii and Herculaneum as monuments belonging to a national heritage, new scientific standards of excavation were introduced. Once the scholarly superintendent Giuseppe Fiorelli had introduced a new policy of preserving paintings in situ, the resources for methodical study began to accumulate.

Such study has been essentially art historical in nature. In keeping with the scholarly disposition of the time, its first efforts set a high valuation on the witness of ancient sources and built their interpretations on this putative

3. Medea contemplating the murder of her children, misidentified as a suicidal Dido. MN 8976. Engraving from Herculaneum, *Le pitture antiche d'Ercolano e contorni incise con qualche spiegazione*, pl. 13. Vol. I. Naples, 1759.

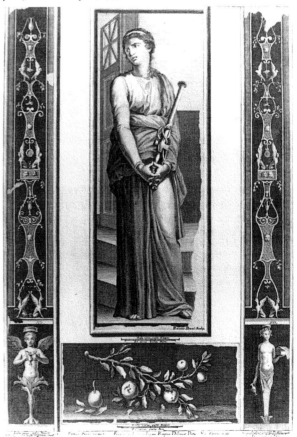

4. Eros delivering a letter to Polyphemus from Galatea. Engraving of a panel from Herculaneum. MN 8984. *Le pitture antiche d'Ercolano e contorni incise con qualche spiegazione*, p. 53. Vol. I. Naples, 1759.

authority. Consequently it was strongly influenced by the progressive orientation of Vitruvius' history of Roman painting. Among the phenomena scholars saw a need to explain was the great variety of compositional patterns ranging from flat, closed walls to those incorporating illusions of architecture and open spatial prospects. Eighteenth-century observers who noticed such differences ascribed them, outside of any chronological context, to the vagaries of individual taste. Thus William Gell remarked about the Casa del Fauno that the owner "liked mosaics and did not possess a painting," because he did not consider that the "vulgar and lurid imitations of marble" clothing the walls should merit this title.[93] By systematizing a framework of chronological interpretation based on Vitruvius' attestations of perspectival development, subsequent art historians provided a corrective to such subjective misreadings as Gell's and demonstrated that the decorative options available at any given moment observed certain guidelines of period fashion. Far from being impoverished substitutes

for "real paintings," such imitations of marble as the Casa del Fauno exhibited comprised the primary attraction in the decorative ensembles of the early first century B.C. Following an historically mediated classification, Pompeian painting could be divided into four major stylistic phases on the basis of its wholistic treatments of the surface of the wall. Alternatively these constructed its surface as a closed, confining background or laid open its visual field through the illusionistic simulation of spatial depth.

Under the names of First, Second, Third and Fourth Pompeian styles, these four phases have persisted until the present moment as the formal basis for the discussion and analysis of Roman painting. Their language is employed equally by scholars considering new discoveries and by the guides who conduct visitors through houses on the site. To the tourist on first impression, but no less to the student first approaching Roman painting who struggles to master their identifying characteristics amid a plethora of detail, these categories may seem to pose a formidable mystique. Small comfort is likely to be

5. Perspectival vista from a Fourth-Style architectural context. *Le pitture antiche d'Ercolano e contorni incise con qualche spiegazione*, p. 329. Vol. I. Naples, 1759.

6. Anthology of decontextualized motifs. *Le pitture antiche d'Ercolano e contorni incise con qualche spiegazione*, p. 173. Vol. I. Naples, 1759.

derived from knowing that their parameters have never lacked controversy.

As the first scholar to systematize the chronology of the four styles, the German art historian August Mau discovered a demonstrable correspondence between the historical development of building techniques and the sequential progression of compositional patterns.[94] That correspondence was further reinforced by the ostensible agreement between the evidence of pictorial chronology and Vitruvius' account of the development of painting from its beginnings until his own time. Nonetheless, these correspondences are limited ones that prevail only for the periods of the Republic and the early Empire when masonry can be readily dated on the basis of its components and facings. By the conclusion of the first century B.C. builders were adopting a more standard and uniform technique of rubble construction that makes distinctions more problematic.

7. House of the Tragic Poet restored. From Gell 1834. Vol. 2, pl. 37.

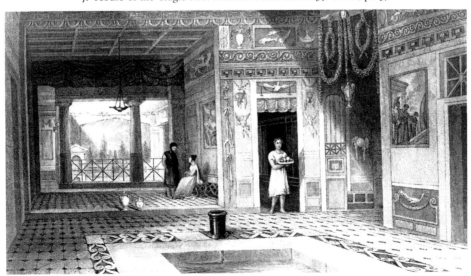

Because the conclusion of the first century B.C. is also the point at which the Vitruvian narrative terminates, the chronology and principles for discussing the art of the later Julio-Claudian and Flavian empire have remained open to scholarly ingenuity.

In his own approach to these questions, Mau based his stylistic rationale on the assumption that all patterns will have derived from foreign sources.[95] Such a premise was the virtually inevitable condition of the low estimate that his era gave to all forms of artistic production within the Roman world. At the same time he did not think that influences had flowed in a steady current from one and the same source. Instead he argued that models for the exiguous architecture and freely applied ornamentation that he associated with the middle Julio-Claudian period (late Augustan to about A.D. 50) had evolved from a pan-Mediterranean architectural style (Republican through early Augustan) by a separate process from that which provided the bolder, more decisively architectural, but no less elaborate fashion of the Neronian-Flavian years. Successive migrations from Alexandria and Antioch, respectively, resulted in period distinctions that he called by the only marginally explanatory names of Ornate (Third) and Intricate (Fourth) but characterized more explicitly with reference to spatial constructions.[96] Two decades later, another German art historian, Ludvig Curtius issued a first major challenge to Mau's chronology by his argument that the Fourth Style had actually followed directly after the architectural Second at Pompeii itself, so that paintings of the so-called Third should be assigned a later date.[97]

As excavation has continued to add new discoveries to the corpus of Pompeian painting, Mau's outline of stylistic chronology has prevailed by general consensus, but with many significant modifications. Although most contemporary Pompeian specialists are no less interested than their predecessors in dating, speculation concerning external influences and origins has yielded to an evolutionary approach. The majority now hold to the belief that the genesis of patterns is Roman. Within these parameters, however, the search for signs of coherent sequential development continues, with not only attention to the larger spatial effects of compositions, but also variations in fine detail frequently examined as the basis for microprecision in dating.[98] Behind this systematization one can perceive a standard model of progress, shaping the narrative in a manner analogous to the Elder Pliny's framework for the history of art. By some the model has been extended to incorporate aesthetic history of perfection and decline in the manner of Winckelmann.[99]

Although there is no denying that this technical and traditional approach can engross the specialist, the non-specialist may justifiably question whether it is the only basis on which a general survey of Roman painting can be constructed. The larger problem that troubles stylistic cross-referencing is its tendency to form a closed hermaneutic corpus in which examples are meaningful primarily in terms of each other, because it implies an intertextuality within the corpus that could only be achieved if each painter or workshop worked with a fully self-conscious awareness of the evolutionary progress of his art. Such a self-referential system works to reinforce, instead of thinning, the barrier of anonymity that distances the present-day viewer from the everyday Roman's response to painting. Not long ago a reviewer writing about one comprehensive study that traces the successive rise and decline of the four styles, expresses impatience with the dominance of this approach and fantasizes a history of the subject that would confine exposition of the style system to a few introductory pages "and would explore further the social function of decoration and the problem of iconographical reference which is connected with the role of patrons and artists."[100]

This challenge is at once appropriate and difficult to answer, for the construction of a socially oriented perspective in which to view painting inevitably raises questions involving historical contextualization. A worker does not begin to climb to the roof by kicking out the ladder. But to say that a diachronic masterplot is a prerequisite of cultural interpretation is not necessarily to posit that the narrative must always follow the same story line. For instance, Bryson, in his study of still-life painting, *Looking at the Overlooked*, writes theoretical spectators into his overview of the four styles as the basis for a cultural history of viewing. While stressing from a synchronic viewpoint the pervasive consistency of purpose with which painters exploit the illusionistic capacities of their art to replace real boundaries with fictional, he also considers in sequential perspective the variable effects of the well-recognized alternation of closed and open prospects in shaping the viewer's experience.[101] From this model one may think that the drawbacks inherent in stylistic chronology lie not in the general concept of succession, the validity of which remains demonstrable, but rather in the way that we allow this concept to dominate our interpretive perceptions. Instead of rejecting the system of the four styles by reason of their limitations or their overfamiliarity, one can productively consider what modification in our approaches to the system might bring its developmental narrative into closer coordination with aspects of everday life, patronage,

and the larger social environment with the possibility of bringing Mme. De Stael's long-awaited owner back home.

Such a revision of the developmental narrative is my purpose in this study. Although my approach remains generally diachronic, it engages stylistic chronology primarily in its interface with the large events that affect Romano-Campanian history and particularly the fortunes of Pompeii: the Pan-Mediterranean affinities of the Samnite city; its reconfiguration as a Roman colony in 80 B.C., its relationships with Julio-Claudian Rome, and finally its response to the damaging earthquake that sparked both rebuilding and repainting during the city's last two decades. While the locations of existing evidence will shift the focus of my narrative alternatively between Rome and Campania, it must always be remembered that Pompeii is its own place and not simply an appendage of Rome, with communal dynamics particular to its social organization. Within these parameters, my revision engages two interrelated cardinal principles that I can briefly introduce as spatial hierarchy and representational code, the first concerning the interior conformation of the house, the second its communicative address to the viewer.

As will be seen in the following chapter, the arrangements and proportions of rooms within ancient houses observe an order that can be understood in relationship to their function within a specified set of activities. The interrelationship between function and location produced house plans that combined a few standard features with a high degree of flexibility. Within such a framework, as Daniela Scagliarini has famously shown, the practical positioning of rooms as spaces of open or controlled access, as passages, or as backgrounds for stationary activity had a critical bearing on the choice of decorative patterns. With flexibility came each owner's options of individuality, and also the need for a clear communicative code of spatial definitions. Through visual coding the proprietor makes social discriminations and controls access to his property. A visual code gives signals to the spectator that indicate not only the action

he is expected to take within the spaces, but also the status of his activity within a hierarchy of functions. The decoration of spaces indicates the degree of privilege that a person's admission to them confers. This principle, which will be treated at greater length in succeeding chapters, is a synchronic one that persists across the chronological mutations of style.[102]

Although the visual effects of spatial coding are readily accessible, they are only half of the story, whose full meaning involves the particular identity of the images that make up their communicative vocabulary. Like the language of literary representation, that of pictorial codes conveys its messages by mediating between the immediate situation and a larger context, in this case the domestic environment that plays host to its owners' social rituals and the larger community of customs to which these ceremonies are relevant. Thus the mimetic energy of painting draws on models from the larger culture within which its fictive constructs have a real existence. Although the visual effects of decorative fictions transform spaces, their simulated reality aims beyond merely deceiving naive viewers. Rather these models furnish the language of the codes in which painting communicates.

By integrating historical and semantic approaches to painting, in this book I track the formation of the codified language of painting by identifying the process by which each model enters into its pictorial vocabulary. This generally occurs the moment at which the cultural associations of the model are strongest and most firmly grounded in social practice. From this perspective the history of painting will appear as a parade of images, whose adoption can be seen in relationship to the social climate and conditions of their times. These images are ashlar masonry and marble veneer, the *porticus*, the stage facade, the garden and, most persistently, the picture gallery.[103] Belonging both to the public world and to the world of luxury, these images form the principal components of the figurative spatial coding that links the individual owner's domestic environment with the public world.

Domestic Context

AINTING WITHIN ROMAN HOUSES OWED ITS IMPORTANCE TO A dynamics of social usage involving a series of activities quite different from those that normally take place within the houses of today. Ultimately the study of paintings should increase our ability to envision this social dynamics in context, but first we must consider what spaces for activities the physical structure of houses provides. The question is closely linked with the relationship between the domestic interior and its exterior context, between "occupants and outsiders" to borrow the terms of a theoretical discussion.[1] Although Roman houses contributed no less essentially than our own to defining the identity and integrity of their families, these houses functioned less significantly as a retreat for the private life than as a showcase for the public life.

In this respect Romans differed from us even less than from the Greeks, who kept their houses closed to all except their familiar associates. While the public spaces of the *polis* comprised the area within which the male citizen, the "political animal" as Aristotle called him, spent the largest proportion of his time, his enclosed *oikos* protected domestic integrity by secluding the female members of his family and their household occupations within a realm of paternal authority.[2] While contributing only one voice among many to decision making in the public sphere, the citizen had nearly absolute power over the autonomous state that his *oikos* constituted. Only his invited associates

might occasionally pass by that symbol of masculine dominance, the guardian herm at the door, to assemble in the masculine preserve of the andron for the sociability of the symposium.[3]

While pebbled or figured mosaic carpeted the andron – and provides the sign by which today we can identify it – other areas of the Greek house seem never to have achieved the decorative complexity of Roman houses, at least not in the heyday of democracy.[4] We might ascribe the difference to differing conceptualizations of the relationships between the authority of a paterfamilias and the employment of domestic space. Rather than enforcing his domestic authority by exclusion, the Roman enhanced it by making his residence into a visual framework for his civic status.

Naturally civic space also provided Roman aristocrats with a communal theatre in which they played out their institutionally defined roles, but the drama did not end with the Forum and law courts. At Rome the spaces of the city housed the institutions of government but not the individuals. Closely identified with the public image of its owner, the house entered into the service of political activity and advancement as the seat of individual prestige. At all stages of his career the house belonging to a Roman of political consequence served both as his chief legal office and as his social salon. The domicile of a celebrated jurisconsult, as a speaker in Cicero's *de Oratore* 1.45.199 remarks, is *totius oraculum civitatis* ("a source of wisdom for all the state").

Links between a man's public image and its domestic frame were not subjective but publically recognized at Rome. Conspicuousness was desirable; here again the Roman differed from the democratic Greek.[5] "My house," declared Cicero in an oration, "stands in view of almost the entire city" (*de Domo sua* 100). As he argued upon returning from exile, his deprivation of this house through the machinations of his enemy Publius Clodius was as much of a disgrace to the *res publica* as it was a source of shame and grief to him (*Dom.* 147). Earlier in the same speech (38.101) he had listed some of history's notorious offenders whose houses had been destroyed as a part of their punishment.[6] Many years later, in *de Officiis* 1.139, Cicero advises on the decorum of the relationship between owner and house with the implication that a properly appointed house can even contribute to a candidate's political success. A house should enhance the *dignitas* of its *dominus* (master), but he must be careful that it does not exceed his dignity, for, in the last analysis, the *dominus* ought to distinguish the house and not the reverse (140: "nec domo dominum, sed domino domus honestanda est").

In this same passage of the *de Officiis* Cicero urges that owners should give attention in planning not only to their own requirements but also to those of other persons. Spacious quarters are requisite wherever many guests must be received and a multitude of persons of various ranks and conditions must be admitted. Vitruvius (6.5.1) might well be echoing the orator's own prescription when he sets forth a hierarchical correlation between space and professions.[7] Ordinary men do not need reception areas – vestibules, atria, *tablina* – in the grand style because these men discharge their social obligations by visiting the houses of other men. Among those who receive visitors, bankers and tax collectors need housing that is commodious, somewhat showy (*speciosiora*), and secure from entry; persons of primarily forensic or judicial occupations require both elegance and space to accommodate their hearers, but magistrates and office holders, whose houses witness affairs of public importance, must have settings of virtually regal grandeur: lofty entrance areas, atria, and expansive peristyles, with tree-stands (*silvae*) and walkways, not to mention both libraries and basilicas comparable to those of the public world.

Such interiors did not merely accommodate visitors; they demanded them. No less shame attaches to an inadequate house, Cicero declares, than that which attaches to an ample one that is empty of visitors. As his brother Quintus reminds him in a treatise written to advise his campaign for the consulship, the house of a consular candidate should be filled even before daylight with crowds of persons from all segments of the populace (*Comm. Pet.* 50: "domus ut multa nocte compleatur, omnium generum frequentia adsit"). The succession of visitors whom the *dominus* greeted throughout each day ranged from dependents to peers. Although the several kinds of ritualized activity to which various areas of the house were accommodated involved different social classes and took place at various hours of the day, *all* of these were relevant to the public life. Therefore, one should not think of the house as a setting for single activities, but rather for a structure of interrelated activities that also entailed spatial interrelationships.[8]

In virtually all societies, the perceptible order or "syntax" of spaces within a dwelling or residence evidences a relationship with a prevailing social ideology.[9] As comments from Cicero and Vitruvius indicate, Roman upper-class society had developed a particularly self-conscious theoretical articulation of its spatial ideology, to which scholars of recent years have frequently

had reference in order to render the physical remains of Campanian houses accessible to reading.

When Andrew Wallace Hadrill discusses the functional architecture of houses, he speaks of "exposing the rhythms of social life that underlie and are implicit in the physical remains."[10] Explaining the significant axis of spatial dynamics within the Roman house as dividing a public preserve from a private, he invokes the distinction Vitruvius makes between the places that are *communia,* or open to all comers, and others that are *propria patribus familiarum* (6.5.1). As an aspect of cultural difference, this notion of containing a consistently utilized public space within the house has proven fascinating to modern scholars, possibly because of its contrast with the Victorian bourgeois parlor off the main route where the "best furniture" sat awaiting rare ceremonial occasions.[11] Even without mohair sofas, however, the sharp divisions between public and private activities as mutually exclusive to which we as contemporary householders are accustomed can easily obstruct our understanding of Roman spatial usage. As a basis for studying mural decoration in situ the essential conceptualization of public and private needs further refinement. Although it is only logical that rooms comprising the central core of the house should be public reception rooms intended to make their impression on a diverse spectatorship; nonetheless, material evidence found in many houses of a more or less traditional plan would seem to indicate that such core spaces were by no means reserved for exclusively formal use. Furthermore, it remains that a major proportion of space in actual houses is given over to side chambers and to rooms less centrally located where conditions regulating access are less obvious. For the investigation of such spaces, Vitruvius' large conceptual prescriptions are only marginally useful. Authoritative as his categories and canons of measurement and proportion may appear to a reader, when put to the test of correspondence with the plans of actual houses in Pompeii, they fall short of encompassing the diversity of the evidence.[12]

Similarly many prescripts of the Vitruvian canon fail to be matched by corroborating notices in Latin literary texts.[13] Reconciling semiotic markers with social practice is a further challenge in understanding the spatial syntax of Roman houses.[14] For this purpose spaces need to have names that associate them not merely with architectural design, but also with everyday use. Although the nomenclature that the *de Architectura* provides has long served as the basis on which designations of spatial function and hierarchy within Roman houses are based, its definitions fall short of populating domestic spaces with inhabitants and filling them with appropriate images of activity. In our quest for information to supplement or correct the categories and definitions in Vitruvius' architectural manual, Latin literary texts offer an underutilized resource. Among the additional literary materials sometimes enlisted in reconstructing the function of domestic spaces are explanations in Roman antiquarian writings such as dictionaries, etymologies, or commentaries. Often the occurrence of a word in such a context indicates some manner of cultural slippage. Thus the second-century antiquarian Aulus Gellius, commenting upon Vergil's employment of *vestibulum* as a term for the entrance space of a building, remarks that its meaning has altered so greatly from its original specification that his own contemporary audience may not understand how to picture it (*Noctes Atticae* 16.5.1–2). Such explanations may or may not be accurate but will usually embed earlier material of an explanatory kind.

Less frequently enlisted but more relevant to actual life, is the indirect evidence to be gleaned from the glancing references and allusions of everyday discourse. It is one thing for Vitruvius as architect or for a lexicographer to prescribe or explain something in a formal and seemingly standardized terminology, with the possible consequence of distorting real practice through oversystematization; it is a different matter for persons to mention something in ordinary speech or writing that both they and their audiences take for granted. Naturally the most productive sources of such unsystematic evidence are those that actually dwell on the routines of daily life: letters, satirical writings, and biographies. Such references to activity, although often less visually specific than we might wish, are among the best indicators of the character of rooms in use as well as their placement and the categories in which these were regarded by owners and builders. When Horace, in *Epistle* 1.5.30–1, urges the addressee to accept a dinner invitation ("Slip out the back door and leave your client keeping his eye on the atrium" ["rebus omissis/atria servantem postico falle clientem"]), we find in the first place confirmational evidence that it was customary for Roman notables to receive their dependents in a front room of their houses. Beyond this, Horace's irreverent attitude toward duty is a comment on custom itself. The way in which any and all literary genres incorporate the names of domestic spaces often conveys a good sense of the symbolic value attributed to them as well as their practical use. Making use of a combination of material evidence and textual insights, we can embark on an exploratory survey of the names and functions of Roman domestic spaces.

SPACES OPEN TO ALL VISITORS

Atrium

While Horace jovially urges Torquatus to neglect duty and abandon his client watching the atrium, the philosopher Seneca calls such conduct derelict (*de Brevitate Vitae* 14.10.4). Both have in mind the Roman senator's ongoing reception of calls from clients to whom he dispensed advice and favors in return for their political support. So essential to the practical workings of everyday politics did some Romans consider the mutual benefit system of patronage and clientship that they placed it among the oldest institutions of their society as the invention of Romulus himself.[15] Seneca (*de Ben.* 6.34.1–5) traces the custom of morning visits back to the late second century B.C., when he attributes its formalization to C. Gracchus followed by Livius Drusus, the senator whose house Cicero was to purchase at the end of his consulate.[16] If participants deemed this combination of business and ceremony essential to the practical maintenance of influence and power, they valued it equally as a symbolization of that power. Cicero spoke of his following as the *turba salutationis matutinae* (*ad Brut.* 2.4.1). Into such a morning crowd, he alleges in his first Catilinarian, Catiline had sent assassins to strike the first blow of his conspiracy, but vainly, because the prescient consul knew who they would be and shut them out on arrival (*Catil.* 1.4.10).

Customarily, as Cicero describes it in *Att* 1.18, the crowds that gather early will later escort the patron to the Forum. Although he grumbled when such ceremonies followed him to his villas, subtracting time from intellectual pursuits (*Att.* 2.15.2), and professed relief at seeing his callers depart (*Fam.* 7.28.2), we can be sure that being so much in demand gratified his self-esteem. Thus he frequently mentions the morning *salutatio* in letters from the period of Caesar's dictatorship, although with a rueful notice of sadness on the part of the *boni* and high spirits among Caesar's partisans (*Fam.* 9.20.3: *laetos victores*). These new circumstances, however, could also invert a patron's role. In a letter to Ligarius of 46 B.C. Cicero represents himself going as a morning visitor to Caesar to urge the pardon of Ligarius with reinforcement from his correspondent's brothers and kinsmen who throw themselves at the dictator's feet (*Fam.* 6.14.2). Gaining this interview was no simple matter but demanded sufferance of *indignitas* and *molestia*.

In spite of changes in Roman government, the *salutatio* persisted as a sign of influence from the Republic through the Empire. Thus Aper of Tacitus' *Dialogus* invokes its traditional ceremonies to describe the gratification of oratorical success. (*Dialogus* 6: "What could be more gratifying to a man of free and honorable spirit and one born for noble pleasures than to see his house always full and crowded with an assemblage of the most illustrious men [*concursu splendidissimorum hominum]*?") Its transactions, while nominally political, will surely have included the various monetary interests that senators would seem to have pursued indirectly through their client connections without taking a visible part.[17]

The spatial framework for these morning visits was provided by a complex of rooms clustered around a broad central space at the front of the house. Sometimes called a *cavum aedium* with reference to its capacious nature,[18] this area commonly went by the name of atrium with a certain ceremonial flavor attached to the word. By the time of the Republic the Romans were uncertain how this traditional space had originated or evolved, but they liked to stress its links with the past, regarding its status as a combination of symbolism and practicality.[19] Cato believed that Roman ancestors used the room for dining (Servius, *ad Ae.* 1.726). Some derived the name itself from Etruscan background, a manner of assigning particular venerability to any institution. Vitruvius considered the space uniquely Roman (6.7.1). The Greeks, as he says, have no use for atria which, in consequence, they do not build. Along with its forecourt, the *vestibulum* the atrium has frequently mentioned counterparts in public buildings. In proposing public functions for the series of atrium buildings with *tabernae* on their facades that were constructed around the Cosan Forum between the years 197–80 B.C., Richardson reminds us of early Roman buildings: the Capitoline *Atrium Publicum* where records were kept, the *Atrium Libertatis* where the censors performed their operations, but additionally the *Atrium Sutorium* of the shoemakers and the old *Atrium Maenium et Titium,* an early Forum building with shops.[20] The imposing decorations to be seen in many existing atria enforce the analogy between these areas and public spaces.

Vitruvius' description has commonly been accepted as the key to the names of the member spaces adjoining the atrium (6.5.1). The names he gives are *tablinum, alae, fauces.* With his traditionalistic leaning toward the alliance of formal design with ceremony, he designates a set of canonical proportions for the size of these rooms and their fixtures, including doors and *compluvium*. The height of the atrium should be calculated in proportion to its width, and the dimensions of *tablinum* and alae were to be determined by formulas based on the length of the atrium. In recommending such proportionate

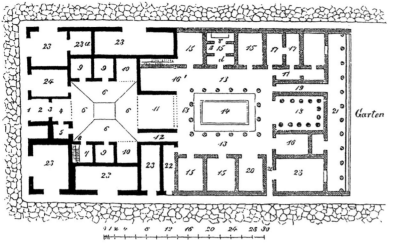

8. "Plan of a typical Roman house," Overbeck 1884, 247, fig. 135.

dynamic centers on what might be called a Greco-Roman axis. The mature house comprises two architectural centers joined together: at the front the *cavum aedium* complex serving the purposes of reception and behind it a peristyle complex, which to his mind was developed under Greek influence and represented the portion of the house dedicated to cultural and leisure time activity. He attributes a deliberately Hellenistic ambience to such rooms by emphasizing the Greek derivation of the names – *triclinium, oecus,* exedra, peristyle – as opposed to the Roman words atrium, *tablinum, alae,* and *vestibulum.*[23]

Although neither Mau nor Vitruvius mentions it, scholars have noticed a particular axial orientation in the symmetrical disposition of rooms on Mau's Vitruvian ideal plan, which they have incorporated into their vision of the manner in which the rooms were used.[24] When considered in the abstract these spaces do appear to intersect one another in a highly ordered design and to shape the viewer's experience accordingly. As a person proceeded through the narrow passage leading into the house from the street, his vision would effectively be channeled across the large space before him toward the far end of the large room where the exedra-like space of the *tablinum* completed the room. With its aperture ordinarily framed by pilasters or columns, this room stood

formulas for houses in the same manner as for public buildings, Vitruvius believes that he is observing the Greek concept of a proportional canon (6.2.1). With symmetry as his guiding principle, he aims to impress harmony (*aspectus eurhythumiae*) on the spectator (6.2.5) and seeks to negotiate a balance between convenience and beauty.

Specific as Vitruvius' instructions may be concerning the aesthetic effects to be produced by these spaces, he gives no precise information about their physical interrelationship which, presumably, he can count on his contemporary reader to understand without explanation. In the desire to fill out his partial image, archaeological interpreters have supplied these interrelationships inferentially with specific reference to the houses of Pompeii at the same time that they have relied on Vitruvius for the identification of rooms. The practice dates back to the very early days of excavation.[21] Our modern didactic equivalent of the architect's diagram is the "typical plan" drawn up by the German archaeologists of the late nineteenth century Johannes Overbeck and August Mau: a schematic common denominator representing no one house exactly but the features common to many[22] (Figure 8). In *Pompeii: Its Life and Art,* Mau presented this plan in a historical perspective as representing a cumulative stage in the evolution of the dwelling, which had begun in a most simple and basic manner and been amplified with an infinite variety of appendages. His concept of spatial

9. House of L. Ceius Secundus, facade with bench. Author's photograph (su concessione del Ministero per i Beni e le Attività Culturali).

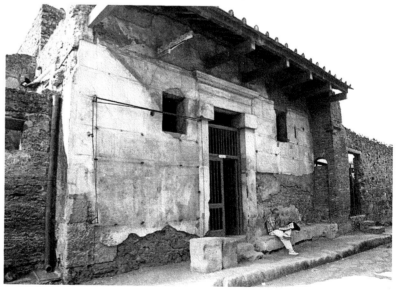

as the center of a symmetrically ordered pattern. The lateral walls of the atrium were usually interrupted by one or more pairs of symmetrically placed doors. The balanced effect was usually continued at the rear of the room by symmetrically placed wings, the alae flanking the *tablinum* in a T-shaped pattern. If the *tablinum* stood open, the vista might be completed by a framed prospect of the columns within the peristyle.

Certainly this impression of ordered formality strikes the modern visitor confronting the empty, imposing spaces of Pompeian atria, but a transfer of this perspective to the morning *salutatio* can greatly mislead. A realistic view of this so-called ceremony will recognize that its atmosphere was unlikely to have been quiet and restrained.

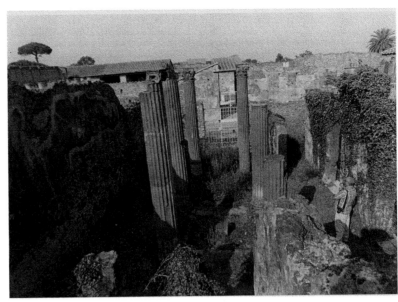

10. Casa dell'Argenteria, *vestibulum*. Author's photograph (su concessione del Ministero per i Beni e le Attività Culturali).

Even the exterior spaces leading into the atrium will have been full of waiting clients, milling about and conversing, all with their own personal objectives to pursue. Arrangements for the admission of clients to the atrium would seem to have differed somewhat between Rome and Pompeii. Roman authors from Republic to Empire speak of the *vestibulum* as the space where clients gathered.[25] From Vitruvius' mention of the word we may consider it as a normal appurtenance of the aristocratic house; yet lacking direct physical evidence, we must attempt to envision it from literary testimony.[26] Where houses were set back from the street, as those in the senatorial district of the Palatine will have been, the *vestibulum* was an area left vacant before the door that was often partially enclosed by neighboring walls.[27] Public buildings such as temples and the Roman senate house had such entrance spaces. Their domestic counterpart is closely linked with the public world. A number of popular etymologies for the name *vestibulum* touch on the function, some of these related to the practice of standing and others to its "dressing" the door. The fact that Cicero uses the word in a figurative comparison to refer to a suitable beginning for an oration stresses this aspect of decorum (*Or.* 2.320).

Although a number of large Pompeian houses have grand portals with double-leaved doors corresponding to literary descriptions, only a few show any semblance of a formally designed waiting area that can be identified as a *vestibulum*. The majority of houses gave access to the atrium directly from the street through a narrowed passage that a doorkeeper will often have guarded in his small side room. It is not unlikely that the difference between Pompeian and Roman structures may have owed simply to differences of weather, with the warmer Campanian climate encouraging a more exteriorized style of interactions, many of which, in the style of stage comedy, were played out in the street. On the sidewalks outside some large Pompeian houses we see benches flanking the grand exterior portals that may have accommodated waiting clients, although not in great numbers at any one moment (Figure 9).

Mau, while acknowledging the infrequency of *vestibula* in Pompeii, did apply the term to a number of spaces. Some were token spaces, although elegantly decorated, such as the broad passageway with its three-dimensional frieze decoration of colonnaded facades leading into the Casa del Fauno.[28] At the Casa dell'Argenteria (6.7.22) on the Via di Mercurio a pair of Corinthian columns inside the doorway placed on axis with the Ionian columns of the *impluvium* separates a lobbylike formal entrance space from the interior of the tetrastyle atrium (Figure 10).[29] The doorway of the House of Epidius Sabinus (9.1.20) opens from a rectangular podium extending almost the entire length of its facade that is raised above the level of the sidewalk by several steps (Figure 11). Beyond the facade and outer door was a little lobby preceding a second door (Figure 12).[30] This exterior space was shallow and will have been unroofed. Its form resembles the entrance to the chamber of the *decuriones* in the Forum.

Two other versions of the demarcated entrance space were perhaps more similar in form to the Roman style.

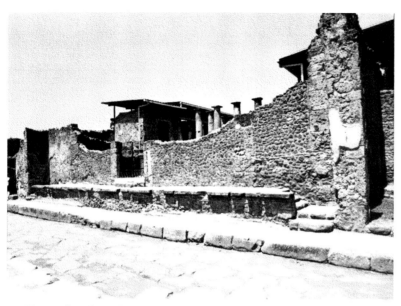

11. House of Epidius Sabinus. Podium and *vestibulum*. Author's photograph (su concessione del Ministero per i Beni e le Attività Culturali).

Mau recognized the remains of a former vestibulum before the entrance to the Casa delle Vestali where the original form gave a shedlike space matching the atrium in breadth that separated the house from the sidewalk. This appears very similar to spaces Cicero mentions, such as the *vestibulum* of Tettius Damion, where he took refuge one evening from a sudden attack by Clodius' gangs who began to pursue him down the Sacra Via armed with "stones, stakes, and swords" (*Att.* 4.3.3). A more spacious Pompeian example exists in the House of C. Julius Polybius (Figure 13).³¹ This was a covered room off the street from which the narrow corridor led into a fully appointed atrium deeper within (Figure 14).³² Because both this entrance space and the atrium beyond it were handsomely painted in the earliest Pompeian style, we may assume that they had long been regarded as a complementary pair. The decorations of the entrance room are particularly imposing with a simulated loggia in the upper gallery recalling the architecture of the public world. When Vesuvius erupted, this vestibular space was in the process of renovation with the ancient paintings doomed to replacement. Although we cannot be certain what the original condition of this area was, in current form it may appear as a version of the Roman plan. The prominent position of the house on the busy, commercial Via dell'Abbondanza strongly suggests that it had always belonged to an owner of political consequence. During the early 70s it housed a politically successful descendent of an imperial freedman, whose well-documented career provides illustration

of the power such well-connected individuals could acquire.³³ He was aedile during the 60s and progressed to the office of duovir in company with a colleague of aristocratic background. Electoral programmata indicate that he had a large clientship among whom were the *muliones* and the bakers.

Once clients came into the atrium itself, they will have encountered a lively scene. The proverbial condition of an influential aristocrat's atrium is crowded (Seneca *Ep.* 76.11.6: *atrium frequens*) Cicero writes to Atticus from Formiae that he seems to be keeping a basilica instead of a villa (*Att.* 2.15.2). Thus Ovid, with a reflection of the senatorial houses of the late Republic that lined the streets leading up the Palatine pictures the atria of the Olympian gods overflowing crowds from their great doors flung open (*Met.* 1.168). Similarly Seneca (*Consolatio ad Marciam.* 6.10.1) speaks of atria crowded to the point that even the *vestibulum* is packed with those still shut out. In another essay he pictures the visitors received in three categories, some privately, some in company with select others, and some en masse (*Ben* 6.34.1–5). *Turba* and *caterva* are the words he uses to describe the throng, characterizing the atrium as a place "full of persons, empty of friends" (*hominibus plenum, amicis vacuum*). Conversely, as he pictures it, an "empty atrium" and an "unaccompanied litter" are the condition of those who have forsaken the ambitious life (*Ep.* 22.9 1). Status has its obligations and the epitome of self-indulgent decadence is the man who avoids crossing his own packed atrium (*atrium refertum*) and deceives the waiting crowd by leaving through a secret rear door (*de Brevitate Vitae* 14.10.4).

Nor were the occasions on which visitors packed the atrium exclusively political. When the body of Publius Clodius was brought home from the Via Appia, a multitude of lamenting slaves and *plebs infima* crowded about the atrium where Fulvia incited even further indignation by showing her husband's wounds. On the following day the crowd was larger still and included even a few persons of consequence (Asconius *Mil.* 28.19). In Statius *Silvae* 1.2.48–49, a congratulatory wedding poem for the young aristocrat L. Arruntius Stella, and the prosperous widow Violentilla, the atrium is aboil with guests. The large crowd that assembles around the door in the most frequented area of Rome (232: *pars*

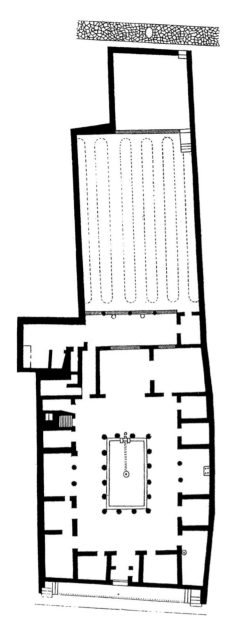

12. House of Epidius Sabinus. Plan after Overbeck 1884, 298.

entire wall. Rather than being organized around focal centers that need to be seen from a vantage point, atrium decoration tends to be paratactic. We can best appreciate this tendency by thinking of houses in which full decorative programs remain extant; and especially those of the Fourth Style in which relatively simple compositions in the atrium contrast with ornate schemes in other rooms. Typical decorations of this period segment the wall in large panels framed or varied by patterned dividers. Two houses not too far removed from each other in their decoration dates provide good examples of differing kinds. Atrium walls in the House of M. Lucretius Fronto (Region 5.4.11) consist of black panels with variegated borders that might simulate tapestry hangings or marble inlays (Figure 15). Red panels in the Casa del Menandro (Region 1.10.4) alternate with pilasters broken by apertures giving glimpses of leafy branches somewhere outside. A figured frieze surrounds this atrium at a height where its landscapes and other images could be easily perceived above the heads of the crowd. Similarly in the Casa di Nettuno (6.5.3) the central zone of the wall is covered with a display of large red

13. House of C. Julius Polybius, *vestibulum*. Author's photograph (su concessione del Ministero per i Beni e le Attività Culturali).

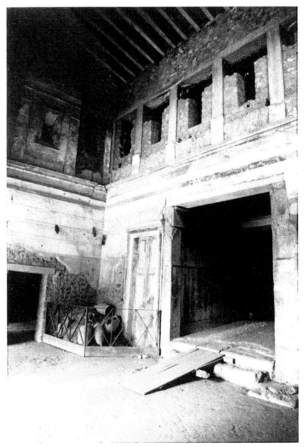

immensae . . . celeberrima Romae) intermingles senators and plebeians, equestrians and women.

In view of the normally crowded state of the atrium, the direct axial line of vision from entrance door across the *impluvium* to the *tablinum* and peristyle that modern visitors find so impressive was probably less clearly visible to the morning visitor at the Roman house than today's empty spaces have led us to assume.[34] Looking at the compositional patterns of the paintings that decorate Pompeian atria we can imagine them well adapted to serve as the background for crowd scenes, for constant coming and going and jostling that will scarcely have afforded spectators an uninterrupted view of any

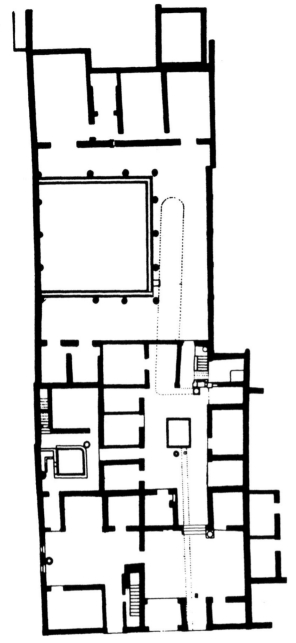

14. House of C. Julius Polybius. Plan after de Vos and de Vos, 1976.

tapestries ornamented with floating figures, and a series of mythological paintings relating to the Trojan War are to be seen in the frieze zone (Figure 16).[35]

While clients waited they had the opportunity to contemplate not only painted designs but also the prestigious background of their patron made visible by a number of symbolic reminders. Roman writers often mention the displays of ancestral portrait masks (*imagines*) that dignified the room as a gallery of family achievement.[36] Through the eyes of the Greek historian Polybius

we understand the essentially Roman nature of the custom along with the strongly impressive physical presence of the *imagines,* whose inspirational challenge to family members was also highly reputed (Polybius 6. 54.2–3; Sallust *Jug.* 4.5–6). Early portraits, Pliny the Elder maintains, were not luxury items of stone or bronze, but actually molded (*expressi*) of wax (35.6). Whereas Pliny has these located in or on cupboards (*in armariis*), Vitruvius situates them, like painted friezes, at a level of visibility (*alte*) over the heads of the crowd.[37] At a later period, as Pliny relates, clients also began to place honorary statues of their patrons in the atrium (*NH.* 34.17.5). Scholars have often expressed disappointment because no Pompeian atrium excavated has ever yielded a series of such portraits nor even shown places such as niches or pedestals clearly intended for their display.[38] The closest approximations to the frequently mentioned custom are single portraits of family members, such as the herms flanking the *tablinum* entrance in the House of Caecilius Jucundus, or in some cases imperial images or those of admired persons.[39]

Not only ancestral portraits but also other features of the Roman atrium symbolized the context of family associations. It was commonly the location of the principle household shrine, the *lararium,* where ancestral spirits were honored in company with the genius of the living master. Extant examples range from standing altars to symbols of Lares and serpentine genii painted on walls. Frequently Pompeian atria contain an ornamental table, the *mensa,* representing family subsistence (see Figure 15). Because this room was thought at one time to have constituted the chief residential area with the *tablinum* serving as the bedroom of the *dominus,* a symbolic *lectus genialis* may sometimes have stood in this space.[40] Another gesture toward ancestral *mores* might have been intended when occasionally a loom stood in the atrium, for it was the proverbial mark of a capable matron that she worked with wool (*lanam fecit*).[41] Although the image is most celebrated in association with the legendary Lucretia, historical instances corroborate both the practice and its symbolism. From Asconius (*in Milonianum* 38) we hear that a lady of exemplary virtue (*cuius castitas pro exemplo habita est*), Cornelia, wife of the triumvir M. Aemilius Lepidus, wove cloth in her atrium in the old-fashioned manner (*telas quae ex vetere more in atrio texebantur*). Nearly every feature of the atrium played a part in forming an impressive context for the current owner that emphasized a close link between public and domestic life.

What happens, however, when the client reaches the *tablinum* which is commonly represented as the goal of his visit? Literary sources other than Vitruvius yield

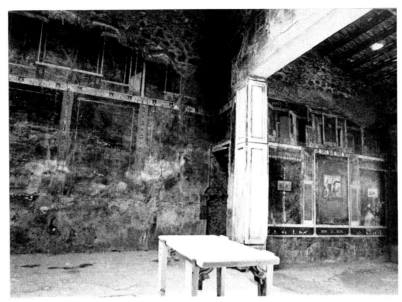

15. House of M. Lucretius Fronto, atrium and *tablinum*. Author's photograph (su concessione del Ministero per i Beni e le Attività Culturali).

surprisingly little testimony to reinforce the architect's seemingly authoritative descriptions of *alae* and *tablinum*. In the first place, the contexts in which the word appears are antiquarianizing. Pliny speaks of the *tabulinum* as a family record room containing *codices* and *monumenta* of deeds accomplished in office (35.2.7: *rerum in magistratu gestarum*). This testimony to the archival function of the *tablinum* is corroborated by the lexicographer Festus who supplies that is a *proxime atrium locus* called *tablinum* because the former magistrates (*antiquii magistratus*) kept there on tablets their reckonings of public accounts.

Another lexicographer Nonus (83M) attributes to Varro a somewhat contradictory idea of the *tablinum* as a spacious place (*locus propatulus*) used for summer dining in city houses.[42] No writer, however, supplies a picture of this space in active use with all the interviewing and advising popularly thought to have taken place there. Consequently one might ask whether the often-mentioned "atrium/*tablinum*" axis was in real life so canonical as it seems to us.[43]

That persons spent time in *tablina* is suggested by the fact that these spaces are generally painted with much

16. Casa di Nettuno, drawing after D'Amelio 1888. *Dipinti Murali di Pompei*. DAI 72.921. Naples.

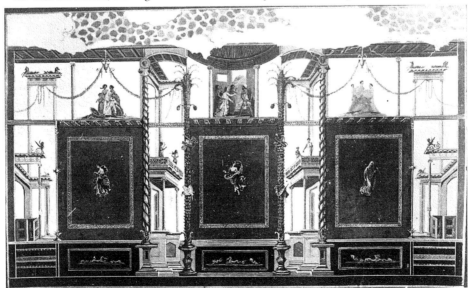

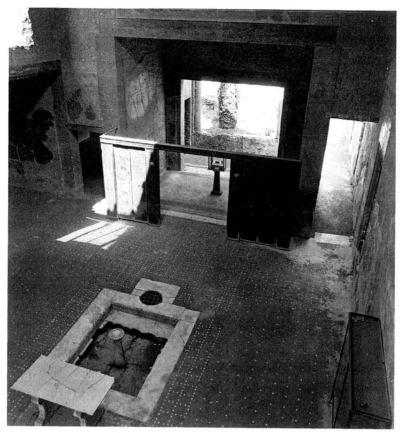

17. Herculaneum, Casa dei Tramezzi di legno. FU11639.

more complex decorations than their neighboring atria. At the same time there are numerous instances, such as the Casa del Menandro, where we see the foundations of a cupboard that will have occupied one wall. In Herculaneum, the carbonized screens standing before the *tablinum* entrance in the House of the Wooden Screens show how the room might be cut off from view (Figure 17). Holes for doorposts appear on the thresholds of many *tablina* and in other cases on the sill at the rear, indicating that the space might regularly be screened either from the atrium or from the peristyle, but in any case that an axial prospect from entrance to colonnade was not an invariably sought-after visual effect. Although we cannot be certain whether the screens were closed to afford privacy during the *salutatio* or opened for access to the room, the former seems more likely, all the more making us question whether the *tablinum* did regularly figure in the business negotiations of the *salutatio* or instead served as a small library, or family counterpart of the municipal *tabularium*. Possibly this was the area where Seneca's consultations "in secret" were conducted.

As for *alae* within the *cavum aedium* complex no writer other than Vitruvius mentions these. His description of the ideal proportions of domestic *alae* in relationship with those of contiguous spaces does ostensibly point to the symmetrical recesses frequently found at the inward end of the atrium. Vitruvius also says in passing that *alae* should be useful, but even Mau, when coordinating spaces and written description (258–9), expressed puzzlement concerning the functional character of these spatial extensions, which he rationalized as a survival from an earlier period with different conditions of life.[44] The more recent discovery of strong boxes preserved in a few *alae* have prompted speculation that these must have served as the offices of the patron's staff. Richardson pictures secretaries moving back and forth between the *tablinum* and the flanking *alae* with papers and records.[45] Given the absence of the word *alae* in any corroborating sense from literary texts, it seems possible that Vitruvius might have borrowed it from the vocabulary of temple architecture because he refers to extensions at the rear of the cella in Etruscan and certain Etruscan derived temples also as *alae* (*de Architectura* 4.7.2).[46] Consequently his application of the term to domestic usage might be considered both metaphorical and idiosyncratic, which is to suggest that no one else ever called these spaces "wings." When Quintilian, in laying out spatial frameworks for memory exercises, mentions the spaces

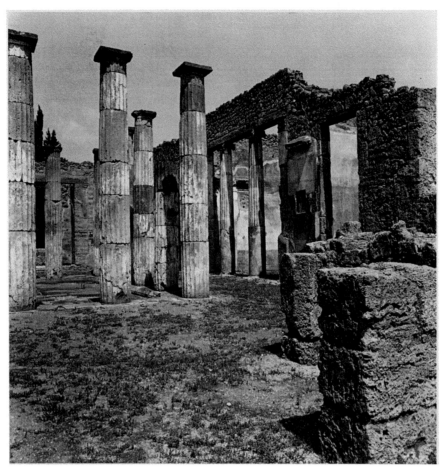

18. House of Epidius Sabinus, Corinthian atrium with colonnaded exedra. FU 11666/1966.

contiguous to the atrium, he calls these either *cubicula* or exedrae.[47] By definition we can tell that the exedrae will have been the spaces open along their full length as opposed to *cubicula* closed by narrow doorways. Symmetrical spaces screened by columns in the grandiose atrium of the House of Epidius Sabinus that archaeologists commonly call *alae* were probably considered as exedrae by the house owner on the analogy of equivalent spaces in the public world (Figure 18).[48] Some houses along the Via di Nola show a cruciform plan for the atrium where the space broadens into symmetrical exedrae on either side of the impluvium (Figures 19 and 20). The pattern echoes that of Carandini's sixth-century houses in Rome.[49]

Richardson has suggested a metaphorical status for *fauces*, the term commonly used with reference to the long, narrow entrance passage leading into the atrium of many Pompeian houses. Although Vitruvius specifies suitable breadths for the *fauces* of large and small atria in relationship with those of the *tablinum*, he gives no further indication of the conformation of the space.[50] *Fauces* designates an entrance in many contexts, but the

very diversity might argue against its canonical identity. In fact the combination of *alae* with *fauces*[51] suggests a degree of personification not uncharacteristic of Vitruvius' tendency to project animate identity on architectural plans.

Vitruvius is right, however, by Pompeian standards, in suggesting that a large, open atrium of the style he calls Tuscanic is the traditional kind (Figure 21).[52] The most common alternative is the positioning of four columns at the corners of the *impluvium* to structure the tetrastyle atrium (Figure 22). This design appears to have been adapted from that of the Greek peristyle, which was a colonnaded interior room. In a few Pompeian examples we find the even more extreme Corinthian atrium that planted a forest of six to twelve columns around the *impluvium* (Figure 23).[53] Neither of the two colonnaded arrangements would seem to have offered any great practical improvement over the Tuscan atrium in supporting the roof; their purpose was nothing more than elegant display. Writers often call attention to the columns that figured in two types of atria as symptoms of the invasion of luxury into Roman life. Thus Horace

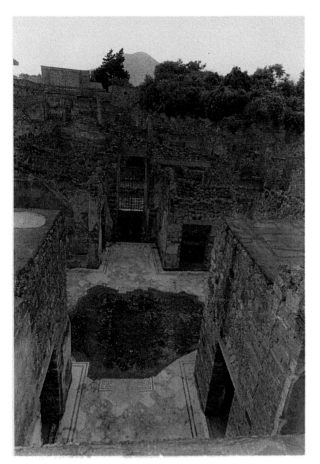

the regularity with which it was reserved for the ceremony of political patronage, another the extent to which it is employed in houses outside municipal centers, and the third its historical persistence as the central room of the house. Modifications of the long-standing concept of formality are the conclusion P. Allison draws from excavation records citing cupboards and chests for the storage of random household goods in atria as well as the occasional loomweights earlier mentioned.[55] On this basis she questions how consistently or exclusively these

19. Region 9.5.6, view into atrium from above. Author's photograph (su concessione del Ministero per i Beni e le Attività Culturali).

20. Region 9.5.6, plan of house with cruciform atrium after Overbeck, 1884, 289, fig. 161.

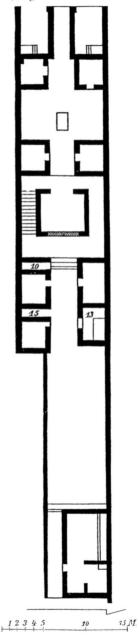

concludes *Odes* 3.1 with the question, "Why should I build up my atrium with conspicuously enviable *postes* in the latest manner; why should I take wearisome luxury in exchange for my Sabine valley?" The purpose of this expression, I believe, is to construct the Sabine valley as a metanomically alternative atrium, the place where the poet confronts and advises his audience in the position of a clientage, but the *postes* are by his time proverbial symbols of luxury. Pliny in his accounts of stonework gives details. Among the early instances of the luxurious atrium was that of the famous second-century orator, L. Crassus who set up six columns of Hymettus marble in his atrium at a time "when marble had not yet made its appearance in public" (*NH.* 17.6.1). Even more flamboyant, at a later date, were M. Scaurus' four thirty-eight-foot columns of Lucullan marble.[54] The owners' justification in both cases was their having imported these luxury items as magistrates to fulfill their obligations of furnishing decorations of a temporary theatrical stage (*NH.* 36.5.6).

Several further questions may be asked about the atrium within the dynamics of the house; one concerns

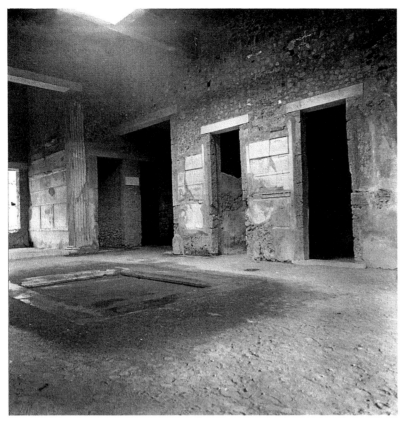

21. House of Sallust, Tuscan atrium. FU 27229/1981.

the peristyle so that crops from the country might be brought in directly, and the atrium stood further within. The Villa dei Misteri, as Richardson has shown, exemplifies this plan perfectly (Figure 24);[57] it was likewise the original plan for the Villa dei Papiri.[58] But not every country villa observed the full formality of an atrium. For all the elegant Second-Style decoration surrounding a peristyle fully accommodated as a center for hospitality, the Villa Boscoreale has no such space.[59] Cicero counsels his brother Quintus against introducing an *atriolum* into the colonnade of a villa he was having remodeled at Arcanum, on the grounds that these are not customary unless a greater atrium also exists (*Q. fr.* 3.1.2.1–3). More than a century later, however, Pliny gives prominent mention to the atria in both his villas.[60] At Laurentium he describes the view on axis from the entrance through a D-shaped porticus to the forests and mountains beyond (2.17).[61] The Tuscanum has *atrium etiam ex more veterum* (5.6: "an atrium according to the manner of previous times"). In my opinion Pliny does not mean that the simple fact of having an atrium conforms with antique custom, but rather that this atrium is structured in the "antique style" without columns, whether this means Tuscan or even testudinate.

Pliny's remark is not, I believe, reliable evidence for a decline of the atrium under the Empire, but some scholars have cited it in this capacity because certain Pompeian houses of the later period do appear to have moved the atrium off the earlier axial line and or even displaced it in favor of other rooms. This is true of some Pompeian townhouses, such as the Casa degli Amorini Dorati,[62] and also of what Richardson calls garden houses, like the House of Loreius Tiburtinus with its terraced arrangement of dining areas and water channels.[63] In Herculaneum the Casa dei Cervi subordinates the atrium to a large room opening onto the garden. In the house of Trimalchio, where a painted dog guards the entrance, the guests appear to progress directly into a painted porticus where they come face-to-face with a pictorial narrative of the master's rise from slavery to his current prosperity. Although the house has an *atriensis,* one might think that Petronius had deprived it of an atrium in token of its master's falling short of the elite

rooms were dedicated to the purpose of ceremonial reception. In fact the absence of any specifically designated women's quarters in Roman houses is an indirect argument for multiple users of common space. Given that activities outside the house occupied male aristocrats from the second to the ninth hours of the ordinary Roman day, Ray Laurence has suggested a temporal gendering of spaces instead of the structural gendering that was built into Greek houses.[56] Cornelius Nepos (*Prologue* 7), however, implies that even such segregation was not the rule when he speaks of the Roman mater familias as holding *primum locum aedium* (the chief location in her house) and moving freely among the crowd (*in celebritate versatur*). As for other family members, the depictions both in Lucretius and in Vergil of children's games in atria suggest that the space, when devoid of clients, was scarcely off limits to even the youngest. In Lucretius' vignette (*DRN* 4.400–4) a child whirling in dizzy motion stops short to see the room continue revolving with columns spinning overhead. Vergil pictures the great halls empty as boys persistently drive their spinning tops in great circles through the space (*Aeneid* 7.377–89).

To address the second question, Vitruvius prescribes a plan for agricultural villas that is an inversion of the townhouse plan, with the major entrance leading into

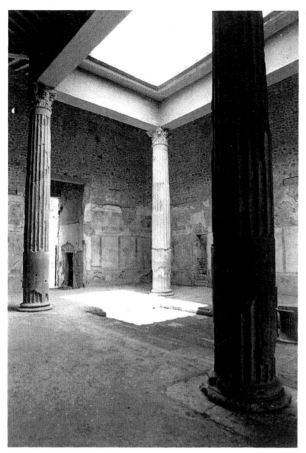

22. Casa delle Nozze d'Argento, tetrastyle atrium, view toward entrance. Author's photograph (su concessione del Ministero per i Beni e le Attività Culturali).

status he emulates. Certainly, at the same moment in the Julio-Claudian era, Seneca writing about Roman rituals and status gives a picture of the traditional room filled with clients and decorated with ancestral masks.[64]

Looking backward at a slightly later date Martial sketches a comparable picture of atria with all their *stemmata* belonging to Pisones contemporary with Seneca (4.40.1–4), not to mention those of the Seneca family itself. In general his *Epigrams* give every impression that the *atria potentum* (halls of powerful men) are seats of influence in his day (5.20.5). As a potential patron in Spain, he directs a client seeking legal aid to cultivate *atria ambitiosa* (12.68.1–2). From a personal point of view his poems rate atria on the basis of their hospitality to verse (1.70). With his particular attention to topographical detail, he invests one such location with a specific reality on the map of the contemporary city. Sending his book to visit the house of Proculus, he directs it to cross the Forum and mount the Palatine slope where a lofty lintel only sets off a doorway symbolically wide open to the Muses. No mere caller at the *salutatio* could present

such verses, he boasts. In contrast to most writers he supplies pictures of clientship from the participant's point of view, stressing the often futile expense of energy in the hopes of getting ahead (3.38.12–13; 9.100.1-2). Juvenal, too, from his podium of intellectual superiority, contrasts ancestors with their degenerate modern descendants in *Satire* 8.19–20, and derides the belief that the *nobilitas* attested by an atrium decorated with ancient "waxes" can substitute for nobility of virtue. Such invocations by imperial authors of the crowded atrium to stand for the politically active urban life is reasonable evidence that the ceremonies of clientship had by no means declined with the imperial consolidation of power. In Pompeii where, in fact, the forms of municipal government continued unaffected by the Empire, they were even less likely to have altered.[65]

In poetry of any period the word "atrium" regularly conveys a sense of grandeur. The effect is enhanced by the common tendency to substitute the plural for the more logical singular. Epic poets in particular invoke the word to create an impression of regal space that suits their narrative purposes in a manner that appears virtually independent of immediate contemporary custom. Anachronistically Vergil endows Dido's Carthaginian palace with atria as the setting for the queen's royal banquet (*Ae.* 1.725–6). What Servius (*ad Ae.* 1.726) found peculiar here was not the cultural anomaly, but rather the feasting, which he explained by a citation from Cato to the effect that Roman ancestors were accustomed to dine in atria from only two courses of food (*ferculis*).

Vergil also gives atria a place in the palace of Priam at Troy to be violated by invading Greeks (*Ae.* 2.483; 528; 665). In similes the atria he envisions are not populated but empty, traversed only by boys driving tops or by circling swallows (*Ae.* 12.473–4). Clearly the euphonic melancholy of *vacua atria* appealed. Ovid in the *Metamorphoses* more often trades on the standard image of the busy atrium to accent the singular atmosphere of supernatural places. Political overtones attach to the atria of the Olympian deities ranged along the Milky Way, a celestial Palatine, as the poet mischievously calls it (1.171–2). Murmurs of confused sound like the distant sea or far-off thunder surround the atria of Fama's citadel populated not by human clients but by throngs of words that facilely come and go (12.39–63). Wild animals are the transformed clients filling Circe's atria (14.10–11), but in human realms atria serve as settings for dramatic scenes, especially the ill-omened weddings of Andromeda (5.2–4; 153) and Perithoos (12.215).

Predictably Lucan's atria are historical recreations with a strong emphasis on moral aesthetics. A contrast appears between the *atria non ampla* (not so sizeable

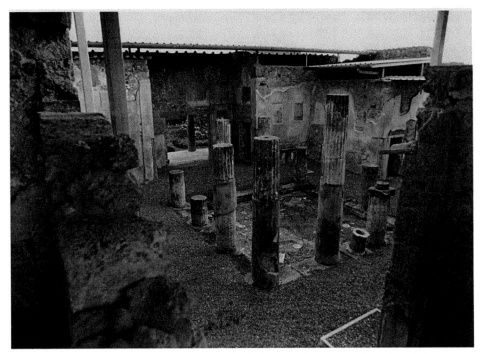

23. Casa dei Dioscuri, Corinthian atrium. Author's photograph (su concessione del Ministero per i Beni e le Attività Culturali).

atria) where a sleepless Cato anxiously ponders Rome's Republican future (*BC.* 2.237–8) and the lavish hall where corruptive Cleopatra banquets Caesar (*BC.* 10.119). Statius likewise, although purportedly writing of the Greek world, attributes atria to deities and princes.

His Jupiter follows Ovid's in summoning divine counsels in the *atria caeli* (*Thebaid* 1.197), while his fraternal opposite (*Jovis niger*) rules in the *vacua atria* of the dead (2.49). In the opening book of the *Thebaid* the Argive ruler Adrastus, abruptly wakened from sleep by the clamor of

24. Villa dei Misteri, entrance into peristyle. Author's photograph (su concessione del Ministero per i Beni e le Attività Culturali).

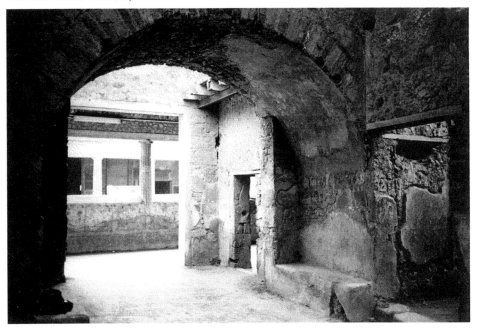

fighting men, crosses his "lofty atria" by torchlight, and unbolts his doors to find Polynices and Tydeus brawling savagely within the shelter of his *vestibulum*. He welcomes these ambivalent guests destined as his sons-in-law with a midnight banquet, hastily arrayed in the hall, which not long after will be filled with a joyous crowd of guests come to witness a double royal wedding. In good Roman fashion the hall is furnished with its complement of bronze ancestral images (2.214: *vivis certantia vultibus aera*). In Book 6 we hear of Adrastus' atrium once more, but the term is not attributed to domiciles at Thebes until the final days when atria echo with feminine grief (10.563). Here as often the appropriation of Roman images within the context of mythological violence carries ominous overtones, yet it seems clear that Statius incorporated these anachronisms with provision for the decorum of the atrium within the various national cultures his epics portray. For royal banqueting in civilized societies they are the appropriate venue. Thus also in *Achilleid* 1.755–7 King Lycomedes on Skyros is host to Ulysses at a banquet within an atrium that has been got ready with much royal noise (*regali strepitu*). For this usage during the imperial period we may entertain alternative explanations: perhaps the poet simply follows an epic precedent; perhaps, like Servius he considers the use of atria archaic, but perhaps he may have the ceremonial splendor of contemporary royal palaces in mind.

Peristyle

With atria we have completed the survey of Mau's Roman rooms, and must turn to what he has called the "Greek-named area" that includes peristyles and chambers surrounding them. Vitruvius classes the peristyle among the places shared with outsiders (*loca communia cum extraneis*), which even uninvited persons (*invocati de populo*) have the right to enter (6.5.2). In view of its location behind the more obviously public reception rooms at the front of the house, this specification may seem odd but can best be explained by its positioning as a transitional zone whose function is not so much exclusion as that of giving an elegant route of access to other privileged rooms situated on its corridors. With its orderly files of columns the physical appearance of the peristyle signals passage; a walk through the ambulacrum produces continual shifts in the spectator's range of vision with the columns now framing, now screening the spatial perspectives of the enclosure. This function as a corridor or walkway is usually highlighted by repetitive patterns of wall decoration with a strongly vertical orientation to reinforce that of the colonnades. Often a secondary series of engaged columns partitions the

compartments. Thus the decoration of peristyles shows less variety even than that of atria; however, the category merits discussion both for its symbolic value and for its importance as the situation for other decorated rooms. As we shall see in a later chapter, its architecture also figures in wall painting as a source of mimetic designs.

The self-consciously Hellenizing adoption of the name peristyle is a point underscored by Varro (*DRR* 2.pr.2.4) in his remarks about the Greek nomenclature that was popularly being applied to the spaces of villas in his day.[66] Notably in this passage he refers to a fashion for *gymnasia urbana,* a point to which I return later. Scholars have long debated the significance of the Greek designation in relationship to the Roman developmental history of the space. Many regard the Roman peristyle as an "addition" to the plan of the traditional house, releasing the severely businesslike spaces of the atrium complex into a self-indulgent Greek freedom.[67] Popularly also the incorporation of this feature has been linked with a dawning Roman consciousness of leisure and the private self. The oldest house plan in Pompeii, that of the Casa del Chirurgo, does not include a peristyle, and another early house, the House of Sallust, has only a single file of columns separating an *ambulacrum* from a small garden space beyond the *tablinum*.[68] According to Emidio de Albentiis, the trend toward expanding the house by colonnaded enclosures follows on the economic growth and more decisive class stratification in the Samnite city of the second century when the initially subdivided insulae comprising several residences were restructured as a single, dominant house.[69] A particular example is the imposing Casa del Fauno, an establishment that exceeds in size the royal palace at Pergamon with its succession of two colonnaded gardens (Figure 25).

Although many peristyles may be additions, it is not productive either for architectural or social interpretation to regard this area as an independent or disassociated quarter of the house. To the contrary, its conceptual integration into the total design of the house from its very beginnings is made evident by the restructuring of social spaces that accompanied its incorporation and the functions that were clearly transferred to it, and also by its later evolution into a focal center in the flow of space to which the atrium complex seems frequently to have become secondary. Because this restructuring is not merely practical but also conceptual, it is useful to consider the peristyle in the light of its origins and models.

Even if actual examples did not argue the contrary, Vitruvius' own remarks make clear that the domestic peristyle is not simply a spatial cooption from the Greek house (6.7.1), because he defines that space as an enclosed and partially covered room at the core of

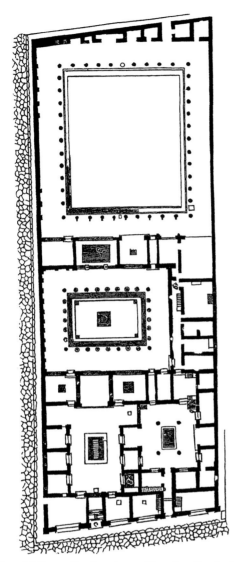

25. Casa del Fauno, Region 6.11.1. Plan after Overbeck, 1884, 347, fig. 177.

the house. Examples to be seen in Delian houses in the Greek style and at Olynthus are paved with mosaic and do not strike one in the manner of Roman peristyles as spaces intended for walking. Thus Richardson argues that in Roman architecture, the tetrastyle and Corinthian atria owe more to the model of this interior Greek peristyle than does the Roman externalized space of that name.[70]

Conversely, as Varro's remarks on the adoption of nomenclature might indicate, there is much evidence both in literature and in architectural remains themselves to indicate that the peristyle area took both its name and its original inspiration from public architecture that, for its part, modeled itself on the Greek gymnasium with its various uses and symbolism.[71] In this respect the space does indeed express the pretensions of prosperous Hel-

lenophiles whose self-fashioning combined images of cosmopolitan sophistication with the exercise of public power. Vitruvius makes reference to the use of the peristyle both in temple architecture (3.2.8) and in that of palaestrae (5.10.5; 5.10.2.16).[72] In the upper-class vocabulary of Latin texts, these semantically charged words, "gymnasium" and "palaestra," along with others of equally elevated associations, are often used as substitutes for peristyle, while the less technical Latin words, *ambulacrum/ambulatio* and *porticus* with their emphasis on function and structure are employed with equal and interchangeable reference both to public and to domestic constructions.[73] In neither sphere, however, should the form be regarded as purely Hellenic but rather as participating in the general conflation of Hellenic and Roman forms.[74] An old Campanian peristyle dating back to the Samnite third century exists in the humble context of a large working villa providing a shaded area for vintage operations on a large scale.[75] Among the first colonnaded enclosures in Rome was the Villa Publica, regarded as the park of the Roman people (Varro *DRR*. 3.2.3–6), which was used both for military levies and for the ceremony concluding the census. A coin of the 50s B.C. shows a segment of the building with the double-storied colonnade. Varro describes this as a shaded retreat.[76] Not only in exercise grounds, but also in other forms of public urban architecture, such as the porticus of Pompey's theatre, the construction of large peristyles kept pace with or anticipated that in private houses.[77] These facts additionally suggest that even the garden ambience providing the shade considered among the chief amenities of peristyles is a facet of their public identity.[78] Vitruvius gives evidence to this effect which is borne out by archaeological evidence and other literary references. On the Marble Plan of Rome, the diagram of Pompey's porticus contains indications of plantings seemingly in agreement with the poet Propertius' description of a spacious colonnade enclosing a plantation of plane trees, with walks and fountains. This enclosure, which was among the architectural sensations of its time, remained a popular place to stroll throughout many generations of the Empire.[79] At Pompeii the Great Palaestra, as it is called, with its large pool at the center, was surrounded on the three colonnaded sides of its *campus* by double rows of plane trees more than 100 years in age.[80] Thus we should probably regard such parks as an evolutionary phenomenon, the particular conformations of which proceeded out of the dynamics of spatial use.

Another point to consider in tracing the development of peristyles, however, is that the existence of these features in Pompeian houses from a date before the colony became nominally Roman should not be taken

to indicate their equivalent prevalence in the houses of contemporary Rome. Rather, when Roman aristocrats began to adopt the peristyle, as Varro indicates, it was within the more expansive spatial framework of the new villas they were so energetically constructing in outlying districts of the city or even on its outskirts.[81] The popularity and perhaps even the origination of this architectural feature in villas may have been owing to the most celebrated builder of villas, L. Licinius Lucullus, a Sullan protége who was proconsular commander in the wars against Mithradates from 73 to 67 B.C. until his political opponents relieved him of his command in favor of Pompey. Relegated to private citizenship, he expressed his pique by investing a large portion of his immense fortune in building on a scale that his colleagues considered offensive to *mos maiorum*. In addition to enlarging his inherited estate at Tusculum, the buildings of which spanned several square miles, he built up a showy mansion on the Pincian in full sight of the city and acquired one villa in the area of Baiae and Misenum, another close to Naples, and still one more on an island off the coast.[82] These buildings were especially noted for their porticoes and surrounding apartments which Plutarch calls *diaitai*.[83] Plutarch highlights the political significance of Lucullus' retirement by a series of anecdotes in which follow aristocrats figure as critical spectators. From these we can gain a sense of the contemporary responses to the ethical implications of these spaces whereby the advantages of a free natural environment – light, air, and even shade – were captured by architectural contrivance as conditions for a comfortable style of life. When Pompey first saw Lucullus' villas where chambers stood next to open-air porticoes, he commented on their impracticality for wintertime use. Such short-sightedness amused Lucullus, who answered that he, like storks and cranes, had the sense to change his home in accordance with the seasons.[84] The response aptly epitomized the true luxuriousness of the peristyle, where the power of resources enabled a combination of natural advantage and human design.

While many of Lucullus' fellow senators took the opportunity to exhibit their moral pretensions by censorious criticism, a good number of his Roman peers found his precedent easy to adopt. After all, they had constantly before their eyes his villa-mansion covering almost the entire Pincian. Ultimately the influence of these extra-urban amenities would seem to have penetrated the city and spurred the ambitions of aristocrats already competing in the magnificence of their personal residences.[85] When Pompey returned from Asia, he built a splendid house with gardens, probably in the area of his theatre (Plutarch 40.8–9).[86] The extraordinary value placed on

trees in such surroundings is indicated by Pliny's and Valerius' accounts of an altercation between two colleagues in the censorship: L. Licinius Crassus, importer of the Hymettus columns, and Domitius concerning the relative value of marble and trees (V. Max 8.1.4; Pliny *NH*. 17.1.2–4). With Domitius constantly accusing him of luxury because of his expensive columns, Crassus finally trapped him into confessing that he valued the six trees in his garden at half the price of his house. The species, a *faba Graeca* called "lotus" in Rome, was, as Pliny explains, valued in houses because it provided abundant and widespread shade from a short trunk (16.53.124).

Because of the spatial limitations of the urban environment, the sense of luxurious extravagance in city peristyles was even more pronounced. Accordingly, we can see that a practical difference exists between such villas as Oplontis and the Villa dei Papiri, where unrestricted spatial freedom made peristyles a part of organic design, and the magisterial houses of Pompeii where the possibility for such constructions depended on spatial availability. De Albentiis cites findings of recent excavations to argue that such great peristyles as those of the Casa del Fauno were achieved by an annexation of neighboring property.[87] However this may have happened in Pompeii, space on the slopes of the Palatine was certainly gained by appropriation. Although we can do no more than speculate on the politics of negotiation that might have surrounded the acquisition of additional spaces in Pompeii, we do know something of the bitter struggles in Rome carried out by Cicero's political enemy P. Clodius Pulcher as he attempted to build up his personal insula in the senatorial district by annexing property belonging to his neighbors. Much of the story is provided by Cicero's oration *de Domo sua* with its account of Clodius' machinations to cap the humiliation of his exile by the demolition of the house that was Cicero's proud symbol of achievement and success. According to Cicero (*Dom.* 116), Clodius took revenge in the name of the goddess Libertas for the execution of the Catilinarian conspirators, but the real reason for this charade of religious scruple was far less his *pietas* toward an offended goddess than his craving to acquire Cicero's commanding site in order to extend his house by a spacious peristyle with a large paved colonnade and a variety of surrounding chambers (*Dom.* 116):[88]

causa fuit ambulatio et monumentum et ista Tanagrea oppressa libertate Libertas. in Palatio pulcherrimo prospectu porticum cum conclavibus pavimentatum trecentum pedum concupierat, amplissimum

peristylium cetra eius modi, facile ut omnium domos et laxitate et dignitate superaret.

[His motivation was an ambulatory and a monument and, upon the overthrow of freedom, that Tanagrean goddess of Liberty. He craved a Palatine porch with a vista and a pavement of three hundred square feet with rooms all around it, and a generous peristyle and other such amenities so that he might easily outdo everyone else's house both in expansiveness and in dignity.]

Even after this offensive had failed and the senate had ordered the rebuilding of Cicero's damaged property at state expense, Clodius, once again taking advantage of exile, succeeded in securing the property of another neighbor, Aemilius Scaurus, but lived to enjoy it for only a few months.[89] By this acquisition, Clodius added a second atrium to his insula and presumably along with it Crassus' celebrated garden with the lotus trees which, by Pliny's testimony, outlived many owners before being destroyed in Nero's fire (PNH. 17.1.3). Whether Cicero's own Palatine property included an interior garden is uncertain, because he responds, while rebuilding the house, to his brother's urging de hortis with the rejoinder that he has never been greatly covetous of these (Q.fr. 3.1.14.1).[90]

Lest one should, on the strength of Clodius' disreputable example, end by regarding peristyles as mere symptoms of self-indulgent plutocratic vanity, it is important to consider not only their proliferation, but also their symbolic significance as perceived and cultivated by many of the actual owners. Associations with intellectual life were the basis of the sophistication claimed for these spaces; in this respect they established points of intersection between the private and the public worlds. For this we have the complementary information of literary testimony, especially that of Cicero's dialogues and letters, which make clear that names given to peristyle constructions such as xystus and gymnasium were meant to recall areas connected with the traditions of philosophy in Athenian life; and, on the archaeological side, the evidence of the Herculanean Villa dei Papiri, where the collection of the Epicurean writings of Philodemus appears as the thematic keynote of philosophical inclinations manifested in a remarkable assemblage of statuary. Together these show us the particularly Hellenistic orientation of the villas centered about colonnades, watercourses, and walkways, all of which fulfilled a quasi-metaphorical function to connect them with the philosophical world of Athens.

Libraries, such as that at Herculaneum, are the most obviously intellectual purpose that can be served by a porticus. Cicero begins De Finibus 3.2.7 by recounting a visit to Lucullus' library where he found Cato buried in Stoic philosophy, preparing to tutor the owner himself. Even Plutarch, amid remarks on the extravagance of Lucullus' constructions and furnishings, gives evidence in a more sympathetic voice that much of his wealth was not unintelligently squandered. He was the first Roman to stock a library with books that he personally had collected. The Greeks to whom Lucullus made his collection accessible, and with whom he particularly liked to engage in philosophical discussion, regarded his house as a katagogion Musiôn where they gladly sought out each other's company. These libraries, as Plutarch reports, were housed in open rooms connecting with porticoes which included reading rooms as well (42.1).[91] Practicality dictated the arrangement, for which the Greek world gave numerous precedents. Courtyards and colonnades were features both of the Lyceum at Athens, and, as Strabo describes it, the Mouseion of Alexandria.[92] Translated into the context of private Roman residences, such spaces could stand as the ultimate sign of cultivation and privilege. For this reason, perhaps, Cicero chose Lucullus' villa as the situation for his dialogue the Hortensius, which opens with the speakers' entry into a graciously furnished environment (frg. 23: "Cum in villam Luculli ventum est, omni apparatu venustatis ornatam").[93] Possibly he had also the Lucullan model in mind when he writes, in anticipation of a visit to Varro, "si hortum ⟨cum⟩ bibliotheca habes, deerit nihil" (Fam. 9.4: "If you have a 'garden' ⟨with⟩ a library, nothing will be lacking").

The richest source of insight into symbolic role of the porticus as a bridge between the individual and the public world exists in those dialogues of Cicero that employ elegant residences of cultivated senatorial aristocrats as their settings.[94] The conversation of the de Re Publica, fictively dated in 129 B.C., takes place during an early spring celebration of the Feriae Latinae when Scipio Aemilianus is passing in hortis the time released from public duties (1.9.14). As his friends begin to assemble, he leads them from his cubiculum into a porticus, where, after several peripatetic pacings, they settle on a grass plot (in aprico maximo pratuli loco) to take full benefit of winter sun, and the conversation passes from the domus bounded by walls to that greater, divinely bestowed dwelling place (domicilium) of the fatherland (1.12.18). The architectural terms in this dialogue are Latin; however, in the de Oratore, the dramatic date of which is 91 B.C., the factual words ambulatio and porticus are metaphorically assimilated to features of Greek institutes of learning, the gymnasium and palaestra. This complex dialogue, set in the Tuscan villa of Crassus, the orator takes place during the Ludi Romani as an alternative, intellectual

form of entertainment. At the beginning of the dialogue its speakers liken an *ambulatio* with a plane tree to the inspirational setting of Plato's *Phaedrus* (1.7.28). The function of the term gymnasium in the dialogue is to amalgamate the Roman world with the Greek so that Sulpicius enthusiastically promises to rank the Tusculan palaestra, this "suburban gymnasium," of Crassus ahead of the Academy and the Lycaeum (1.98.4). Although speakers at the beginning of Book Two debate the status of exercise versus philosophy as the function of the Greek palaestra, clearly the association of gymnasia with philosophers highlights the philosophical evaluation of rhetoric that is conducted within the dialogue.

The *xystus* is another Greek spatial designation that Cicero elevates by philosophical associations when he locates the second dialogue of his *Academica* in the *xystus* of Hortensius' country house at Bauli (*Acad.* 2.3.9).[95] Perhaps it really was this orator who first employed this term to distinguish space within a Roman villa, but the word itself carried specific associations as the name of a gymnasium at Elis, called *xystus* to commemorate its legendary establishment by Heracles who was said to have cleared the place of thorns (Pausanius 6.23.1). This establishment contained tracks for running. Vitruvius, when speaking of public palaestrae (5.11.4), distinguishes the forms of Greek and Roman *xysti,* the former being covered exercise grounds, the latter open spaces where trees grow between a double colonnade.[96] Trees may be considered the mark of this garden, which may have involved only a single colonnade.[97] Pliny adopts it as a name for his gardens, no doubt in full awareness of its traditions; however one may question whether it should be randomly given to spaces in Pompeii.

Within this vocabulary of honorific nomenclature should be included the exedra, another term linked with the public world, but one that designates a spatial appendage rather than an independent construction. In the Greek world an exedra is a recess with benches; it is uncovered and generally associated with the porticoes of gymnasia as the setting for philosophical discussions. Vitruvius in his chapter on civic buildings describes a Greek palaestra with spacious exedrae in three porticoes where philosophers, rhetors, and others dedicated to learning can sit and dispute (5.11.2), and also in another colonnade an exedra with benches especially for ephebes. Cicero also mentions an Athenian exedra in the fifth book of *de Finibus,* (5.4.8) which is set in the groves of the Academy. Piso speaks of the sentimental associations with the exedra where Carneades was accustomed to sit. The public usage carries over into settings of two dialogues in which Cicero represents visitors approaching their friends seated in exedrae; one being the

contemporaneous *de Natura Deorum* (1.15.4); the other *de Oratore* (3.17.6) dramatically ascribed to a date earlier in the century.[98] Although it seems possible that Cicero may be anachronistic when he attaches such names to features of Roman private architecture in the previous century, the terms themselves must have been familiar already to men of their time. In his contemporary settings we may assume that he does actually draw on a shared terminology that cultivated Republican aristocrats have self-consciously borrowed from the Greek world.

Some occurences of exedrae, however, have a more limited significance designating merely a spatial configuration. Varro *de Re Rustica* 3.5.8 mentions M. Laenius Strabo as the first to pen birds by means of a net within an *exhedra* of his peristyle. From Vitruvius we may derive the idea that exedrae are categorically open. In one place (7.3.3) he says they are not exposed to smoke, and in another he compares (7.9) them with peristyles. His discussion of painting (7.5.2) contains a passage on decorating exedrae with *scaenae frons* designs. Here specifically he mentions the openness of the spaces and also their size (*locis patentibus ut exhedrae propter amplitudinem*). The passage has caused much controversy in the interpretation of Roman wall painting. One point of difficulty is that most of the identifiable examples of stage fronts do not really seem to occur in exedralike rooms. Ultimately exedrae may be furnished as picture galleries. In one letter (*Fam.* 7.23.3) concerned with commissioned purchase of decorations, Cicero requests some *tabellae* to decorate the new *exhedriae* he has just created in his small *porticus* at Tusculum.[99] Paintings, he here declares, are his favorite species of art. One might think of the small exedrae, scarcely larger than niches, located close to the library room in the Casa del Menandro one of which was decorated with images of Greek dramatists.[100] In the House of the Mosaic Atrium at Herculaneum a larger exedra decorated with small paintings opens full length onto the glassed ambulacrum of the peristyle.[101] Pliny mentions no exedrae in either of his villas, but he does in a letter to Trajan mention dedicating to the ruler an exedra within a *porticus* in Bithynia. Thus, like the *xystus* that both Cicero and Pliny mention, we may assume that it is a private feature meant to stress affinities with the public world.

Cicero's letters and dialogues indicate that he had given the names exedra, *xystus,* and gymnasium to spaces within his own villas. At Tusculum, as we learn from two dialogues, he called his upper gymnasium "Lycaeum" (*Div.* 1.5) and the lower "Academia" (*Tusc.* 2.4). Letters from the early sixties indicate that he had already established the name at that time (*Att.* 1.11.3). Perhaps the

seriousness with which Cicero regarded the philosophical implications of the term is most clearly revealed in the letters in which he discusses his eagerness to acquire decorations unmistakably signifying the philosophical disposition of the house owner.[102] While furnishing Tusculum he repeatedly asks Atticus to procure for him in Athens objects suitable to a gymnasium or palaestra (1.6, 1.9, 1.10). Later he expresses to Atticus his great pleasure in the acquisition of a Hermathena (*Att.* 1.1.4), which he has placed as a thematic center "to which the entire room appears to pay tribute." Another letter indicates that this space is the "Academia" (1.4.2.4). Apparently the judgment of another commissioned purchaser, Fabius Gallus, proved less discriminating than that of Atticus because Cicero (*Fam.* 7.23) complains to him about the inappropriate choices made on his behalf of statues that he had intended to decorate his villa in a manner suitable to a gymnasium.[103] But even plants and trees could contribute to the thematic definition of their ambience, as Cicero demonstrates when he notes in a letter to his brother Quintus how the art of landscape gardening (*topararium*) enhances the colonnade of the little house (*aedificatiuncula*) that Quintus is building at Laterium (3.1.5). Ivy covers the foundations and even the spaces between the columns, so that the Greek statues (*palliati*) themselves seem to be playing the gardener's role. Since Cicero calls this the most philosophical of Quintus' villas, we may imagine that the full-length, standing Greek statues will have represented philosophers or orators as do many of those discovered in the Herculanean Villa dei Papiri.

Undoubtedly the compulsion to equal his peers is one motive driving Cicero's self-conscious attention to the exhibition of intellectual status. Rather than the set of Maenads that Fabius Gallus has bought in his name, Cicero was wishing for Muses "like those of Metellus" (*Fam.* 7.23). We hear about Lucullus' statues in the *Hortensius* when a speaker admires the collocation of images that, in spite of their inanimate substance, "seem to live and to breathe" (*Non.* 128.2). For a real-life model of what Cicero has in mind as he seeks decorations for his Tusculan Academia, we may look to the excavated Herculanean Villa dei Papiri in whose two colonnaded gardens Giles Sauron sees an example of such spaces marked for intellectual dedication. Because the philosophical writings of the Epicurean disciple Philodemus comprise a large portion of its papyrus rolls, this property is commonly attributed to the Calpurnii Pisones, Roman patrons of the philosopher. While Cicero may have sneered at this connection as part of the philosophical pretensions of his contemporary L. Calpurnius Piso in his defamatory *in Pisonem* (28.68–29.72), his statements

are scarcely to be trusted in view of his hostility toward an aristocrat who, as consul in 58 B.C., had failed to oppose his exile.[104] A more positive view of the owners' intellectual engagement is argued not only by the library collection but also by the copious assemblage of statues representing notable orators, philosophers and enlightened Hellenistic monarchs distributed throughout the various rooms.[105] Scholars studying the form and decoration of this villa have correlated the semiotics of this sculptural display with the fundamental concept of the gymnasium in its complex of public and private symbolism.[106] Although it may seem perverse to connect Cicero with the property of the enemy he derided, its population of celebrated intellectual and civic figures, combined with Athena, Hermes, and woodland deities, clearly help us to understand what were his premises in speaking of decorations suitable for a gymnasium, lacking only the participants of a philosophical discussion.

Placing the peristyle in this context may explain why Vitruvius classes it among the "public" spaces that "outsiders" may enter without invitation, but should likewise highlight its significance as a zone of transition between various parts of the house. The final function of the peristyle was to guide persons toward commodious and comfortable spaces within the recessed interior of the house. Cicero's description of what Clodius was ambitious to acquire – "a very ample peristyle with *conclavia*" – is in fact the very designation of the use to which the peristyle was coming to be put during the years of the later Republic. In addition to libraries for which the bright light of the peristyle provided a natural ambience, these activities are dining, sleeping, and oftentimes bathing. A practical, behind-the-scenes glimpse of such a feature appears in the accounts of work-in-progress that Cicero sent to his brother Quintus while he was stationed in Gaul during 54 B.C. Cicero supervised work on the restoration of his properties, visiting each several times. At Arcanum, he observes work progressing on baths, *ambulatio* and aviary. The latter must actually be different from the *porticus* because that is already near completion (3.2.1). The paved floors, he remarks, give dignity and the columns have been polished. The *ambulatio* (3.1.2), however, seems to lead to the baths and contains *cubicula*. Concern here for appearances certainly suggests that the area was an important status location.

Although Vitruvius appears still to be talking about Greek houses when he refers to a species of "larger" peristyle that serves as a locus for a great variety of rooms including libraries and guest chambers, this designation fits both the kind of space that Cicero is describing and also Plutarch's descriptions of the apartments

fronting on open-air porticoes in the mansions of Lucullus. Without mention of sculptural decorations, the Younger Pliny reveals ideas similar to Cicero's as he walks the reader of his letters through descriptions of his villas that unite an owner's practical consumerist view with a retrospective concept of the peristyle as a seat of intellectual self-representation. At the same time the practical information he gives us is useful in showing how the peristyle serves as a central locus around which various apartments may be disposed. Likewise it is in agreement with the configuration of apartments surrounding peristyle spaces in Pompeii. To consider these as carriers of decoration we should consider the literary information about rooms thus located and the kinds of activities associated with them.

SPACES *PROPRIA PATRIBUS FAMILIARUM*

Of the remaining spaces in the Roman house that receive decoration, the majority will have been for dining and sleeping. These are the spaces Vitruvius calls *propria . . . patribus familiarum* because visitors cannot enter them without invitation (6.5.1).[107] Mention of invitation suggests that such rooms are also on exhibition. Although the categorical *propria* places the control over these spaces within the realm of paternal *auctoritas,* they are not all the same "private" quarters exclusively restricted to occupancy by their owners.[108] The most common names for such rooms, *triclinia* (dining) and *cubicula* (sleeping), acquire a certain figurative semiotics in discourse whereby *in triclinio* connotes conviviality and *in cubiculo* implies seclusion, but even *cubicula* are often depicted as settings for consultations with persons outside the immediate family. The names of these rooms carry no fixed indication of place. Vitruvius does not assign them canonical locations, but rather discusses the most advantageous seasonal orientations, with the implication that a variety of such spaces commonly existed within a single house. The number and size of such rooms were among the economic variables of houses. In the most opulent establishments such rooms preempted an area volumetrically equal with that of the more public reception rooms, whereas many small houses, even those with formal reception areas, would scarcely seem to have had enough sleeping space to accommodate their families. Nonetheless we cannot be certain of the precise extent of such quarters because second stories, whose existence is indicated by staircase remains, may well have provided a large amount of additional space, especially quarters for sleeping.

Not only because of the large proportion of space they occupy, but also for their social functions and for their place in the hierarchy, these rooms are of the greatest interest to students of painting. In all periods they constitute the chief body of rooms for stationary activity and thus exhibit the most interesting designs, both figuratively and iconographically. At the same time they present much thornier challenges to identification than the spaces previously discussed. The challenge demands attention, nonetheless, because the question is so frequently raised whether the images employed in decorating rooms are thematically linked with the activities that take place in them. Many well-known interpretations have proceeded on the assumption that the images in a *cubiculum* should be relevant to sleeping or at least to private contemplation.[109] Yet how, in fact, can a *cubiculum* be distinguished? Richardson has obtained little agreement with his controversial proposal that many so-called *cubicula,* and especially a certain type characterized by two intersecting vaulted alcoves, were women's dining rooms.[110] Even though this idea is idiosyncratic, it calls attention to a larger and generally underappreciated principle of arranging rooms contiguously as components of small suites. Furthermore, as the literary evidence will indicate, there is a likelihood that many rooms of undistinguished size or shape could, depending on the furnishings placed within them, be used for the dual purposes of sleeping and dining.

Thus the question to take up in this preliminary chapter is how these rooms possess identity. Is it because of their location? Because of their specific shapes? Because of their owners' intentions at the time of building? Because of the kind of furniture placed in them? Or in fact, do they only borrow an identity from the kind of action in progress in them? As we will see by examining literary texts, architectural vocabulary comprehends two classes of nomenclature. In first place is the familiar vocabulary of function or furnishing which contains the Latinate *cenatio, cenaculum* and *cubiculum* along with the Greek *triclinium,* similarly derived from furnishing, and the more polysemantic Greek *thalamus* which becomes in Latin contexts a primarily poetic word. Secondly, however, there is an important but unduly neglected vocabulary based on structure or form which comprises the names *camera* or *conclave* given to rooms of unspecified function whose practical destination often seems to be eating or sleeping. In actual usage the structural and functional terms are not mutually exclusive; literary mention sometimes gives both kinds of identity to a room. But the frequency with which the structural words are employed, especially in contexts that involve the processes of designing and building, suggests that the Romans themselves tended to think of rooms as spatial containers that took their real identity from action.

Accomodations for Dining

After the ceremonies of political counseling, the other socially significant ritual played out in aristocratic Roman houses was that of dining: the occupation for the end of the day. Among the various Roman social ceremonies known to us through literary evidence, dining is perhaps the best documented. Invited dinners served the purpose of social interaction among different groups of the owner's acquaintance. Some gatherings were confined to circles of intimate friends; others consisted of peers or superiors on whom an impression must be made; others included the clients or the dependents of guests, even to freedmen. Roman wives also joined in dinner parties.[111] From the playwrights and Cato onward, writers in all genres of Roman literature provide lively accounts of transactions on some of these occasions.

For the political consequence of dining, numerous references in Cicero's letters to strategies laid or reconciliations effected furnish abundant testimony. Attempting in 56 to promote the interests of Lentulus Spinther for a commission in Alexandria, he writes of a fortuitous dinner at Pompey's house, their most comradely time ever (*Fam.* 1.2.3 *magis idoneum quam umquam antea*) in the aftermath of a highly collegial senate meeting in which the two had favored the same cause. Two years later, with the triumviral alliance of Pompey, Caesar, and Crassus recemented, Cicero sends Lentulus an elaborate narrative in justification of his own shift from a staunch optimate position to acquiescence with the three. He tells of a fairly formal reconciliation with Crassus arranged to take place on neutral ground in the extraurban *horti* of his son-in-law Crasipedes as Crassus prepared to leave Rome (*Fam.* 1.9). While such meetings were overtly political, Cicero also assigned importance to dinners as an opportunity for gathering information or sounding out dispositions, a role that he frequently delegated to Atticus, perhaps because his generally disinterested stance allowed him to be a guest in many companies. So for instance towards the end of April 59, Atticus dines with Clodia Metella (*Att.* 2.14), and Cicero, who has begun to see the hostility of her brother Clodius shaping itself into a plan of attack, thinly veils his anxiety as a craving for society gossip: "How you prime my anticipation about that conference with Lady Ox-Eyes (*de conloquio* βοώπιδος), about that luxurious banquet (*de delicato convivio*)." With policy and strategy thus highlighted, we unfortunately learn little about all the company present on such occasions, or whether such discussions took place at a full *triclinium*.

Idealistic representations of dining as an occasion for intellectual exchange appear in some of Varro's and Cicero's writings. In *de Senectute* 13.45 Cicero makes old Cato list among the pleasures of advanced age the Roman style of *convivium*, pointing out how the name highlights good fellowship instead of the simple drinking together that gives to Greek assemblages the name of symposium.[112] He elaborates the idea in a letter to his Epicurean friend Papirius Paetus (*Fam.* 9.24) that he was composing at roughly the same time. In a passage of a *Menippean* approvingly abstracted by Gellius (13.11), Varro endows dining with a tone of high culture when he pronounces that the number of invited guests he prefers ranges from the Graces to the Muses – that is, no fewer than three nor more than nine. To which he adds rubrics for social disposition, neither excessively talkative nor taciturn (*mutas*). Also the conversation should avoid topics rousing anxiety or provoking discomfort (*Men.* 337: *non super rebus anxiis aut tortuosis*) but only such pleasing and stimulating subjects as will elicit the best in the diners themselves (*ex quibus ingenium nostrum venustius fiat et amoenius*). The leisure (*otium*) that sociable dining thus affords to talk about matters of everyday life provides an alternative to the business preoccupations of the Forum.

Quite similarly Cicero in *de Officiis* 1.134–5 sketches a conversational protocol that calls for a spontaneously orchestrated dialogue with each participant decorously modulating his self-representation by standards of social propriety and judging his fair turn to participate. Desirable topics of conversation, as Cicero specifies, are "domestic business, public affairs, or else the study and teaching of the arts." As leader a host should be sensitive as to whether his guests are enjoying the exchange, while all should take care to repress any thought or expression detrimental to harmony. The emphasis on community of life, the nourishment both of body and of spirit by means of friendly conversation take on a pointed significance when we consider the adverse political circumstances surrounding Cicero's composition of this text.

The political utility of dining gives it also an economic function as Gruen argues when discussing certain fragments of Lucilius' satires that mention banquets and large-scale invitations.[113] He proposes that the introduction of state support for the lower classes increased competition for clientage in the form of rivalry through lavish feasts. That such dinners might be quite large in the mid–second century is suggested by Lucilius' addressing someone who "nurtures" twenty, thirty to one hundred *cibicidi* (food-slayers) at his house (Krenkel 693). The passage at this time of sumptuary laws also suggests that both the expenditure and the influence were extensive.

These matters were certainly a focus of political controversy in 63 B.C. when Cicero (in *pro Murena* 74–7) defended the public munificence of large banquets and spectacles as time-honored instruments for seeking political success. During the period of Caesar's dictatorship when sumptuary laws were again in force, Cicero wrote to his Epicurean correspondent L. Papirius Paetus about dining regally at the gourmet tables of Caesar's associates, Hirtius and Dolabella, with whom he trades lessons in rhetoric for cuisine (*Fam.* 9.16, 9.18). Less-favored friends, including Paetus himself, are struggling to make cheese and boiled greens into delicacies. Whatever the size of the party, or even the composition of the menu, the company, on many occasions, was likely to constitute a mixture of rank and status; by this arrangement it was particularly easy to pay tribute to the importance of the chief guest, especially if his own satellites comprised a number of the invitees. Horace (*Satire* 2.8) paints a picture of social politics in such a situation where the host Nasidienus has polarized the company by including not only some companions of Maecenas, but also certain of his own dependents on whom he counts for social support in the face of his superiors.

Horace's socially ambitious Nasidienus is full of gaucheries. Possibly because the proprieties and guidelines of dining were so easily violated, its occasions were frequently a subject for satire.[114] Roman authors especially like to conjure up the absurd possibilities offered by exhibitions of pretentious food and stagey service. Their characteristic snobbishness associated violations particularly with social ambitions and a lack of traditional education. Thus Plutarch can write derogatively of the extravagant senator L. Licinius Lucullus by stating that his "everyday meals were such as those affected by the newly rich and made him an object of envy to vulgar persons" (*Lucullus* 40.1). We meet such descriptions from Horace to Juvenal, but Lucilius and Varro's *Menippeans* were undoubtedly precursors. The paradigmatic instance is Petronius' *Cena Trimalchionis*. At the same time that we find these amusing, we must regard their "evidence" with caution; the revelation of Roman snobbery is unquestionably more reliable than are their exposures of actual manners. All the same Roman sumptuary laws provide partial testimony to the manner in which dining often challenged the limits of extravagance.[115] Certainly it was theatrical. No less important than the meal itself was the nature of the entertainment that the host provided for his guests. Although it might be as simple as a reading of literary compositions by some member of the company, it could be, and often was, a full performance by a group of professional actors and dancers. The significance of such theatrical entertainment for the decoration of dining rooms will be discussed later.

Vitruvius prepares us to expect ample provision of rooms for dining, prescribing four as desirable complement for the well-appointed house (6.4.2). Notably, this is the very number that Trimalchio brags of having within his house. The simple fact of multiplicity should not in itself be judged extravagant because seasonal variations in climate practically demanded a variety of exposures and orientations. Common sense dictates the location of winter rooms in protected places where expensive heating would not be wasted. A favored position for such rooms was at the rear of the atrium, often beside the *tablinum*. In the intermediary seasons, however, sunshine was desirable and in summer whatever shade afforded by a northern exposure turned away from the sun (6.4.2). Thus the various sides of the peristyle became a common location for dining rooms of various sizes and in various combinations that gave an owner far more freedom to indulge his ingenuity, so far as space and personal finances allowed, than did the traditionally more conventional reception and business rooms.[116]

For this reason we should probably place many more Pompeian rooms within the category of potential dining spaces than has been the case. Such spaces confront us with a large variety of shapes and sizes, some accommodated to small parties and others to large. In many instances, especially in the corridors of peristyles, large and small rooms occur in combinations of two or even three. While the ampler rooms accommodated large parties, acoustics alone could have made smaller spaces preferable for small groups. It is useful to begin our consideration then with vocabulary and its implications concerning the characteristics and use of the rooms.

Four major words designate spaces that are specifically for dining: two of Greek origin – *oecus* and *triclinium* – and two Latin *cenatio* and *cenaculum*. Of these the *oeci* are the most pretentious. Identification rests entirely on Vitruvius, the single Latin author to use the word, with the exception of Pliny the Elder, who applies it once (36.60.184) – not with reference to architectural design, but to the *oecus asarotos* a species of mosaic pavement depicting scattered remains of a meal. Several examples exist of this pattern, which would seem without question to signify a space used for dining. In Greek, of course, the word, *oikos* means house in the inclusive sense and less often a single room. Vitruvius uses *oecus magnus* of a room in Greek houses where characteristically the women supervise work done with wool (6.7.2). The word is also used, however, with honorific associations of large chambers in the public sphere. At Alexandria, according to Strabo, an *oikos mega* near the

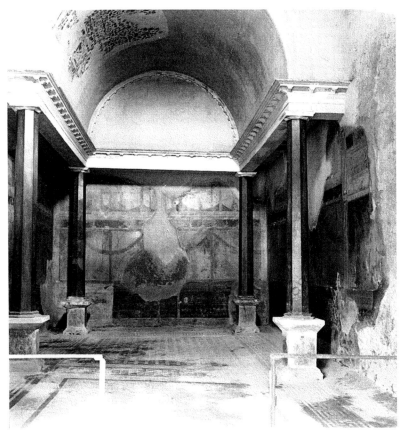

26. Casa delle Nozze d'Argento, tetrastyle oecus. FU 2558/1938.

Museion in the royal palace served as dining chamber for the scholars who worked there (*Geography* 17.1.8 [794]). Vitruvius also appears to associate *oeci* with dining, or at least he discusses them within a section headed by *triclinia*. When he chooses the word it is presumably because of the specific structural characteristics of the spaces he describes, but it no doubt also recommends itself by its exotic international flavor.[117] This is enhanced by the names of four specific subspecies (6.3.8): tetrastyle, Corinthian, Egyptian, and Cyzicene.

The architectural possibilities of these rooms caught the imagination of Palladio who reconstructed them in an elegant manner for use in his own designs. In an article taking rise from this source, Amadeo Maiuri pointed out the existence of three of these exotic types in houses at Pompeii and Herculaneum.[118] The tetrastyle *oecus* whose vault is carried on four columns appears as part of the Second Style decoration (reconstructed) in the Casa delle Nozze d'Argento in Pompeii (Figure 26).[119] but also in the House of Augustus on the Palatine in Rome.[120] One single example of the Egyptian *oecus* exists, but it is a good one. Vitruvius (6.3.9) calls this a basilicalike room with an upper gallery and clerestory windows, which is just what we see taking the place

of the conventional *tablinum*-box in the House of the Mosaic Atrium in Herculaneum.[121] For the Corinthian *oecus* there are two excellent examples – one early, in the Pompeian Casa del Labirinto (Figure 27), and the other late, in the Casa di Meleagro (Figure 28 and Color Plate VII).[122] Both illustrate Vitruvius' prescription for the room as having single files of columns surmounted by an architrave (6.3.9). These were specifically intended for dining. All three of these rooms, as Vitruvius prescribes, should be of the proportions of *triclinia* save that their columns make them more spacious. For Vitruvius' fourth type, the Cyzecene *oecus*, a situation proximate to gardens is required. Such rooms are constructed with sufficient length and breadth to accommodate two sets of couches facing each other with room to pass in between. To right and left these rooms have windows that open like folding doors "so that the guests from under cover may look out through the green spaces of the gardens" (6.3.8–10). Such rooms, the architect goes on to say, are rarely used in Italy, a point that Maiuri acknowledges in proposing only a somewhat dubious example of a type generally considered nonexistent.[123] As De Albentiis has pointed out, the locational requirement of a place where double windows on both sides of the

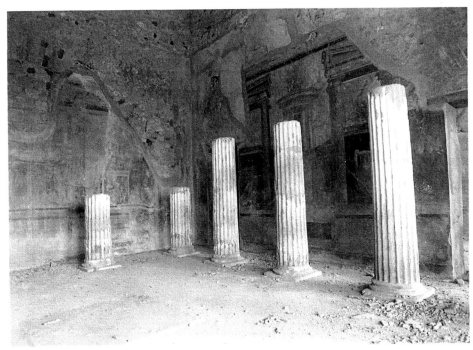

27. Casa del Labirinto, Corinthian oecus. Author's photograph (su concessione del Ministero per i Beni e le Attività Culturali).

room can open toward garden prospects is difficult to meet.[124] Nonetheless, I cite this description because it is my theory that the structure of the Cyzecene *oecus* can be seen in painted imitations. The two examples I propose are in the House of Augustus (Figure 29) and the House of Livia (Figure 30), where at either end of the long walls, ressauts mark off apertures painted in the manner of windows opening on exterior views.[125] As

will be seen in Chapter 4, this unusual mimetic configuration serves in both cases as a framework for the newly developing style of the picture gallery.

Not only the names of these four *oeci*, but also their architectural features highlight associations with the public world so as to place them among the public representational areas of the house.[126] Pompeianists, however, have not limited their applications of the Greek

28. Casa del Meleagro, Corinthian oecus. Author's photograph (su concessione del Ministero per i Beni e le Attività Culturali).

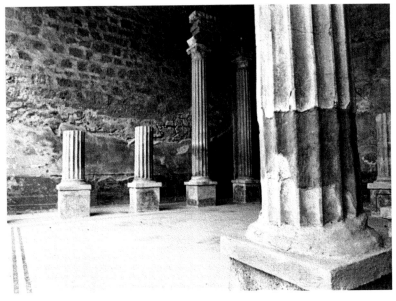

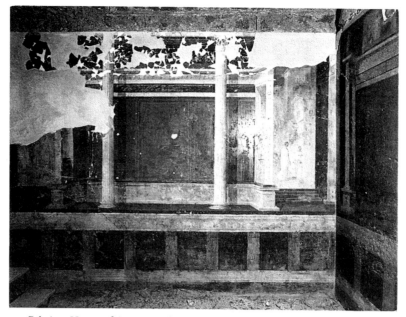

29. Rome, Palatine, House of Augustus, "lower *cubiculum*," replication of a Cyzicene *oecus*, side wall with window prospects. DAI 82.2237.

nomenclature to these rare, but recognizable types, but have attached the label *oecus* to various other generously proportioned spaces. Vitruvius dictates a lofty height for *oeci quadrati* and on this basis the name is often assigned to large square rooms in Pompeii. Richardson defines the *oecus* as a large reception room without the characteristic shape of the *triclinium*. Recognizable *oeci* occur in some contexts such as the room paved with the Alexander mosaic in the Casa del Fauno; however, it is not always possible to make a precise distinction between these and exedrae.

No less Greek in origins than the elusive *oecus*, the commonly used word *triclinium* reflects the items of furnishing from which it derives: the traditional

30. Rome, Palatine, House of Livia, replication of a Cyzicene oecus. DAI66.70.

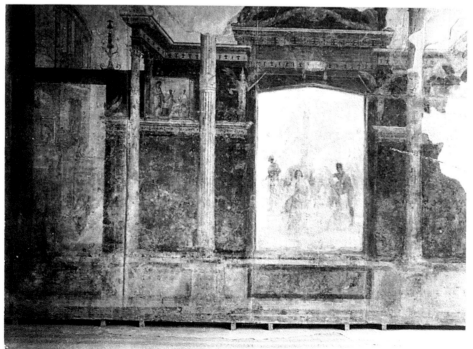

three-person dining couches normally deployed in a U-shaped assemblage of three. The Greek name points to the foreign origins of reclined dining, a custom whose adoption into Roman society was once tainted by imputations of luxury, but had long since been accepted as common practice, provided that the couches themselves were not overly ornate.[127] Although *triclinium* is the standard Roman apellation for a dining enclosure, its twofold designation of couches and the space they occupy can prove confusing in considerations of location and size. Conversational interchanges in many literary dramatizations give us to imagine dining parties occupying only one set of couches. Nine persons can be counted in Horace's dinner of Nasidienus, and even Trimalchio's flamboyantly orchestrated banquet seems to be staged for only nine guests. Still we should not regard this number as immutable. Octavian's "secret" "Banquet of the Twelve Gods," a costume party of mixed sexes, violated not only the canon but also other proprieties as Suetonius attests by the scandal to which its divulgence gave rise. "Answer me how many you'd like," Horace writes in an invitational epistle to Torquatus (*Ep.* 1.5.30), indicating room for a few "shadows" (*locus est et pluribus umbris*), while adding the reservation that tightly packed gatherings (*arta convivia*) are liable to "smell of the goat." Packing four to a couch, which by his witness does often happen (*Sat.* 4.86–9), is a social indignity liable to redound on its perpetrator, when some ungracious guest flings malicious tidbits under the pretense of "urbanity."

Some literary evidence makes mention of large dinner parties requiring multiple *triclinia*. Suetonius records that Julius Caesar when traveling in the provinces was accustomed to entertain in two *triclinia*, one for ethnics and the other for local officials and his own retinue (Julius 48.1.1). This context does not make clear whether two separate rooms were intended or merely two sets of couches; however, it seems certain that far more than two sets were put into service when Julius Caesar spent the night with 2000 soldiers at Cicero's Puteolan villa during the Saturnalia of 45 B.C. in a sojourn "more like a billeting than a visit." On the previous day he had stopped at a neighboring villa where the host could barely find a *triclinium* empty for Caesar to dine. At Cicero's place the company copiously filled three *triclinia* with freedmen and slaves spilling over (*Att.* 13.52.1.4).

Two distinct kinds of *triclinia* appear in actual Pompeian houses. One kind, comprising a set of three fixed stone couches, is only tangentially relevant to wall painting because these fixtures seldom stand within rooms at all but within open or semi-enclosed areas connected with gardens, whose decorative furnishings provide a

three-dimensional ambience (Figure 31). The biclinear structure on the first terrace of the House of Loreius Tiburtinus, for instance, is dominated by its fountain and euripus, and an unusual combination of *triclinium* with piscina appears in the Casa del Centenario.[128] Neither the size nor the seasonal accommodation of these rooms raise any questions, because they are unambiguously dedicated to the single purpose of summer dining, but their number is small in comparison with the prevalence of unfurnished *triclinia* into which couches could be moved. These are the rooms which, as architectural references make clear, were designed for different seasons. They also present archaeology with the most difficult problems of distinction. Although many can be identified on the basis of the markings in mosaic pavements to indicate positions for couches, in surveying the identifiable *triclinia* of Region 1, Ruggiu has remarked how many of them show none of the expected characteristics.[129] Vitruvius calls *triclinia* oblong, in contrast with *oeci*, which are square, and includes them within a general class of *conclavia*. Unfurnished *triclinia* are not restricted to any given location. However, all the architectural references make it clear that such rooms are designed for different seasons. Varro notes that both doors and windows differ with the season (*LL.* 8.28.4). Vitruvius uses *triclinia* with four seasonal adjectives: *hiberna, aestiva, verna,* and *autumnalia* the latter two having similar eastern exposure. The host faced with the ambivalent privilege of "billeting" Caesar at Puteoli must have needed to utilize all his spatial resources irrespective of the seasonal orientations.

When commenting on the state banquet with which Dido welcomes Aeneas in Carthage, Servius advises readers that *triclinium* as an arrangement of three couches should not be confused with the actual dining space of a basilica or a *cenatio* (*ad Ae.* 1.698). He insists that the "ancients" spoke of *triclinia* because the *stibadium* had not yet been invented. By this token he would put the majority of earlier writers in the wrong. In contrast to *triclinium*, which suggests a semblance of intimacy or close association with emphasis on the sociable aspects of dining,[130] I believe that *cenatio* indicates a larger room.[131] Suetonius uses this word for the opulent dining room in Nero's Domus Aurea reputed to have a ceiling of movable ivory panels, and Seneca may well refer to the same in *Moral Epistles* 90.14, when he mentions *cenationes* with movable ceiling panels. Seneca also uses *cenatio* (*Ep.* 115), although in a generic designation, when he speaks of a room with marble columns that is *capax populi*, obviously intending more than the traditional nine guests. More specifically, the elder Pliny uses it in reference to a grandiose dining room with thirty onyx columns built

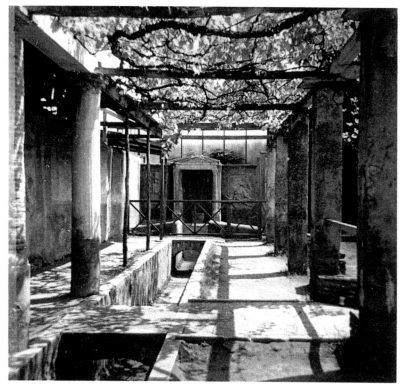

31. House of Loreius Tiburtinus, *biclinium* on terrace. Photograph, Harriet Leach (su concessione del Ministero per i Beni e le Attività Culturali).

by the freedman Callistus – perhaps a Corinthian *oecus*. All these rooms would seem larger than the normal Pompeian dining room, yet some Pompeian houses contain rooms of very large dimensions such as one facing the peristyle of the Casa del Menandro.[132] Trimalchio in boasting of his four dining rooms calls them *cenationes,* but in view of the malapropisms with which Petronius imbues his speech, we cannot reliably conclude whether the term is rightly or mistakenly applied. Even so *cenationes* are not invariably large because Pliny (*Ep.* 2.17.10) speaks of a room that can be considered either a generously sized *cubiculum* or a modest *cenatio*. His letters appear to differentiate rather precisely between *triclinia* and *cenationes,* but the rationale for the distinction is not readily apparent from context. Perhaps his *triclinia* are the kind with fixed couches, but several possess windows and views.

Spaces for Sleeping

The Roman vocabulary for sleeping chambers includes also words of Greek and Roman derivation: *thalamus* and *cubiculum,* but the distinctions between these differ from those for dining chambers because, in this case, the Greek word, instead of designating a particular architec-

ture or characteristic furnishing, seems to be linked with semantic levels of diction. Infrequent in everyday use, it is common in poetic vocabulary where it often conveys a certain formality appropriate to royal apartments or else may underscore the institutional sanctity of marriage chambers. Beyond this, a *thalamus* is always a bedchamber, whereas the spaces denoted by the Roman word *cubiculum* may witness a variety of personal activities.

Of all the words that refer to domestic spaces, *cubiculum* figures most frequently both in narrative and in description, encompassing not only a wide variety of functions, but also a semantic range from technical to symbolic. Since I have earlier raised the point that one and the same space may serve alternately as a *cubiculum* and as a *triclinium*, it is not necessary to dwell here on the physical shapes of these rooms. Instead I concentrate on the evidence literary sources provide concerning the location of rooms of this name, the activities they witness, and what they symbolize within the total picture of the house. Recent discussions of *cubicula* have scrutinized their implications for the Roman conceptualization of privacy with particular attention to the intimate personal activities, both legitimately sanctioned and "immoral," that present-day societies tend to carry out in seclusion.[133] Within the context of domestic decoration, the privacy or seclusion of cubicular activities is

interesting primarily as an index of the rooms' probable visibility. One point that should emerge from discussion is that the particular range of activities carried out in a given room depends on its position. In the Greek house bedchambers appear to have fixed places, perhaps in relationship to the gender axis of the house. In Roman houses there are many possible locations. Although many *cubicula* may be private insofar as access to them is invitational, the range of their uses makes them semipublic. Especially it is the rooms of variable identity that are most likely to function as settings for private interviews. Additionally, as we will see, one or more *cubicula* may be included in small suites or apartments known by the name of *diaetae* that were commonly used as guest lodgings. Even discounting possible invitations, however, Wallace-Hadrill has done well to remind us how little privacy could actually obtain in a large Roman house with its multitudinous *familia*.[134]

The spaces most commonly associated with the word *cubiculum* and identified as sleeping chambers are the sequences of similarly sized little rooms ranged on the two long sides of many – but not all – atria.[135] Two sources attest to the nomenclature, but not necessarily the function of these rooms. Cicero writes to Quintus about the *cubicula* and other *membra* surrounding the atrium (*Q.fr.* 3.2); while Quintilian, invoking the atrium as a spatial framework for the images that serve to prompt artificial memory, mentions *cubicula* and exedrae along with statues and portrait representations (*similibus*) as visual points of reference in the circumference of the room (11.2.20). Historically we can imagine that such rooms were sleeping chambers in an era when the atrium served as the center for all domestic activity. Certainly they must also have continued as bedrooms in many houses, but Allison's investigation of excavation records revealed that many of these interior spaces in Pompeii were not only undecorated but also actively utilized for storage. Storage, of course, can be seasonal, and the presence or absence of decoration is hardly reliable evidence for a bedroom; rather so full and up-to-date a program as one sees in the elegant House of Marcus Lucretius might suggest a less restricted use. Nonetheless rough plaster is sufficiently different from even the most perfunctory sort of finishing as to justify Allison's suggestion that many bedrooms had migrated into other quarters of the house.[136]

Cicero portrays his enemy Clodius as a timorous mannikin (*pro Caelio* 15.35: *pusio*) whose nighttime terrors caused him to bed down with his older sister (*cubitabat*) and the mature Clodius as sallying forth from his sisters' bedchamber (*Har.* 5.9: *egressus ex cubiculo sororum*). As a guest in the dining room of Ti. Claudius Nero, Octavian led off his host's wife Livia, into a *cubiculum* from which

she emerged red at the ear tips with her coiffure disarranged (Suetonius *Augustus* 69: *feminam consularem ex triclinio viri coram in cubiculum.*). The rooms, one might conjecture, were not too far separated, but presumably the complacency of Claudius Nero was unusual. Although *cubicula* figure frequently in historical and biographical writing as settings for adultery,[137] death,[138] and murder,[139] rooms either upstairs or otherwise removed from normal traffic would best accomodate socially marginal activities.[140] Literary references give little insight into this aspect of seclusion because they seldom explicitly locate a *cubiculum* upstairs,[141] but the majority of Pompeian houses, as indicated by their surviving vestiges of stairways, did have upper stories; in present-day Pompeii, the House of Julius Polibius provides one of the few fully preserved examples. Mention of *cubicula* located near peristyles occurs more frequently. The villa of Quintus Cicero at Arcanum has two *cubicula* in the *ambulatio* near the baths; they are large, and the one termed an *hibernum* is also high roofed (*Q.fr.* 3.1.2).[142] Some rooms in this location were used for sleeping. The single chamber in which Augustus was reported to have slept both summer and winter for forty years was located, for the sake of its healthful advantages, near a peristyle (Suet. *Augustus* 82.1.3).

Even though the visibility of Augustus' *cubiculum* can only be speculated, *cubicula* located near peristyles are more likely than hidden ones to assume a place in a decorative heirarchy, and thus – as perhaps elaborately painted *cubicula* in atria – to belong within that category of spaces, which although personal, were not employed exclusively for sleeping, but also for intellectual pursuits and even sociability.[143] Cicero (*Fam.* 7.1.5) pictures his friend Marius enjoying his mornings at his Pompeian villa reading in a *cubiculum* which he has pierced to lay open the entire prospect of the Stabian bay (*ex quo tibi Stabianum perforando patefecisti senum*). Pliny 1.31, in praising the villa of a friend on Lake Como, speaks of day and night *cubicula*; later he writes of his own villa that it is situated so close to the lake that he can drop in a fish-hook from the couch in his *cubiculum* (9.7.3). The more extensive and detailed descriptions of his Laurentine and Tuscan villas indicate that he uses their numerous, well-situated *cubicula* as studies for reading and writing. One apsidal *cubiculum* at Laurentum is fitted up as a *biblioteca* with shelves for the books he most often likes to peruse. Within his favorite, personally designed *diaeta* at the end of the cryptoporticus is a complex of three *cubicula*, one of which can accommodate a couch and two chairs. Presumably this is also a room for study and writing, but he also consults with his closest friends in a *cubiculum* (5.1.4) or summons them there for a reading

of his verses (5.3.10). Although Pliny gives no hints of his use of wall decoration, he does often elaborate the out-of-door prospects afforded by windows in a manner that incorporates these landscapes into his decor.

Whatever the real degree of privacy in *cubicula*, they are certainly as much symbols for personal occupations as is the atrium for the public profile of the house. When Cicero is prosecuting Verres, he represents the conduct of judicial business in a *cubiculum* as a decadent abuse of power (*Ver.* 2.2.53.133, 2.3.23.56, 2.3.34.79). Writing to his brother Quintus in Gaul, however, he praises such accessibility as service beyond the requirements of duty (*Q.fr.* 1.1.59). Pliny's *Panegyric* utilizes a similar ethical semiotics in stressing that Trajan as emperor has brought government out of the *cubiculum* into the public eye.[144] Most striking, however, is the contrast posed by two books representing the Republic and Empire. At the opening of the *de Republica,* Scipio dresses and walks out of his *cubiculum* into the *porticus* to begin his discussion of the state. At the beginning of Tacitus *Dialogus* (3.1.1) Julius Maternus receives his callers in his *cubiculum,* where they remain (14.1.1) throughout their conversation about the decline of oratory as the powerful discourse of public life. Whatever the status of space in the Roman house and its employment, Tacitus' symbolic scene setting aims to signify that the temper of public life has suffered change.

Diaetae

Further evidence for the interchangeable and interconnected nature of *cubicula* and *triclinia* appears from the way in which the terms come together in references to still another open-ended spatial designation, the *diaeta.* Plutarch employs this word in its Greek form, *diaitai* when talking about apartments on open-air porticoes in Lucullus' villas (*Lucullus* 39.2). In the Greek world *diaita* is a word of multiple significance whose occurrences go back to the fourth century. From its original designation of a regimen, it gravitates to a lifestyle and seemingly from thence to an apartment, but this can be either public or private. Vitruvius writes within the category of Greek houses when he mentions a species of "more ample" peristyle that serves as a locus for a great variety of rooms including libraries and guest chambers (*hospitalia* [6.7.4–5]), but this designation fits Plutarch's descriptions of the spaces that must have been among Lucullus' Hellenic affectations. This is the earliest historical point of reference to which the word is applied but does not constitute evidence for its currency in the usage of Republican Rome. It is neither among Cicero's Greek adaptations nor in Vitruvius. Rather, a survey

of uses indicates that it enters into Latin vocabulary in the early Empire. Pliny employs *diaeta* several times in describing the layout of his villas. Statius also applies it to a species of rooms in villas (*Silvae* 2.2.83), and it occurs as a standard term in Justinian. Therefore I suspect that Plutarch has adopted this term grown common in contemporary Latin usage to describe a phenomenon that earlier writers had called by other names. In Pompeian studies *diaeta* has commonly been used to designate a bedroom for daytime rather than nighttime use, or sometimes a dining room, but literary references suggest that these are more accurately seen as spatial nuclei formed of two or three rooms.

Pliny, who seems thoroughly familiar with the term, documents the creation of *diaetae* in his villas in passages that clearly indicate the multiplex composition of such apartments because he often catalogues the subordinate chambers making up the total unit. His *diaetae* tend to be located at some remove from the central areas of the house and are frequently oriented with reference to a cryptoporticus, which serves them as a partial source of light, although most have windows opening on spectacular views. At Laurentum there is also a *diaeta* located in connection with a tower. Each suite contains a combination of *cubiculum* and *triclinium,* or else several *cubicula.* That Pliny's wife Calpurnia had such a suite, including a bedroom, for her personal use can be inferred from a passage of conjugal sentiment in *Ep.* 7.5 written to her in her absence. Here the lonely husband records his nocturnal wakefulness when his feet by habit carry him to the *diaeta* "at those hours in which I was accustomed to look in on you," then back from it as one excluded from an "empty threshold."

Among the several *diaetae* in his own villas Pliny describes his favorite in the Laurentium comprising three rooms, each receiving a different exposure of sunlight. This suite includes specifically daytime and nighttime *cubicula.* One might recall the similarly configured suites affording privacy to guests, that Vitruvius terms *hospitalia* in the Greek house, yet the majority of Pliny's suites appear to have been designed and reserved for his personal use. Removal from domestic noise is the asset he praises because it makes them conducive to his cherished intellectual pursuits. Pliny does mention a *diaeta* used as guest chamber, however, with reference to the visitors' accommodations in Pomponius' house at Stabiae where his uncle was housed on the night of Vesuvius' eruption (6.16.3). This was close to an open area where ashes threatened to block access, and the elder Pliny was sleeping in a *cubiculum.* In Justinian also one notes that *diaetae* as quarters are essentially separate and probably contain multiple rooms.

49

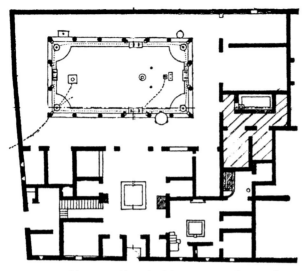

32. House of the Vettii. Plan after Mau 1904, 322, fig. 158, showing corridor and *diaeta*.

Almost every Pompeian peristyle complex includes a small cluster of rooms that might be available for use as a *diaeta,* but in all likelihood those most valued are designed expressly to fulfill this role. Thus especially one will notice configurations of rooms that open out from a common space. A likely example is a pair of enclosed rooms with its own small courtyard and corridor situated off the peristyle in the House of the Vettii (Figure 32). Scholars had sometimes called this suite a *gynacaeum* before the point became firmly established that women did not occupy segregated spaces within the Roman house. One ample suite that has been commonly recognized as a *diaeta* is at the rear of the grand central peristyle in the Casa del Citarista,[145] a house whose owners were

33. Casa del Citarista (house of Poppidii Secundus). Plan after Overbeck 1884, 360, fig. 179.

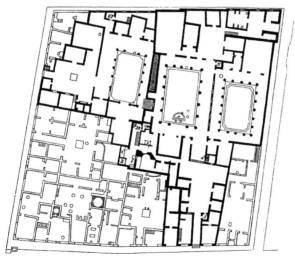

once among Pompeii's firmest and most favored Neronian loyalists.[146] Here, with access to the best peristyle is a virtual residence within the house: a suite comprising six intercommunicating spaces of varying size and decorated with some of the finest paintings in the house (Figure 33). That it is indeed a place for visitors' accommodation might be suggested by the wall that screens its spaces from the peristyle and by the fact that a ramp leads out of this quarter directly into the stable.

TECHNICAL NOMENCLATURE AND VARIABLE FUNCTION

Additional written evidence for the interchangeability of function in rooms comes from the frequent appearance within a variety of texts of those terms I have earlier called structural designations because they refer exclusively to form without prescribing function. Insofar as squareness characterizes the *oecus* and openness the exedra, these spaces also belong within the structural category; however, Roman writers use these names infrequently and primarily in contexts where their Hellenic affiliations attach some symbolic coloring to their use. Much more frequently employed are two terms of humbler pretensions: *camera* and *conclave,* which in themselves carry no implication of status or size. The textual currency of these structural terms makes them particularly important to the investigation of spatial hierarchy because it offers evidence that rooms of unremarkable size or shape but advantageous location will have specifically been intended for variable use. Depending on what furnishings were placed within them, they could serve multiple purposes: sleeping, dining, study, and private reception in accordance with the dictates of weather and need. The portable nature of Roman furniture made such variable usage possible. Consisting primarily of couches and tables, it could readily be moved from one to another space as desired.[147] On the basis of recorded finds, allowing, of course for the possibility of salvage either before or after the eruption, we may conclude that the majority of Pompeians, and even some of the more prosperous, did not rival Seneca in owning tables by the hundred, nor even an excess number of couches either for sleeping or for dining. Especially the small number of couches, as items whose size or bulk would have made them difficult to salvage, would suggest that households owned no more of these furnishings than needed and moved them from one to another room in accordance with the seasons.[148]

The word *camera,* which has a specific technical meaning, occurs frequently. Derived, as the Romans see it, from the word for curve, it designates a ceiling vault

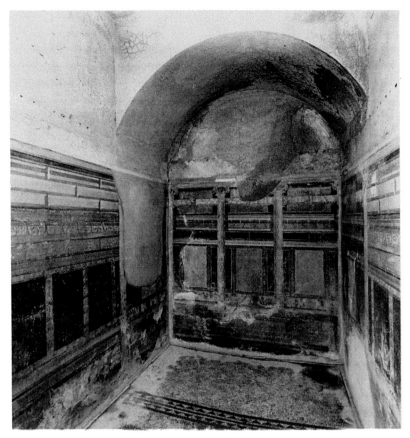

34. Casa delle Nozze d'Argento, *camera* at the back of the peristyle. ICCD N49723.

or a vaulted room. Instructions for building *camerae* in the architectural manuals of Vitruvius (7.3.1–11) and M. Cetius Faventinus explain how to make frames from wooden lathes and reeds, cover them with cement, and finish the stuccoed surfaces of the vaults and cornice moldings. This form of construction is by no means limited to domestic spaces. It is commonly used with reference to the vaulted chambers of baths (Vitruvius 5.11.5).[149] Thus *camera* is a term associated both with public and with private architecture.

Looking at some appearances of *camera* in Latin texts tends to give the impression that form often preceded function in the designer's and the patron's thinking. Letters that Cicero wrote to his brother Quintus in Gaul describe building operations at Quintus' villas and his Roman house which Clodius had wrecked during Cicero's exile. These are useful descriptions of work in progress from a fairly technical point of view. At Arcanum where an extensive renovation campaign was in progress under the direction of a rather slow-moving architect named Diphilus, Cicero found certain vaulted rooms (*camerae*) unsatisfactory and ordered them to be redone (3.1.1). These rooms form their own class that appears to be categorically different from the *cubicula* be-

cause those are located on another side of the peristyle in proximity to the baths (3.1.2).

A great many Roman and Campanian rooms come into the category of *camerae*. Apart from the elegant but rare tetrastyle *oeci,* we find barrel-vaulted chambers of every period, often, but not exclusively, opening onto peristyles (Figure 34). In the Roman Casa dei Griffi on the Palatine, three such rooms were decorated in the early first century B.C.[150] (Figure 36). Especially within the architecture of the Second Style, a kind of room with two vaulted alcoves and prominent cornices was popular. Elegantly decorated examples occur in the Villa dei Misteri, the Casa del Labirinto, and the Villa Oplontis. Although the ceilings we know are finished in stucco, writers in every period – Varro, Propertius, Elder Pliny, Seneca, Statius (*Silvae* 1.5.36) – mention *camerae* in a luxury context, with ivory, marble, glass, or gilded decorations. Varro, however, uses the term to describe the niches in a dovecot and also the best kind of chamber for storing fruit (*DRR.* 1.59.2–3). Some people, as he remarks, like to spread their dining tables in such chambers because they are coated with marble to keep them cool. Why not enjoy a *spectaculum naturae* while one dines?

Frequent as vaulted rooms may be both in description and in practice, still *camerae* do not occur as settings or backgrounds for narrative or dramatic action in the same manner as the other words I shall discuss, except when technical information is important. For instance, Phaedrus (*Fab.* 4.26.23), when retelling the well-known story of Simonides and the ceiling, whose collapse buried his fellow dinner guests, gives the story an anachronistic Roman coloring by calling the fatal accident a *ruina camerae*. No doubt he was thinking of the potential frailty of plastered vaults. Valerius Maximus (6.7.2) recounts the anecdote of the Roman matron Turia who concealed her proscribed husband between the vault (*camera*) and roof (*tectum*) of the couple's *cubiculum*, keeping him both safe from execution and available to her embrace. One exception to the principle of technical implication may be of interest. References to the doorway and ceiling of the room where the elaborate feast of Petronius' "Cena Trimalchionis" is staged suggest that this dining room had an arched entrance and was itself vaulted.[151]

The significance of *conclave*, the most general and neutral word in the technical vocabulary of the house, deserves particular attention. It has gone virtually unnoticed by students of Roman architecture, but a simple search of Latin vocabulary brings out the frequency with which *conclavia* occur and in what a variety of contexts in Roman writing from Plautus to the Bible. Festus explains *conclave* as a room to be closed with one key, but this prescription may not have been strictly observed. The *Thesaurus Linguae Latinae* lexicographer gives the information that the word is not used by poets save for the comic playwrights, Horace in the *Satires* and Martial. So much the better; it is a down-to-earth, everyday word. Suetonius (*Augustus* 72) uses this term with such implications in asserting the emperor Augustus' domestic unpretentiousness: his *conclavia* had neither marble nor showy pavements. Furthermore, its range of use suggests that it is a word outside variations of fashion and, as I will further demonstrate, it is without specific implications of shape or size. *Conclavia* may serve alternatively as dining chambers or bedrooms and can be decorated as elaborately or as simply as the owner desires.

Several sources attest to the use of *conclave* as a builders' word. One is Cicero's correspondence with Quintus where, as already mentioned, the chambers appear to be designated by technical names. At the Roman house a roof has just been completed over a series of *conclavia*, which slopes down to a lower colonnade (*Q.fr.* 3.1.14, 3.9.7). Quintus did not want this roof gabled; it has accordingly been made with a slope. This passage suggests that *conclavia* are to be associated with peristyles, but their locations in Vitruvius' discussions of domestic architecture are ubiquitous. For him the word seems to be a generic term that encompasses various spatial configurations. In 6.8.1 the classification *conclavia* includes both oblong *triclinia* and squared *oeci*; in another passage he links the words *triclinia* and other forms of *conclavia*. In 7.2.2 we find vaulted *camerae* classed as a species of *conclavia*. In other passages he speaks of their proper orientations and decoration. In 7.3.3 we see that they can be either summer or winter rooms because he mentions that some of them must be artificially heated and lighted, but in the opening sentence of his history of interior painting, he cites spring, autumn, and winter *conclavia* along with atria and peristyles as the original venues for mimetic decorations (7.5.1). In the same category we can place a remark Varro makes in *LL.* 8.32 that twin (*gemina*) *conclavia* may be dissimilarly furnished.

In some contexts where activities are associated with *conclavia* the designation is completely neutral with no indication of specific use. So in Plautus' *Mostellaria* the word is used to gesture toward the rooms of the house being inspected on the assumption that it has been offered for sale. In other cases where the use is indefinite, there is all the same a suggestion of privacy. In *Aulularia* (434) the suspicious miser Euclio angrily accuses Congrio, the hired cook, of having invaded every corner of his *aedes* and *conclavia* instead of tending to his offices by the hearth. Privacy also obtains in Plautus *Miles Gloriosus* where a *conclave* figures in the plot. Pyrgopolynices has assigned such a room (*unum conclave*) to Philocomasium as her private space (141: *quas nemo nisi eapse inferret pedem*), and this is the room that is dug through to facilitate Philcomasium's meeting with her lover Pleusicles. Notably this must be situated near a party wall. Finally in Terence's *Eunuchus*, the virgin whom Chaerea will soon ravish is mentioned seated in a *conclave* decorated with a picture showing Jupiter's descent to Danae in a shower of gold. Context identifies both these women's rooms as bedrooms; however, the usage is sometimes even more explicit. In *Pro Roscio Amerino* (23.64) Cicero cites the example of Titus Cloelius, a well-known citizen of Tarracina who was murdered while sleeping in a *conclave* with his two adult sons.[152] Celsus refers more than once to the *conclave* used as a sickroom, while Justinian mentions it as a birthing chamber. Cicero (*Div.* 2.20) tells a story about a prophetic omen that prevented King Dioterius from a journey where he would have slept in a *conclave* that collapsed in ruins next day. Nepos ("Life of Dion" 8.5.2) mentions sleeping in a *conclave*.

Varro's reference to twin *conclavia* differently decorated implies an association of the name both with bedrooms and with dining rooms because it makes the point that the couches used for dining might be of a

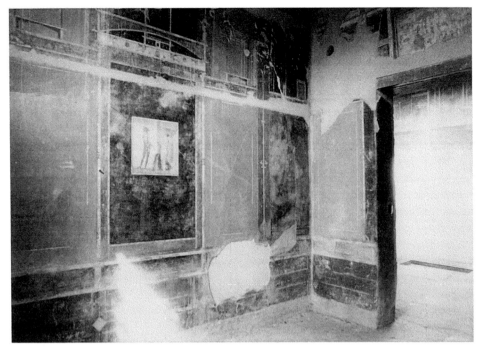

35. House of M. Lucretius Fronto 5.4.11, *conclave* off the atrium. Author's photograph (su concessione del Ministero per i Beni e le Attività Culturali).

higher grade of material than those used for sleeping. For indication of a *conclave* as dining room Cicero (*Ver.* 2.4.58) testifies to the governor's megalomania by claiming that he can dress thirty dining couches in individual *conclavia* with tapestry coverlets, not only in Rome but also in all of his villas. The name certainly signifies a dining room when Cicero (*Phil* 2.28) remarks on Antony's tenancy of the house of Pompey that he has set up stables in the *cubicula* and cookshops where *conclavia* used to be (*pro conclavibus popinae sunt*). Also the room within which Horace's town mouse introduces his country visitor to the advantages of city dining is a *conclave* (*Satires* 2.6.113).

On the basis of common usage of the word and its application to diverse literary scenarios, one may suspect that many rooms in Pompeii may have been called *conclavia* by their owners. Such closed chambers occur in all quarters of the house from corridors of the peristyle to interior corners of the atrium (Figure 35), and with finishings that range from rough plaster to some of the most elegant decorations in the city. Interpretations of their decoration should be referred to their place in the hierarchy of the program as indicated by their location within the house plan rather than by their exclusive dedication to the activities of sleeping or dining. Thus one might also explain why in August, when Vesuvius erupted, the majority of enclosed rooms located within the core of the house were either empty or utilized for

storage while some of the more open rooms, especially those around the peristyle, housed a certain number of dining or bed couches.[153]

SPACE, HIERARCHY, AND DECORATION

Before turning from the physical structuring of Roman houses to look at the particular patterns applied to decorate them, it will be useful to outline some general principles of pictorial decorum operative across a long spectrum of time. The first point to emphasize is that the decoration of a house comprises a complete program of visual signifiers; this synchronic principle is operative even when redecorations have taken place at different periods. Within such programs what Daniela Scagliarini has termed the "semantics of decoration" rests on the two interrelated signifying principles of functional hierarchy and representational code that I mentioned at the close of the introductory chapter; the first principle involving patterns that reinforce the practical usage of spaces; the other a schedule of figural complexity appropriate to the valuation of the activities they contain.[154] Impressive monumental compositions placed in areas of public or invitational access lend their status value to the activities conducted in these rooms.[155]

The simpler principle is the decorum of practical usage that cuts across those chronological variations in subject and spatial perspective that comprise the history

of figurative and stylistic trends. By strolling casually through a series of painted rooms one readily sees that those for stationary activity are painted in a manner different from those intended to make a momentary impression on persons walking through a room. This differentiating principle is in general agreement with Vitruvius who notes, with historical reference, how particular kinds of patterns were popularly employed within specific spatial conformations. In this respect the principles governing the design of wall paintings observe a decorum that would also be valid for real architecture.[156]

In passages and in other areas that were intended to be traversed rapidly, programmatic decoration favored paratactic compositions formed by the alternation of panels and regularly spaced dividers of such a kind as to make minimal claims on the spectator's attention. Thus the function of the peristyle as a corridor or walkway is usually highlighted by a serial application of motifs to complement the progressive orientation established by the colonnades. When the passageway comprises a covered interior space, such as a cryptoporticus structured without such obvious spatial markers as columns, then perspective elements may be employed as pointers to indicate the expected direction of movement.[157] Where subject paintings suggesting a more leisurely passage are deployed in such areas, still these tend to be of a continuous or sequential nature in the form of friezes or narrative panels. Places where crowds will have gathered and obscured the view commonly use repetitive background decorations. Thus, as mentioned, the decoration of atria is often paratactic and sometimes little more varied than that of corridors. Symmetrically designed walls are rare in these spaces, and items of subject interest tend to be placed above the cornice in a frieze zone. Whenever we see spatially enclosed backgrounds in such surroundings, we should remember that stylistic evolution is not the absolute determining factor in the treatment of space and surface. All the same, the quantity and the character of ornamental components along with the technical articulation of fine details most likely do reflect whatever was the current mode.

Areas intended for stationary uses such as dining were commonly designed in a symmetrical or quasi-symmetrical manner with perspective elements framing the wall center as a point of visual and thematic interest. Within spaces of this kind, the areas for seating and for circulation could be marked out by subdivisions in the organization of the design and in the mosaic pavement into an antechamber and interior space. Rooms in this category are most likely to exhibit the current predilections for closed or open space, as we will see when we examine the architectural megalographies of the late Republic. As a spokesman for this period, Vitruvius specifically mentions dining areas (6.2.2 *in cenis pictis*) as the environment for such trompe l'oeil elements as "projecting columns, mutules, and prominent statuary figures." In this same class of rooms at a slightly later moment, mythological panels came to be frequently employed; however, the images mimetically depicted in such compositions should not always be expected to show a direct thematic reflection of the activities carried on in the room. Rather, representational coding that governs the images dramatizes any and all activities by metaphorically relocating them within a broad social frame of reference that may extend to the public world. Furthermore, as we have seen in the preceding discussion, the practical employment of stationary spaces will have been variable in accordance both with seasonal conditions and domestic needs.

Within the more elaborate compositions that endow stationary areas the principle of hierarchy is most fully apparent. This principle aptly serves interpretation by virtue of its capacity to analogize the structural interrelationship of spaces to the structural interrelationship of activities, while concomitantly providing a direct link between the status gradations of spaces and the decorum of painting. Recent studies of painting have made productive use of this principle to explain variations within pictorial programs, such as the simultaneous presence of closed and open wall prospects, on the basis of their placement.[158] The programmatic operations of hierarchy can be visually apparent not merely within decorations of a single period but even when redecorations have been carried out at a later date in conformity with preexisting patterns of spatial employment.

Such visual principles, similar to those regulating architecture, transcend specific stylistic changes, although their precise application undergoes some alteration with time.[159] As logical as these visual principles may appear, however, it is only recently that scholars have come to accept them as a premise for interpretation where they have exerted a tempering influence upon the rigidity of stylistic classification. By understanding the consistent use of paratactic decoration in appropriate locations, for instance, we can better understand how one and the same decorative campaign might produce a total program encompassing both closed and open walls, while the principle of hierarchy can similarly explain discrepancies in the complexity of design in contiguous rooms. Consequently we are able to resist the temptation to an overly precise differentiation of the margins and overlappings of stylistic periods. With this reservation in mind, we may take up the narrative of Pompeian styles.

CHAPTER TWO

Panels and Porticoes

HEREAS THE SIGNIFYING PRINCIPLES OF FUNCTION AND hierarchy I outlined in the previous chapter remain consistent over long periods of time, compositional patterns show dramatic change. The changes involve both the objects of imitation and the techniques by which they are realized. The following three chapters address the questions of what these objects were and why they were imitated. By objects I mean not simply the individual elements composing an ensemble – the clearly articulated column capitals, cornices, or sculptures whose transformation of the plane surface, as Vitruvius puts it, does not allow vision to perceive true forms, but rather tricks the judgment of the mind (6.2.2: "Non enim veros videtur habere visus effectus, sed fallitur saepius iudicio ab eo mens"). Such forms are easy to identify, but the critical questions are semantic. What do the separate elements add up to, and what does their totality represent? Should we regard the designs they make simply as "compositions" in the abstract and eclectic sense, or does each one shape a coherent unity comprising a subject identifiable in its own right? Is the purpose of imitation really a simplistic aim of tricking the eye by means of simulated images and spatial illusions, or is there some further message to be conveyed?[1]

Questions of this kind cannot be answered on the basis of painting alone. Rather we must approach the subjects of imitation within the larger contexts that give them meaning, which is to say not only their immediate functional

domestic locations, but also their place within a larger cultural system in which the house itself participates. At the same time the separate status of Rome and Pompeii as communities deserves more attention than commonly given in such studies. The paintings from Rome and Pompeii that I discuss in this chapter belong to the final century of the Republic. The forms and images they employ will be seen to have their larger frame of reference within a strongly political environment characterized by interaction between the civic and domestic spheres.

STATUS AND INTERIOR FURNISHING

The narrative begins on the Roman Palatine and with the objects imitated rather than the imitations themselves. During the later Republic, the prestigious residential area for members of the senatorial classes was the hill's north slope which rose up behind the Domus Publica, as Andrea Carandini has described it "like a great backdrop to the Forum stage."[2] Here from the second century several blocks of large townhouses were built on the site which had once seen the first Roman dwellings. Thirty-six proprietors and twenty-seven properties can be ascribed to this quarter. Convenience to the forum gave practical cause for the development of the neighborhood, but as time went on its compelling attraction was the prestige which its inhabitants lent to each other. Senators buying property here intended their houses to be seen. Cicero mentions in *de Officiis* (1.39.138) that Gn. Octavius, the first consul of his family, built a house which was so *praeclara et plena dignitatis* that it may well have advanced his political fortunes by winning votes. During periods of political candidacy these great stage frames may have afforded clients access to their patrons not only by day, but even at night.[3]

Another notable Palatine resident, M. Livius Drusus, the reformist tribune of the plebs of 91 B.C., who argued perspicaciously for granting citizenship to the Italian allies, spoke of building a house so conspicuously in sight of the city that anything he might be doing could openly be viewed by all (Velleius 2.14.3). This prominent location *in conspectu prope totius urbis* (*Dom* 100) would later recommend the house to Cicero, who purchased it for 3.5 million sesterces from Crassus, the interim owner, who may have looked upon it as an investment rather than a residence (*Fam* 5.6.2).[4] Upon Cicero's death the house passed to L. Marcius Censorinus and later to Augustus' close associate Statilius Taurus.[5] Although this particular history of changing ownerships entailed the political murders of two residents, it was not untypical of the status of Palatine properties many of which passed

from one to another owner more than once. The house which Octavius built in 150 B.C. remained in the family from first owner to grandson, but was then annexed by M. Aemilius Scaurus who passed it to his own son, the aedile of 58 B.C.[6] Some changes, like Cicero's accession, were the consequence of social mobility. When Cicero purchased his property with borrowed funds in 62 after the close of his consulship, he expressed his sense of worthiness by observing that it would save his clients a long walk (*Att.* 1.13). The long walk had taken them to a house in the Carinae, which their father had bought to facilitate his sons' education. This Cicero now turned over to his brother Quintus, who, only a few years later, managed to join him in the Palatine district (*Q. fr.* 2.4.2; *Att.* 4.3.2).[7]

Articulate as Cicero habitually was concerning the symbolic import of his house, he gives virtually no complementary insights into the architecture or furnishings of its interior, nor does any other source enlighten us in this respect. Conversely social scrutiny did penetrate the houses belonging to some of his Palatine neighbors making them subjects of critical rumor and discussion both by reason of their own conspicuousness and the preeminence of their owners. The use of imported ornamental stone in decoration seems especially to have aroused notice. Although a consequence, and implicitly a sign of Rome's expanding power, this practice falls into the provocative category of luxury. For this reason it is well attested, but for the same reason, clear, unprejudiced information concerning its origins and history is not easy to obtain. The names of certain persons are fixed in the discourse centered about the intensification of luxury at Rome, whose proverbial highlights are embedded in sources so far removed from the actual event as to indicate a long-term persistence of transmission. Whatever factuality this transmission embodies has doubtless undergone the distortion that inevitably affects traditions launched as rumor and scandal.

As our chief witness on the employment of marble, the Elder Pliny weighs public against private practices with a concern for upholding the sense of ancestral austerity. The ancient Romans, he insists, did not value such embellishments. As he would have it, even the Greeks who first employed marble columns in their buildings had no thought of decorative elegance but used them merely for strength (36.5.45). Whether the first uses of marble in Rome were token or substantial he does not make clear. According to Festus (Lindsay 282), the Elder Cato was already proclaiming against "Punic pavements" by which Numidian marble might be understood.[8] For being the first to build a marble temple at Rome, Velleius Paterculus makes Q. Metellus

Macedonicus a leader either in magnificence or in luxury (I.11.5: *vel magnificentiae vel luxuriae fuit*). In arguing that this building was indeed of solid marble, Leena Petilä-Castren points out the symbolic significance of the Greek "conquered material" for the commander who had completed the conquest of Macedonia in 148 B.C.[9] By 100 B.C. marble had certainly been brought into use in the public world, but Pliny claims that the first structure to have had marble walls was the stage that M. Scaurus decorated as aedile in 58 B.C.[10] Whether these walls were veneered or solid Pliny is not certain, but he claims to find no other evidence of veneer (*secti marmoris vestigia*) in Italy at so early a date (36.7.50).[11] If indeed marbles had enjoyed great *auctoritas*, he says, paint would never have been valued so highly (*NH.* 36.5.46). To the contrary, Varro in the satire *Taphê Menippou* 533, datable like the rest of his Menippean collection to the years 80–67 B.C., speaks of *lithostrata* as comprising both pavements and veneered walls (*parietes incrustatos*). Because the satirical fragments forming the context for these phrases contain references both to luxurious houses and to urban scenes, we unfortunately cannot determine whether this mention of veneering points to the public or to the private sphere. When Papirius Fabianus, a declaimer in the Elder Seneca's book of *Controversiae*, inveighs against patterned stone that cloaks a wall with a thin facing, the reference is clearly to the furnishing of individual houses (*Cont.* 2.1.12). Thus invoked, the subject of veneer would seem already established as a commonplace within the discourse of luxury, but one cannot reliably determine whether Elder Seneca's reminiscences are faithful to their historical origins or colored by preoccupations of his own day.

Among the first recorded users of marble in the private domain was M. Lepidus, consul in 78 B.C. who employed Numidian giallo antico in the doorframes of his house. For this as Pliny mentions, he was widely criticized, even though the stone had not been worked into columns or veneer, but came in blocks for the lowly purpose of door-sills (*NH.* 36. 48–50: "non in columnis tamen crustisve, ut supra Carystii, sed in massa ac vilissimo liminum usu"). Pliny ascribes the first use of marble columns to the orator L. Licinius Crassus. Although they were of Hymettan marble and only twelve feet high, they earned their owner the nickname of Palatine Venus. Even more controversial, however, were the columns of the younger M. Scaurus. In decorating the stage of the temporary theatre he built as aedile, he had installed 360 columns along with many works of art to create the most lavish *scaenae frons* ever seen in Rome. When the stage was disassembled, Scaurus transported four large columns to his atrium. According to Andrea

Carandini this was a double atrium which he developed after his acquisition of a neighboring house.[12] Perhaps he was changing its structure from Tuscan to tetrastyle.

As Pliny will have it, the nefarious veneer, whose inventor he brands a man of misguided intelligence (*NH.* 36.9.51: *importuni ingenii*), made its entry later. Traditions attribute its origins to King Mausolus of Caria who covered the brick walls of his palace at Halicarnassus with a veneer of white marble from Marmara (*NH.* 36.6.47; also Vitruvius 2.8.10). According to Pliny the first Roman ever to dress all the interior walls of his house in this manner was one Mamurra, Caesar's engineer in Gaul, who profited shamelessly from the campaign and employed his wealth in all manner of corrupt practices, at least as Catullus' scathing attacks in poems 27 and 54 give us to understand. With reference to this poetic defamation, Pliny declares that such an origin for incrustation was itself sufficient to degrade the practice whatever one's general opinion of *luxuria* might be (*NH.* 36.7.48). Nor did Mamurra ever integrate himself into the upper ranks of society since the house he so exhibitionistically decorated was not on the Palatine but the Caelian.

That the luxury of Palatine decorations was rapidly increasing during the early first century is abundantly witnessed by Pliny. In 78 B.C. as he says, the house of Lepidus was rated the most beautiful in Rome, but within thirty-five years a hundred at least were placed above it. Among the furnishings of such houses he lists both marble and painting. At the same time that Pliny's notices attest to the increasing frequency with which luxurious furnishings were employed in Roman houses, they also indicate that the materials employed were coming from progressively more distant and exotic places. Hymettan marble from Athens was an early import (V. Max. 9.1.4), but Festus' identification of Cato's "Punic pavements" as Numidian would give these also an early date, because it seems likely that Rome's increased dealings with Numidia following the destruction of Carthage, and the subsequent conquest of Numidia itself, will have facilitated the importation of this stone.[13] During the next century the wealthy consular L. Licinius Lucullus gave his name to a richly variegated dark marble from Chios which he favored (*NH.* 36.7.50).[14] The 360 columns Scaurus incorporated into the stage decorations of his theatre were made from this stone. The marble columns employed by the reprehensible Mamurra were of Carystian from Asia Minor, the green veined marble now known as cipollino (*NH.* 36.7.48). Carystian columns recur, although as a negative presence, in company with the Phrygian pavonazzetto and the first mention of the popular Taenian blood-red

rosso antico in an elegy of the Tibullan appendix where the proverbially impoverished lover catalogues the luxuries absent from his house.[15] Egyptian onyx, which Pliny erroneously attributes to Arabia, was initially restricted to small items such as drinking cups and chair frames, yet Nepos saw four tall columns of this stone; (*NH.* 36.12.60). Fragmentary as they are, these accounts convey some sense of the standards of luxury set by the Roman aristocracy with access to the resources of the East. Additionally they provide a valuable index of the materials replicated by mimetic painting.

Of these much-talked-about decorations installed in houses that occupied the first ranks in the senatorial quarter no traces have survived. The greater number must have been destroyed either in the fire of A.D. 64 or else Nero's restructuring that followed it (Pliny *NH.* 36.24.110; Suetonius *Nero* 38.2). One of Nero's aims in locating his vestibule was to repossess the site where his ancestor Domitius Ahenobarbus had lived.[16] Ultimately the senatorial settlement on the Palatine itself was either razed to make way for imperial palaces or else covered by the foundations of these palaces. One single example of Republican decoration survives as a group of seven rooms buried within the foundations of Domitian's palace.[17] The house to which these once belonged will not have stood in the front ranks of senatorial residences but rather in one of the more remote blocks. Its rooms are not paneled, but merely painted. Because their masonry is in part the irregularly faced construction, *opus incertum,* characteristic of Republican buildings, scholars have assigned them to a date fairly early in the first century B.C.[18] Like the houses we hear of in literary sources, this one underwent restructuring during its history. At one point some rooms were added on the ground floor, and also a second story. At a later moment, most likely to have been in the Augustan period, this upper story became the ground floor with a new atrium, and the painted rooms of the lower story were abandoned and filled in.[19]

In its original form the house must have extended broadly along the side of the hill. Because the present remains constitute only a portion of the original, the floor plan is not wholly recoverable, but three rooms ranged side by side would seem to have fronted on an open area – a peristyle or paved court.[20] As we will see, the walls of these rooms call to mind Vitruvius' comments on the progress of painting. In each room the decorative system divides itself horizontally into three zones: a dado finished by a cornice, a central zone formed by large orthostat panels, and an upper zone of isodome blocks beneath an entablature.[21] In two rooms the surface of the wall is illusionistically recessed behind painted

columns that rise above the dado appearing to support the entablature. In Room II these columns stand on forward-projecting podia so that the entire solid wall surface appears to be located behind them on a recessed plane (Figure 36).[22] In Room IV the columns are set on a continuous dado painted to imitate grill work or scale pattern.[23] This most ornate of the three chambers has a high frieze zone consisting of three elements within each intercolumnar space: a set of string courses, a floating cornice and three rows of isodomes all standing behind a file of high Corinthian columns on which rests a continuous architrave. Through the use of discontinuous cornicing the intercolumniations are partitioned into separate bays in a manner that lends an appearance of deep recession to the wall surface.[24] The third room, which is barrel vaulted, has no columns but only a series of multicolored orthostat panels standing upright within its central zone with an isodome frieze above; its signal decorative features, filling the lunettes of the two end walls, are designs in stucco relief, on the one side griffins and acanthus calyxes on the other.[25]

Tripartite divisions such as these are characteristic of Roman wall decoration throughout its history and appear with many variations of subject and form. Their effect in this immediate context is to lend predominant emphasis to the large upright panels of the central zone illusionistically located on a plane "behind" the columns. Here we see panels painted with boldly swirled designs easily identifiable as imitations of alabaster. In Room II these panels are centered within the intercolumniations so as to form the chief visual interest of the decoration. In Room IV these alabaster panels, so positioned as to appear directly "behind" the column shafts, alternate with a second design of small diamond-shaped wedges set in a rhomboid pattern that gives an appearance of texture to the surface of the wall. In Room II, where the rhomboid pattern appears in a small patch of inlaid stone blocks marking the center of the floor, it comprises the decoration of the dado from which the column bases project forward. From this we may understand that the wall decoration imitates *opus sectile* (stone cutwork).

Pursuing mimetic identifications still further, we may appropriately recall Vitruvius' description of the earliest phases of painted mural decoration, in which the inventors of polished finishings (7.5.1. *expolitiones*) began by imitating "varieties and arrangements of thin marble slabs" (*crustarum marmorearum varietates et conlocationes*), and thereafter added cornices and [flint] wedges to their ensembles ("deinde coronarum et [sileaco]rum cuneorum inter se varias distributiones"). The phrase "varieties and arrangements of thin marble slabs" may

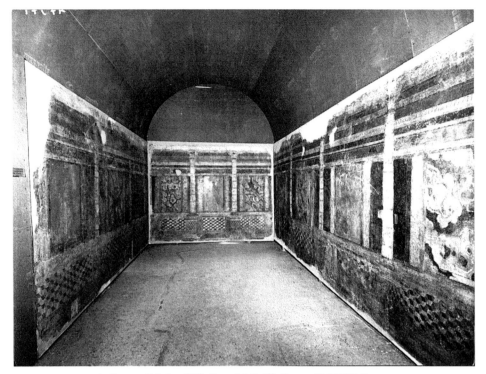

36. Rome, Palatine Hill, Casa dei Griffi, Room II. ICCD E47971.

make us think of the alabaster panels in these two rooms. Looking closely at the borders surrounding these panels we can see that other colors also are patterned. The deep red shows a stippled effect that identifies it as red porphyry; the green is similarly stippled, whereas the yellow shows the veining of giallo antico, and the brighter red will be rosso antico. In the rhomboid pattern used here for its effect of illusionistic depth, we may perhaps understand Vitruvius' "flintstone wedges in their varied distributions." Translated from tessellated mosaic into *opus sectile*, the tromp l'oeil cube pattern of east Mediterranean background was frequently employed in pavements of late Republican rooms.[26] Ultimately projecting elements – "gables, entablatures and columns" – intensify depth (7.5.2: "postea ingressi sunt ut etiam aedificiorum figuras, columnarum et fastigiorum eminentes projecturas imitarentur"). These salient features of the decorative system correspond with Vitruvius' descriptions of actual painting while the subjects they imitate may remind us of Pliny's accounts of the importation of luxurious finishings for Roman houses during the last century of the Republic.

Given the apparent correspondence between literary and pictorial evidence in this Roman house, the question has repeatedly been agitated whether Vitruvius' description should be accepted for an equally reliable representation of the early stages of painting in Campanian houses that go by the name of First Style.

Components of these paintings, commonly described as "geometrical," consist primarily of rectangular, raised stucco blocks brightly painted and often variegated with patterns. Are we also to regard these as imitations of marble incrustations? When Mau as the first scholar to systematize the chronology of paintings named this phase of painting the "incrustation style" he was translating Vitruvius' *crustarum marmorearum varietates et conlocationes – crusta* being the standard word used to indicate marble veneer of the kind whose influential appropriation into a Roman interior Pliny charged against Caesar's rapacious Mamurra. Noting that this decorative technique was common throughout the Mediterranean, Mau thought it logical that its imitation should be employed in Italy.[27] Despite the undeniable existence of incrustation decorations in the ancient world, some scholars have objected that the earliest Pompeian decorations do not look like incrustation and certainly not like these Palatine rooms.

To illustrate this counterargument we may look at the atrium of the House of Sallust: an old upper-class Pompeian house dating back into the second or late third century B.C., the period of limestone atria (Figure 21). Although its current decorations were probably applied only after renovations made in the late second or early first century B.C., they still represent the pre-Roman period of Pompeii.[28] Both atrium and *tablinum* walls have a pronounced structural character. The imposing height of the lofty atrium is accentuated by columns framing

the entrance to the *tablinum* and double-leaved doors marking the *cubicula*. The lower portions of the lateral walls comprise a set of large ashlar blocks serving as the base for a series of smaller ashlar isodomes with one final large panel above. Above these was a dentilated cornice molded in stucco relief. Likewise the individual blocks stood out from from the background in an imitation of drafted margin masonry. They are painted in a variety of colors: continuous yellow and black in the dado and an alternation of red, yellow, and purple in the zone of isodomes. One set of blocks is stippled for a marbled effect. The decorations of the *alae* and *tablinum* are complementary but different, with larger orthostats and a greater variety of colors in the isodomes, as also within an exedralike room facing the garden walkway behind. Remains of similar patterns are to be found throughout the city. One of the best-preserved single examples with a brilliant combination of red, green, and marbled isodomes appears in the *fauces* of the Casa Sannitica at Herculaneum.[29] Although the interior rooms of this house had seen redecoration during the Empire, the accretive Casa del Fauno retained its complete program of masonry decorations throughout its entire history.

Because of the clear-cut simulation of stone blocks with drafted margins and the constructed appearance that their graduated arrangement gives to the surface of the wall, the contemporary scholars Vincent Bruno and Anne Laidlaw have challenged the appropriateness of Mau's "incrustation" to characterize this kind of painting.[30] Instead of replicating a mere surface finishing, Bruno argues, this molded stucco work is meant to reproduce the solid structure of a masonry wall. He observes how the corner blocks in the House of Sallust appear interlocking as if bonded into a wall.[31] By suggesting the coordination of interior and exterior appearances, such a pattern lends an impression of solidarity to the wall. Models for the architectural fabric on which the Masonry Style is based can be seen in virtually every classical ashlar wall, communicating, as Bruno expresses it, a particularly classical sense of order to the visual dynamics of construction.[32] The employment of drafted margins, for which the Athenian Propylea stands as a seminal instance, lends elegance to finishing by articulating the mass and fitting of individual blocks. The Masonry Style, Bruno asserts, was "invented by architects, not painters" and "in this sense can even be considered "as an interruption in the history of painting."[33]

Likewise Laidlaw emphasizes a coordination of exterior and interior in the definition with which she prefaces her catalogue of extant First Style examples: "Essentially a First Style decoration is a copy of a carefully finished ashlar facade applied to the walls of an interior

space." When its architectural affiliation is thus highlighted, the idea of a "Masonry Style" poses a philosophical difference from incrustation, one exercising great appeal for scholars who either regard domestic luxury as suspect in the manner of Elder Pliny, or else consider the concept of surface imitation tainted by implications of cheapness or flimsiness.[34] Realistically speaking, however, the simulation of masonry architecture is no less fictive than the imitation of veneering, especially when the architectural simulation masks the irregularities of rubble walls as it does in Pompeii.[35] Furthermore, when this mode of structural mimesis is applied within the multiple enclosures of residential buildings whose many interior walls do not correspond to an exterior architecture,[36] the structural design assumes a new and overtly fictive status. Rather than pretending to replicate an underlying structure, the architecture frees itself to assume a compositional autonomy with the capacity to subvert spatial limitations and transform appearances on a monumental plane. Thus the most important point to be taken from Bruno's arguments concerning the Masonry Style is that it does not originate within the domain of residential architecture, but rather migrates from the public into the private world. Following this line of thought to its logical implications, one may come to understand Pompeian First Style decoration as one regionally self-consistent version of a practice that was widespread throughout the Hellenized Mediterranean world.

As a first example of drafted margin finishing adapted to interior decoration, Bruno cites Phyllis Lehmann's reconstruction of the Sanctuary of Hera at Samothrace where an arrangement of blocks alternating isodomes and string courses in five zones differentiated by size and colors manifests the familiar pattern of stone construction. Traces of similar decoration can be found in some fourth-century buildings of the Athenian Kerameikos and Agora.[37] These examples clearly locate the Masonry Style within the sphere of classical public building. Although there are no currently known instances in the Greek world of contemporaneous houses and public buildings on one and the same site that might document the crossover, still remains of interior decoration at Olynthus, Pella, and Delos show plaster similarly molded in imitation of masonry blocks. Representing three versions of Hellenic culture as well as different dates, the three sites have sufficient points in common both with each other and with Pompeii to show their participation in a common vocabulary of decoration, but also specific differences to set them apart.

Although the painted plaster from the houses at Olynthos is fragmentary, it gives evidence for the use of

molded stucco blocks which, by analogy with a painted tomb outside the city, can be interpreted as forming five zone arrangements similar to the decoration of the Hereion that approaches these houses in date.[38] The paintings from Olynthus represent the tradition as it derived from Athens. At Delos in houses of almost two centuries later the prevailing pattern is also one that divides the wall laterally into five zones of orthostats and graded isodomes with the frequent interruption of patterned cornices and string courses with figured frieze designs.[39] Because these late Hellenistic houses were among the first examples of specifically Greek painting discovered, they were inevitably compared with Pompeian paintings and generally claimed as prototypes.[40] Accepting this background, Mau categorized the Delian style as incrustation.[41]

Between these two chronological markers, which is to say between the late fourth and the second centuries B.C.[42] the excavated examples of Macedonian painting can be located. Until recently nothing was known of this repertoire other than the facades and inner chambers of tombs, but to these can now be added a substantial reconstruction of painted plaster decorating four rooms of a private house in Pella that has been dated to the early third century B.C.[43] While the entrance room of this building displays the standard five-zone pattern with emphasis on colorful isodomes, a greater degree of compositional autonomy appears in the complex decoration of a large open room, termed an exedra, which creates a fictive surrounding gallery with a file of white pilasters joined by a red balustrade above which we see an open region of blue sky. This superstructure rests on a base composed of plinth and white orthostats separated by headers and surmounted by a string course composed of blocks painted in brecciated patterns. Above this are two molded cornices framing a single course of gold-painted isodomes. Like the masonry decorations of Pompeii, these are raised blocks with drafted margins. The use of such brecciated variation in the string course may seem to follow the actual practice of making this course visually conspicuous by the use of wood or some valuable substance.[44] On one side of the room a broad doorway with two columns *in antis* opens into a peristyle so that the fictive gallery in the upper-story gives the effect of moving from one open area into another partially expansive space. This is different from the upper-story colonnade in the Heraion at Samothrace, which appears high above eye level in the position of a second story such as many temple cellae actually possess.[45]

Likewise in the interior chamber of the Great Tomb, or Tomb of Judgment at Lefkadia, we see a surrounding array of half columns or pilasters resting on a solid construction of plinth and orthostats.[46] This design echoes but does not replicate the complex facade of the tomb, which combines a Doric first story, complete as far as the triglyphs and figured metopes, with an Ionic superstructure including a figured relief frieze topped by a file of doors and half columns below a painted tympanum.[47] Such a combination of elements, as Stella Miller observes, creates an impression of structure that is not intended to be analyzed to its logical conclusion.[48] In company with simpler single-story facades such as the Tomb of the Palmettes, this imitates a temple cella, the columns meant to be seen as a peripteral colonnade with the door frame located behind them. Although Bruno's proposal, on the basis of color, of the Parthenon as the model may be overly grandiose and specific,[49] this is clearly a status architecture and perhaps also an architecture with religious connotations. In the four panels of the facade we see the deceased as a Macedonian warrior led by Hermes psychopomp into the presence of the judges Rhadamanthus and Aiacus. The juxtaposition sets up a tension between the prestige acquired by means of mortal accomplishments and the potential severity of judgment. Within this dramatic context, the architecture may be understood to frame the doorway to Hades as a passage for the deceased from the world of the living into the world of the dead, while the inner chamber with its fictive gallery may predicate a residential space for the afterlife, but concomitantly functions as a shrine. It would be a mistake to consider that the individual elements of the design acquired a permanent funereal symbolism from their participation in such a context. Rather, the architecture embodies a principle of crossing over between the two worlds; it acquires connotations of liminality. This same principle of visual transference can pertain to any application of mimetic painting. Whenever a set of signifiers is transmitted new sets of associations can be constructed around them.

On this basis we may look back at the Pompeian First Style patterns already considered. In keeping with his designation of the Masonry Style as Athenian, Bruno attributes an associative semiotics to these patterns. Thus he concludes: "In Italy, in the later Hellenistic period, as in other distant centers throughout the Mediterranean, it was probably the very symbol of Greek culture and taste to build a house with a Masonry Style interior no matter how much the details changed in the hands of foreign artists."[50] Given, however, the almost universal distribution of this form of finishing throughout the Hellenized Mediterranean, the notion of influences and transfers seems negligible in the face of regional idiosyncrasies of conceptualization and style. When Bruno and Laidlaw compare Italian paintings with those at Delos,

they point out a several variations in detail which set the Pompeian First Style apart. One is its mode of enclosing space by encircling the room with a continuous line of blocks.[51] Another is the freer, apparently less regimented use of color in the Italian world. Whereas all Greek decorations tend to distribute colors within discrete zones, Pompeian houses often create diagonal patterns across a single zone by alternating diverse colors.

This idea of a direct self-conscious borrowing of Campanian fashions from the Greek world is where my interpretation parts company from the otherwise irrefutable claims of the Masonry Style. The important point that Bruno and Laidlaw have established is Pompeian autonomy within the parameters of Mediterranean style. We cannot too often remind ourselves that Samnite Pompeii, although scarcely existing in isolation from Rome, is nevertheless not Roman, but a part of the Greco-Etruscan milieu of Southern Italy.[52] Salmon has pointed out that there are two kinds of Samnites: the isolationists and the assimilators. The assimilation of Greek in combination with the Roman is the keynote of Oscan settlement at Pompeii.[53]

A comparable process of assimilation produced many of the Hellenistic houses at Delos since the Roman traders who lived in these luxurious residences did not bring the architecture with them, but adapted to the prevailing local style.[54] These are Greek houses with spatially dominant peristyles, coming as close as any extant buildings to Vitruvius' generalized prescription for the Greek house. That the Roman owners were not aristocrats of an established lifestyle but freedmen on their way to prosperity through trade may also be important.[55] Although we cannot precisely determine the relationship between public and private style on the island, the fact is that a pattern of migration from public to domestic in the Greek world is replicated in Pompeii. Even so one great difference pertains since Pompeian atrium houses differ from these Delian peristyle houses in their apparent symbolic foregrounding of the relationship between public and domestic life: the relationship that had, in the Roman world, altered the old multifunctional character of the *cavaedium* complex we call the atrium into a ceremonial reception space.

Numerous examples of interchange between public and private decor in Pompeian buildings illustrate this point. As I mentioned earlier, the Pompeian basilica stands as the earliest example. Within its colonnaded aisles a colorful pattern of marbled blocks filled the intervals between engaged Ionic columns. This wall was a classic Masonry Style with a continuous plinth in purple with green margins, and a row of black ashlar blocks with drafted margins (Figure 37). Then, above a

colorful string course in cinnabar and yellow were six courses of isodomes in combinations of yellow, green, and purple marbling alternatively disposed to complete the wall. Except for the greater height of the wall, the arrangement of blocks and colors closely resembles those in the House of Sallust and Casa del Fauno, houses whose decoration, although early, must nonetheless postdate the basilica.[56] Thus, while Bruno seems to be accurate in his identification of the patterns as architectural imitations, there are issues to consider which his discussion has not, in fact, taken up.

The catalogue of First Style paintings published by Laidlaw lists approximately 400 examples of fully or partially extant compositions in 180 buildings, the great majority belonging to private houses.[57] Of these the preponderance are in small *conclavia*, nonetheless sufficient variety characterizes these examples to show us that applications of the style are by no means restricted to a uniform design. Although the regrettable deficiency of our present-day corpus is the lack of any fully extant decorative program, even the limited remains of programs in a few houses are sufficient to demonstrate that its patterns are deployed with consideration for a hierarchy of rooms. Color is one means of differentiation. Even within the compass of a single room, codes of hierarchy may appear to govern the adaptation of style to space. A vaulted alcove room in the Casa del Centauro (6.9.3–6) employs a limited color range to achieve a complex contrast of effects within a space divided on two levels into antechamber and alcove. The outer room has a main zone of black orthostats above a green marbled dado. Above this middle zone is an alternation of colored and marbled isodomes in the simulation colors: yellow, green, and red bounded by two dentilated cornices that are colored red as if they might be sculpted in marble. In the raised alcove the pattern is simpler. The dado is yellow, and the isodomes are uniformly green.[58] In the Casa del Fauno, whose long history saw very little replacement of decorations, rooms of varied size and location make hierarchy readily visible. The exedra paved with the Alexander mosaic was the most prestigious chamber; its importance was also marked by an extensive use of marbled effects in the orthostats and isodomes on the walls, while the dado was finished with the imitation of a curtain,[59] as if some other valuable decoration stood there screened from view. The atrium has a standard arrangement of blocks on the model of the basilica, but the use of molded stucco pilasters in the walls of the first and second peristyles creates the illusion of additional space within these already ample enclosures by simulating corridors standing before a recessed wall.[60] Here also some of the blocks are marbled.

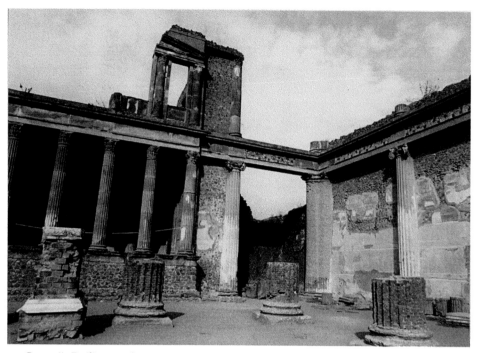

37. Pompeii, Basilica, northwest corner with tribunal and First Style painting. Author's photograph (su concessione del Ministero per i Beni e le Attività Culturali).

These materials and designs suggest that not even the masonry pattern of the First Style was used consistently, but rather was considered appropriate to certain types of rooms. Neither do its differences depend exclusively on color choices nor the insertion of an occasional figured frieze into a cornice zone,[61] but sometimes incorporate aspects of monumental architecture. Some First Style decorations, such as the *vestibulum* of the House of Julius Polibius include false painted doors like those belonging to sanctuaries or other public buildings[62] (Figure 14). Both this entrance area and the atrium of the Casa Sannitica at Herculaneum have galleries in the upper range of the decoration which combine elements of real and imitative architecture.[63] On three sides of the entrance room in the House of Polibius a succession of simulated pilasters frames window apertures in the upper story.[64] In the Casa Sannitica the structural design of the open gallery belonging to a *cenaculum* on the rear wall is translated into decoration on the remaining three walls with engaged columns and simulated grill work in their interstices.[65] In the *vestibulum* area of the Casa del Fauno the decoration in the frieze zone is literally architectural with two facing shrine pediments supported on columns, and it has been proposed by some scholars that an interior colonnade surrounded the entire lofty atrium of this house.[66] Several lesser-known houses also have such interior galleries, some even with fully rounded freestanding columns. One of the best examples can be

seen at the back of the atrium of the Casa del Cenacolo (Figure 38), a small house of the tufa period in the shadow of the Casa delle Nozze d'Argento but antedating it[67] (Figure 39).

Such loggia decorations that carry the spectator's gaze above eye level lend to their ambience a particular grandeur most appropriate to the purpose of public reception.[68] Although the spaces above may well have served the practical end of ventilated summer dining, their architecture, with its bold appropriation of elements from the public world, will have added a semantic reinforcement to the imposing visual dignity of the space. Such semantically charged borrowings are even more appropriate to houses within the framework of Roman society with its close linkage of public and private life than to the Greek world where the activities proper to the two spheres of experience are independently defined. Thus, in spite of its visually stated Hellenic pedigree, the concept of a Masonry Style in decoration has been modified from the very beginning of its Campanian acculturation.

It remains to consider whether the Pompeian Masonry Style we have been examining can or should be reconciled historically with the incrustation painting we see on the Palatine Hill. Differences involve the use of raised stucco to shape blocks and cornices, the size and patterns of the orthostats, and the range of colors. Evolutionary explanations of the differences in

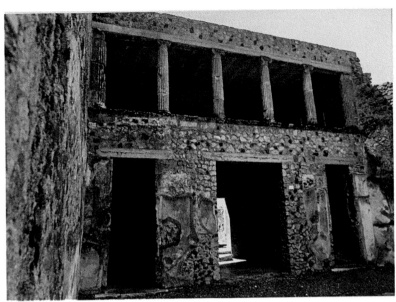

38. Pompeii, Casa del Cenacolo, atrium with colonnaded interior loggia. Author's photograph (su concessione del Ministero per i Beni e le Attività Culturali).

shape and size in the orthostats have resort to chronology, dating the Palatine rooms sequentially later than the Pompeian examples as transitional harbingers of a new "Second Style."[69] This explanation presumes that the orthostats of the Masonry Style had become elongated and changed orientation from horizontal to vertical so as to turn themselves into decorative panels in the central zone of the wall. This purely evolutionary approach entails certain undemonstrable assumptions concerning the prior existence of a "Campanian" Masonry Style in Rome, not to mention the larger assumption that Rome and Pompeii experienced identical stylistic histories.[70] By minimizing the importance of incrustation, it correspondingly diminishes the semantic significance of mimesis while challenging Vitruvius' worth as a knowledgeable historian of decorative customs. Rather than considering the deliberate imitation of constructed masonry in Pompeian First Style as evidence by which to correct or contradict Vitruvius, we must allow that its patterns are of a different species of imitation from those which the architect describes. By bringing literary testimony to the increase of luxury in Roman domestic environments of the late Republic to bear on the Palatine paintings, we may achieve a revised understanding of what was taking place in Rome.

Although the Casa dei Griffi cannot be authoritatively dated on the basis of its *opus incertum,* still it is usually assigned to a time between 100 and 80 B.C., a period which, by Pompeian standards, would be early for illusionistic painting. Thus assigned, the paintings cannot logically be thought to imitate marble veneering in private houses, not simply because they antedate those innovations in domestic furnishing that Pliny describes, but also because these innovations in themselves comprise no more than a token deployment of marble. Instead we should regard the imitations of marble in the Casa dei Griffi as meaning to invoke the decorum of the public world. When the introduction of marble veneering into the decoration of private houses does eventually occur some forty years later, this reality supplants or rivals imitation. Such a development accords with Pliny's testimony that the discovery of techniques for cutting veneer followed after the employment of solid marble (*NH.* 36.7.48, 8.50), as well as explaining why he says that a higher valuation of marble would have diminished the prestige of painting. From this also follows logically the process on which Pliny comments when he says that painting in his time has been completely displaced by marble and finally by gold (35.1).

Although one should not undervalue the importance of marble simulation in Pompeii, one should also not confuse marbled masonry with incrustation.[71] Granted that the fictions of decoration enjoy a freedom from economic constraints that limit the use of solid marble in reality, the two modes of imitation are no more mutually exclusive than they are chronologically interdependent. The marbled blocks in the Masonry Style walls of Macedonia provide a useful parallel for the incorporation of expensive stone courses into classical ashlar masonry. Visiting the Casa del Fauno while it was still in the process of excavation, Gell looked scornfully

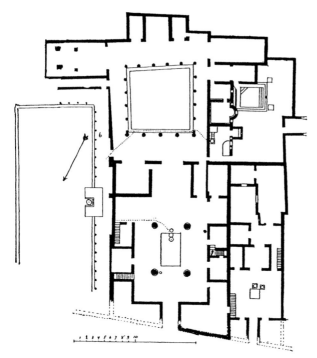

39. Casa delle Nozze d'Argento and Casa del Cenacolo, Region 5.2. After Mau 1904, 302, fig. 146.

on its bright colors and especially the "vile imitations of imaginary marble which cover the walls in glaring colors."[72] Laidlaw's careful reconstruction of the wall schemes from original reports shows extensive use of marbled effects in the majority of rooms.[73] Although the atrium decorations resembled those of the House of Sallust in representing ashlar blocks of graduated sizes, the walls of the *vestibulum* were paneled with elongated orthostats simulating alabaster, and a perspective cube pattern filling the dado corresponds with the *opus sectile* work on the pavement. When one looks at the diamond pattern of *opus sectile* that paves the impluvium basin, it seems clear that the principal colors of the painted blocks on the walls are meant to replicate the smaller segments of real stone composing the floors. The walls of the Alexander exedra exhibited Gell's "vile imitations" in combining marbled orthostat panels in yellow, green, and purple with variegated blocks above. Finally the peristyles with their molded stucco colonnades incorporate marbled blocks among their isodomes. The critical question is not whether marbling techniques were employed in the Masonry Style but where and when these came to represent the practice of incrustation or veneer.

To answer this question we can turn our attention to the marble imitations of somewhat different proportions and visual effects that figure prominently within the comprehensive programs decorating the Casa delle Nozze d'Argento and Casa di Cerere (1.9.13).[74] In both

situations these programs replace an earlier application of First Style decoration; the configuration of patterns has altered to suggest that incrustation in the Roman-Vitruvian manner now supplants the imitation of masonry. Owing to its delayed publication the modestly sized Casa di Cerere is little known. It forms one unit of a block once composed of equivalently sized houses from the second century. With the majority of its decorated spaces concentrated around the atrium and *tablinum,* its long garden area sloping upward on uneven ground lacked architectural systematization.[75] Except for a *tablinum* repainted in Third Style, this house shows little evidence of alteration during its history and had suffered no perceptible damage from the earthquake.

Within the Casa delle Nozze d'Argento more changes had intervened.[76] Several rooms, probably damaged, had been repainted in recent years. Now, at the moment of the eruption, the atrium itself was in process of redecoration under the ownership of L. Albucius Celsus, an aedilician candidate, whose father had held office before him.[77] Even in this renovation, the decorators were making an apparent effort to preserve the lineaments of the earlier panel division beneath a new application of paint. The imposing dimensions of the long and lofty atrium are accentuated by a series of elongated black orthostats with a design of blocks of porphyry, giallo antico, and green in the frieze zone.

In both houses the decorations observe, with a single exception, the paratactic closed-wall arrangement that is traditionally associated with the First Style, yet their patterns differ conspicuously from those typical of earlier Samnite decoration in their free structuring of an enlarged middle zone surmounted by several isodome courses. Illusionistic moldings now replace projecting cornices making possible an entire new range of patterns including not only the popular egg and dart but also rows of brackets and consoles. Dark porphyry, giallo antico, and green are the dominant colors of orthostats, isodomes, and their surrounding borders, but variety both in the middle and the frieze zone is provided by the introduction of swirled alabaster and of brecchiated patterns very precisely articulated in the gold and red veining of giallo antico. Likewise the creamy tones of moldings and cornices are swirled with the markings of alabaster. An alcove decoration in the Casa di Cerere varies the traditionally horizontal layering of isodome courses by placing a series of alabaster and brecchiated blocks vertically in alternation with a series of green headers. Here, as in the Casa del Fauno, the presence of colored stone chips in the pavement of *opus signinum* reveals the intention to coordinate decorative elements through imitation.[78] Additionally certain rooms

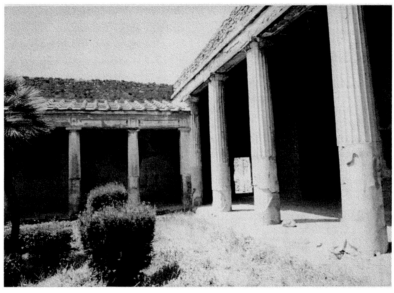

40. Casa delle Nozze d'Argento, Rhodian peristyle, view toward North portico. Author's photograph (su concessione del Ministero per i Beni e le Attività Culturali).

have walls distinguished by simulated colonnades and entablatures suggesting implicitly hierarchic rankings within the program. Within these systems we see for the first time painted apertures opening illusionistically on an exterior glimpse of blue sky.

The Rhodian peristyle of the Casa delle Nozze d'Argento, which was, for Pompeii at least, architecturally avant-garde, served as center for a variety of surrounding rooms, distributed with an almost geometrical symmetry, and decorated in complementary patterns (Figures 39 and 41). In summer the rear corridor will have enjoyed the shade afforded by the raised North

portico (Figure 40).[79] At the center of this corridor was a small square exedra painted entirely in yellow monochrome, even to the garlands looped within the intercolumniations, which thereby appear to be sculpted in low relief of the same substance as the wall (Figure 42). Fine architectural details include brackets in the form of satyrs and a simulated loggia of short, fluted columns. Flanking this space are a pair of barrel-vaulted chambers decorated with incrustation patterns in the ubiquitous colors porphyry, giallo antico, and green. Simulated columns distinguish the rear walls (Figures 34 and 43, Color Plate II). The same colors and features are

41. Casa delle Nozze d'Argento, south peristyle corridor. Author's photograph (su concessione del Ministero per i Beni e le Attività Culturali).

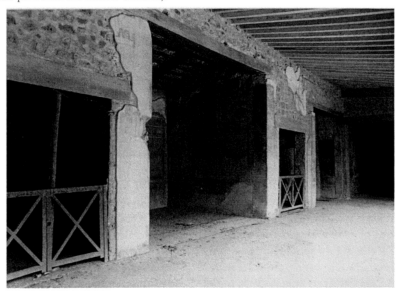

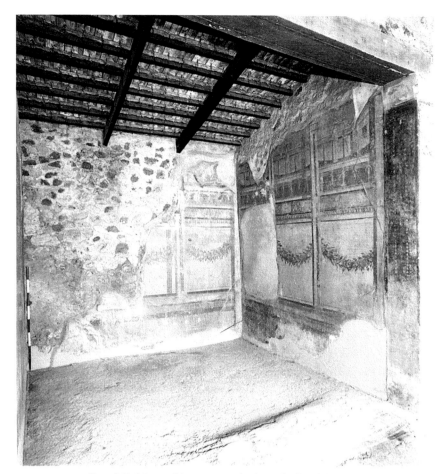

42. Casa delle Nozze d'Argento, exedra in peristyle. ICCD N49730.

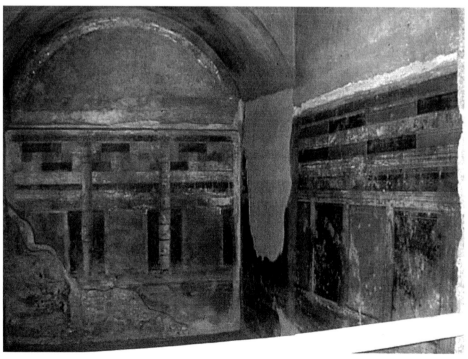

43. Casa delle Nozze d'Argento, *camera* in peristyle. Author's photograph (su concessione del Ministero per i Beni e le Attività Culturali).

repeated in a divided alcove room on the western side. Although the restrained palette appears almost somber in comparison with the brilliant rosso antico and the swirled alabaster patterns of the Casa dei Griffi, all the same the combination of ornate architraves, projecting columns, and cornices in these rooms closely recalls the schemes in the Roman house. The unusual tetrastyle *oecus* on the eastern side placed red ground panels festooned with a polychrome garland above a black dado (Figure 26). The zone above the panels stood open with glimpses of sky and an exterior colonnade.

The unique decoration will have marked this room as one of the most important in the house, allowing for the possibility that equally or even more elaborate patterns may originally have lent hierarchic distinction to spaces such as the *tablinum*, or perhaps the exedra on the northern corridor of the peristyle, whose redecoration the eruption had interrupted still in the rough plaster stage. The variety of configurations afforded by the incrustation style enabled such multifaceted accommodations of decoration to a hierarchy of spaces. Not only does the use of rich colors and surface marbling procure such variety, but also an abundance of architectural fine details such as those already seen in the Casa dei Griffi, which easily correspond to Vitruvius' descriptions of illusionistically rendered columns and entablatures that entered into the decorative repertoire. In his opinion these developments represent progress. Certainly this idea of "evolution" indicates continuity in decorative traditions, a point that Laidlaw also argues, but on different grounds, with reference to the persistence of certain elements such as floating cornices and paneling translated from their First Style embodiment in stucco relief molding into a trompe l'oeil simulation rendered with illusionistic shadows and highlights.[80] At the same time she believes that the new style of decoration constituted a "change of taste." Such has in fact been the consensus opinion, which predicates not only a technical but also a philosophical change in the nature and aims of mimesis. Granted the demonstrable existence of transformations, still their attribution to "taste" explains little unless we can understand the visible signs within a signifying context that establishes their meaning as communicative codes.

SOME LATE REPUBLICAN HOUSES OF CAMPANIA

Such a context can be understood from the fact that both the Casa delle Nozze d'Argento and Casa di Cerere owe their decorations, if not their architectural beginnings, to the period of social and cultural change that followed upon Rome's victory in the Italian Social Wars. When Sulla established a colony of his military veterans at Pompeii in 80 B.C., the political identity of the city underwent reconfiguration as a municipality under Roman guidelines. With Sulla's nephew, P. Cornelius Sulla as *patronus coloniae,* the magistracies became a scaled down version of the Roman system with aediles as junior officers in charge of public services, with *duoviri iure dicendo* responsible for the administration of justice in the courts, and a legislative council, the *ordo decurionis,* formed of ex-magistrates and other prominent persons. A quinquennial duovirate comparable to the Roman censorship gave opportunity for the most illustrious former duovirs to rise to an even higher distinction. Donations by such citizens enhanced the resources and physical appearance of the city. As quinquennial duoviri, the Sullan patrons C. Quinctius Valgus and M. Porcius bestowed a *theatrum tectum,* or *odeon,* alongside the large theatre and later constructed the amphitheater.[81] New baths were located at the intersection of two major streets near the Forum, and major temples experienced renovations. Whether these civic improvements aimed primarily to serve, and consequently segregate, the body of new citizens come from Rome, or whether they sought chiefly to impress the indigenous populace with Roman generosity is not to be discovered from the physical evidence.[82] The partial insights into the process of integrating colonists and Pompeians that Cicero retrospectively affords as items of his court defense of P. Cornelius Sulla in 62 B.C. indicate complex negotiations tempered by a measure of diplomacy (*Sul.* 21.61–2). That colonists and old inhabitants differed on questions of campaigning (*ambulatio*) and voting (*suffragio*) might be expected, but Cicero claims that their opinions concerning the common welfare were united.[83] Furthermore, he praises his client P. Sulla as a leader able to maintain his popularity with both constituencies while executing a certain practical discrimination in their mutual *fortunae.* By Cicero's interpretation, Sulla would seem less to have displaced native Pompeians than to have promoted the welfare of both citizenries. As Fausto Zevi has recently suggested, sheer numbers may have motivated Sulla's conciliatory policies; old settlers greatly exceeded the new.

Additionally Zevi proposes that the preservation of precolonial decoration within such houses as the Casa del Fauno, a virtual museum of the Masonry Style, indicated that their ownership (and the prosperity of their owners) remained stable amid governmental change.[84] Correspondingly it would seem logical that dwellings that were restructured and redecorated should have belonged to new and active members of the municipal establishment even if we cannot at this distance

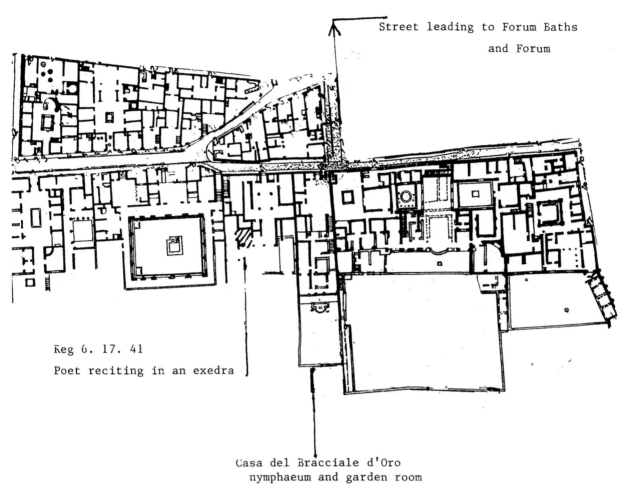

Street leading to Forum Baths
and Forum

Reg 6. 17. 41
Poet reciting in an exedra

Casa del Bracciale d'Oro
nymphaeum and garden room

44. Insula Occidentalis. Plan of houses from the colonial period, street level. After Eschebach, 1993.

succeed in matching houses with such known careerists as Quinctius and Porcius.

Resemblance to the Vitruvian incrustation of Palatine houses suggests that new Roman arrivals brought their concepts of decoration with them. As a visual code, this style will have encased its owners with a sense of the familiar amid their unfamiliar surroundings. Doubtless for some it will even have signaled an elevation of status to a degree exceeding what they might have achieved at home. Looking at this decoration from the indigenous Pompeian point of view, however, we can imagine its having presented a spectacle of unfamiliarity that highlighted the differences of background and social affiliation. Within the redecorated Capitoline temple, preeminent symbol of the city's new Roman identity, Pompeians will have seen walls newly painted in the paneled incrustation style.[85] The visual correspondence to these public decorations will have been immediately apparent whenever business might bring them into a colonist's house. Accordingly the incrustation mode as it emerges during the early first century in Pompeii be-

longs within the category of stylistic intervention rather than evolution.

One further circumstance that sets the Casa delle Nozze d'Argento and Casa di Cerere apart from the large First Style houses of the Samnite era is their location in remote corners of the city rather than on major business streets.[86] Just as these two houses stand far apart, so the other few survivals of Second Style programs are also widely disseminated. Zanker makes the logical suggestion that a full survey of Second Style remains might give some sense of the distribution of new citizens over Pompeii.[87] If these decorations are the mark of the colonist, their location goes all the more to suggest on the one hand that no comprehensive takeover occurred and on the other that distribution of these new inhabitants might have seemed a more productive strategy than ghettoization.

Some new colonists do, however, appear to have clustered, either for family or for political reasons. In comparison with the two houses just examined, it is interesting to look at a group of demonstrably new houses

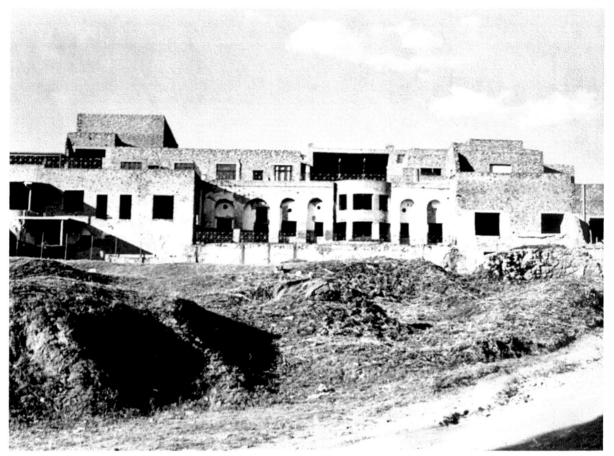

45. Insula Occidentalis, terraced houses, seaward side. Author's photograph (su concessione del Ministero per i Beni e le Attività Culturali).

that are ranged seriatim with party walls in a block commonly called Insula Occidentalis on the northwest side of the city at the edge of the wall.[88] That this land was open and available could be argued both from its marginal location and from the likelihood that its steep slope had not invited previous building activity. Because of their multilevel accommodation to the existing terrain, the houses have frequently been termed architecturally innovative and compared with contemporary modern developments.[89] With reference to the increasing employment of multistory residences at Ostia during the empire, they have also been seen as a later development at Pompeii. Certainly "innovation" describes their substitution of vertical for horizontal extension by means of a series of terraced levels linked by staircases, but it does not necessarily follow that elements of difference could not coexist with what was traditional. The arrangement of street-level rooms in each house follows the common atrium plan. Furthermore, one should not equate the final condition of these houses with what their earlier stages will have been. Although much of the decoration in the southernmost house, called the House

of Fabius Rufus belongs manifestly to the Fourth Style period, this certainly reflects a postearthquake restructuring, such as was still in progress in the adjacent Casa del Bracciale d'Oro, which was finished in some rooms but with panels and architectural members still roughly blocked out in the atrium. In both houses, however, the remains of earlier painting in several scattered locations suggest that their initial decoration and conception was late Republican, while a full Republican program survives in the upper level of the next house to the north (6.17.41).

What the houses have in common over and beyond their parallel orientation is a pattern of spatial use (Figure 44). Four lofty atria open off the street; their spaces are complemented by the typical layout of contiguous exedral and enclosed spaces.[90] At their outer limit each would seem to have terminated in some manner of colonnaded terrace on which will have faced rooms of the kind that ordinarily open on peristyles. From this level, five staircases of a narrow width lead downward to a series of four levels. On each second floor the principal enclosed chambers, large and small, enjoyed panoramic

70

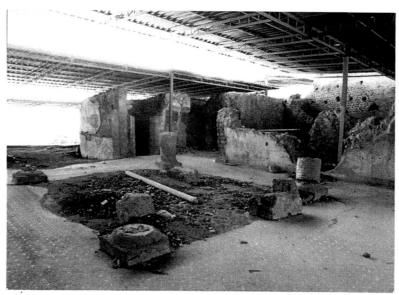

46. Insula Occidentalis, Region 6.17.41, tetrastyle atrium. Author's photograph (su concessione del Ministero per i Beni e le Attività Culturali).

views of the coastline through the large windows that shape the exterior profile on the western side (Figure 45). Behind these rooms there extended a network of service corridors and storage rooms. A third level contained in one case a bath and in others files of small chambers. Although the spaces of each unit were separate on the upper level, some of their lower terraces were interlocking. Finally on the even ground at the bottom of the slope were gardens and nymphaea presently clad in late decorations but showing evidence of having been furnished from at least the Augustan Third Style period (Figure 83). In sum these houses are not to be seen as a late development precociously heralding future trends toward multistoried architecture, but rather as a unique Republican installation peculiar to the edges of the town.

The northernmost house had retained the fullest program of Second Style in its entrance floor. Although its area was in fact the first excavated in 1759, at which moment two arresting segments of its decoration were taken into the royal collection at Naples, it is now the least thoroughly explored because its situation on the crumbling wall has precluded excavation on lower levels, while some of its atrium walls are so twisted and disaligned that one wonders if there is not earthquake damage still unrepaired. The tetrastyle form of its atrium replaces a former Tuscan (Figure 46).[91] Both the vestigial remains of decorative colors in the main space and the better-preserved walls of contiguous chambers show typical paratactic patterns of orthostats and isodomes in an equally typical selection of purple, green, and yellow. An adjoining chamber employs panels of these

same colors to articulate a podium and projecting colonnades. Behind the atrium is a narrow transitional space paneled entirely in simulated giallo antico.[92] The same workshops that decorated the Nozze d'Argento and Casa di Cerere could certainly have executed these, but the images of the *tablinum* walls are altogether different from anything we saw in those houses. Above a dado supported by telamones stand the prows of two large ships, each resting on its own rectangular pedestal base.[93] One might recall how Pompey's vestibulum displayed the rostra of captured pirate ships (Cicero *Phil.* 2.28). Vitruvius' (7.2.1) listing of *naves* (ships) among the real objects painters ought to imitate might even suggest currency of the motif in Rome. Vitruvius does not, however, prepare us for the arresting images in the chambers facing away from the atrium whose compositions involving both architecture and human figures – to be discussed in the following chapter – are singular within the repertoire of Republican style (Figure 47).

The simulation of architecture leads us at last to that repertoire of painting commonly known as the Second Style, a category of compositions that has traditionally been characterized by its mimetic development of spatial illusions in company with megalographic architecture. Interpreters posit a desire for spatial expansiveness as the effective motivation for enlisting standard formulas of parallel projection to dissolve the internal boundaries of an enclosed chamber into perspectival imitations of contiguous prospects. These assumptions have fostered the notion that the style must represent a new aesthetic of its own. Granted that we may perceive certain readjustments of mimetic premises from the fact that the

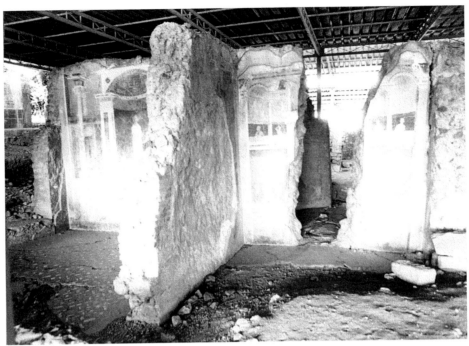

47. Insula Occidentalis, Region 6.17.41, rooms behind atrium-*tablinum*. Author's photograph (su concessione del Ministero per i Beni e le Attività Culturali).

new decorations, encompassing a far more ambitious repertoire of images than the Masonry or Incrustation Styles, no longer present a literalistic replication of whatever subjects they represent but only an allusive simulation. As the distance between representation and reality increases, so also must the spectator's receptivity toward fictions.[94] Impressive as these expansive spatial prospects may be, their primary message is not a purely aesthetic one but an assertion through pictorial language of the individual status claims of their owners.

48. Casa del Labirinto, atrium. Author's photograph (su concessione del Ministero per i Beni e le Attività Culturali).

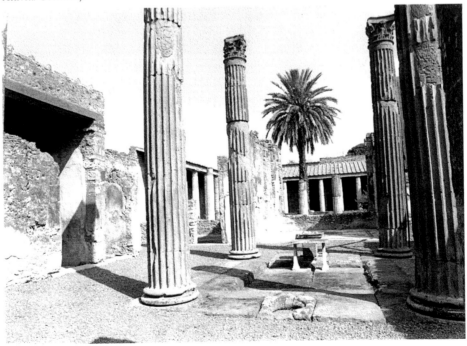

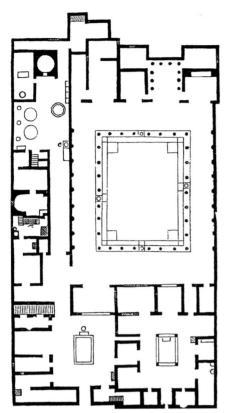

49. Casa del Labirinto, Region 6.10.11. Plan after Overbeck 1884, 342, 175.

The critical mass of spatially expansive Second Style decoration exists within a group of four houses, each of which contains a set of rooms illustrating the programmatic hierarchies of the style. Although one of these

houses came to light within the city in 1832, it has been only during the current century that additional examples of this painting sufficient to comprise a coherent stylistic repertoire have been discovered. Thus we should not expect early histories of painting adequately to account for the place of the Second Style, although recent scholarship has accorded it virtually the lion's share of attention. Naturally this limited repertoire must be understood to represent only a fraction of Second Style programs once existing within late Republican houses.

Differing markedly in plan and in location, these houses will doubtless have differed also in function, yet the number of images and patterns they share shows their programs closely interrelated in conception and idea. Among the four houses, only one stands within the Pompeian city walls,[95] the Casa del Labirinto, whose entrance fronts upon a secondary street, the Vicolo di Mercurio, that bounds the property of the Casa del Fauno at the rear (Figures 48 and 49). Because this early discovered Second Style house remained for many years as the single representational example, it provided the basis for the art historical conception of the style.[96] Originally a typical Pompeian double atrium townhouse, exemplifying fine Samnite architecture in the manner of the Casa del Fauno and House of Sallust, it profited from ample space to construct a full peristyle with a series of elegant rooms fronting on its rear corridor[97] (Figure 50). The central room beneath a gable is one of only two examples of the Corinthian *oecus* for dining which Vitruvius describes: a particularly elegant style of room with an

50. Casa del Labirinto, peristyle N. Corridor. Author's photograph (su concessione del Ministero per i Beni e le Attività Culturali).

73

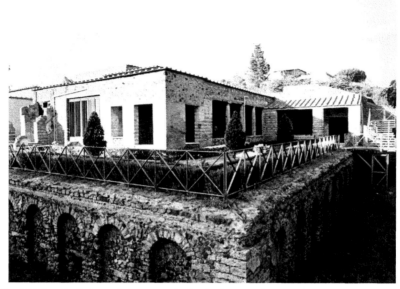

51. Villa dei Misteri, platform facing west. Author's photograph (su concessione del Ministero per i Beni e le Attività Culturali).

interior colonnade (Figure 15). The large tetrastyle atrium shows traces of Masonry Style decoration,[98] but the remainder of the rooms including the series at the rear, the small rooms surrounding the Tuscan atrium, and the peristyle corridors themselves are similarly decorated. If, as prosopography has argued, the house remained in possession of one and the same family from the colonial period onward, this continuity might easily account for the retention of old paintings.[99]

The other three houses belong within the category of villas, although all are of different types. The location outside the city walls of the celebrated Villa dei Misteri can remind us how geological changes have altered the shoreline landscape over 2000 years. The villa block was constructed on a platform that placed it above the level of the surrounding territory and provided an elevated situation with a seacoast prospect for the rooms at the rear (Figure 51). The design exemplifies Vitruvius' scheme for the villa suburbana where the principal entrance leads directly into the peristyle with the atrium located behind.[100] Because villas constructed on this plan were primarily working farm villas, Richardson is surely correct in his assertion that the establishment must have been agricultural from its beginnings (Figure 52). The wide entrance to the peristyle gave space for the carts and produce to pass in and out (Figure 13), and the peristyle connected directly with the wine-pressing room which will have produced a considerable volume of juice to fill the great storage dolia below. The approximate date of about 50 B.C. that he assigns to these origins places them just at the period

when the Tirrhenian coastline had been freed from pirates and establishments of some pretension to luxury could safely be placed outside city walls.[101] Although the villa underwent considerable expansion over the decades, the alignment of rear entrance and atrium remained unchanged. Certainly this reverse plan of rooms suited not only practical purposes but also the coastal situation of the villa because it had allowed, in lieu of the conventional *tablinum*, space for a pleasant exedra that will have opened on a view of the sea beyond the terrace.[102]

52. Villa dei Misteri. Plan after Eschebach, 1993.

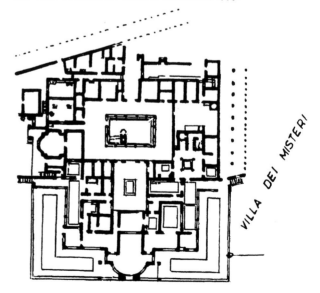

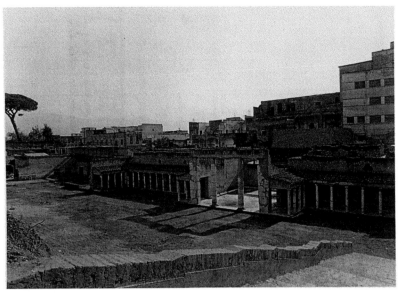

53. Villa Oplontis, north facade. Author's photograph (su concessione del Ministero per i Beni e le Attività Culturali).

Likewise the rooms of the central block remained substantially unaltered. Owing to the utilitarian character of the peristyle, the rooms serving private and hospitable purposes were not located here but, with one exception, were positioned between atrium and terrace with doorways giving prospects of the surrounding landscape through the colonnades. On one side a space covered by a tetrastyle roofing, possibly what Cicero in his letter to Quintus (*Q.fr.* 3.3.1) meant by an *atriolum,* served as the center for a group of small decorated rooms. No such rooms opened directly from the atrium, which was in the process of redecoration.

The second extra-urban villa was one of several situated on the lower slopes of Vesuvius in the area of modern Boscoreale.[103] This was a territory of vineyards, and the painted villa, like some of its less elegant neighbors, was unquestionably home to agricultural production, given its inclusion of a large forecourt, a kitchen, and a bakery. Hasty, incomplete excavations plague our full understanding of the establishment. The excavated portion involves a complex of decorated rooms surrounding a peristyle. No atrium is known. Although the date of its construction is only conjecturally placed just after the middle of the first century B.C., the name of the chief builder, Marius Structor, was inscribed on a tufa block in the wall.[104] Another graffito scratched into a column in the courtyard provides the information that the house was sold at auction in A.D. 12, and also shows that its courtyard underwent renovation at about that time. Although Lehmann proposes that the villa will have been the property of an absentee landlord at the time of the

eruption, this need not imply that all preceding owners would have managed the property from afar.[105]

Another coastal villa whose original decoration was entirely in the Second Style mode is located close to the shoreline between Pompeii and Herculaneum at a site that appears to have been labeled Oplontis on an ancient map. For this reason the villa has been given the name Oplontis (Figure 54).[106] Unlike the Villa of the Papyri, which may have approached its final dimensions early in its history, this establishment underwent several stages of expansion from its mid-first-century beginnings.[107] One addition likely to have been made at a later period is the pool of gigantic proportions faced by a complex of open chambers on the further side of the garden. Although this feature might corroborate the identification on the Tabula Peutingeriana of Oplontis as a thermal establishment,[108] we must spare hasty conclusions because we do not yet know, for instance, with the full extent of the villa still unexcavated, how the colonnades terminated on any side. We also do not know the relationship of the villa to the local economy. Its rustic quarters are less clearly defined than those of demonstrably agricultural villas. Like the Villa dei Misteri, it has a large, high-walled peristyle with an underground storage area, but unlike the other peristyle, this one is not located on an axial line with the atrium. Because both sides of the atrium now open onto corridor spaces, we cannot divine the original plan of access. If, in fact, an earlier peristyle entrance existed in front of the atrium on the landward side, all traces had been obliterated by a remodeling that included a large-scale room facing

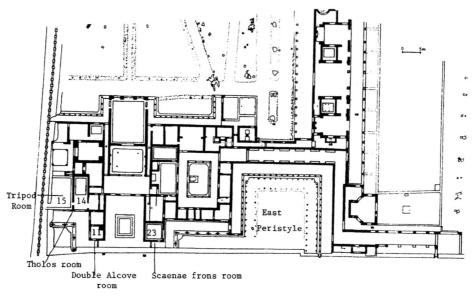

54. Villa Oplontis. Plan after Richardson, 1988.

the rear colonnade and garden.[109] Also there is no trace of a *tablinum* on the seaward side of the atrium where another colonnaded ambulacrum encircles the house.

Although the final disposition of Oplontis scarcely appears to be that of a villa rustica, and the absence of storage equipment on a large scale argues that it was not serving in this capacity in its final period, it may have resembled this type more closely when originally built. Even at that time, the size would have betokened the owner's prosperity, and it is also possible that he had placed this house close to the practical source of his wealth. The most recent excavation in the area is that of the large wine factory previously mentioned, whose interior Tuscan colonnade indicates a date as early as the third century B.C. and thus well in advance of the villa.[110] On this evidence, John D'Arms has speculated that the profits of an old agricultural industry might ultimately have supported the owner's fashionable house.

We may begin our examination of the four houses with a focus on the most conspicuous of the images shared among their decorative schemes. This is the round, colonnaded structure known as a tholos: one of the earliest rounded forms to be employed in ancient architecture. Decorations in each of the four houses incorporate one such monument that serves as a center to the kind of illusionistically open perspective associated with the Second Style at its height. In each case the centrality of the tholos is emphasized by architectonic framing, but hypothetically located beyond the articulated interior surface of the wall within a colonnaded enclosure open to the sky, which is to say a painted peristyle.

In the Villa Oplontis this structure is opulent (Figure 55). A series of screen walls masks the division between the space of the room and that of the colonnade. These screens stand at the back of a deep podium behind an array of columns supporting an elaborately articulated entablature, which defines the upper plane of the wall. Flanking the two sides of the door, the front columns project forward on ressauts. Their shafts are richly decorated with jeweled flowers and golden tendrils. Sphinxes crouch on top of the ressauts; victory motifs adorn the frieze zone as well as the peak of the gabled gate whose posts are guarded by griffins. Other objects of furnishing include incense burners with carved bases and silver craters over the gates.

Within the perspectival framework of the composition, the image of the tholos is curiously positioned. Logically one would expect it to appear planted within the illusionistic interior space of the courtyard, but this tholos cannot be standing within the courtyard because its podium and column bases are not visible through the aperture of the entrance gate. Rather, with the roof and entablature projecting upward into the space enclosed within the ressauts, the little building occupies a hypothetical position in front of the visual plane of the interior wall while its base and columns disappear behind the gate located on that same interior plane. One suspects that the painter sacrificed convincing perspective to give the tholos prominence as a central form.

Comparing this example with occurences of the tholos in the other houses, we discover a different segment of the structure displayed in each. Only the very summit appears within a circular opening in *cubiculum* 16 in the

76

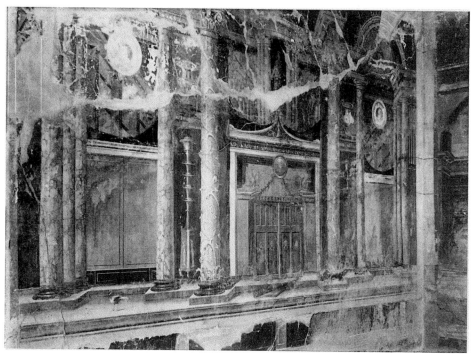

55. Villa Oplontis, tholos room (Sala 14), east wall. Pompeian superintendency D 108469, 1973 (su concessione del Ministero per i Beni e le Attività Culturali).

Villa dei Misteri, where it is curtained and flanked by ressauts. The south wall of the so-called summer *triclinium* from Boscoreale, now in the Mariemont Museum, resembles the improbable order of the Oplontis composition in projecting the capitals and roof of a tholos both upward and outward into the space before the inner barrier of the entablature while allowing its lower part to vanish into the exterior colonnade.[111] In both instances the central part of the tholos is opened to show the statue of a god within, but the higher position of the Boscoreale construction, and its placement above a solid gable rather than a gate, gives it an even more improbable appearance than we see in the Oplontis room. In two other instances, the painter has contrived to display half the tholos by the arrangement of framing elements in the foreground. Within the Corinthian *oecus* of the Casa del Labirinto, where real columns contrast with simulated ones, the tholos stands recessed at the center of the fictive enclosure, whose entrance is framed by a broken pediment supported by two columns. It is decorated with shields and has a circular hanging lamp within[112] (Figure 27). This pattern occupies the entire wall, but the tholos images in the decorated *cubiculum* of the Boscoreale paintings in New York are stationed within two facing panels forming the sides of the rear alcove (Figure 56). The architectonic design accentuates this framing with a hollow gable that echoes the triangular shape of the tholos roof. The entire composition

is simpler than those on adjoining wall segments. In the absence of luxury objects, a few garlands, fruit, and flowers are the only additional ornamentation. The columns of the tholos itself, however, are of the same bejewelled type as the interior columns of the Oplontis wall, and the same kind of column appears on the rear walls where we see a limestone grotto overgrown with ivy sheltering a marble bench fountain. Above this is a trellised arbor hung with grapes and a marble balustrade.

In addition to these tholoi located within fully extant decorative contexts, another example displayed as a fragment in the Naples Museum can be recontextualized within the Second Style decorations of Insula Occidentalis 6.17.41. Here we see the full form of the monument exposed on its own podium; behind it a single obliquely positioned building closes off the background instead of the accustomed colonnade. A woman stands beside the tholos depositing a very large pear at its base. Lehmann has remarked how such discrepancies of proportions may exemplify a tendency of Roman representation to focus on the point of thematic emphasis.[113]

Placing temporarily aside the question of what these painted monuments might signify within their decorative schemes, we may consider the practical information, which they give us about the style in which they participate. Their similarities of conception and execution are sufficient to identify them as common products of one group of painters working in all three houses. Common

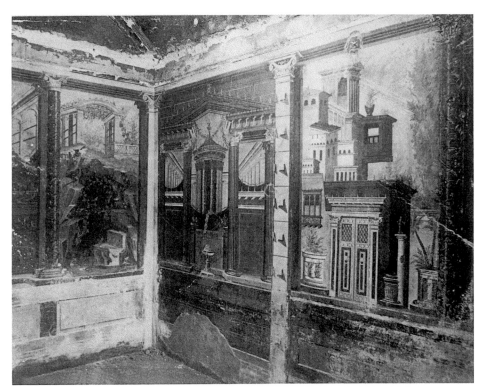

56. Boscoreale, New York *cubiculum*. DAI 56.937.

forms notwithstanding, ornamental details so markedly individuate the structures that we can be certain the painters intentionally diversified their visual effects as they moved from one to another commission. Consequently we may understand the tholos form as one item within a decorative vocabulary, with resources that offer limitless possibilities of recombination.

Forms, materials, and spaces all constituted signifying components of this vocabulary, as we can see by looking briefly at the dissemination of certain images conjoined with the tholoi. Broken pediments such as that in the Casa del Labirinto (Figure 27) or hollow pediments like that in the New York Boscoreale *cubiculum* are common framing devices. In a small double-alcove room at Oplontis, a broken pediment frames a garden view that includes a limestone grotto.[114] Although no more than the rocky outline of the cavern's mouth is shown here, in contrast with the interior depths of the Boscoreale image, it is noteworthy as a second example of a garden feature well attested by literary evidence. The back wall of the corresponding alcove contains a statue of a goddess doubly framed within a syzygium and hollow pediment. Ressauts are used in several instances at Oplontis and in the Villa dei Misteri to divide an entablature into paratactic bays. A triple-arched entablature stands before a paneled wall in the second alcove of the tholos "*cubiculum*" of the Villa dei Misteri.[115] On the

opposite side of the house, the single arch is used in the place of a pediment above a false door.[116] These occur also behind gateways in the central panels of the Boscoreale room. In every case, half-walls or screen walls afford views into deep illusionistic space surrounded by columns. The summer *triclinium* from Boscotrecase opens such prospects and similarly four Oplontis rooms, the grandest of which boasts a double-storied colonnade in colored marble with a gigantic tripod as the central ornament of the enclosure (Figure 57).

Likewise we may consider the various material objects incorporated into the paintings as elements of their pictorial vocabulary, and with these the technical tricks of light and shadow commanded by the painters to render these forms convincingly naturalistic. By means of well-placed highlights, they are able to give a remarkably realistic gleam to the gilded tendrils and jewels on such columns as we have seen at Oplontis and Boscoreale.[117] Likewise, they employ highlights and shadows to articulate a convincing sculptural quality in the egg and dart pattern they use so often or in the intricate convolutions of their capitals. Their systematization of patterns for imitating variegated marbles is also striking. In the Casa dei Griffi we saw wall schemes centered on imitation alabaster panels. Several Oplontis rooms include columns with the swirled yellow pattern. Because the stippling of porphyry and the veining of giallo antico are also

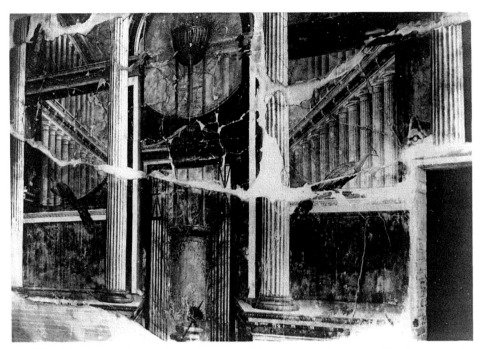

57. Villa Oplontis, tripod room (Sala 15), east wall. Pompeian superintendency, D 108470. 1973 (su concessione del Ministero per i Beni e le Attività Culturali).

frequently imitated in these columns and panels, there is no question that these decorations illustrate Vitruvius' testimony to the imitation of marble incrustations.[118]

With a freer adaptation of those same skills that articulate the textures of moldings and capitals, the painters also simulate unique single objects of fine workmanship, sometimes imitating marble relief carving and sometimes toreutic to enhance the individuation of walls and rooms. Some of these objects are incorporated into the architecture. I have mentioned the sphinx acroteria in the Oplontis salon as counterparts to that sphinx of Corinthian bronze which Hortensius notoriously received from C. Verres (Pliny *N.H.* 34.38). In the Villa dei Misteri and also in Oplontis room 23, elegant golden (bronze?) lamps are mounted atop the ressauts. In a number of places decorative shields hang on the walls; several of these show the Macedonian star, but the Oplontis atrium contains a row of shields with feminine faces that have been called faces of the provinces. Bronze hydria flank the central gate in the New York Boscoreale room. Salon 14 at Oplontis is especially rich in such furnishings. Silver craters and carved candelabra stand on the side walls while the shrine at the rear has an embossed silver quiver and also an example of a metal box decorated with figures in *opus caelatum*. Once again Cicero's Verres with his greed for silver comes to mind. Although many Latin references to such objects are merely categorical, the detailed narratives of the Verrines vividly construct for our imagination dinners in which Sicilian

officials bring forth their household's entire service of silver in honor of their high-ranking Roman guest (e.g., *Ver.* 2.4.18). As a decoy to entice such exhibitions Verres often sets out his own silver. In one exchange of pseudo-hospitality with the Syrian heir Prince Antiochus, Verres fatally spotted a candelbrum made of gems that the visitor had destined for presentation in Lutatius Catulus' reconstructed Capitoline temple (*Ver.* 2.4.27–9). This rapacious officer even had a workshop in which decorations stripped from silver vessels were reapplied to new forms of pure gold (2.4.54).

Likewise within this category of imitation belong the panels of landscape representation that we commonly call monochrome; they are, to the best of our knowledge, the first landscape representations of any kind to appear in Roman painting.[119] Salon 14 at Oplontis boasts a series of six such landscapes ranged on the paratactic series of orthostat panels situated in the antechamber of the room. Standing with minimal projection above a base of isodomes and string courses, and separated by bands imitating red and green porphyry, they appear to form a part of the flat surface of the wall. Above them is an elaborate cornice with brackets. The panels themselves are golden in color with highlights and shadows in brighter and darker tones. Each contains vignettes of buildings and trees; the images stop short of the drafted margins of the panels. Strong highlights and shadows give the effect of shadows cast by the light actually entering the room.

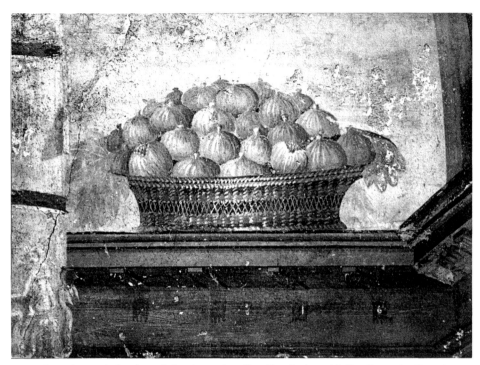

58. Villa Oplontis, tholos room (Sala 14), north wall, willow basket with figs. Pompeian Superinten-
dency D 108472 (su concessione del Ministero per i Beni e le Attività Culturali).

Because of the consistency with which this shadow effect has been carried out we may understand the decorations as intended to imitate relief work, either painted stucco or carving in marble, the latter being more in conformity with the general elegance of the room. Another such monochrome panel appears on the rear wall of the Boscoreale *cubiculum* where it has now been cut through by a window.[120] This composition seems to have been somewhat more elaborate than the Oplontis examples, presenting a coherent harbor scene rather than a set of topographically unrelated vignettes. Mau claimed to have seen similar panels in gold with violet shadings in a room of the Casa del Fauno.[121] Not only gold, but also red and green backgrounds are used for such paintings of which several more examples exist within the corpus of the Second Style.[122] As Eric Moormann suggests in his study of pictorial representations of sculpture, the positions occupied by such monochrome panels must offer a reliable clue to the manner in which their real-life models were displayed.[123] Perhaps something of this sort is what Cicero had in mind when asking Atticus to procure him some relief panels (*typos*) to be set into the plaster of an *atriolum* (*Att.* 1.10.3).

Of all the single objects incorporated into these architectonic schemes, the various still-life images have compelled most attention for their verisimilitude. Both Oplontis and Boscoreale display fruit bowls remarkable for their translucent glass as well as the fresh, rounded forms of summer fruit. In Sala 14 at Oplontis we see a braided willow basket filled with green and purple figs (Figure 58). Although two ripe figs are bursting seeds through split skins, still this fruit is a little too regular in its forms to be called fully realistic. The podium in Room 23 supports several such items: a veiled basket with a torch beside it, a species of dessert cake placed on a small table, and a heap of glassy green fruits: grapes and apples. The naturalism with which these items are rendered bears out Pliny's remarks concerning the imitative skills of ancient artists. Comparable examples of fruit and glass vessels have long been known in Pompeian painting and are generally explained as derivations from a Greek custom of painting portable tablets with food items called *xenia* to signify hospitality.[124] The appropriation of this custom into Roman painting is verified by written descriptions of two paintings termed *xenia* in the second century collection of ekphrastic writings, the *Imagines* of the Elder Philostratus.[125] Those *xenia,* however, are independent compositions, probably framed within panels. Many Pompeian examples also segregate the objects from their backgrounds within frames, but the direct integration of edible items into their decorative contexts appears to be a uniquely Roman development within this particular corpus of illusionistic painting.[126]

Pieces of fruit are not the only items from nature that these Second Style painters render convincingly. Birds within Oplonis' architectural settings have an arresting

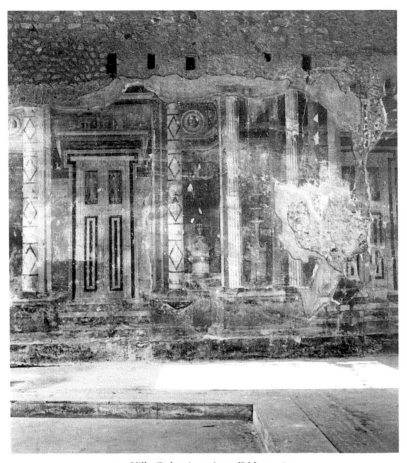

59. Villa Oplontis, atrium. DAI 74.2692.

freshness and vivacity about them; two great peacocks in the tripod salon, a pheasant in Room 23 and a perky rail who stands on the podium of Room 14. Although similar birds appear amid the ivy vines veiling the grotto of the Boscotrecase ensemble, it is only in these Oplontis rooms that a bird invades the architectural framework of the painting. Even if these creatures may not be so readily explained as are the food items by the traditions of *xenia,* this category gives them meaning. Philostratus' second description of this kind pictures a caged live hare in juxtaposition with one that has already been killed and gutted (*Imagines* 2.26). The discursive context in which these creatures are positioned surrounds them with other edibles, whereas the rhetorician's descriptive focus wanders in and out from the world of nature where an abundance of fruits and other items lies ready to be gathered. Hospitality thus proffered lavishes nature's abundance on the receiving guest. Within the world of the paintings, a comparable stretch of imagination will understand the birds as live inhabitants of the *ambiente* who have just wandered in from outside. Serving as transitional figures to bridge the levels of simulated space created by the interior and exterior architecture

of the painting, they perch here as if poised to enter the space of us spectators. Like other fine details of the mimetic composition, they are articulated more persuasively then the large perspective framework itself, but their status as animate creatures renders their naturalism highly paradoxical as a mimetic invasion of the real interior belonging to the audience passing judgment on these atmospheric illusions.

That our attention to the verisimilitude of these objects is culturally appropriate is easily verified by reference to the rhetorical discourse on lifelike representation in ancient art. Pliny tells of grapes painted by the Greek artist Parrhasios so realistically that birds flew up to the stage where they stood (*NH.* 35.66.5). At Oplontis, however, we see not only the grapes but also the birds. What can we make of the intentions with which this illusion addresses the spectator? Should we be regarding these images primarily as naturalistic conversation pieces, a species of momentary visual trick like the traditional painted dog in the *cave canem* whose power to halt the incoming stranger furnishes Petronius with an introductory play on reality and illusion at Trimalchio's house (*Satyricon* 29).[127] Within that particular

81

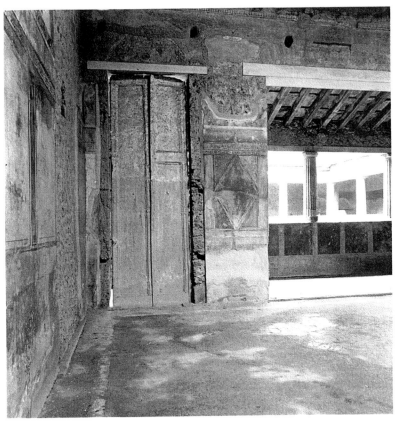

60. Villa dei Misteri, atrium and peristyle entrance. FU 11700/1966.

context the dog is a joke, a means of disadvantaging the uninitiated, and Petronius later spins out this humor at the expense of Encolpius, his fallible narrator, when the bark of the genuine dog proves far more terrifying than his painted image (*Satyricon* 58). It is important that the fictive dog is positioned to produce a response that is instantaneous, but momentary so as to highlight the condition of the deceived person as a gullible stranger at the point of his entry into the proprietor's realm. Similarly the effectiveness of the birds as conversation pieces can also be only of short duration; but unlike the guardian house dogs, they are not seen by persons in transit but rather by those who belong to or have been received within the house. Accordingly we should look for their significance as an aspect of their permanent status. The question can best be approached by consideration of the likely status of the rooms in the decorative hierarchy of the house.

For this purpose Oplontis offers the most productive resources, but the conclusions to be deduced from it are applicable to the representational hierarchy of decorations in other houses as well. One reason the Villa makes so significant a contribution to our understanding of programmatic illusions in Second Style painting is the fact that it contains an undisturbed Second Style atrium (Figure 59). Previously the Villa dei Misteri offered the sole example from the period and that one was undergoing redecoration in A.D. 79 with portions of its patterns scraped to their ground color (Figures 60 and 61). For this reason it remains a matter of debate whether the four doors of this atrium, which appear to be blocked and stripped of their covering, were once functional doors leading into the side rooms of the house, or simply a framework to which facsimile doors were attached.[128] Here the panels of a large orthostat zone rest on a high dado. The orthostats themselves simulate dappled stone, probably meant for breccia, and are varied by a pattern of superimposed diamond panels. Two cornice bands of egg and dart and meander key pattern, respectively, are surmounted by a full-figured polychrome landscape frieze surrounding the room, the first known example of its kind which has been called Egyptian on the basis of its few remaining figure traces, a palm tree, and a crocodile.[129] In fact, the polychrome coloring as opposed to monochrome stucco imitations may well be intended to simulate figured mosaics such as that in the Casa del Fauno, which supplied the main subject interest of First Style decoration. Although the decorative

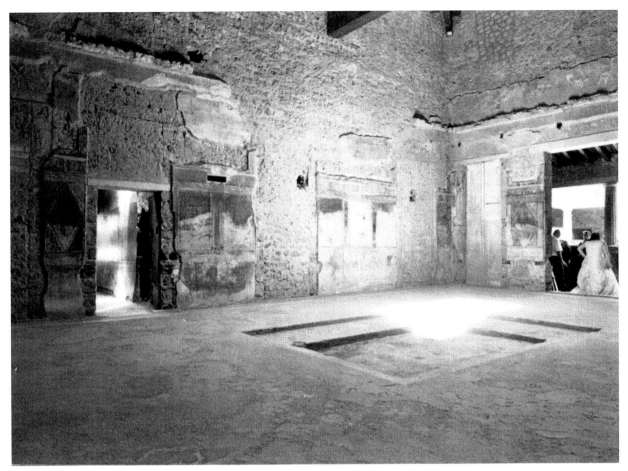

61. Villa dei Misteri, atrium north wall. Author's photograph (su concessione del Ministero per i Beni
e le Attività Culturali).

ensemble itself is spare, with relatively limited compo-
nents, its pretensions to richness should be understood in
the kinds of stone imitated and in the elegant cornicing.

The Oplontis atrium, however, in all its monumental
proportions, is more or less complete in its middle zone,
lacking only the topmost register above the cornice, and
any traces of decoration on its rear walls. Like that of the
Villa dei Misteri, this atrium decoration has two fictive
doors on each side wall that are raised above steps to
open at the level of the podium supporting the columns
that flank them, but the level of opulence in this fictional
ambience is much higher with unmistakable imitations
of expensive material. One set of columns shows the
swirled markings of alabaster; the others are giallo an-
tico. The door frames must be of marble and the doors
ivory with tortoise shell inlay such as those which Vergil
in *Georgics* 2.463 ascribes to the residences of the rich
and powerful. A pair of winged Nike figures adorns the
upper panels of each. Heavy candelabra and cylindrical
boxes, perhaps book boxes, flank the doors and a series
of shields appears in the upper register. Directly over

the columns is an entablature decorated with a series of
rosettes and bucrania framed by triglyphs.

The materials of this decoration and certainly some
of the forms are appropriate, as Fittschen has argued,
to a regal residence. All the same, we have no reason
to believe that such a residence constitutes the imme-
diate point of reference for a decoration so Roman in
many of its components. Although scholars have dis-
agreed as to whether the decoration was once symmet-
rical with three doors rather than asymmetrical with
only two doors as it now stands, the very fact that the
two doors are identical sets the composition apart from
imitations of a *scaenae frons*.[130] On the seaward side of
the room the atrium wall turns the corner into a cor-
respondingly decorated corridor. From this side, which
should be considered as the entrance, the perspective il-
lusion of the doors is seen to its best advantage. Beyond
the second pair of doors, corridors with colonnaded
sides run at an oblique angle out of sight; these corri-
dors occupy the place normally belonging to the *alae*
and should be understood in this capacity, while the

doors themselves are located in the customary positions for atrium doors.

To this may be added that the decoration, although belonging unquestionably to the Second Style period, does not, to all indications, contain any trace of the spatial openings considered characteristic of the Second Style at its height. If ever the closed wall had any form of attic zone, this might well have been a species of loggia such as we have seen in First Style walls. The important inference to be derived from this absence is that the characteristics of the composition cannot be ascribed to chronology, because the total decorative program of the villa includes spatially open prospects in interior rooms. Instead of developmental sequence what we see here is a manifestation of a decorative decorum that deems open vistas inappropriate to the purposes and position of an atrium. Consequently we may understand that the decoration itself simulates the furnishing of an atrium on a higher plane of luxury boasting such accouterments as the doors of ivory and tortoise shell that Vergil attributes to the dwellings of powerful men. The shield masks readily fit such a context. As a form of decoration with ancient precedent, portrait shields called *clupei* had served as a mode of familial status assertion in public contexts and had more recently been brought into at least one private residence, that of M. Aemilius Lepidus, as a bridge between the spheres.[131]

With these points in mind let us return to the three rooms previously considered. The level of luxury to which their furnishings pretend is perfectly compatible with that which the atrium imitates. As both Fittschen and Lehmann recognized, this luxury involves a double perspective.[132] Although the mere existence of such pretentious paintings is a mark of high luxury, the even higher plane of luxury invoked by their material apparatus would seem elevated far above the economic capabilities of the house owner. In this respect all components of the program cooperate in one and the same representational enterprise irrespective of their specific disposition of perspective and space.

At the same time the spatial effects of these decorations fulfill a practical function in enhancing the advantageous physical situations of their rooms. Placed at the seaward side of the house, these rooms are ranged around the ambulacrum of a peristyle the full dimensions of which are still unknown. By their juxtapositions of closed and open spaces the compositions effectively play off their fictive prospects against the real.[133] A fully paneled antechamber precedes the open walls structuring the interior space of the large tholos salon so that a person entering this room would seem to proceed through an enclosed space into one bordered by

gardens.[134] Room 11, the double-alcove room, shows similar contrasts. Its architectural structure is one quite common in houses of this period; its two alcoves are constructed side by side so that their vaulted roofs spring from a common corner post.[135] One of these alcoves is paneled, but with a window opening onto a view that includes a divided pediment. Above it appears the roof of a limestone grotto – the single counterpart of the Boscoreale grotto in the extant repertoire. At the back of the left-hand alcove the wall itself appears to be pierced with a broken pediment framing a view into another colonnaded area with a central statue. The apertures that occupy the middle zones on the sides of this alcove are particularly interesting. They are constructed as windows facing on a prospect entirely filled with shrubbery. The little balustrades that appear at the podium level show that these are meant for balcony windows as they would be seen from the interior of the room.[136] An exterior view of comparable structures can be seen in the buildings that comprise the lateral panels of the Boscoreale *cubiculum*. On the two opposite sides of the Oplontis room are doors and windows facing the peristyle and the sea view. In combination with these real apertures, the architectonic decorations construct a semienclosed shell of space pierced on all its four sides by perspectives.

This set of rooms is completed by the great tripod salon whose perspective views are the most complex of all in this quarter of the house (Figure 57). The grandiose colonnade that appears through the apertures of its double propylon is, as I have mentioned, a double-tiered structure built of marble in two colors. The Doric tier is rose hued as to suggest pavonazzetto and the upper, Ionic tier is of grey blue. On either side of the central gate the apertures of a colonnaded screen wall shows glimpses of foliage. Also the base of the tripod framed by the propylon is surrounded by foliage. The colonnade, as we can see, clearly surrounds a park of large dimensions. Like the birds of the tholos salon, the peacocks here perched on the screen wall would seem to appear as the inhabitants of this region inviting imaginative interchange between its half-visible spaces and the interior of the room. Here also, as in the double-alcove room, the fictive prospects are played off against the real. On the side facing the peristyle the tripod room opens with great double-leaved doors. The use of enclosed and open space emphasizes this interplay so that three levels of reality appear in the schemes.

Behind the group of rooms stands a kitchen handily located for service to the entire area. This fixture provides concrete information for an identification of the function of the rooms, that would otherwise rest merely on conjectural principles. Without question they

comprise a complex of dining areas so situated as to take full spatial and thematic advantage of the surrounding *porticus*. Variations in orientation and size bear out the general principle of providing varied spaces for dining within the prosperous Roman house. The grandeur of the decoration signals dining as a ritual of consequence, and the symmetrical ordering of the perspective vistas frames the couches and creates an atmosphere appropriate to stationary activity.[137] On this basis they are closely comparable with the Corinthian oecus in the Casa del Labirinto whose architecture clearly signals its status. If we apply the same principles to the rooms surrounding the Boscoreale peristyle so often regarded as private *cubicula,* the similarity of decoration would seem to argue for their importance within the public accommodations of the villa. For this reason the contributions of Oplontis to our social understanding of decorative hierarchy are significant. It remains to consider how the coordination of location and spatial effect can also yield insight into social code. At the same time Barbet expounds, both here and elsewhere a principle of a hierarchy of decorations with reference to use and location that can go far toward answering some of these questions.[138] It remains to transfer these principles from the realm of abstraction into Roman social dynamics by further interpretive examination of their mimetic vocabulary.

MIMESIS AND MEANING

The opposition of naturalistic representation and architectural improbability in these life-sized megalographies has set the parameters of a continuing interpretive dialogue into whose exchanges over a period of time there have entered a number of rival theories concerning probable sources or models for these architectural constructions. Behind such inquiries one can perceive, even when not explicitly acknowledged, a desire to discover some symbolic point of reference that will unlock the communicative code by which these visual fictions restructure their practical environment. Locations that allow for a juxtaposition of simulated spaces with real ones increase the semantic conundrum by discrepancies of opulence. Through their interaction with the concrete realities of their context these images visibly punctuate their illusion in a manner that cannot be ignored.[139] Thus to refer to their images as simulated luxury, fictions at a secondary stage of removal from reality, only displaces the question of what this pretension signifies in terms of cultural semantics. Even when the technical refinements of the architecture or its components are seen as "deriving" from an established repertoire of elements, this is not a decoration satisfac-

torily explained by the simple urge to reconfigure visual space.

Responding to the newly discovered Boscoreale paintings, the scholars who initiated the quest for models operated within the conventional framework of determining what was Greek and what was Roman, a question never specifically addressed by Vitruvius' remarks on architectural simulation.[140] At this time it was assumed that the accurate identification of a single model could satisfactorily explain all individual manifestations as copies or derivatives. With the refinements of evolutionary study, as well as the expansion of the corpus to show how greatly even the recurrent components of the patterns vary, the search for explanatory models has shifted from direct to indirect. Today the majority of scholars espouse an eclectic view of the paintings that credits the inventiveness of Roman painters in working with a set of components forming a repertoire. Even with this latitude the semantic implications can be differently interpreted as the contrast between two recent studies will show. On one hand, a romantic, essentially privatist, view persisting from the interpretations of Phyllis Lehmann reads the paintings as expressions of personal fantasy, "transporting the householder to a world of magical luxury." On the other hand, the current French view, more structuralist and socially oriented, considers the walls almost as the product of bricolage, compounded of available materials and building a mediating image that, to quote Alix Barbet, "operates in a selective manner with the memory and collective preoccupation of its time, invoking no single world but serving rather as an intermediary between the complex world of Roman society and those who make use of them."[141] This explanation has the merit of allowing for flexibility, for the interchangeability of elements and for hierarchic status signification in a general sense. All the same it raises the question whether the valuation of these elements should be seen in primarily self-referential terms as forming their own self-contained status hierarchy or whether their significance is not partially compounded by determinable points of external reference.

First we must consider that placement in accordance with a decorum of hierarchy constitutes in itself a signifying system that points to a particular social valuation for the symbols. Just as the identification of elements in the atrium decoration as conforming to the decorum of usage makes the rationale of its composition legible, so also that of these dining rooms. A first clue to the subject of these compositions is offered by the colonnaded tholos with which I began my survey of the Second Style repertoire. The form is used ubiquitously in the

ancient world, but a passage in the third and final book of M. Terentius Varro's *de Re Rustica* places this common image within a meaningful contemporary context.

In this place Varro, complying with a request of his fellow participants in the conversation, describes an aviary garden that he has designed in his own villa at Casinum (3.5.9–17). This is a multifaceted precinct combining several areas for the breeding of birds made amenable for social use by colonnades, trees, fish basins, and the surrounding wood. The building itself is a round, colonnaded structure (*rutundus colonnatus*) with a row of interior and exterior columns separated by a space of five feet. Wooded parkland encircles the outer circumference save on the entrance side that opens at the end of a broad, uncovered walkway flanked by colonnades and lined with twin *piscinae*. The interior spaces of the colonnades are screened by nettings so as to serve as the pen for a great variety of birds, primarily songbirds. The interior circle contains a duck pond sunk below the level of its platform, with a central island and an elaborate table and seating arrangement for dining. From this place Varro's guests may look through the aviary into the spaces of the landscaped park beyond which forms a background for the actions of the birds who are nonetheless penned away from it. The need for this penning arrangement can be understood by an earlier mention of the unsuccessful attempt of Lucullus to combine a dining pavilion with an aviary. Aiming to create an area where "one might dine exquisitely seeing some birds placed cooked on one's plate and other captives flitting about the windows" (3.4.3), Lucullus failed to anticipate how unappetizing the odors of the living birds would be. Varro describes the interior space between the two circular colonnades of his own aviary as a kind of "bird theatre," likening its structure to the seats of the real theatre: (3.5.13: "Inter has et exteriores gradatim substructum ut *theatridion avium* mutuli crebri in omnibus columnis impositi sedilia avium"). What may surprise expectations here is making the birds into spectators rather than performers.

Whether they have gained their knowledge firsthand or only by hearsay, Varro's colleagues show familiarity with this villa. Because Casinum was located on the well-traveled road between Rome and Campania, some of them will conceivably have enjoyed its hospitality during their travels. Because they praise Varro's ingenuity not only for solving the problems of dining in proximity to birds, but also in surpassing the large-scale constructions (*magna aedificia*) that Lucullus had introduced on his Tusculan estate (3.5.8–9), the description reveals Varro's affinities with such plutocratic contemporaries as Lucullus or the orator Hortensius. Nor in-

deed does he conceal that he has built this truly aristocratic construction for the sake of enjoyment (3.4.2: *causa delectationis*) rather than for profit. In this respect the exposition borders on confession because earlier parts of the treatise even implied criticism of the luxurious villa building for which these senators were renowned. Especially from Varro's father-in-law Fundanius, who represents a conservative older generation, we hear criticisms of new-fangled farmhouse architecture (1.13.6–7), although this speaker is also gently mocked for his quaint, folkloristic beliefs (1.2.26).

But the concept of proprietorship and villa development represented in Book 3 is enriched by the amenities of contemporary culture, in keeping with the general purpose of the *de Re Rustica* as a guide to the modernization of Roman agricultural economics: a process that admits an aesthetic dimension in villa arrangement as well as a practical. The argument of the third book, in which the aviary description occurs, is that the area of the farmstead can be profitably employed in service to the economic reality of increasing consumer luxury through the cultivation of animal products for the luxury table (3.2.13–18).[142] Varro's good management sets his villa apart from those of Hortensius and Lucullus, as we see when the conversation turns to fishponds, and Varro recounts with evident amusement the sparring that went on between these two piscatory enthusiasts as the one criticized the other's failure to provide for the circulation of salt water to freshen the basins (3.17.8–9). Fishponds, as these gentlemen managed them, subvert all practical goals proper to agriculture. They are a poor economy in Varro's estimation, simply because these *domini* have made fetishes of their fish, cultivating them virtually as *clientes* rather than for the table.[143] The final point, however, which Varro's own villa illustrates, is that good economics tolerates and even encourages such luxury in an alliance with practical profit. Offering a detailed picture of the gracious life which Roman gentlemen cultivated at the end of the Republic, the aviary fulfills a complex role within the structure of the dialogue bridging the distance between traditional economy and the innovations of modern life.

Similarities between Varro's bird garden and the paintings of rooms such as the Oplontis salon are obvious. Modern scholars who have attempted to reconstruct the garden landscape with which Varro surrounds his tholos have even been influenced by these paintings.[144] Now one must ask whether the propositions work in reverse. Although it seems clear that the paintings represent a prospect into such a colonnaded park such as Varro describes, and the stray birds in the composition imply that this area functions as an aviary,

still it requires some stretch of credulity to conjecture that one single literary passage might be responsible for an entire phenomenon in the visual arts. Indeed the simplest objection one might raise is that Varro's treatise appeared too late to have exercised such an influence because the paintings are dated generally in the early to middle 40s B.C. while the *De Re Rustica* was published only in the mid-30s. It is not specifically Varro's description but the way of life it represents that should be associated with our paintings. This association has important consequences not only for the identification of painted subjects but also for the social statements of painting.

In the first place, Varro enlarges our understanding of the tholos as a motif. This architectural form, as mentioned earlier, has many employments in the public sphere: religious, celebratory,[145] funerary,[146] and even commercial. Most persons think first of the religious.[147] The fourth-century tholos located in the sanctuary at Delphi is among the best-known examples. Surviving Roman versions built in Republican times are to be found in Temple B of the Largo Argentina, in the Republican temple by the Tiber, and in that of the Sibyl Albunea at Tibur. The first of these, on the basis of Varro's comparative mention of a colonnaded tholos, can be identified as Q. Lutatius Catulus' Temple of Fortuna Huisce Diei constructed in fulfillment of a vow to celebrate victory over the Cimbri in 101 B.C.[148] An earlier Roman version, however, the Temple of Hercules Musarum in the Circus of Flaminius was as much a monument to culture as to cult. Built by Fulvius Nobilior to commemorate his Aetolian campaign on which Ennius had accompanied him, the sanctuary was celebrated for its association with poets and poetry.[149] Thus, instead of causing a quest for religious significance in the tholos, Varro's connection between the religious and secular should direct us to the latter realm.

Today the best-known examples of the tholos in Italian municipal architecture are those at the centers of the *macella* in Pompeii[150] and in Puteoli,[151] but these are merely two representations of a form that was virtually ubiquitous.[152] Vitruvius associates it generically with such places. That the form was so used in Rome during the late Republic is witnessed by a passage in Varro's Menippean satire "Bimarcus" (53–6; written circa 80–67 B.C.) that has Jupiter Tonans sending a three-forked bolt into the *tholos macelli . . . chortis cocorum atque hamiotarum aucupumque.*[153] This intermingling of provisioners and suppliers suggests the commercial activities surrounding the tholos, but its municipal and its gastronomic associations come together in what F. Cooper and Sarah Morris have identified as a special class of round buildings in sanctuaries intended for ritual dining.[154]

Based originally on the temporary shelter of the tent, the dining tholos occurred from the archaic period onward, but its most significant permanent example was the tholos in the Athenian agora intended for the everyday communal dining of the fifty members of the *prytaneium*.[155] Although the associations of these meals were serious and businesslike, with the diners seated in the plebeian rather than the aristocratic leisured style, in later years the term *prytaneium* seems to have become associated with the hospitality offered to Greek guests. The name is included in the roster of buildings at Hadrian's villa, but much earlier, by Plutarch's testimony, the house of Lucullus served as a hospitable *prytaneium*, for Greeks residing in Rome. Practically speaking, he means that Greeks could always find meals there, but one might speculate that his choice of the word encompassed its architectural associations as a reminiscence of the original structure of that name in Athens. Thus our inquiry into the significance of the tholos returns us to Lucullus and his villas.

As mentioned in the previous chapter, open-air apartments situated near porticoes were a notable feature of the villas built by this senator who, if never absolutely the wealthiest among late Republican plutocrats, gained the greatest reputation among them for lavishness in the architectural embellishment of his private sphere.[156] With a show of self-indulgence probably best understood as a defiant flaunting of the aristocratic establishment that had betrayed his service to its codes of government,[157] his innovations carried to new pinnacles that Hellenizing lifestyle that the aristocrats of the Republic loved to cultivate. In the plan of his villa on the Pincian, Filippo Coarelli has seen an echo of the hemicycle colonnades of the Temple of Fortuna at Palestrina.[158] Because the Luculli were patrons in Praeneste, such an architectural allusion in a townhouse high and conspicuously perched above the level of the city would seem to constitute an assertion of family history and connections, but also the experience of his eastern campaigns against Mithradates was no small aid to style.[159] Capitalizing on his cosmopolitan exposure, he gave his name to a rich Chian marble veined in red, black, and gold. Both the Pincian and the Tusculan villas were fabled for their picture galleries, while the Neapolitan or Baian property was notorious for its fish ponds connected by channels to the sea.[160] Plutarch's biography describes this estate in monumental terms: "He suspended hills over vast tunnels, girdled his residences with zones of sea and with streams for the breeding of fish, and built dwellings in the sea." A scholar has suggested that it was especially this feat of engineering that prompted Pompey to assign the well-publicized epithet, the "togate Xerxes."[161]

Even while Lucullus remained alive his luxuriousness was circulated in anecdotes. The critical remarks that Plutarch attributes to Pompey aim clearly to reflect the norms of Roman life from which Lucullus departed with the aim of shocking his fellow aristocrats. The motto of Lucullus' extravagance was that he did nothing for others that he would not have done for himself. Insofar as the maintenance of figure was concerned, he clearly spoke the truth. His outlay on food was commensurate with the settings in which it was served, and it was especially in this area that his defiance of Roman standards of moderation stood out. Placing an especial value on all that was costly to procure, he lived in a manner to resemble the potentates he had conquered. We can thank him for being the first importer of sweet cherries into Italy. When Cicero and Pompey attempted to trap Lucullus into serving a simple meal by stipulating that he should entertain them without giving advance orders to his servants, they found his resources already prepared to counteract such a trick. Seemingly each one of his many dining rooms had its fixed budget and table service; Lucullus entertained his guests in the Apollo whose budget was 50,000 drachmas, thus provoking their amazement at the speed with which a banquet could be prepared.

Such ostentation unsurprisingly invited censure on the grounds of poor taste. Plutarch must again be reflecting contemporary opinion when he says, "The daily meals of Lucullus were such as the newly rich affect. Not only with his dyed coverlets and beakers set with precious stones, and choruses and dramatic recitations, but also with his arrays of daintily prepared dishes did he make himself the envy of the vulgar." In de Legibus (3.30–1), Cicero shows Lucullus competing in ostentation with two of his Tusculan neighbors, an equestrian and a freedman, himself the guilty perpetrator of this unrestrained extravagance.

But not merely the vulgar. References to Lucullus in Varro's description of the aviary are cues to his intention of imitating and indeed of surpassing Lucullus, in the manner that Lucullus and Hortensius competed with each other. We should scarcely even find it surprising that Roman aristocrats, traditionally so competitive in their military and political activities, should also have competed in building and furnishing their villas with an ingenuity constantly expanding in scope.[162] Hortensius' shoreline park at Laurentium possessed a feature surpassing anything his contemporaries would seem to have boasted: a wild game preserve within an enclosed fifty acres of forest. Like Varro's aviary, this amenity furnished spectacles for dining. In an outdoor triclinium positioned on an eminence, Hortensius would summon a servant dressed as Orpheus, who would sound a horn to summon crowds of stags, boars, and "other quadrupeds" (3.13.1–3).[163] Hortensius was reportedly the first Roman to serve peacock as a dinner meat. Even Cicero, when dining out, knew how to relish a good dish of peacock, although he protested that it was beyond his own culinary ambitions as a host.[164]

Few men imitate Lucullus' virtues, but many have copied his magnificent villas, Cicero remarks in de Officiis (141). Less censorious than his earlier remarks on Lucullus as model, the comment befits the persona of a man who was no less caught up in the villa competition than his peers. Cicero's engagement in this competition, as witnessed by his eagerness to make known the intellectual nomenclature that he gave to his porticoes, reminds us of the strategic importance of the properties to social self-representation, supporting the aristocratic lifestyle in ways no less political than hedonistic.[165] Although the majority of Lucullus' emulators may not have christened their porticoes "academies" and lycea, it seems likely that they also concentrated their imitative efforts on such spaces along with the decorative programs that enlivened them.

Unlike Romans of the senatorial class, the commissioners of our Campanian porticus paintings may not attempt to rival, let alone surpass Lucullus, yet I believe that their decorations participate in the cultural discourse generated through his precedent. A migration of decorative ideology from a plutocrat flaunting resources with the indiscretion of the nouveaux riches to the new patrones coloniae in post-Sullan Pompeii must logically involve certain intermediary stages of communication, yet the dissemination of aristocratic villas also disseminated their fame. Varro, Plutarch, and Cicero bear witness to the scarcely disguised admiration in which Lucullus particularly was talked about. As Wallace-Hadrill rightly observes of the urban magistrates' house, it is not so much wealth as status that is exhibited by these means.[166] As we continue seeking their significance in the eyes of the late Republican world, we may usefully remember Cicero's observations in de Officiis (1.140) concerning the decorum of house and owner.

Despite the naturalistic rendering of detail that figures so prominently as the visual index of illusion in these paintings, they can scarcely have been expected to succeed like Trimalchio's painted watchdog in deceiving spectators with the false impression of a reality. As Lucilius had observed, only preverbal children could confuse artistic simulations with life. But even if some effect of deception were intended, the fictive prospects of these paintings are far too tolerant of inconsistencies and incoherences to produce genuinely convincing illusion. Vitruvius' criteria for probability allow the same

latitude. When he speaks of projecting elements that can deceive judgment as well as sight (6.2.2: "Non enim veros videtur habere visus effectus, sed fallitur saepius iudicio ab eo mens"), he describes a palpable effect of individual forms that is essential to the persuasiveness he so values in painting; when he declares (7.5.3) that a painting must represent something that can really exist, he refers to the probable existence of the original as a basis for imitation. Certainly the spectator's role is critical in assessing such probability, but a further question that escapes Vitruvius' insistence on persuasion is the probability of the image within its environment, and this is the area in which the signifying capacity of these images is to be sought.

For this reason I have pursued positivistic identification within a specifically Roman frame of reference, but the larger conclusion to be drawn herefrom is that the employment of verisimilitude does in itself constitute a sign. We greatly undervalue the semiotic capacity of these images if we ascribe them to some romantic mystique based on half-formed notions of exotic splendor existing in distant places long ago.[167] Although one cannot deny that their appearance of expanded spaces may have in some manner gratified the particular personal desires of their patrons, one should not hypothesize an imagined entry into these spaces as a refuge from the real circumstances that they serve to enhance. Rather, as Jaś Elsner has observed, their rhetoric of mimesis is concomitantly that of denial and presentation.[168] By effacing what does exist, the real and limited spaces to which they have been applied, these images implicitly declare the inadequacy of these spaces to serve the status claims of their owners but also validate such claims within their own proper social and geographic parameters in the form of a power to command visual transformation. Thus privileging imitation over reality, the employment of trompe l'oeil perspective serves cognitive communication within a commonly recognized code of *aemulatio,* presenting the objects it wishes to portray in a manner more allusive than illusory. Precisely this allusivity with its flexible capacity for a graded ranking of spaces permits the expanded metaphor of a decorative program from the inner-city fictions of the Casa del Labirinto to the actual seaside luxury of Oplontis where fictive decorations enhance an already palatial and intrinsically elegant residence. It remains to consider briefly the social affiliations of these programs in their settings insofar as they can be related to the history of ownership.

The closest we may come to definite identification of owners is the family of the Sextilii at the Casa del Labirinto who were politically successful during early years of the colony but thereafter suffered an apparent eclipse until the city's last period. Their record of office holding in the colonial period would suggest renovations carried out in connection with their period of influence.[169] In this instance decorations reliably document stages of expansion because the atrium-*tablinum* complex retains its First Style panel decoration in molded stucco. A later campaign saw the refurbishing of the peristyle area with a set of five richly decorated rooms opening at the far side with easy access to a kitchen large enough to supply major feasts. Considering how the general decorum of programmatic decorations would seem to have mandated closed prospects in atrium and *tablinum,* there will have been no abrupt discrepancy or disharmony between the two quarters of the house. All the same Zevi reads a political history in this combination of old and new furnishings[170]:

> its splendid Second Style paintings demonstrate, in the days following the colonial deduction, the persistent wealth of a family who, while magnificently renewing their residence, at the same time conserved intact the atrium with its original First Style decorations in order to glorify the memory of their proper Samnite identity, the unbroken continuity of their own family narrative, *domi nobiles* as much before as following the Social War. We can easily imagine that houses such as this played an effective role as intermediaries, when the known controversy concerning *ambulatio* and its *suffragio,* as already mentioned, rendered opportune that intervention, delayed but effective, as Cicero indicates on the part of the "patrons of the colony."

Whatever the nature of the gatherings they witnessed, the rooms on the peristyle corridor are of varying shapes and sizes and, by reason of their intercommunicating doorways, would appear to have been conceived as suites (Figure 50). Coordinated decorations confirm this point, and the elaborateness of the mosaics appears to establish status grades among the spaces. The combination of large and small rooms in the complex resembles that which we see in the Casa delle Nozze d'Argento, but is far more opulent in design. It is interesting that size and decoration do not correspond because the more elaborate figurative patterns are in the group of three rooms to the right while two larger chambers to the left have only paratactic paneling.[171] Might these lesser rooms have accommodated the retinue attending on the masters served within the finer rooms?

At the center of this group is the singular Corinthian *oecus* with its tholos courtyard, one of two extant examples of a style of room Vitruvius commends. Beside it

in the room that is actually central to the entire group is a megalographic decoration that would certainly be celebrated if fully extant. Before a view of a recessed courtyard screened by curtains two massive sea-centaurs, bearded and carrying rudders serve as the supports for projecting ressauts.[172] They appear to provide a ceremonial entrance to the courtyard in a context more elaborate than that which housed the rostra earlier seen as a motif in the Insula Occidentalis, but once more reminding us how Pompey had displayed these items as trophies in his *vestibulum* (*Phil.* 2.68). Whether or not the decoration inherently carries a symbolism of victory, we must certainly consider the Casa del Labirinto as the sort of Pompeian townhouse connected with the life of a politically consequential citizen.

Looking outside the city gates to the Villa dei Misteri we find a house, the socioeconomic and architectural history of which have remained controversial. Interest in the house has centered about the so-called Room of the Mysteries painted with life-sized figures most often considered as enacting some manner of ritual. Although its particular collocation of figures is unique, two contemporaneous parallels to its depiction of large scale human presences argue for the likehood of a period fashion.[173] Also the Julio-Claudian statuary found in the house has had much influence on its interpretation. Maiuri's complex history has traced the house from a simple core of early rooms to an expansive late Republican and Augustan rebuilding as a luxury villa. In its final stage, as he sees it, the villa had fallen on hard times and was vulgarized by agricultural production. This paradigm of interpretation, which is typical of Maiuri's evaluation of the condition of most Pompeian houses after the earthquake,[174] is at variance with almost everything we know about the Villa dei Misteri and about Pompeian history as well.

We may look again at the plan of the house, in which L. Richardson has perceived the design of the Vitruvian country house whose principal entrance leads into a working peristyle.[175] That such plans go back to the period of Republican villa building and also do not preclude luxurious accommodations is corroborated by the Villa dei Papiri.[176] Thus the villa may be considered as a productive property from its origins, built as the appropriately elegant residential seat of a prosperous family. That this family was the local Istacidii whose descendants or freedmen still possessed the villa in A.D. 79, is very plausible. As Sabellan notables they would seem to have found themselves outside public life just after Roman colonization, but N. Istacidius Cilix advances to the duovirate and donates a "seating wedge" in the amphitheater during the Augustan period. Cas-

trén has plausibly connected this benefactor with the Istacidia Ruffilla, priestess of Livia-Ceres, whose image was found within the house[177]; it is not unlikely that a massive campaign of Julio-Claudian cultivation had attended the family's return to political consequence. The unaltered state of decoration in several rooms may be owing to continuous family ownership of the house, a condition that might also seem to be argued by the preservation of sculpture from the Augustan period. At approximately this period, or at least during the period that we term Pompeian Third Style, a restructuring on the seaward side divided the grandiose L-shaped room at its Northwest corner into a pair of smaller *camerae*, painting over their one-time illusionistic megalography with solid (and mediocre) Third Style panels (Figure 62). Richardson proposes that the alteration took place because the experimental design of the L-shaped room proved unworkable as an accommodation for dining.[178] What remains now of original painting above the curve of a vaulted ceiling is a *fastigium* quite similar to that within the courtyard flanked by sea-centaurs in the Casa del Labirinto. Clearly this illusionistic, open-wall decoration will have marked its unusually configured space as the most grandiose room within a decorative program that employed open wall prospects sparingly.

More certainly the villa at Boscoreale was in the hands of a freedman, P. Fannius Synistor, during its final period. The name of this owner is inscribed on agricultural implements and there is also a verse inscribed to him. A bronze stamp, however, gives us L. Herennius Florus, an aristocratic owner. The large number of owners makes it an instructive example of the tendency of Campanian property to change hands.[179] Lehmann's argument that it was the property of an absentee owner is based on her conviction that the quality of the wall paintings was too fine to have been commissioned by a local farmer.[180] It is a genuinely rural villa, located in close proximity to others of a similar kind. To date it is the most elegant in its neighborhood; its megalographic paintings might even be considered pretentious. Its partial condition and unorthodox plan make interpretation difficult.

Finally the history of the Villa Oplontis remains still tantalizingly incomplete. While the excavators like to assign the later ownership of the property to Poppaea Sabina, this attribution scarcely affects the earlier history of the house.[181] Bronze stamps with the names of two possible owners have been found – one within the house itself, the other at the large factory villa close by.[182] The presence of a working peristyle in the early stages of habitation seems clear, whereas the extensive bath quarters, the excavation of which is still unfinished, would seem to be a latter-day addition to the house. They lack

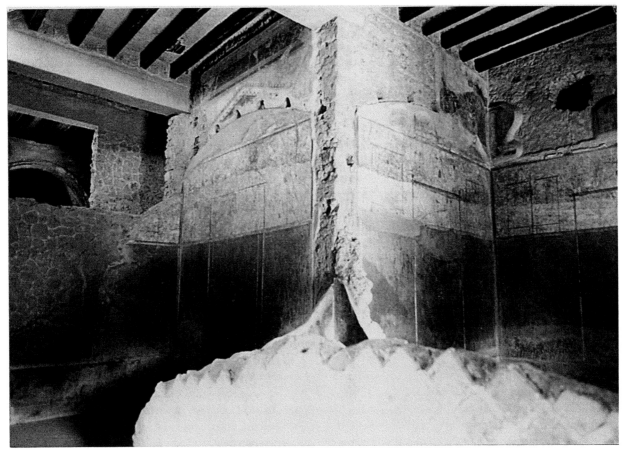

62. Villa dei Misteri, redecorated Second Style L-shaped room at the northwest corner of the platform. Author's photograph (su concessione del Ministero per i Beni e le Attività Culturali).

the close architectural ties that we see in the Villa dei Papiri. The collection of more than forty-four sculptures found in house and garden, ranging from four male and female Centaurs to the widely distributed Aphrodite of the Sandal, appears more eclectic than that in the Villa of the Papyri if we can use this criterion to distinguish between the thematic or ideological and the purely decorative.[183] All the same we must understand the symmetrical plan of the main block of the villa, including its elegant exterior colonnades, as belonging to the original structure. Such ample accommodations suggest the builder's importance and active engagement in local society.

Local society is the context because no evidence has been discovered that any one of these well-decorated Second Style villas belongs to a member of the Roman aristocracy.[184] Rather they would seem to have been the residences of members of a local gentry whose tightly structured society, just as the organization of their magistracies, was a miniature of Roman upper-class society. It would also seem significant the *porticus* style that is common to these villas does not appear in any of the ex-

cavated houses in Rome. Repetitions of pattern and design make the work appear to be the product of a single workshop. The traditional practice of dating individual rooms in accordance with the degree of openness occurring in their paintings can be questioned with reference to principles of decorum. Large rooms featuring broad, open vistas are the appropriate context for the deployment of megalographic compositions. All four of the houses do possess such a range of rooms, even the Villa of the Mysteries whose extant walls are covered primarily with paneled incrustation designs. The hierarchic distribution of the entire program of the house would appear more clearly had the owners not effaced the decoration of the L-shaped room at the North west corner of the house whose surviving traces imply the existence of an architectural megalography comparable to the showpieces of contemporaneous houses (Figure 62).

As I have suggested, the placement of designs was probably determined in the main part by conditions of seasonal exposure, but proprietors must surely have exercised some independence in selecting motifs and themes for their rooms. The repetition from house

to house of such elements as the tholos or jeweled columns in diverse combinations suggests their choices were made from a vocabulary of standard components that the painters combined according to request or volition. In each situation a master workman must have determined the lineaments of the composition, which his coadjutants proceeded to execute. Phyllis Lehmann's analysis of the execution of the Boscoreale *cubiculum* conjectures the work of three painters: a master artist who painted each segment of the design once and two assistants with discernibly differing characteristics.[185] Consequently we may see that brush technique is not in itself sufficient ground for making definitive distinctions among workshops, although these can be differentiated by their methods of handling shadows and highlights. Whereas some groups work by the superimposition of colored highlights to create effects of depth and sculptural dimension, others secure these results through the use of cross-hatching and single lines. On a similarly visual basis we may consider that certain kinds of designs are products of particular workshops.

Although it is possible that our Campanian workshop did evolve and develop over a period of some years, it remains more profitable to consider its productions synchronically. A useful principle is the relationship of the design motif to its contextual space. Although both von Blanckenhagen and Barbet have commented on this matter, it can still be invoked more precisely than they have done to give insight into the principles of design selection. In the two large salons at Oplontis the architectural constructions are painted on a scale proportionally adapted to the size of the rooms.[186] One exception is the tholos in Sala 14 that has been squeezed into a space at once too shallow and too narrow to contain it so that it gives the impression of floating awkwardly at an undefined location. A different kind of crowding appears in the double-alcove room where the entire syzygia on the rear wall appears to have been shrunken into an ill-fitting space. The concept of the room as an open balcony is unusual and consistently executed, yet it is completed by the adoption of a design element inappropriate to an area of its size.

The same concept may explain the thematic multiplicity of the famous Boscoreale *cubiculum* that Beyen seized upon as a replica of theatrical designs in Vitruvius' three categories of comic, tragic, and satiric scenes. Lehmann to the contrary attempted to harmonize and integrate these under the title of villa scenes, yet her persuasive and extensively researched identifications of many single objects and structures does not disguise the fact that the antechamber and alcove juxtapose inharmonious and even incongruous designs. The series of vistas combined here opens too many contradictory perspectives to convey that impression of architectural continuity that overrides minor illogicalities within the Oplontis rooms. Particularly jarring is the abrupt spatial transition from the solid wall framing the tholos in the alcove to the complex of porches and balconies forming the symmetrical wings of the antechamber ensemble. In fact this same balcony segment appears to greater advantage in the Corinthian oecus of the Casa del Labirinto, where, perceived through the interstices of the interior colonnade, it occupies the entire back wall.[187] This duplication, especially, betrays the formulaic nature of our decorative components and raises a suspicion that the conspicuously overcrowded exuberance of the Boscoreale *cubiculum* owes to the owner's indiscriminate craving to possess all his options in one place. Thus, by a series of steps, the regal posturing of the plutocratic L. Licinius Lucullus found its way into the fabric of Roman municipal life.

The Model of the *Scaenae Frons*

O NE LATE REPUBLICAN ROOM IN THE VILLA OPLONTIS DIFFERS significantly in the architectonic structuring of its decoration from the *porticus* rooms examined in Chapter 2 (Figure 63).[1] This corner room faces the peristyle on the west side of the house. Its broad doorway opens the entrance wall toward the ambulacrum for the greater part of its length. A black dado surrounding the room unifies the space and provides a deep shelf for the complex structures of the central zone. The two facing walls are symmetrically decorated with arrangements of columns, screen walls, and entablatures, including projecting porches that stand out against a solidly paneled background. Centered within the rear wall is an elaborately gabled porch with a pediment supported on sturdy columns with square bosses. Ressauts stand on either side of this structure before screen walls, the ends terminating symmetrically in double doorways each with one panel open. Above the central doorway is a large theatrical mask in an alcove niche flanked by pinakes. Open spaces between the screen walls and entablatures show the full prospect of a receding colonnade, with blue sky above it. But the blocking of the central aperture diminishes the visual importance of the colonnade, giving greater prominence to the foreground structure as it joins with the closed architecture of the side walls.

This composition can be compared with another located within one room of a complex on the Palatine Hill now commonly accepted as being

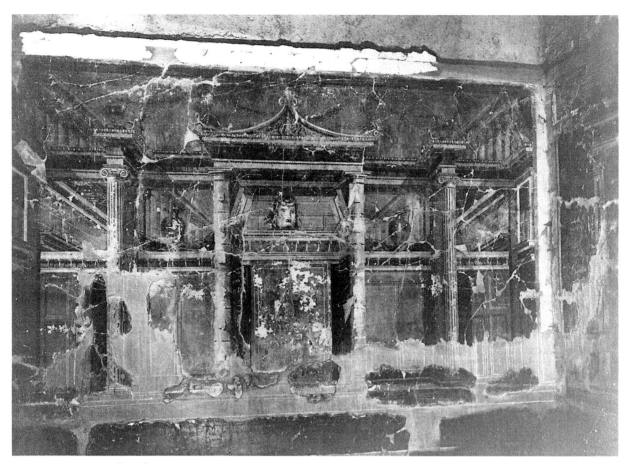

63. Villa Oplontis, Room 23. Pompeian superintendency D 108471.1973 (su concessione del Ministero per i Beni e le Attività Culturali).

the House of Augustus. The room was named the Sala dei Mascheri (Room of the Masks) by Carettoni, its excavator (Figure 64).[2] Here we see that the central zone on each of the four walls stands above a two-stage podium and is symmetrically structured around a gabled *aedicula* with a projecting porch and flanking screen walls. Beyond this, however, the compositions of the short and long walls differ. While the architectural structures on the two shorter sides terminate in projecting ressaults at the ends of their screen walls, the structures on the longer sides continue into half pediments above open doors. This variation indicates that the decorators have adapted a standard pattern to areas of variant size. Above this structure the closed background surface is formed into an arrangement of receding niches with coffered ceilings as if the fabric of doorways and architraves were itself encased within a slightly larger confinement of space. This background differs conspicuously from that of the Oplontis wall with its open prospects of blue sky behind a receding interior colonnade. Other details of workmanship and material also differ significantly; nonetheless, comparisons

between the two compositions show their fundamental similarity in the symmetrical disposition of their three framed doorways. With this recognition one must also admit a conspicuous difference from the less formally regulated garden architecture of the *porticus* style, which indicates that a different model is to be understood as the imitative point of reference for the designs.

The model for these compositions is unquestionably the tripartite architectural structure, called the *scaenae frons*, that provided the background for performances on the Roman theatrical stage.[3] That such structures were deliberately incorporated into domestic wall painting is attested by a Vitruvian passage (*De Arch.*7.5.2) that mentions the *scaenae frons* as a pictorial motif sometimes employed in open rooms, such as exedrae, and popular during the period just preceding the time when he wrote, a specification that coordinates with the dates that are otherwise to be assigned to these paintings. In his chapter treating the architecture of theatres, Vitruvius prescribes that the *scaenae frons* should have three doors (5.6.8). A double-leaved door at the center, the "royal door" ought to be decorated in a manner

94

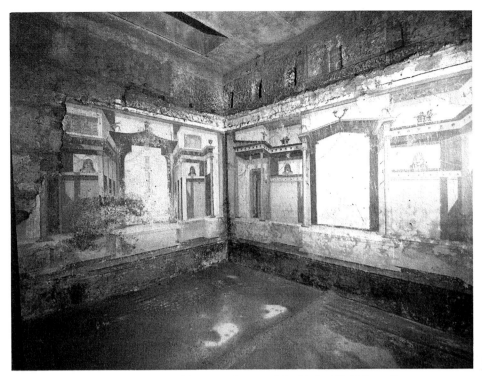

64. Rome, House of Augustus, Room of the Masks. ICCD E47768.

befitting a palace; the side doors are those of the guest chambers. Remains of Roman stages, not only at Pompeii but universally throughout the Mediterranean world, show these three doors as a standard feature, as do also a number of relief plaques depicting the performance of plays on the stage (Figure 65).[4]

Once the general lineaments of the pattern have been recognized, it is not difficult to identify its occurrence amid variations or modifications of form. Two examples contemporary with the paintings first examined show the central *aedicula* within a double-storied construction. One of these, the Sala dei Prospettivi, is again located in the House of Augustus in a vaulted room fronting on the peristyle (Figure 66).[5] Somewhat loftier in height than the chambers at the back of the house, this accommodates as its central *aedicula* a two-tiered structure whose lower story resembles that of the Room of the Masks, but whose upper story includes a perspective of greater depth. Colonnaded balconies set above the lateral wings project to an indefinite terminus and open to the right and left sides a view of upper stories and rooftops. Both the center and the side panels include human figures.[6]

Architecture resembling that of this gabled two-story structure appears within a small enclosure forming part of a suite of interconnected rooms on the lower floor of the Casa del Criptoportico in Pompeii (Figure 67).[7] We perceive the structural similarity beneath a load of

ornament that is more elaborate than that of the Roman example. More extensive files of columns project toward the foreground space, but also are seen through the apertures receding to surround an exterior courtyard space. The interior columns have Corinthian capitals, while those in the two levels of the courtyard are Doric. The dense ornamentation of this architecture constitutes in itself a virtual museum with large Atlantides supporting the central gables; sphinxes, sea-tritons, and griffins standing as acroteria, and life-sized statues filling the niches at either side. From a sculpted base at the center of the second-story balcony rises a golden tripod with winged nikes, a trophy of choragic victory. Such furnishings contrast with the light, slender columns and sparely decorated architraves in the House of Augustus.[8]

A comparable difference of material sets apart the two single-story representations of the stage that I earlier mentioned. The paintings in the Villa Oplontis manifest luxuries of material and workmanship on a plane with those displayed in other rooms of the house. The columns and doorframes simulate crisply carved giallo antico. The Ionic capitals contain small gems within their scrolls. The acroteria are gilded.[9] By contrast the materials from which the architectural constructions in the House of Augustus are made have the flat look of painted wood,[10] and the acroteria, brackets, and other components of the decoration are rendered with brush strokes too sketchy to indicate clearly what their

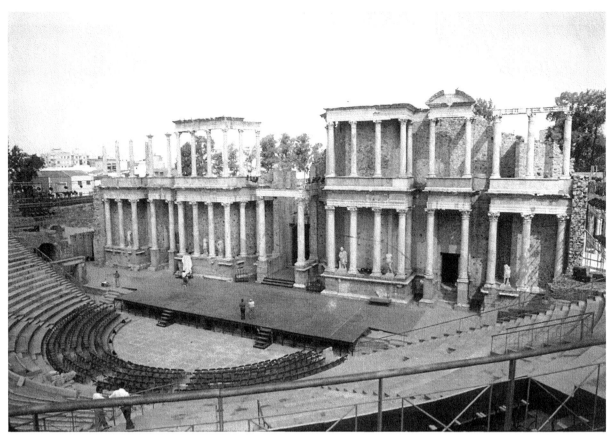

65. Merida, Spain, Roman theatre stage with triple doors and statues. Photograph by Author.

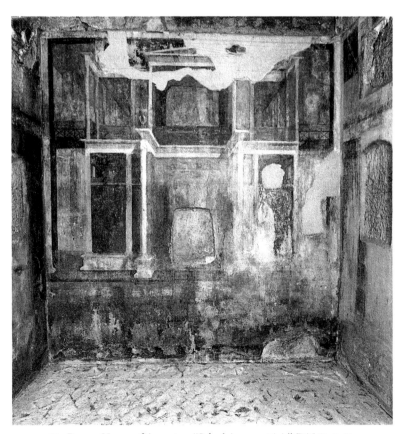

66. Rome, House of Augustus, "Sala dei prospettivi." DAI 82.2180.

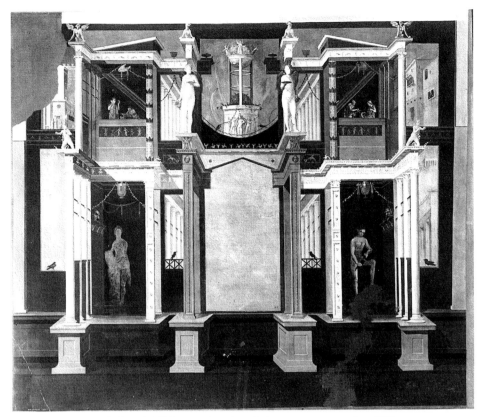

67. Pompeii, Casa del Criptoportico, theatrical room, reconstruction. DAI 54.1017.

substance should be. Instead the emphasis would seem to be on the symbolic import of such figures as swans and cornucopias – elements of the personal symbolism of success that Augustus was coming to appropriate.[11] The differences of materials further indicate that the degree of elaboration or opulence exhibited by individual manifestations of the stage-front pattern is not intrinsic to the form itself, but is instead a variable contingent on the patron's choice or the workshop's individual style.

These four rooms, to the best of our knowledge, comprise the first examples of this symmetrical, triple-doorway structure in the repertoire of Roman wall painting, but they are scarcely the last. Although the popularity of the pattern is strongest during the late Republic and early Augustan period, some version of it appears in each of the traditional categories of period style. The entire repertoire exhibits a considerable range of variations in scale and in ornamentation with examples seen in several locations within the structural divisions of the wall. One room, which is also in the House of Augustus, shows the pattern moved upward to occupy the frieze zone of a paneled antechamber (Figure 68).[12] Some fifty years later in the Pompeian decoration of the House of M. Lucretius Fronto, the style of which shows characteristics of the later Julio-Claudian period, we

see a similar structure occurring once again in a frieze zone (Figure 69),[13] while certain decorations of the Neronian or Flavian period show us once again stages taking over the center of the wall. A limited number of examples incorporate full stages with representations of dramatic action in progress; others show stages without actors but populated with statues, the one class of figures often hard to distinguish from the other. A third form of representation, although it does not include full and continuous stages, incorporates such features as doorways and columns into otherwise nontheatrical settings.[14] The consistency and range of dissemination indicate that theatrical backgrounds were a widely recognized pattern employed by a number of different workshops.

The idea of decorating a room for sociable use with a stage replica may sound even more foreign to our contemporary imagination than the creation of an illusionistic peristyle. Without Vitruvius' written testimony the resemblance, even if recognizable, might conceivably have seemed no more than accidental. Such is the strength of textual evidence in interpreting antiquity. Paradoxically this most useful aspect of Vitruvius' remark, his verification of the *scaenae frons* pattern as a deliberately representational species of decoration, is

97

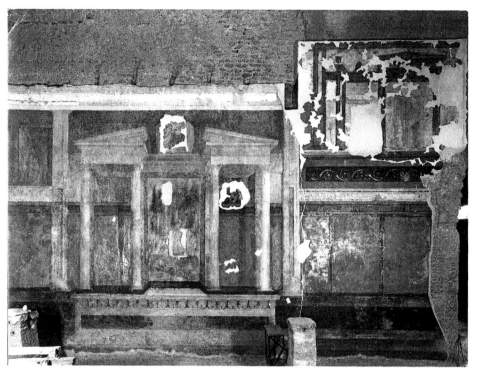

68. Palatine, House of Augustus, tetrastyle *oecus* with *scaenae frons* decoration in the frieze zone. DAI 82.2171.

also the item that has rendered his testimony no less controversial than informative within the history of scholarship. Controversy follows from the architect's not having supplemented his identification with comments on the rationale of the design. Because the controversy haunts most discussions of the subject, it is useful, as a preliminary to further examination of the paintings, to consider some of the questions scholars have raised concerning the way in which their particular object of imitation is related to Roman custom and culture.

First one must realize that the preeminence of stage-front paintings is a relatively recent discovery in Pompeian studies. Its scholarly history is closely linked with the history of excavation and the makeup of the known repertoire. At the end of the nineteenth century, when only a very few excavated houses actually belonged within the Second Style category, examples that might corroborate Vitruvius' testimony to late Republican fondness for *scaenae frons* paintings remained virtually unknown. Therefore Mau, when touching on the subject in a typological survey of the Second Style, speculates that stage-front paintings will have occupied an entire wall and been presented complete with dramatic action in progress. No such illustrations having come to light, he concludes that they may have been rather infrequent,[15] and this opinion seemingly clouded his

notice of a theatrical model underlying decorations later than the Second Style, but an architect of contemporaneous date, G. von Cube identified the pattern in a number of Neronian and Flavian examples.[16]

The first scholar to demonstrate the chronological persistence of *scaenae frons* decoration by linking Vitruvius' comments with examples of Republican painting was H. G. Beyen, whose ideas were prompted by the intervening discovery of the Boscoreale rooms with their simulated architecture and theatrical masks (Figure 56).[17] Indeed it was the masks rather than the architecture that caught his eye and inspired his theatrical interpretation. To explain the presence of these features he turned to that passage of the *de Architectura* that speaks of decorating exedrae in the comic, tragic, and satiric modes (7.5.2), and he glossed this passage with another from Vitruvius' chapters on stage construction (5.5.9) that specified the types of ornamentation appropriate to these three dramatic genres.[18] His adherence to the notion, then almost universally accepted, of the non-Roman sources of wall painting led him to treat the designs as a replication of Hellenistic stage decorations, directly imported from the Greek world. On this basis Beyen proceeded to create a context for the images of the Boscoreale *cubiculum* within a comprehensive history of pictorial styles based upon their derivation from dramatic scenery.

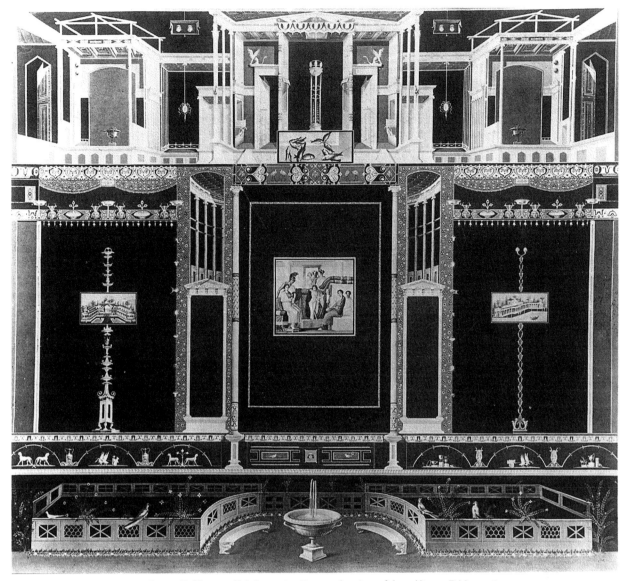

69. Pompeii. House of M. Lucretius Fronto, drawing of the *tablinum*. DAI 39.158.

Beyen did not propose that theatrical designs had been suddenly interpolated into the repertoire of Roman decorations, but envisioned them as forming the final stage in a gradual progress toward opening the visual surface of the wall, a progress he traced through a series of developmental phases. Thus he opined that a composition with a partial aperture, such as the tholos wall in *cubiculum* 8 of the Villa dei Misteri should antedate such fully open prospects as we see at Boscoreale and the Casa del Labirinto. Conversely, he regarded compositions with open centers but fully closed sides as signs of retrenchment leading to eventual restoration of the fully closed wall. This chronology had the capacity to encompass virtually every constituent architectural or decorative element that Pompeian painting could offer.

Not only did it integrate Boscoreale into a progressive series comprising all the previously known examples of Second Style decoration in the Villa dei Misteri and Casa del Labirinto, but it also incorporated a proleptic grasp of its Third and Fourth Style embodiments. In effect Beyen argued for the explicit derivation of all Roman painting from the Hellenistic stage model.

So strong has the influence of this theory been that virtually all succeeding interpretations have been defined either in agreement with it,[19] or in opposition,[20] yet both positions are extreme, and criticisms directed at the weakest point of Beyen's argument – his comprehensive applications – are counterproductive if they refute it completely.[21] As the correspondences between the Palatine decoration and that of Oplontis confirm,

the tripartite stage-front was a basic pattern known and employed by a number of workshops. All the same, it was not universal but only one among several possible formulations within a repertoire of imitative designs. Beneath the ornamentation that individualizes separate examples, the mark that gives particular coherence to the general class of stage-front decoration is the architectural unity of its three doorways so clearly visible in the Oplontis and Palatine examples. Because this pattern appears in Rome as well as Campania, we may conclude that it was actually better known and more widely employed than the Second Style *porticus* pattern.[22]

This clarification makes it possible to understand the sense of Vitruvius' three categories as indicating that different programs of ornamentation, rather than a fundamentally different architecture, set apart the tragic, comic, and scenic genres. Some decorations, like the double-tiered constructions in the Casa del Criptoportico or House of Augustus, may suggest the houses and balconies of the comic style and others the regal trappings of tragedy, but there are no known examples of the trees, caverns, and mountains said to constitute the ornamentation for satyr drama.[23] In what form these might have existed or whether they were ever transplanted into the Roman theatre, not to mention domestic decoration, are questions that existing evidence cannot answer.

As to Beyen's general argument for Greek derivation, it is important to distinguish between a mere copying of Hellenistic designs, and an adaptation of theatrical patterns to the institutions of Roman life. In so far as Greek theatrical production antedated Roman, the entire concept of theatre design and stage buildings owed much to this precedent, but this derivation scarcely prevented its mutation into forms whose meaning and function were products of the culture in which they participated. For instance, the simulation of wooden stage decorations deserves notice because many Roman theatres were built of wood.[24] Accordingly further inquiry into the significance of theatrical design in Roman painting requires further consideration of the theatre as an institution of Roman society.[25]

As will be seen in the course of this chapter, Roman stage decoration, as literary accounts have represented it, was indeed eclectic and certainly increased in complexity over the course of time. Consideration of real-life models underlying these decorations highlights many points of intersection with other institutions of the Roman aristocratic life that served the purpose of status display and that tended to enlist the same species of luxury objects and forms. Thus statuary, as the literary sources confirm, was prominent both on stage and in peristyles, while a monument such as the tholos

that functions chamelionlike in diverse contexts with so many diverse meanings was readily preempted by the constructions of the stage. In such areas the details of stage decorations manifestly overlap with those of the porticus style.

Finally, the various questions to be posed about the origin, dissemination, and recurrence of stage-front representations may be distilled into one large semantic question. Does the representational content of these paintings aim to communicate any manner of thematic or ideological significance, or do they constitute a mere decorative fashion whose popularity is best explained on stylistic grounds? If ideology is involved, we will want to ask further: Is the stage-front design the product of a particular period or the message carrier for any specific ideology?

In this chapter, I demonstrate that the domestic *scaenae frons* pattern does reflect ideology, but in a manner more appropriately viewed as social rather than specifically political. Whereas its immediate significance contributes to rituals of hospitality that have a bearing on both public and private life, its origins are deeply rooted in Roman culture. Its messages concern the distribution of power within varied segments of society. Naturally the course of Roman political and social history sees the negotiations of presentation and spectatorship controlled in different manners and with different balances of power at different times.[26] Thus its mutations trace an interesting history in the shifting of power. From this standpoint I look at differences in form and deployment characterizing stage decorations of three political-historical periods. These involve all the personages connected with the theatre: spectators to watch, actors to perform, and sponsors to foot the cost. Forming backgrounds for social negotiation, domestic stages provide the opportunity for encoding some of those negotiations of power that the real theatre represents – the presentational role in interaction with that of the spectator and the function of the giver vs. that of the beneficiary.

ROMAN THEATRES AND THEATRE DECORATION

From early times the control of theatrical spectacle in Rome rests in the hands of the aristocracy as an instrument of status assertion. Public games, which came to include *ludi scaenici* (i.e., staged plays) are the gift of magistrates on certain festival days. Unlike Athens, where dramatic performances were concentrated within one annual festival of Dionysus, Roman festivals spread themselves over the entire calendar in connection with several divinities. Many of these festivals had been

instituted at times of state crisis, both natural and military, to placate angered gods. Provisions for annual celebration were incorporated into the Roman political system. Two regularly elected city magistrates, the urban praetor and the curule aedile, carried as fixed duties the arrangement of certain festivals into which theatrical performances were ritually incorporated. Far from shirking the expenses of public entertainment, potential benefactors took it up eagerly.[27] Popularity gained through the provision of games was vital to a political career. The magistrate selected the plays to be performed; he was present in person to preside over the games, and he set his stamp on them.

To consider briefly this form of patronage as background, we should understand the development of staged plays and the creation of physical theatres within a tradition of performance rituals each of which constitutes a separate contributory strain of Roman theatrical culture. The traditions underlying the rituals are much older than their theatrical housing, reaching backward almost to the beginnings of the city itself. Recent reevaluation of certain items of literary evidence that scholars have long taken for granted places particular emphasis on aristocratic participation in spectacle.[28] Passages in Cicero's civic philosophy and his rhetorical writings refer to King Numa as the musical founder of the city through his establishment of religious banquets, dancing, and choral songs (*Tusc.* 4.3; *Or.* 3.197; *Leg* 2.22). These rituals extended to the larger populace the opportunity for engagement in the preservation of communal memory through songs that belonged to the elite classes who performed virtually all their activities on behalf of the city.[29] Although the specific details remain merely conjectural, the importance of the Salic dances points to one fact of Roman entertainment spectacles that must be emphasized: its intermixture of political significance with religious occasion. Beyond this it explains the cultural background that provided a framework for the ultimate reception of Greek plays and the elements merged into them by Roman playwrights.

At some point in Roman history there occurred a conversion of roles by which Roman aristocrats became no longer the dramatic performers of the city, but rather, in the manner of Greek liturgy payers, the presenters and sponsors of drama. The change was perhaps more gradual than sudden. Two well-known passages in Livy's *Histories* touch on this development. The first refers to the institution of the *Ludi Romani* in celebration of the compromise *concordia ordinum* with its revision of the magistrate structure initiated in 366 after severe class conflict. At this point, the historian notes (6.42.14), a special day was set aside on which the curule aediles

offered a *munus* to the people, willingly shouldering the expense of games that the plebeian aediles had refused to assume – all naturally in honor of the gods.

But a second notation by Livy a few years later attributes the introduction of *ludi scaenici* to a need for extreme measures to placate angered divinities (7.2.1–7). In a season of plague that neither human wisdom nor religious resources could alleviate, *ludi scaenici* were instituted. Musicians and players called *histriones* brought in from Etruria danced silently to music without song or gesture imitating song.[30] Their performances were a novelty to a warlike people who had previously witnessed their *spectacula* only in the Circus, but also they were novel to aristocratic youth who imitated the dancers, adding to the movements their own form of dialogic exchange which was, Livy declares, less crude than the Fescennines that had been their previous mode of verbal exchange. With an emphasis on what he considers progress, Livy sees these practices as leading toward the inauguration of the historical Roman theatre a century later when Livius Andronicus presented the first spectacle that involved an argumentum or plot at the *Ludi Romani* of 240 B.C. According to tradition Livius emanated from Tarentum, a city that cultivated a strong Greek tradition stemming directly from Athens. During the fourth century, the plays of Euripides were performed at Tarentum almost as soon as they had been introduced in Greece.

Livius' innovation is attributed to the period following the first Punic War. Certainly this period saw the establishment of major religious festivals that provided the official occasion for theatrical performances at Rome. The Ludi Apollinares in July were first celebrated as votive games on the advice of the Sibylline Books in 212 B.C., when Italy was oppressed by Hannibal, a "foreign plague," and were made permanent a few years later during a real plague. The *Megalensis,* celebrated in honor of Magna Mater in April, were also connected with the expulsion of Hannibal. *Ludi scaenici* became a permanent feature of these festivals of the gods and the number of days available for them continued to increase during the Roman Republic. The additions came about both by prolongation of the festival periods and by the institution of new festivals. The historian Lily Ross Taylor plausibly attributes the initial impetus for the prolongation of festivals to the good reception of plays written by Roman playwrights, especially comic plays.[31] She has counted an increase in the number of days given to *ludi scaenici* during the six major festivals to 43 in the early Empire, and the addition of dedicatory, votive or funeral games could provide even more days.[32] Victory games were celebrated by Sulla and also by Caesar and Pompey.

After Caesar's death, the *Ludi Romani* were extended for a day in his honor. By this time, of course, virtually all occasions for the performance of games were political rather than religious. A historian proposes that some 50 percent of Roman senators would have sponsored games at some point in their careers. This figure includes special games given to attract attention such as funeral games for prestigious kinsmen.[33] Theatrical performances were an area in which the will and interests of Roman magistrates and people were amicably coincident.

It was not only the living spectacle that the sponsoring magistrate funded as his euergistic *munus,* but the theatre itself. Unlike Greek cities where permanent stone theatres were the possession and property of the whole community, Rome had no permanent theatre building during most of the Republic. Rather *ludi scaenici* were performed on temporary structures erected for each holiday occasion. On account of their impermanent nature, the theatre and its stage were constructed of wood. The locations were traditional; the stages were built in the circus, in the Forum or near the temples of the gods being honored. For example, the well-known theatre temples of early Republican Latium clearly mark out the space where ritual performances, and perhaps other kinds of spectacle, could be staged.[34] Thus in contrast with Athenian liturgists who financed only the costs of the playwright's chorus and production, Roman aristocratic sponsors on each occasion created and decorated both theatre and stage. Although the Roman state treasury allotted a sum to defray some expenses of staging these games on behalf of the community, magistrates were free to supplement it and would appear increasingly to have done so with the progress of the Republic.[35] Consequently the offices that entailed theatrical donations as their responsibility, the curule aedileship and the urban praetorship, became virtually self-limiting to candidates who could bear the expense. Under these circumstances theatre flourished with an ever increasing number of productions and days for performance.

In view of such repeated expenses and especially with the increasing popularity of dramatic performances, one might ask why constructing a permanent state theatre was not considered a desirable economy measure. Just such a project is recorded during the mid–second century of the Republic. This was the era to which we may trace the building of stone theatres in several Italian towns, such as Pompeii.[36] The models therefore existed. Livy and other historians record that the censors of 154 B.C., Valerius Messala and Cassius Longinus, let out a contract for a stone theatre constructed at the back of the Palatine, close to the Lupercal.[37] The structure had come almost to completion when P. Cornelius Scipio

Nasica as consul intervened to over-rule the project. He tore down the theatre and insisted that its building materials should be sold at auction (V. Max. 2.4.2). He followed this with a *senatus consultum* that prohibited anyone to offer seats for spectators within a *milia passuum* (one mile) radius of Rome. Some scholars have taken this story literally as evidence for a Roman moral objection to the theatre. This explanation appears to be based on Saint Augustine's version of the episode (*CD.* 1.31), which attributes to Scipio a serious oration urging the Romans not to allow their manly habits to be invaded by Greek luxury. Such moralization, however, is only to be expected from Augustine's Christian critique of Rome's customs, and the explanation overlooks the fact that the new theatre had been endorsed by censors as the most powerful guardians of disciplinary codes. Such an implicit contradiction of attitudes weighs against a moral explanation. More recently scholars have inclined towards a political explanation, as proposed by Rumpf, who deduced from the provision against seating the Roman populace that the difficulty posed by the Greek affiliations of the theatre had nothing to do with the drama itself but rather stemmed from the availability of the theatre as a place for popular assembly. By this theory the democratic symbolism of a stone theatre will have been offensive to Nasica's optimate position.

This argument is certainly more Roman, but additional factors to be considered involve the combined economic and political implications of the move. As to Scipio's own interest, a clue appears in the *didascalia* of Plautus' *Pseudolus,* which records the inauguration of the Palatine Temple of Magna Mater in 191 as the occasion for the play. The dedicator was that year's consul, P. Cornelius Scipio Nasica, father to the consul of 154, a man who had been closely associated with the cult and its celebration since the symbolic stone representing Cybele arrived in the city from Asia in 204 (Livy *AUC.* 29.10; Ovid *Fasti* 4.37). On that occasion he had been chosen as the most upright young man of the city to receive the goddess. Conceivably, then, the location of the theatre by the Temple of Magna Mater, which would have given the state control over these festivities, offended Scipionic familial pride.

The building of a permanent theatre would greatly have reduced the expenses of games to magistrates and would probably have made it possible for the state itself to assume a firmer control over the patronage of games. In this sense we may consider Scipio's position restrictive. We are talking about a period when the cult of political personality was beginning to show its effects in Rome. By rejecting the easy possibility of staging plays in a permanent theatre, Scipio guarded the prerogatives

of the rich. He was clever enough to use public morality as his excuse.

Throughout the Republic the custom of temporary theatres persisted, ostensibly with that very effect of aristocratic self-assertion that Scipio defended because their elaborateness increased with the increase of Roman wealth. Reports of remarkable stage decorations have come down to us from the years just before Rome began to acquire permanent theatres. In his aedilician games of 99 B.C., Appius Claudius Pulcher won acclaim for painted sets whose realistically executed rooftops lured birds to perch on them (*NH.* 35.23). According to Valerius Maximus (2.4.6) he was the first patron to apply varied colors to the stage, but later magistrates vied in employing all manner of valuable materials and ornaments. C. Antonius is said to have covered the rear wall of his stage with silver, Petreius with gold, and Q. Lutatius Catulus with ivory (V. Max. 2.4.6). In 58 M. Aemilius Scaurus, as aedile, built the theatrical extravaganza of all time. His *scaenae frons* was in three stories (*NH.* 36.114), the first covered with marble, the second glass mosaic, and the third gilded wood. Three hundred sixty columns, with 3,000 bronze statues placed in their interstices, decorated this showpiece; the *apparatus* included embroidered tapestries (*Attalica veste*), painted tablets and other objects whose aggregate worth was assessed at 30 billion sesterces. Thus the theatrical *scaenae frons* became a part of the history of Roman luxuria.[38]

Against this background we can understand the political ramifications of Pompey's construction of a free-standing stone theatre during the fifties B.C. He inaugurated the theatre with a lavish spectacle during his second consulship in 55 B.C. and completed its dedication in 52 when he had been appointed sole consul with powers to preserve the state. With the triumviral alliance already worn thin, he could anticipate the certainty of Caesar's triumphant return from Gaul. With his theatre he might hope to consolidate his popularity of the moment into a more stable form of personal leadership that had never effectively succeeded by ordinary channels. His grandiose gesture was controversial precisely because it capitalized in an unorthodox way on the customs that made theatrical patronage a time-honored method of angling for political popularity.[39] In the first place it was not connected, as the earlier abortive attempt to build a stone theatre had been, with any traditional area of theatrical performance, but rather was erected in the Campus Martius. The legend is that he fabricated a religious excuse to silence the opposition, combining the building with a temple to his own personal deity Venus Victrix. Frézouls emphasizes the popular implication of the gesture by noting that senatorial suppression of *collegia* during this period would have entailed the cessation of the *Ludi Compitales,* festival performances akin to drama staged under regional sponsorship and carried great popular appeal.[40] Thus it would seem that the theatre attempted to capitalize on this deprivation by offering compensatory theatrical performances for the plebs.

Certainly it was in keeping with Pompey's competitive motivation that the theatre also constituted a monumental commemoration of military activity. His Eastern experience was emphasized when he claimed inspiration from the theatre at Mytilene (Plutarch *Pompey* 52.5).[41] The colonnade behind the cavea, one of Rome's first public display places for art, utilized the form of the Hellenistic gymnasium with an interior landscape of fountains trees and walks. Images of women dominated the sculptural collection, giving it perhaps that reputation as a place of erotic intrigue on which Ovid capitalized in *Ars Amatoria*.[42] Among these were the fourteen nations Pompey had subdued, but also Muses to vouch for his appreciation of art. Although Cicero, who attended the opening days of games, gave the performances uniformly a roasting, he also indicates how extravagant was their *apparatus,* which quite overwhelmed the spectacle: 600 mules in Clytaemestra and a collection of 300 craters in the *Trojan Horse* (*Fam.* 7.1). The theatre did in fact become the setting for demonstrations by the spectators in Pompey's favor. Its popular success was sufficiently impressive, as Gros has reminded us, that Caesar had it in mind to create a rival structure by the summit of the Mons Tarpeia (Suetonius *Julius* 44).[43] Yet even before this, in 52 B.C., C. Curio had taxed his ingenuity to outdo previous donors by a *maior insania* (greater folly) as Pliny called it (*NH.* 36.116.20): a pair of adjoining wooden theatres, balanced on pivots, that served a double purpose. Independently they accommodated the staging of simultaneous dramatic performances, then, revolving precariously, with some spectators even holding to their seats, they joined to form an amphitheater for gladiatorial spectacles. Was it such large-scale competition that those second-century magistrates who moved to create a state theatre out of the funds of the Roman treasury had been attempting to forestall?

Two more stone theatres followed that of Pompey in the Augustan period, a time that also saw increased theatre building in the Italian cities.[44] But even the establishment of permanent theatres under stable patronage did not spell the end of competition in providing stage decoration. Not only did permanent stages require decoration, but also the practice of building wooden theatres continued. During the saecular games of Augustus Latin plays were performed on a wooden stage built

near the Tiber,[45] while a temporary theatre that was built in the same way each year figures in Josephus' account of the assassination of Caligula.[46] Thus the importance of theatrical patronage in the life of Roman elites should be considered to have persisted after 52 B.C. This framework is important to the symbolic crossing over of theatrical design into the private sphere of Roman decoration.

STAGES IN DOMESTIC DECORATION

Accounts of temporary stages, constructed and ornamented in accordance with the magistrates' resources and taste furnish, I believe, the best explanation why Roman domestic painting appropriated the decorative syntax and vocabulary of the Roman public stage. Although the accoutrements may be called Greek insofar as a familiarity with Hellenistic culture characterizes the cultural display of upper-class Roman taste, they are more immediately Roman in their allusions to purposeful status display. While the wooden architectonic frameworks in the House of Augustus may advertize the *princeps'* adherence to simpler ways before the invasion of luxury, the stages in Campanian paintings exhibit some semblance of the material opulence to which written reports of stage decorations attest. In images such as the double-story stage in the Casa del Criptoportico (Figure 67), we see decorations that also suggest the way in which the theatre itself approximated an art gallery fitted out with statues and paintings in columniated frames. Such decorations suggest the general interchangeability of architecture and decoration between the public and private spheres.

Theatrical connections also best explain the presence of masks in many Pompeian architectonic designs; they allude to the enlivening of these stages by actual performances. Also the peristyle columns to be glimpsed behind the stage fronts can be referred to a model in actual practice. Pompey had enhanced his theatre with a *porticus* to which Vitruvius refers in advising that theatres should provide a colonnade behind their stages to shelter spectators in rainy weather and also facilitate stage machinery (5.9.1). Augustan theatres at Volterra, Ostia, Pompeii, and Mérida, among others, include such colonnades in their architectural plan. More generally this background might also explain why the theatrical style was more widely disseminated than the *porticus* style because it was less closely bound up with a particular area and more with a universal function of Roman political life. In Pompeii and other places where the existence of permanent theatres gave the magistrates no need to construct architectural shells for performance, they will nevertheless have assumed the responsibility

of trimming out the stage for their own *ludi scaenici*. Occasionally either stage or seating space might need rebuilding. The distinguished magistrate of the Augustan period, M. Holconius Rufus, whose career often followed in the footsteps of the *princeps*, gained honor for rebuilding the cavea and other parts of the large theatre.[47] Evidence for the recurrence of such efforts appears in a public notice posted during Pompeii's final years of games sponsored by the magistrate Cn. Alleius Nigidius Maius in connection with his dedication of *opus tabularium*.[48]

In spite of these many interassociations between political status and theatrical sponsorship we should hesitate to assume that domestic *scaenae frons* decorations intend an imagined translation of the domestic interior into the public sphere of the Roman theatre. Rather one must consider the general interpenetration of public and private life among the Roman aristocracy and thus the manner in which theatricality imbues not only staged dramas but also rituals shaping the conduct of private life. Painted theatrical imagery of the kind we see at Oplontis or on the Palatine underlines a metaphorical transference from public into private life of the upper class prerogative and *officium* of sponsoring games to serve as a bond of hospitality between host and guests.

The stages of Republican and Augustan decoration are constructions intruded into the spatial structure of the house. Their architecture is projecting rather than recessive. It does not aim at expanding the spatial boundaries of the room, but instead shows no reservations about crowding the spatial illusion, in which respect it differs notably from the sense of amplitude afforded by the *porticus* style. This effect, which scholars have noted in the abstract, deserves to be considered in interpretation. Because its own underlying model involves simulation, the stage front advances its image on a different plane of representation from the *porticus*. Claiming a position twice removed from reality, it extends an illusion of what is already, by its very nature, illusionistic. This twofold removal mirrors the way in which the form of the Roman theatre demarcated a world apart from the everyday.[49] We may consider once more the relationship of the Oplontis painting to its position at the corner of a peristyle. On the one side of the room a broad doorway opens on the space defined by ambulacrum and columns. The painted backdrop offers a similar prospect in the opposite direction so that the stage appears to have been built into the design of the house.

On at least one occasion in Roman history this actually happened, as we learn from fragment 2.70 of Sallust's *Histories* pertaining to the year 75 B.C., which

Coarelli has cited for its relevance to late Republican architecture.[50] The passage describes a triumphal banquet prepared by a Roman quaestor to honor the consular Q. Metellus Pius (cos. 80) when he returned to Spain to participate in the war against Sertorius. The house, as Sallust records, was "decked out in excess of the customs of Romans and even of mortals" with "statues and curtains and with stages built like those for the presentation of actors. . . . Once Metellus had taken his seat, an image of victory let down in a sling with a great creaking of machinery placed a crown on his head and incense was burned in the manner of a god." Metellus reclined wearing the toga picta. The feast was exquisite.

To Valerius Maximus, who describes this same theatrical banquet (8.1.5), it appears with hindsight as a landmark in the chronicles of luxury. He categorizes the overdressed occasion as an example of the way in which excessiveness enforces power. This view is in keeping with criticisms of the extravagant *scaenarum frontes* affected by late Republican magistrates and their tendency to preserve the occasion by bringing bits of their decorations home. It was probably not without symbolic import (added to good Roman economy) that the aedile Scaurus installed the largest of the 360 marble columns from his temporary theatrical decoration within his Palatine house.[51]

Although it might be a pleasant fantasy to postulate Metellus' banquet as one demonstrable source for the popular pattern of wall decoration that made its appearance only a few years later, it is more realistic to consider banquet and motifs interrelated within the context of ceremonial upper-class life. Even if the degree of elaborateness in this reception surpassed the norm, the interassociation between theatricality and hospitality had already taken root in the Roman world.

The association of communal dining or drinking with artistic performance is as old as any recorded tradition of antiquity. One may recall the various occasions in the *Odyssey* when a singer performs for participants in a festival meal, but Roman tradition became more formalized than the Greek. From Republic through Empire, there is abundant evidence for private domestic performance as a regular feature of aristocratic dinner entertainment.[52] Along with coverlets and gemmed cups, Plutarch (Lucullus 40.1) mentions choruses and dramatic presentations as features of Lucullan luxury. By contrast Sallust portrays the commander Marius as boasting that he does not dress up his banquets by hiring an actor or an expensive cook (*Jug.* 85.39). The contrast highlights controversy concerning Republican *mores,* yet the custom of convivial entertainment was certainly much older than either Marius or Lucullus, and rooted

in aristocratic traditions extending backward to the banquets of an earlier Republic.[53] Also it was not confined to the dinners of the very rich but became a general feature of hospitality. Reading was obviously the entertainment most commonly offered, but singing, dancing and mimes are well attested. Pliny (*Ep.* 1.15), when he reproves a correspondent for his failure to honor a dinner invitation, lists a range of high-culture performers he might have heard: "comic actors, or a reader, or a lyre-player, or all of these (such is my generosity)," but the renegade has opted for another host's rich food and dancers from Cadiz. The dignified old consular Spurinnus, whose style Pliny considers as a model of contemporary decorum, enlisted *comoedios* to alleviate the seriousness of his hospitality (3.1.9). Some households may have maintained acting groups among their *familiae.* Pliny mentions the troop maintained by Ummidia Quadritilla, a rich old lady of his time, but most likely for large displays such itinerant groups as the Campanian mime players led by Actius Anicetus, whose popularity Franklin has documented through graffiti, were brought in.[54] Most good households, however, will have kept one or two slaves well trained in reading aloud.

Not only literary, but also archeological evidence attests to the domestic staging of theatrical entertainment. In one notable case, the Casa degli Amorini Dorati, the rear floor of the peristyle is built up under a gabled *aedicula* in a manner suggesting that it could have served as a stage (Figure 70).[55] The occurrence of a number of theatrical reliefs relating to well-known plays among peristyle decorations suggests that this was actually the case.[56] Ordinarily, however, when a stage was needed, the open space of the peristyle corridor directly outside the dining room was probably used. Richardson has suggested that the double folding doors of the *cubiculum* 8 in the Villa dei Misteri served as "stage curtains" to open up the performance space in the peristyle after the meal.[57] The tripod salone in the Villa Oplontis also has such doors, while the opening of the *scaenae frons* room is also broad enough to afford the necessary area. In this context we can also explain the compositional scheme of a stage front standing before a colonnaded peristyle as an allusion to performances within the house itself.

At this point one might logically wonder why living figures engaged in performance are not more frequently shown in these decorations. The answer can be found indirectly, I think, by looking at two situations in which such figures do appear. Although the majority of Romano-Campanian stage decorations follow the general pattern I have been describing, recent excavations have uncovered two Pompeian variations on this concept, both located within the Insula Occidentalis

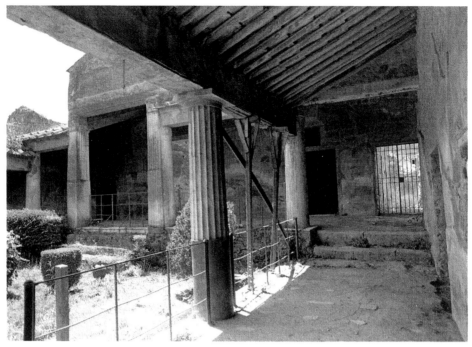

70. Pompeii, Casa degli Amorini Dorati, Region 6.16.7, stagelike podium in peristyle. Author's photograph (su concessione del Ministero per i Beni e le Attività Culturali).

(Region 6.17.41 and 7.16.22), the townhouse complex situated on the extreme edge of the slope facing the sea, whose origins, as I have noted in the previous chapter, may be attributed to the Sullan colonists who moved into the town after 80 B.C. Although these paintings are products of the Second Style period, their difference from previously known theatrical decorations of the same period is such as to reinforce our overall understanding of theatrical mimesis.

Both paintings represent actual human figures in performance. In the House of Fabius Rufus, a small and narrow space, more like an elongated niche than a chamber, houses the image of a woman peering through the double leaves of a central stage door (Figure 71).[58] An Eros mounted on her shoulder is touching her chin. Although she has been called Venus, she more likely to be an actress, probably a mimic actress, representing a human character impelled by passion about to make her entrance on stage. Her jeweled diadem identifies her as a royal figure, perhaps either Helen or Phaedra, while the rich decoration of the surrounding architecture suggests that it represents the "royal backdrop" placing the scene itself within the tragic repertoire. This architecture compresses the three doors that are the salient features of the *scaenae frons* to fit the narrow confines of the space by overlapping the two side doors with the projecting columns that support the pediment. The narrow spatial conformation might remind us of the elon-

gated chamber in which the double-storied *scaenae frons* in the House of Augustus is located, but the small enclosure that houses this Pompeian painting contains a singular and puzzling construction. Standing before the figured background, and apparently installed at a later date, is a blocking screen wall painted with a central *aedicula*, but lacking human figures. To all appearances this wall has been constructed with the deliberate purpose of concealing the dramatic representation without the irremediable act of destroying it. Did the owners lose patience with the actress who never acted?

Even more startling in subject matter and composition, the second example depicts two personnages, a poet and perhaps a philosopher, engaging in recitation (Figure 72, Color Plates IV and V).[59] Their figures are framed within shallow, exedralike niches standing before paneled screen walls. The poet's exedra has a half-domed apsidal ceiling and a circular bench on which rest both a lyre and round box containing book rolls. Perhaps the instrument indicates the kind of poetry he is reciting. The performer wears an ivy garland and a short bordered toga over his tunic to indicate the Roman topicality of the scene.[60] Similarities in the handling of architecture, color, and detail suggest that the same group responsible for the actress and stage door also painted these performance scenes.

These two scenes have a representational specificity that would seem to refer quite pointedly to the kinds

106

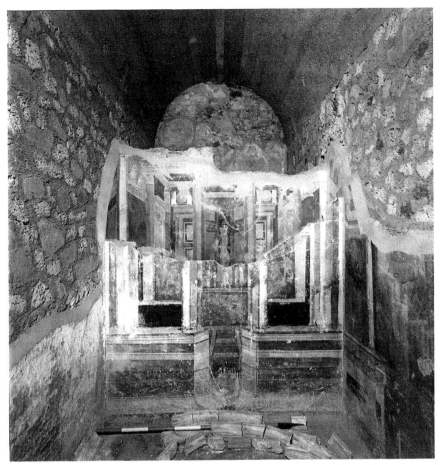

71. Pompeii, Insula Occidentalis, House of Fabius Rufus, Region 7.16.22, theatrical scene covered by later wall. ICCD N45226.

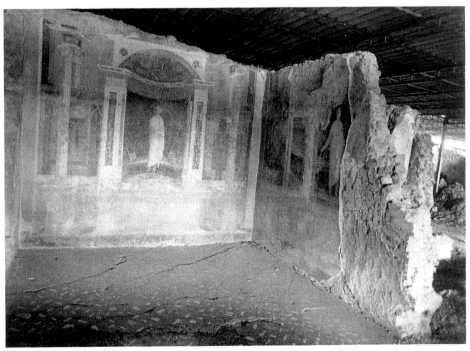

72. Pompeii, Insula Occidentalis, Region 6.17.41, poet reciting in an exedra. Author's photograph (su concessione del Ministero per i Beni e le Attività Culturali).

of entertainment staged in most houses: either mimes or recitations. Performances in these same categories also took place on the public stage. Looking at the poetic recitation we cannot reliably determine whether its elaborately composed and decorated frames mean to represent a construction within a private house, or the kind of stage decoration used when poets recited in auditoria like that of the small theatre or odeon at Pompeii.

The fact that such representations are not more common may tell us something about the Roman employment and significance of theatrical painting.[61] The small size of these two rooms makes one wonder whether they were indeed dining rooms or spaces intended for individual literary activity such as reading. In the case of the blocked stagedoor, an answer might be extrapolated from the location of the space that opens onto a corridor raised as if on a podium from which three steps lead downward into a capacious open chamber below (Figure 73). Possibly the space was indeed conceived as an actual backdrop for performances so that the overpainting was installed with the intention of creating a more neutral setting than the original *scaenae frons*. From this one may further speculate that such life-sized representations of actors (as opposed to statues trimming the stage) were not universally popular in spaces that might be used for dining because their static representations of activity would impinge on the realities of entertainment and also preempt the spectators' active contribution to the recreation of entertainment. Conversely the open backdrops provided by empty stages enforced the generally ceremonial quality of Roman upper-class social dining.

Finally one may consider the position conferred on diners within such surroundings. Sallust censures the Spanish extravaganza for Metellus (*Hist.* frg. 2.70), staged, as he alleges, with the actual foreknowledge and consent (*voluntate*) of the honoree, claiming that it "subtracted no small part from his esteem, especially among the older and more revered men who judged such pride to be unworthy of a Roman in possession of commanding power." Valerius Maximus presses the ethical implications of the event even further. Noting that these ceremonies were not staged in Greece or Asia but rather in a *horrida et bellicosa provincia* ("rough and warmongering province") where Sertorius had immobilized Roman battle lines, he asks with what disposition Metellus had seen Attalic tapestries covering the walls and *ludi* interposed into a sumptuous banquet. With what temper did he receive his golden crown? Given that Sallust's description probably figured among Valerius' sources, we can observe how these rhetorical questions interrogate the earlier narrative, interjecting their reminders of Roman discipline between Metellus and the drama

that is elevating him, as if to convert the central actor into a critical spectator. Not only does this indecorous spectacle offend by its luxury, it also erases the distinction between entertainment and participation. Doubtless Metellus thoroughly relished his participation, leaving Valerius' reader to enact the censorious spectator.

Additionally we may recall how Varro described the elaborate aviary in his villa at Casinum as a "bird-theatre" built up with steps and mutules affixed to the columns to furnish "bird-seats" (*DRR.* 3.5.14). The playful characterization foregrounds the speaker's provision of vicarious spectacle by means of description itself. As Appius, the interlocutor who solicits the description, observes, Varro has designed his garden *causa animi,* but Appius also regards it as an entry into the ongoing contemporary aristocratic competition in building. The comment brings out the sense of mutual understanding among the aristocratic participants of the dialogue. A lesser degree of mutual understanding appears in Horace's vicarious narrative of the *Cena Nasidieni* (*Satire* 2.8.53–5) in which a reference to a domestic furnishing that is also theatrical, the collapse of a dusty curtain into the serving platter that contains the evening's culinary piece de resistance, underscores the awkward anxiety of a host ambitiously striving to impress his social superiors as a provider of gastronomic delicacies. As related by Horace's satirical narrator the comic playwright Fundanius, the dinner itself becomes the *ludus,* playing out before Nasidienus' eyes a farcical drama he has not scripted. The unpredictable interactions of his contrary guests change his role from that of patron provider to discomforted spectator.[62] Only his loyal parasite remarks condolingly on the thankless role of the giver (65–6): "The glory you get never equals your effort." This satire, whose representation of social disequilibrium might be seen as a forerunner of the *Cena Trimalchionis,* reflects not uncritically a certain snobbery of taste practiced within the inner circles of the Augustan elite. In this situation, the guests take their departure before the expected end of the meal thus aborting the host's opportunity to entertain them in any prearranged style.

As an ultimate point of reference for these mimetic stage decorations one should think of the generally theatrical flair with which the Romans staged not only their hospitable entertainments, but also ceremonies of all kinds. Roman aristocrats of the Republic did not perform in theatres; strict prohibitions forbade the appearance of the senatorial class on the stage.[63] Even to compare an aristocrat with an actor was a recognized form of insult.[64] Although the prejudice against acting may infer an elitist distinction between commanding

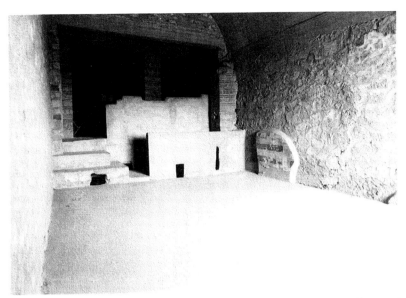

73. Pompeii, Insula Occidentalis, House of Fabius Rufus, space opposite theatrical scene. Author's photograph (su concessione del Ministero per i Beni e le Attività Culturali).

and performing, it also recognizes the influential power of performance. As Catherine Edwards observes in a recent essay, Roman attitudes toward actors and theatre reveal divided sentiments in characterizing as despicable what obviously was also glamorous.[65]

In fact Roman nobles had ceremonies of their own caste in which to perform. Although taking the actors' part was considered unworthy of their *dignitas,* no prohibitions were attached to pageantry, which made the aristocratic life into a constant participation in public show. Ritual ceremonies attended many steps of the *cursus honorum* such as election and lot casting; sacrifice was also a highly showy occasion. Most dramatic of all was oratorical performance, which demanded, as its practitioners were not ashamed to remark, the force and presence of a master actor (Cicero *de Orat.* 1.128–30).[66] That orators kept the real stage in mind is even more explicitly attested in *de Oratore* 3.59.220, where Crassus, speaking about delivery, instructs his hearers that the vocal tones they employ to play on the emotional susceptibilities of their audiences should resemble those of the stage, while the gestures are to be those of the parade ground and palaestra.[67] Oftentimes in his own voice Cicero mentions the two famous actors whom he numbered among his friends: Aesopus and Roscius Gallus, the first of whom instructed him in elocution. Indeed one may think that the aristocratic code would not have considered the actor's role so compromising, were Romans not in considerable awe of its power. That the teaching of rhetoric in Rome was also looked on with suspicion at a critical period in the Republic seems not irrelevant.

The analogies Cicero perceived between acting and his own rhetorical performance extended also to his activities as a magistrate. As early as his prosecution of C. Verres, he had employed stage performance as a metaphor for the self-consciousness of the responsible public official under public gaze. As quaestor in Sicily, he declares, he had seen himself acting as if within a theatre of the entire world (*Ver.* 2.5.36: "quasi in aliquo terrarum orbis theatro versari existamarem"), and he goes on with the voice of aedile-elect to anticipate the "supreme care and ceremonialism" with which he will officiate at the festivals of the gods and oversee the integrity of the Roman city's shrines. Especially the events of the mid-fifties caused him to think in theatrical terms. In soliciting an historical monograph on his consulship from Lucceius (*Fam.* 5.7), he adds plot to performance as he refers to its vicissitudes as a drama, a *fabula,* whose *actus* embody stunning reversals of fortune to hold the reader in awe. In a contemporaneous speech (*Pro Sestio* 56.119–25) he brings Aesopus on stage through a kind of narrative *prosopopoeia* to reenact a performance that had figured instrumentally in the politics of his recall, rehearsing through a set of quotations from Accius' plays how the actor had elicited the sympathy of the Roman populace for his case. Writing at around the same time to his brother Quintus concerning the performance of his propraetorian administration in Gaul, he echoes his own earlier metaphor of *Verrines* 2.5. With the self-consciousness of Pseudolus managing a production, Cicero urges him to emulate good poets and industrious actors in making the third year of his office into a climactic third act (*Q. fr.* 1.1: *perfectissimus et*

ornatissumus). Precisely this kind of Roman self-consciousness may appear to be reflected by the employment of the theatrical *scaenae frons* in domestic decoration. Forming backgrounds for social negotiation, domestic stages provide the opportunity for encoding some of those negotiations of power that the real theatre represents: the presentational role in interaction with that of the spectator and the giver with that of beneficiary. As a thematic link between hospitality and status display, the pattern comes to be as fully absorbed into Roman decorative custom as the instinct for dramatizing ceremony is entrenched within the culture.

AUGUSTAN SELF-STAGING AND THE *SCAENARUM FRONTES* OF THE PALATINE RESIDENCE

What is to be made of the fact that our second stage-front paintings (Figure 64 and 66) are in the House of Augustus? These examples must be considered within their own consistent decorative program. This Palatine site, which archaeologists have gradually been bringing to light over the past three decades, partially discloses a domestic environment that complements our knowledge of Augustus' civic monuments. Of course, as was generally the case with Roman houses, the private dimension of Augustus' residence was closely interrelated with the public dimension of his office.

Suetonius provides a few facts about the structure and symbolism of the house, which he had seen because it was maintained as a public monument until his own time. It was located close to the Palatine temple of Apollo which commemorated Augustus' victory at Actium. Augustus had bought it at some years before that time, conceivably taking advantage of confiscations following Philippi to acquire the first segment from the estates of the orator Q. Hortensius, while he later purchased the second from the property of Q. Lutatius Catulus. Although excavation has not clarified the original interrelationship or the subsequent integration of these two properties, it has revealed that the size of the house was extensive and occupied two levels.

No more has contemporary excavation made completely clear what was the physical relationship between the house and the temple. The temple, as the historians tell us, was built on a place struck by lightning. Clearly its consecration completed Augustus' integration of the public and private spheres of his life. Later, when he had acceded to the long-desired position of Pontifex Maximus, after decorously awaiting the death of Lepidus, Augustus set aside a portion of his house as public property. What this statement might mean in terms

of practical topography remains still to discover, but the symbolic import is unquestionable. Likewise the gesture of incorporating comprehensive Greek and Latin public libraries into the complex has its symbolic implications. While recalling the world of Ptolemaic Alexandria, it also reenacted the precedent of Lucullus who had by this feature made his house into an intellectual gathering place. Clearly as Propertius shows in the poem celebrating the dedication of the temple and libraries, Augustus hoped to achieve a similar status.

Likewise Suetonius' comments on the physical characteristics of the Palatine house, which he terms the "modest property of Hortensius" (72.1: *aedibus modicis Hortensianis*), address its symbolic dimension more explicitly than its practical nature. It was furnished, the historian claims, in a manner that exemplified Augustus' standards of moderate conduct, his rejection of late Republican extravagance. The porticoes were short and composed of columns in Alban stone (peperino). The *conclavia* were without marble or figured floors (*insigni pavimento*). Suetonius, however, says nothing whatsoever about wall painting, which is one of the major revelations of recent archeology.

With the exception of one upstairs room, which appears to have been decorated or redecorated at a later time, the context for painting comprises several clusters of rooms situated around a peristyle on the lower terrace of the house.[68] On one side the rooms approached close to the temple precinct to which a ramp gave access. If, as Carettoni believes, the principal atrium was located on the upper floor,[69] then the area unearthed will have been less public than private. In his opinion the decoration of these rooms comprises a program of great consistency characterized by "sobriety of rendition" in which architecture takes precedence over ornament, but, within these parameters the excavator also makes distinctions.

The Room of the Masks, which I discussed at the beginning of this chapter, is the largest in a suite of small rooms reached by a narrow corridor running behind the peristyle. In considering this key embodiment of the *scaenae frons* design, we must entertain the possibility that it was not even Augustus' commission but rather came to him as a legacy from the original decorations of Hortensius. Against this can be argued that the orator's death in 50 B.C. would place the decoration too early, while the construction marks above the cornice suggesting an originally higher ceiling, allow for an Augustan campaign of redecoration. An earlier stage of decoration may have included a loggia of the First Style variety.[70] Whatever the genesis of the stage motif here it notably recurs in several locations throughout the house.

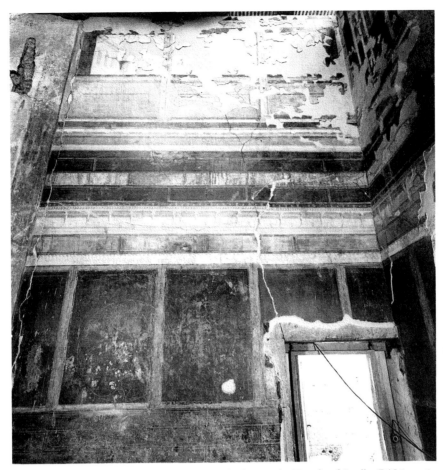

74. Rome, Palatine, House of Augustus, ramp leading to the Temple of Apollo. DAI 82.2169.

The total design of the room incorporates stage fronts on each of its four walls. The architectural similarities of these structures present a strikingly coherent effect. In comparison with the lavishly furnished stages Pliny mentions, or indeed the rich materials and ornamental profusion of Oplontis, this representation may appear quite modest. Its naturalistic detailing clearly alludes to the temporary Roman stages built of wood. As mentioned earlier, scholars have argued that many of the details may be understood as symbols of Augustan victory: the swans and bucrania which ornament the entablature frieze zones, the cornucopias surmounting the gables, the amazons and griffins which serve as acroteria.[71] Also the betylus dedication appearing on the more legible of the long walls can be associated with the iconography of the Augustan regime, whereas the Pan or Silvanus dedications on the short wall are more appropriate to the Palatine district itself with its traditions of early civilization and pastoral life. One must, however, remember that the hypothetical date of the decoration in the mid-thirties B.C. precedes the battle of Actium as well as Augustus' topographical resystematization of the district. One might more appropriately think of the symbolism as votive than celebratory. Another point to observe is that Augustus, when commissioning a decoration, did not seek for anything novel and individualistic but rather adapted a mode that was, on the evidence of Vitruvius' subject categories, still current if slightly conservative and old-fashioned.

In Carettoni's view the quality of the brushwork in these paintings is inferior to that in the most recently excavated cluster of rooms located closer to the temple. Consequently, he suggests that this newly discovered area is more formal or public than the back rooms. Within this complex the first painted wall to be seen is that enclosing the ramp that leads up to the Temple of Apollo (Figure 74).[72] Its design is a combination of orthostats, string courses, and loggia joining the attic zone. Because of the diagonal plane of the ramp itself, the orthostats are placed high; the usual dado is supplanted by an area of dark isodomes. The remainder of the decoration is a colorful alternation of red, gold, white, and green. Two cornices vary the upward progression, the lower one featuring brackets and dentilation, the higher

a series of mutules. The loggia itself is painted, perhaps in imitation of a clerestory, to reveal open space through its architectural apertures. Viewed in separation from its context the entire composition might more readily be identified as an example of the late First Style than of the Second, and thus it serves the more clearly as evidence for the simultaneity with which patterns were employed. Carettoni makes comparisons with the second- and first-century decorations on Delos.[73] Certainly it is a general Romano-Hellenistic koine which we see here, but the primary aim would seem to be that of conferring dignity upon a public space.

The room adjoining the ramp is an *oecus* of 8.80 × 6.20 meters, the largest covered space within the extant structure of the house. Column bases on the floor have led Carettoni to reconstruct the architecture with an interior vault to form a tetrastylon resembling that in the Casa delle Nozze d'Argento.[74] This reconstruction takes account of the arch-shaped construct at the far end of the room, which is now blocked with a reticulate facing, which he explains as a filling for an apsidal niche at the far end of the tetrastylon. This covering was, to all appearances, left unplastered and he argues that a sacral-idyllic landscape on the model of those of the Casa del Menandro must originally have filled the niches. A mosaic border encircles the vaulted space on the floor, enclosing the columns.

Not only the pavement and the architecture, but also the decoration divides the room into two parts. The space beneath the canopy and vault is decorated with its own independent pattern, which repeats the *aedicula* centered form and also places masks above the cornices of the screen walls (Figure 68). Although the design is formally indebted to the structure of the *scaenae frons,* it is not a thoroughgoing replication because the gable is broken and frames a shuttered pinax at its center. Furthermore the structure stands on its own little projecting podium. As Carettoni puts it, this is no longer a stage, but rather a stage translated into real architecture, and he notes how the painter has emphasized this effect by bringing out the shadows cast by columns that fall across the rear wall. The central panel frames a sacral-idyllic landscape. Cut out areas in the frieze zone reveal blue sky behind the pilasters. In contrast to the purely symbolic imagery of the antechamber, this appears realistic.

The middle zones of the antechamber wall comprise a series of red orthostats framed within borders of green and deep porphyry. Nothing about this is unusual, but the attic zones are wholly unconventional in their incorporation of a miniaturized stage-front design painted entirely in green, but containing human figures within the central *aedicula.*[75] Clearly the decoration serves the symbolic purpose of designating this portion of the room as a performance space for after dinner entertainment. Suetonius' biographical evidence (74) confirms Augustus' practices in this respect; in keeping with his personal fondness for the theatre, Augustus was generous in providing theatrical entertainments for the guests he invited to dinner. Most frequently these offerings consisted of storytellers (*aretaloges*), but sometimes there were shows staged by troupes of actors, acrobats (*acro[a]mata*), and even *ludii triviales* from the Circus. Such performers will have needed ample space for their movements, and this the divided room afforded, while the guests remained at their places within the tetrastylon. Column bases at the entrance show that the door was also colonnaded, as a formal entrance, no doubt, but with the advantage of creating a backdrop for the performers.

In company with an adjoining chamber 3.5 meters square, this room will have comprised, one may think, the formal dining suite of the house; the tetrastyle room intended for large parties that featured staged entertainment, and the second room for smaller groups. The Room of the Masks, although longer than this one by 2 metres, remains a more intimate space in a less public area of the house. Between the two areas lies a peristyle, still unexcavated in its central space but bordered along its inner corridor by a series of small rooms. These, as Carettoni has pointed out, are symmetrically disposed with architectural emphasis on the central space.

Most unusual of the rooms in the sequence is the central room, which was apparently open on one side, but on the other three was surrounded by a low podium that could be mounted on either side by a set of three steps. This room, as Carettoni sees it, cannot be a *triclinium,* but must, in spite of its unusual location, be a *tablinum* with attached alcoves on either side. Surviving decorations to be seen on the right wall of the room echo the shape of the *aedicula* employed elsewhere within the house. Behind the podium is a theatrical panel, flanked by wings seen in perspective, whose front terminals are white pilasters. Inside the supposed *aedicula* which contains the central panel, bright red predominates. White pilasters with floral motifs divide the chamber from the antechamber. In this projecting podium arrangement Carettoni finds the "decorative principle of the Second Style" transformed into a real third dimension. Against this background, as Carettoni would have it, Augustus staged his receptions.

Flanking this central space is a pair of identical rooms with inner walls cut by a series of niches. The decoration of these rooms is a spare decoration of paneled dado and illusionistic cornices. The niches themselves are painted

with yellow panels. Carettoni takes these as book spaces in library rooms. If so, they were certainly not those celebrated Palatine temple libraries which housed Greek and Latin collections for public use in imitation of the libraries of Alexandria, but rather small private libraries. The interior paneling and the lack of shelves, however, might rather suggest that the niches served to display statuary.

With the exception of these symmetrical chambers, each room in Augustus' house employed some version of the framed doorway, ranging from the conventional gable embellishing the stage doorway to a frame for pictorial representation to a frame for the princeps. Within the known history of the Second Style, this is the most consistent deployment of the pattern, a situation that seems to emphasize not only its relevance to Augustus' personal campaign of self-exhibition but also its embodiment of his personal tastes. That he appropriated a familiar pattern charged with Republican associations is not surprising. The gesture is characteristically in keeping with his redeployment in civic contexts of Republican forms and traditions with an appearance of respect and its significance is to be seen both in the public and private aspects of his policy.

In Augustan Rome an exploitation of theatricality by no means disappeared with the change in the structure of government and society, but was merely channeled into a subtle embellishment of centralized authority. In this respect one might say that the *princeps* had laid the metaphorical foundation for the future self-dramatization of imperial office, but he did so in a manner that did not alter but reincarnated the familiar customs of the past. What transpired in the political sphere as a matter of verbal definition, the assimilation of new powers through old channels with old names, can also be seen to have taken place in the material environment with the Augustan rebuilding of Rome. Augustan architecture and artistic display comprise a truly intertextual contrivance systematically deploying recognizable features of past monuments to posit new statements that have to be read with a significance derived from a broad field of associations.[76]

One of the Republican precedents most available for imitation was that of theatrical patronage as a means of compelling attention and ingratiating oneself with the general populace. As Suetonius testifies (43), Augustus surpassed all his predecessors in the variety and magnificence of the spectacles he staged, not to mention his popularly oriented show of interest in watching them himself. Provisions for spectacle were conspicuously incorporated into his rebuilding of the physical fabric of the city. So far as this was concerned, he did not allow

the Theatre of Pompey to stand alone, but reproduced and rivaled it by his completion of the project that Julius Caesar had commenced beside the Capitoline as the Theatre of Marcellus, which stood in the important position at the head of the Circus of Flaminius. Outside the city, where, as Bejor has shown, the gesture of theatrical euergetism could be even more conspicuous, he sponsored either the construction or reconstruction of several municipal theatres whose expenses, all the same, he cannily diverted to the care of local patrons and magistrates.[77] His capitalization on this particular form of symbolic benefaction to establish the centrality of his presence is one more testimony to the effectiveness of theatrical patronage. The theatres of Ostia and Volterra are among those owing to Augustan encouragement. In these towns outside Rome, both the central location of theatre buildings and their function of assembling the populace were appropriate symbols of the dynamics of Augustan government.[78]

To this form of monumental staging, however, may be added other kinds of publically presented ritual variously accommodated to operations across a spectrum of classes. Some festivals, either innovated or enhanced, marked points of the calendar; other rituals solemnized transitions from one to another stage of life. The famous *ludus Troiae* commemorated in the *Aeneid* made warfare into a proleptically ritualized drama for young aristocrats. Of a more popular appeal were the *ludi* performed at *compita*,[79] a restoration of discontinued custom that not only offered various species of diversion, but also opened opportunities for sponsorship to *vici magistri* placed in charge of the *princeps'* division of the city. As Richard King has argued, the shrine landscapes centrally situated within the *aediculae* of the Room of the Masks, such as the betylus of Apollo Aguieus (Figure 64), may well represent the kinds of shrines to deities that marked the *compita*.[80] Similar, although more complex landscapes, appeared also in the central *aediculae* of the tetrastyle *oecus*, where they were also flanked by masks displayed on the screen walls.[81]

Is it reinforcement of such policy gestures that we should see in theatrical images of the domestic sphere? Although one may read the implications of these visual constructions within multiple frames of reference, I am less inclined to perceive them as carriers of a strategic political message than as signs of the *princeps'* awareness that theatricality may be assimilated to power on the private level as well as the public when the alliance is masked by facades of hospitality and taste. Suetonius says much about the *princeps'* personal love of the theatre and his patronage of it. He especially enjoyed the old Roman comedies and liked to attend them. This

Horace seems to corroborate when he urges in *Epistle* 2.1 that the comedies of Plautus should not be held as a criterion of literary excellence. Augustus himself tried writing a tragedy, an *Ajax* which he finally abandoned as unsuccessful. In company with Maecenas he is said to have established the popularity of pantomime [82] and fostered the careers of the dancers Pylades and Bathyllus, although he also did not hesitate to expel Pylades from Italy for an improperly obscene gesture made on stage (Suetonius 45). Therefore, if Augustus liked to enforce his dominant patronage by offering theatrical spectacles to his guests, he did so on the grounds of sharing his own personal enthusiasms.

Suetonius also saw Augustus as one who acted. I am not certain whether he developed this notion out of the material presented to him by the career, or because of his personal experience of the flamboyant theatricality of later emperors, or, more generally, within the context of his Roman cultural heritage, but I will venture to say all three sources combined.[83] The perception shaped his portrayal of the *princeps*' career as divided into two developmental stages: a ruthless grasping for power yielding to a thoughtful and mature execution of it. But Suetonius also perceives the uneasy juncture of a facade and an interior, a mask and a human personality behind. So he tells us that Augustus had not quite the physical stature desirable for his role. No Cicero in physique, he did not fill out his toga, he wore elevated shoes to gain height (53). He was concerned about facial appearance to the point of enduring the hated services of his barber.

Suetonius highlights his thematic perception by a series of *scenarii* that show Augustus providing either theatre or spectacle in association with the exercise of power. First is the notorious exhibition of callousness when he assumed the dress of Apollo at the masquerade "Banquet of the Twelve Gods" staged during a moment of famine. This indiscretion, which gave even Antony cause for righteous satire, was scarcely out of keeping with Augustus' politically intemperate early career (Suetonius 70). The matured leader studies his roles more circumspectly. Suetonius gives information about his habit of writing out and rehearsing personal pronouncements of even a private nature (85); his concern to create dignity in dress and bearing (73); the formality of his dinner parties (74–75) and the deliberateness with which public receptions were staged (53). No small part of the total performance was the appearance of informal affability adopted to erase distances between himself and the senatorial elite (53–4). Through the idea of conduct transformation that shapes the biography, we see the principate itself as a grand performance based on Augustus' sense of

expediency. As the final action of this series, the famous deathbed scene brings Suetonius' Augustan life to a thematically apposite conclusion (9a). Having summoned friends to attend his last moments, Augustus arranged his face before a mirror and asked if he had played his part well in the mime of life, adding in Greek the tag lines by which an actor solicits applause. The gesture is interesting not merely for its self-conscious acknowledgment of the strain of acting but also as an artificial ceding of power from the actor-producer's hands into those of the spectator-judge. But the parameters within which he created this role were bequeathed to him by aristocratic Republican culture no less than the *aedicula* style of *scaenae frons* decoration.

IMPERIAL REVIVAL OF THE *SCAENAE FRONS*

By recognizing the deeply rooted affinity between theatricality and Roman culture, we do not merely explain the occurrence of stage imagery in Roman painting but may also be cautioned against regarding it as the message carrier for the ideology of any single period or person. As the Augustan period continues, the fashion for large-scale architectonic simulation gradually disappears with the consequent displacement of stage facades from their preeminence in the central zone to subordinate areas of the wall. One may be tempted to read some political implications into this relegation by referring it to a Tiberian prohibition that forbade performances by the actors of pantomimes elsewhere than on the theatrical stage (Tacitus *Ann.* 1.77) As W. J. Slater interprets it, this prohibition reflected the insecure emperor's fear of the subversive potential of theatrics.[84] Despite its loss of preeminence, still the pattern of the triple doorways does not disappear. Rather, its significance as an emblem of hospitality is indicated by its translation into the frieze zone of rooms decorated in other manners (Figure 67), a position that it frequently occupies throughout the course of Pompeian art.[85] During the later phases of painting, beginning with the period of Nero, the pattern of the *scaenae frons* returns to the central zone of the wall where it is manifested in a variety of forms ranging from very specific dramatic representations to the mere incorporation of such theatrical elements as gabled doors or balconies with figures as perspective indicators within settings of a nontheatrical character.

Interpreting the significance of theatrical motifs in paintings of the Neronian and Flavian periods is where our understanding of cultural continuity becomes vitally important. Literary testimony and opinion makes theatricality and the Neronian age virtually synonymous. If Augustus, with his personal love of the theatre, added to

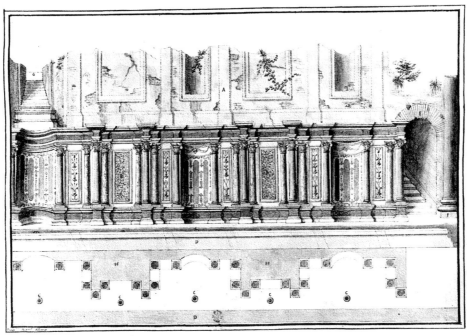

75. Rome, Domus Transitoria, fountain stage. Drawing by Francesco Bartoli, Eton College Library, Topham Collection Bn 7.100. Reproduced by permission of the Eton College Trust.

his keen sense of the strategic exigencies of politics and public relations, used theatrical images and frameworks as a mode of self-presentation, for Nero it would seem to have had different and even more intense implications. This flamboyantly exhibitionist great-grandson of Augustus did not merely try to write plays but notoriously performed them in public. On one hand, it was a way of losing himself, as Suetonius implies by mentioning those particular spectacles with autobiographical implications in which he participated; on the other hand, it was a mode of political control. Backing the patron producer's role with imperial prerogative, he carried the power of holding an audience captive to an extreme. Beyond this he displayed his control over the city by transforming it into an open-air theatre, sometimes for constructive reasons as when he staged an investiture of the Armenian King Tiridates in the Forum, but sometimes scandalously, as Tacitus records in a lurid description, to display his private perversions. In Tacitus' view, Nero's obsessive theatrics not only imprisoned audiences, but also converted Roman life and politics itself into a spectacle that he produced and stage-managed, thus reducing all previous rituals of dignity to charades.[86]

Not surprisingly his palaces contain theatrical installations. By constructing some of these in three dimensions he bettered the Republican tradition of dining before the *scaenae frons*. The major surviving segment of the Palatine Domus Transitoria is a complex of chambers, once lavishly revetted in colored marbles, that cluster about a fountain in the shape of a miniature *scaenae frons* (Figure 75). Records of painting in the Golden House show stages deployed in several locations, some of them symmetrical and tripartite, and other adapting single elements such as gables and niches to create paratactic decorations of a theatrical nature. The most imposing is a double-storied structure centered about a "royal door" with two tiers of projecting porches and colonnaded balconies (Figure 76). These features bear full complements of statuary. Each aperture on the lower story contains a figure in a lifelike pose.

Obviously Nero's deployment of such theatrical images follows the aristocratic custom of patronage, but in contrast with the traditions from which it derives this patronage is enforced in a new manner that excludes audience from spectacle. Separated from the diners by cascades of water, the spectacular fountain stage cannot be entered even imaginatively. The benefit offered to diners is a cool antidote to summer heat. Likewise the corridor stages shut out the spectators as they move them along to a further destination. Even the present-day visitor traversing the buried passageways can find the effect of these figures startling because of the confined space within which one confronts their deep perspective and lifelike forms. From balconies towering high overhead to barely visible ceilings, the figures look down on us. Yet these stages were once merely preliminary to the real performance lying within for which the emperor was at once the sponsor and the actor. No more explicit

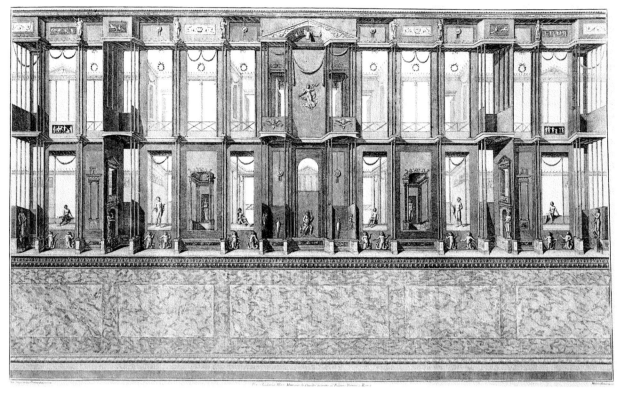

76. Rome, Domus Aurea, stage front corridor, engraving. Plate 27 from *Le antiche camere delle terme di Tito e le loro pitture restituite al pubblico da Ludivico Mirri Romano,* Rome 1776. Reproduced by permission of Yale University, Yale Center for British Art, Paul Mellon Collection.

parallel can be adduced for kind of passivity imposed by these decorations than the responses of the captive guests in Petronius' dramatization of the dinner staged by the freedman Trimalchio, a parody of dining rituals carried to an extreme whose every moment is a new form of spectacle. Far more successful than Horace's Nasidienus in controlling the conduct of his guests, Trimalchio flaunts his power in a theatrical orchestration that holds them dazzled, but immobilized, nourishing a wild desire for escape.

What then do we make of the Pompeian revival that returns the *scaenae frons* to the central zone of the wall? So far as the scholarly history is concerned, the stage decorations of this later period were discovered and identified before those of the Second Style, but knowledge of the earlier material was essential for understanding these as a recurrent form. Since that recognition, scholars have debated the rationale for the recurrence, some considering it within the parameters of stylistic chronology as a primarily aesthetic phenomenon and others as a sign of ideological awareness. In the first of these categories it is asked whether the recurrent form should be seen as a deliberate revival or merely as a sign of the mutual dependency of both forms on models imported into the

Roman repertoire. When political considerations are introduced into the discussion, the real contemporary theatre is seen as the primary model and the questions concern its potential alignment with imperial ideology. Thus, for instance, G.C. Picard has argued, pace Beyen, that only a few elements of the Second and Third Style stage-front paintings were genuinely theatrical, whereas the Fourth Style incarnations created a complete theatrical decor, which, to his mind, is influenced by the emperor Nero's particular obsession with the stage and with theatrical performances in which he himself so notoriously participated.[87] A more moderate approach to the problem of period affiliation appears in Eric Moormann's study of a group of seven Campanian paintings, which to him represent primarily an increased social interest in the theatre.[88] Although the general question is more appropriately to be discussed within the context of its stylistic period, still I will consider it here with reference to two Pompeian decorative ensembles frequently cited as having a particular indebtedness to the *scaenae frons.*[89]

Immediately one notices that these decorations involve exactly what is missing in Second Style decoration: the presence of actual figures on the stage. In a limited

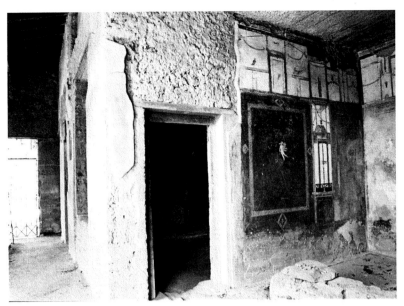

77. Pompeii, Casa di Pinarius Cerealis, Region 3.4.6, corridor, location of stage front room. Author's photograph (su concessione del Ministero per i Beni e le Attività Culturali).

number of cases we see full stages populated with figures enacting scenes from recognizable dramas. In an equally limited number of cases full stages surrounding a room are decked with figures to be taken for statues. Most common of all are elements of stage decoration incorporated into architectural settings as the dividers or surrounding frames in pinacotheca rooms. Although these latter do occur in the painting of the Neronian period, they are even more common in paintings of the Flavian post-earthquake period. Thus stages, like Roman theatricality in general, are not so much a deliberate endorsement of contemporary politics as a cultural response to them. Separating audience from actors, forcing a spectatorship that had become endemic to imperial society, they are no less pertinent to the Flavian world than to that of Nero.

The complete patterns occur in relatively inconspicuous places. The first of these is a Pompeian house on a side street off the central Via dell'Abbondanza, belonging to one Pinarius Cerealis (3.4.4). While the gens name, Pinarius indicates clientship with a large, old family represented in Campania, the cognomen, Cerialis should represent the bearer's Greek affiliations. Pinarius was not a member of Pompeii's decurial class, but rather a craftsman-tradesman, a carver of gems. At the same time he was a priest in the cult of Hercules and a person interested in local politics.[90] We can easily imagine how a lively commerce might bring prosperous and well-connected visitors whom Pinarius wished to impress. Evidence for Pinarius' own prosperity lies in the fact that the house was ransacked after the eruption.

The most elaborately decorated space within the house is a small, squared room beside the entrance corridor, which has been decorated with the familiar *scaenae frons* pattern (Figure 77).[91] Repairs made to the socle show the coarse breccia patterns typical of the Flavian period, but the colors used for these are carefully keyed to those of the original decoration, once again suggesting the owner's high valuation of the work.

The most imposing of the decorations is that on the rear wall of the room where the regal *aedicula* functions as the facade of a temple (Figure 78). Behind it we see not only the statue of Artemis, the presiding deity, but also the outline of a lofty tholos. Balustrades flanking the *aedicula* stand before side doors, each one marked by a projecting gabled porch. Acroteria in the shapes of sea creatures support gilded branches from which garlands are suspended giving a remarkable unity to the entire design. Beyond this every visible edge of the structure is ornamented by fretwork, grillwork, and carving that, in combination with the garlands, conveys an intricately lacelike appearance on the whole. The structure preserved on the entrance wall is only slightly less elaborate, lacking the balustrades and central gable, but replete with garlands, armatures, and porches. Granted these minor differences, it is clear that the stage pattern remains almost invariable, irrespective of the drama for which it provides the setting.

This is the more noteworthy because the two dramas in progress on the walls are of different genres. Each is clearly recognizable. The gabled porch of the rear wall forms the setting for a performance of *Iphigenia in Taurus.*

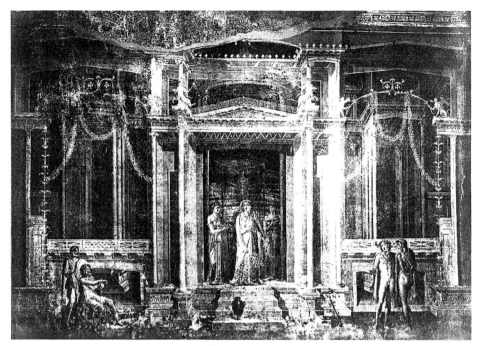

78. Pompeii, Casa di Pinarius Cerealis, *scaenae frons* decoration with figures. DAI 36.28.

Iphigenia with two attendant priestesses holding the apparatus of sacrifice stands framed in the doorway beneath the statue of the goddess. In one hand she carries a patera; in the other the *xoanon* representing the goddess. The two heroic figures talking together at the right are Orestes and Pylades, Orestes nude and Pylades dressed in a traveling chlamys. Not only do their bound hands show that they have been taken prisoner, but also they are garlanded as sacrificial victims. Seated at the left with one attendant, King Thoas raises a threatening arm toward the captives. Were it not for this gesture, we might identify the moment as that in Euripides' drama when Iphigenia, keeping secret the identity of the captives, brings out the goddess for a sham purification and justifies her action to the king, but Euripides does not bring Thoas together with the captives in this scene. Pacuvius, however, does stage this confrontation, as we learn from Cicero (*de Amicitia* 7.24), constructing it as a paradigm of loyalty in which the two friends confuse Thoas with mutual claims to be Orestes.[92] The scene, part of a *nova fabula* in the time of Laelius, brought the audience to its feet with applause. Clearly the scene is a cliffhanger, whose resolution the spectator must be able to supply.

Another Italian connection is to be understood for the scenes from the drama of Attis depicted on the entrance wall. Originally a religious drama performed in connection with the festivals of Magna Mater, the Attis legend became one of the most popular mimes. Nero himself, as Dio Cassius tells us, liked to perform his own

lyric composition on the subject (52.20). The backdrop shows how minimal are the adaptations made in the *scaena* to accomodate the specific ambience of the play. A single tree behind Attis' figure in the central *aedicula* must signify a rural ambience. A winged Eros urges him to give his attention to the female figure standing at the base of the *aedicula*. This person, as her urn indicates, is Sangaritide the nymph, whose aggressive love for Attis sent him to dedicate himself to Cybele. While Eros points him toward her figure, Attis holds in his hand the sickle that predicts his castration. To the left are two figures engaged in conversation. One of these is the river god Sangarus, father of the enamored nymph, and the other must be a second representation of Sangaritide, thus challenging the spectator to interassociate two stages of the drama. In the discrepancy between the architectural setting and the pastoral subject we see a good representation of the theatre of the empire when mimes were enacted on the formal stage with status equal to that of the drama.

The fragmentary condition of the facing wall leaves the question of mime or drama open. The destruction of the central panel by ransackers leaves the two end sections intact. These show fragments of an architecture exactly matched with that of the Attis panel. Each section also contains two figures; on the left a man in running position engages in lively dialogue with a second figure; to the right are women carrying a patera and a garland. The second of these moves toward center

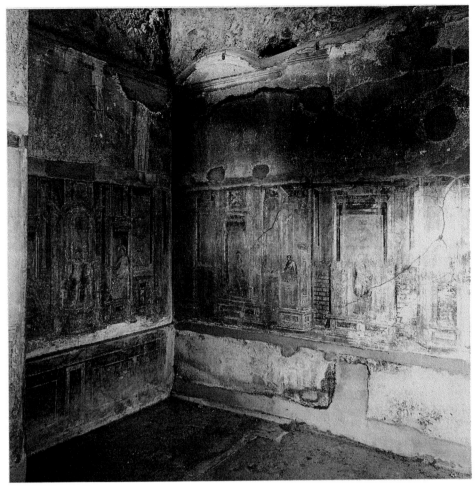

79. Pompeii, Casa di Apollo, *scaenae frons* decoration with figures. DAI 72.2268.

stage where the keynote action must be taking place. From the images no identification is possible, but the left-hand pair of figures has been taken for a messenger scene. If this is the case, it would be an interesting testimony to the theatrical literalism of these stage representations because it is more often the habit of ancient painting to realize the contents of messenger reports as actual scenes – for example, the dragging of Dirce by the bull – than to depict the mechanics of reporting as it happens on the stage.

Two more pairs of figures on the ends of the side wall cut through by the window are seemingly of a comic sort. One is a Venus dressing her hair beneath the gaze of a lascivious satyr; the other is a hermaphrodite grooming before a mirror. Although Spinazzola thought these scenes irrelevant to background, it is likely that they also represent the theatrical customs of the empire. The stage itself forms the common bond among the myths represented. That the painters were themselves responsible for placing the actors on a fully dressed stage can easily be demonstrated by the existence of duplicate repre-

sentations of the Iphigenia figure group against diverse backdrops.[93] Among several examples the one most similar to the figure composition seen here is that in the Casa del Citarista where Iphigenia is about to descend the steps of the temple. She is alone and is moving directly toward Thoas, who seems to be awaiting her approach. The bound captives stand to the side, outside her field of action. A second painting, however, only partially preserved, includes the priestess' attendants but omits Thoas. A predella in the House of the Vettii has the principal actors repositioned horizontally on a single ground line. These several reconfigurations provide evidence that the painters of Cerealis' decorations adapted their figures from some common source, whereas the highly elaborate stage front is their own design.

That this workshop was making a specialty of such animated facsimiles is clearly suggested by the occurrence of similar decorations in a house in the Via di Mercurio located close to the city wall (6.7.23). Somewhat grander than the establishment of Cerealis, the Casa di Apollo follows the traditional design of the formal

atrium and *tablinum,* but we have far less information about its owner if, indeed, della Corte's attribution to one A. Herenuleius Communis is correct.[94] For the name itself, Castrén suggests clientship with the Herenni, a distinguished family with an old Campanian branch. Perhaps this Herenuleius Communis may be identified with a signer in the wax tablets of Jucundus.[95]

Whoever its owner may have been, the house indicates prosperity. The *scaenae frons* paintings decorate a small room at the back of the garden, which formed part of a complex of *porticus* and small enclosures. A stage-like fountain closed the prospect at the garden wall. The room contains two alcoves in a manner reminiscent of a structure once common in Second Style architecture (Figure 79). As with the room in Cerialis' establishment, the decorations represent two theatrical genres but they differ in their distribution of actions.

On the north, south, and east walls are a series of panels identifiable as events in the story of Marsyas. Three phases of action on the north wall include Athena's short-lived essay at flute playing and Marsyas performing before some of the Muses. On the south wall are figures of Apollo and Olympias separated at the two ends of the couch. Finally we see Marsyas bound to a tree. The figures are framed within niches that seem to isolate their roles as participants in the drama.

The scene in the rear alcove has long posed a challenge to identification. Executed with grander style than the Marsyas story it centers on a gabled *aedicula* intricately patterned with shining gold fretwork (Figure 80). The figure of Apollo enthroned beneath the canopy identifies this setting as the palace of the sun. Less certain, however, are the identities of the two figures, one male and the other female positioned at either side of the god. The most commonly accepted proposal has been a contest between the Morning and Evening Stars.

Although nothing is intrinsically wrong with this idea, Moormann has proposed a plausible and more interesting identification of the scene as representing Euripides' tragedy *Phaeton,* which takes place in Apollo's palace.[96] Several fragments survive from this lost drama which Wilamovitz reconstructed as centering about a projected marriage between Phaeton and Aphrodite, which Phaeton's earthly parents, Merops and Clymene, had contrived in exploitation of his semidivine status as Apollo's son. Kenneth Reckford has recently given a new interpretation of the story line in which one of the daughters of Helios will have been substituted for Aphrodite as bride. The reconstructed plot has Phaeton sent to Apollo's palace to claim his bride whom nonetheless he rejects, asking instead to drive Apollo's chariot for his proof of paternity.[97] The

scene on our *scaenae frons* shows Phaeton confronting his designated bride in Apollo's throne room.[98] The bright opulence of throne and canopy no doubt shows a traditional stage dressing for the tragedy; it may well be reflected in *Metamorphoses* 2.1-5 when Ovid shows us the quicksilver and chrysolite of the solar palace through Phaeton's dazzled eyes.

Good evidence to confirm the identification of the subject appears in two closely comparable panels that show the same figure group. These also have puzzled interpreters. One is in the house of Gavius Rufus, duoviral candidate of 79, and the other a more recently excavated panel in the House of Fabius Rufus in the Insula Occidentalis. In the Gavius Rufus panel the principal figures are surrounded by a ring of divine spectators. The Fabius Rufus version shows Apollo's palace more clearly. The god holds his sun torch while seated on a throne decorated with a griffin chariot. Between the two figures appear a torch and a pitcher of water as unmistakable symbols of marriage. Eros stands behind the woman, urging her. Because the woman herself holds two doves, she may indeed be Aphrodite. Insofar as the expressions on Pompeian faces can be interpreted, that of the young man in the Gavius Rufus painting certainly indicates reluctance. Thus the parallel subject paintings, like those of Iphigenia and Attis, clearly show that our painters created exquisite stage settings as their own individualistic contribution to the depiction of dramatic scenes involving standard figure groups.

A third example of such a room in the Casa della Caccia Antica conforms to the same general characteristics, yet is too fragmentary for prolonged discussion. This decorated *oecus,* with three walls includes only the royal door of the *scaena* on its rear wall. Here the scene is one familiar from version in tablet painting: the discovery of Achilles on Skyros. On the side walls also were scenes from the life of Achilles.[99] This windowless room off the atrium was again dedicated to literary culture.

In these three examples the pattern of the stage set regains the decorative preeminence that had marked its career as a Second Style subject, yet with very different communicative implications.[100] The *scaenarum frontes* of the late Republic provided self-dramatizing backgrounds for persons who were the producers of the theatricalized rituals that were an established feature of the public life. Drawn into the domestic context they echoed the public world with rituals of private hospitality. If their primary significance was to promise hospitable entertainment, they also dramatized the roles of the persons who occupied these spaces. The banquet staged in honor of Metellus Pius demonstrates this point, which Augustus in his own time was quick to recognize.

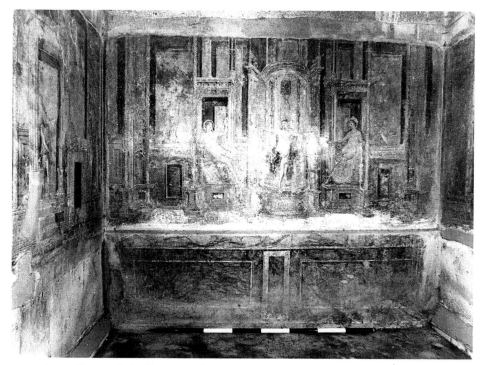

80. Pompeii, Casa di Apollo, alcove, dramatic scene in Apollo's Throne room. ICCD N40415.

Pompeian Fourth Style stages are different. Smaller in scale than those of the earlier period, they scarcely suggest the comprehensive drama of quotidian interactions, but are the self-contained focus of tightly enclosed spaces. Moormann has proposed that they show a change from interest in stage architecture to an interest in theatre,[101] but the change may be seen as more conceptual than that. Although their dramatic scenes might be characterized as command performances arranged by the house owner, still they celebrate the world of the theatre as one removed from his own, a world of glamour and elegance that offers an alternative to daily life. The performance remains to be elicited from the paintings when the spectator recreates their actions, watching the drama and tracing its progress from his knowledge of the real theatre where he has seen the plays enacted. However their fullness of representation may resemble Nero's theatrical decorations, there is a significant and much more hospitable difference between the specifically populated character of these stages and the grandiose backdrops of the Domus Aurea. Although physically excluded from the stage, these spectators are nonetheless invited to participate imaginatively in reconstructing the drama.

As I have mentioned, the final owners of these houses are not major political figures; their names do not appear as candidates in the *programmata*. The occupations of Cerealis' life, at least are those of craft combined with the

politics of sales. His participation in municipal politics is ancillary to his practical business. He will never seek support for his own advancement by sponsoring a public show. Yet we may think of his selection of paintings as a form of alternative sponsorship, exhibiting his taste and discrimination when his routines gave him contacts with persons of higher station. Thus I believe that the social ideology of the paintings echoes the character of the empire not as an expression of political ideology, but as an endorsement of the private life as a world removed from the public sphere. It also is a quotidian life to which the theatre stands both as an antithesis and a cultural asset. What the paintings show is no longer a parallel between public and private lives, but the opportunity of the private life for personal enrichment and self-cultivation. With their specific literary reference, they commemorate the theatrical world as a self-standing sphere of culture, a world of glamour and elegance intended for festive occasions as an alternative to daily life.

EPILOGUE: BREAKING
THEATRICAL BOUNDARIES

As the institution of theatre did not disappear from the life of imperial Rome, neither did the *scaenae frons*. In the views of many scholars the physical elaboration of the theatre is in proportion to the impoverishment of theatrical art. Certainly the facades still remaining in

actual theatres of the imperial period show great richness and complexity of architecture and ornamentation so that the examples from cities such as Sabrathra with its triple-tiered colonnade of polychrome marbles finally outdo even the legendary decorations of Republican aristocrats.[102] As evergetism is always a presence within theatrical spectacle, so we find entire imperial families framed within the niches and *aediculae* of the stage.

As MacDonald has observed under the heading of "thematic columnar display," these elevated stages come more and more to take on the aspect of urban streets. Using projecting podia to frame the traditional doorways with "iterated identical pavilions," they transform the traditional Hellenistic palace facade into an approximation of the continuous city thoroughfare lined by close-knit buildings. This stylized urbanism as a reflection of the town's public architectural reality recalls also the generic setting of Roman comedies in "a city street," and MacDonald suggests that such an engagement of the audience in a replica of its everyday world might account for the persistent popularity of the stage. Yet also outside the confines of the theatre the design begins to be employed on a monumental scale in civic architecture. In the facade of the library of Celsus at Ephesus, the Nymphaeum of Herodes Atticus at Olympia, or the market gate at Miletus we find the columniated tripartite stage front bearing an immense load of decorative elements.[103]

An interesting example from the standpoint of patronage is the gate of the city at Perge.[104] In the late second century A.D., an aristocratic woman, Plancia Magna, who had served her town both as priestess and as magistrate, dedicated an imposing new entrance to the city. Rebuilding the old Hellenistic hemicycle gate with more spacious dimensions, she shaped an urban *vestibulum* in the form of a paved horseshoe courtyard. Before the background wall with its niches for statuary stood a two-story Corinthian columnar facade of marble. Niches on two stories were filled with the complex program of statuary that united Greek legendary founders of city from the Trojan War period with historical benefactors, including men of Plancia's paternal family. Opposite the *scaenae frons* was a triple-bay arch that enclosed the space and framed the visitor's first view of Perge; its sculptural program joined city gods with the personages of imperial Rome. In commenting on the personal nature of Plancia's donation, Mary Boatwright notes how imperial women outnumber their male relatives in the display. Such a female preeminence calls attention to the donor's own gender as well as her power as a representation of aristocratic Roman matronhood in Asia Minor.[105]

That the city gate of Perge was not in fact unique but part of a contemporary trend is a matter no less significant than is the character of the architecture itself. In a form more permanent than the stage fronts of temporary Republican theatres, private evergetism has placed its stamp on public activities. The new embodiment of the stage front breaks out of the confines by which the theatrical world screened its dramas from reality and lends instead its sense of dramatic enhancement to the goings and comings of everyday life. It is in fact the theatrical background of Second Style domestic decoration writ large.

CHAPTER FOUR

Gardens and Picture Galleries

N AN INTRODUCTORY CHAPTER OF THE *DE RE RUSTICA*, VARRO FRAMES
an antithesis between two kinds of spectacle contemporary villas may
offer: *pinacothecae* and *oporothecae* (1.2.10: collections of pictures; collec-
tions of fruit). He attributes the picture galleries to that ever-present
background figure L. Licinius Lucullus, creator of the luxury villa, while as-
cribing the "fruit galleries" to the estates of Gn. Tremellius Scrofa, who is to
play a leading role as exponent of agricultural methods in the dialogue.[1] As
Varro remarks in his own speaking voice, "The farms of Scrofa are to many
a sight far more pleasing for their *cultus* than the regally refined buildings of
other men" (1.2.10: "fundi enim eius propter culturam iucundiore spectaculo
sunt multis, quam regie polita aedificia aliorum"). Scrofa's orchards, he adds,
are the image of the summa Sacra Via where fruit is weighed against gold.

The thematic juxtaposition thus set forth continues pervasively throughout
the *de Re Rustica,* but Varro's further elaboration modifies the dichotomous
impression that his initial formulation gives. Although a contrast between
nature and culture might be said to provide the point of departure for his
original antithesis, it must all the same be admitted that both orchards and
their fruits are the products of skilled human cultivation; they can assume the
status of aesthetic objects and can also be represented through art. Add to this
that a Roman reader might well have recognized the pseudo-Greek word
oporotheca as the original coinage of a writer fond of indulging his penchant

123

for etymological wordplay, and Varro's antithesis itself emerges as the product of artful contrivance.[2]

Later in the first book Varro mentions in a playful tone, but surely not without some basis in reality, the practice of dining in *oporothecae* (1.59.2–3). Why not? he adds, since the practice of dining in picture galleries is common, and the walls in both kinds of apartments are best when coated with a fine marble powder to keep the interiors fresh and dry. By the final book of the *de Re Rustica,* the seeming alternatives have been drawn together even more closely to form a pair of complements in place of an antithesis. Varro dedicates this book to his friend Pinnius, owner of a villa adorned with stuccowork and pavements, not to mention its owner's literary products, but deserving beyond this an ornamentation of "fruit" (3.1.10 *fructu* with a pun on its additional meaning of productivity or profit). This rapprochement between two forms of culture reflects a real situation: both gardens and picture galleries are in the service of hospitality in the Roman world.

Likewise both gardens and picture galleries are simulated in painting, and their representations frequently appear conjoined. Whether or not Varro himself knew any actual examples of the painted garden, it was not long after his time that this form of mimesis would become a common feature in the repertory of domestic painting at the same time that *pinacothecae,* initially established for the display of famous original statues and movable *tabellae* (easel paintings), were also coming to be created through paint. Thus Varro's dichotomous complementation is reflected in two patterns of wall painting that, like others previously discussed, have their origins in the complex of late Republican painting. The garden room of Livia's villa at Prima Porta, which presents a perennial display of flowers and fruit trees in an enclosed environment, is the first extant example of its kind. Early examples of the gallery arranged with framed pictures appear in the two houses on the Palatine attributed to Livia and to Augustus. Unlike the porticoes and stage patterns discussed in previous chapters, garden rooms and picture galleries do not disappear with the decline of the megalographic Second Style, but increase in popularity, persisting throughout various mutations. Their presence ranges ubiquitously from rich houses in Rome to the most modest Pompeian dwellings, where no more than a small garden room and single *pinacotheca* support the claim to entertain in good society.

Aside from the thematic appeal of these rooms, their popularity surely reflects the opportunities they offer to artistic enterprise. Although the compositional patterns come with time to acquire a certain predictability, their subject matter, by its very nature, offers lim-

itless scope for variation. Beyond this the painters find room for inventiveness in their practice of appropriating forms of architecture and ornament from a contemporaneous stylistic vocabulary. Examples of gardens in Third Style painting show attenuated columns comparable with those which we see in interior paintings of the period, whereas those of the Fourth Style are elaborated with an exuberance equivalent to the early imperial proliferation of luxurious ornamentation. Not only are the developments of these pictorial genres chronologically parallel, but also they are frequently intermingled. As we have seen in previous discussions of literary testimony and archaeological evidence, art objects are commonly introduced as furnishings into real gardens,[3] whereas in many cases picture galleries are situated in peristyles overlooking gardens. Likewise in many painted *pinacotheca* walls, painted plants fill the dado and garden plans are even miniaturized within the ornamentation of some pictorial contexts.[4] Thus Varro's thematic duality of nature and culture highlights two complementary areas of human enterprise that might be said to provide an axis of hospitality within the dynamics of spatial employment.

GARDEN DECORATIONS

Lacking the complexities that contort the perspectival depth of architectural paintings, painted images of the garden, when judged by a standard of illusory verisimilitude, might be thought to achieve a higher degree of persuasiveness than images of the *porticus* and *scaenae frons.* Consequently many spectators who have taken this impression have proceeded to inquire how seriously the overt naturalism of garden paintings aims at persuasive illusion. In the case of the first known garden painting in Livia's Villa at Prima Porta on the Via Flaminia, the question arises not only because of its painstaking execution of detail, but also because the proliferation of blossoming plants and fruit trees within the garden exceeds the order of seasonal growth,[5] calling to mind such mythical places as the Homeric Garden of Alcinous with its twice yearly yield or, a counterpart closer to home, the garden Vergil describes in *Georgics* (4.125–48), cultivated by an old Cilician pirate resettled at Tarentum. Although this fictive garden does not bear miraculously, it does exceed the limits of ordinary gardens by pushing at the boundaries of season in response to its owner's assiduous tending.

Like the Tarentine garden, that of Prima Porta combines both fruit trees and flowers. Sixty-nine birds of varied identity are visible, along with twenty-four kinds of trees, shrubs, and flowers,[6] all depicted, as is often remarked, "with an almost scientific precision." No two

birds or fruits are exactly alike.[7] Continuation of this floral exuberance into a dense wall of background foliage has led many interpreters to apply the word "paradise" in a highly romanticized fashion that implies the makers' deliberate defiance of natural probabilities with the intention of constructing an ideal ambience.[8]

In recent years the archeological researches Wilhelmina Jashemski has conducted into the composition of Pompeian gardens and their integral relationship to the economy of domestic life have cast much light on the general question of idealization and representation in such paintings.[9] As the first technically exact investigation of the subject, her work, which encompasses both the internal gardens of houses and villas and those in public situations, has done much to alter some traditional assumptions. Her findings instruct us to distrust the authenticity of many excavated gardens replanted for picturesque effect in a formal layout based more closely on the Younger Pliny's descriptions of his villas than the evidence found in situ.

Consideration of root cavities left by decayed plants and trees in combination with pollen and vegetal remains has demonstrated how frequently garden enclosures served the practical purpose of contributing culinary resources at the same time that they provided an inviting ambience for summer dining. Thus Varro's notion of dining in *oporothecae* may not be purely whimsical. In their full range of applications, Jashemski's discoveries support the veristic implications of garden mimesis in painting, but with allowance for effects that vary from one to another milieu. That the large-scale representation in garden paintings should outlast the parallel Republican scenarios of the *porticus* and the *scaenae frons* is only logical in view of their being so frequently deployed to reinforce the identity of a real environment. All the same, they are also subject to changes in form and representation. This can best be indicated by a brief diachronic conspectus of outstanding examples, beginning with the earliest known and extending to those of the Fourth Style.

Restorative overpainting has reinforced the original stylized effect of Livia's garden painting lending a Rousseauian tropical touch to the articulation of certain fronded shrubs in the foreground and the lush ripe fruits. The structural elements of the composition can be discussed in independence of its modern appearance, however. Two characteristics are noteworthy: first the spatial distancing of the garden plantings from the spectator and second the overall symmetry of design. A serrated border at the cornice line just below the springing of the vault indicates that the landscape with its background of blue sky constitutes an exterior view seen as

if from within a roofed structure.[10] To the best of our knowledge, the garden room was underground making it a place that afforded a cool ambience for summer dining without sacrificing the attraction of an outside view.[11]

This impression of exteriority is reinforced by the placement of the vegetation at a visual distance from the spectator. The dado itself forms a platform. Above this a space extends backward to a fence of gold-colored lattice that both marks the boundary of the garden and also offers access to it through a central gate. A second stretch of greensward separates this latticework barrier from the low stone balustrade that bounds the garden beds. Just in front of this are arranged a series of plants with variegated foliages: ivy, so frequently mentioned as a garden plant in literary sources,[12] ferns, and iris. Along with the apertures in the lattice these walls shape the symmetrical appearance of the garden because each is recessed at its center to accommodate a single tree – three types of evergreen. Beyond this low barrier are ranked the blooming flowers and foreground shrubs on a line. Most of the shrubs bear fruit or flowers. Their distribution to the right and left of the evergreen center maintains a subtly inexact symmetry.

From the combination of random abundance with seeming accidents of order the garden acquires its celebrated air of natural freshness. The plants are growing with the vigor of real ones, yet the quest for variety might also be thought to subvert the natural illusion by conveying permanence on phenomena of limited temporal duration, especially the activities of the birds. They are hungry birds drawn into the garden by its mature fruit. Although some perch on branches, we see others suspended in midair or approaching the trees with whirring upraised wings. Thus immobilized in their motion, these figures subvert the mimetic pretensions of the garden; sustained contemplation can only render their frozen attitudes unlifelike. By this token the garden becomes overtly fictive, constituting an allusion to real gardens rather than an outright replication. Likewise the plenitude of blossoms subverts probability. Consequently the garden image may be thought to function as a catalogue of species or a conversation piece rather than an idealization. Such improbabilities will stand out less glaringly in later renderings where the number of vegetable species is less while the mimetic valuation seems to be higher.

In view of the generally widespread distribution of garden decorations one may question the reliability of considering this single example as the model for succeeding instances, yet admittedly some of these show similar characteristics. Nevertheless, the use of garden

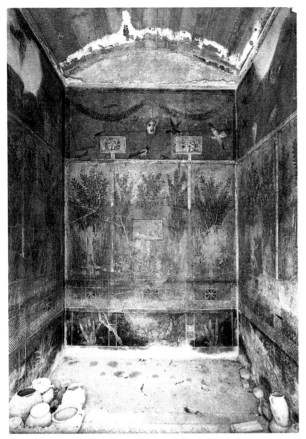

81. Pompeii, Casa del Fruttetto, Blue Garden Room. DAI 1964.2261.

images to shape the character of a fully enclosed interior space is rare. The most noteworthy instances are the two small rooms, located apart from each other, in the Pompeian Casa del Frutteto, Region 1.9.5.[13] At first glance the visual effects of the two rooms seem quite opposite. Backgrounds in blue (Figure 81) and in black (Figure 82) respectively show that the one is intended for a garden seen by daylight and the other as viewed by night. Granted this distinction, we can see that these two share many features of structure and style. Among these is the framing of the spectator's position through the architectural construction of the intermediary spaces across which the garden is viewed. Instead of the open, transparent space that intervenes between viewer and object in the Prima Porta room, here we see simulated columns and entablatures that define the fictive interior space as that of a pavilion set amidst plantings. One consequence of this architectural framing and the intercolumnar spaces it demarcates is its segmentation of the landscape elements into a series of centrally balanced designs. This formal symmetry is more apparent in the night garden, where single plants and shrubs show brightly against their dark background. Here, however,

the isolation of forms commonly cited as a purely artistic stylization might be viewed as a naturalistic rendering of the fictive nocturnal atmosphere when only the images closest at hand would stand out illuminated against the darkness. Perhaps this enclosure and the larger black ground picture gallery adjoining it may also exemplify Vitruvius' counsel for the painting of winter rooms with black because the soot from the lamps would inevitably darken light colors (7.4.4).

The vaulted ceiling of the chamber completes the figurative construct with a canopy of vine leaves and ripe clusters amid which masks and Dionsysiac instruments are suspended to define the location as a small pergola. The wall is the outer limit of this enclosure, but within its confine the dado effects a sense of interior distancing through its assemblage of garden apparatus consisting of lattice barriers, planters, fountains, and rose bushes in flower.[14] The crowning flourish of mock-verisimilitude is a serpent slithering up the trunk of a lemon tree at the rear (east) wall, whose presence seems no deterrent to the many painted birds inhabiting the area.

The blue daylight garden located off the atrium is more often compared with that of Prima Porta by reason

82. Pompeii, Casa del Fruttetto, Black Garden Room. DAI 64.2256.

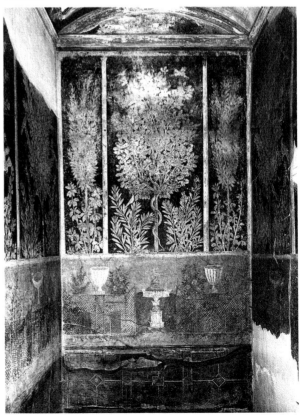

of its background color and seemingly more naturalistic luxuriance of interlaced stalks and branches of trees and shrubs. Here a variety of recognizable fruits and flowers – including lemon, arbutus, myrtle, and oleander – bear out Jashemski's remarks concerning the practical value of gardens with particular reference to the realities of the Campanian ambience. That the garden is no mere copy; a genuinely Campanian creation appears in the number of characteristics that set it apart from the so-called Roman model, both in composition and in content. Although a lattice once again marks the inner boundary of the garden, the plants rise up close behind it, bringing the viewer close to an exterior prospect in which the tallest trees and shrubs raise their branches in isolation against an area of blue sky. Lacking such gradations of color intensity as give spatial depth to the foliage of the Prima Porta garden, these ranks of vegetation are not really continuous; furthermore, they are interrupted by framing columns that segregate clusters but do not segment individual forms. The effect is a pronounced vertical regimentation imposed on the garden as a whole. Another difference between this architecturally ordered prospect and the unconstricted natural freedom of Prima Porta is the abundance of art objects distributed within the garden precinct. Through the intercolumniations and a partial masking of shrubbery we can discern the figures of seated Egyptian divinities. Sculpted *tabellae* with mythological scenes and *oscilla*, both characteristic of peristyle decoration in Pompeii, appear in the frieze and middle zone.

Clearly both this garden and its dark counterpart are fictive peristyles, yet the presence of their real architectural counterpart within the house indicates that these painted versions are not intended to make up for any deficiency of garden space. Although the Casa del Frutteto is small, it possesses a partial peristyle on which three rooms once opened. The amplest of these, undecorated at the time of the eruption, was a large square room directly confronting the *tablinum* on axis across the peristyle. Rather than compensating for missing outdoor amenities, the painted gardens may be taken as crossing the limits of season by bringing summer indoors.

On the basis of their attenuated column shafts the two rooms of the Frutteto can be dated to the early Julio-Claudian period. As we will see in the portion of this chapter concerning *pinacothecae,* this slenderizing of the structural members in painted architecture is characteristic of the period. Until recently the two rooms appeared to have no extant contemporary counterparts, but excavation on the lowest level of the terraced Insula Occidentalis complex on the Western slope of the city has recovered another blue garden room, whose massed

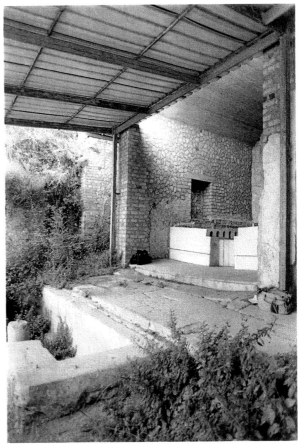

83. Pompeii, Insula Occidentalis casa del Bracciale d' Oro. Location of garden room and marble biclinium. Author's photograph (su concessione del Ministero per i Beni e le Attività Culturali).

foliage a comparable series of *tabellae* and frieze decorations enhances.[15] Comparing the varieties of vegetation and the brushwork, Moormann has identified this room as a product of the Frutteto workshop.[16] It is, all the same, a less regimented prospect, not only lacking the interior architecture but also presenting a more continuous bank of tangled foliage thickly populated with birds against a background of blue sky that closely resembles the Prima Porta room. Its form is that of a vaulted rectangular chamber facing on an open space that will certainly have been a garden. The paintings wrap around the corners of their enclosure to serve as a background for the plantings outside.

In its final period, this complex, with considerable renovation and addition, was dominated by an outdoor *triclinium* whose marble fixed couches stood before an elaborate mosaic fountain with a water stair, one of the most elegant such constructions in all Pompeii (Figure 83). The innovation embodies a development that will greatly have affected the planting and landscaping of garden areas in Pompeii: the introduction of aqueduct water in the first century.[17] Without the pressure

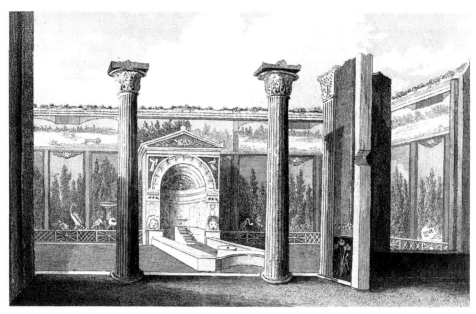

84. Pompeii, Casa della Fontana Grande. Fourth Style garden paintings. Gell 1834, Vol. I. pl. LIII (53).

supplied by aqueduct transmission, fountain jets would have been difficult. The expanded supply made it possible for houses inside the town to imitate villas by the development of watered gardens and fish tanks. If the volume of water thus expended was actually not, as Richardson thinks, extensive, the supply was all the same reliable and available during the summer months when it was most needed.[18] It is, in fact, as a decorative el-

ement within real gardens that garden painting is most frequently employed during Pompeii's final period.[19] Its uses fall within several categories: as an ornamental surrounding for wall fountains and nymphaea, as the finishing for a terminal wall, as a background to set off some grandiose thematic decoration.

Decorations behind the water jets of nymphaea sometimes take the form of glass mosaics but are frequently

85. Pompeii, Casa della Venere in Conchiglia, peristyle, garden paintings. FU 1958/4962.

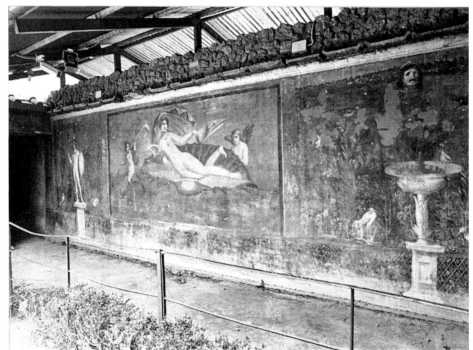

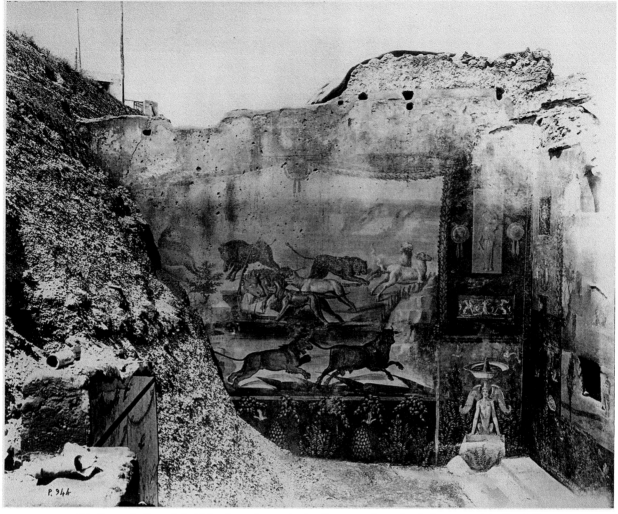

86. Pompeii, Casa di L. Ceius Secundus, peristyle. Beast megalography during excavation. Scavi di Pompeii, Neg. no. 644.1919 (su concessione del Ministero per i Beni e le Attività Culturali).

painted (Figure 84). When mosaics are used, they commonly represent water plants, such as papyrus reeds, that might have grown within pools themselves, but the painted backgrounds show a variety of trees and shrubs differing little from those in enclosures without fountains. These, as Jashemski has it, are intended to function illusionistically as visual extensions of the garden space. Seldom encompassing the entire periphery of the space they decorate, they are commonly positioned on the rear wall of a two- or three-sided peristyle at the point most visible from inside the house. The facing walls of the ambulacra are likely to be decorated paratactically and in the richest settings as picture galleries, thus forming precisely the axis of *pinacotheca* and garden earlier mentioned. Masses of shrubbery or flowering plants regularly occur in these settings, their mimetic ambitions sometimes extending to the simulation of such luxury furnishings as painted statuary and fountain basins com-

parable to those in actual use. In the elaborately programmed display at the rear of the Casa della Venere in Conchiglia in Pompeii (Region 2.3.3), a lively image of the goddess positioned within a scallop shell and attended by Amorini floats on a watery background. The flanking panels extend the garden metaphor with ornamental objects placed amid plants; on one side a fountain and on the other a pedestal supporting a statue of Mars whose small, rather delicate form is painted white as if to simulate faded marble, presents a striking contrast with the robust image of the goddess. The pairing of bird species in the panels makes Venus' erotic influence visible (Figure 85).

Behind the shrubbery stands the blue background typically used to lend a naturalistic appearance to such simulations but the walls of a small side chamber projecting into the garden enclosure are painted instead with a golden base color imitating giallo antico, a background

that intensifies the green coloring of shrubs set in pots and surrounded by ivy clumps. Among the most spectacular displays of this kind is the honeycomb of small enclosures lining one corridor that faces the piscina in the bath complex at the Villa of Oplontis. Here, where the polychrome garden paintings are interspersed with spaces bearing a white ground decoration, the intention of imitating giallo antico is clear. The garden installations are situated in niches and also small enclosed spaces with irrigation channels that indicate the planting of real vegetation within to be glimpsed against its artificially supplied background through large windows.[20]

Strong similarities in technique would suggest that the painters of these decorations operating in the postearthquake period were the same group who furnished subordinate backgrounds for scenes of another kind: large-scale paintings of exotic animals depicted against landscaped backgrounds of rock-studded terrain with stunted bare trees. Comparisons among the figures in these scenarios show similarities both in conception and attitude so as to suggest their derivation from standard models. The animals are well and knowledgeably drawn. Most common are stags and antelope of varied species, cats of African origin, wild donkeys, bulls, boars, and bears. Occasionally the groups include some unusual creatures such as an elephant and large serpent in the House of Romulus and Remus. For the most part the animals are shown interacting with each other rather than their environment, and some of the interactions are violent. Herbivores pursued by carnivores leap over the ground. A bull stands trapped between a lion and a pard; another spotted cat tears at the side of a donkey; a boar at bay bristles before his attackers. The majority of such confrontations bring together animals from different habitats. Some are peacefully disposed, and a few even stand like spectators of some nearby combat.

Paintings of this description are distributed throughout the city in houses of varying size; the scenes are frequently set against framing backgrounds and bordered with plants and garlands (Figure 86). Compelling in appearance, they have provoked much speculation as to what their significance might be. Many interpreters have made them out as a particularly grandiose form of garden representation based on *paradeisoi*, the animal parks developed by Eastern monarchs to exercise their royal privilege of hunting.[21] Xenophon's descriptions had publicized these in the Greco-Roman world and perhaps initially invested hunting itself with regal glam-

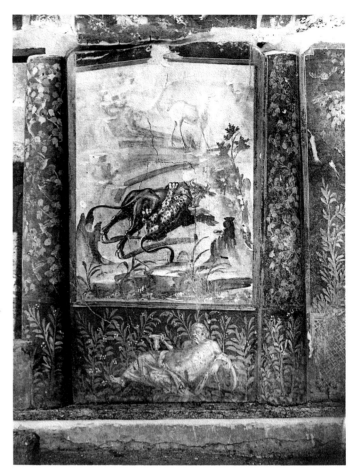

87. Casa degli Epigrammi. Beast megalography. FU 7248.

our, which was greatly enhanced by Alexander, said to have hunted with his nobles in a park containing 4,000 wild game creatures (Curtius Rufus 1.11–19). According to Polybius (31.29.4–11), Scipio Aemilianus built up his virtue of courage by chasing game in the Macedonian royal preserve, and Polybius takes the occasion to air his gentlemanly Greek background by adding that he enjoys a bit of a hunt himself. On such grounds Jashemski proposes that Roman nobles valued *paradeisoi* as signs of a social power derived from cosmopolitan sophistication.[22] Roman literary evidence, however, fails to support so precise a connection between hunting and *paradeisoi*, while the second-century writer Gellius enforces the "argument from silence" when he calls *paradeisoi* a Greek term of "recent" currency of which he finds no trace in earlier texts (2.20.4).[23] Even without this negative witness, it is hard to imagine what the Hellenistic posturing of vanished Republican aristocrats might have to do with Flavian householders in Pompeii.

Looking closer to home for a culturally mediating source that brings concentrations of exotic animals into the Pompeian world, we can readily find one in the

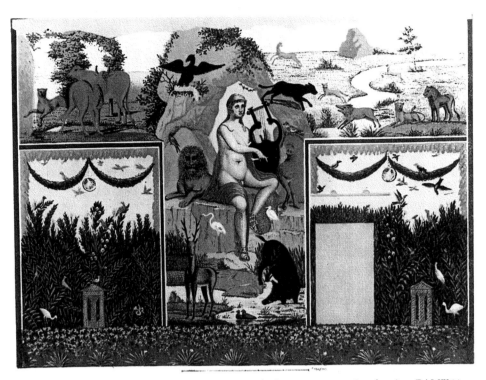

88. Pompeii, Casa di Orpheo. Orpheus charming the beasts reconstruction drawing. DAI W66.

venationes popular here, as everywhere, on the schedule of amphitheater games.[24] A funerary inscription honoring the distinguished magistrate of the Augustan period, A. Clodius Flaccus, specifically mentions the animals that he as quinquennial duovir provided for a *venatio* during the Ludi Apollinares: bulls, boars, bears, and "various other items for the hunt."[25] Virtually every Pompeian animal scene includes these three species, whose classic appeal to the crowds is corroborated by their mention in contemporaneous literary sources including Martial's book of epigrams *de Spectaculis* celebrating the shows of the Flavian Colosseum. Also in an earlier "Eclogue" in the pastoral collection of Calpurnius Siculus, a rural visitor to Rome describes to fellow country people his bedazzlement before "every species of wild animal" (*genus omne ferarum*) exhibited by Nero in a wooden amphitheater (7.57–72). Among the specific items of this wide-eyed catalogue, we again find boars and wild bulls, but also the elk "rare even in its native forests," which appears in several scenes including those in the House of M. Lucretius Fronto.

Movable scenery was a part of such spectacles. In the Neronian games of Calpurnius' *Eclogue* the sandy caverns of the arena floor from which the wild creatures spring forth subsequently give birth to golden arbutus trees showering clouds of saffron. Lacking the golden arbutus, sandy caverns with rocky outcroppings and twisted trees are the substance of most of the Pom-

peian scenes. Very similar configurations of rocks and trees appeared as settings within a series of paintings on the parapet of the Pompeian amphitheater depicting battling beasts, many of whose figures were similar in outline and execution to those appearing on the garden panels,[26] save that paratactic compartments here separated the animals into hostile pairs: a lion pursues a horse; a leopard faces a boar, a bear, and a bull, each of these tethered by cords. Because the identity of these scenes is beyond question, their evidence militates against the animal hunts as *paradeisoi,* either simulated or symbolic, and reveals them instead as trophies of theatrical spectacle. This identification suits the visual aspect of the painted panels very well. Whereas their interior landscapes give the impression of space and depth, the framing elements, the swags and garlands, are appropriate to banners suspended on the walls. In the amphitheater the paintings are suspended between niches holding herms with a series of richly textured marble panels positioned above. Some of the amphitheater panels also depicted gladiators, and one panoramic animal painting in the viridarium of the Casa della Caccia Antica includes hunters battling the animals with spears. This ostensibly direct allusion to the popular *venationes* of the amphitheater seems to point conclusively to a point of reference in public spectacles.

Among those scholars who do attribute the paintings to such an inspiration, an explanation for their

emergent popularity has been proposed on a chronological basis in connection with the senatorial ten-year prohibition of gladiatorial exhibitions that punished the Pompeians for instigating the riot of A.D. 59.[27] Although no literary record documents the Pompeian response to this prohibition, the notices of *ludi* painted on walls of postearthquake date suggest the compensatory staging of *venationes*.[28] Beyond this a more specific motivation might be sought in patronage.[29] Among the animal megalographies known, several are in the houses of attested candidates: The Casa del Centenario (9.8.3–6), where the hunt murals enclose the upper level of a nymphaeum with a water stair, belonged to Aulus Rustius Verus, whose *ludi* were advertized in four posters that are still extant.[30] The Casa dei Ceii, with its large *venatio* dominating a small *viridarium* belonged to L. Ceius Secundus, duovir of A.D. 78, while M. Lucretius Fronto, having previously served as duovir, stood for a quinquennial magistracy during some year late in the decade.[31] Another recorded sponsor of a *venatio*, who was an Augustalis but not a magistrate, was L. Valerius Priscus, a freedman whose family history must have been connected with the Valerii who held office during the Augustan period.[32] The name of the Valerii is attached to the Casa degli Epigrammi (5.1.18), where a latter-day campaign of redecoration had also installed a particularly ferocious beast megalography with a spotted feline tearing at the shoulder of a bull (Figure 87).[33] Finally, the presence of such paintings within the tomb of the young aedile, C. Vestorius Priscus, in particular would suggest such a political connection,[34] whether as funerary ritual or as a *munus* sponsored during his brief tenure of office.

A singular variation on the *venatio* topos of an almost certainly theatrical nature appears in the peristyle of the Casa di Orpheo attributed to Vesonius Primus (6.14.21), said also to be the owner of a fullery next door.[35] Here a panoramic depiction of Orpheus charming the animals occupies the entire back wall (Figure 88). The musician is seated on a rock construction in front of a ledge with a grotto framing his figure within its aperture. A lion couches placidly at his one side, and a pard on his opposite side rears on its hind legs, but, aside from these two, the congregation of animals does not seem especially attentive to the musical spell. A boar wades in the stream that runs by Orpheus' feet; a stag stares out from the foreground in statuesque immobility. In the upper reaches to the right and left animals run freely in wild settings. They are primarily cats of varied species, large bears, and a boar. Inset garden panels to the right and left at ground level show massed foliage with birds, small shrines beneath garlands, and a curtain fringe.

Both the placement and scale of this painting suggest that its appropriate point of comparison is with the *venationes* rather than with framed *tabellae* of the mythological sort. It is not just a myth exploded to larger-than-life proportions. Jashemsky includes this scene within the category of *paradeisoi* citing in proof of its Hellenistic resonances a description in the *de Re Rustica* (3.13) of a spectacle that Hortensius staged for guests dining within his wild game park in which a musician dressed as Orpheus charms stags, boars, and other animals with his lyre.[36] Once again, however, literary context argues to the contrary, and this time not *ex silentio*. When Axius, Varro's speaker, describes this little pageant, he calls it unusual, not typical, and terms its modality Thracian rather than Eastern or Greek. He furthermore likens the entertainment to the *venationes* staged by aediles in the Circus Maximus.[37] Thus it seems far more likely that the cultural point of reference is an immediately contemporary one, involving a particular species of amphitheater scene in which participants, primarily condemned criminals, enact some manner of mythological scenario in which animals figure as instruments of execution: Acteon and his hounds; Dirce and the bull.[38] Martial's celebratory epigrams on the Colosseum shows of Titus, the *Liber de Spectaculis*, describe several such spectacles "that make fable into penalty" (7.12). Orpheus is the subject of two epigrams, the longer of which (21) describes an elaborately staged dramatization including Mount Rhodope with admiring forests crowded about the rocks and every manner of bird and beast. This drama diverges from mythology when a bear impervious to singing lacerates unhappy Orpheus (21.24). Perhaps the bear came as messenger from Eurydice to bring Orpheus below (25.21b). Whether this Orpheus is a criminal enduring punishment or simply an unlucky entertainer Martial does not make clear. No more do we know whether such a spectacle was ever staged in Pompeii, but there is no reason why it should not have been. There is something suspiciously ominous about this startlingly larger-than-life Orpheus dominating the garden.

PINACOTHECAE: REPRESENTING REPRESENTATION

The *pinacotheca*, or room arranged as a showcase for the display of art objects including framed pictures, is the model for Roman decorative schemes, the real embodiments of which are most extensively documented by literary evidence. The combination *signa* and *tabulae pictae* occurs repeatedly in Cicero's writings, with the *tabulae* almost as frequent as the *signa*.[39] While C. Verres, who

notoriously filled his spaces with stolen objects, may have been among the first collectors, the custom soon becomes respectable, especially when the objects have been legitimately purchased. In *de Oratore* 1.161, the tribunician candidate C. Cotta compares the celebrated L. Crassus' first exposition of oratorical theory to a "rich and well-endowed house where ... the statues and picture panels had not openly been displayed, but all the magnificent objects stored in hiding." Perhaps the comment is anachronistic for the dramatic date of 91 B.C., but beginning with the references in Varro earlier mentioned, *pinacothecae* occur in numerous contexts until the second century A.D. Vitruvius includes *pinacothecae* along with *bibliothecae* and *basilicae* in a series of features appropriate to houses of great *dignitas* (6.5.2). Aside from the Elder Pliny's numerous informational references both to public and to private galleries, two literary *pinacothecae* are of particular note. The one is that gallery of unspecified geographic location in Petronius' *Satyricon* (88–9), whose display prompts Eumolpus' tendentious speech on the decadence of contemporary painting; the other is a Neapolitan gallery that provides Philostratus with material for his two books of descriptive *Imagines,* the rhetorical exercises that bring paintings vividly to life.[40] The first of these galleries is unquestionably fictive, the other of more uncertain status. The ekphrastic rhetoric of both texts shows speakers interacting affectively with individual paintings in ways that furnish good material for the study of viewing, yet in other respects these descriptions merely pique our curiosity; neither provides sufficient information to let us visualize any immediate context of framing and display. For our purposes, however, we may understand these galleries as counterparts of a decorative genre that exists in a variety of situations, both expansive and constrained – either in genuine luxury houses or in houses imitating genuine luxury houses.

Although the phenomenon of the *pinacotheca* has not been wholly overlooked in scholarly treatments of painting, still its origins and development have not been allowed their appropriate role in its stylistic narrative, especially as this focuses upon the "transition" from Second to Third Style. For this Vitruvius bears a large share of responsibility by his omission of them from his influential list of Republican pictorial types. Although the earliest painted galleries are virtually contemporaneous with Varro's mention in the *de Re Rustica,* never does he acknowledge this representational model in the same authoritative manner that he mentions the late Republican *scaenae frons.* Furthermore, as discussed later, when writing of the style of his own Augustan, by which time *pinacothecae* were well established, he prejudices his descrip-

tive account by a critical dissection of its architecture and ornamentation as symptoms of a decline in taste.

Another reason for the imperfect recognition of the *pinacotheca* as a representational genre is that those scholars who have discovered, as it were, its conceptual integrity have all the same treated it as something much more special, more distant from the routine activities of daily life, than it was. An article by van Buren brings literary and archeological evidence together to describe Greek precedents of the form and to identify examples from the Second through the Fourth Style.[41] Schefold also speaks of the figurative "museum" with thematically programmed contents as an imitative model whose popularity grows strong in the Third and Fourth Styles.[42] Van Buren seems to envision the ancient *pinacotheca* on the model of the gallery in Henry James' Gardencourt as a ceremonial repository where large collections were displayed for the purpose of occasional viewing.[43] From this notion follows the assumption that Roman houses were likely to contain no more than one example of the *pinacotheca.*[44] Van Buren fosters such an impression when he cites the Elder Pliny on men who "patch out" their galleries with old panels (35.4: "pinacothecas veteribus tabulis consuunt").[45] Implicitly he gives us to understand that the *pinacotheca* was exclusively a museum space, dedicated to no practical purpose save that of display. Thus, when identifying examples of this phenomenon in Pompeii, he limits his descriptions to spaces for which he can see no other conceivable use. Although framed panels decorate virtually every room in the House of the Vettii, Van Buren allows only the two largest rooms fronting on the peristyle within this class.[46] To the contrary the painted Roman *pinacotheca* is not merely a functional dedication of space, but a compositional genre of widespread occurrence and manifold use. In the hierarchy of domestic decorations it ranks high because its configurations are for the most part symmetrical and are located in areas for stationary occupation.

Viewing these rooms as sequential steps in development builds an implicit narrative history of Pompeian painting by which the spatially expansive Second Style transforms itself into a more restricted Third. If, to the contrary, we allow that the intention of simulating a *pinacotheca* is the effective cause for the closing of spaces rather than its accidental by-product, we will revise this idea of a gradually realized transition to that of a mimetic takeover. Rather than steps in an aesthetic process, we can see them as aspects of Republican self-expression persisting and expanding amidst numerous social and political changes. By priviledging the private over the public their patterns fit the cultural climate of the

Augustan Age without being – as they have so often been judged – a vehicle for propaganda. Once the primacy of the *pinacotheca* has been established, the further history of painting constitutes primarily a series of contextual variations ranging from simple to grandiose. As a framework for display with a compelling appeal to the imaginations of painters and patrons alike, it dominates the wall-decoration industry not only for the lifetime of Pompeii, but also into the later centuries of the Empire.

As an introductory example of *pinacotheca* representation employed within the House of Augustus, in competition as it were with the *scaenae frons,* I return to the small room close to the entrance to the temple that Carettoni called the "lower *cubiculum* (Figure 29).[47] I mentioned the pictorial conformation of this room in my first chapter to show Vitruvius' specifications for the Cyzicene *oecus* – rooms spaciously accomodated for the placement of two *triclinia* with garden views. In the lower *cubiculum* the architectonics of the two facing side walls might best be described as a reverse of the common symmetrical disposition in that their framed apertures occur at the sides rather than at the center. This closed central zone comprises a recessed spatial compartment articulated with a podium, panels, and cornice and terminating in ressauts. Beyond these the full-length apertures framed in black extending from the podium to the frieze zone open on a prospect of clustered buildings and groups of figures positioned against an area of blue sky with a convincing illusion of depth.[48] Saving only the substitution of street views for garden prospects, these symmetrical window apertures correspond precisely to Vitruvius' pattern for the dining chamber with exterior views from two sets of couches. Its urban scenes might be considered as an accommodation to the populous area of the Palatine where real windows might well have faced a comparable prospect of houses. Although elements of its decoration show affinity with stage painting, its overall design differs significantly from those theatrical compositions, whose columniated doorways echo the canonical tripartite structure of the *scaenae frons.*

The end wall of this room differs from the sides in containing no simulated apertures, but instead a painted *tabella* framed within a generously proportioned *aedicula* that is positioned on a recessed podium with forward columns that support the painted entablature (Figure 89). Visually situated behind these columns and elevated on a second, shallower podium, the *aedicula* and its surrounding architecture form a coherent structure. Full-length panels flank the *aedicula,* closing the recessed plane with a cornice at the height of the gable and pilasters projecting as ressauts. A row of dentils, a string course, and a frieze of paterae and lotus buds make up the

complex cornice, and the ressauts support sea-centaurs as acroteria. Above the cornice, two shuttered pinakes occupy the frieze zone. Beneath the *aedicula,* five broad steps interrupt the podium; at the left corner of the space that its ample frame encloses, one can decipher three images remain decipherable: an athletic, bronzed figure of the Hercules type; a small boat; and a boy. The subject represented will certainly have been mythological. Thus this dining room embellishes its Cyzicene architecture with the furnishings of a *pinacotheca.*

The likelihood that Augustus' *cubiculum* is a deliberate adaptation of the Cyzecene format to pictorial representation is enforced by the similarity between the lateral apertures of its design and those in another well-known room of the nearby Palatine complex called the House of Livia, where the inscription *Julia Augusta* on a piece of lead piping suggests that these rooms belonged to the *princeps'* widow who had become his adopted daughter on his death (Figure 30). One difference appears that is accommodated by the much greater size of this second room. In the House of Livia, not merely the end wall but also the extant side wall has an *aedicula* framing a mythological painting at its center. This intervention tends to obscure the otherwise close structural similarity between the two side walls, except that the House of Livia contains no double dado. Instead the foremost columns rise from projecting bases on the dado while the columns of the ressauts stand on bases that are further recessed. The gable of the *aedicula* rises higher and a larger frieze zone includes two Nike figures acting as Caryatids for the entablature and a pair of shuttered pinakes. In fact this new scheme appears to combine elements from both walls of the "lower *cubiculum.*" Architectural history supports the kinship between the two designs because the presence of doors plastered shut beneath the current decoration in the House of Livia indicates that these paintings followed a reconstruction that took place some time after the house was originally built, a reconstruction that might conceivably have followed the widowed Livia's retreat from her conjugal residence.[49]

Because the framed pictures in these rooms are clearly mythological representations in the dramatic mode, they can by no means be confused with stage decorations. Likewise the subordinate pinakes point to the thematic definition of the room as a gallery arranged in the service of display. The Elder Pliny gives evidence for the employment of an *aedicula* as the frame for an independent picture panel when he mentions how the orator Hortensius built an *aedes* in his Tusculan villa to house a painting of the Argonauts by the fourth-century artist Kydias, which he had bought for 144,000 sesterces (*NH.* 35.130). By this *aedes* we should probably

89. Rome, Palatine, House of Augustus, "lower *cubiculum,*" end wall with *aedicula.* DAI 82.2237.

understand a gabled, colonnaded structure. It might have been freestanding or a half structure attached to the wall. Although the frame of Pliny's story was presumably meant to confer a sense of enshrinement motivated either by homage or pride of possession, this visual mark of valuation was to enter ultimately into common, everyday use.[50] The situation is one in which the replica would seem to provide information concerning the model. Probably some not dissimilar framing elements were employed when real picture panels, or *tabellae,* as opposed to background settings, were displayed on the stage. Because it seems wholly plausible that an elegant Cyzicene dining room might be decorated with valuable pictures, the exotic identity fits both our *aedicula* rooms,[51] but these are not the only examples of the *pinacotheca* format to be found in the repertoire of Second Style painting. Having identified this pattern we can also invoke it to explain certain other wall schemes of the period that fit badly into the category of *scaenae frons* decoration.

The first example is a small *conclave* located within the peristyle of the Casa degli Epigrammi at Pompeii (Figure

90). This house belonged to the well-to-do family of the Valerii, whose first important member, as I have earlier mentioned, was Augustan magistrate L. Valerius Flaccus, who served as duovir in A.D. 1–2.[52] Originally the house contained a program of Second Style painting, the greater part of which was later replaced by decorations in the Third and Fourth Styles.[53] Perhaps the survival of the decorations in this small room might even be owing to the similarity between their compositional patterns and those of Third and Fourth Style *pinacothecae.* A series of five elegantly decorated *aediculae* standing on a projecting dado serve as the major partitioning elements of the wall. Their prominence is enforced by their imbricated scale pattern, a pattern that was popularly used for painting columns during this period. On the rear wall, these columns mark off three compartments that are further articulated by recessed pilasters standing in apparently lower relief. On the two side walls, the central *aediculae* are flanked by painted niches containing statues on pedestals. Sketches made at the time of excavation show refinements in the detail. The base of the rear walls includes a decorated predella.

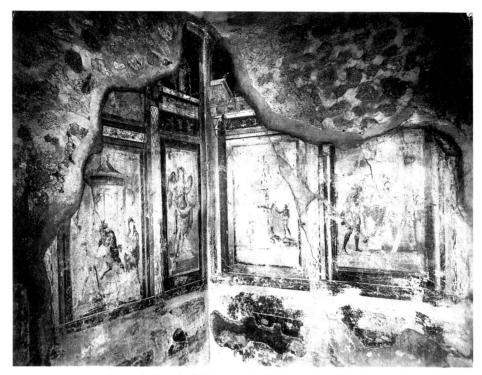

90. Pompeii, Casa degli Epigrammi, *pinacotheca* room. DAI 56.1218.

The five pictures, all of which depict figures acting within landscape settings, are among the few examples of figural painting whose status as literary illustrations is certified by an accompanying text.[54] A Greek epigram is inscribed within each frame. From left to right the subjects are (1) the wrestling contest between Pan and Eros, (2) the dedication of hunting, fishing, and bird-catching nets to Pan, (3) the two fishermen proposing a riddle to Homer, (4) the sacrifice of a goat to Dionysus, and (5) Dionysus (or Ariadne)[55] on a pedestal. Several scholars have speculated concerning the rationale to unite the subjects. Among the proposed themes are the power of the gods or the virtuous life. Such guesses do not violate the Roman spirit of the ensemble, because as we shall later see, the combinations of paintings brought together in Roman *pinacotheca* rooms frequently make sense in a thematic way, and are certainly deployed to induce the beholder to seek some common ground.

More important, however, are the cultural credentials to which the ensemble bears witness. The display of Greek epigrams advertises the owner's familiarity with the language; their close resemblance to certain texts in the Greek anthology might even suggest that these are variations on familiar originals that he had composed in the spirit of *aemulatio*. The cultural interest is further brought out by the fact that two of the statues are probably Muses: one a winged lyre player, the other a draped figure who may have held a globe.[56] Cultural vanity is

perfectly compatible with the social standing of the Augustan Valerii, a branch of a Roman family, whom Castrén classes among those supporters of the *princeps* who entered Pompeii during the period.[57] By this combination of statues and pictures, the room becomes thematically a little sanctuary of art in which we can recognize a miniature version of the *pinacotheca* for which Lucullus and his fellow Republican plutocrats were renowned. In his letter of commission to Fadius Gallus (*Fam.* 7.23.3) Cicero requests a selection of *tabellae* to install in his *porticula* at Tusculum, declaring that painting (*pictura*) is the species of objêt d'art that delights him most of all.

In the Casa degli Epigrammi, the thematic concentration on epigrams intimates associations with reading and reciting, yet the room provides little evidence on which to conjecture its function, except that its size seems smaller than could accommodate even a minimal number of diners. No more can its place within the decorative hierarchy of its original program be determined because all other contemporaneous decorations have been replaced. All the same its five panels set it apart from compositions of approximately equivalent date in other locations. A room that similarly combines an *aedicula*-framed painting with statuary occurs as part of a suite of small *camerae* in the Casa del Criptoportico (Figure 91) Here the statues are framed in the manner of paintings, while arched apertures flanking the art objects show colonnades and standing figures that might

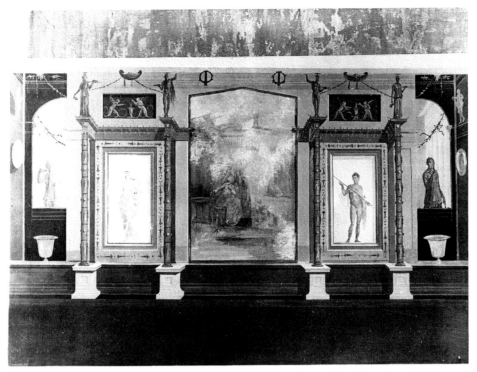

91. Pompeii, Casa del Criptoportico, underground *camera* with *pinacotheca* decoration. DAI 60.92.

be either statues or spectators. A room within the Second Style program in the House of Obellius Firmus contains only a single *tabella,* framed within an *aedicula* on the rear wall. The scene refers to the beginning of Sophocles' tragedy *Electra,* in which the protagonist and her sisters visit Agamemnon's tomb. Files of columns on the side walls interact with those of the peristyle visible through the broad entrance of the enclosure.[58] Clearly this room was the showpiece within a program encompassing all the rooms in its quarter of the house. No external information establishes its dating, but their introduction of a closed wall with an *aedicula* and the use of elaborate secondary ornamentation has led these decorations to be grouped with those of the House of Livia as transitional from the Second to the Third Styles.[59]

Turning once more to Rome we find for the first time a decorative program based almost entirely on *pinacotheca* schemes within the remains of a villa located by the banks of the Tiber. Four rooms and portions of three corridors comprise the ensemble, which occupied the wing at the side of a hemicycle turned away from the river. In comparison with the rooms, in the Houses of Augustus and Livia these are small, the two largest not quite four meters in length and three in height. Roughly similar in design, these two rooms construct an antechamber and alcove arrangement that foregrounds a series of richly ornamented *aediculae* against a background of panels in brilliant red. Although many as-

pects of these rooms resemble those of the two Palatine houses, their closed walls have impressed scholars as differing significantly from the pierced walls of the "lower *cubiculum*" or the room of the mythological landscapes. Placed on a shallow podium their architectural structures appear closer to the articulated surface of the wall. Omission of projecting ressauts and a reduction in the degree of forward projection in the *aedicula* also produces an impression of flatness. Above the upper cornice the paneling continues to form a frieze zone variegated by a number of interruptions: by niches for ornaments and candelabra and by shuttered pinakes. A hypothetical projection of the architectonic elements represented in Red *Cubiculum* B, as Irene Bragantini and Mariette de Vos have included it in their publication of the entire corpus, shows what a solid and complex architectural structure they constitute.[60]

In its opulent accumulation of ornament, this Farnesina decoration, is actually more closely comparable with the luxurious conglomerations of the Villa Oplontis or Boscoreale than the more restrained Palatine rooms. Brilliant colors complement the red background: blue and green in columns and pilaster, and added gold and white in panels of intricate tracery that stand for intaglio or *opus sectile.* While the central *aediculae* house panel paintings, those in subordinate positions form shallow bays framing candelabra in the shape of such deities as Isis and Fortuna, probably to be considered

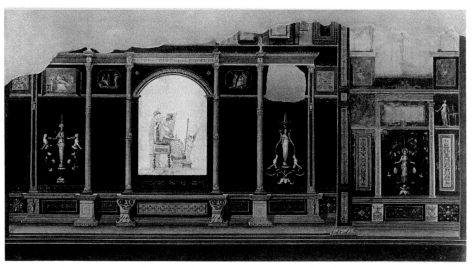

92. Rome, Villa della Farnesina, Red Room B, reconstruction drawing. DAI 37.1340.

more as art objects than emblems of religious devotion. Flanking the gabled *aedicula* on the end walls are Caryatids combined with Nikes in niches and the elaborate gable is itself crowned by a Nike. To complete the *pinacotheca* concept, a novel form of display is utilized on the end walls in the figures of kneeling sphinxes or telamones, who support small panel paintings in elaborate frames. On the side walls the friezes contain shuttered pinakes, but a still higher attic zone included a whole gallery of statuary now only partially preserved.

Above all a visible difference results from a reduction in the scale of the entire composition so that the fine points of ornamentation draw the spectator's attention more insistently. A new kind of brush technique has executed this ornamentation, one that creates its chiaroscuro and modeling effects by using single lines in place of shading. In consequence the spectator's visual impressions change in accordance with the distance from which he or she views the walls. As one enters the room the bright colors blend together to convey an overall sense of great richness. At middle range the component ornaments stand out with a chiseled clarity, which dissolves at closer range when their sculptural illusion fragments into patterns of lines and dots. One can recall how Horace in *Ars Poetica* 361–4 compares differences among poems to those of paintings, some of which are most pleasing viewed close at hand, others from far away.

That some concept of artistic selectivity distinguishes these Farnesina rooms may be deduced from the diversity of framed pictures that differ significantly from each other so as to suggest various origins and prototypes. The large *aedicula* panel on the left wall of Red *Cubiculum* B shows an elegantly robed Venus wearing a heavy gold crown and seated in a richly carved throne (Figure 92).[61] A female attendant, possibly Peitho, stands behind her draping her shoulders with a filmy veil, and a winged Eros perches on her footstool.[62] The style is that of a fourth-century white-figured lekythos. The two quadri on the end wall, which show seated women holding musical instruments, are also attributed to the lekythos style. The postures and compositions of these graceful figures are complementary. In contrast to their elegant spareness, the full polychrome painting in the aedicula of the end wall shows the nymph Leucothoe as the nurse of Dionysus with two other women.[63] These figures are placed within an architectural setting, a wall and a portal, typical of landscapes. In the companion room D, the same kind of selection pertains. Both in the antechamber and in the alcove, the *aedicula* paintings, as well as those of the end wall mounted on *tabulae,* are line drawings, whereas the *aedicula* of the alcove's end wall, less well preserved than its counterpart in B, shows a group of three women sometimes identified as Electra and her attendants at Agamemnon's tomb.[64]

The spectacular detail of the Red Rooms should not be allowed to overshadow the other rooms of the house. The enclosed space of the *White Cubiculum* E forms the terminus of a corridor extending from the hemicycle (Figure 93).[65] Its white ground color continues that of the corridors. Smaller in compass, with aediculated alcoves at its opposite ends, and a closed paratactic wall in its center, it seems like a variation on the form of the Cyzicene *oecus* but without the windows. Columns resting on telamones partition central walls into eight panelled compartments, each of which contains a female figure centered within a bordered panel. De Vos likens the style of the representations to that of Attic

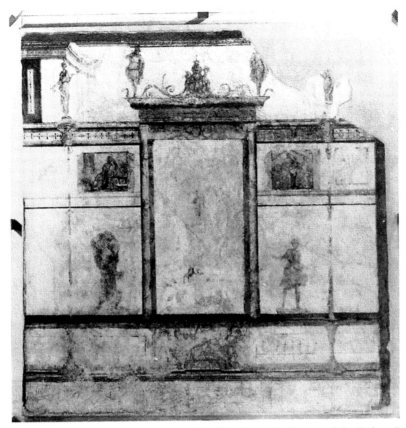

93. Rome, Villa della Farnesina, Alcove wall, White Room E. Photograph by Barbara Bini.

vase painting.[66] This is most clearly apparent in the well-preserved image of a woman decanting perfume.[67] Her activity might be considered preliminary to a banquet because the remainder of the women are carrying objects of some sort. On the alcove walls the *aediculae* are flanked by statues that, like those of the Casa degli Epigrammi, have been considered as representations of the Muses. Walls in the corridor spaces outside the room are paratactically decorated with caryatids and garlands; in-tercolumniations in the frieze zone alternate landscapes with theatrical masks and musical instruments.

More squarely architectonic in construction are the walls of the *cryptoporticus* A that formed a terrace on the Janiculum side of the villa.[68] Here the form of the colonnade is echoed by the designs on facing walls that extend its spaces (Figure 94). A series of sturdy columns set on projecting pedestals partitions the space so as to frame the paratactic panel sequence of the rear wall.

94. Rome, Villa della Farnesina, Drawing of *cryptoporticus* A, partial length. DAI 8090.

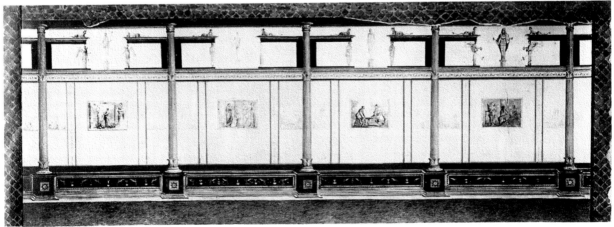

At the center of each panel is a figured *tabella,* and the walls directly behind the columns feature unframed monochrome landscapes at eye level whose effect is to render these areas transparent with a sense of continuing depth. Open pediments in the upper zone frame statuary and rest on a variety of caryatid figures. Fine details in the articulation of cornices and columns compare with those of the interior rooms. Although the difference in scale and structure between this decoration and the more slender elements in the corridors has often been interpreted as a sign of chronological separation, it can with equal plausibility be explained by location. Because of its outward orientation, the *cryptoporticus* takes the form of a constructed *porticus,* whereas the more attenuated forms decorating the enclosed corridors suit their narrow spatial confines.

These points lead us to consider possible interrelationships between the locations of the rooms and their function. All three of those commonly termed *cubicula* make use of an antechamber and alcove arrangement, the alcoves being larger than the antechambers, just as they are in the dining rooms of the Villa Oplontis. Such a spatial demarcation suggests the employment of the interior portion as a unit with the exterior as entrance and service space. On the plan of the house we can see that they occupied lateral wings extending from the hemicycle. Rooms B and D were contiguous to the *viridarium,* and their principle entrances gave on that space. These two rooms afford ample room for dining couches. The Black Room C was a *conclave* with a doorway facing a kind of forecourt that was likewise oriented facing the *viridarium.* The paratactic nature of the decoration in room C and in the corridors fulfills the guidelines of spaces intended for motion; however, the fact that the corridors face the river and therefore look toward the Campus Martius might be considered in interpreting the small landscapes framed within their frieze zone as suggestions of the view beyond the walls. Likewise a large number of references to music and dancing seem to carry out a unified theme.

Recently the Palatine has yielded a comparison point for these rooms in the so-called upper *cubiculum* of the House of Augustus, pieced together from fragments of fallen plaster (Figure 95).[69] Here also the colors are brilliant and a particular richness is achieved through the simulation of borders and inlays that can be taken for intarsia work, presumably executed in colored marbles. This decoration includes several motifs of an Egyptianizing nature, birds, lotus flowers, and other items associated with the Egyptian landscape or the cult of Isis. Eager to maximize the symbolic significance of these ornaments, Carettoni has called them celebrations of Augustus' Egyptian victories, even suggesting that Alexandrian painters introduced after Augustus' conquest had been specifically commissioned to incorporate Egyptian motifs into the decorations in reference to the event.[70] The Farnesina likewise includes Egyptianized motifs in its candelabra representing Isis and Fortuna. Even more topical is the pattern of alternating cobras and lotus flowers decorating the cornice of the so-called Aula Isiaca, a vaulted *pinacotheca* also of early Julio-Claudian date discovered in isolation beneath the foundations of Domitian's aula basilicata. All these images may easily be understood as a fashion equivalent to the chinoiserie of the European seventeenth and eighteenth centuries. Stylization is their keynote. The cobras with looks not unfriendly and little leaf clusters crowning their heads puff themselves upright from curled acanthus tendrils. Stylization tames the exotic; ornament thus domesticated lends itself aptly to the new reduced scale. Perhaps it is not beside the point that the aesthetic of the Hellenistic poet Callimachus symbolically adopted by Augustan poets from Vergil to Propertius and Horace foregrounds the *tenuis* as a mark of literary artistry.

Among the modes of stylization characterizing these paintings in general, the most novel is the tendency to combine vegetable ornament with postures of the human figure. In the complex frieze areas of the Red Rooms caryatids support finials, which in turn support the entablature cornice of the frieze. In the paratactic white corridors and black room, such figures are mounted on very thin dividing columns and bear even weightier burdens on their heads. Another balancing act is that of the Nike perched at the summit of the gable on complex arabesque tangles of stalks and tendrils. The novelty of these elements is corroborated by what the architect Vitruvius has to say about the development of ornamentation in the paintings of his own day.

As we have seen in discussions of late Republican painting, this writer's understandable predilection for architecture, reinforced by a culturally conditioned fondness for naturalism, shapes a taste that is closely in sympathy with the wall schemes and images of the Second Style. Although productions of the recent past draw his praise, he claims that this alliance of style and subject has currently suffered decline. Both painters and patrons, he declares, are blameworthy for a monstrous corruption of taste (*de Arch.* 7.5.3):

Sed haec quae ex veris rebus exempla sumebantur, nunc iniquis moribus inprobantur. [Nam pinguntur] tectoriis monstra potius quam ex rebus finitis imagines certae: pro columnis enim struuntur calami striati, pro fastigiis appagineculi cum crispis foliis et

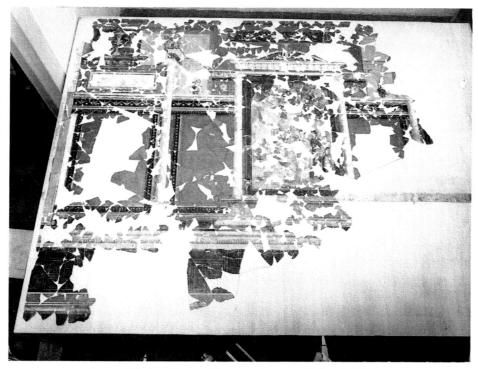

95. Rome, Palatine, House of Augustus, "upper *cubiculum*." DAI 82.2154.

volutis, item candelabra aedicularum sustinentia fig-
uras, supra fastigia eorum surgentis ex radicibus cum
volutis teneri plures habentes in se sine ratione seden-
tia sigilla, non minus coliculi dimidiatia habentes sig-
illa alia humanis, alia bestiarum capitis.

[But these examples which are taken over from
genuine objects, now are denigrated by reason of cor-
rupted customs. For monstrosities are now painted on
plaster work, rather than determinate images from
substantive models: in the place of columns are dis-
posed fluted stalks; in the position of acroteria are
gew-gaws with curled leaves and volutes; likewise
candelabra holding up the figures of their gables,
above their summits fragile shoots arising from roots
having statues seated within them, devoid of all logic,
and no less calyxes holding statue busts some with
human heads and some with the heads of beasts.]

Paradoxically Vitruvius' complaints about the new fash-
ion of images pay tribute to the success of trompe l'oeil
in lending a convincing appearance of weight and di-
mension to the unreal. This same technique that had
molded the naturalistic forms he had valued in earlier
paintings now violates that prescript that determines the
very essence of a painting as something "that has been,
that is or can be" ("Haec autem nec sunt nec fieri pos-
sunt nec fuerunt"). Such forms, as he declares could
not sustain their structural function in real settings. No
reed can support a roof; no more can a seated statue

rest on a stalk. Therefore the paintings have entered a
realm of willful fantasy, a development that is the more
to be deplored because it results from such a concinnity
between the capricious whims of the painters and the
taste of their patrons (7.5.4):

At haec falsa videntes homines non reprehendunt sed
delectantur, neque animadvertunt, si quid eorum fieri
potest necne. Iudiciis autem in infirmis obscuratae
mentes non valent probare, quod potest esse cum auc-
toritate et ratione decoris.

[But persons viewing these false objects make no
objections, but are delighted, nor do they pay any
attention whether any of these could or could not
exist. For minds clouded in weak judgements haven't
the ability to discern what can exist with the authority
and reason of propriety.]

Considering these animadversions in the light of Vit-
ruvius' background makes them appear especially per-
verse, and even self-contradictory. As an architect he
should certainly have acknowledged the traditionally
accepted nature of such elements as the caryatid, es-
pecially in view of his having recounted at some length
the legendary history of how these figures came to be
the bearers of a burden (1.5–6) along with their male
counterparts, the Persians. Not only does he insist on
the need for architects to know these stories, he also
gives his aesthetic sanction to these figures as "having

greatly enriched the diversity of their works." Also, in view of the architectural imitations on which he has earlier bestowed his praise, it does not make sense that he is simply reacting against pictorial appropriation of these forms. Rather it is the very dynamics of fashion resulting from an interaction of craftsmen and patrons that seems to disturb him. Elsner has suggested that the apparently conservative bias displayed here propagandistically serves the Augustan fiction of restoring the Republic, yet even the *princeps'* own decorations were not impervious to the new mode. The reactionary aspect of Vitruvius' censoriousness lies in his refusal to acknowledge the identity of the *pinacotheca* as an amalgam of ornament and pattern.

In view of Vitruvius' Augustan context, his animadversions have supplied the historians of pictorial chronology with a pivotal point for dating. By his testimony they assign any wall scheme in which caryatids, vegetal columns, or other such forms appear to the Augustan period. Yet the *princeps'* rule was a long one, whereas the architect's exact dates are unattested,[71] so one must assess critically the practical assumptions derived from his remarks. Also one should look skeptically at chronological conclusions proceeding from theories about the owners of the paintings. All aspects of their interpretation have been greatly influenced by the notion, first introduced by Beyen, that the villa was built as a residence for Augustus' daughter Julia. Construction having been inaugurated in anticipation of her marriage to Marcellus, its completion and decoration were suspended, in the aftermath of his premature death, until her remarriage to Marcus Agrippa.[72] Beyen's argument for this idea rests on one material point: the nature of the masonry and one conjectural point: the proximity of the site to a bridge that Agrippa had built across the Tiber that gave access to the naval yards and the Campus Martius, in both of which he had particular interests. For the art historian, the benefit derived from introducing Julia as patron is that of linking the highly refined style and execution of the decorations with a figure whom the literary sources have commemorated for a sense of style. Preceding Beyen's proposal, scholars had postulated an owner of an earlier generation, but with a similar cast of personality, because the villa was first associated with Catullus' Lesbia (in real life the Clodia married to Metellus Celer) on the basis of Cicero's description in *Pro Caelio* 15.36 of her strategically located Tiberside *horti* where Rome's jeunesse dorée came to swim. Although Beyen invoked the reticulate masonry of the villa in opposition to such a Republican date, his very proposal should remind us how many Roman aristocrats of the Republic and early Empire did own

villas on this desirable strip of land. Although we can unhesitatingly consider the villa an elite property, we cannot with any certainty assign ownership to a known historical personality.

On the hypothesis of their association with Julia's second marriage, Beyen influentially set the date of the paintings at about 19 B.C., a point of time that fixes their place in the progressive sequence of paintings from the House of Augustus and House of Livia that they are said to resemble, although on a more advanced and attenuated basis. But adding the Palatine "upper *cubiculum*" into this series introduces certain considerations capable of upsetting this neat chronology. Historical sources report a serious fire that ravaged some part of Augustus' Palatine residence in 1 B.C. According to Suetonius and Cassius Dio, the damage was serious enough that money for restoration was raised through public subscription, although Augustus did not accept it for that purpose (Suetonius 57.2). Perhaps the subscription had to do with the fact that Augustus, on assuming the role of Pontifex Maximus had made a part of his house public property. Whatever the circumstance, one might ask what allowance should be made for the redecoration of Augustus' house within our chronological presuppositions. The extensive suite of rooms around the peristyle on the lower story seems complete and shows no evidence of change except for the sometime blocking of the niche in the large *oecus,* but the stylistic differences of the upper *cubiculum* are a different matter. Here perhaps is the area in which damages had to be repaired.

Needless to say the attribution of so late a date to these paintings would work havoc with the traditional chronology that has the beginnings of Third Style development well underway at about 20 B.C., and a mature point achieved before the close of the century,[73] but already three of the most chronologically oriented analysts of the style, Bastet, de Vos, and likewise Wolfgang Ehrhardt, have called certain traditionally sacrosanct dates into question.[74] Ehrhardt's approach to the study eschews a one-by-one succession in favor of "stylistic groupings." This is a reasonable way to approach the unknowable and absolutely unverifiable.

GALLERIES AND HOUSES OF THE THIRD STYLE IN CAMPANIA

Although the existence of the Room of the Epigrams within a Second Style Pompeian program indicates the autonomy of the *pinacotheca* form within the city, without necessary obligation to its developmental history at Rome, it is also true that both cities witness an increasing popularity of the form. With this development

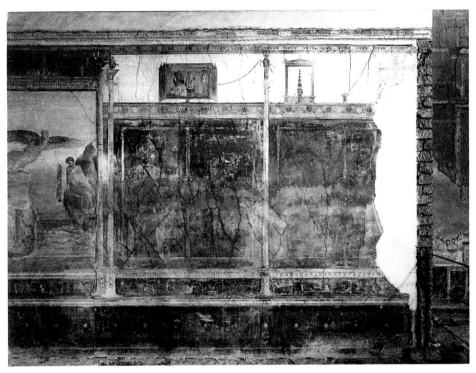

96. Pompeii, Villa Imperiale, *pinacotheca* room. DAI 64.2286.

comes a change in the decoration of high-status areas from perspectival vistas and constructions that valorize the entire wall surface to symmetrical compositions focused on their central panels. Whereas the assemblage of paintings in the Red *cubicula* of the Farnesina is eclectic, perhaps even conceived as a deliberate collocation of stylistic variations, the collections displayed in Pompeian versions of the gallery adopt less idiosyncratic and more overtly thematic principles, even involving the imitation of specific models or types. In Pompeian embodiments of the gallery style dated early because of the thickness of their architectural members, the paintings displayed are large-scale images in what is called the Greek mode.

One example often compared with the Red Rooms of the Villa Farnesina for its similarly refined detail is a vaulted *pinacotheca* room of ample proportions in a building commonly known as the Villa Imperiale, which features three large-scale paintings associated with Theseus and the Cretan Minotaur (Figure 96).[75] Architecturally, however, the Pompeian scheme is far simpler, lacking the columniated bays that partition the walls of the Red Rooms. Instead the shallow projecting *aediculae* stand in conspicuous isolation at the centers of red-paneled walls, which on either side are subdivided by only a single attenuated shaft supporting a caryatid. The composition resembles the paratactic white corridors of the Farnesina more closely than the elaborate Red Rooms. The caryatid figures holding garlands rise into the frieze zone, where their polychrome coloring stands out against a white background, along with shuttered pinakes and stylized floral arrangements framed within miniature *aediculae*. But those few structural elements that do exist are elegantly articulated. Acanthus scrolls pattern the shafts of the *aedicula* columns while the dividing columns have calyxlike bases studded with gems. Both the cornice and the pedimental entablatures are decorated with a refined and elegant lotus pattern in blue, purple, and gold. This stucco relief bordering imitates metalwork applique, as real examples show. Finally one may note that the selection of subjects and styles is not eclectic but unified: a set of three pictures centered about the Cretan adventures of Theseus is clearly the work of one painter.

Another room of the building with extant decoration on only one wall introduces gold panels flanking the central quadro along with the red. The entire complex poses interpretive questions. The elevated title of Imperial Villa commonly attached to the structure rests on no more conclusive evidence than the scale of the building and quality of the work. Located just outside the walls of the Porta Marina and below the Temple of Venus, it comprises a group of three rooms with a long exterior colonnade but was undoubtedly once larger than these remains, perhaps consisting of two conjoined wings.[76] The extant rooms, clustered at the corner of the portico, are not interconnected but surrounded by corridors as if to allow for the passage of servants in attendance.

The arrangement suggests banqueting, and the nature of the decoration indicates high status. Adding that the location commands an exceptional view of the shipping and seashore activity at the mouth of the Sarno river, Richardson proposes that the complex comprised a suite of meeting rooms, possibly connected with the temple of Venus, for use by the magistrates of Pompeii. Given the absence of any other apparent entrance to the complex, a close association with the temple seems likely. Such a public designation would be in keeping with the choice of decorations for the room. The subject of Theseus was associated in Greece with public life. The Theseon at Athens displayed a series of paintings by Mikon. Whatever the use of the complex, it was apparently discontinued after the earthquake; the rooms were found filled with rubble.

A continuing history of *pinacotheca* decoration unfolds a spectrum of variations in structure and ornament within a now canonical scheme. Generally the framed *aedicula* dominates the wall; its columns may be single or multiple, but they are regularly slender and variegated with patterns or floral designs. The chronologically ordered survey of the Third Style by Bastet and de Vos catalogues these variations in detail.[77] In combination with *aediculae* are ornamental cornices, often simulating inlay. Predellae are frequent; pinakes are sometimes used, although they are more likely to contain signs of hospitality – food or masks – than figural compositions. Occasionally they frame small sacral idyllic landscapes. Additionally the slender architecture of the central walls may be carried into frieze zones where openwork constructions, niches, or even pavilions and balconies may appear. Sometimes the separating members are pilasters or half-pilasters; sometimes they take the shape of exiguous, intricately wrought candelabra situated within shallow niches. The effect of these differences is, of course, to shift emphasis from architecture to the *aedicula* and its paintings.

Another development in these new compositions that is fully as important as their use of a closed background wall is their diminution from the large-scale imitative designs of the Second Style, which addressed themselves clearly and boldly to spectators standing at a distance. Of the large-scale decorations attributable to the early Julio-Claudian period, the *oeci* in the House of Livia and the House of Obellius Firmus comprise practically the last examples. As we have already seen in the decoration of the Farnesina rooms, paintings in the newer style create a double impression. Here the painters mold the appearance of form through the use of a single line technique that seems three-dimensional when seen from a distance but sketchy at close range. Subsequent Third

Style paintings procure their chiaroscuro by the more familiar plastic techniques of light and dark shading, while they miniaturize the forms themselves. Because the side walls of the room in the Villa Imperiale are long in proportion to the size of its *aediculae,* the decorative scheme appears spare with its series of unadorned red panels, and the ensemble gains a somewhat odd appearance for the discrepancy between its large-scale dimensions and the relatively fine detail of such ornamentation as the acanthus columns with their slender rinceaux.

The paradigmatic example of refined decoration occurs in a series of *pinacotheca* rooms in a villa commonly known as Boscotrecase, which like the Villa Boscoreale, was situated outside the city on the slopes of Vesuvius. That this incompletely excavated villa was begun during the late Republic is evident from the Second Style paintings remaining in the peristyle.[78] Its formal reception area has not been excavated, however, nor have the agricultural quarters that so large an establishment must surely have possessed. The house has slave quarters and a series of rooms opening onto a long walkway commanding a view of the bay. Three of these chambers were painted with monocolor backgrounds, respectively red, black, and white. All have fully closed, paneled walls with *pinacotheca* decorations composed of *aediculae* and candelabra, both incorporating many small ornaments of a particular delicacy and refinement. Unlike the Farnesina, these paneled walls do not simulate *opus sectile,* and their architecture consists of continuous easel and cornice structures that appear to stand flat against the wall. Seen from a distance their slender members appear almost rigid and austere. Only when the viewer has moved closer to the surface of the wall does the intricate workmanship of the decoration become clear: the jewellike scales that form patterns on the *aedicula* columns, for instance, or the fine windings of metal that make the candelabra seem so graceful. The paintings displayed on the easels represent two popular new subjects of the period, mythology and landscape, and these also, because of their small figures, must be observed at close range. Here again we may think of Horace's distinction in the *Ars Poetica* (361–2) between paintings meant to be seen close at hand and those intended for distant viewing. In fact this intricacy of workmanship is fully compatible with the contexts of the decorations because they are for the most part located in small rooms.

This diminished scale should be kept in mind as we turn from initiatory examples of picture galleries to study their key position in that Julio-Claudian mode of painting known as the Third Style, whose hallmark is the enclosed, fully paneled wall. As a preliminary to this consideration of Third Style programs in Pompeii,

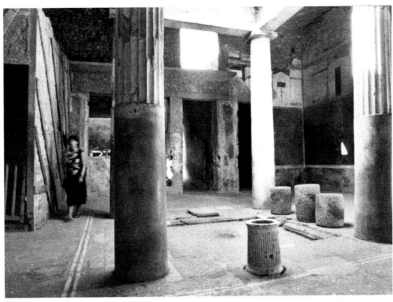

97. Pompeii, House of Ceius Secundus, Third Style atrium. Author's photograph (su concessione del Ministero per i Beni e le Attività Culturali).

it is important to notice where and under what circumstances it occurred. Although the extant number of Third Style rooms, including those with only one or two preserved walls, is greater in sum than the total of Second Style rooms, their distribution is different. Whereas the large Second Style programs belong to houses outside the confines of the city, Third Style rooms can be found in locations throughout Pompeii. Unlike Second Style decorations, they seldom exist within the context of comprehensive programs. Thus Richardson from his architectural standpoint remarks on changed building practices during the Julio-Claudian period: the absence of large, regular houses completely decorated in Third Style, the preponderance of small houses and the appearance of idiosyncratic complexes.[79] One must, of course, make allowance for accidents of preservation. Some Third Style decoration will have been destroyed in the earthquake, whereas a few houses found with denuded atria, but a full complement of *pinacotheca* rooms, will conceivably have contained full Third Style programs at an earlier point in time. A notable example is the so-called Accademia di Musica of Region 6.[80] These are infrequent enough, however, to bear out Richardson's suggestion that the period did not witness extensive domestic building on the late Republican scale. What did take place was restructuring and redecoration, occasionally of an entire house, but more often on a minor scale affecting only a few rooms such as the addition of a bath suite might have necessitated. Thus we see in the rooms fronting the platform of the Villa dei Misteri a series of changes including the remodeling of an

L-shaped room with monumental Second Style decorations into two smaller vaulted chambers with central *aediculae* and flanking closed panels (Figure 62). Also in the passage that lead from the atrium into an apsidal *tablinum* overlooking the bay was a simple black-ground decoration with ornaments. In the Insula Occidentalis, with its many period layers of remodeling, are clusters of Third Style rooms. The consequence of this architectural difference, whatever its causes, is that we have for this period few samples of a complete programmatic hierarchy such as can be seen in Second Style houses. In seeking such a program we must, of course, look first at the "canonical" houses.

Among these the House of Ceius Secundus most approaches the specifications insofar as its entrance corridor leads directly into a tetrastyle atrium, but this atrium is a diminutive, boxlike square whose interior space is wholly dominated by the columns surrounding its large *impluvium* (Figure 97). In place of the usual side chambers, there is in each corner a relatively large *conclave* in various locations, making them appropriate for use during different seasons. That at the rear opens into the peristyle with a view of the megalographic painting on the back wall. Except for one additional *conclave* within the *viridarium*, these indoor rooms appear as the principal provision for social dining, whereas other accommodations had been transferred to an upper story only recently constructed over the front quarters of the house. At the back was a small garden decorated during a later period with the panoramic animal hunt earlier described in this chapter.[81]

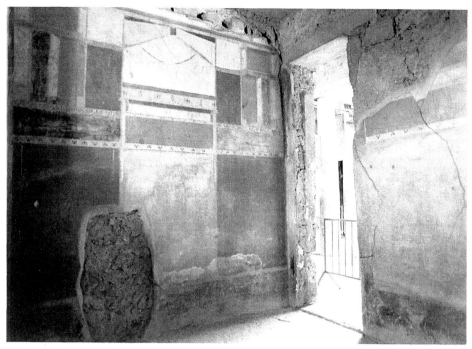

98. Pompeii, House of Ceius Secundus, Third Style *conclave* off atrium. Author's photograph (su concessione del Ministero per i Beni e le Attività Culturali).

Within the interior spaces the paintings show a certain consistency that appears to take account of the visual character and potential function of available spaces. Although the columns are large for the constricted area of the atrium, they stand against a restrained paratactic decoration of solid red and black panels with only small flying figures for ornament. The virtue of the spatially oversized *impluvium-conpluvium* is its generous admission of light whose effect is picked up by the white stucco tops of the columns and by the deep white frieze zone.

In the small rooms surrounding the atrium, the schemes are similar. Patterned intaglio cornices that mark the divisions of panels and frieze give a geometrical appearance that is virtually two-dimensional, but the *aediculae* contain figured panels (Figure 98). The red and black of the atrium are repeated in the elaborate room at its rear, decorated with a variety of vegetal ornaments and Dionysiac motifs. The single *aedicula* frames a landscape featuring the god's statue on a pedestal within a grove. Additional columns flank pilasters with graceful decorations of grapes and vines. When repairs for these spaces were needed, whatever may have been the reason, they involved imitations and patchwork. As some have argued, the decorations of the *conclave* at the front, consisting of panels and white apertures, but little tapestry, were done ex novo in imitation of the Third Style. Their colors, which were both lighter and brighter than those of the atrium, may have answered to the need for light

in a space with only small windows.[82] The largest of all the rooms accessible from the rear of the atrium, and opening on its opposite side into the *viridarium*, was coated with rough plaster but contained remains of furniture decoration, suggesting the presence of couches in use.[83] In a house so small the occupants may have had no alternative to dining in a room with decoration that remained incomplete.

One instance of a complete Third Style program in a house that is both large and traditional is the Casa del Marinaio (7.15.1.2), originally a canonical atrium house of the early second century, in which a steady program of enlargement seems to have attended the owners' discovery of a route to prosperity in the grain trade.[84] Further enlargements during the Republican period made little change in the structure of the central core, yet the presence of covered-over Second Style decorations indicate that a campaign of redecoration took place, perhaps after a second atrium was added beside the first. The most massive rebuilding, which entailed a full program of Third Style redecoration, was coordinated with the installation of a full-scale business and storage area in the rooms below the house. The decoration was both complex and elegant. The atrium's wall space was restricted by the regular placement of *cubiculum* openings, and black panels framed colorful images of the Four Seasons. Surrounding rooms featured a large number of *pinacothecae* decorated with mythological landscapes

99. Pompeii, Eumachia Building, exedra with statue of donor against Third Style wall. FU 24769/1981.

in the continuous narrative mode.[85] Along with exedral *alae* in complementing colors the surrounding *cubicula* had also been repainted. The major rooms were at the rear of the house, flanking the *tablinum,* but opening in the opposite direction with views of the sunken garden.[86] Also at the back was a complete *pinacotheca* with four mythological *tabellae* in a room connected to the baths.

From these examples we may extrapolate the conventional Third Style program; its atrium will have had a paratactic arrangement of panels in solid colors with upper-story decorations of the loggia type. In some cases small central figures may have adorned the panels, and their divisions might be marked by candelabra,[87] slender columns, or inlaid border strips. Such decorations appear also in public contexts as we can see in the Crypt of the Eumachia building where slender columns behind the donor's statue create a colonnade that projects subtly forward from the wall (Figure 99). On the staircase the panels are separated by candelabra. Gold border strips with figured inlay interrupt dark panels in the atrium of the magistrate, M. Lucretius Fronto, generally con

sidered a late manifestation of Third Style.[88] Restraint here spells elegance. The spare paratactic format harmonizes with the multifaceted decorative makeup of the *tablinum* where subject paintings compete with the rich ornamentation of a brilliantly colorful *pinacotheca* composition (Figures 15 and 69).

Among the irregular houses the Casa di Jasone, located at a quiet, out-of-the-way corner of the Vicolo di Tesmo, may have possessed one of the most extensive programs. Paintings from three rooms transported to the Naples Museum are the partial survival from a probably much more extensive program replaced by Fourth Style decorations when the northern quarter was almost entirely rebuilt after the earthquake. Lacking the conventional atrium entrance space, the configuration of rooms more resembles Vitruvius' notion of Greek design than Roman because its core space is a peristyle constructed around a stone basin that serves as a center of rooms of varying size. That its use was actually residential is suggested by the several objects for personal use and bronze serving vessels that were found during excavation.[89] According to Zevi, who has most

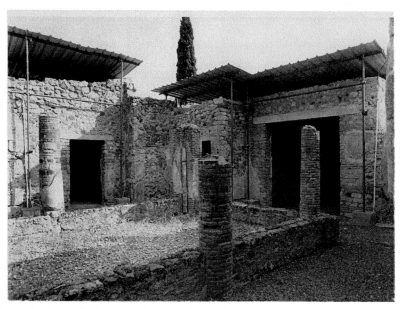

100. Pompeii, House of Sulpicius Rufus, central space facing garden exedra. Author's photograph (su concessione del Ministero per i Beni e le Attività Culturali).

recently analyzed its building history, an original fabric of *opus incertum* identifies it as a colonial house built on previously unoccupied land, but resystematized with an original Third Style decoration.[90]

At the southwest side was a series of three *pinacothecae* with simple, geometrical decorations featuring gold-paneled walls and slender columns. Their signal distinction rests in the apparent deliberateness with which the paintings in each were selected to compose ensembles with both visual and thematic interconnections. The largest room, which opened with a wide door directly on the center of the *viridarium* room was divided into an antechamber and alcove.[91] Spare panels ornamented with single figures occupied the paratactic middle zone of the entrance. Decisive moments or moments of recognition marking transitions in the careers of young heroes unite its three pictures: Jason arriving at the court of Pelias, Phoenix on Sciros, Dionysus supervising the toilet of Pentheus. In a smaller room three scenes from tragic drama are united by their common use of stage architecture: screen walls surrounding a central door. Thematic emphasis falls on a moment of decision as Phaedra prepares to accost Hippolytus, Medea to kill her children, and Helen to depart with Paris.[92] In a third combination, Jupiter in the form of a bull courts Europa, while the Centaur Nessus urges Heracles to entrust him with carrying Deianira across a flooded river.[93] With gestures that point toward actions ensuing offstage, all these ensembles supply ample subject matter for spectators to discuss.

Another small complex of spaces known as the House of Sulpicius Rufus, Region 9.9.18 had likewise no

atrium at all. Much smaller than the Casa di Jasone, its plan has the characteristics of a large *diaeta,* a suite of rooms grouped around a peristyle with an enclosed kitchen located at its further end (Figure 100). Perhaps its real function was that of a gathering place for banquets. The most notable room, a *conclave* with a broad doorway opening onto the end of the peristyle has a form of garden decoration unlike any other known in Pompeii. One might call it a Cyzicene plan in reverse, because it combines solid red panels and simulated windows with the latter placed not at the ends, but rather at the center of the wall (Figure 101).[94] These open on garden vistas that were once colorful, but also, by reason of the exact symmetry with which their small pavilions, statuary and shrubbery were disposed, had an air of formal stylization that made them more artful than illusionistic. The panels are divided by niches holding intricate candelabra.[95]

If Pompeii did in fact have a center of Third Style decoration, our extant evidence locates it on the Via dell'Abbondanza and especially on the southern side of the street where a number of houses of probable second-century origin had retained their initial ground plan and distribution of rooms. Especially two houses of insula 1.9 that, like those of insula 9.5 discussed earlier, had been structured long and narrow to accommodate a full sequence from entrance to peristyle kept pace with each other in redecoration. Although both were in the process of postearthquake redecoration with some rooms still incomplete, their owners seemed concerned to preserve whatever remained intact. For the Casa del Frutteto this was the two garden rooms already mentioned: the blue-ground, daylight garden off the atrium

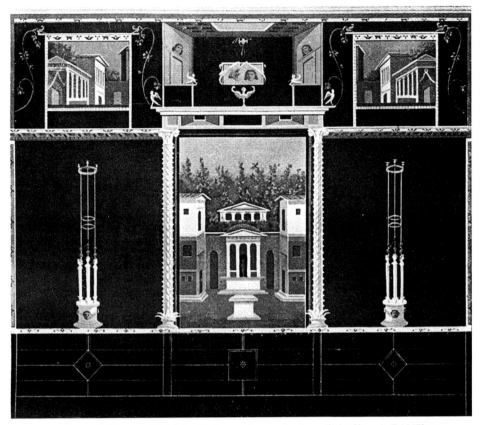

101. Pompeii, House of Sulpicius Rufus, garden exedra (so-called *tablinum*). DAI W387.

and the black-ground night garden located at the back of the andron, beside which stood a fine black *pinacotheca* containing a set of four mythological landscapes (Figure 102). Its near neighbor, the Casa di Bel Impluvio, is similar in plan and contains on a partially preserved wall the single example of a Third Style *tablinum* decoration from the period. The composition is tripartite and rich in design elements with a double tier of columns. Red side panels flank a complex center containing an *aedicula* with a winged *porticus* of narrow-banded columns, shield masks and framed pictures. What the contents of the *aedicula* might have been is uncertain, but it appears to have been of sufficient breadth to have contained a figured panel, and the room may even have had an antechamber division. Behind the andron are remains of a black decoration similar in the detailing of its cornices and columns to that of the similarly positioned black *pinacotheca* in the Frutteto; it is one of few examples of Third Style decoration by the same workshop.[96]

Another house in nearby insula 7 that once contained a full program of Third Style paintings is the Casa del Sacerdote Amando, a truly diminutive dwelling whose total ground space occupies no more than a tenth of its irregularly carved up insula.[97] The house shows the effects of this irregularity in the unusually long entrance

corridor, sandwiched between the corner bar and a street front shop, that leads into its tiny atrium.[98] Within this small space are packed no less than ten rooms, including a two-sided peristyle with contiguous chambers entered through a connecting exedra open at both sides. The remains of a balustrade over the *porticus* suggest that the second story was also incorporated into active living space. The house is well known for its diminutive *pinacotheca* that includes continuous narrative representations of the two Boscotrecase subjects, Polyphemus and Perseus, that are similar in compositional pattern to their prototypes yet so altered in detail as to invite the spectator to a revised reading of the stories (Figure 103). To these, with obvious attention to the theme of travel, the subject of Daedalus and Icarus has been added.[99] A conspicuous difference of style and background composition sets the three pendants apart from the representation of Hercules and the Hesperides that constitutes their fourth member. Although the subject matter fits the thematic emphasis on journeying, its large figures and vestigial background mark it as a composition added at a later moment.[100]

The fact must not be overlooked that Third Style mythological painting achieves a subtle integration of style and thematic complexity previously unknown in

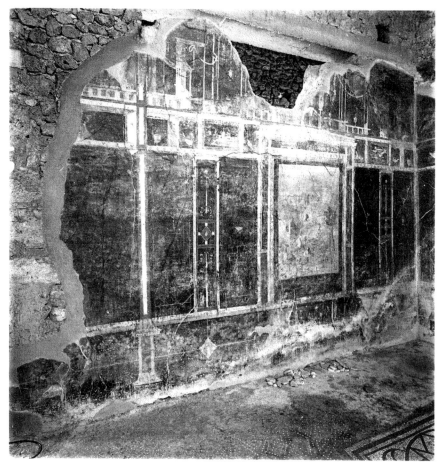

102. Pompeii, Casa del Frutteto, black *pinacotheca*. ICCD N34972.

extant Roman ancient painting. Over and beyond their refined and often intricate ornamentation, its *pinacothecae* are distinguished by a novel form of subject painting commonly called continuous narrative. With an emphasis on plotline, this manner of treating myths employs recurrent images of one or more principal figures to adumbrate a sequence of actions. Although certain standard patterns can be recognized among figure groups, such as Diana and Acteon, that recur in a number of paintings, many features of the individual compositions are unique. In place of architectural backgrounds, these panels use prospects of an almost uncultivated aspect centered often about picturesque dolmens, caverns, or monuments as the stories require. The new departure in landscape involving vegetation and shrines as focal centers for the action closely parallels the sacral-idyllic painting that was contemporaneously popular and demands similar skills and techniques.

One effect of these new compositions is to create an apparent divorce between the apparently public affiliations of status decoration, as we see these realized by First and Second Style ensembles, and a more

private signification. The point has been often made with reference to the celebrated paintings in the Villa Boscotrecase. For this reason the Boscotrecase paintings have readily lent themselves to an analysis centered on the aristocratic good taste of their patrons, here again as in the Farnesina, considered as Augustus' daughter Julia.

Perhaps, all the same, one should reflect whether a woman with Julia's inclinations and lifestyle would find residence on the slopes of Vesuvius sufficiently amusing to merit a major effort of interior decoration. In the Tiberian period the villa was the property of a Julio-Claudian freedman, T. Claudius Eutychus, and there is no reason to think that the decorations were commissioned by anyone else.[101] To assume, as von Blanckenhagen does, that a freedman could not be responsible for so high a level of decoration is greatly to underestimate the culture of such persons in the imperial period. Nor should we so overestimate the refinement of the paintings. When their graceful forms are compared, as Bastet and de Vos have done, with decorations from within Pompeii, many parallels appear. Comparably

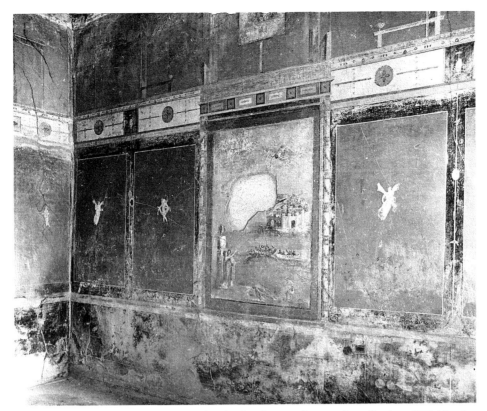

103. Pompeii, Casa del Sacerdote Amando, Third Style *pinacotheca* opening off atrium. DAI 66.1784.

elegant flower sprays, for instance, decorate the black "winter triclinium" in the House of Ceius Secundus.

Similar combination of mythological landscapes and intricate decorations were particularly favored on the Via dell'Abbondanza. Especially continuous narrative flourished here. The refined detail of these small figure paintings, whose interwoven stages of action invited close inspection, harmonized well with the small-scale ornamentation of these rooms – their intricate floral candelabra, inlaid cornices, jeweled columns, and other details of their contexts. Notably a certain selection of subjects achieves preeminence in this mode: Acteon, Dirce, Perseus, Polyphemus, Daedalus.[102] If we look for a source from which this treatment might derive, it is in all probability the theatre, whose standard settings may even be explicitly suggested by such backgrounds as Andromeda's cliff, Polyphemus cave or the cavern on Mt. Cithaeron. The complex four-stage presentation of the drama of Antiope and Dirce, appearing almost identically in the House of Julius Polybius and in the Casa del Marinaio, demonstrably employs images belonging to the actual staging of the play.[103] These two panels replicate each other exactly, but ordinarily painters go in the other direction, making every effort to vary the depiction either by landscape or by the interactions of

figures so as to achieve a different emphasis or implied sequence of actions. For example, in the Casa del Sacerdote Amando, the omission of Polyphemus' stoning the ship of Ulysses shifts emphasis from epic action to romance to create an entirely more sympathetic view of the Cyclops. Three versions of Acteon's story similar enough in their rendering of the rocks and trees of Mount Cithaeron to suggest the work of one painter, incorporate differences in postures and interaction of the principal figures to adumbrate different interpretations of Actaeon's culpability in viewing the bathing Diana.[104] We can regard modifications of this kind as resulting from an effort to bring out similarities among the particular myths chosen to compose an ensemble.[105] Spectators will have perceived such similarities the more readily because the multiple figures of continuous narrative compositions solicit their mental recreation of successive stages of the story. Furthermore, the use of Third Style in rooms clearly intended for dining in in keeping with the general conceptualization of the *pinacotheca* style, and shows us that the style, with its highlighting of subjects, was considered appropriate for sedentary rooms where occupants might engage in literary conversation, even if it was only of that perfunctory nature Seneca derides in his critique of literary studies (*Ep.* 88.7–8). "Was

Penelope unchaste? Did she suspect Ulysses' identity before he revealed it to her?"

Something is surely to be learned from these patterns of distribution. Almost all the houses involved are either remodeled or else reconfigured from older structures. If indeed no new, large-scale domestic architecture was in progress, how might this circumstance reflect the political or economic condition of the city? Given that the Augustan Age at Pompeii was ostensibly a peaceful period of flourishing prosperity, Richardson registers his surprise at the lack of domestic building activity but perhaps these conditions are not contradictory. In the Forum the era saw extensive building. Two massive new structures on the southeast side, the Eumachia Building and the so-called sanctuary of the Genius of Augustus, were donated by prominent women, both priestesses in major civic cults. The existence of Third Style painting throughout the Eumachia building shows this to have been a construction of the period (Figure 89).[106] Every aspect of this massive building, dedicated in the name of mother and son to the deities Concordia and Pietas, shows awareness of the *Porticus* of Livia, even to the visual reminiscences of the Ara Pacis in the marble decoration and association and the inclusion of specifically Julio Claudian myths in the facade.[107] This building was twinned with a second tribute sanctuary, that of the Genius of Augustus built by the priestess Mamia, to whom her fellow citizens dedicated a funeral schola in the necropolis at the Herculaneum Gate.[108] Another prosperous and distinguished Pompeian M. Holconius Rufus, along with his son, Holconius Celer, remodeled parts of the large theatre on the plan of Augustus' Roman Theatre of Marcellus to commemorate the senate's bestowal of the title *pater patriae*.[109]

Clearly for Pompeii as for other municipalities, the Augustan period was one of finding the way under new rules. Unquestionably conspicuous public donation of buildings with an Augustan orientation was a means of displaying loyalties. Rewards followed. Holconius came to carry the title *tribunus militaris a populo,* which would appear to have given him the right to a cuirass statue on the model of the Prima Porta. He and likewise his son Celer were priests of Augustus' cult.[110]

What were the power and clientship circles like at this time? Castrén suggests that the inner circle of power was formed by a few old Campanian families, with the addition of some new Augustan families, to whom he gives the term *gauleiters,* to whip up enthusiasm for Augustus.[111] This would not, however, be the case with the Eumachii who have an old Campanian name, and also the Ceii. Even the successful Holconii, associated with viticulture would appear to have been Campa-

nians because the name is not recorded outside Pompeii. Some of these families intermarried. At the same time the new regime brought some revisions in the social structure.[112] Epigraphical evidence indicates in 7 B.C. a reorganization of the *vici* with accompanying appointment of *magistri Augusti*.[113] The new cult will have altered somewhat the nature of magisterial personnel. The *ministri* had the right of fasces and one may assume that they had need of housing suitable to their office.

Little is known about specific ownership in this period. From the apparent lack of new building, one may deduce that the available resources of preexisting houses adequately served the political lives of these newcomers. Remembering the strong Augustan emphasis on Republican terms, forms and ceremonies as a code of political reassurance, we may see no reason for radical revision in houses, at least not so far as their provision for public life was concerned, but such a transformation of old plans with new prospects as we see in a house like the Casa del Frutteto might suggest some alteration of ownership or status. Within limits, then, the distribution of building activity in Pompeii may have exemplified Cicero's famous remark in *pro Murena* 76 that the Roman people shun private extravagance but esteem public magnificence.

THE *PINACOTHECA* AND PERIOD AESTHETICS

Seeking to fix each of his Four Styles by distinguishing characteristics, Mau called the Third Style, as he knew it, "ornate" for its "free use" of refined detail.[114] Sparing the pejorative judgmentalism, he follows Vitruvius in observing that its architectural design has lost all semblance of construction, and furthermore that "every part of the architectural frame is profusely ornamented." Although he believes the style to be Alexandrian, and perhaps imported from Egypt in consequence of the new relationship following the Battle of Actium, his concern is with sources, not ideology. Subsequent efforts to integrate Third Style into an ideological aesthetic appropriate to the Augustan Age have produced a rather different vision of the "ornamental," one that subordinates rather than highlights the richness of the compositions. By focusing on the symmetrical order of walls that concentrate their subject interest at the center, Otto Brendel turned Mau's profuse ornamentation into a "spareness" that exemplifies his conception of what an Augustan classical mode ought to be. By his interpretation, the wall decorations of the Romano-Campanian Third Style, "characteristically late Augustan, shared with the political art of the time their partiality for

neat planes, low relief, and gemlike outlines – in short all the symptoms of that Latin redefinition of the classical that accompanied the Augustan reorganization of the *res publica*."[115] Similarly Zanker unites politics with aesthetics in ascribing what he designates as a self-conscious new simplicity in the Third Style to Augustus' aims of reforming the morals of Roman upper classes.[116] Zanker's version of stylistic history differs from that of his predecessors in that he does not attribute its emergence to an evolutionary process, but rather seems to see it as a new creation, in which, all the same, there is an eclectic blending of previous forms. By this token the ascendency of Third Style comes to figure as a major testimony to the success of Augustus' campaign, and Zanker declares, "In short an altered mentality brought about a change in public taste and aesthetic sensibility, that is, in everything that was considered pleasing or beautiful."

In evaluating this pronouncement, we would do well to keep in mind the strictures of Vitruvius, in whose eyes simplicity was not a salient quality of the new pictorial style. That a transformative eclecticism of architecture and ornament shapes and furnishes Julio-Claudian painting is undeniable, and it is no less clear that the new compositional patterns show a reduction in illusory perspective, the fact that these changes accompany the privileging of art objects within the *pinacotheca*, must be taken into account, along with an appreciation of what the *pinacotheca* itself signifies within the history and discourse of luxury. Less architectural than their predecessors the compositional patterns of the walls may be, but the avowed plainness has much to do with the scale on which decorative systems are applied. When we look closely at the component details of the systems, their intricate intarsia patterns, the traceries and jewels of their columns, and even their rich backgrounds of expensive cinnabar, we can actually perceive these elements to be no less opulent than those of Second Style architecture and incrustation, only that the sense of audience and the significance of the address has changed. Rather than contextualizing this audience within a hypothetical spread of Augustan ideology, it is useful to look from the literary side at pictures of the good life in the Augustan Age, the positive and the negative ones. Who indeed were these patrons whose taste was so corrupted by Vitruvius' measures?

From this perspective I think one can justifiably question not only whether the *pinacotheca* style should rightly be called simple, but also whether simplicity, per se, accurately characterizes the tenor of Augustan society. Although the self-representations of lyric and elegiac speakers may profess their freedom from burdensome

material wealth, the details of their negative manifestos argue for some familiarity. Literary allusion may supply some resources. When Horace (*Odes* 2.18.1–5) claims proudly that "no ivory or golden ceiling gleams in his house" (*Non ebur neque aureum... renidet... lacunar*), or when Propertius (3.2) similarly disclaims ownership of any "ivory vault within gilded beams" (*nec camera auratas inter eburna trabes*), the ivory and gold directly echo Bacchylides' (fr. 20B 13) homage to the palace of the Macedonian King Alexander as standard literary appurtenances of royal luxury.[117] But what about the ceiling coffers that both Roman poets appear to have added primarily to declare them dispensable. Are these merely written luxuries? Or indeed are the marble columns supporting these coverings whose material fabric the poets specify with exactitude? Propertius claims freedom from columns of Taenarian marble, and Horace from Numidian columns upholding Hymettan beams. "Since pavonazetto allays no pain," Horace declares at the conclusion of *Ode 3.1* ("quod si dolentem nec Phrygis lapis... delenit"), his atrium can do without conspicuously enviable *postes* in the new mode. Although the futility of material wealth to solace emotional crises is commonplace, the allusion here seems pointedly contemporary if we can believe that an oblique reference to the pique (*dolentem*) of disempowered aristocrats might politicize the moral aesthetic. Whatever the case, Horace implies more than a mere counterbalance of frugality against expense; rather he suggests that his personal authority stands superior to the material symbols of status. The same, however, is not true of the contemporary associates to whom his lyrics, and especially those of *Odes* 2 are addressed.

Images of the material world that Horace employs in two poems addressed to former participants in the civil wars are a case in point. Ode 2.2 to Sallustius Crispus invokes the use of silver that has no color when hidden in the greedy earth. Realistically the color of exposed silver is tarnish, yet "may gleam with well-tempered use." Granted that the use of silver is a metaphor for the use of talents by which Horace urges Crispus to exercise temperate virtue, one may note that silver is not gold, not Pindar's highest standard of excellence, nor indeed the highest luxury, but nonetheless an intermediary one compatible with a well-regulated life.

In addressing Quintus Dellius (*Ode 2.3*), whose political perspectives were perhaps even less constructive than those of Crispus, Horace's phrases an even stronger exhortation to relax with the savor of luxury in sympotic images[118]: "Order wine brought here and perfumes and the too brief flowers of the delightful rose." With his eye on mortality, Dellius should not unbalance his

equanimity by precarious cravings, but rather appreciate the good things he possesses in life: gardens, symposia, the "villa by which the tawny Tiber washes" (2.3.19), remembering that an heir will someday take over his riches while he himself enters into "pitiless Orcus" no better equipped than the meanest pauper.

Recommendations to enjoyment are of course the substance of the carpe diem motif for which several of the poems are noted. They have often been termed Epicurean, which might seem no misnomer except that we should recall that canonical Epicureanism eschews the very luxuries that Horace is urging his addressees to enjoy. The good life is that of the *Pax Augusti*. Throughout Book 2 Horace develops a theme as practical and material as it is philosophical, and one cannot consider it in isolation from the circumstances of those persons to whom it is addressed. Comfort takes various forms. From the constructive potential of Sallustius Crispus' wealth to the slave girl fancied by "Xanthias of Phocis" (who might just be a captive princess), the majority of the addressees have something to value, use, or enjoy. When Pompeius of Ode 2.7 returns from his post–civil war exile, Horace welcomes him with the apparatus of the symposium, calling for cups of "forgetful Massic wine," for garlands of parsley and laurel, and for Venus to name a *magister bibendi* (lord of the drinks). Moribund piety is the obsession that Horace holds up to Postumus; hecatombs of 3,000 black cattle will not appease underworld deities. Postumus, who like Dellius is the proprietor a pleasing villa, replete with garden and well-stocked wine cellar, must learn to savor his resources before a less cautious inheritor takes over the keys (2.14). In contrast to Postumus, the Sicilian landlord, Pompeius Grosphus has mastered the comfortable employment of *otium* on estates where great herds of cattle and teams of chariot horses pay tribute to his lordship (2.16). The strategy behind these exhortations is simple and, in a manner, one may consider it the most astute Augustan propaganda Horace ever wrote. Even though Augustus may have been attempting to deflect the attention of powerful surviving Roman aristocrats from the competitive political struggles of the past and to channel their energies into psychological support for the regime, this effort did not necessarily mean a deprivation of the material benefits of prosperity. Horace's message is a mandate to look around and enjoy the new world that Augustus has created; it is a mandate wholly compatible with the aesthetic refinements of the Farnesina gallery whose individualism is asserted through taste rather than by spectacle. It also suggests that one does not need to infer the social position of a Julia as

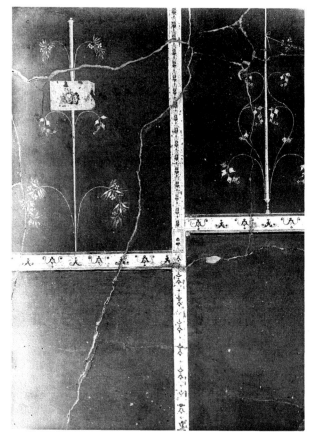

104. Villa Boscotrecase, Red Room, details of ornamentation. DAI 59.1978.

a commissioner for the decoration; Dellius, who also lived by the banks of the Tiber, would be capable of exercising exquisite taste.

When Augustan luxury emerges some years later within the framework of Ovid's *Ars Amatoria*, the evidence for its dissemination is even stronger, but the politics assume a different aspect in a cleverly, if not so subtly, implied conflict with a less permissive Augustan ideology. With the passage of time Augustus does now appear to be concerned with a new problem: the outright contradiction between a peaceful world of comfort and the new sexual morality he was inventing to govern the conduct of married partners within the Roman senatorial class. Ovid's view of the civilized unites sex and luxury in perfect harmony. Preaching a doctrine of *cultus,* he praises the sophistication of contemporary society over the rude simplicity of the past (*Am.* 3.113–114). Modern Rome is golden in its possession of all the wealth of the conquered world. Although Ovid places a higher rhetorical valuation on personal cultivation than monumental public splendor, all the same he construes this splendor as a sanction for the indulgence of personal

freedom. Especially the third book of the *Ars Amatoria* with its emphasis on the niceties of women's dress and adornment celebrates elegance as the culmination of the cultural process uniting the resources of nature with the refinements of art.

A comparable elegance in painting can be seen not only at Rome but also in the fine decorations of such houses as Boscotrecase with their intricate floral windings and slender columns patterned by marble incrustations (Figure 104). Scholars ordering the chronology of Third Style painting have, in effect, echoed Mau by remarking on its tendency to incorporate ever more elaborate ornamentation.[119] In this respect we can find a close correspondence between the paintings at Pompeii and the real decorations to be found in Julio-Claudian Rome in pleasure palaces built by the emperor Caligula in the Horti Lamiani. Here in real substance were the gilded fixtures and gems that the painters are imitating.[120] Tapestry decorations are still another item that adds new elegance to the painting of the period. These innovations and the social situations they reflect are subjects for the chapter that follows.

The Style of Luxury

DOMUS AUREA

The problem of Neronian history, as the preface to a recent volume of reevaluative essays defines it, is one of credibility. How do we reconcile the emperor's legend of flamboyant, ostensibly recreational extravagance with sober-sided historical probability without spoiling a good story?[1] Similar problems haunt our practical investigation of the residences that Nero built to showcase his legend at successive periods of his reign: the Domus Transitoria, which Suetonius describes as extending from the Palatine across the valley to the Esquiline (*Nero* 31), and its gilded reincarnation, following the fire of A.D. 64, in the more extensive Domus Aurea, whose multiform components extended even into the Forum but were largely distributed over a large parkland in the quarters of the Caelian and Esquiline.[2]

Of the Domus Transitoria little remains but isolated chambers, the most securely attested being a nympheum complex on the Palatine, once lavishly revetted in colored marbles but despoiled both in antiquity and by its eighteenth-century discoverers[3] (Figures 75 and 105). While the scattered locations of the Domus Transitoria vestiges bear out Suetonius' testimony that the construction was adapted to available spaces, the Domus Aurea by the same testimony took possession of a vast area including those parts of the Forum that were converted into its ceremonial approach and vestibule. The pavilion on the Caelian generally agreed to have been its center was a palatial

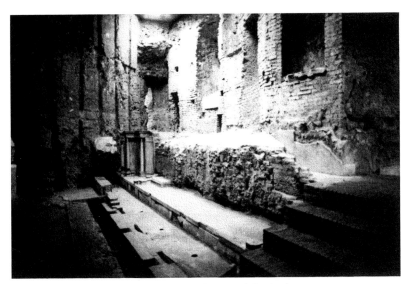

105. Domus Transitoria, fountain stage. Photograph by Author.

structure comprising hundreds of rooms, the design has often been compared with that of the extra-urban villa. As mentioned in my introductory chapter, the ceilings of several chambers in this new palace have been known since the Renaissance although the building's identity was only definitively established in the late nineteenth century.[4] An eighteenth-century excavator uncovered several full rooms on the western side of this central block and charted the initial plan; the discoveries of more recent years have progressively expanded on its dimensions[5] until at last Fabbrini's work of the 1970s confirmed the existence of an eastern suite of rooms symmetrically corresponding to that on the west side and also of a wholly dismantled upper story (Figure 106).[6] Still at this moment the entire ground plan has not been uncovered, nor is this all, because reports from random diggings to the west of the building during the nineteenth century mention fragments of gilded and mosaic paved chambers that probably also belonged to the house.[7]

All these spaces remain underground. Nero himself had buried the Palatine nymphaeum beneath his own later constructions, and it now lies beneath the floor of the great *triclinium* of Domitian's palace.[8] Visitors to the Golden House approach its extant chambers by a course leading downward through labyrinthine passages segmented by the foundations that once supported a hemicycle of Trajan's baths. This aura of concealment that seems so well suited to the emperor's

own notoriety enhances the mystique. High expectations, however, can lead to disappointment, as even the excavator Fabbrini observes.[9] In few situations do the fragmentary remains of past grandeur prove more frustrating than when we attempt to reconcile the denuded masonry fabric of these underground walls with the legendary resplendence of Nero's ostentation.[10] The fact that the two chief literary witnesses, Suetonius and the historian Tacitus, place their primary emphasis on the architecture and situation of the Domus within a vast landscaped park on the scale of a village does not diminish our expectations of interior splendor. Suetonius pictures the opulence of gilding, gems, and seashells (31), while Tacitus belittles this same gilding and gems as items that familiar usage had long since rendered unremarkable (15.42: *solita pridem et luxu vulgata*). Both testimonies agree credibly with the extant remains of the building in which the bare walls of the major reception rooms indicate that they were once revetted,[11] whereas the upper zones of important corridors preserve their traces of painted decoration and the walls in lesser areas are painted to the socle, thus manifesting a hierarchy of status by which the greater proportion of wall painting shows the lesser consequence of the space.[12] So within the principal rooms of the Domus Aurea the significant painted feature would appear to have been the complex vaulted ceilings, which proved so fertile a source of images for Giovanni da Udine and his fellow artists of the Quattrocento. Recent restorative work that partially uncovers the colors and intricacy of these "grotesque" figures helps us to understand their fascination,[13] but, in view of the overall deterioration of painted surfaces,

106. Plan after Fabbrini, 1995.

drawings from previous centuries, even if not wholly reliable, are indispensable for the study of full compositions.[14]

In the imagination of da Udine and his colleagues to whom the identity of the area was unknown, the figures of the ceilings represented not any single sponsorship but rather Roman artistic invention in general, and, as I will ultimately argue here, their response was not so far off the mark, at least for the period of later first century A.D. that we are about to consider. Once the site had been identified as the Domus Aurea, with sponsorship attributable to an historically familiar mentality at an historically documented moment of commencement, the nature of inquiry and interpretation radically changed. On the assumption that work at the very center of imperial power must inevitably have been both innovative and influential, many scholars want to credit Nero and his decorators with originating a stage in the chronological development of painting. Especially those who regularly look to Rome as the source of fashion have cited the Golden House as a repertoire of trendsetting developments that later filtered into such provincial municipalities as Pompeii.[15] Yet chronological considerations argue to the contrary. As the most securely datable of all buildings, with the Great Fire of A.D. 64 as its *terminus post quem,* the paintings in the Golden House must follow after many Campanian decorations of comparable design that were demonstrably executed before the earthquake of 62 including the Stabian villas of the imperial freedmen.[16] Should we conclude that painters working in those locations were already trusted imperial artists? In view of connections between Nero's wife Poppaea Sabina and the city of Pompeii, some interchange of workshops might be conjectured, but such a possibility makes it all the more likely that the Golden House was decorated merely in keeping with contemporary currents of style.[17]

Unlike Suetonius and Tacitus who say nothing about the presence of painting in the interior aspect of the palace, the Elder Pliny does approach the subject with remarks that tease curiosity. He mentions Fabullus (or Famulus; the text is unstable), an accomplished painter, for whose works the building is a "prison" (*NH.* 35.120). This account may well be influenced by the story of Alcibiades' locking up Agatharcos, a painter celebrated for his stage architecture, to decorate his house (Plutarch *Alcibiades* 16).[18] Thematically these stories highlight a conventional linkage between power and decadence, but Pliny's phrase *carcer . . . artis* implies also the exclusion or restriction of spectators so as to remind us how uncertain it is whether accounts of the Domus Aurea come

from firsthand witness, or if they are merely the products of rumor. Pliny accords high praise to Fabullus' talents, yet describes them with coded generic adjectives of the kind used in descriptions of literary style (35.120): "fuit et nuper gravis ac severus idemque floridus et vividus pictor Famulus" – recently also there lived the painter Famulus who was at one and the same time majestic and spare and also colorful and full of life. The implied contradiction between the first and last pair of adjectives has led some scholars to conclude that the same artist practiced two modes of painting,[19] while others think that one set of adjectives described the painter's character and the other his work. The contradiction can be resolved within the sphere of art if we understand the *gravis ac severus* as referring to line and the *floridus et vividus* to use of brilliant, expensive colors.[20]

Pliny commemorates Fabullus as a figure painter, citing his creation of a Minerva who appeared from every angle to be watching the spectator who looked at her. If also we can trust his report that Fabullus painted from a scaffold, it would follow that he had some hand in painting such elevated areas as ceilings and lofty walls. The two items are not incompatible if such a dramatically arranged, precisely articulated figural composition as the Achilles on Skyros panel is to be seen as his work (Figure 107).

In the opinion of Nicole Dacos, the best paintings of the Domus should be regarded as products of Fabullus' workshop. Following Pliny, she credits this painter with planning the state apartments as a whole, executing the most important parts himself and delegating the lesser areas and details to his subordinates. Other rooms with bordered tapestry decoration she attributes to a different outfit also responsible for the two corridors behind the main rooms. Where Dacos saw only two workshops in the Domus Aurea, the more recent analysis by the Dutch scholars Moormann and Meyboom distinguishes three on the basis of compositional geometry and ranks their importance by their employment of raised stucco and gilding.[21] Certainly the hasty construction schedule will have engaged a large workforce, while principles of decorum should also be given due weight in accounting for differences of style.

We can consider these matters further by taking up another frequently debated question: how the stamp of Nero's own character shaped the house. In spite of the brief space of time for construction available between 64 and 68, historians confidently attribute its imaginative conceptualization to Nero, recalling the declaration reported by Suetonius that its inauguration would "allow him to reside (*habitare*) like a man" (*Nero* 38). Although

THE STYLE OF LUXURY

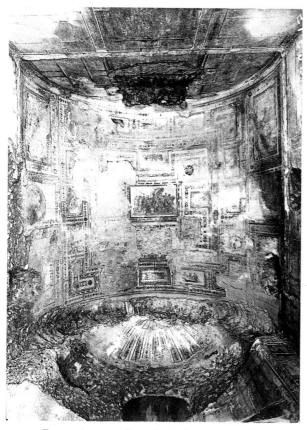

107. Domus Aurea, ceiling of apsidal room. GFN E54520.

was well attuned to playing a role on a large international stage with a sense of presence for which, in fact, a nonsymbolic interpretation of luxury as mere personal gratification provides an inadequate rationale.

Along these lines, Yves Perrin proposes that the Domus Aurea marked the center of a Neronian *urbs nova* (new city), which the emperor filled out with his dominating presence.[25] A large number of his spectacular banquets and ceremonies took place out of doors. To stage an event lavishly in the open air asserts prerogative through spatial domination; the higher the degree of extravagance, the more forceful the domination. Tacitus implies this in stating that Nero appropriated the whole city as his *domus* (*Ann.* 15.37).[26] When the emperor received the Parthian ruler Tiridates during the period following the fire, he made the center of Rome into his showplace. Suetonius mentions a grand spectacle (*Nero* 13), but Cassius Dio more colorfully reports that the entire city (62.3.4) had been decked out with lights and garlands; decoration was the first manifestation of control. The pageant of Tiridates' investiture as king of Armenia staged in the Forum might be viewed as a remaking of Republican rituals that verged on parody. The Forum was packed with citizens ranged in ranks as if in a theatre. The emperor placed his dias on the rostra. At the climax of the ceremony, the foreign dignitary also mounted onto the rostra by means of a special front ramp to declare fealty. Perversely the significance still clinging to this monument as the platform of Roman politics is expanded when Rome becomes the center of a universe where rights of sovereignty are ceremonially given away. Ceremonies on this occasion also took place in a theatre that had been dazzlingly gilded in all its parts. When Nero drove a chariot and demonstrated his lyre-playing skill, Tiridates came to despise him, as Dio would have it (62.6.4), for undermining all dignity of the ceremony. Yet for the citizens of Rome, as Perrin has pointed out, the significance of such displays was celebration of the city's centrality as the world's supremely important place and a guarantee of stability for that status.[27]

How did the Domus Aurea reflect this new regal urbanism on a public rather than a private level? In the face of the controversies surrounding its creation, it was public in being designed for impressive view. Perrin envisions its standing dramatically alone as the center of a still-ruined city. David Hemsoll imagines how the dazzling spectacle of its resplendent terraces might have been glimpsed obliquely across the lake.[28] It is commonly represented as an inflated villa, a new edition, so to speak, of the Lucullan combination of showcase and retreat. So far as the form of the palace is concerned, this must be

Suetonius also reports that Otho spent extravagantly on the house, one scarcely imagines that the turbulent "Year of the Four Emperors" afforded Nero's successors excessive time to consider niceties of domestic decoration while their imperial status was undergoing siege.[22] The essential idea must be Nero's, and even Otho's efforts paid tribute to the memory of his friend.[23] Various forms of obsession have been seen as his driving motivation: his theatricality, his megalomania, his arrogation of a place at the center of the universe or his escalating illusions of divinity to the point of identification with the sun. Such explanations have tended to foster the theoretical reconstruction of the house as a self-indulgent projection of personality with emphasis on idiosyncracy rather than statecraft.[24] Perhaps it really was personal craving for luxury that incited the Domus Aurea, or even the prompting of Poppaea Sabina whom Tacitus represents as having initially hung back from a commitment to marriage with the emperor on the grounds that the life her husband Otho afforded her could not be equaled either in intellectual or material refinement (*Ann.* 13.46). But between the lines of historians' prejudice, are intimations that the emperor's penchant for showmanship

159

true. A coin image shows a colonnaded facade on two stories much resembling structures depicted in Campanian villa paintings. The *porticus,* as Moormann has recently pointed out, was necessary to shield the front-lying chambers from western sun.[29] The architecture of the upper story, as Fabbrini has shown, was a complex network of colonnades, loggias, and fountain courts that erased boundaries between interior and exterior space, full of perspectival intricacies produced by channeled or interrupted vistas. This kind of pavilion construction, as we shall see, was an elaboration on what had for years been the mode of imperial pleasure building in the Esquiline parks and *horti.*[30] On the lower floor, the most spacious and elegantly decorated rooms such as that of the celebrated Volta Dorata faced the park.[31] In no way incompatible with ideology, this merging of architectural fabric into setting can be seen as another approach to that form of spatial control that out-of-doors ceremony flaunted. Every aspect of the fragmentary remains makes sense if we consider the Domus as a place of official representation whose furnishings were conceived to impress foreign visitors not only with the emperor's personal glory, but also with the dignity and traditions of the Roman world he ruled. Recalling how long continuing Rome's negotiations with Asian nations had been, one might even think that the planning had been undertaken with the Parthian royal visit specifically in view. Considering the panoply with which the public, out-of-door ceremonies were staged, it is only logical that Tiridates' vast cortege that had traveled across the Mediterranean world required housing in some suitable place.

In this light we may return to extant remains of the lower story. Although literary sources give us little specific indication of what transpired there, save perhaps for the opulent banqueting in the famous octagonal room (Figure 108),[32] one advance effected by recent archeological explorations is to discredit the long-held notion of public and private quarters with locations in the east and west wings, respectively.[33] Where once the house was presumed to be an asymmetrical design in two sections, we now know that it was partially – but in all likelihood fully – symmetrical with two pentagonal forecourts interrupting the colonnaded two-story facade. Within these spaces irregular patterns of rooms were imposed on a rectangular block. At the center will have been the unique octagonal room with controlled spatial perspectives in and out of its surrounding chambers (Figure 108). On either side were elegantly decorated apsidal rooms with stucco relief and gilding setting off their iconographically complex ceilings (Figure 109).

In the western extension of the palace, rooms were grouped about a large peristyle, which, in the accus-

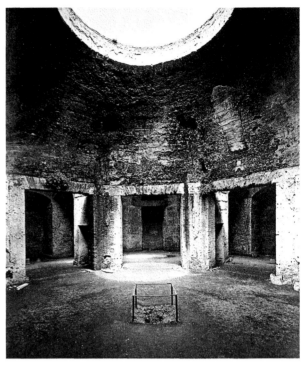

108. Domus Aurea, octagonal room. FU 1957.3514F.

tomed manner, will have formed a center for dining spaces. With a row of chambers at the side that would have housed retinue, this was perhaps an ambassadorial reception area, an expanded *diaeta,* in the Hellenic mode. Possibly the portal with two columns located in the area, served as a separate entrance to this suite of rooms rather than as the principal entrance for the palace, which should logically have been situated closer to its center. The largest of the spaces facing the peristyle was an immense *oecus* open on all sides with multiple doors, and standing in its turn before the large, rusticated fountain grotto called the Nymphaeum of Polyphemus from the mosaic panel at the center of its shell-covered vault representing Odysseus offering the cup of pure Maronian wine to the Cyclops. The topic had long since become an imperial motif which Moormann deftly explains first in relationship to an association with water, and then because of the mastering effects of wine.[34]

Although the room facing this area will surely have been the most ample dining chamber in the suite, a smaller one located on the long south side of the peristyle directly facing the fountain is particularly interesting.[35] Two columns framed its doorway; its importance was shown by the fact that it was from floor to ceiling wholly revetted with marble plaques in two series, and an inner alcove was also revetted with marble.[36] Naturally we must imagine this decoration to have been

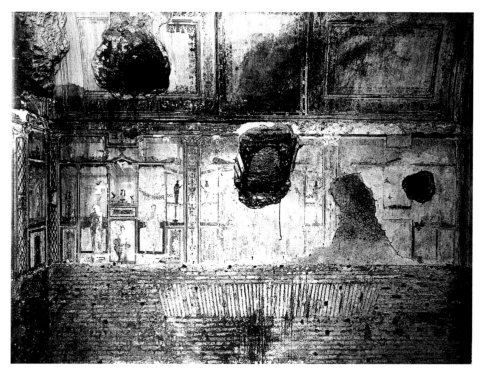

109. Domus Aurea, apsidal room. GFN E54508.

composed of figured patterns that may well have resembled the painted illusions in other rooms. But the identity of the room as a banqueting place is most clearly established by its ceiling, especially admired by Renaissance artists under the name of Volta delle Civette[37] (Figure 110). This, as the visiting artists already had perceived, and as Perrin has recently reemphasized, imitated the form of a dining tent, and possibly the specific festival tent erected by Ptolemy Philadelphus of which Athenasius has transmitted an elaborate eyewitness description from the second-century writer Callixines of Rhodes.[38] Nero's emulation of this regal construction incorporated candelabra, amazon *peltae,* and picture medallions, as well as the border frieze of owls that inspired its name. Perrin sees the points of iconographic interest as being linked within an octagonal shape that articulated the pavilion form. The form was highlighted also by a painted simulation of draperies hung from arc-shaped beams that were elaborately patterned with scrolls and grotesques. Whatever the materials that clothed the walls may have been, the situation of the room, facing an open courtyard, indicates the pavilion design as still another manner of bringing the outside within. These were accommodations couched in an Eastern vocabulary that Eastern delegates would presumably understand.

Among other decorated surfaces documented in this quarter of the palace, a certain hierarchy is suggested both by the amount of revetment used and by the complexity of the ceilings. Of particular interest among these are two corridors in which we can match ceilings and walls.[39]

One of these is a long corridor that led toward the nymphaeum of Polyphemus and which takes its name "Corridor of the Eagles" from the prominence of that imperial bird in its painted vault.[40] Although the access route to this corridor runs obliquely across the front of the house, it is long and straight. Originally its dado had been revetted with giallo antico, but excavators found this stripped and replaced with paint. The walls themselves constitute a complete *scaenae frons* in two stories of equal height with a central *aedicula* and two flanking doors,[41] however, the facade is so broken by colonnaded compartments, in the manner of the most ornate stages, as to give the impression of a paratactic composition (Figure 76). This also must have been the impression of persons traversing the corridor who could not have seen the whole prospect of the wall from a sufficient distance to take in its complete structure, but would rather have appreciated the statuary contents of each individual compartment as they passed by. Paired Triton figures resting on the podium support the window apertures of the alcoves each of which contains its own statue. The lower part of the architecturally enhanced central *aedicula* frames Dionysus with a dancing Maenad suspended in the upper space. Closed backgrounds beneath a hollow pediment accentuate these figures while openings

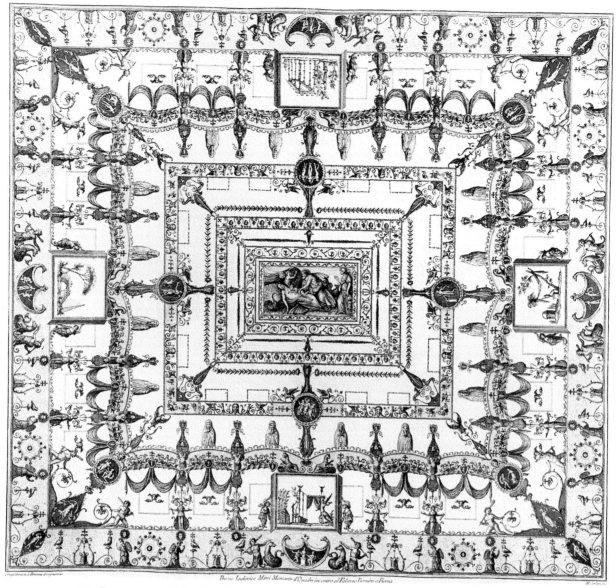

110. Domus Aurea, Volta delle Civette, engraving. Pl. 6 from *Le antiche camere delle terme di Tito e le loro pitture restituite al pubblico da Ludivico Mirri Romano,* Rome 1776. Reproduced by permission of Yale University, Center for British Art, Paul Mellon Collection.

in other recesses, especially in the second tier of the decoration, give a light and spacious air to the whole.

The brilliantly painted ceiling creates the regal character of the space. Positioned at its center was a panel depicting the legendary divine origins of Rome with the figure of Mars descending to a sleeping Rhea Sylvia watched over by Morpheus (Figure 111).[42] Pendent compartments contain scenes of harvest and sacrifice to link Roman themes with themes of abundance. At the outer edges of the vault, tripods and figured candelabra separate compartments containing shield portraits flanked by griffons but almost dwarfed by the colossal, spread-winged eagles that perch on their rims. On the

shorter end sides, two of these imposing birds face each other; on the long sides they turn their head toward the center, where peacocks sit on acanthus scrolls.

The iconography of a second corridor similarly advanced the imperial dynastic theme. The paratactically decorated walls of this corridor are particularly imposing (Figure 112).[43] Above a marble dado rise three tiers of colonnaded compartments; the first composed of doors, the second of balconies, and the third of open panels, screened by grillwork. Columns in raised stucco emphasize the perspective appearance. In the half-open doors of the lower register appear a series of figures carrying scrolls; they are philosopers in a literary gallery.

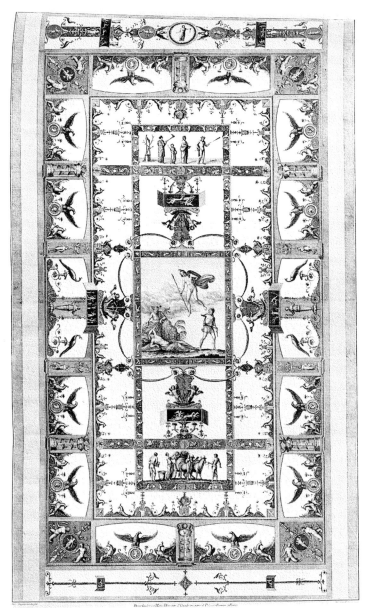

III. Domus Aurea, engraving. Pl. 44 from *Le antiche camere delle terme di Tito e le loro pitture restituite al pubblico da Ludivico Mirri Romano,* Rome 1776. Reproduced by permission of Yale University, Center for British Art, Paul Mellon Collection. "Corridor of the Eagles," vaulted ceiling with Mars and Rhea Silvia.

the two ends of the lunettes presented perhaps two aspects of Dionysus. These were flanked by panels involving Tritons, dolphins, and sea-horses. Both the marine and the Dionysiac themes extended to other parts of the ceiling. On the two sides of the vault are pairs of river deities. These bands are interrupted by central niches containing seated figures of Dionysus. The dynastic theme appears in a series of portrait medallions supported on arches hung with grapes and with sphinxes and eagles perched above. Masks suspended at a level with the portraits complete the merger of theatrical and imperial themes.

The two parallel corridors provide alternate routes of access to the nymphaeum and its facing *oecus:* the longer one leading in from the exterior and the other a corridor for interior access. Possibly the one channeled visitors entering from outside, and the other visitors housed within the buildings. The two spaces are similar not only in the visual grandeur of their architectural painting and the richness of the vaulting but also in their dynastic themes, which must surely have been intended to impress the eyes of official visitors. The central emphasis on Mars in company either with Venus or with Rhea Sylvia points to the divine origins both of the city and of the Julio-Claudian family.

Turning from these primarily documentary reconstructions in search of some extant traces of the original splendors of decoration, we approach it most closely within the two apsidal rooms flanking the octagon whose decoration involved revetment, painted illusionary perspectives and a ceiling richly paneled in a geometric coffered design (Figures 107 and 109). The marble covering in these rooms reached high on the walls. In the zone above them, the spatial layering of architectural perspectives with recessive balconies was accentuated by raised stucco columns in a scale-pattern design with composite capitals while the ceiling compartments also were bordered with the stucco molding that Meyboom mentions as the hallmark of the most important designs. The succession of niches and balconies formed by the scaffolding frame statuary. A visual juxtaposition of large-scale figures in the longer alcoves with smaller ones in the galleries is probably contrived to increase the depth of perspective illusion by two levels of space. The curved vaults of the

Reclining nude male figures alternate with shield portraits in compartments of the attic zone. This is coordinated with the *scaenae frons* itself by Triton figures, but its iconography is generally heraldic intermingling Dionysiac and Roman motifs. A long-figured strip, bordered with *fasciae* and divided into garlanded compartments emphasizes the center of the vault. Within a spacious central compartment floated a paired Mars and Venus (Figure 113). Two pendent compartments also contained floating pairs, while sacrificial scenes at

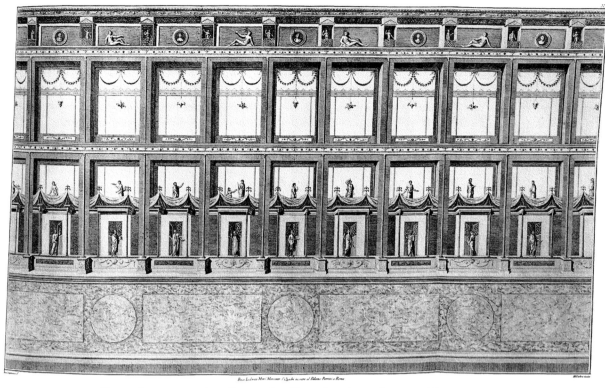

112. Domus Aurea, paratactic wall, engraving. Pl. 45 from *Le antiche camere delle terme di Tito e le loro pitture restituite al pubblico da Ludivico Mirri Romano,* Rome 1776. Reproduced by permission of Yale University, Center for British Art, Paul Mellon Collection.

apses are stuccoed in a sculptured scallop-shell pattern with ridges separated by colorful strings of acanthus, intertwining in their volutes decorative lyres in two different forms. Floral bands also fill the spaces dividing the ceiling compartments, and here we see figures of sphinxes and winged genii among the tendrils. Just at the spring of the vault in the right-hand room can now clearly been seen the scene discovered by Renaissance visitors of Andromache's pleading with Hektor on the Trojan ramparts, a four-figure composition grouping of women caused it for many years to be misidentified as the women of Rome approaching Coriolanus in the camp of the Volsci. Also visible, although less distinctly, is a meeting of Paris and Helen attended by a small Eros pointing toward Helen and a female figure between the two who might represent either Venus or persuasion. An armed warrior stands behind Paris. The two scenes might well be taken to refer to the same book of the *Iliad.* Figures intertwined with the vegetation include griffons, lions, and winged vegetal Psyches.

This room contained other panels, including a central image now destroyed, but the painting of Achilles on Skyros at the center of the ceiling in the opposite room (119) remains among the best-preserved mythological scenes in the palace[44] (Figure 107). Recent cleaning has brought out the firmly sculpted articulation of its figures and the complex pleating of draperies that accentuates the dynamic composition of its figures even though the colors have subsided into a faded blue and dull red. Achilles and Deidamia – he standing, she seated – form the center group, their interaction enforced by diagonal tension that brings out the drama of the moment. Although Achilles' figure inclines toward Deidamia, his gesture pulls away from her as he brandishes his large shield upward, exuberantly revealing his suppressed masculine energy. His other hand holds a spear that points in the opposite direction, slanting across the seated figure of Deidamia, who grasps at the hero with both arms in a gesture that is both and embrace and a restraint. Emphasis also falls on the women so disposed in clusters at the sides of the principal figures as to emphasize the lines of their postures while their own gestures are clear indications of surprise, and even dismay. Less prominent here than in other treatments of the subject are the two recruitment officers, Ulysses and Diomedes, both relegated to the background ranks of figures and recognizable only by their headgear – the helmet of Diomedes still standing out clearly against the

164

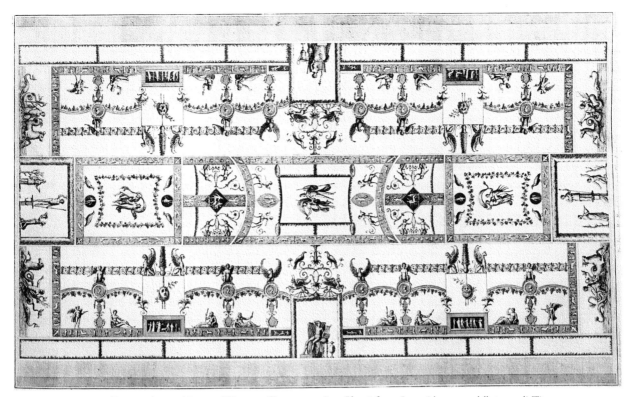

113. Domus Aurea, Mars and Venus ceiling, engraving. Pl. 26 from *Le antiche camere delle terme di Tito e le loro pitture restituite al pubblico da Ludivico Mirri Romano,* Rome 1776. Reproduced by permission of Yale University, Center for British Art, Paul Mellon Collection.

background, while the other's rounded covering would seem to be Ulysses' characteristic hat. If this is indeed, as it ought to be, the work of Pliny's Fabullus, then its arrest of dramatic tension – its visibly suppressed energy – shows that his designation as a master painter was no exaggeration. But in spite of the clearly Trojan theme of the two rooms, their tone is less dynastic than that of the western extension, with the heraldric figures less consicuously integrated into the elaborate floral patterning of the grotesques.

Between these fine rooms and other areas of the palace that may have been used for less ceremonial traffic there is a notable difference. Scholars have recently noted that the irregular conformation of some of these minor enclosures was dictated by the shapes of preexisting rooms.[45] The angled corridor behind the Volta Dorata and the even longer cryptoporticus running behind the octagon, and crossed by its aqueduct, must have been used for service and the movement of the residents themselves. Their paratactic, but much less elaborate, decorations alternated a succession of colonnaded niches with bordered tapestries. Above these a very lofty attic zone was painted with an airy scaffolding that reached to a ceiling decorated with an all-over carpet pattern.

In such windowless spaces, the white grounds are surely intended to maximize available illumination.

Within the celebrated octagonal room, the bare masonry surfaces indicate that the walls had once been revetted, at least to the springing of the dome (Figure 108).[46] Within this concrete shell, if anywhere, will have been located that rotunda Suetonius mentions (31.2) whose continual motion by day and by night likened it to the turning world (*vice mundi*).[47] Flamboyant as the biographer makes it seem, one must remember its precedents in earlier construction, and even cosmic decoration, such as that which Varro claims for the roof of his aviary theatre.[48] Fragments of fluted marble pilasters suggest the richness of this room and traces of painted decoration cling to its architectural facings. Whatever the covering of the walls may have been, we must imagine its coordination with the spatial embrace of the piers and vaults that shaped the enclosure. Doorways piercing the central space lead into radial surrounding chambers to create a variable set of perspectives. The interior architecture of their interlocking enclosures is also complex. Small galleries in their upper zones were probably, like the attic zones in painting, utilized for the display of statuary and lights. Moormann cites Pliny *NH.* 34.84 to

the effect that Nero had positioned many masterpiece statues that he acquired within the dining chambers of his palace.[49] Such an arrangement might also have employed dividing screens and curtains. It would be the material counterpart in three dimensions of the little open pavilions or balconies so frequently constructed in paint. Without the monumental octagon, the Domus Aurea might indeed seem to fall short of its reputed grandeur; however, we should not forget the vanished upper story with its porticoes and fountains. The two levels in combination might seem to offer the features of a summer and a winter palace.

The compositions of the Domus Aurea draw on a variety of models – *scaenae frons,* tapestry, sculpture gallery, all of these primarily paratactic in organization. In this disposition Eric Moormann sees a preponderance of "kinetic" spaces, created for circulation rather than for contemplation and making up a sequence of accessible rooms from the western peristyle to the porticusshaded facade. Otherwise, as he notes, the use of particular spaces is virtually impossible to determine; in the smaller, but often equally conspicuous rooms, no clear signs distinguish a *cubiculum* from a *triclinium*.[50] Like the House of Augustus in its time, it does not introduce major innovations into the repertoire of mural painting, but organizes existing forms for its own specific communicative purposes. Nor should it be credited with having exerted a major influence in and by itself. All the same its incorporation of open spatial vistas may be seen as an indication of contemporaneous architectural tendencies, while its traces of material opulence testify to the high valuation placed on luxury.

CLAUDIAN LUXURY

Given that the painting of the Domus Aurea incorporates the trends of contemporary painting rather than establishing new ones to enhance its luxuries of marble and metal, we may go on to inquire whether Tacitus reported reliably or was being characteristically supercilious when he remarked that gems and gold had already become commonplace luxuries by this time. On the imperial level the evidence argues unambiguously that they were. We should consider two items: not only the small piece of building attributed variably to Nero and to Claudius[51] but also fragments of even earlier luxurious finishings gleaned from excavations in an Esquiline garden area where Caligula had constructed buildings.

Both in the imaginativeness of its design and in the exquisite refinement of its rich decorative detail, the nymphaeum construction located beneath the regal *triclinium* of Domitian's palace almost surpasses the

Domus Aurea (Figures 75 and 105).[52] Its showpiece was a fountain, shaped with alternating niches and alcoves in the manner of a miniature *scaenae frons*.[53] Above this thematic backdrop, water cascaded down a water-stair, then disappeared and rose up in fountain jets before the columns, falling back into a series of channels that carried it about the room. Opposite this theatrical fountain, a colonnaded dias would appear to have provided a platform for dining.

When this complex was discovered during excavations conducted by the Farnese family in 1721, its decorations must have been almost intact. Such, at least, is the impression one gains from Francesco Bartoli's descriptive account of the "fine mixed marbles forming a most beautiful ornament all along the front." Red porphyry, alternating with giallo antico, formed the series of tripartite column clusters, while panels of green porphyry and green serpentine filled the niches. The columns had bases and capitals of "Corinthian metal," and Bartoli speaks also of "crystal" ornaments that may well have comprised some of the intarsia patterns that variegated the surface of the niches.[54] A subsequent description in the supplementary volume of Montfaucon's *Antiquities* adds mention of statues in the niches, but without indication of their subjects or number.[55]

Ranged about the circumference of the room were twelve porphyry columns that sustained the ceiling. To the right and left of the dias, these were screening columns that separated the central space from adjacent interconnected spaces. Ceilings composed of figured medallions within a network of arabesques covered the spaces. As always their brilliant colors impressed the viewers. At the sides of the subordinate chambers were a series of vaulted bays within which additional streams of water cascaded from above. Subject panels in the vaults and lunettes that arched above these fountain basins depicted epic scenes bordered by delicately scrolled rinceaux and rosettes (Figure 114). The flowers were set with paste jewels. The ceilings also had jeweled patterns. One can imagine how these sparkled with the motion of the water and the reflections of lights. That all these rooms were revetted with marble plaques can be seen from the impression left in their walls. Traces of socle and pavement patterns show a brilliant assortment of colored marbles arranged in a hierarchy of designs; their degree of complexity must have marked the status grades of the spaces they decorated.[56]

Yet even before this chamber was decorated, gilding and marble had been introduced into imperial dwellings. Specific material evidence has emerged from Eugenio La Rocca's restudy of the finds from excavations in the Esquiline *horti* that can be attributed to Caligula, into

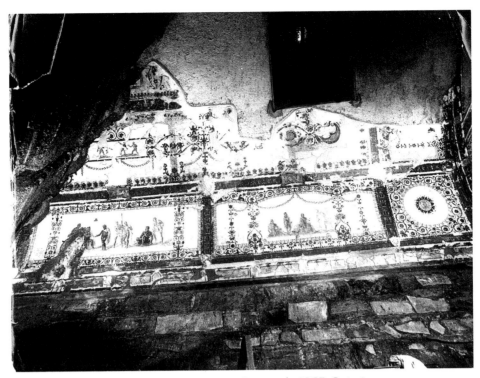

114. Domus Transitoria, ceiling panels. ICCD C16508.

whose hands had devolved the choice garden territories once owned by plutocrats of the Augustan circle: Maecenas and the Aelii Lamiae.[57] Philo of Alexandria records this emperor's determination to renovate the gardens with luxury surpassing their previous appearance (*Leg. ad Gaius* 231). Nineteenth-century excavations in this area revealed numerous small pavilion constructions with lavish furnishing: a *porticus* with garden paintings and behind it a *cryptoporticus* with alabaster pavements, giallo antico columns with gilded bronze capitals, and bases.[58] The pavements compare with those of luxury vessels at Nemi commonly identified as Caligula's "Liburnian galleys" fitted for pleasure which Suetonius describes.[59] In another place was a chamber decorated with fictive architecture trimmed with gems and gilded bronze. Agate panels may have decorated its walls. From these structures come examples of two features commonly imitated in wall painting: one a colorful *opus sectile* capital made of porphyry and giallo antico, the other a plethora of trimmings in the form of gilded branches set with precious and semiprecious stones.[60] In this collection the stones are genuine, but in the Domus Transitoria pastework gems have already been substituted for the real. These traces of luxurious materials are important in giving a substantive basis for the written discourse of luxury, which I examine in the following section. Also, such furnishings comprise the "originals," whose painted representations are widespread within the elaborate constructions of the Neronian and Flavian *Fourth Style*.

WRITTEN LUXURY

Comparing the decorative materials of the Domus Aurea with vestiges of previous Julio-Claudian luxury may help us to understand how Tacitus, wanting above all to stress the outrageous intrusiveness of its artificially constructed environment, might justifiably reduce its interior adornments of marble veneers and gilded ceilings to the status of the commonplace. Aside from its unprecedented size and stolen location, Nero's new palace building improved on its immediate predecessors by concentrating luxury within a single building block and by its integration into a programmatic ideology that combined imperial self-enhancement with a view of Rome as the center of world-empire. This new deployment of opulence expressed a kind of imperial confidence that would eventually elevate itself on an even grander scale in the public reception and banqueting spaces of Domitian's palace, which were, as Statius describes them in *Silvae* 4.2, truly *capax populorum*. For the materials used in that palace we will also see some agreement between the literary account and the archeological evidence.

Still one suspects that Tacitus' scornful estimation of Nero's furnishings as *solita pridem et luxu vulgata* (*Ann.* 15.42), while clearly aimed at cheapening the value

of opulence to tyranny, must extend beyond imperial "pleasure palaces" to the establishments of the Roman senatorial aristocracy. Earlier in the *Annales* (3.52–5) he represents an interchange between the emperor Tiberius and certain senators hoping to curry favor by urging the passage of sumptuary restrictions for the curtailment of extravagance, which ends with the dour and enigmatic emperor's reluctance to incur hostility by interference in private life. Where, he asks, would such restrictions begin? With the size of villas? The accumulation of bronzes? The adornment of women? From this briefly follows the historian's digressive archaeology of Roman luxury reaching back to the time when certain noble families ruined themselves by their craving for impressive splendor until "savage massacres" taught wisdom, an eventual influx of high-minded provincials brought with them domestic frugality and Vespasian entered as the champion of former *cultus*. Which representation is the more accurate? Does the historian's desire to diminish Nero prevail over his social perspective? In fact the testimony to the diffusion of luxury in other contemporaneous writers would support both sides of the proposition, but especially suggest that Tiberius' timorous permissiveness had a foundation in material reality. In turning to such literary evidence as the inevitable field for this inquiry, one must nonetheless judge circumspectly on account of its propensity to incorporate sentiments that are in themselves commonplaces in the discourse of luxury.

No less than in earlier periods, evidence by way of specific language for upper-class acculturation of luxury in Neronian and Flavian Rome comes filtered through a screen of attitudes, some moral, some social, but always raising issues of status and power. Because many such descriptions embody traditional conceptions and phrasing, it is not always easy to determine whether their ideological bias should be attributed to the writer immediately providing the information or to some earlier source. Whatever their derivation, however, these biases, either because of their moralizing or their exaggeration, place the subject within contexts so fully politicized that it is sometimes difficult to know what we should believe.

For instance the Elder Pliny remarks how the palaces of the "bad Caesars" Gaius and Nero encircled (*cingi*) the city in their heyday (36.111), but nonetheless, with a twist of backhanded Republican chauvinism, he awards the prize of folly (*insaniam*) to the Republican aedile Aemilius Scaurus (36.113), whose temporary theatre, built with private resources, proved no less an evil to public *mores* as the proscriptions of his stepfather Sulla. The comparison seems not merely insensitive, but also oddly off center, since Scaurus was not, like Lucullus,

known for permanent architectural projects but only for converting selected ornaments from his theatrical showpiece into decorations for his townhouse and villa (36.115).

While deriding the monuments of private indulgence, Pliny praises (*NH*. 36.102) great public buildings such as the Basilica of Aemilius Paulus, the Forum of Augustus, and the Vespasianic Templum Pacis as the most beautiful in the world. His remarks are in the spirit of Cicero's pronouncement (*pro Murena* 36): "the Roman populace hates private luxuriousness, but loves public magnificence." One reason that the discourse of luxury had circulated so actively during the Republic was its employment for purposes of political castigation. Thus Pliny, in his retrospective adaptation of this material, biases description by superimposing his own prejudicial perspectives. When he lauds contemporary customs that allow the *maiores* of the present day to regard their predecessors' decadence from a superior point of view, the moral tone in his strictures against luxury conceivably reflects his allegiance to the ideology of his preferred emperor, Vespasian.

Present-day aesthetics often associate luxury with vulgar, indecorous ostentation. As we have seen, Lucullus' aristocratic position did not shield him from such denigration. Cicero mentions imitation of his extravagance as a contagion spreading among social classes and returning to spur its originator to still greater outlays (*de Legibus* 3.30). Perhaps it was this passage Plutarch had in mind when he observed that Lucullus began to live like the newly rich. To associate luxury with freedmen is one means of denigration. Trimalchio is the unanimous favorite. Even so, the descriptions are generic. Such writers as Cicero give virtually no concrete details, while as earlier noted, Augustan literary references to interior furnishing more often vaunt the absence than the presence of luxurious materials,[61] while tending to catalogue self-indulgent wealth in terms of movable goods: clothing, furniture, or tableware: such as the embroidered bed coverlets that cure neither fevers nor lovesickness (Tibullus, *Elegies* 1.2.75–8) or the exquisite touch of Tullius' Mentorean cup (Propertius 1.14). Horace sums it up (*Ep.* 2.2.180–2): "Gems, marble, ivory, Etruscan bronzes, painted tablets, silver, cloths dyed with Gaetulan purple: there are persons who have none, and someone who does not care about having them." Such an inventory might easily be based upon Cicero's catalogues of Verres' Sicilian plunder.

Pursuing the literary record into the Julio-Claudian years and beyond them gives the impression of a progressive assimilation of luxury into upper-class life. Although ornamental trappings continue to be mentioned, there

is a new focus on luxury in the actual fabric of building. Ovid describes architectural luxury in a few passages pertaining to the homes of divinities. The sun god's celestial palace gleams with ivory and metal, whose effect is nevertheless outdone by the pictorial doors, Mulciber crafted (*Met.* 2.1–16).[62] In his own palace Mulciber has ivory doors, which he throws open to expose to divine eyes the spectacle of Mars and Venus "bound together in shame." Ovid's Circe beguiles her visitors within a marble-clothed atrium (14.260).[63] One early post-Augustan mention of stone occurs in the Elder Seneca's book of *Controversiae* written during the A.D. thirties, but purporting to record speeches remembered from the declamatory schools of the late Augustan period. Here, in a colorful castigation of ostentatious prosperity, we find not only "mad luxury" quarrying stones but also variegated marbles being sliced to cover walls with flimsy veneers (*Cont.* 2.1. 12 [113M]: "*varius ille secatur lapis et tenui fronte parietem tegit?*").

As Martin Bloomer has shown, one source for the kinds of rhetorical commonplace that the declaimers employed was the anecdotal compendium of Valerius Maximus, *Facta et Dicta Mirabilia* (*Remarkable Deeds and Sayings*),[64] which, in company with the Elder Pliny's *Natural History,* is a major source of information on the specific details of luxury. The majority of Valerius' examples, like so many of Pliny's, look retrospectively to the Republic, yet both authors present their information for the sake of its bearing on the present age. Their witness is corroborated and extended by writers in several genres of imperial literature whose descriptive attention to objects and environments incorporates an increasing tendency toward specific identifications of decorative marbles by name in a manner that implies an audience's knowledge of their characteristic colors and patterns. Surveying such allusions chronologically with attention to their individual literary contexts, we can observe a political shift in the discourse of luxury, a decentering of the power connection with a concomitant lessening of moral strictures. Although imperial luxury was employed in literature as well as in reality to enforce a kind of power exceeding the imaginations of Republican aristocrats, elegant furnishings could also surround an individual living, in Lucullan fashion, on the margins of power. With this broadening of applications there develops an eventual difference of descriptive tone. While Republican and Augustan writers generally employ the discourse of luxury with pejorative colorings, in the Empire we see it slowly gravitating into the rhetoric of praise.[65] Consequently, the moral status of written luxury in the Empire may be regarded both as a function of chronological changes and of the particular literary genre that it inhabits. The following pages examine this discourse with a particular emphasis on colored marbles.

Elder Pliny

As our first and, to a degree, most objective witness, the Elder Pliny's observations span the Neronian and Flavian years, as always combining technical knowledge with anecdote and firsthand description. His introduction to Book 36 hyperbolically emphasizes the bold violence of quarrying. Decorative stones (*lapides*), he expostulates, are the "especial madness of fools" (36.1 *praecipua morum insania*). Inflating folly on an epic scale he envisions whole mountain ranges that Nature intended only to structure the lands and resist the force of ocean being carried across the seas in costly ships designed especially for this purpose just so that perishable mortals can luxuriate amid the variety of colored and patterned stones (36.1.3: *ut inter maculas lapidum iaceant*). He furthermore marvels that sumptuary laws, such as those which C. Claudius Pulcher, a censor of 169 B.C. had passed to forbid consumption of dormice at banquets, had never been promulgated to oppose the importation of colored marble. Nonetheless, while the environmentalist philosophy underlying his science decries the audacity of quarrying as an offense against nature, his science also causes him to report immediately afterward the rumor that marble grows back in its quarries to foster the "hope" that the demands of luxury will perpetually be satisfied (*NH.* 36.34.125).[66] In treating color and pattern, Pliny often represents painting and marblework as rivals (36.5.45). Veneering serves the craving for luxury by dividing it (sic) into many portions (36.9.51). Its inventor was a man of misdirected talents (*importuni ingenii*). The culmination of artificiality in decorative stonework is painting designs on marble itself.

In an interesting *praeteritio,* Pliny notes that the colors and species of marble are too well known to require mention, but also too numerous to be easily listed (*NH.* 36.11.1). All the same, he serves his scientific purpose in identifying the stones both by provenance and by color. This information is of great importance to us, in view of the tendency just mentioned among imperial writers to employ the stylistic nicety of designating the stones by place of origin with the expectation that such information is a part of their readers' store of knowledge. Spartan green is green porphyry (36.9.55). It is only one of several varieties of serpentine. Red porphyry and red granite come from Egypt. Egypt also produces a variety of onyx (alabaster), a stone that comes also, in differing qualities, from India, Syria, and Asia (Cappadocia).

Among its many varieties, of which different ones suit different purposes, the most prized species has the color of honey with a swirled pattern (36.12.61).

Illustrating the contribution of colored marbles to the escalation of Roman luxury, Pliny mentions several examples of their deployment in the private sphere. Most recent among these is the dining room of the Claudian freedman Callistus with its thirty large onyx columns. By contrast his laudatory remarks on such major public monuments as the Augustan Forum and Vespasian's Templum Pacis make no mention of the varicolored marbles and colored granite that we know to have figured brilliantly in their decoration.[67] In general his moral bias attaches more closely to private indulgence than to public splendor. Whereas his antipathy to Caligula and Nero consigns their buildings to private indulgence encroaching on the public sphere (36.3.111), he allows a certain national enthusiasm to invade his informational mission. While moralizing about the fires that punish human extravagance, he nonetheless shows Roman public buildings becoming always bigger and better (36.34.110). With seeming enthusiasm he calls the Basilica of Aemilius Paulus remarkable for its Phrygian columns (36.24.102). On the whole Pliny's view of progress suggests a broad audience and foreshadows an eventual acculturation of luxury among the upper classes that confirms Tacitus' remark on its widespread distribution.

Neronian Writers

While Pliny's moralizing bias does not compromise the general reliability of his information, the ring of conventionality in the examples aired by Seneca and Lucan, two kinsmen at Nero's court, seems more revealing of attitude than actuality. In keeping with the Stoic stances he cultivates in his philosophical essays and letters, Seneca frequently inveighs against luxury. He paints a contemporary landscape where "houses and temples are gleaming with marble" while massive stones are made round and smooth to form colonnades or support structures large enough to contain an entire populace" (Ep. 90.25). Inside such buildings are certain standard items of furnishing such as gilded ceiling coffers, highly polished tables of variegated marble, and pavements more costly than gold. (de Ira 3.35.5; de Beneficiis 4.2). Seneca criticizes Ovid's implied identification of ostentation with glory when he portrays Apollo's palace as a luxurious dwelling with columns and gold (Ep. 115). Seneca deplores the involuntary bondage of men who could not live without the marble worker or metalsmith,

nor dress themselves without the silk merchant (Ep. 90), He refuses to grant any status among the liberal arts to painting, sculpture, marble working, or other decorative crafts that serve luxury (Ep. 88.18–20). Slavery lives beneath marble and gold (90.10). In the words of Hippolytus in his tragedy of Phaedra, the independent spirit does not seek to be sheltered by a thousand columns or golden roof beams (Phaedra 446–97). Allowing that Hippolytus' ethos is abnormally antisocial, the character all the same overlaps with his author in social perspective, while the Phaedra as a whole associates regal luxury with corruption.

Although the general tenor of Seneca's remarks carries an air of the commonplace, whose tradition exists as securely in literature as in life, he sometimes shows himself capable of a focused vision that paints scenes precisely. Visiting the villa of Scipio at Liternum, where the utilitarian bathing quarters are dark and cramped, Seneca describes by contrast the modern thermal establishment with great precision of detail (Ep. 86.4.6). Walls gleam with large circles; Alexandrian marble (Egyptian porphyry) is set off with veneers in Numidian giallo antico, bordered with mosaic patterns and finished by glassy ceilings and white marble lined pools. Yet these are mere plebiae fistulae beside which, as he goes on to say, the establishments of freedmen are even more luxurious with their plethora of statues and superfluous columns, supporting nothing, placed for no reason save to flaunt wealth. Are these establishments public or private, we may ask? Are their owners imperial freedmen?

Additionally his comments attest to practices and corroborate information from more technical sources such as Pliny by visually situating luxury materials within contexts of everyday activity. Variegated marble bulks large in such contexts. A fastidious man, according to Seneca's characterization, is unable to look on marble unless it is patterned and recently polished (varium ac recenti cura nitens marmor) or to value a table unless it is inscribed with many veins (de Ira. 3.35.5). Adult cravings for this stuff are like the passions of children but more costly. While speckled pebbles from the beach can satisfy children, their elders must have maculated columns dragged out of the sands of Egypt or the deserts of Africa to support a porticus or a dining hall large enough to contain a whole populace (115.8). Frequently he associates conspicuous show with hypocrisy. In the words of his Hippolytus, the independent spirit does not seek to be sheltered by a thousand columns or golden roof beams. At Thyestes 640–9, the messenger who reveals Atreus' butchery of his nephews to the chorus reveals also the inner topography of the palace on a familiar Roman

plan. Gilded roof beams elevated on lofty variegated columns (*variis columnae nobiles maculis*) cover the ample hall that receives the populace, while the secluded dark garden comprising the *penetralia regni* ("inner depths of the kingdom") houses dedications commemorating the crimes of the race.

Another fashion well documented by Seneca's comments is veneer, for which, on account of its thin substance and mendacious covering function, he reserves a special scorn. Like other writers he defines it as imported marble, usually cut into thin slabs and arranged in patterns (86.6). In *de Beneficiis* (4.6) he complains how men devalue the masses of solid and beautifully patterned stone that structure their divinely given, natural *domicilium* while paradoxically attaching great value to slabs thinner than the knife that cuts them. Whatever the context in which marble clothes walls, one suspects that it hides nothing good. In *de Providentia* 6.4, Seneca compares unreliable men with the houses they inhabit whose dirty walls are covered with thin plaques. We admire walls overlaid with thin marble facings, although we are aware what is beneath and we overlay ceilings with gold. His language stresses the superficiality of gilding as a moral analogy, warning men against a *bratteata felicitas* ("thin-plated happiness").

Many of Seneca's strictures against luxury occur metaphorically in discussions of style, where he establishes coordinating links between verbal and visual manifestations of modern decadence. Comparing a piece of writing with a house (*Ep.* 100), he notes that a good one may lack "variety of marbles," "water flowing through the *cubicula*," and other devices to serve luxury. In the essay on style he discusses the growth of obsession with luxury. First men go wild over furniture. Then, turning their attention to houses, they want walls that gleam with imported marble and polished floors reflecting gilded ceilings (*Ep.* 114.9.4:"ut parietes advectis trans maria marmoribus fulgeant, ut tecta varientur auro, ut lacunaribus pavimentorum respondeat nitor). The same doctrinal metaphor seems implicit when he counsels Lucilius that a painstakingly polished style of oratory betrays a spirit given to trivial preoccupations (*Ep.* 115.2).

Naturally Seneca was an eyewitness to Nero's interior luxury, but since he never refers expressly to it, we are left to conjecture the extent to which his comments incorporate an indirect response. *Epistle* 90 specifically addresses luxury as a misuse of human ingenuity and refers in this context (90.15) to dining rooms with ceilings of movable panels (*versatilia laquearia*) capable of shifting their patterned appearance as speedily as the courses of

a banquet are changed. This last description coincides sufficiently with Suetonius' description of the Domus Aurea as to make it appear that Nero's construction is at least the prototype for what Seneca specifically attacks. Size also is compromising. The phrase *capax populi*, used in 115.8 to describe the *cenatio* raised on variegated columns seems to carry a particular coloring of megalophilia. In this case it may not be that the structure is imperial, but rather that its decorum may be. Conceivably Pliny is referring to one of the same kind when he mentions thirty columns of onyx marble (alabaster) in the dining room of Claudius' freedman Callistus (*NH.* 36.12). In 90.25 it is less certain that the marble porticoes and *capacia tecta populorum* (enclosures to hold a crowd) belong to private quarters, but in *de Ira.* 3.35 the generically wealthy addressee also dines in a room capable of accommodating an assembly (*eodem loco turba contionis*).

Allowing, of course, for the discretionary curtailment of free opinion that his imperial environment made advisable, Seneca's remarks give the impression of luxury as a widespread phenomenon. The categorical terms in which he couches the majority of his criticisms direct them ad mores rather than ad hominem regardless of specific instances that might be lurking in the writer's own mind. Moreover, as Dio Cassius, at least, reports, some taint of luxury was imputed to the philosopher himself. Thus his strictures on luxury would seem to appear more culturally and less specifically oriented than Republican remarks on the subject, but the writer seems also to show a knowledgeable familiarity with the phenomena he describes.

The same point holds true of Seneca's nephew Lucan. Some of the specific experiences of luxurious furnishing implied by Seneca's descriptions might appear to underlie the general tenor of the poet's proleptic passage on Julius Caesar's reception by Cleopatra in Egypt. Ovid had described the palace of Circe with a marble-paved atrium. For the Augustan poet this conveyed an air of exoticism suited to the erotic experience. In *Pharsalia* 10.104–26 Lucan represents the seductress Cleopatra as celebrating her triumph over Caesar's resistance through what might be considered an appeal to kindred megalomania as she unfolds before him wealth on a scale that had not yet invaded Roman culture (110: *nondum translatos Romana in saecula luxus*).[68] By this predictive rhetoric, which establishes the keynote of the passage, Lucan instructs his reader to envision present-day Roman reality indirectly by means of comparison. Within the templelike banqueting hall of Cleopatra's palace the ceilings are thickly gilded, but no thin marble slabs have been used to create a surface veneer on

the walls (113–15). Instead the very fabric of the walls is itself constructed from solid agate and porphyry (*lapis purpureus*). The doorposts are thick beams of Egyptian ebony. Alabaster pavements are underfoot. Ivory clothes the atrium, its doors hand-inlaid with Indian tortoise shell and thickly studded with emeralds (10.119–20). Predictably the couches are gem studded, carved from jasper, and spread with rich coverlets.

Because Lucan throughout the poem treats luxury as one of the evils leading toward civil war, it seems clear that he means this background setting to reflect the decadent opulence resulting from the institution of the principate. What he has surely in mind amid this general picture of Mediterranean luxury is the immediate excesses of imperial Rome. Not yet corrupted in Caesar's day, the city has now become a world of appearances imitating foreign models with gilding and veneer. Lucan's rhetoric creates a paradoxical situation in which the deceptions achieved by contemporary imitation are by their nature more honest than the solid reality of their corruptive model because the degree of extravagance they entail is actually less. But what are the standards? By virtue of this insistence on the material distinctions between reality and imitation Lucan's description acquires a rhetorically self-undermining quality that makes it seductive in spite of its moral stance. The paradox suggests how difficult it became for Roman writers who moved frequently amid luxurious surroundings to sustain high philosophical disapproval, especially when the contexts were not political. That their own surroundings partook of the same species of luxury they denigrate is certainly what Juvenal (*Satire* 7.80) wants us to know when he pictures Lucan himself, reclining content with his fame, *in hortis marmoreis* ("in his marble gardens"). Imagining how this same poet might have treated contemporary material luxury in his lost occasional poems, the *Silvae*, might also give pause to our trust in his condemnatory attitudes toward the corruptive past. Similarly luxurious installations may be seen in the writers of the Flavian and Trajanic periods, the Younger Pliny and Statius, who describe residences in fuller detail than previous writers and whose primary subjects are neither emperors nor rich freedmen who ape emperors, but members of the everyday senatorial class.

Post-Neronian

That Flavian literature presents the most abundant and precise written evidence for the dissemination of marble is no accident. The causes are several. For one thing Vespasian's accession and his reform of governmental policy dissolved that association between luxury and imperial corruption that had cast the topic under a pejorative cloud. Instead of a record of private extravagance, Vespasian built a personal legend of plain and quasi-military restraint calculated to validate the responsible temper of his economical administration. Titus also, despite his mastery of showmanship, was not called luxurious, perhaps because he did not offend by those other indulgences that draw opprobrium. Conceivably the positive reputations of these emperors, combined with their ostentatious euergetism, may have sanctioned the spread of luxury among the upper classes. Domitian is a somewhat different case, because the familiar charges are brought against him after his death. Juvenal's fourth satire mocks both his megalomania and the toadyism of his court. In Juvenal 7. 180–2, a *dominus* who can be only Domitian builds a porticus in which to drive on rainy days and raises a banqueting hall with Numidian columns to catch the winter sun. Specific references must be intended. But unless written evaluations of the emperor's lifetime are totally ironic, it is not because of Domitian's unpopularity that luxury is associated with his name, for the contexts in which his royal surroundings are described are not ostensibly intended to condemn. Rather, his Palatine *domus* appears to attain the status of a public work by virtue of its enhancing his personal, imperial image.[69]

This would suggest not only a change in the status of luxury, but also in the literary situation. Certain new modes of writing that emerged during the Flavian period brought the individual and his habits of life to the foreground through a new combination of spectatorship and self-projection. Although Seneca too had focused on personal conduct and routines, his discussion was controlled by his philosophical persona, which projected a temperate lifestyle as a criticism of contemporary indulgence. In the descriptive spectatorship of Statius' and Martial's first person poems, we encounter a very different point of view, which, in the case of Statius, has often been attributed to the patronage relationship between the poet and the recipients of his verse but nonetheless embodies a new social discourse of value that alters the status of luxury from political weapon to cultural condition. Genre, which in some cases observes long-standing attitudinal codes, continues to determine the selection and significance of detail. Allowing for a touch of *invidia*, satire remains self-righteously condemnatory. Epic exploits traditional symbolisms, but is surprisingly sparing in its incorporation of luxurious settings into its historical and mythological reconstructions. However, the newer genres of epigram and occasional lyric that proceed from ostensibly personal points of view, as well as the self-presentational discourse of Pliny's *Letters,*

assume greater latitude and furnish what is at once the more abundant and more credible evidence.

Personal Genres

In self-conscious concern for personal image no writer of any period can be said to have outdone the Younger Pliny. The standards he professed owe much to traditional representation of the intellectual life, yet with a revised scale of valuations that unabashedly claims superiority for creatively productive *otium* over the time dedicated to civic obligations that the social and political system had rendered trivial and tedious (*Ep.* 1.9). In this voluntary embracement of *otium* Pliny is the intellectual follower of Horace and Seneca rather than of Cicero, notwithstanding that the seats of his *otium,* like those of Cicero, were the extra-urban villas he had acquired and renovated to accommodate his life and habits. Letters describing these villas trade on the traditional identification of house and owner in such a way as to make them visible texts from which his studious and literary preoccupations can be read.

In view of the elitist rejection of luxury professed by Pliny's uncle and others of the earlier writers whom Pliny most honored, we may justifiably ask whether Pliny attempts in these descriptions to conceal luxury within his house. One might think this of his letter concerning the Laurentian villa where the information he gives centers on the locations of rooms, and the more atmospheric portions of the description dwell on natural advantages such as proximity to gardens and the orientation of windows toward prospects of sea and shore (2.17).[70] These remarks give useful evidence of an owner's deliberate attention to the framing of prospects both interior and exterior. Although there is occasional mention of furniture, virtually nothing is said about the decoration of rooms. Similar information also appears in Pliny's descriptive tour of the Tuscan villa, but this one seems somewhat more opulent, possessing more expansive grounds and gardens distinguished by an occasional marble fixture: a white fountain basin placed near a *diaeta* that featured walls decorated with garden paintings (*Ep.* 5.6.20–5), and even, in another place, a quartet of Carystian columns, although Pliny's use of the diminutive *columellae* to mention these keeps them modest. Their practical function is to support a vine arbor that shades a marble stibadium. The greater part of the description represents the interplay of garden greenery and white marble within the enclosure which is represented "as if one were reclining in a grove" (*Ep.* 5.6.36–40). This room is oriented toward a *cubiculum,* seemingly half open, with which it participates in a kind of reciprocity of ornamentation. Although it is hard to imagine that no other part of his residences does contain marble decorations, still the particular pride of invention with which Pliny highlights this description distinguishes it as the summit of his taste. Nor indeed would any connoisseur of the marble trade have considered it as high luxury; the gleaming white marble that so effectively complements the surrounding greenery stands at the very bottom of the scale of extravagance. Likewise it is hard to imagine that walls over and beyond the illusionistic garden paintings of the *diaeta* were undecorated but perhaps it was in too ordinary a fashion to have seemed worth special mention.

Far more opulent pictures of the upper-class house takes shape in Statius' collection of occasional *Silvae* and Martial's books of Epigrams. Statius' testimony is useful for two reasons. In the first place this author, whose purpose is to praise other persons' houses rather than reflecting his own properties, has every reason to display them at their most spectacular. In the second place he does not, like Seneca, speak categorically of patterned or spotted marbles, but rather employs a plenitude of designs and colors with a technical specificity resembling the Elder Pliny's usage. Martial's more detailed ekphrase-is focus chiefly on such portable components of luxury as cups or statues, but he also depicts contemporary places, including several that also Statius describes, ordinarily with less specific detail. Both authors picture Domitian's palace with the dramatized voice of a dazzled spectator, but Martial's description deals only with the exterior impression, while Statius takes us into interior rooms.

Amid the dazzle of reflected light and shining waters that blur the sharp outlines of objects in Statius' Roman houses, colored marbles stand out with focused specificity. Without precise definition of dado, panels or friezes, we see their rich juxtaposition conferring distinction on a single space. Generally, Statius expects his readers to be familiar with the color designations implied by names. Their rehearsal gives his passages a particularly exotic flair. Moved by the elegiac eloquence of L. Arruntius Stella, Venus herself enters the home of Violentilla, his longed-for bride (1.2). This typically elegant Flavian woman with high-piled hair occupies an opulent family mansion on the Tiber, a residence worthy of a goddess. Statius describes its interior primarily in terms of its marble decorations, here using the geographical designations *Libycus Phrygiusque silex* (hard African and Phrygian stone) and *dura Laconum saxa* (the tough stones of Sparta) to specify giallo antico; pavonazzetto and green porphyry (146–8); onyx alabaster is textured like the white veining of the deep sea, and red porphyry shines out like the Oebalian cliffs. "Countless"

columns support the roof beams; the ceilings are gilded, and clear running fountains come alive within their marble basins (155).

One favored *diaeta* in the Sorrentine villa of Pollius commands the distant prospect of "Parthenope" across the bay (2.2.83–95). Here Statius creates a pan-Mediterranean ambience by interlineating the colors and patterns in the marble with landscapes of their provenance. Syene (Egyptian) granite shows (red) veins; the purple and white swirling of the Phrygian (pavonazzetto) declares its origin in the fields where Cybele lamented Attis; the Amyclaean (Spartan verde antico) is as green as the grass on cliffs; desert rocks (*Nomadum saxa*) gleam tawny; Carystian with its wavy appearance rivals the surface of the sea.[71] Like a glorified *aedicula,* the entire room stands as a shrine placed to honor the view of Pollius' homeland, Puteoli, across the bay, but also, by the Hellenic provenance of its marbles (*Graecis metallis*), monumentalizing his predilection for Greek customs and thought.

The differences in details from one to another description argues that Statius does not merely draw on a conventionalized vocabulary for each exercise, but actually wishes to give as accurate an impression of his subject as his owners might expectedly desire. Thus there are differences between Pollio's villa and the Tiburtine villa of Manlius Vopiscus, which does not have a marble room. In the latter description marbles are played down, being referred to summarily as *marmora picturata lucentia vena* ("marbles shining brightly with painted vein";1.3.35–6). Possibly these patterns are natural, but they may well be painted imitations. The house has also gilded beams and "moorish" doorposts. Its floors are artfully figured mosaics. But the real emphasis is on channeled streams and miracles of running and spouting water within and outside the house.

One of Statius' most telling indications of the acculturation of luxury is its diffusion across different classes of society. Each book of the *Silvae* intermingles private with public places. Little but the degree of familiarity in the speaker's address sets aristocratic villas apart from imperial palaces. When we turn from the private world to the public we find minimal differences, so far as the quality and costliness of decorative materials are concerned, not only between the houses of senators and the baths owned by the freedman Claudius Etruscus but also between Etruscus' baths and the dining hall of Domitian's imperial palace.

The small and elegant baths of Claudius Etruscus were described both by Martial and by Statius. Statius' poem, as he says in the preface, was read between the courses of a dinner (*intra moram cenae*) in the owner's

presence. As Alex Hardie remarks, Statius' encomiastic rhetoric justifies his Callimachean verse celebration by highlighting what the elegance of the establishment owed to the owner's artistry of selection.[72] Approaching his ekphrasis of the bathing facility as a recreational exercise that gives respite from the burden of serious poetry, Statius transforms its chambers into another art grotto of the Muses. One point on which both Statius and Martial seem well agreed is the effect of shimmering light, which, according to Martial (6.42.9) lingers longer in this place than any other. Statius explains why this happens by noting how the vaults (*camerae*) gleam with glassy mosaics and sunlight streams through upper windows (clerestory?) only to be scorched by another heat within (42–6). Particularly interesting are the catalogues of colored marbles, again much fuller in Statius than in Martial. According to the latter, the chief stone is Spartan green (*Taygeti virent metella*) while Phrygian (pavonazzetto) and Libyan (giallo antico) contend in the upper regions. Rich alabaster (*pinguis onyx*) breathes the dry heat while serpentine (*ophitae*) is positioned where it grows warm with the flame. In the frigidarium the gleam of pure white Parian shines through the transparently crystalline waters of the Aqua Marcia and Acqua Virgo (6.42.21). Statius' more complex rhetoric elaborates the figure of competition among marbles in order to emphasize the patron's control. Excluding some of the popular stones such as alabaster and serpentine (here Statius' evidence conflicts with Martial),[73] Etruscus has created a color scheme of rich gold, red, and green. The floors are yellow Numidian and Phrygian, with purple markings imagined as Attis' blood. It is thus the ultimate compliment to the tasteful judgment of this prosperous freedman that he has admitted no lower-class effects within his baths (*nil plebium est*). This praise, as Hardie remarks, enforces Statius' own discriminating Callimachean aesthetics.[74]

In spite of the fact that Martial himself praised these baths, Hardie suggests that his brief send-up (9.19) of a poet who praised a bathing establishment to gain a dinner was directed at Statius. Bathing places in Martial's other poems are on a higher social level. Torquatus, a former consul, has constructed baths gleaming with various marbles in his mansion (*praetoria*) at the fourth milestone (10.79), while his envious neighbor, Otacilius, tries to rival him with a little "cooking pot" of a bath. In this case, the pretentious imitator, rather than the initiator is the object of Martial's ridicule.

Within the palace of Domitian at a banquet of 1,000 tables, the scale of construction is grander, and the level of Statius' descriptive rhetoric accordingly rises to meet the demands of imperial decorum.[75] A sense of space

is given by the loftiness of the roof and the vast number of columns deployed to support it. Raised to so great a height that gazing upward "wearies the eyesight" the gilded ceiling could easily be confused with the sky (4.2.30–1), and the vast number of columns, far exceeding 100, might substitute for Atlas in sustaining the burden.[76] Five kinds of stone are conspicuous: yellow Numidian (Mons Libys), multihued Chian (portasanta), rose-colored Obelisk granite (Syene), purple-mottled pavonazzetto from Phrygia (Iliacus), and a stone that competes with the blue-grey of the sea, which can be only Carystian cippollino. Not even native Luna, although outclassed, has been denied a place. Archeology confirms these colors and also Statius' care for specificity.[77] Although the poet as a performative speaker never omits to declare how spectacular marbles compel wonder, the frequency of their occurrence belies spontaneity, while the codified form of reference by place names show that he directs his ekphraseis toward an audience of connoisseurs. Their particular educated taste allows him to use language that combines specific visual information with a sense of Rome's geographic command. The several varieties of stone in the banqueting hall emanate from imperial quarries.[78]

One area in which Statius goes beyond other writers in conferring the stamp of reality on contemporary practices is in describing actual collections of art objects, particularly statuary, in context. In the poem to Manlius Vopiscus these are mentioned only categorically as "living works in metal," but the array in Pollius Felix' villa more specifically combines archaic ancestral faces and bronze statues (*Silvae* 2.163: *veteres ceraeque aerisque figuras*). Further descriptions leave it vague whether the works attributed to the artistry of Apelles, Phidias, Myron, and Polyclitus are actually from their hands, but regardless of authenticity, we see the artists' skill in bringing materials to life. More clear is the fact that the collection comprises faces of commanders, poets, and philosophers (2.169). A programmed assemblage like that of the Villa dei Papiri should be understood, although we can only speculate how it may be distributed throughout various rooms.[79]

In *Silvae* 4.6, written for Nonus Vindex, Statius focuses on a single object: Nonus' small bronze copy of the Hercules Epitrapezius by Lysippus, which is the chief treasure of an ambience where Statius has enjoyed a generous impromptu meal. From festivity he creates a context to contain the heroic image that is itself disposed in festive relaxation. As usual Statius praises the verisimilitude of the statues on the verge of speech, but here the *topos* has a particular significance because of the owner's own discursive ability to animate the work of

old masters. Vindex is a knowledgeable collector who possesses the genuine discernment needed to recognize the work of old masters, even when previously unidentified (23–4). His colorful narrative of Hercules' creation and of the vicissitudes of ownership takes over the body of the poem. Martial's poem on the same statue also disclaims Roman origins for this noble work of Lysippus and traces in a short narrative his passage from the hands of Alexander to Hannibal to Sulla until at last, wary of the intimidation of royal courts, he is happy to inhabit a private dwelling. Despite these incorporations of Vindex's learned discourse, there is no guarantee that his bronze treasure is a true product of the master, or merely the catalyst to elicit his fund of art historical knowledge. Certainly the miniature Heracles represents the kind of copy made available to Roman collectors.[80]

Imperial Epics

Lucan's passages on the luxury of Cleopatra brought the viewpoint of satire into an epic context, combining the commonplace of "oriental luxury" with a historical pattern. For this reason, as well as the specificity of its detail, it appears as a cultural paradigm. Because the traditional genres of epic and satire are more likely than the personal genres to exploit the imagery of luxury for its established symbolic associations, their value as evidence for contemporary practice is more difficult to assess. When the house of wealthy Asturius burns, as Umbricius complains in Juvenal's third Satire, a rich friend will be quick to supply new marble, other statues and still another bronze. In Juvenal 14 Cretonius builds villas at Tibur, Praeneste, and Caieta furnished with Greek marbles, surpassing the temples in those places. What remained of his fortune his son wholly depleted by constructing a new villa with "better marbles" (14.85–95). Anxious Licinius fears that any night a fire may destroy his amber, his statues or Phrygian columns, his ivory, and tortoiseshell (14.305–8). Extravagance, purportedly contemporary, is the topic of the entire poem, and its practitioners bear common Roman names, but the detail itself might be found in any period. Signs of status become perverse when the owner is corrupt, as the sexual deviant of 9.103 whose marble columns betray his secrets or the diner of 11.175 who stains his Spartan marble with vomited wine.

As an epic writer, Statius certainly does not follow Lucan in constructing luxury as a sign or source of social corruption. Rather, with a pronounced moral inversion luxury actually bespeaks the civilized. The palace at Thebes antedates luxury (1.144–6). Statius characterizes it by the absence of gilded coffers or Greek marble

columns. But this appearance, which might in other contexts figure as praiseworthy simplicity, is here a condition verging on raw primitivism, rhetorically highlighting the uncivilized emotions with which the brothers contend for naked power (*nuda potestas*). When the ghost of Laius returns with loathing to this palace which has become his son's possession, he recognizes lofty supporting columns, but also the chariot stained by his own blood.

In the Argive palace of Adrastus, once a seat of pacific government before violent Polynices and Tydeus intruded into it, a more conventional scene appears. Embroidered coverlets, curtains, and golden lamps create the ambience of King Adrastus' hastily prepared royal reception for his future sons-in-law. The monarch takes pleasure in the decorum of proper appearances and in the *obsequium* of his servants setting forth these furnishings. Statius' attribution of these royal trappings to one of the few morally acceptable personages in the *Thebaid* bears out the idea that luxury not only escapes the opprobrium it has borne in earlier epics but even becomes a marker of propriety.

TWO POMPEIAN HOUSES: M. LUCRETIUS FRONTO AND L. CAECILIUS JUCUNDUS

Comparing actual Pompeian architecture and decoration with that which Statius attributes to Pollius' Sorrentine villa just across the bay would initially appear to produce negative evidence concerning the dissemination of private luxury. Citing the presence of marble as a criterion to test the incursion of luxury into areas outside Rome, Gnoli notes how infrequently the colored varieties appear in large amounts throughout Pompeii.[81] Granted that some opulent houses possess one or more rooms paved in *opus sectile,* a realistic assessment will note how small the component pieces are. Fully veneered walls are a rarity; only the walls of one small room in the House of the Telephus Relief at Herculaneum preserve their complete marble revetment in colored panels. Admittedly our knowledge in this area is incomplete since wall impressions in the large garden *oecus* of the Casa dei Dioscuri (Figure 133), the atrium-*tablinum* of the Casa di Arianna, and a few other locations indicate the use of veneering in limited areas that must quickly have been stripped in the aftermath of the eruption.[82] These may conceivably have been colored, yet the one domestic installation found undisturbed within recent years, the fountain *triclinium* combined with garden decorations on the lowest level of Insula Occidentalis (Casa del Bracciale d'Oro) was veneered in white (Figure 83). Although here and there we see marble columns enriching

areas of high status, such as the two Carystian (cipollino) in the terrace biclinium of the House of Loreius Tiburtinus, a full series of marble columns exists in only one peristyle, that of the Praedia Juliae Felicis, an edifice that will more likely have served the activities of a group than a single owner.[83] Although elegantly fluted, with two files of rosettes incorporated into their Corinthian capitals, these columns are slender and carved of white marble. While some columns in tetrastyle and Corinthian atria may have sculptured capitals, the majority of these and virtually all peristyle columns are stucco coated and painted. The consistency of this practice from the inception of peristyles as a feature might be attributed to a combination of economics and established custom.

All this may go to remind us that Pompeii, while prosperous in municipal terms, was never egregiously rich. Rather its luxury must be considered on a relative scale within the parameters of economic possibility, but it is for this precise reason that the material evidence for the intensification of Roman luxury furnishing with its tapestries and gilded edgings, marble inlays, and gems, along with the concomitant verbal incarnation of these items, is significant. For if luxury constitutes a cultural discourse, the imitation of luxury must be seen to participate in this discourse no less than the solid objects themselves. It is to this broad context of dissemination rather than to any specific model that we should look for insight into the changes that seem to mark the conversion of Third Style compositions into Fourth Style during the late Julio-Claudian period in Pompeii.

After the apparent curtailment both in the scale and the pretensions of residential buildings during the Augustan and early Julio-Claudian periods, activity that involves both the renovation of existing structures and the creation of new ones recommences in the later Julio-Claudian era. New architecture involved new painting. The hallmark of this new manner is a recurrence of perspective illusion, especially in *pinacotheca* rooms where central *aediculae,* now grown more elaborate, come to be flanked by simulated apertures in the surface of the wall. Behind this revision lie models, whether actual or merely hypothetical that clearly betray reference to the contemporary development of luxury. This must be a style of prosperity, expressing the personal well-being of its commissioners. Two houses with different social and architectural histories have similar decorations. The histories of building and rebuilding are interesting because they appear to tell us something about the careers of the owners and the use that each one made of his house.

The house of M. Lucretius Fronto is one of the most certain examples of a house that served a political career. An unusual verse programma on the exterior proclaims

the occupant's suitability for office on the basis of his *pudor*.[84] It is even possible that Fronto may personally have built the house for his own use since his candidacy for the office of quinquennial early in the seventies could place his aedileship as far in the past as the mid-fifties.[85] Who his immediate relatives might have been is not clear. His gentilician name links him with the extensive and seemingly powerful family of the Lucretii,[86] but he had perhaps acquired the surname Fronto through an intermarriage with a magisterial family of the Augustan period.

This is one of a few houses built as a complete unit during its period[87] (Figure 117). It received its first decoration upon completion. Later years saw additions in the garden area with a new decorative effort in a different mode. Because it was placed within an already developed residential block, the house needed to utilize its available space in the most efficient manner possible. The resulting complex of rooms shows us something about priority rankings. A great difference between this house and earlier examples of the aristocratic residence is that it has been built with an exclusive emphasis on the needs of the social life of politics. No attempt has been made to surround the atrium with lateral *cubicula,* but rather the room is cut narrow to accommodate a suite of two large *conclavia* at its side. There is no indication that any rooms on the ground floor were specifically dedicated to sleeping, although virtually any room could, of course, have been used for this purpose. But the house was built with a second story where the majority of the bedrooms must have been located. One of these rooms above was a loggia with a view of the garden.[88] Because of these provisions the rooms on the ground floor have low ceilings.

Considering the variety of enclosed spaces suited for dining that surround the atrium, one might wonder whether the house might not originally have lacked a summer *triclinium*. Because the entire garden quarter in which rooms answering this description are located is the product of a Fourth Style remodeling, we can be certain that this area, at least, was Fronto's addition. Renovations produced a set of *oeci* facing the opposite colonnade whose two walls a large-scale *venatio* covered. Conceivably this will have commemorated a spectacle that Fronto himself had produced for the town so as to suggest that the period between his aedileship and duovirate might have been a logical time for the decoration.

In the much older House of Caecilius Jucundus the new painting represents only one of several campaigns of redecoration in a house that also saw architectural restructuring more than once (Figure 115). The owner of

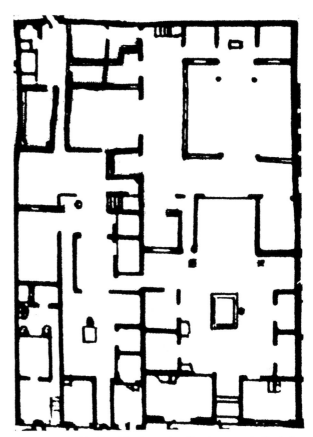

115. House of L. Caecilius Jucundus, Region 5.1.26. Plan after Eschebach, 1993.

the house in its final period is popularly the best-known personage in Pompeii, a banker and auctioneer records of whose business dealings from A.D. 52 to 60 are preserved in inscribed tablets of wax and wood. The succession of names might suggest that Jucundus took over his business from a freedman father, L. Caelius Felix.[89] A bronze herm bust in the atrium bearing the inscription "From Felix to our patron Lucius" might suggest that the freedman family will have inherited the house from its previous patron. This circumstance, which would not be unusual, may explain the architectural history of the house, in which the limestone quoined shell and conventional ground plan indicate an original second-century date.[90] Remains of First Style decoration are extant in one room. Traces of Second Style in the atrium and other rooms might indicate an extensive remodeling at the time when the peristyle was added, particularly if Dexter is correct that a square shape for the peristyle was favored during this period.[91] Possibly no other changes took place until the much later time when the house next door at entrance No. 23 was added; this gave additional space in the peristyle area for constructing a set of three *oeci* which now encroached on the space of the other house so as to render its garden useless for

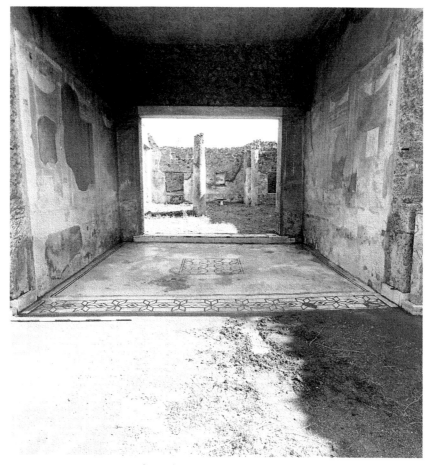

116. House of Caecilius Jucundus, *tablinum*. ICCD N48473.

entertaining. As C.E. Dexter speculates, the service functions were moved into this house. The last construction activity may well have repaired earthquake damage within the peristyle because the structure shows reused columns of different kinds. At this time three more open rooms at the back were added under what had been a portico. Possibly the smaller house was originally purchased by Caecilius Felix with assistance from his master.

117. House of M. Lucretius Fronto. Plan after LaRocca, de Vos, and de Vos, 1976.

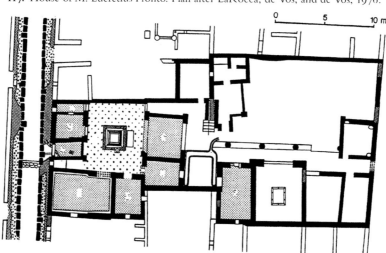

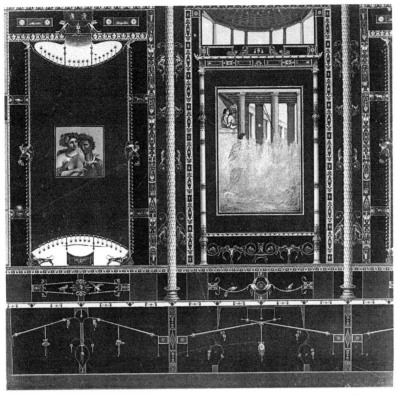

118. House of Caecilius Jucundus, *tablinum,* reconstruction drawing. DAI W325.

When ultimately the freedman family inherited the patron's own house, they incorporated the two into one.

The rooms that are similarly decorated in the houses of Jucundus (Figure 118) and Fronto (Figure 169) are the *tablina* whose highly ornate compositions layer rich decorative fabrics on surfaces illusionistically pierced by small apertures. In both cases the Third Style *aediculae* preserve their characteristically exiguous character in columns and entablature; these members are not, as in previous contexts, attached to a solidly paneled background but have instead taken on partial autonomy as components of an architectural shell. Simulated curtains and embroideries fill the areas at either side. In the House of Caecilius Jucundus these curtains, fringed with gold bullae, are stretched by decorative braces (Figure 118).[92] These braces articulate the forward surface of the wall, which stands behind the front plane as it is defined by scale-pattern columns based on the podium. Above and below the loosely suspended curtains, semicircular apertures reveal background space. In the central panel a glimpse into this space shows the center of a coffered dome. The total effect, instead of clarifying the location of the component elements, is to lose them within a field of opulence. Here as in previous Third Style walls gilded ornaments provide the final mark of luxurious refinement.

Even greater richness appears in the *tablinum* of the House of M. Lucretius Fronto (Figure 69), where the full range of colors employed creates an individual identity for each element of the decoration. By virtue both of its colors and of its intricate design, the *tablinum* seems intended to complement the much simpler atrium whose walls are decorated with a spare, yet strikingly effective, paratactic composition of black panels above a red dado.[93] The panels are partitioned by flat yellow bands with a pattern of alternating panthers' head and Isis masks in simulation either of embroidery or of inlay (Figure 15). Airy scaffolding in the frieze zone creates complex pavilions that continue the colors of the main wall. Black might appear to be a curious choice for this small and low-ceilinged atrium, with sources of light more restricted than most; the owner may have thought it created a certain dignity that a brighter tone would not have conferred on the confined space.

Within the facing *pinacotheca* walls of the *tablinum,* black panels flank the central *aediculae* against whose red backgrounds small mythological panels are displayed. The open space glimpsed through the columns of the aperture behind the *aedicula* panel is also black, perhaps in this context to adumbrate a nighttime prospect. The apertures appear above decorated half-pilasters framing the inner boundary of the central *aedicula,* but these

supports do not frame the painting, which instead is merely mounted against the background of the red panel. As in the *tablinum* of Caecilius Jucundus, a domed roof supported on columns projects outward behind the central panel, but the open space here is greater, extending on both sides so that the *aedicula* seems to stand before a colonnaded apsidal recess. This contributes to the impression that the whole interior surface of the wall floats within a protected spatial shell. On the black side panels small villa landscape panels are mounted on twisted candelabra brackets. Once again as in the Caecilus Jucundus *tablinum,* the appearance is a confusion of spatial demarcations.

Rich multiplicity of ornament even more thoroughly confounds the indefiniteness in this case. The curtains are laid against figured backgrounds. The side panels are framed by intricately detailed bands of green leaves dotted with golden berry clusters – Dionysian ivy for certain, in view of the sympotic array of miniature instruments: lyre, tambourine, horn that border the panels. The cornice above the panels, which uses additional colors, gives the impression of intaglio; it is similar to what appears in the atrium, but more intricate. In the dado we see the boundaries of a garden; balustrades, and a fountain urn while the frieze zone contains a full-scale miniaturized stage setting that might even recall the marble fountain stages in the Palatine fragment of the Domus Transitoria but is distinguished by projecting gables and deep recession, a spatial sculpting that makes this upper area appear to embrace more open space than the wall. In addition to the central tripod and griffin acroteria ornamenting this stage front, Bacchic instruments and a tambourine hang from above, perhaps to suggest both drama and dance. Just above the *aedicula* appears a panel of traditional still-life subjects. If one wonders why these *xenia* symbolic of dining have been included within the *tablinum,* it might be that this room served the function of principal summer dining room after the house was initially built and before the construction of the peristyle rooms. The elegance and good taste of these decorations are in inverse proportion to the size of the accommodations. Adjacent rooms, although they incorporate some similar trimmings, are simpler than the *tablinum,* containing some familiar elements of picture-gallery walls.

Because the decorations of these two *tablina* appear so pivotal in the narrative of Pompeian stylistic history, their probable dating still occasions debate. Typically scholars categorize them at the upper edge of the Third Style aesthetic as signs of an approaching transition to a new mode of composition in which space and architecture

and illusion are to play an increasingly prominent role.[94] In my opinion, the suggestion is too teleological, as if the artists themselves could foresee future destinations for their work. Beyond this, the notion of a gradual evolution belies the profound change of *mentalité* and the appropriation of new models represented by these walls. Although many familiar elements in these paintings might seem carried over directly from Third Style compositions, and many are borrowed even from the Second Style period,[95] these paintings nonetheless depart from their predecessors as a forthright imitation of luxury, which appears both in their agglomerations of valuable and expensive objects and also in the indication of spaces beyond those enclosed by the walls.

Rather than heralding a new stylistic disposition, these decorations might be taken to celebrate the arrival of a new opulence and the means to bring it about. Among their most conspicuous innovations are the ornately patterned panels imitating either intaglio or rich embroidery employed as dividers in paratactic walls. Needless to say, the mimetic work itself will also have been expensive with its intricate patterns requiring skillful employment of the brush and a great variety of colors. Another atrium decorated with similarly elaborate patterns is that of the Casa dei Quadri Theatricali in the Via dell'Abbondanza (1.6.11).[96] Likewise, in the elegant atrium of the Villa Varanno at Stabiae, purple-bordered tapestries contain a scrolled acanthus design interwoven with Dionysiac emblems: panther masks, cantheri, and rhyta.[97]

These embroideries and fringes constitute a major change in the form and manner of representing curtains. As items of common household usage, curtains appear in mimetic painting even from the beginnings of the First Style. Their primary function in domestic contexts was presumably to provide shade. Hooks to suspend them have frequently been found in peristyles.[98] The type we see frequently in Second Style megalographies are made of black cloth, slung on rings and usually shown hanging slack before a visible backdrop, most frequently the open space of a peristyle. In this manner they marked the dividing line between interior and exterior space. Adding a touch of additional verisimilitude while remaining unobtrusive, they functioned as a part of the illusion rather than the decoration proper.

Such curtains as we see in the House of Caecilius Jucundus and other contemporaneous decorations are objects of an entirely different species.[99] Now rendered in bright colors with intricate embroidered borders, they have become an essential element of the decoration. Instead of being strung on rings, they are commonly

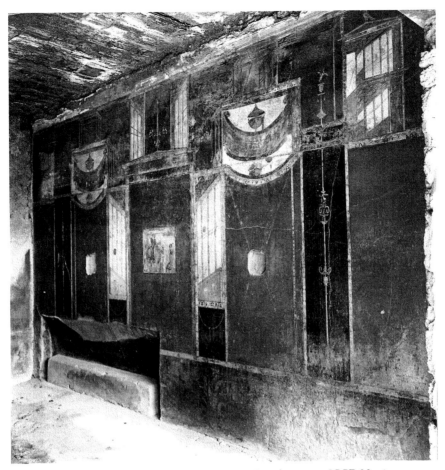

119. Via dell'Abbondanza, Caupona 1.8.8, *pinacotheca* room. ICCD N34621.

stretched on elaborate braces that are often gilded and sculptural. Often they substitute for panels, but sometimes they are depicted in so ambiguous a manner as to confuse their identity with panels. This visual ambiguity characterizes the decoration of a *pinacotheca* room roughly comparable in date with those I am discussing that was located in the back quarters of the Taverna of L. Betutius Placidus at Via dell'Abbondanza 1.8.8–9.[100] The long side walls of this room demanded a decoration virtually paratactic, that was supplied by bordered red ground panels alternating with narrower black niches framing candelabra (Figure 119). The regimentation of alternating red and black panels is relieved by glimpses of exterior colonnaded spaces: porticoes framing the central *aedicula,* and balconies opening in the frieze zone. Notably this attic lacks the complex scaffolding seen in the previous two examples of the Style. Instead what seems to be created is some manner of clerestory light. To enhance this impression of exterior space, the inner pair of red coverings hangs slack, its drape reinforced by another scroll of cloth hung above, beyond which a

tripod ornament can be seen. This loose draping of the inner panel makes it uncertain whether its counterparts on either side are panels or tapestries.

That such simulated fabric coverings had real-life counterparts in decorative custom cannot be doubted. That they belong within an elevated category of luxury is also unquestionable. Richly colored, as if with expensive dyes and often with gold threads picking out their figured borders, their real prototypes will have been visible signs of intensive labor, the more valuable because their deployment was oftentimes temporary in connection with festive occasions.[101] Literary texts emphasize their exotic associations with the rich courts of the Hellenistic East, Alexandria and Pergamon being rival sources. With hindsight Servius (*ad Ae.* 1.697) incorporates culture into etymology when he explains with reference to the trappings of Dido's banquet that *aulaea* ("painted awnings") are so-named because they were first displayed in the great hall (*aula*) of King Attalus of Pergamon. By adding that Attalus had made the Roman people heir to his kingdom, he may be suggesting

that this bequest had something to do with the migration of the form. Even in private houses, as he says, they were deployed in imitation of tents.

As witness to Alexandrian associations, the most celebrated exhibition of curtains is in the dining pavilion of Ptolemy, as described by Athenasius (196A), who in turn derives his material from a description of Alexandria by the Hellenistic writer Kallixenius of Rhodes. Athenasius' elaborate ekphrasis gives information not only about the stuff of curtains themselves but also about their context for display. This was a festival pavilion, called a *symposion,* large enough to hold 130 couches set in a circle erected for the regal entertainment of the king's favored guests. The structure was supported on wooden columns, some shaped like palm trees and others like thyrsoi. A peristyle galley provided space for servants to minister attentively to the guests. Thus the pavilion was separated from the exterior world by two compartments of space.

Movable decoration appeared in several parts of this structure. Tapestries with a tower pattern border suspended from the cross beams of the roof framed painted compartments. The sides of the pavilion were faced with purple screens in between which animal skins were displayed. But the walls themselves constituted a *pinacotheca* on a large scale. One hundred statues placed by the piers were the most conspicuous part of the decoration. Panels by painters of the Sicyonian school, placed in between these, alternated with cloaks on which were woven mythological scenes. The upper-story arrangement was quite elaborate, including shields and a series of deep niches containing figures arranged in symposiast groupings, but said to represent characters from tragic, comic, and satiric drama. Gold drinking vessels were placed beside these and other niches were filled by heavy gold tripods.

Nothing from the Roman world, even in Athenasius' own age of ekphrasis, equals this description. Many references, however even from the Republican period, suggest that tapestries had reached Rome in a form more palpable than mere reputation. As Livy recounts the Asian triumphal procession of Cn. Manlius Vulso in 187 B.C. (39.6.7–39.7.2), it caused wonder mainly because of the novel items of booty displayed: bronze furniture, rich garments, and woven tapestries. In Plautus' *Pseudolus* 145–7, dated 184 B.C., Ballio the leno threatens to pattern the skins of his household with floggings like a figured coverlet from Campania (*peristromata picta Campanica*) or a shaven Alexandrian hide (*Alexandrina tapettia tonsilia bestiaria*).[102] The qualification of the Greek *peristroma* with a designation of Italian regional manufacture

suggests that there was already commercial traffic in such trappings, which would also have been familiar among the displays of booty taken in foreign wars.

It is in keeping with the meta-theatrical quality of *Pseudolus* as a play about competing poseurs that Ballio, an impresario of female flesh, should threaten perverse showmanship on the bodies of his captives. Naturally curtains attach a sense of theatricality, but a theatricality that goes beyond the physical staging of spectacles to encompass the entire function of the theatre as a place of display. I have mentioned already the curtains hung in the porticus of Pompey's theatre and those that figured as a part of the theatrical transformation of the house where Metellus Pius was ceremonially feted in Spain. Although this latter occasion was unusually self-conscious, the majority of literary contexts in which curtains are mentioned associate them with special luxury arrangements for banqueting. Horatian references suggesting luxurious fabrics and ostentatious display attach a certain pretentiousness to curtains. *Cenae sine aulaeis et ostro* ("dinners free from curtains and from purple"), he argues in inviting Maecenas to the country (3.29.15–17), are most effective for quieting civic anxieties. The virtual opposite of such simplicity welcomes Maecenas as a dinner guest at the banquet given by the upstart Nasidienus where collapsing curtains that raise a cloud of black dust cause a minor disruption in the order of dining that signifies the greater social disorder of the banquet itself (*Satires* 2.8.53–8).

Several illustrations exist of curtains in sympotic contexts. The Morgan cameo cup of the first century A.D., whose subject is ritual preparations for a symposium, shows a satyr hanging a curtain (Figure 120).[103] Beyond this two of the three sympotic paintings in the *triclinium* of the newly excavated Casa dei Casti Amanti at Via dell' Abbondanza 9.12.6 show different modes of deployment. On the eastern wall panel a background for two couples on a couch has light curtains festooned between upright pillars. Behind them is an outdoor prospect. In the second scene a heavy embroidered curtain with gold and red patterns, fringed with gold bullae, furnishes a tentlike canopy for the couches. The view beyond it extends out of doors.[104] The room in which these panels are themselves located is an interior Third Style context visually enclosed by continuous paneling in black and red.

Allowing for the difference that this curtain is suspended overhead rather than hung on the wall, its clearly delineated embroidery and border provide analogies with the various tapestries used as a feature of Fourth Style decoration. Additionally many of these curtains are

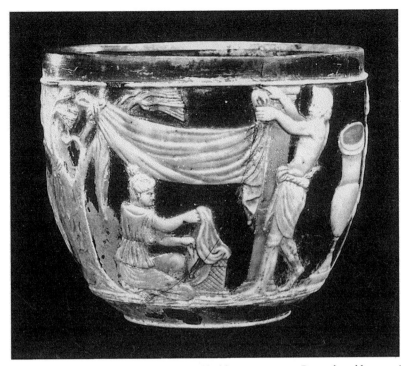

120. Corning glass museum, Morgan cup, first half of first century A.D. Reproduced by permission of the Corning Museum of Glass, Corning, New York.

not simply bordered but also contain at their centers fig-ured panels which, in contrast to those *tabulae* supported on easels in Third Style *pinacothecae,* appear to be sus-pended without support. A good explanation for these unframed *quadri* apparently hung in midair can be found in the description of Ptolemy's boat which men-tions curtains or cloths woven with mythological scenes. From Helen's web to Ovid's weaving contest of Arachne and Pallas pictorial tapestries have of course always featured prominently in the literary ekphrastic tradition. The version of Arachne's story represented in the pan-els of the Forum Transitorium has women inspecting a completed tapestry in the shape of a long rectangular stretch of cloth.[105]

Although we commonly associate pictorial weaving with coverlets, it is highly probable that many such prod-ucts were displayed vertically and in public spaces. Pan-els mounted on tapestries in Pompeian decoration are generally, although not invariably, smaller than the im-itations of *tabellae* so frequent in the Third Style. Both in the Fronto *tablinum* and in the Taverna the panels are small and intricately composed. Often they are framed with double borders. Besides mythological scenes, some of the floating figures of ubiquitous popularity during the Fourth Style period are also to be taken for im-ages woven on tapestries. Sometimes the picture bearing

panels are stretched on rods; in other instances they are held taut by stretchers or braces. Occasionally we see them tacked at the corners or even at six points, possi-bly imitating stretched skins.[106]

This potential flexibility of curtains gives them an in-trinsic advantage over the rigidity of purely architectonic screening arrangements and makes them an important element in the new spatial expansiveness characterizing the Fourth Style, whose keynote, as defined by William Archer, is the "central window zone."[107] Because cur-tains can appear by virtue of their draping quite natu-rally to reveal glimpses of background prospects, they are aptly combined with architecture, and the apertures that frame them are often extended with balconies or loggie so as to lend the appearance of a spatial shell to the enclosures they decorate. The reality of such combina-tions was conceivably to be seen in the octagonal hall of the Domus Aurea with its side chambers and balconies, the latter corresponding quite closely with the Athena-sius' description of the upper-story niches in Ptolemy's pavilion.[108] Also, as Eugenia Riccotti points out, the use of curtains on the ground level as an integral part of dec-oration must have divided spaces that to us appear open so as to provide intimacy for small groups of diners.[109] Many passages in description or narrative suggest their use in domestic contexts either for screening purposes

or to alter the size or shape of a space. The curtain in Nero's Palatine residence behind which Agrippina concealed herself to overhear senatorial consultations stood before a certain back doorway (*Annales* 13.5: "ut adstaret additis a tergo foribus velo discreta"). The spatial conformation that figured within an earlier event can be visualized more clearly. After the murder of Caligula (*Claudius* 10), the praetorian guards found Claudius, who had withdrawn into a *diaeta* called the Hermaeum hiding between the curtains hung in the doorway. The space thus screened was a *solarium,* a terrace or balcony located near the *diaeta* where he had originally gone to rest. Pliny (2.17.21) in describing a room in his Laurentian villa, mentions an alcove that can be opened or closed off by a curtain.

The use, then, of spatial openings in Fourth Style compositions can be distinguished from that of Second Style megalography on the basis of what its mimetic pretensions might be. In the earlier programs, the fictive extension of space was articulated as a self-contained structure on each individual wall, most often a spacious peristyle featuring garden architecture such as tholoi or syzygiae. On walls of the later period similar types of architectural configurations, such as tholoi and pavilions, may be adumbrated, but these are situated within ambiguously open-ended prospects that are not visibly completed by background planes.[110] Often the constructions appear miniaturized and their architectural components no less exiguous than those characteristically associated with the Third Style. Eclecticism far exceeds that of any previous period and the profusion of acroteria, filigree, garlands, and wought metal ornamentation is what led Mau to term this style "intricate." In a recent study of the architectural constructs, Hélène Eristov compares the inventive practices of the painter composing ad libitum from his repertoire with the creative bricolage of Levi-Strauss' myth makers who "elaborer des ensembles structurés non pas directement avec d'autres ensembles structurés mais en utilisant des résidus et des débris d'événements." The desirable illusion has now become an indefinite spatial extension while decorative emphasis rests with the texturing of the interior surface that stands before this space. Although Eristov rightly stresses the common acceptance of improbability that underlies these illusions, one should not forget that the cultural existence of luxury is the point of reference, and the owner's personal valuation of luxury is the visible status declaration.

Returning to the Houses of Jucundus and Fronto, it is also instructive to consider how these decorations bear witness to life in two sectors of society. Although we cannot be certain that Jucundus himself was the pro-

prietor of his house when its *tablinum* was redecorated, his business was already established at that time. The income it yielded will have made him comfortable. Calculating from the tablets Willem Jongman estimates that 2 percent proceeds from auctioneering transactions conducted in A.D. 57–8 amounted to approximately 2,000 sesterces, or twenty times basic subsistence need.[111] The house, as Jongman, suggests, bears witness to prosperity, but also would seem to signify a certain dignity in the profession because Jucundus' business dealings as auctioneer brought him into contact with a cross-section of his fellow Pompeians, including members of the municipal elite whose names appear as witnesses in his tablets. M. Lucretius Fronto, on the other hand, is an aristocrat whose source of income is not known, but his political career will appear to have progressed through the steps of the *cursus honorum* with the straightforward success of a Pliny. For the duovirate his candidacy was paired with C. Julius Polybius who commanded a large clientship among tradespeople. According to Franklin, the small number of Fronto's own programmata in contrast with thirty-one recommending Polybius indicates that the aristocrat needed less public endorsement than his socially mobile freedman colleague.[112]

The careers and lifestyles of these two notables would seem to attest to a new period of activity and prosperity in Pompeii, a prosperity evidenced by a large-scale recommencement of building, and perhaps even reflected in the epithet *celebris* by which both Seneca and Tacitus characterize the town.[113] As Richardson has pointed out, certain house types previously unknown develop in this period.[114] They are larger than the majority of Third Style houses and are characterized by unorthodox arrangements of rooms. In the devising of these new forms the increasingly widespread penchant for building luxury villas would seem to have exercised its influence within the city. Especially peristyles lie in a different relationship to atria, frequently opening off the side and entered directly without the conventional passage through andron or *tablinum*. For an example of such placement one may look at the Casa degli Amorini Dorati, a townhouse whose formal reception area comprises a small, square atrium and proportionally small exedral space that faces the door in the position of a *tablinum* but lies inconspicuously out of the path of any person purposefully moving toward the bright, inviting prospect of the peristyle corridor open to the left. The space of the entrance rooms is scarcely a quarter that of the peristyle which is surrounded on all sides by rooms of various sizes and configurations.[115] Such decentering is sometimes attributed to alterations in political customs entailing a decline in close clientship relationships, but

this is highly unlikely. Even in imperial Rome, as the Younger Pliny bears witness, the adjustment to imperial government had brought no lessening in the ceremonies of social hierarchy, but if anything an increase. As he complains to Minucius Fundanius (*Ep.* 1.9), not a day passes that has not required his presence at some social ceremony: from family rituals to legal counseling. While coveted magistracies were less powerful, they were also more numerous involving more persons in the negotiations of civic recognition. A decline in social ceremony is equally unlikely in such a municipality as Pompeii where the structure of magistracies under imperial patronage remained unchanged with offices still tenable for a year while large clientships, support networks, and public benefactions are well attested by programmata and inscriptions commemorating achievement.[116]

In fact the shift to the peristyle-centered house should be attributed to much more practical circumstances: a combination of ready cash for building and the recognition how the ready supply of water from the aqueduct might be utilized to landscape fountain gardens, provide irrigation, and make possible a variety of rooms for different seasons of the year. Widespread prosperity is also indicated by the need for large dining chambers, which had not been a feature of Third Style houses and which can hardly have been installed for the exclusive use of their proprietor's families. These architectural innovations provide the context for the proliferation of new decorations, the complexity and intricacy of which I mentioned earlier. In these decorations we find, as with surviving instances of the Second Style, complete programs in which the parameters of decorative decorum are clearly visible. Certain of these ensembles are so well known as to count as virtual by-words of ancient art history. One need not be deeply versed in Pompeian scholarship to recognize the name of the House of the Vettii, whose five colorfully decorated *pinacotheca* rooms some scholars have denigrated as the ill-modulated taste of freedmen while others have defended them as the apex of period craftsmanship.[117] Equally comprehensive in its program was the Casa del Menandro in which many have pleased to see a thematic emphasis on literature and drama centered around the eponymous representation of the comic playwright (who will once presumably have had a tragic counterpart) in a library alcove of the peristyle.[118] Fans of Bulwer Lytton's *Last Days of Pompeii* can be guided through the principal rooms of Glaucus' residence, "The House of the Tragic Poet" in Bettina Bergmann's hypothetical reconstruction, which creates a visual context for the panels in the Naples Museum.[119] Equally well known to Pompeian specialists is the Casa dei Dioscuri named for images of the twin heroes in its fauces, where Richardson identified the stylistic hallmarks of work by master painters of figured panels as a point from which to track the employment of these artists around Pompeii. This species of decoration is the most abundantly represented throughout the city and the vagaries of its fortunes during the final two decades of Pompeian life will be the substance of the chapter that follows.

CHAPTER SIX

The Final Decade: Demography and Decoration

HE FINANCIAL TRANSACTIONS OF JUCUNDUS AND THE ESCALATION of domestic building activity are two indicators of prosperity in early Neronian Pompeii, a prosperity that would seem to have enjoyed flourishing connections with Rome. Among magisterial families, Franklin finds many declaring in one manner or another support for the emperor whose public image may well have been shaped indirectly through these contacts. Such loyalty existed apparently in spite of the ban that the Roman senate had declared in A.D. 59 on gladiatorial contests in the arena (Tacitus *Ann.* 14.17). That the ban did not bring about a complete deprivation of spectacle might be seen from an announcement of contests dedicated *pro salutate Neronis* by the duovir Ti. Claudius Verus, which included *venationes* and *athletae* as well as such imperial luxuries as *sparsiones* and a distribution of 373 sesterces to each spectator.[1]

Because these beneficent games had been set for February 25–26, it seems likely that their occurrence, not to mention the general prosperity of the city, will have been set back by the earthquake that struck in early February of the year 62,[2] affecting a broad area of Campania that, as Seneca put it (*NQ.* 6.1) "while often imperiled, had previously escaped with no more than fear." This earthquake, according to Tacitus' brief notice, "threw a large portion of Pompeii to the ground" (*Ann.* 15.22: "et motu terrae celebre Campaniae oppidum Pompei magna ex parte proruit"). Probable effects on the social and

economic structuring of the town have occasioned much speculative analysis. Although damage was widespread, it was also unevenly distributed, and so also was the progress of repair. From the fact that many public buildings were still undergoing restoration in 79, the effects in this sector have been judged to be among the most severe,[3] but the slow pace at which some of the restorations were moving toward completion can also be imputed to the ambitiousness of the campaigns. In domestic sectors, where the extent of damage was more varied, a more varied spectrum of disparities prevails, offering possibilities for a closer study of relationships between decoration and social dynamics.

As noted in the previous chapter, Pompeian painters and patrons well in advance of the year 62 had begun to cultivate the opulent blending of architecture and ornamentation that we know by the name of Fourth Style, but no one doubts the instrumentality of seismic damage in giving this species of composition the predominance we see today, no matter whether we think of a single event or, as many volcanologists have recently suggested, a continuing series of minor shocks.[4] For this reason the earthquake and its aftermath have become a marker of stylistic history frequently scrutinized for evidence of continuity and innovation in the Fourth Style,[5] a repertoire that, by sheer reason of its volume, has proven far more difficult to comprehend and classify than earlier styles. In recent years these attempts have increasingly been directed toward identifying the characteristics of workshops and tracking their circuits throughout Pompeii. No less interesting from a socially oriented perspective than the artistic questions, but not wholly unrelated, is the demographic distribution of new painting throughout the city. From this angle it is worthwhile examining not only the decorum visible within individual domestic ensembles, but also the evidence for repairs and redecoration to consider its stages of progress or completion as indications of the status of those contexts in which it is being carried out. Whereas a walk through the House of the Vettii with its five brightly painted *pinacotheca* rooms might give the impression that all Flavian Pompeii vibrated with color, those visitors whose explorations take them into further reaches of the city will notice the presence of many bare walls and rooms in various states of disarray. Although in some cases the absence of painting can be attributed to the treasure hunting mentality of early excavators, or simply to the degeneration of exposed plaster over time, it is also clear that the eruption found some rooms still in the process of redecoration with their walls either stripped to their underlying masonry, or else replastered and partially painted. Even

the House of the Vettii contains one such undecorated room.

Well recorded in encyclopedic documentation but scarcely relevant to discursive treatments of style, such decorative hiatus take on a new interest when considered for their economic implications. Economic inferences may also be drawn from situations in which partial redecoration has left previous installations of painting untouched. Consequently, in this chapter I continue discussion of Fourth Style painting from a new perspective looking not only at the components of schemes and their adaptation to spaces, but also at the contexts in which these examples occur, which is to say not simply at single rooms but rather at houses that represent selected segments of society. For this purpose my investigation will focus on three categories. First I consider the distribution of Pompeian postearthquake painting within one neighborhood, the Via di Mercurio, which was advantageously located at the center of the city. Although conclusions to be drawn concerning the status of redecoration are subject to the qualification that not all damage may have occurred simultaneously, yet the likelihood that similar conditions pertained within the confines of a given neighborhood makes this survey informative. My second category of inquiry, ranging more broadly over the entire city, will survey a number of houses that can be attributed to attested candidates for political office during the final period of the city to focus on a group of Pompeians whose demonstrable common ground is achieved civic status. Finally, to consider the intersection of public and private, people and patronage, I take up the state of decoration and redecoration in several buildings framed for public use, whose situations range from central areas of the Forum to the outer margin of the town.

THE NEIGHBORHOOD OF THE VIA DI MERCURIO

The Via di Mercurio of Region 6 is the broadest of all Pompeian streets with a width of thirty-two feet at the end near the Forum. Through the arch of Julio-Claudian date that at once screens and frames its territory, it opens a spacious prospect to the Torre di Mercurio (Figure 121). Mau spoke of this street, in contrast with the Via dell'Abbondanza and Via di Nola, as a quiet residential place.[6] Perhaps this was its original condition, which would have been in conformity with the generally self-confined nature of Region 6,[7] but its later aspect will have been less exclusively residential if not less sequestered. In spite of the many imposing houses with entrance portals spaced at irregular intervals along

121. Via di Mercurio, looking north through the arch. Author's photograph (su concessione del Ministero per i Beni e le Attività Culturali).

the sidewalks of its four insulae, the street shows considerable variety in the nature and size of its buildings indicating instead of a purely elite population, the characteristically Pompeian symbiosis of classes and occupations wherein current *decuriones,* rich freedmen, and small tradesmen brushed shoulders within the network of patronage attested by the electoral programmata on the walls.[8] Within such a neighborhood residents might find a portion of their needs readily satisfied.

Up and down the street the facades of the houses, some made of limestone blocks, some of tufa, and others of stucco-covered concrete, indicate a history of continuous building and renovation. A narrow but well-traveled cross street, the Vicolo di Mercurio, separated the insulae (Figure 122). As you walked out from the Forum you would find the first insula substantially commercial[9]; its deep wheel ruts are evidence of heavy traffic.[10] On the western side a fruit seller's shop and a tavern were followed by a line of six small shops of one or two rooms each with similarly brick-faced doorways that suggest their having been built at one time[11] (Figure

123). A barber operated in one of these spaces (6.8.14); another was associated with the fruit sellers' guild. Beyond these stood the limestone ashlar facade of an old double atrium house that had been wholly converted into a commercial establishment, a fullery that was the largest in Pompeii with offices in one atrium, decorated showrooms for receiving clients, and a large work area in the peristyle (6.8.20–1).[12] On the eastern side of the block just below the Vicolo di Mercurio crossing stood a tavern with a front counter and two interior rooms; the differences in decoration between them might suggest a difference in the classes of their clientele. Closer to the forum a second tavern stood between the entrances of the Casa dei Cinque Scheletri (6.10.2) and the Casa dell' Ancora Nera (6.10.7), the latter with a large sunken peristyle overlooked by a terrace and surrounding chambers that might possibly have furnished travelers' accommodations (Figure 124).[13] Thus the district would seem to have been self-serving, no doubt with necessities available at the end of the street and gathering places for servants and idlers near the Forum.

Beyond the crossing of the Vicolo di Mercurio, the upper portion of the street shows fewer signs of traffic and is more residential, although not exclusively so. On the eastern side of the street the facades of four capacious mansions stand in a continuous line uninterrupted by shops. All four houses had achieved their final expansive configurations by the conflation of smaller structures, merged with differing degrees of unity (Figure 124). Closest to the wall with a stable directly facing from across the street is the Casa del Duca d'Aumale, which has been suggested to be an inn, frequented, perhaps, by Egyptian merchants.[14] There follow, in order, the Casa di Meleagro, the Casa del Centauro, and Casa dei Dioscuri. In this last house Nigidius Vaccula, the *filius* it would seem of a wealthy merchant family connected with the bronze trade of Capua, carried on a business in expensive vases and furniture. Benches and braziers given to the Stabian and the Forum Baths publicized their donor's identity by their bovine legs.[15]

On the western side commercial establishments decreased in number but did not wholly disappear. That the first corner building was some manner of workshop is clear from its internal division into a variety of compartmentalized spaces. Figures of Minerva, Mercury, and Daedalus painted on its exterior pilasters (6.7.8–12), as well as another painting of a procession advertising the craft of Daedalus under the protection of Minerva and Mercury, were taken by Mau as indications that this was a carpenter's *officina.*[16] Another double atrium house, the Domus P. Antistius Maximus, also included a utilitarian workspace behind a third entry next door (6.8.20–2).

122. Crossroads with Vicolo di Mercurio. Author's photograph (su concessione del Ministero per i Beni e le Attività Culturali).

A deposit of fourteen silver vases within the house has given rise to the name Casa dell'Argenteria, suggesting the presence of work or repair space. The final entry on the block (6.7.26) led into an empty space, a stable yard located under the wall, where the owners of some of the large houses will have kept the animals they used for transportation.[17]

Houses in this western insula are generally smaller, their various portals interspersed with narrow entrances into smaller areas or staircases leading above to suggest an intermixture of classes among the inhabitants. In its first stages during the tufa period, this block had comprised nine uniformly sized houses, each constructed long and narrow to fit the space[18]; however, a certain amount

123. Via di Mercurio, block toward the Forum. Author's photograph (su concessione del Ministero per i Beni e le Attività Culturali).

124. Casa dell'Ancora Nera enclosed sunken garden. Author's photograph (su concessione del Ministero per i Beni e le Attività Culturali).

of spatial negotiation resulted in the expansion of some houses and the diminution of others. Thus, for instance, one finds a small house (6.7.16) whose atrium along one side lacks rooms that would seem to have been added to the house next door, while its garden space at the rear had gone to enlarge the luxurious Casa di Apollo.[19] Some neighboring houses have shallow peristyles extended laterally by conflation. Thus the interconnected houses 6.7.20 and 21 share a large, two-sided *viridarium,* each one with rooms that open onto the space. The greater part of this restructuring and spatial redistribution had preceded the earthquake, as suggested by the fact that walls show signs of mending but are not actually new.

Many signs of early and late prosperity distinguish the Via di Mercurio. Among its several double atrium houses, two of the largest, the Casa della Fontana Piccola (6.8.23–24) and Casa dei Dioscuri, are among the newest. The street boasts two unusual atria, a Corinthian

in the Casa dei Dioscuri and a singular hexastyle in a house converted into a fullonica (6.8.20–21). Another house, the Casa dell'Argenteria, has one of Pompei's few marked vestibular spaces with lofty Corinthian columns flanking the entrance into the atrium (Figure 10). The houses also took full advantage of the aqueduct built during the Augustan period to make their elaborate gardens glory in water. Two *viridaria* are built around large mosaic fountains; the Casa di Apollo contained two separate gardens, both landscaped around small pools. Peristyles in the larger houses across the street featured large fish ponds, while files of rooms on two stories in the Casa dell'Ancora surrounded a sunken garden with fountains and statuary (Figure 125). Several houses, such as the Casa di Meleagro and Casa dei Dioscuri, had installed fountain jets in their *impluvia.*[20] Within the hedge of columns screening the large square basin of the Dioscuri's Corinthian atrium, one might see water bubbling up from a marble calyx resembling a flower or

125. Via di Mercurio, Houses of Insula VI 9. Plan after Overbeck 1884, 330.

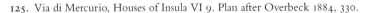

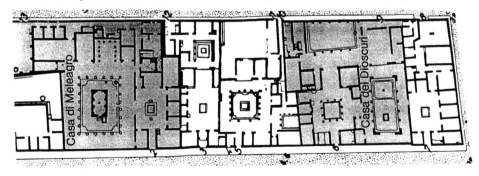

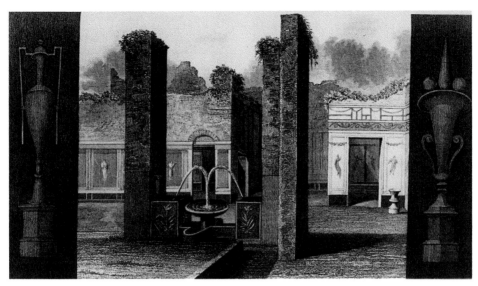

126. Fullonica at 6.8.21, atrium with marble fountain. After Gell, 1834, Vol. 1, pl. 50.

cluster of leaves (Figure 23).[21] Needless to say, a utilitarian water supply was also important to the operations of the fullonica, but this building also contained a marble fountain in the *impluvium* of its restructured atrium near the show room (Figure 126).[22] Although the street had seen many changes from the structuring of the fullonica to the consolidation of large houses, the earthquake had shaken a well-settled neighborhood.

The most interesting aspect of the Via di Mercurio for this study is the consistency with which its inhabitants, amid differing circumstances, had made their efforts of recovery from the earthquake. The situation affords good insight into the practices of rebuilding and redecoration in Pompeii. Virtually every house on the street had sustained some damage – some more, some less – and every house contained some new painting. Survivals of Republican masonry decoration are rare and confined to small and inconspicuous rooms.[23] Even examples of Third Style painting are infrequent, although those that do exist were of an elegance visibly worth preserving, as the *pinacotheca tablinum* of the Casa del Centauro and the theatrical *biclinium* in the garden of the Casa di Apollo discussed in Chapter 3. With a few exceptions, such as the Casa della Fontana Grande where workmen's tools and paint pots were found amid general masonry disarray, the work of redecoration was already completed. The corner shop with the so-called sign of Daedalus is one place where repairs were lacking. Here traces of Second and Third Style decoration persisted from an earlier phase of use.[24]

The greater number of peristyles had suffered damage and were being rebuilt, often with a resystemati-
zation of the rooms surrounding them. These rebuildings sometimes showed new trends such as a decreased emphasis on the traditional atrium-*tablinum* alignment in keeping with some of the newer houses elsewhere in Pompeii.[25] *Alae,* where they existed, were often remodeled. The Casa dei Dioscuri was totally replastered and repainted after postearthquake repairs to make it, as Richardson has observed, a showcase for the finest painters in Pompeii.[26] In the contiguous Domus Caetani, owned by the same family, but most likely occupied by their dependents, redecoration was not yet completed. Few spaces, however, remained wholly without decoration, which puts the proprietors on this street in advance of many of their fellow townsmen holding current magistracies.

Several decorations show hallmarks of the same painter or workshop. Large red panels with images of divinities represented as statues were popular. We see these not merely in the atria of the opulent Casa dei Dioscuri, and more modest Casa del Naviglio, but also in the peristyle of the fullonica which, as Gell observed, was painted in the same manner as some of the best houses in Pompeii.[27] Here the space they decorate is, at least in part, a showcase for receiving customers. In other cases similarities in the handling of decorative contexts indicate work by the same group of painters, as with the ornate *aediculae* in the Casa del Naviglio and the Casa di Adone Ferito. Among the most distinguished decorations was the *tablinum* of the Casa del Centauro with large-scale mythological panels of outstanding quality.[28] The Casa dei Dioscuri has a marble revetted room as its outstanding luxury.

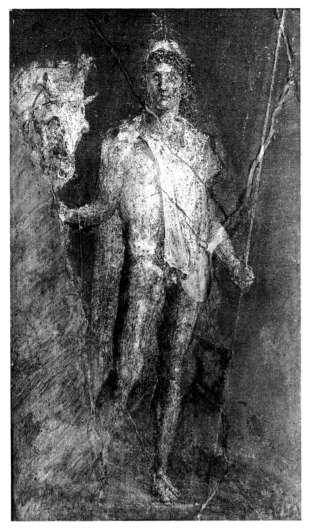

127. Casa dei Dioscuri, Dioscuros from entrance, Naples Museum. DAI 64.715.

To consider more specifically the demography of these restorations, we may begin with the northeastern insula where the two mansions of prosperous trades persons, the Casa dei Dioscuri and Casa di Meleagro, show rennovation on a lavish scale far in excess of ostensible need (Figure 124).[29] These interiors combine grandiose colonnaded spaces with monumental picture galleries in some of the most imposing formats offered by the Fourth Style. Spaces within these interiors are designed and decorated to be seen through and across each other.

The figurative program of the Casa dei Dioscuri began in the *vestibulum* with images of the eponymous twins, patrons of commercial enterprise, and their horses enshrined in statuelike form against red panels (Figures 127 and 128). Paratactic red panels also surround the walls of the atrium, although somewhat cast into shadow by the lofty columns of the Corinthian style *impluvium*

that preempted the central floor space, segmenting the viewer's perspective from any and all angles so as to allow only partial lines of sight from one to the other side of the room. No matter how large or small the number of persons circulating within its spaces, this will always seem to be a crowded atrium.

Within these architecturally channelled vistas, the team of decorators made advantageous use of the spaces. Corners were articulated by fluted pilasters with Corinthian capitals that harmonized with the columns, and polychrome figures of divinities in statuelike form, nine in all, were placed at the centers of some panels. The double framing in the intervals of the columns enhanced the illusion of the figures. The largest and most conspicuous was a polychrome Jupiter standing to the right of the entering visitor on the west wall. On the south side the space broadened into a deep bay that formed a transitional *vestibulum* for the peristyle (Figure 129). This area, whose masonry shows it to have been formed during late remodeling,[30] was the most ornate sector of the atrium with majestic images of Ceres and

128. Casa dei Dioscuri, Dioscuros from entrance, Naples Museum. DAI 64.716.

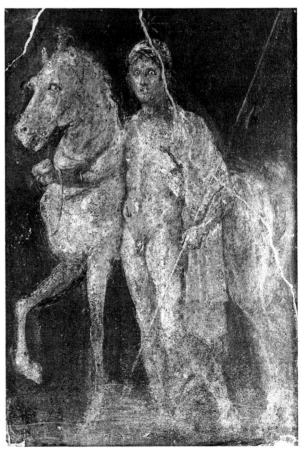

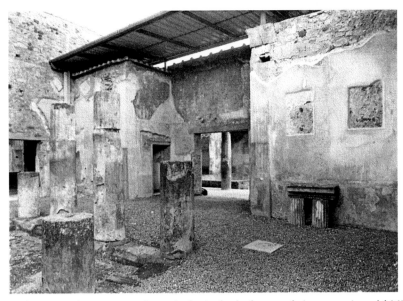

129. Casa dei Dioscuri, entrance to the peristyle. Author's photograph (su concessione del Ministero per i Beni e le Attività Culturali).

Apollo flanking the doorway on the inner wall and a small painting of Perseus and Andromeda above. Mythological paintings of small size were positioned in the upper zone above the doors. Over the door of the atrium was the well-known Satyr mistaking a hermaphrodite for a nymph.[31]

In contrast to the restrained elegance of the atrium, the architectural simulation of the *tablinum* flaunted a grandeur in keeping with the heroic panache of its two mythological paintings representing critical moments of Achilles' career: his apprehension by Odysseus on Skyros and his momentous quarrel with Agamemnon (Figures 130 and 131). From within the atrium one would easily have seen these large panels, situated against bordered red backgrounds on walls of imposing height and framed by intricate arrangements of columns in their

130. Casa dei Dioscuri, drawing of *tablinum,* south wall, with discovery of Achilles. DAI 36.373.

131. Casa dei Dioscuri, reconstruction drawing of *tablinum* panel, north wall with quarrel of Achilles and Agamemnon. From Gell 1832, 233.

at their centers. Polychrome landscapes are in the frieze zone.

Next to the *tablinum,* the peristyle was the showplace where the finest pictures were situated. Spacious as it is, with broad corridors behind the porticoes, it seems to appropriate even greater space through the apertures of its decoration. Large yellow curtains structure a paratactic succession of panels with small intervening apertures. Some pilasters carry small still-life panels and occasional polychrome figures float on the tapestries. Two painted niches on the interior piers at the western end of the enclosure framed a pair of gold colored candelabra shaped as Delphic tripods, thematically ornamented in a singular way. Encircling their tiered shafts were figures enacting the slaughter of the Niobids: the female victims on one side, the young men on the other and the vengeful Diana and Apollo drawing their bows at the bases. Two large panel paintings, Perseus rescuing Andromeda and Medea with her children, occupied the end piers of the colonnade directly opposite the large doorway of the grand Cyzicene *oecus* that opened at the eastern end of the space (Figure 132). This grandiose enclosure, fully half the size of the peristyle itself, was designed in close coordination with the colonnade. A basket-weave pattern in the pavement demarcated a kind of antechamber space in the *porticus* outside (Figure 133). The interior was revetted in its entirety with a pattern in marble veneer.[33] From within this opulently furnished space, the diners – as we may safely imagine the occupants to be – might gaze on vistas of colonnaded spaces in two directions. Through the room's broad doorway a slightly off-center prospect down the long peristyle garden with its two fountains caught the side of one corridor but also

flanking apertures. Projecting pylons enclose the *aedicula* with files of slender columns; a second tier of columns is finished by a curved entablature covered by a circle of coffering so that a complete hemicycle appears to encircle the *aedicula* from behind. A wealth of gilded ornament enhances the richness of the display: acroteria and the intricate metallic bordering of the background panel, formed of griffins and bulls-head lyres, which Zahn meticulously reproduced.[32] The side panels consist of blue curtains stretched from rods with floating figures

132. Casa dei Dioscuri, view from peristyle *oecus*. Engraving from Gell, 1832, Vol. 2, pl. 65.

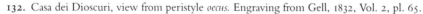

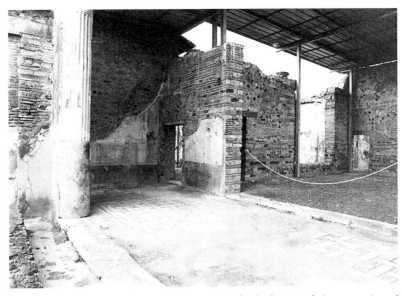

133. Casa dei Dioscuri, exterior of the peristyle *oecus*. Author's photograph (su concessione del Ministero per i Beni e le Attività Culturali).

encompassed a full view of the four painted piers (Figure 134). On the other side a viewer looked through a large window into a garden, the end wall decorated with garden paintings between engaged pilasters. If, however, you entered that space from its atrium side, you would see that it, too, was a picture gallery.[34]

Given the advantageous situation this marble-clad *oecus* enjoyed, not to mention the expense its furnishing

will have entailed, one should not be surprised that the Nigidii had made it their chief investment on behalf of hospitality. Aside from its one smaller pendant room, as well as a modest room at the end of the garden peristyle, the number of spaces offering an ambience suited to dining is limited. Smaller rooms surrounding the atrium will have been the alternative, each one a richly decorated *pinacotheca*, but none capacious enough to

134. Casa dei Dioscuri, view from peristyle *oecus*. ICCD N6795.

accommodate large parties. Although the size and scale of pictures was conditioned by available space, care would seem to have been taken to distinguish each by its individualized design. At the back of the atrium, the largest of these enclosures has a broad window giving onto the smaller garden. A tall room, its appearance of height is enforced by the pronounced verticals of its *aediculae* and framing apertures, whose unbounded white background space contrasts dramatically with surrounding red and blue panels and gilded cornices. These apertures are divided into three balcony stories that continue into the frieze zone so that their pavilions appear to extend uninterrupted from dado to ceiling. On the second level they project outward with airy balconies and intricate vines. Height is also emphasized by an upper zone of white with complex pavilion architecture.[35] There are spectator figures in the *apertures*. The fine-cut griffin and candelabra pattern decorating the cornice has in recent years been adapted commercially as a decoration for silk ties and scarfs. Such richly detailed architecture and curtains comprising the *pinacotheca* context distract attention from the mythological subject paintings, the Birth of Adonis and Minos and Scylla; however, the juxtaposition of such unusual topics suggests a degree of attention to the selection, which might even have paid tribute to Ovid. A thematic link unites the two as instances of troubled relationships between fathers and daughters.

The smaller rooms made use of typical white ground walls with decorations composed of scaffolding, curtains, and candelabra. A small room beside the *tablinum,* entered from the andron, has an open architectural frame against a white background. Tapestries bordered with red ivy leaf designs fill the side panels; at the center of each floats a small landscape vignette. There is a stuccoed cornice with a palmette design but no attic zone. Instead constructions that might have been expected to decorate the attic seem to be located in the red dado.

The nearby Casa di Meleagro is another thoroughly restructured house exhibiting comprehensive redecoration (Figure 135). Whatever its earlier history had been, the final disposition of the rooms represented developments typical of Pompeii's last period with an immense peristyle opening directly from the north side of the Tuscan atrium to occupy the largest portion of the house. That this construction was built on the remains of former houses can be seen from the continuous facade of ancient limestone that spans the two areas. A few small rooms behind the peristyle may be survivals of this structure, but there is no relationship between earlier plans and the three large chambers opening onto the peristyle: *oecus,* exedra, and *triclinium* as

Warsher names them, observing of the owner, commonly identified as a newly rich merchant, L. Cornelius Primogenes,[36] that he "liked to give banquets and adapted the East part of his house to that purpose."[37]

Although damage from the earthquake necessitated rebuilding the peristyle, whose late construction is indicated by the stone and brick fabric of the columns, the same was probably not true for the small *conclavia* opening from the atrium in which the unaltered *cacciopesto* pavements maintained the shape of the original plan. Rather their redecoration was added for good measure. As if competing with the Dioscuri galleries in the sheer number of mythological paintings, the owners had made all three of these rooms – and virtually every other space within this lavishly appointed house, including the peristyle corridors – into a *pinacotheca* with architectural apertures surrounding the *aediculae* that contained either bordered or tapestry panels. If the settings show a certain uniformity, so also the paintings of which the greater number are two or three figure compositions without much dramatic action. Richardson attributes their extraordinary number to the same painter whose rich stylistic qualities of color, texturing, and chiaroscuro masked real weaknesses in his drawing.[38] One might say that he specialized in scenes that involved either expectation or reaction, but not the critical action itself. Certain unusual aspects of the settings also show a deliberate effort toward unity, as, for instance, the consistent decoration with a series of forty Nereids on sea beasts of the dado running around the major reception areas: atrium, *tablinum,* internal *triclinium,* and peristyle.[39] Another conspicuous element of luxury was the pervasive use in large areas, such as tapestry simulations, of the expensive color blue.[40]

The program begins immediately in a very long entrance corridor with an architecturally structured decoration, the three horizontal zones of which are respectively black, red, and white. The central zones have figured panels, which were bordered with fine garlands. Such a tripartite paneled structure would seem more normal in an enclosed space, some manner of *conclave,* than in a passageway. Both the dado and frieze zone include caryatid figures. The northern wall panel, that of Meleager from which the name of the house is derived, shows the hero seated with the boar's corpse at his feet, and a standing figure of Atalanta in her hunting costume.[41] This is, in fact, a scaled-down version of a larger, multiple figure composition such as that in the Casa del Centauro. In a panel on the opposite wall (Color Plate VI), Mercury looks complicitiously at the viewer as he drops a fat purse into the outstretched hand of Ceres, seated with her torch by her side: a collocation

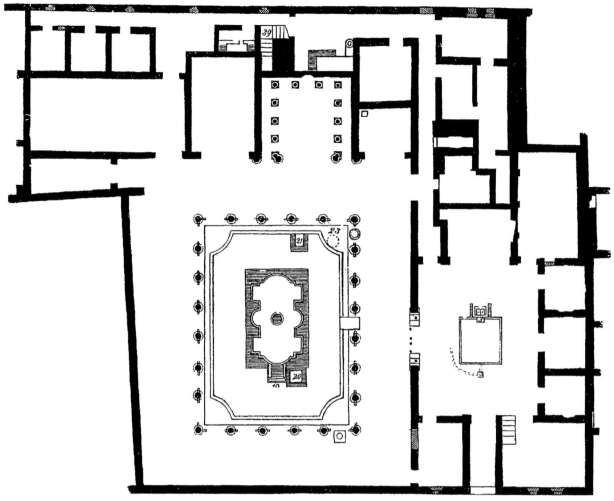

135. Casa di Meleagro, Region 6.9.2. Plan after Overbeck 1884, 308, Fig. 168.

of divinities that some have taken to indicate that agriculture sustained the commerce from which Cornelius Primogenes derived his wealth.[42]

Whatever visitors the owners' pursuits may have brought to their *domus,* the decorations that greeted them did not observe the custom of the paratactic atrium. This relatively small room was almost square in shape, its form emphasized by a square *impluvium* with a marble revetment. It ended in a boxlike exedra-*tablinum* lacking windows, but elaborately decorated (Figure 136). On its right-hand side it featured a row of three *conclavia,* but the left-hand wall was unbroken save for a wide doorway with a threshold of marble blocks pierced to accomodate the movable panels of a four-section door that screened the entrance of the peristyle.[43] Each of the four widest spaces on the walls frames a mythological panel; with Daedalus and Pasiphae in the workshop facing Thetis in the forge of Vulcan, the assemblage might seem to highlight craftsmanship as a common theme, but this scarcely encompasses the two pendant pictures:

the so-called Dido abandoned by Aeneas and a seated man with a lyre.[44] On the walls of the small exedralike *tablinum,* divine seductions might be thought to connect Mars and Venus (MN 9256) with Io and Argus (MN 9556) but the really conspicuous feature of this room is the colorful stucco-relief decoration of its attic presenting images of the *scaenae frons* decked with a wealth of statues and pinakes modeled in careful detail. Some *aediculae* hold statue groups such as the "drunken Heracles," but others frame figures of actors emerging through doors and about to descend to the stage.[45] This motif, although common in the period, might also be called a unifying theme within the house because it recurs in the apertures of the peristyle and in other decorated rooms.

With twenty-four columns ranged at close intervals, the broad-aisled peristyle surrounds an enormous marble pool with a water-stair and a basin shaped by an alternation of square and curved bays[46] (Figure 137). Here, as in the atrium, we see that the custom of decorating

197

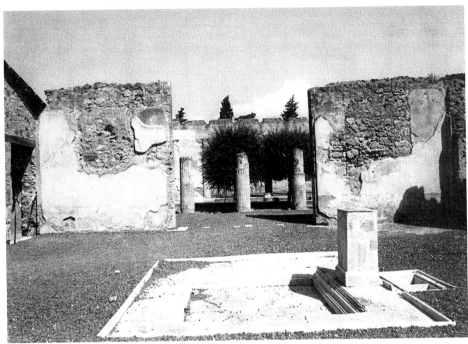

136. Casa di Meleagro, atrium, crosswise view north toward peristyle. Author's photograph (su concessione del Ministero per i Beni e le Attività Culturali).

transitional spaces with nonfigurative painting has not been observed. Two walls of the four-sided structure display a continuous paratactic gallery alternation of apertures and framed *tabellae,* twenty pictures in total. Here, too, the decorative setting has a theatrical cast. The niches separating the panels have masks on their screen walls and figures descending stairs. Several paintings in this collection depicted gods or demigods with children:

137. Casa di Meleagro, peristyle from the Corinthian *oecus.* Author's photograph (su concessione del Ministero per i Beni e le Attività Culturali).

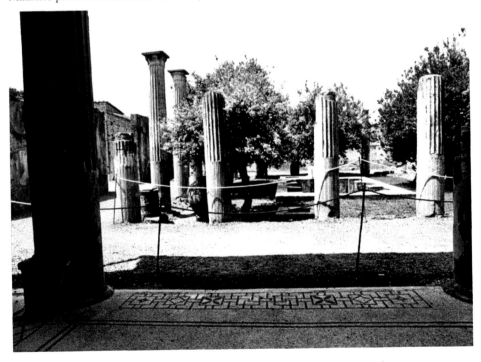

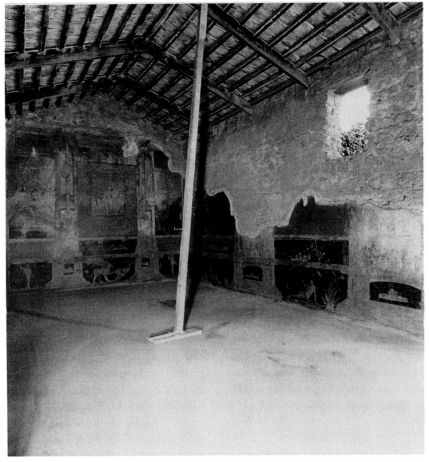

138. Casa del Meleagro, black *pinacotheca* east in peristyle. ICCD 55859.

Venus with Cupid; a baby Bacchus with a Satyr and Nymphs; an adult Bacchus giving a bunch of grapes to an Eros; Silenus with a young Satyr; Ariadne with a sympathetically tearful Eros.[47]

Although the owners seemed content with a certain sameness of decoration in the interior rooms, three large chambers opening at the eastern side of the peristyle present differences in aspect. These comprise two *pina-cothecae* and a Corinthian *oecus* that opens along its entire length and is itself also a *pinacotheca* in a secondary way (see Color Plate VII). All three rooms have black-and-white mosaic floors with various patterns, the most elaborate being pentagons bounded by lunette shields. The conspicuous Corinthian *oecus* is one of only two Pompeian examples of the form and the only one in the Fourth Style. In the eyes of its excavators, whose assumptions probably reflect the influence of contemporaneous Roman literature, its yellow monochrome coloring represented gilding as the summit of luxury, although in fact it is probably to be taken for a no less luxurious giallo antico. A red porphyry dado below it is decorated with monochrome landscapes. A certain im-

probability attaches to the entire structure. While the tall columns raised on pedestals with false marbling support an arched entablature, the background walls are structured with an exiguous Fourth Style scaffolding of the kind that dissolves wall surfaces into transparency leaving the architecture within a open-ended extension of space. All the same, as if the background were a genuinely solid surface, the room includes two mythological paintings in monochrome chiaroscuro, which are themselves a rare occurrence. Theatrical masks appear in the frieze zone. From the similar treatment of apertures, cornices, and entablatures, these same painters would appear to have decorated a small intermediate room between atrium and peristyle where a golden framework stands against a blue background.[48] Images of Hermes and a lyre-playing Apollo seem to have formed a part of this decoration.

A very different impression is made by the two rooms on the north side of the *oecus* where the customary aperture and curtain style is given a particularly rich appearance by trappings of red and blue. The larger room, a rectangle that turns its long side to the peristyle, is of

a size to accommodate multiple couches (Figure 138) and is painted to enforce its height with a particularly high dado, partitioned by pedestals matching the colors of those supporting the aediculae. In the black interstices are figures of reclining nymphs and water reeds. The predella is also raised to an unusually high level. At this line the bases turn into open doors with large figures descending the stairs. Large *tabellae* picturing Paris judging the three goddesses and Paris with Helen are situated at eye level with the second aperture of the balcony rising above them. The collocations of colors stand out against the curtains painted between. As Warsher puts it, the room takes on a massive appearance from the heavy bases of the architectural dividers and large, sculptured telamones in the dado.[49]

Between these two showy tradesmen's mansions stood the Casa del Centauro, no less extensive in size and likewise formed of two intercommunicating nuclei, but less closely integrated in structure and less homogeneous in decoration.[50] At the time of the eruption it was the residence of the neighborhood's most recently active politicians, A. Vettius Firmus, who had stood for the aedileship during the previous decade, and his adopted son, A. Vettius Caprasius Felix, who had gained the aedileship in A.D. 71 and served in 74 as duovir.[51] Adopted late in the life of the heirless Firmus, Caprasius, at the time of his first candidacy, was a recent arrival in the neighborhood from his original residence in Region 9.7. As Franklin conjectures in a recent study, he was never fully at home among the neighbors, who supported his campaigns less enthusiastically than they had that of his adoptive father.[52]

Given this coresidency, it seems likely that the two interconnecting *cavaedia,* which stood on slightly different ground levels, belonged to a pair of independent establishments serving the needs of parallel careers.[53] Each space has its own separate entry from the street; that of the smaller house (6.9.3) leads into a Tuscan atrium with a full array of *cubicula* on one side. The larger space at 6.9.5 was dominated by an installation with sixteen brick columns stuccoed in white with painted Corinthian capitals. This, as Overbeck speculated, was originally a Corinthian atrium, made over into something more like a peristyle.[54] Nonetheless, he proceeds to treat the space as an atrium – and probably with good justification because other features of the two houses, especially the fact of their possessing full sets of *conclavia* and exedral spaces, support their status as adjacent *domi*. Each house has its independent garden area at the back, but neither has a monumental peristyle. In the larger of the two houses, a cluster of rooms off the atrium would appear to have formed a *diaeta*; its presence makes best

sense as the survival of what was once a peristyle. Another indication of late separation is the fact that one of the two doorways leading from the atrium of entry 3, which stands on a slightly higher ground level than the communicating space of entry 5, had been blocked. Thus one might even consider that two stages of adaptation had occurred here, the first in transforming a double atrium house into an atrium-peristyle mansion and the second in restoring the double atrium arrangement with suitable redecoration of its communicating spaces.

Further testimony to revision is given by the patchwork of styles that comprises the decoration. The house with the Tuscan atrium contains several First Style survivals including a well-preserved alcove room on the street side (Figure 139), but also remains in two *conclavia* of the garden area presenting a marked contrast with one Fourth Style exedra with mythological subject panels related by their focus on heroes and armor: Venus presenting arms to Aeneas in one is paired with Achilles' seizing weapons at the court of King Lycomedes.[55] Both houses contained Third Style decorations of varying degrees of complexity; that of the *tablinum* in entry 3 was a dark ground with spare ornamentation, and rooms giving on the Corinthian atrium had an abundance of brightly colored ornament,[56] especially a large room that opened with a window upon a secondary garden area. The true showroom of both houses was certainly the "*tablinum*" area linking Corinthian atrium and garden, an unusually open space more like a passage than a room. From its facing walls were taken two monumental paintings often considered among the best-composed specimens of Pompeian art[57]: Atalanta and Meleager in company with the latter's two ill-fated maternal uncles, and Deianira, Hercules, and Nessus. Their juxtaposition highlights the familial connection between brother and sister, the latter destined to destroy her husband and the former to become the victim of his mother's wrath. Architectural contexts indicate that these were creations of a later period, in all likelihood installed at the time when the final revisions of the forecourt were made. Perhaps at the same time an exedra within the ample *viridarium* was endowed with an imitation marble decoration in the First Style manner. This *viridarium* contained marble bases for statues probably plundered after the eruption; also the atrium of the first house held statues and other luxury objects attesting to the owners' prosperity.

Although the smaller houses of the north western insula had enjoyed no comprehensive campaigns of rennovation to match those of the two great northeastern mansions, these also show evidence of spatial recombinations and self-conscious decorative programs with an eye to coherence. Following the series of single-room

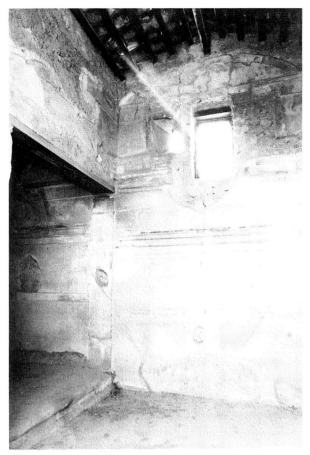

139. Casa del Centauro, Region 6.9.3.5, First Style alcove room, south of entrance. 56055.

shops that line the sidewalk closest to the Forum and the three entrances of the Fullery come two ample houses, named Fontana Grande and Fontana Piccola for the glass and shell mosaic fountains standing as the central features of the shallow pseudo-peristyles, the limits of which are fixed by the depth of the building plots on this side of the street. Each of these brightly colored ornaments is a pedimental shape framing an apsidal niche with a marble basin. The mosaic patterns in lively polychrome consist of flowers, geometric patterns, and water plants, with scallop shells to border the edges. The larger and older installation in the Fontana Grande included a water-stair and a pedestal to support an ornament or a pipe. Two tragic masks, sharply articulated with complex features, stare out from the arched facade; the lion-skin cap on the right-hand persona identifies him as Hercules.[58]

The decorative settings of the two fountains visibly seek to enlarge the dimensions of their confined spaces. Garden paintings in Gell's engraving of the Fontana Grande show a series of panels depicting shrubbery (cypresses) with water birds and a single-footed round marble fountain basin (Figure 84). These stand behind a

balustrade on the floor of the area, which is flush with the base of the fountain, thus lending an air of deeper recession to the small courtyard space.[59] The even smaller garden enclosing the Fontana Piccola, involves one of the most ambitious programs of pictorial imitation in all Pompeii: within the interstices of a simulated colonnade on the rear wall are depicted nothing short of a villa garden, and a distant prospect – a fictive landscape decoration that visibly chafed against the spatial limits of its situation (Figure 140). On the south side there unfolds a panorama of shores and buildings such as might have appeared from the window of a loggia directly overlooking the coast (Figure 141). On the adjoining rear wall the garden appears to be extended with villa architecture as if one looked into a series of exterior spaces closer at hand.[60]

In the Casa della Fontana Grande (6.8.22), renovation was actually in progress, and perhaps only recently commenced (Figure 142). With the exception of some small rooms looking toward the fountain, the garden paintings were virtually the only completed portion of its painting. All the entrance rooms, atrium, *alae*, and others off the traditional atrium had been stripped to their stonework and awaited replastering, while any fine furnishings would appear to have been removed for the process, showing the place likely to have been uninhabited at the moment of the eruption.[61] Because there is minimal evidence for mending in the stonework, we need not assume that earthquake damage had necessitated such extensive repairs; rather, it may have been a late inaugurated campaign of gratuitous renovation such as owners across the street had carried out. Some interaction with the fullery atrium to the south also seems possible. Originally, and perhaps before the installation of the fullery, these two atria formed a double atrium complex; they are interconnected along their party wall by a series of doors that were, at the moment, blocked by a thin rubble fill.[62] Possibly both belonged, as Warsher proposes, to L. Veranius Hypsaeus, a sometime quinquennial candidate who had served as duovir in 58–9,[63] endorsed in nearby *programmata* by the fruit sellers, whose residence, she also suggests, might conceivably have been next door in the Fontana Piccola (6.8.23–4).

Warsher notes the error of those who wish to see this contiguous house as contemporary, when, in fact, the Fontana Grande with its tufa facade is much earlier and merely imitated by the Fontana Piccola through the use of painted stucco blocks to cover a facade of rubble faced with *opus incertum* (Figure 143).[64] Despite her speculative stab at ownership, the house is wholly anonymous, its cultural profile dependent on material signs of prosperity, such as the several bronze statues found within,

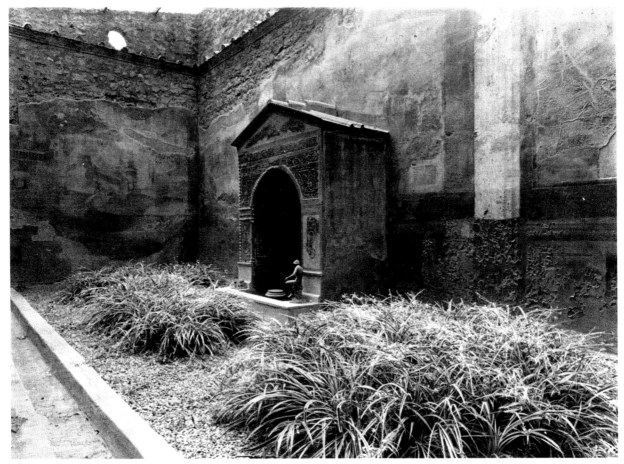

140. Casa della Fontana Piccola, *viridarium* with mosaic fountain and landscape representations. Author's photograph (su concessione del Ministero per i Beni e le Attività Culturali).

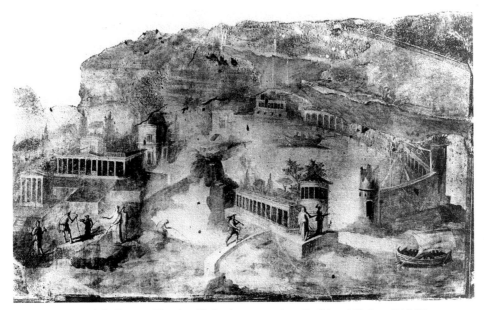

141. Casa della Fontana Piccola, villa landscape, south wall of the *viridarium*. DAI W122.

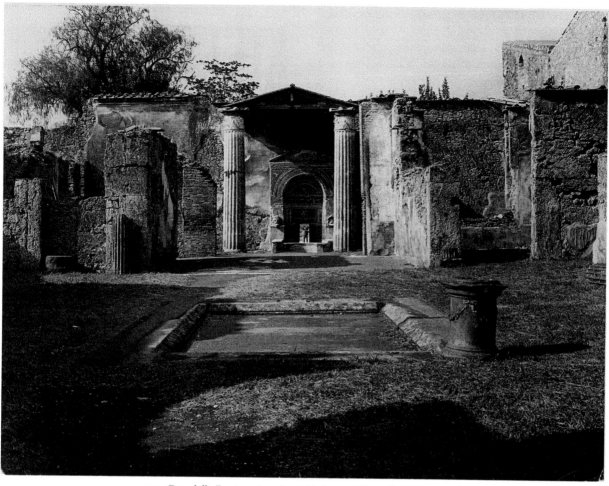

142. Casa della Fontana Grande, *viridarium* and fountain. DAI 72.3559.

and a building history that had extended over a long period of time. As a double atrium *domus,* the Fontana Piccola gained its final dimensions through the amalgamation of two adjoining houses. Despite the continuity between the rubble and stucco facades of these two, they were originally the properties of separate owners as indicated by a boundary marker in the sidewalk, which also tells the limits of the original spaces.[65] Early amalgamation had begun in the rear quarters during the late Republic or Augustan period, at which point a staircase and partial upper story had been built and several mosaics laid.[66] More recently the wall separating the two

143. Via di Mercurio, northwest insula, Region 6.8, including *Fullonica,* Casa della Fontana Grande, and Casa della Fontana Piccola. Plans after Eschebach 1993.

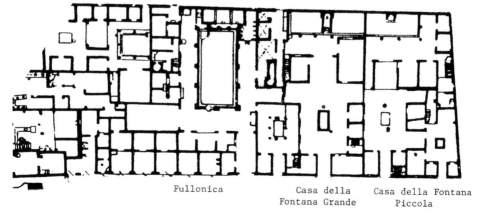

Fullonica Casa della Casa della Fontana
 Fontana Grande Piccola

atria had been broken through, joining the two spaces by an open intermediary room. Various explanations have been proposed for this secondary complex. In keeping with interpretive customs of her day, Warsher suggested that it was an apartment for the women of the house,[67] but more recent ideas make it an example of the *hospitium* such as Vitruvius attributes to Greek houses.

This is a house in which the thoroughness of rebuilding had resulted in a total obliteration of whatever previous decoration might have existed, save for the masonry blocks of the facade. Because the reconfiguration of spaces had indeed gone on so long, one might wonder if some of the rooms were finished at all until their Fourth Style application, which appears also to have taken place in stages, with some late building involved and primarily, according to current analysis, in the aftermath of the earthquake, with only a few mending interventions in previously finished walls. Although an overall consistency characterizes the compositions, these two have been seen as the product of two workshops, the more recent which worked in no. 23 with the larger atrium being superior in the execution of details.[68]

Although the peristyle with its combination of panoramic and garden landscapes surrounding the late Fourth Style mosaic fountain is a showpiece that Gell chose to engrave in illustration of the refinements of Pompeian life, the remainder of the decoration falls below the level of neighboring houses both in subject interest and in complexity of detail. Especially one notices the absence of mythological subject painting, the sole example of which in the larger house, no longer legible, appeared in the *tablinum* giving access to the garden.[69] This was a grand room with a black-and-white mosaic pavement raised by two steps above the floor level of the atrium. Both atria have a fairly consistent, paratactic Fourth Style decoration with red dominating the main zones, although they are scarcely identical. In the larger house, red and black panels broken with two pairs of flying Bacchantes and Satyrs stand above a black dado. Ornate candelabra separate the panels in the smaller atrium. Walls of adjacent rooms appear to belong to a consistent program carried out throughout the house; they tend either to black or white backgrounds and favor spatially expanding devices, such as airy pavilions and rods wound with garlands over large mythological panels. An *ala* at the right of the atrium is decorated in giallo antico. The subject paintings are restricted to small landscapes and often vignettes. Sometimes the surface of the wall seems completely dissolved through the confused perspective. Such strategies are aptly suited to increase the apparent size of small rooms and capture light to brighten enclosed spaces. Interior compositions

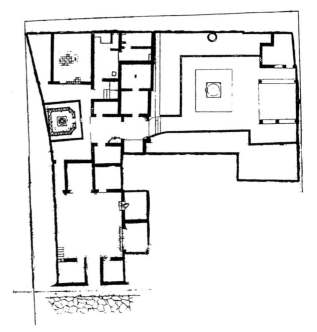

144. Casa di Apollo. Plan after Warsher (Museo Borbonico).

are of a somewhat routine paratactic patterning. Thus as in the garden paintings themselves, emphasis falls more strongly on visual appearance than upon theme.

Crossing the Vicolo di Mercurio to the northwestern insula, we find the greatest discrepancy of sizes, and presumably levels of prosperity, in the series of houses facing the grand mansions. Given that their plots and plans were originally uniform, these discrepancies also constitute an illustration of the structural encroachment that amplified some owner's properties at the expense of others. The most extreme instance of such transformation took place in the House of Apollo whose owner had capitalized on his advantageous situation toward the end of his insula to extend his properties to the city wall through the appropriation of his next-door neighbor's garden area and the rear spaces behind the stable (Figure 144). The spacious sunken garden thus created was home to the theatrical *biclinium*, the facade of which was shaded behind a small *porticus* supported by two brick columns. The glittering baldican framing Apollo's throne in the *scaenae frons* painting (Figure 79) will have been matched by the sparkling chips of mosaic glass encrusting these columns (Figure 145). This and other areas are commonly considered Neronian in style,[70] but because the masonry gives no sign of mending or patching the entire campaign of restructuring seems likely to have taken place in the aftermath of A.D. 62. On the basis of three entries in the tablets of Jucundus, its putative owner, Heren[n]uleius Communis, although probably not a member of the Pompeian elite, might be

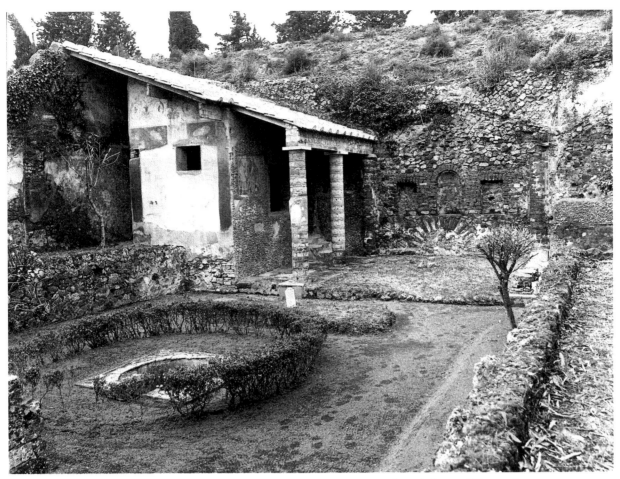

145. Casa di Apollo, lower garden. Fototeca Unione, American Academy in Rome, FU 24897/1981.

considered as actively engaged in business, and no doubt prosperous, by that date.[71]

Marble fountains were the nuclei of luxurious accommodation in the two garden areas, enhanced by an abundance of statuary, that this remodeled house possessed. The lower garden reached by a passageway beyond the *tablinum* was landscaped on two levels with a terrace surrounding it on three sides. Its fountain basin, currently outlined by a low boxwood hedge, filled almost the entire sunken center, leaving only the space between the two small colonnades open (Figure 145). A second *porticus* once faced that still standing; traces of the mosaic glass that enlivened the columns still adhere to parts of the summer house facade along with a colorful three-figure mosaic composition of Achilles, Deidameia, and Ulysses on Skyros. A companion mosaic showing Achilles about to draw his sword on Agamemnon is now housed in the Naples Museum; one cannot miss the parallel with the subjects of the more monumental paintings in the Dioscuri *tablinum*. Bits of pumice coating the summer-house wall, and once also the rear wall, make a pseudo-

grotto as the setting for a series of waterless niches that Stafani terms a pseudo-nymphaeum.

At the rear of the house on the upper level, the second marble fountain, in the shape of a water pyramid, formed the center of a raised garden bed against a background of garden paintings highlighted by an image of Diana in hunting dress. This miniature fountain court served as the antechamber, so to speak, of an enclosed room with heating pipes concealed beneath the outer surface of its walls. The presence of a kitchen and storage room show this as a dining suite. From the atrium the entire ensemble could be seen through the so-called *tablinum*, so narrow as to be little more than a decorative passageway leading toward the richly accoutered suite of rooms. Space within the once constricted atrium had been amplified by the installation of a stepped exedra in the area carved from a neighboring house. Directly facing it on the single unbroken wall of the room the commanding image of the sun god from which the house derives its name stood out against a white background. Although merely illegible traces of the atrium decoration

146. Casa di Apollo, atrium and *tablinum*. Fototeca Unione, American Academy in Rome, FU 24892.

remain in situ, the well-preserved composition of the *tablinum*, lofty for the narrowness of its space, compares with that of the Dioscuri *tablinum* in the intricate pavilion architecture showing through the apertures between its richly bordered tapestry panels. Only the small and undistinguished central panels indicate a lesser expenditure (Figures 146 and 147). Considering the number of parallels with the house of the Dioscuri – the Achilles topics, the marble-clad *oecus,* and this complex *tablinum* composition – one might suspect either sharing or emulation between the owners of these across-the-street houses.

The Casa di Adone Ferito (Figure 148) was once the structural reverse image of its next door neighbor, but had since outclassed it in architectural innovation and in painting. In stages the owners had rebuilt its modestly sized peristyle area with a configuration of interrelated spaces, some of which were gained by appropriation of garden space from the neighboring house. Its eponymous pièce de resistence, located on the wall beneath the *porticus,* is a megalographic mythological painting (Color Plate VIII), surely meant for the dramatic representation of a pantomime, of Venus and a languorously expiring Adonis attended by three sedulous amorini, while a river goddess mourns gracefully amid the rocks and trees that build up the background setting. At the sides of the panorama, this landscape seems to shade into the garden with a statue of a sleeping Eros. Additional pieces of garden statuary are stationed at the bases of the fluted red Ionic pilasters, framing the spectacle. These are replications of the two famous sculptural pairs, whose originals stood in the Roman Baths of Agrippa:

Achilles with Chiron and Marsyas with Olympus. The relationships between the figures of instructor and pupil in these painted versions are much more intimate, not to say erotic, than is the case with their counterparts in the Herculaneum basilica (Figure 149).[72]

Facing the platform and positioned for a full view of this mural is a large open room with rebuilt walls that had not yet completely received decoration. Another, partial view was afforded through the window and doorway of a second room, distinguished by the richly detailed painting covering three walls (Figure 150, Color Plate IX). Monumental projecting *aediculae,* their gables supported on gilded stalk columns, dominated these walls. Housed within generously proportioned spatial boxes these massive frames were flanked by open doorways behind curving porticoes (Figure 151). The gilded ornamental trimming of columns and cornices and the rich embroidery of the flanking tapestry panels are all precisely articulated. Beside it another smaller, narrower room displayed similarly rich compositions. Here again we seem to encounter the owner's inclination toward erotic suggestivity, because both central panels in the larger room portray Hermaphrodites, while those of the smaller room are satyrs and nymphs.

That the same group that produced this opulent assemblage of ornaments also painted a large *triclinium* facing the garden in the Casa del Naviglio shows from the boldly projecting *aedicula* and the gilded columns with bursts of leaves that are the hallmarks of their work. Here again the frame stands above the podium, giving the appearance of a deeply recessed bay. The large painting filling the *aedicula* portrays Zephyrus awakening

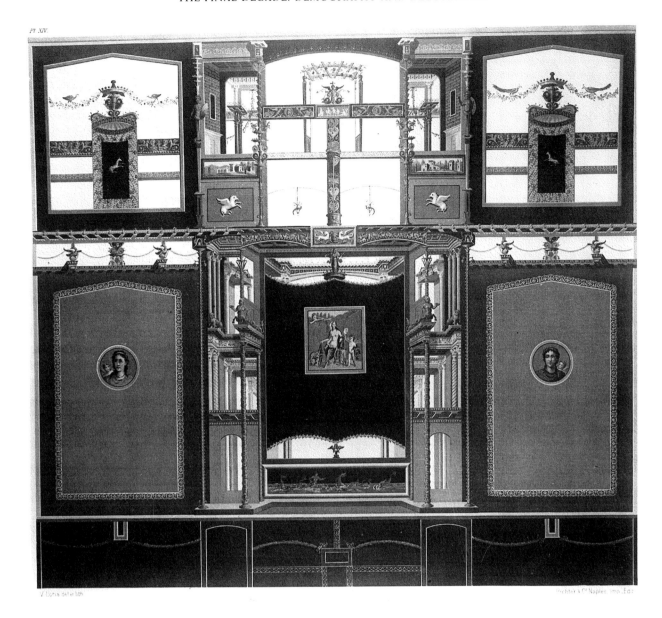

147. Casa di Apollo, *tablinum*, Drawing from d'Amelio. DAI 56.330.

the sleeping nymph Chloris (Figure 152). Flanking screen walls and balconies that comprise the boundaries of the *aedicula* open onto an empty black depth of space. All parts of the ensemble are richly ornamented. The front of the wall is marked by richly colored tapestries in the side panels before which are suspended figures of graceful ivy-crowned Bacchantes wearing transparent, swirling robes.[73]

Richness added to height gave also a particular grandeur to the atrium of the Naviglio (Figure 153). In proportion to its size, this room was imposingly tall, with an attic zone that, as Warsher described it, represented a "grand edifice," resembling, and perhaps inspired by, a basilica.[74] Here decoration had adapted its lineaments

to the traditional disposition of the ground plan. With a full complement of *cubicula* opening in the customary places from a space of moderate size, the atrium walls were segmented into eight successive small panels between the doors (Figure 154). Each of these was treated as an architecturally framed compartment with slender columns at the sides, a bordered pattern within the frame, and the polychrome figure of a deity symmetrically centered within each compartment (Figure 155). On the side walls were minor deities either floating or standing. Figures of Jupiter and Hera enthroned flanked the *tablinum* door on the north wall, and Bacchus and Ceres the *fauces* and outer door opposite on the south wall.[75] Several of the figures, as, for instance, the

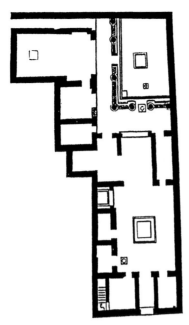

148. Casa di Adone Ferito, Plan after Overbeck 1884, 275, fig. 153.

Jupiter, appear to have copied famous statuary, which was also the case elsewhere. In a Fourth Style *triclinium* the figures included a representation of the Hermes of Praxiteles.[76] At the back of the house is a single colonnade with a small garden. Three rooms, all with Fourth Style decoration, gave onto this space. It was the substantially proportioned central chamber that housed the imposing Zephyr and Chloris.

Extending from the late Neronian period through the Flavian, the Via di Mercurio is a showcase of Fourth Style decoration whose resources of ornament and spatial illusion might seem to suit the status representation of its owners very well. The general prevalence of redecoration on this street of old houses might be taken to indicate that the entire area had sustained significant damage, while the total or partial extent of activity provides some evidence by which to judge varying investment of resources. From this one might conjecture that owners such as the Nigidii Vacculae of the Dioscuri or L. Cornelius Primogenes of the Meleagro who took the occasion to order their entire houses redecorated must have exceeded in wealth the owners whose redecoration was restricted to repairs. Likewise it might follow that the owners who were first to redecorate were also the most prosperous. Thus the modest Casa di Adone Ferito in which several rooms would seem to have been disordered must have belonged to a less wealthy owner than the Meleagro, give or take the possibility that the damage motivating changes did in fact occur simultaneously throughout the neighborhood. But the retention of old decorations, especially when efforts have clearly been made to preserve them, raises other complex questions of status and family representation. Already we have seen that some of the more outstanding examples of Republican decorations exist in connection with some outstanding architectural feature such as the *vestibulum* of the House of Polybius, the tetrastyle *oecus* of Albucius Celsus' house or the

149. Casa di Adone Ferito, view into the *viridarium*. Author's photograph (su concessione del Ministero per i Beni e le Attività Culturali).

150. Casa di Adone Ferito, room with a view into the *viridarium*. Author's photograph (su concessione del Ministero per i Beni e le Attività Culturali).

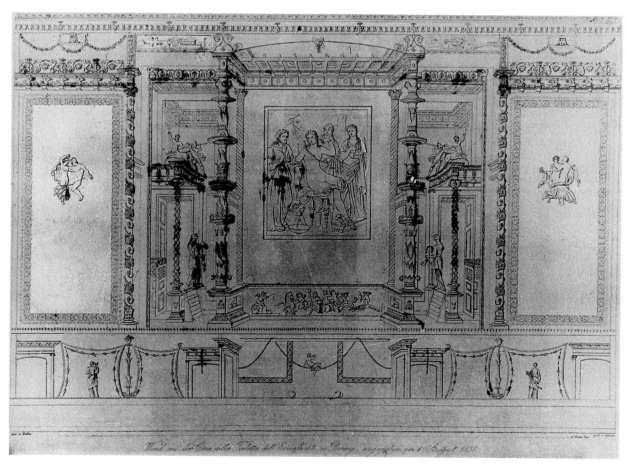

151. Casa di Adone Ferito, reconstruction drawing. DAI W 59.

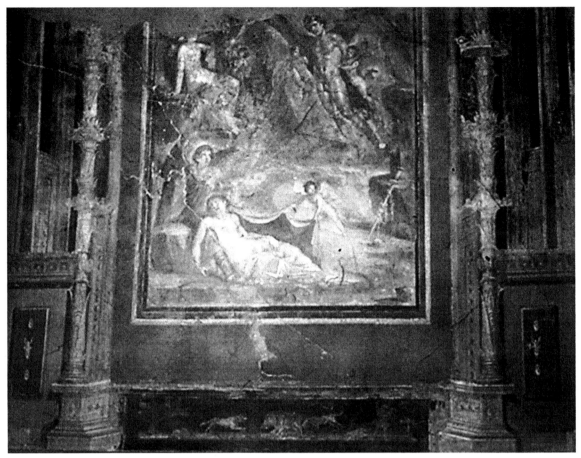

152. Casa di Naviglio, Region 6.10.11, painting from the garden *triclinium,* Zephyrus and Chloris, Naples Museum 9202 (courtesy of the *Soprintendenza Archaelogica di Napoli e Caserta,* Neg. AFSN A/6135).

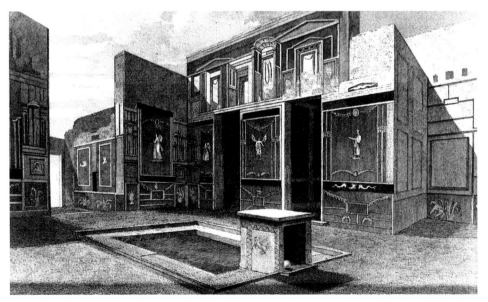

153. Casa di Naviglio, atrium, south side, facing entrance, reconstruction drawing. Gell, 1834 Vol. 1, pl. 62 (therein called the House of Ceres) p. 181.

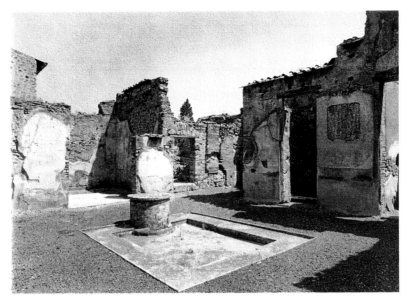

154. Casa di Naviglio, atrium, north side facing *tablinum*. Author's photograph (su concessione del Ministero per i Beni e le Attività Culturali).

peristyle suites in the Casa del Labirinto. Were decisions against redecoration, then, made solely on the basis of expenditure, or was some ideological significance attached to the preservation of old decorations, so that a certain class of owners might in fact prefer to retain what they had as a repository of cultural memory?[77] This question assumes primary importance as we turn our attention to some of the actual houses of persons verifiably successful in Pompeian politics.

HOUSES OF THE CANDIDATES

The condition of certain houses attributed to known candidates for political office during the seventies gives a different conspectus of painting from that of the Via di Mercurio. In contrast to the social cross-section seen within the physical coherence of a neighborhood, this examination of candidates' houses will range across districts to view a demographic cross-section of persons whose civic achievements, if not their inherited status, were roughly equivalent. As I have mentioned previously, Pompeii differs from Republican Rome in having no apparent concentration of elite residences or even areas of social homogeneity, and it differs also in the demography of its governing class.

As Franklin has made clear in his study of electoral publicity, residences of the prominent politicians of the Neronian and Flavian periods were broadly distributed throughout the city.[78] Even the district that some British scholars have recently dubbed that of "deviant conduct," the complex of irregular streets in Region 7 where several of the city's brothels were located along with an

abundance of taverns,[79] had its resident decurial families. Although groups with common allegiances did tend to cluster, electoral slates often combined persons from different districts. For instance the duoviral slate of A.D. 77 was formed by Epidius Sabinus from the Via dell'Abbondanza and A. Suettius Certus, who lived within the area of Region 7 on the Via degli Augustali, a curving street that was the district's main throughway.

In size as well as location, magistrates' houses show considerable diversity. While some were originally spacious, and some had gained space by annexation, others, such as that of this same Suettius Certus, or L. Ceius Secundus, duovir in 78, were proportionately modest. Naturally an investigator will be curious as to what families might be living in ancestral houses. Although prosopographers can tell us who the political newcomers of any given period may be, family residential continuity is more difficult. Two of the most likely are the aedilician candidates on the Via dell'Abbondanza, C. Cuspius Pansa, the son of a very distinguished magistrate of the Neronian period whose family could trace its political prominence back to precolonial days, and A. Trebius Valens, who emanated from an old Samnite family as witnessed by an inscription of the kind used on statue bases embedded in a wall of his garden commemorating an ancestor who had served as *medix* in the pre-Roman city.[80]

Unlike the houses of the Via di Mercurio with its preponderance of Fourth Style decoration, the greater number of the houses that we will now be considering retain decorations from two and even three of the traditional stylistic period definitions. Even in the opulent

211

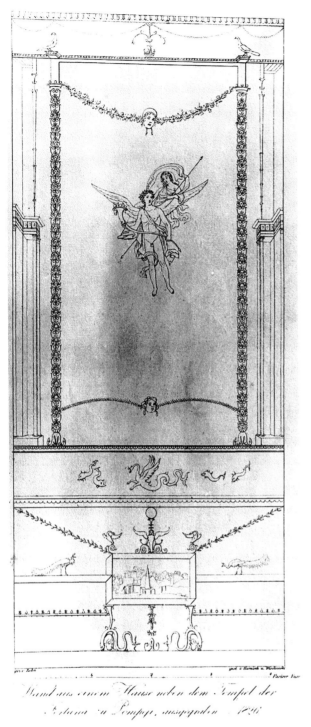

155. Casa di Naviglio, atrium, panel with winged genius. DAI W 157.

northeastern block of the Via di Mercurio, those politically active Vettii who occupied the Casa del Centauro differed from their neighbors in the Dioscuri and the Meleagro in having incorporated minimal Fourth Style decoration into their house, and perhaps only

where reconstruction was needed. Among Pompeii's last decurial families, that of the distinguished and well-off D. Lucretius Satrius Valens, who lived in the handsomely appointed Casa della Venere in Conchiglia at the far end of the Via dell'Abbondanza, was unusual in having undertaken comprehensive redecoration in consequence of repair, but even here one area of restoration remained incomplete. Generally such stylistic miscellanies as that we find in the Centauro were the rule within the decurial class, with decorations ranging from the well-preserved First Style in the Houses of Polybius and A. Vettius Firmus (Centauro) to examples of the ornate later Third Style in the House of C. Cuspius Pansa and also that of Polybius. As might be expected Third Style is dominant among surviving preearthquake decorations in patterns ranging from simple paratactic to monumental *pinacothecae,* although these latter are actually few in number. Sufficient Second Style examples exist to indicate latter-day respect for its patterns. Judging by the efforts at mending and patching visible in rooms opening on the peristyle of the Casa delle Nozze d'Argento, the owner, L. Albucius Celsus, set a high valuation on preserving the style.

In addition to chronological accretions were also many situations where decoration was either in progress or stalled. This condition would not seem particularly significant in the case of small rooms with a possible storage function, especially when these are located in the somewhat inert surroundings of the atrium,[81] but more significant when large rooms in prominent positions are incomplete, as is the case with a room in Albucius Celsus' house facing the peristyle and stripped of plaster as an obvious candidate for redecoration, or even more conspicuously in the Casa della Venere where we see one of the largest rooms in Pompeii, a room that likewise faces the peristyle, also bare of decoration.

In view of these differences, more of which will emerge in the course of the ensuing discussion, the conclusions reached by Jongman concerning the correlation or noncorrelation of wealth, material ostentation, and social prestige well merit keeping in mind. Jongman has studied this correlation in the light of the prestige ranking he has made from the positions of signatories in the wax financial tablets of Caecilius Jucundus. Because a large number of these witnesses are drawn from among the inhabitants of Jucundus' own neighborhood, Jongman considers that the group is demographically representative irrespective of class. His criterion for estimating the wealth of these persons is a correlation between the apparent ranking of their owners' names in the tablets and the size of houses in terms of floor space. On this basis he reaches the conclusion that wealth is somewhat

overrepresented among the names of witnesses and membership in the *ordo decurionis* underrepresented.[82] As social conditions relevant to this disproportion, Jongman invokes two contrary aspects of Roman elite ideology: the understood link between political success and visible self-representation and the countertendency to associate the virtues deserving of responsible leadership with restraint.[83]

By adding evidence of redecoration to floor size and variety of rooms, it becomes possible to enlarge more specifically on Jongman's criteria for determining wealth in relationship to houses. Rather than drawing statistical conclusions, I look at particular properties inhabited by identifiable members of the *ordo decurionis,* utilizing whatever information seems appropriate concerning their lives and careers.[84]

Who They Were and Where They Lived

On the basis of reconstructed electoral slates, it is possible to view the houses of sixteen persons who either attained or aspired to Pompeii's annual magistracies during the years from A.D. 71–79. The sampling includes nine duoviri who will have stood unopposed for their posts. Six of this number had also gained their aedileships during the period. Naturally the nonappearance of the other seven names as duoviral candidates leaves their success in gaining the aedileship in question. Among the candidates at both levels, the greatest concentration of residences is on the Via dell'Abbondanza beginning east of the crossroads with the Via di Stabiae. On the left-hand side of the adjacent insula two descendants of established political families, C. Cuspius Pansa[85] and M. Epidius Sabinus,[86] were neighbors – the one a political beginner, the other so far advanced as to have earned the honorific title *defensor coloniae* from his work with an imperial agent adjudicating matters of property ownership. Directly across the street in the Casa del Citarista (1.4.5) two aedilician candidates, L. Popidius Ampliatus, who stood in 75, and L. Popidius Secundus of 79, were living with their two homonymous fathers.[87] One of the political success stories of the period, these Popidii were the freedperson's branch of the family whose aristocratic members inhabited a large house in the area of the Via dell'Abbondanza approaching the Forum.[88] Three graffiti on columns within the lowest peristyle wish good luck to "Luci," the elder L. Popidius Secundus, in his role as an Augustianus, a member of the programmed claque that attended Nero's public performances to guarantee sufficient applause.[89] Political affiliations were also revealed by the portrait busts of Nero's family that shared space with those of family members within.[90] Next on the southern side of the street came Paquius Proculus, another Neronian supporter.[91] Close by on the opposite side, and covering half its insula, stood the palatial mansion belonging to the imperial freedman C. Julius Polybius.[92] Surrounding this old but restructured house were enterprises of clients who favored its owner: bakeries and *popinae*.[93] Two blocks further to the east of Polybius lived A. Trebius Valens, whose house facade was distinguished by the unusual number of programmata the owner had posted on behalf of other candidates.[94] Throughout much of the Roman period this family had been politically inactive, although a brick industry had sustained their economy,[95] until Trebius' father revived their fortunes by progressing through the magistracies to stand as a quinquennial candidate.[96] Below these Valentes, on the opposite side of the street, toward the palaestra and amphitheater, in what might be called the garden district, the Casa della Venere in Conchiglia (2.3.3) was home to D. Lucretius Valens, aedilician candidate of 68–9,[97] who will recently have inherited the property from his father D. Lucretius Satrius Valens, who became *flamen perpetuus* of Nero in A.D. 50–4.[98] A graffito at the back of the peristyle pronounced good wishes (*feliciter*) to four members of a nuclear family: Satrius, his wife Justa, a daughter Valentina, as well as Valens *filius,* but Satrius' death had occurred not long before, leaving young Valens to manage his own progress on the *cursus honorum* within a household that presumably will have included his widowed mother.[99]

Lucretius Satrius Valens' unusual history and career status deserve notice. Although his adoptive father, D. Lucretius Valens, had been a magistrate honored by Emperor Claudius, as well as his citizen peers and his clients, and his natural father M. Satrius Valens was a quinquennial candidate of 75, he himself apparently never held a magistracy, but rested his civic position entirely on the prestige of the imperial flaminate that must have given him strong connections with Rome. That these involved personal contact can be seen from a visitor's graffito in the *vestibulum.* Poliaeus Marsus, a *cubicularius Neronis,* salutes the *sanctissima colonia* and *populo Pompeiano.*[100] During Nero's reign Valens sponsored gladiatorial games four times on behalf of imperial welfare; each exhibited twenty pairs and in two shows ten pairs were for the son who must have been quite young at the time.[101] The memory of one such event stands in perpetuo from the appearance of Lucretius' name on the wall of the building opposite the amphitheater in the well-known "journalistic" picture of the riot. Painted announcements left in place show only a faint effort to erase Nero's name following the *damnatio memoriae.* Some are posted on the

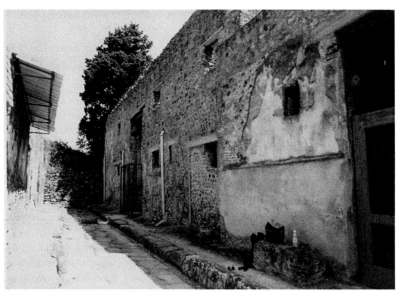

156. House of L. Albucius Celsus, facade on vicolo. Author's photograph (su concessione del Ministero per i Beni e le Attività Culturali).

facade of the still unexcavated property at 3.6.2 directly across the street where Satrius' own father, M. Satrius Valens, lived.[102] Suggestions for the influential nature of our Satrius' position can be taken from the presence of one of the largest putative banqueting rooms in Pompeii in the area between atrium and peristyle. Immediately accessible from the atrium, with a small doorway giving on the recessed front corridor of the peristyle, this room would allow visitors a full view of the amenities without encouraging them to penetrate into the more private interior chambers. Undecorated, with only a coating of rough plaster at the time of the eruption, the room all the same suggests how great a number of clients must have been attached to the house in the glory days of its master's service to the state.

Among the candidates remaining to be mentioned, however, there is less clustering. Furthermore, at least so far as the current extent of excavations discloses, no one lives on a major thoroughfare. To the contrary some candidates seem strangely isolated in out of the way parts of the town. The palatial house of L. Albucius Celsus with its regal tetrastyle atrium stands on a minor street two blocks from any major route (Figure 156). Located even further toward the city wall, on a vicolo off the Via di Nola, the house of M. Lucretius Fronto is close to the end of its block. Across the city in a district bordering on the commercial quarter, the compactly structured house of L. Ceius Secundus faces the larger Casa del Menandro (Figure 9).[103] Lollius Fuscus, a political newcomer well publicized by ten programmata on the Via dell'Abbondanza lived at possibly the furthest degree of removal of all.[104] The lower level of his Casa

del Mariniao, incorporated a complex of horrea for the grain trade, stood in the northeastern edge of the city, close to the wall.[105] In the middle of the complex of streets at the interior of Region 7 is another man whose success is uncertain, P. Vedius Nummianus, aedilician candidate in 75 (Figure 157). Whatever his fortunes had been, his immediate family credentials were good; his father P. Vedius Siricus, a former duovir, had been one of the two experienced magistrates called on to form a new government after the amphitheater riot of 59. At that moment of history he may have owed his selection to his membership in the faction called the Neropoppaenses; however, he would appear to have retained his standing and secured political allies during the Vespasianic period.[106] Two more probable inhabitants of the region are the Suettii Certii, father and son.[107] The first bearer of his nomen to appear in Pompeian politics,[108] Certus was aedile under Nero, but delayed his duoviral candidacy until 77 when he formed a coalition with Epidius Sabinus. In the same year his son, Suettius Verus was a candidate for aedile. In his own aedileship of the Neronian years Certus himself had sponsored gladiatorial games that were said to feature his own *familia gladitoria*.[109] Perhaps it was the combination of his status as newcomer in combination with his removal from the center of commerce that made Certus think the games necessary. His posters spanned the city, appearing both in the forum area and on the far side of the Via dell'Abbondanza as well as closer to home near the Lupanar.[110] Not only will they have summoned spectators, but also kept his family name green in the public eye.

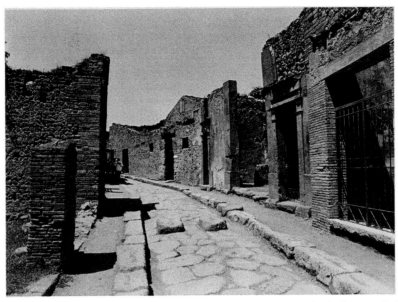

157. House of P. Vedius Nummianus, facade on Vicolo del Lupanare. Author's photograph (su concessione del Ministero per i Beni e le Attività Culturali).

A first conclusion that we can draw from locating the houses of successful candidates within the framework of Pompeii's demographic diversity is that a centrally located residence was not necessary for success. Naturally it was possible to compensate for removal through electoral publicity as well as by games. For instance, three conspicuous facades on the Via dell'Abbondanza – those of the candidate Trebius Valens, his freedman neighbor M. Epidius Hymenaeus in the Casa del Moralista, and the caupona across the street – carry recommendations not only for neighbors such as Cuspius Pansa and Lucretius Valens, but also Albucius Celsus and Suettius. As Franklin has observed, the frequency of programmata on main thoroughfares demonstrates their importance, if only as reminders of the family record of service.[111]

In second place, this roster of aedilician candidates who achieved office during the seventies also reveals little coordination between the opulence of a house and the success of a political career. Among the six candidates who completed both stages of the *cursus honorum* within this temporal framework, the shortest interval (two years) intervened between the campaigns of L. Ceius Secundus (aedile 76, duovir 78), the owner of one of the modestly proportioned and modestly decorated houses that had, in addition to its atrium and *viridarium,* only six rooms on the ground floor. For a magistrate it seems not only small but ill adapted, having none of the traditional spaces, neither *tablina* nor exedrae, opening on the atrium whose interior space seems virtually devoured by the heavy columns of its tetrastyle *impluvium* (Figure 97). The house of M. Epidius Sabinus (aedile 74,

duovir 77) rises commandingly from a stepped podium elevated above the sidewalk and boasts an imposing Corinthian atrium with colonnaded exedrae flanking the *impluvium* (Figure 18), yet its ground floor accommodations are limited, even within the extensive garden space at the back. Among modest houses, the newer residence of Lucretius Fronto (duovir 73), restricted as it also was by the boundaries of the property, offers ampler spaces for hospitality. The house of Pacquius Proculus (aedile 71, duovir 74) possessed a large peristyle; its atrium was paved with an elegant carpet mosaic but was scarcely conspicuous for size (Figure 158). Pacquius' colleague in both years, A. Vettius Caprasius Felix (aedile 71, duovir 74), shared the Casa del Centauro with his adoptive father, but this well-accoutered double atrium house on the Via di Mercurio was still less showy than those of its neighbors on either side. The residences of the two other candidates C. Gavius Rufus (aedile 73, duovir 79) and M. Holconius Priscus (aedile 76, duovir 79) are uncertain, although the name of the Holconii is commonly associated with a large house at the intersection of the Via dell'Abbondanza and the Via di Stabia across from the cuirass statue of M. Holconius Rufus, the *tribunus militaris a populo.*[112] As one of Pompeii's most powerful Augustan families, the Holconii had continued prominent through the forties, but those members who had signed in Jucundus' financial records of the fifties were undistinguished. Given this hiatus, D'Arms has suggested that the Priscus who emerges successful within the seventies may indicate a new freed branch of the name.[113]

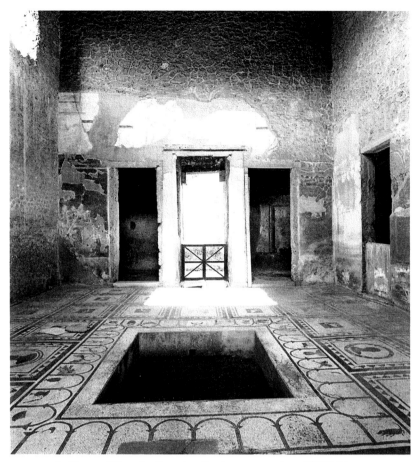

158. House of Pacquius Proculus, Region 1.7.1, atrium. ICCD N34735.

Among the persons who held or campaigned for only one office during the decade, there is a similar discrepancy of visible wealth. The House of the Suettii on the Via degli Augustali (7.2.51), had an imposing doorway but was of modest proportions within. The only surviving trace of decoration was a number of red and yellow First Style blocks in the entranceway. One candidate whom we do not find seeking the duovirate is Trebius Valens. The omission seems odd not only because he was the son of a quinquennial father, but also because the duoviral campaign of his former running partner C. Gavius Rufus might suggest that he had indeed gained the aedileship in 74, although Franklin suggests that he might even have campaigned unsuccessfully for the office at an earlier date.[114] As a rogator supporting Epidius Sabinus, Trebius calls himself a *cliens*.[115] Because Sabinus stood in 77, four years after Trebius' aedilician candidacy, the epithet is surprising, although possibly explained by Sabinus' unusually strong ties with Vespasianic power in Rome.[116] Whatever his personal fortune he took an active role in politics as a rogator. The long facade of the house supported an unusually large number of electoral programmata, including many couched as requests

for Trebius' support. Many of the prominent names of the decade were posted here, although the particularly large number may have owed as much to the advantageous position of the house as to its owner's political influence. This seems the more likely because space on the facade had also been granted to residents of the Via dell'Abbondanza for the announcements of gladiatorial contests they were sponsoring. Although Trebius' house is not large, it possesses a well-appointed garden area and more space than those of some candidates of documented success in their elections.

Chief among these of conspicuous wealth would be C. Julius Polybius with his large house and network of commercial connections no doubt aided by his role as an imperial freedman (Figure 14).[117] By far the largest house in terms of its ground space is the agglomerated Casa del Citarista belonging to the two pairs of Popidii, which was unusual even among Pompeii's largest houses in terms of the structural complexity resulting from the transformation of separate earlier dwellings (Figure 33).[118] The younger Lucretius Valens comes also from a wealthy family within whose bosom he has apparently remained living until the death of his father made him

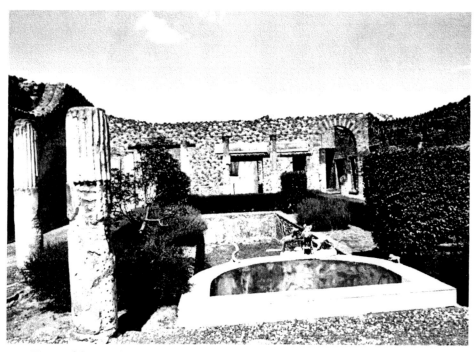

159. House of the Popidii (Casa del Citarista), D-shaped pool and second peristyle. Author's photograph (su concessione del Ministero per i Beni e le Attività Culturali).

independent. In the case of other families with two active candidates there is some effort to create a double atrium house by joining two separate residences on different streets. The two Vedii and the family of Cuspius Pansa had such artificially connected houses, and especially it is the story of the four kindred Popidii, whose Casa del Citarista possessed half its insula with its ample spaces. Two atria opening from different streets provide the poles of combination, the one belonging to a house of Sabine origins situated on the high ground of the Via dell'Abbondanza, the other forming part of a more recent house that stood at a lower level on the Strada Stabiana. Each had its own peristyle, and to these had been added, at the expense of a neighboring house on the Strada Stabiana, a third peristyle with a complex of surrounding rooms. A wall pierced by a series of windows at once separated the two enclosures and provided for their visual interpenetration. These three interconnecting peristyles with an ample complement of surrounding chambers formed the center of the complex dissolving spatial boundaries in a manner that challenged the traditional autonomy and confinements of domestic interiors[119] (Figure 159). Distinguished by amenities of waterwork construction in its gardens, the house contained also a large amount of decorative sculpture, including the bronze Apollo Citharoedus from which it has acquired its name.[120]

How They Decorated

A comprehensive view of domestic decorations in this particular cross-section of the Pompeian population yields a virtual archive of Pompeian styles. Remains of First Style survive in seven houses; in at least one of these instances it had been carefully repaired after damage. Second Style occurs less frequently than its predecessor. Among these houses only three, those on the Via dell'Abbondanza attributed to Pacquius Proculus and Trebius Valens and that of Lollius Fuscus near the Porta Marina, have no Fourth Style at all, but only a combination of surviving Second and Third Style decorations with the majority in the latter Style. These stylistic distributions are conveniently favorable to our survey of Fourth Style redecoration as an index of prosperity and social prestige. To measure the extent of this decoration across the spectrum of ownership I employ five categories: (1) gratuitous decoration, or decoration undertaken without apparent evidence of sufficient damage to necessitate rebuilding; (2) redundant decoration that may have been inaugurated to repair damage but which exceeds apparent necessity; (3) decoration exactly fitted to damage; (4) mending or patching as a substitute for redecoration; and (5) incomplete work, a category within which are included some instances of all the previous four conditions.

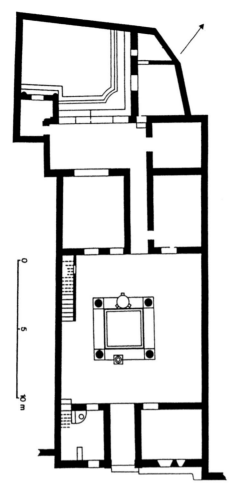

160. House of L. Ceius Secundus. Plan after La Rocca, de Vos and de Vos 1976, 190.

Because magistrates' houses are so widely scattered across the city, certain discrepancies in the extent of damage each suffered are naturally to be expected, but the presence of intact decorations from before the earthquake is the only reliable evidence of this. In all of these categories, the area that sustained the greatest shock would seem to have been those blocks of the Via dell'Abbondanza and Via degli Augustali closest to the Stabian Baths, which had themselves required extensive repairs. So far as can be seen, no houses had suffered totally incapacitating damage, but rather a general weakening of doorframes and crumbling of plaster. Naturally we cannot assess what the damage had been to plaster now replaced. Also one should not discount the possibility that recurrent seismic acting had damaged walls that were already undergoing restoration.

Proceeding with these several caveats, one can identify gratuitous decoration in the Houses of M. Lucretius Fronto (Figure 117) and L. Ceius Secundus (Figure 160), where well-preserved Third Style interiors suggest min-

imal damage,[121] while the garden areas are completely redecorated in a Fourth Style idiom with megalographic *venatio* scenes in which beasts are pursuing and attacking each other in various attitudes and pairings of natural enmity: cattle and dogs confronting boars; felines chasing cattle amid a variegated landscape terrain. In the M. Lucretius Fronto, a series of these scenes covers two walls of the *ambulacrum* (Figure 161)[122] while the single large panel on the rear wall of the *viridarium* in the House of L. Ceius Secundus is flanked by Egyptian landscapes on the two sides (Figure 86).[123] These animal scenes, as earlier mentioned, recall those on the interior parapet of the amphitheater, where niches with herms or candelabra separate the individual panels.[124] Translated into their domestic contexts, the scenes stand within a garden ambience involving statuary and fountains with plants in the dado. As if to show the effects of trimming and training, the plantings in Ceius Secundus' paintings are highly stylized. Clumps of ivy in globular shape alternate with young oleanders. At the two ends are sphinx fountains. The upper parts of these walls too are solid with trophies of various kinds. Although the garden furnishings are illusionistic, this effect does not extend to the bestial panoramas, which, with their framing ivy garlands, are less like windows than great tapestries.[125] They are not to be taken as action scenes but rather as trophies, probably commemorating games their owners had sponsored in connection with the civic offices they held. In Fronto's house the upper zone is filled by a checkerboard pattern in red, white, and gold. Because these colors, on the evidence of Lucretius *De Rerum Natura* (4.75–6) are those of the awnings used in theatres to shield spectators from the sun, we might think that this upper zone represents the patron's additional gift of awnings. In this house a spacious garden area allows room to view the paintings from a distance, whereas the flamboyant wall in the House of Ceius looms up at close quarters within a confined space.

On a scale comparable to that of the garden *venationes* the eye-catching banner emblazoned with a floating, shell-borne Venus on the uncolonnaded back wall of D. Lucretius Valens' peristyle might also seem like gratuitously added decoration, save that the absence of any surviving earlier work within the interior of the house suggests that the peristyle decoration formed part of a comprehensive campaign (Figure 162). To this politically engaged family living at the far end of the Via dell'Abbondanza the extensive damage done by the earthquake must have caused serious inconvenience, with virtually every door frame needing reinforcement,[126] but rather than settling for patchwork repair, they had undertaken a program of full

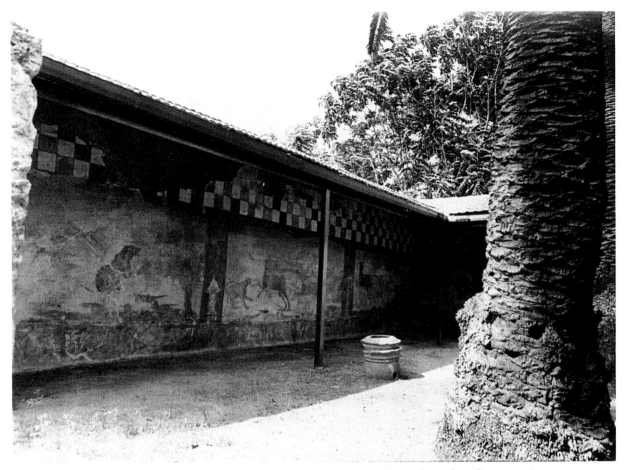

161. House of M. Lucretius Fronto, *viridarium,* Fourth Style installation of animal conflicts suggesting *venationes* as staged in the ampitheater. Author's photograph (su concessione del Ministero per i Beni e le Attività Culturali).

redecoration. Given their ownership of a villa within the *Ager Pompeianus,* the Valentes may well have been able to decamp completely while these renovations were in progress, conducting their political affairs from afar. Conceivably, also, the recently intervening death of the paternal Satrius, the one-time *flamen Neronis,* will have disrupted the restoration program and may account for the still rough plastered condition of the large banqueting room between atrium and peristyle,[127] but whatever the pace at which the work had proceeded, the greater part was now substantially completed.

Seven separate picture-gallery rooms exhibited a variety of mythological subjects with pendent landscapes amidst Fourth Style architectural designs. Around the circumference of the spacious atrium hung gold-colored tapestries with fine filigree borders on which were centered medallions of the four seasons. Lacking a *tablinum,* the atrium connected through a broad doorway with a deep bay on the inner side of the peristyle. When the doors stood open, this entrance afforded a long, channeled prospect through a framing pair of columns to the back of the garden where Venus' bouyant shell shone out brilliantly against its blue oceanic background (Figure 163).

Within the peristyle, decorations exploit the polarity of gardens and galleries, the inner side colorful with a bright decoration of red and gold panels, separated by black or white apertures with candelabra, while the opposite walls extend their spatial boundaries with fictive garden imagery (Figure 164). Dominating the enclosure, the rear wall preempts the viewer's attention with its megalography of the goddess and attendant Erotes, as vivid and vigorous as living presences. Although the traditional topos of the goddess' birth can be understood, the representational status of the figures is ambiguous, their size and spirit causing us to ask whether we are viewing a painted narrative hung as on a large *tabella,* or an arrangement of statues within a large garden piscina (Figure 85). Whatever the conclusion, we cannot overlook the boldness of the claim that this dramatic reenactment asserts of bringing the goddess' benevolent influence into the enclosure, an influence whose immediate

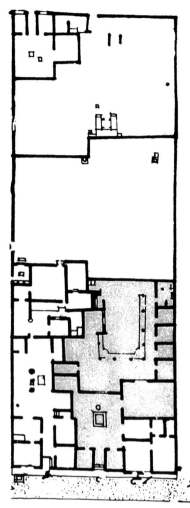

162. House of the Lucretii Valentes (Casa della Venere in Conchiglia). Plan after Eschebach 1993.

workings are visible in the conjugal pairings of birds, both large and small, visiting the garden plots that flank the panel. Bordered by thick leafy garlands, these panels pierce the gold-colored boundary wall like windows extending the reach of the garden into hazy indefinite space. Against this background the marble garden furniture stands out sharply. Centered against the left-hand panel stands a white marble image of Mars with a painted cloak, hair, and helmet on his disproportionately small head. Unlike Venus, he is unquestionably a statue, whose willowy physique in *contrapposto* stance presents so great a contrast with his robust consort as to appear comical – to a present-day viewer at least. The right-hand panel centers about a white marble fountain.[128] Behind the two sculpted images a low lattice marks the edge of the painted gardens whose shallow files of shrubbery screen an unlimited blue distance.

For this ensemble as the major investment of their decorative efforts, the Valentes would seem to have called on a different painter, one specializing in garden megalographies,[129] conceivably more expensive and perhaps more sought after, than the one who supplied those mythological quadri still extant in the rooms adjoining the peristyle. Although color variations and balcony apertures with diverse architectural configurations and depths of perspective illusion give each of these *pinacotheca* rooms a distinct identity, the small *tabellae* mounted within their central *aediculae* seem perfunctory both in conception and in execution, their figures statically posed, lacking any interaction that could dramatize their stories. Through chipping flakes of paint we can make out a confrontation of Apollo and Daphne in which we miss any hint of the god's traditional erotic aggression or the nymph's athletic defense of her virgin identity. Here Apollo sits quietly, or, more precisely, sprawls with a rubbery curvature of the spine. With one hand he steadies his garland while reaching out languidly with the other toward Daphne standing close by him, obliquely turned away from the spectator and pulling her himation tightly beneath chunky buttocks. More compliant it would seem than resistant, she would hardly be recognizable as the fleeing nymph of the story line without the foliage branching from her shoulders. In another two-figure panel showing Atlanta and Meleager, the boar hunt appears to be over; the hero, sprawled like Apollo with a similar rubbery inclination of the torso, gazes straight before him, as if unaware of the presence of Atalanta who in turn stares directly but expressionlessly toward the viewer.[130] What can we make of such weak compositions within so dramatic an ambience? Was the painter working hastily or simply lacking in imagination and talent? Richardson treats the pictures generously by identifying them as early works of a painter who came to have wide currency and whose skills developed in stages over a long career. Furthermore, as he argues, this painter worked without any assistant, executing all the figure work in the rooms that he painted by himself. But in spite of a large output that came ultimately to include the famous Sacrifice of Iphigenia,[131] he remains, in Richardson's classification, a secondary painter.

Dazzling as the decorative program appears in its totality, a close look at its components gives us to see that its overall effectiveness rests more upon framed vistas and brilliant color contrasts than quality of execution, and thus, to estimate its cost correspondingly less than that of the Casa dei Dioscuri or others of its status.

LIMITED FOURTH STYLE ADDITIONS

Among houses whose decoration comprises a mixture of period styles, that of C. Julius Polybius stands out

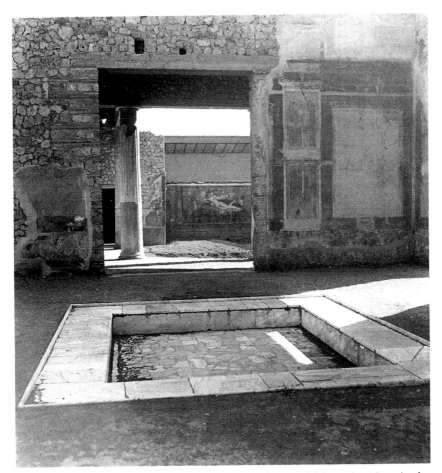

163. Casa della Venere in Conchiglia, vista from atrium. Fototeca Unione, American Academy in Rome, FU 4964/1958.

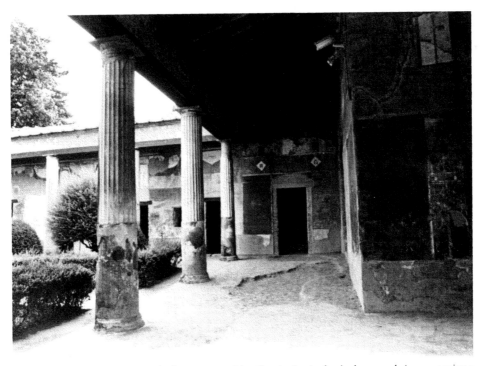

164. Casa della Venere in Conchiglia, entrance side of peristyle. Author's photograph (su concessione del Ministero per i Beni e le Attività Culturali).

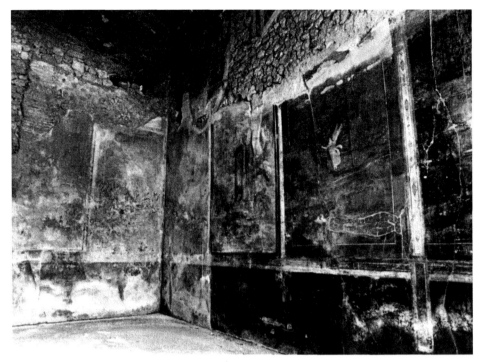

165. House of Polybius, late Third–early Fourth Style. Author's photograph (su concessione del Ministero per i Beni e le Attività Culturali).

for the apparent self-consciousness with which the visual record of its decorative history had been preserved despite at least one certain change of ownership that had brought the venerable residence into a freedman's hands (Figure 14). The preservation effort is obvious in the monumental First Style *vestibulum* with its loggia and simulated doorway (Figure 13) from which a narrowed passage leads into a more spacious atrium with adjoining chambers, where also First Style traces adhere to the walls. In A.D. 79 these spaces had at last been designated for renovation; old painting surfaces in both corridor and vestibule were canceled by the striped zebra pattern with a supply of plastering material standing ready in amphorae against the wall. Some of the smaller chambers surrounding the interior atrium had already been refurbished with Fourth Style tapestry decorations, but others remained unfinished. As if to sustain some kind of stylistic compendium within the decorative program one of these rooms, that standing beside the *vestibulum* passageway, is paneled in the Second Style manner with orthostats and isodomes. Within this enclosure we can see that the painted doorway of the *vestibulum* covers the blocking of an earlier passage. One might expect that the decoration itself would date from this revision, yet certain incongruous details raise suspicion of latter day imitation. A series of large triangular shapes with breccia patterns emblazoned within the dado resembles characteristic Fourth Style marble simulations, while one half

the wall facing the doorway shows a tholos and gateway composition that lacks the customary perspectival background vista.

To the socially interesting question of when Polybius had acquired the house, the decoration gives no clue. Wax tablets attest to his public role in the late fifties and programmata to his magistracy in the sixties, while the preponderance of Third and early Fourth Style decoration might be owing either to his commission or that of a previous owner. The rooms around the peristyle also exhibit a stylistic spectrum indicating a probable two separate redecoration campaigns. Behind the ranks of sturdy Doric columns, stuccoed and painted in white, a simple paratactic alignment of white panels, ornamented only by xenia and landscapes in the frieze zone, captures light within the deep corridors of the *ambulacrum* to expand the expansive appearance of the central space. Inside this enclosure, as Jashemski's explorations have ascertained, was a planting of fruit trees, an almond and a pine.[132] Remains of a ladder suggest that the trees were actively being harvested during the summer. At the northwest corner is a pair of Third Style rooms: the larger of these, a *pinacotheca* with red and black panels highlighted by colorful strips of intarsia, contains in situ the continuous narrative of Antiope and Dirce (Figure 165, Color Plate X); tidy square cuttings in the places where pendent quadri belong suggest that these had been either removed for replacement or

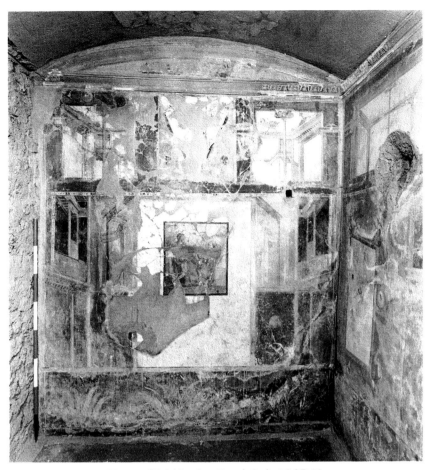

166. House of Polybius, late Fourth Style. ICCD N44535.

salvaged after the eruption.[133] In the narrow space beside this room a Third Style combination of Cyzicene garden decoration combines with a plain gallery wall.

Stylistic attribution is less easy to determine for the elaborate *pinacotheca* room across the peristyle, which configures the architecture of its apertures most singularly by a collocation of disjunctive views, a veritable montage of balconies and pavilions opening both the middle and upper zones of the wall (Figure 166).[134] Even the location of an interior surface plane is scarcely apparent with large central panels in white and red ground screen walls competing for primacy of place. On either side of the panels and in the frieze zone, these are punctured by large apertures in gold, black, and white respectively, each one containing a set of illusionistic scaffolded constructions with a perspective orientation entirely its own. In the gold panels flanking the white central plane, a curvilinear *porticus* swings out into open space; beside it in black is the corner of a roofed *porticus,* while the large white openings in the frieze zone contain angled entablatures on two or even three receding planes. Such discontinuity virtually explodes the spatial

confinement of the small *camera,* but challenges the spectator to discover any manner of visual coherence in its effects. Fine painted detail distinguishes these configurations, however, and the three mythological paintings are all good ones including a unique representation of the goddess Minerva with the serpent-child Erycthoneus.

Apart from these unusual decorations, the one notable for its high quality and the other for its form, no other individual room is outstanding. A large black *camera* at the eastern corner contains only bordered tapestries and scaffolding. The absence of figured panels from its *aediculae* and any manner of motif from the flanking tapestries creates a curiously blank impression of spatial confinement despite the refinement with which its component details are rendered. With an opposite effect the equally large *camera* beside it, similarly decorated with tapestries and scaffolding, dissolves its confines through the transparency of its uniformly white coloring. Here, however, all the framing elements contain small panels including three mythological compositions on familiar subjects (Figure 167): Apollo and Daphne, Eros and Hermaphroditus, and Narcissus. Comparatively

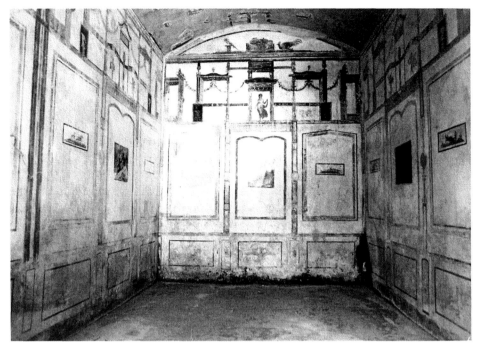

167. House of Polybius, white *pinacotheca*. Author's photograph (su concessione del Ministero per i Beni e le Attività Culturali).

undistinguished as these individual decorations may be, the collective effect of the peristyle decorations is one of great dignity and elegance.

That decoration in the House of Cuspius Pansa had been limited to necessary repairs, and repainting of the *tablinum* seems logical in view of the evidence that this entire house had previously been given a coherent new program, probably in association with a major restructuring of its central spaces, at some time in the years just preceding the earthquake (Figure 168).[135] According to Warsher, who saw it still in a state of good preservation, it was an elegant house with a large number of paintings.[136] The walls of the atrium, now totally faded, were covered by lace-bordered red tapestries with medallion landscapes at their centers. With this typically restrained mode of atrium decoration the complex architectural illusion on the two side walls of the *tablinum* presents a striking contrast. Within a fully articulated, boxlike *aedicula,* the suspended tapestry stands out from the wall. Behind this is a complex apsidal structure composed of balconies on at least three levels. Thus the forward wall appears, as Warsher put it, to be standing at the center of a constructed space.[137] Along with this decoration, the lararium to the right of the entrance is an apparently Flavian addition. It has the form of a small *naiskos* on a podium, which is the kind that Franklin identifies as being a lararium of the imperial house.[138]

Although the initial appearance that the house presents to a visitor entering the atrium on the Via dell'Abbondanza has neither the advantages of spaciousness nor of height, but rather seems somewhat confined, the spatial arrangement of the interior is among the most ingenious in the city. Like the neighboring house of the Epidii, Pansa's house was situated on rising ground to which it had been adapted by terracing, but in this case the adaptation involved acquisition of a contiguous property. Originally occupying a very narrow strip of property on the Via dell'Abbondanza, the first house had extended itself to the back of its insula through the addition of another, and probably somewhat larger house, whose atrium was entered from the Vicolo del Tesmo. The original confines of the two component houses are not easy to determine because their joining at the intersection of their two peristyles was the occasion for considerable renovation of the surrounding rooms. Behind the principal atrium entered from the Via dell'Abbondanza stood a transverse peristyle on a higher level, whose main access was by two broad steps leading up from the open back of the *tablinum*. The peristyle was on two levels, the difference being resolved by the use of a sunken garden plot at the center that allowed the surrounding walls to rise at unequal heights. This lowered area was in fact a nymphaeum featuring a pool and fountain, and its back walls were decorated with garden paintings. At the foot of the peristyle an

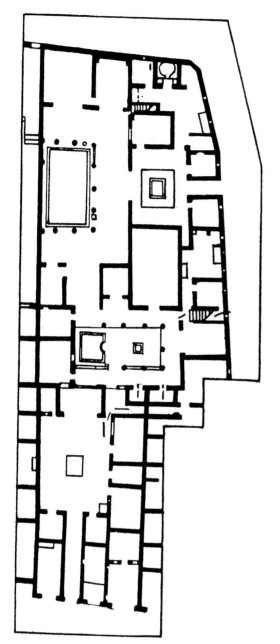

168. House of Cuspius Pansa. Plan after Warsher *Codex* IX.I, no date.

open room facing the fountain afforded a long view down the center of the euripus (Figure 169).

The higher of the two corridors rose as a solid platform terrace on which were situated a pair of decorated rooms, the one a *conclave* of substantial dimensions and the other a much smaller single-entrance room with an antechamber and interior space. With elegant tracery ornaments of vines and fine floral garlands against black grounds to set off its mythological landscape panel, the larger room will have been the showplace of the house.[139] Additionally two small decorated rooms stood

behind the nymphaeum. The wide and fully decorated passageway that joins the two peristyles suggests open communication between them. The walls of the upper peristyle contain First Style decoration, which Mau believed to be, at least partially, a latter-day imitation. Although this area of the added house was presumably in common use, the status of its entrance quarters would not seem to have ranked equally with those of the Via dell'Abbondanza; its small Tuscan atrium includes several surrounding chambers of only modest size, with a complete bakery and bath quarter behind it.

Likewise, the apparent rebuilding of the Casa del Centauro as a serviceable double atrium establishment has resulted in a miscellany of period styles, and new decoration had been restricted to a minimum. Only one *pinacotheca* room in the *viridarium* of the smaller house had been repainted in Fourth Style. An exedra within the ample *viridarium* was endowed with an imitation marble decoration in the First Style manner. This *viridarium* contained marble bases for statues probably plundered after the eruption; also the atrium of the first house held statues and other luxury objects attesting to the owners's prosperity.

By contrast the houses of the two Vedii had preserved only one room of their preearthquake decoration. This father and son configuration comprised two complete houses on slightly different levels located at cross angles spanning their insula (Figure 170).[140] A door broken through the common walls of their contiguous peristyles had connected the two, as Overbeck would have it, ever since the late Republic. Thus conjoined the two spaces bridged both the interior area of their insula and its exterior boundary.[141] The upper portion (7.1.47) was entered from the heavily trafficked Via Stabiana; the other entry (7.1.25) is located on the Vicolo del Lupanare, the less-than-respectable throughway that connected the Via degli Augustali and Via dell'Abbondanza (Figure 157).

Which of the two entries belonged to the distinguished Vedius Siricus and which to his son Nummianus is an interesting question not merely with respect to their differing access routes, but also in view of the differing paces at which their repairs and redecorations had progressed. Both houses had sustained considerable damage and the presence in each atrium of a gleaming marble *impluvium* would seem to indicate a coordinated campaign of repairs, but the work in the upper house was virtually complete, while that in the lower was finished in one room only and in others scarcely begun. The upper house was small with its atrium opening directly into the peristyle. At the rear of the peristyle were a series of vaulted *pinacotheca* rooms with mythological quadri,

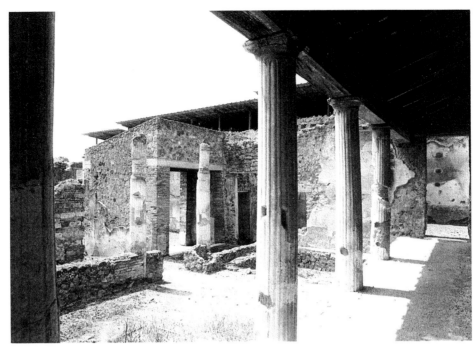

169. House of Cuspius Pansa, peristyle. Author's photograph (su concessione del Ministero per i Beni e le Attività Culturali).

whose decoration, although finished, would appear to have been unremarkable.

Spaces in the lower house were ampler; in addition to a larger atrium with a *tablinum* and adjoining rooms

170. Houses of P. Vedius Siricus and P. Vedius Nummianus, Overbeck 1884, 320, fig. 171.

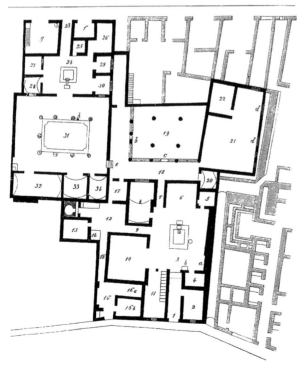

(Figure 171), it possessed a large kitchen and bath suite and a space of uncertain purpose adjoining the peristyle. Two fragments of painted plaster, one small portion of egg and dart and a piece of column shaft still clinging to the rear wall of the atrium attest to its history as a Second Style room but the area, along with the *tablinum,* was now only rough plastered.[142] Others were not yet stripped for preparation. New decorations were probably also accompanied by restructuring. The room at the entrance seems to have had its doorway widened along with the installation of a new central pier support. On one side was a grandiose pinacotheca fully completed in glowing colors with a complex architectural framing of its *aediculae* that scholars have unanimously attributed to the last period (Figure 172). The floor had not yet been laid. The threshold was brick. In the lofty attic that fills the preponderance of space in this high ceilinged room, appears an unusual kind of *scaenae frons* with a central shrine, rich doors and curtains in the interstices.[143] Further within the house is another, partially vaulted room with one window opening on the peristyle that appears to belong to the opulent preearthquake mode. Against its black panels with flying figures, diversely bordered tapestries give variety to the architectural compartments while an architectural scaffolding formed of curvilinear porticoes and projecting pavilions frames the *aedicula* containing the well-known painting based on *Aeneid* 12.411–40, of Venus bringing the herb moly to heal

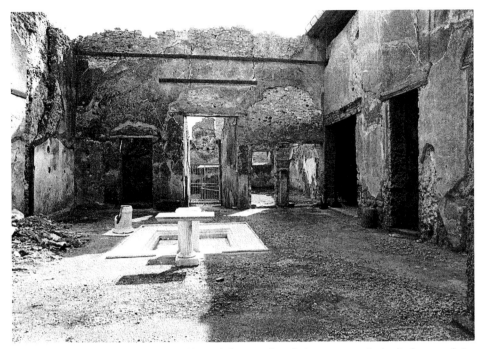

171. House of P. Vedius Nummianus (Siricus), lower atrium facing entrance. Author's photograph (su concessione del Ministero per i Beni e le Attività Culturali).

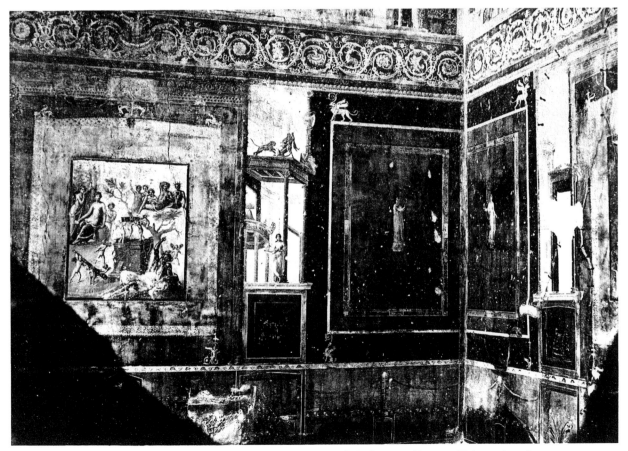

172. House of P. Vedius Nummianus (Siricus), Fourth Style *oecus*. Fototeca Unione, American Academy in Rome, FU 72040F.1961.

Aeneas' battle wound.[144] The cast of characters in this image clearly declares its status as one of few actual text illustrations in extant painting; we see it through the eyes of the reader-narrator to whom the goddess' ministrations are made visible while her intervention seems only miraculous to the hero and his son. A companion panel recorded in two nineteenth-century drawings must also refer to an earlier moment of Book 12. Although its recorded description is "a woman fleeing from an armed warrior," this does not at all fit the action of a person who turns aside raising her hands in a gesture of demurral, while the partially armed figure stands in quiet converse with another female figure wearing a crown.[145] Surely the moment is that preceding the single combat between Aeneas and Turnus when the Latin Queen Amata pleads with her chosen son-in-law, urging him to spare himself this peril while Lavinia her daughter responds with an inscrutable blush (12.54–80). In the background stands a two-wheeled chariot, which will be carrying Turnus under the protection of his sister Juturna around the battlefield until the deferred duel finally takes place. That the Vedii Sirici as Neronian partisans had wanted to display some flattering attention to Roman origins might be reinforced by the choice of pictures in the large *pinacotheca,* which included not only the fairly common Thetis in Vulcan's workshop but also a unique subject: Neptune and Apollo building the walls of Troy.

Fourth Style additions were also represented among the numerous rooms in the agglomerative House of the Popidii.[146] In spite of damage suffered from the earthquake, the house retained ensembles of mythological subjects from several periods located primarily in the variety of rooms, both large and small, that flanked the peristyles. Decorations in the *pinacotheca* format had begun with the owners of the Second Style period in the room housing the large, partially preserved panel that depicts an exhausted Maenad in a wilderness setting approached by a masculine intruder. At the rear of the central peristyle, a cluster of rooms of differing sizes fronts on the open space from which it is all the same screened by partial walls; two *conclavia* positioned within a larger space. The combination of a large *oecus* and a smaller room entered from an antechamber will surely have formed a *diaeta* to which the outer room served an entranceway.[147] Because the complex has direct access to the stables, the likelihood of its being used as a visiting apartment seems good. Commenting on the architectural complexity of this construction, which had greatly transformed earlier spatial demarcations through displacement of the service quarters, Elia assigns it a Claudian date as a part of the comprehensive campaign that had unified the areas of the house. Linking this chronology to the career history of its occupants, she finds its particular motivation for aggrandizement in the new public importance that the elder L. Popidius Secundus had attained by virtue of his role as Neronian *Augustianus.* Amid the abundance of paintings disposed in largely Fourth Style contexts she discovers a particularly self-conscious selectivity concerning both stylistic background and theme. Several compositions, including a "cold and mannered" Judgment of Paris derive from Neoclassic aesthetics. Some subjects correspond with topics that Pliny attributes to named painters: an Iphigenia at Tauris to Timomanthes' original; a Sleeping Maenad to Artemone. The majority of the panels are of large proportions. At the back of the third peristyle the grandest of the galleries contains large-scale representations of Io and Hermes; Bacchus and Ariadne; Iphigenia: a triad clearly representing divine rescues. Their monumentality dominates the enclosure, quite overshadowing the "lively but simple" context of schematic architecture that forms their background. In a smaller room at the center back were three pieces with a distinctly musical theme – Apollo Citharoedus, Pindar and Corinna, and Apollo with Marsyas – suggesting certainly both variations and fortune in taste and skill. Especially the elegant bronze Apollo Citarista distinguished the peristyle. Was it indeed Popidius' uncritical devotion to the performative talents of Nero, his diplomatic intention of publicizing such a devotion, or, as we shall see, a borrowing from his across the street neighbor Epidius that inspired these tributes to artistry as so prominent a theme in the decoration?

Mended Decorations

Mending and patching were the shifts that owners had employed to maintain decoration within a number of houses of each period. No candidate occupies a house similar to the Sallustio and Fauno where the early Republican Masonry Style dominates, although this style may well have been predominant in the House of Epidius Sabinus until severe seismic damage forced redecoration. Surviving remains of heavy plaster cornices both in the atrium and the exedrae opening onto it bear witness to its original state. Here, where repairs were still in progress, damage had clearly necessitated new work. The same does not seem true of the *vestibulum* in the House of Julius Polybius where the presence of amphorae filled with plaster and the application of stripped cancellation paint show that the impressive decorations of the *vestibulum* with their false double door and second-story loggia were slated for replacement.

Along with the facade and entrance area of Suettius' house, these are the most conspicuous survivals of First Style painting; however, a large number of candidates did have First Style rooms or areas in their houses. When these areas were in out of the way places, such as small *cubicula*, their survival might be ascribed to neglect, but that would scarcely seem true in the Casa del Centauro where a double alcove room in strong colors of marble imitation survives beside the entrance as well as First Style in rooms of the *viridarium* (Figure 139). Perhaps this was simply because the walls did not need redecoration, but it seems likely that they were consciously acknowledged as witnesses to the venerable history of the house. It is hard to believe that plaster and paint remained always intact, thus preservation, especially of the venerable First Style, must have cost some effort. One unquestionable instance of restoration appears in the House of Cuspius Pansa where, as Mau argued, one wall of the secondary peristyle had in large part been patched and repainted, thus again suggesting the kind of value assigned to original decorations of this kind.[148]

There can be no doubt concerning the deliberateness of the efforts to patch and mend in the residence of L. Albucius Celsus, aedilician candidate of A.D. 78, where the program of incrustation paintings from the early days of the colony (discussed in Chapter 2) comprises the oldest decorative program in any candidate's house, existing in a close visual harmony with the imposing proportions of the house with its lofty tetrastyle atrium and clustered rooms at the back of the Rhodian peristyle (Figures 26, 39, 40–3). That preference, rather than mere economy, had motivated the retention of these paintings appears likely from the fact that the house had, in years intervening after its construction, been greatly amplified on both sides with virtually no change in the distribution of spaces or decorations at its core where, rather, the efforts to patch damaged plaster are clearly visible. In the unique tetrastyle *oecus* at the rear of the peristyle, a makeshift effort to match new work to the original egg and dart pattern shows clearly because of the difference in painting techniques. While the original forms were molded by shading, the restorer has articulated them only with outline strokes. On the opposite side of the peristyle the desire for preservation had gone so far that the antechamber of a large room retained its paratactic columns and panels while the inner chamber had been redone in a black-ground illusionistic decoration.

Naturally all this effort makes one question why, in other areas of the house, a gradual program of redecoration was in process. It had begun, perhaps, with one small area of the peristyle corridor, a shallow exedra, scarcely more than a niche, that had been refinished in

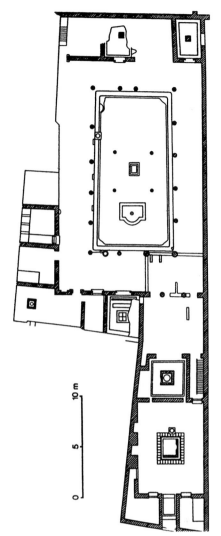

173. House of Pacquius Proculus. Plan after La Rocca, de Vos, and de Vos 1976 210.

Third Style with red panels and landscape vignettes at their centers. In the final analysis, however, the owners had ordered redecoration on a larger scale with the result that *tablinum, alae,* and small rooms off the atrium were given typical tapestry and architecture decorations, paratactic compositions without quadri of a kind to be found in many Pompeian houses.[149] Commonly called early on the basis of their details, these paintings are really of indeterminable date. At some corresponding point the walls of the peristyle were completely repainted and a large *oecus* at its north side was completely stripped of plaster. At the moment of the eruption, the atrium itself had finally been undertaken, but even so, a certain reluctance to change appearances completely would seem to have dictated the painters' visible effort to adapt the new layer of decorations to the basic outlines of the old. Header and stretcher blocks in the upper zone appear

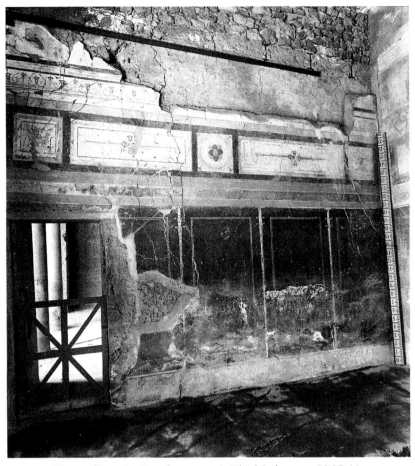

174. House of Pacquius Proculus, paratactic Third Style room. ICCD N34757.

still intact, while the original outlines of the orthostats in the central zone stand out clearly, save that the black panels are now outlined in bright red.

Small survivals of mended Second Style appear within the houses of two other candidates of the period, Paquius Proculus and Trebius Valens. In both cases these are minor examples of paratactic decoration significant primarily as indications that their houses had once seen more extensive decorations in the style.[150] The same appears true for the grain-dealing establishment of Lollius Fuscus where an earlier Second Style had largely been replaced during the period 20 B.C. to A.D. 25 when the horrea were added below and the amenity of an elegantly decorated bath quarter on the upper story beyond the peristyle.[151] At least one of the *pinacothecae* containing large-scale mythological paintings located in a *diaeta* at the rear of the central peristyle in the house belonging to the Popidii is commonly called Second Style.[152]

The majority of houses have Third Style decorations that might be called programmatic insofar as they mark a set of hierarchical distinctions affecting atria and principal areas of the house. Differences in the complexity

of composition and ornamentation among these several programs has caused them to be dated at several points of the Julio Claudian era from early to the edge of the sixties. Little modification was ever applied to the largely paratactic decorations in the House of Paquius Proculus (1.7.1). That the house was originally an old one appears from the remains of dentilated First Style cornices and traces of paneling in a room near the doorway, as well as mended Second Style in a space intervening between the *tablinum* and the peristyle[153]; however, the elegant polychrome mosaics that furnish the keynote of the program were installed during the Augustan period. The showpiece is a large carpet mosaic, imitating a coffered ceiling, that covers the entire floor of the atrium (Figures 158 and 173). The squares that form a continuous pattern are bordered with diamonds to simulate perspective molding; the interior panels contain small animal figures. The majority are in black and white, but a few are colored.[154] Polychrome mosaic figures also in other rooms. That of *oecus* 18 just outside the peristyle entrance has a central panel of theatrical masks set within a guilloche border. Throughout its history there

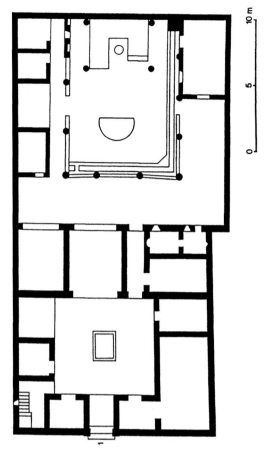

175. House of A. Trebius Valens. Plan after La Rocca, de Vos, and de Vos 1976, 232.

What remains of the frieze zone shows simple scaffolding. Originally a Second Style room, this had sustained much damage so that its frieze zone is patched over in Fourth Style. The extensive peristyle whose spatial dimensions greatly exceed those in the forward quarters of the house, covers space equivalent to any of the small houses in the insula.[155]

The House of A. Trebius Valens (Figure 175) had also seen a major systematizing campaign of Third Style decoration which, like that in the house of Paquius Proculus, was simple and basic, but nonetheless given an appearance of unity by its use of fine intaglio borders on white ground and the repetition of jeweled columns throughout the house.[156] At the time of the eruption its atrium lacked decoration and was coated with rough plaster (Figure 176).[157] Although the interior space of the room was limited, it was surrounded by an ample complement of side chambers. To the right of the entrance is a good-sized *conclave,* the canonical winter *triclinium* decorated in black, that was once entered directly from the atrium but later through an antechamber. It had *aediculae* and probably figured panels on the north and south walls. On the left side of the atrium opens an exedra decorated with a white ground design of panels bordered with leaves and flowers and with animals and birds in central vignettes.[158] A deep white attic zone within the *tablinum* echoes this white area in a manner that gives visual continuity to the two spaces. This *tablinum* was the most complexly decorated area with large *aedicolae* framing two Dionysiac figured paintings, which were thematically complemented by a frieze decoration above the rear window of goats plundering grapevines (Figure 177, Color Plate XI). Red panels flanking these were bordered, while a high attic zone contained simple scaffolded pavilions with suspended garlands and masks.

A large window at the rear of the *tablinum* gave on the peristyle which, like others on this north side of the Via dell'Abbondanza, was situated on higher ground. Here were located both the bath quarter and a number of rooms suitable for seasonal use. At the inner side, and contiguous to the *tablinum,* red and gold panels decorated a moderately sized room. The *aediculae* were empty but the panels themselves were set against black dividers with finely articulated scrolls and filigree borders. The showpiece, which served, as it does still today, to enliven the entire peristyle, was a summer *triclinium* with fixed masonry couches that occupied the entire rear corridor of the colonnade. This was decorated by a black dado with plants, above which a paneled pattern that alternated files of white stretcher blocks with headers in colors of blue, red, porphyry, and yellow filled the entire wall. Drafted margins, shadowed in paint, give

would seem to have been a deliberate effort to maintain simplicity in the wall paintings as a complement to the elegantly mosaiced pavements. A major decorative campaign of the Third Style period had supplied the house with a consistent, although again quite simple program of panels and candelabra. The *tablinum,* framed by fluted pilasters in stucco, has a white background with candelabra and small vignettes. The atrium was in this style as well as the walls of the peristyle and several surrounding spaces intended for hospitality at different seasons of the year (Figure 174).

At one time the house may have been larger since the atrium on the eastern side lacks the traditional doors, having instead niches where their position might be. These were closed with paneled doors of which one casting remains in place. That these may have concealed closets is suggested by the shelf hole in one niche. The western wall opposite was unbroken but, since this was the street wall of the insula, there will never have been any *cubicula* on this side. This wall was unplastered, but elsewhere the atrium decoration consists of red and yellow panels with borders and plants in a black dado.

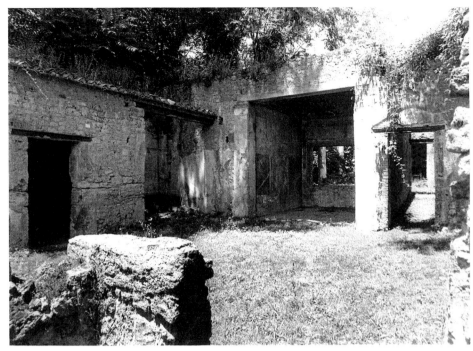

176. House of A. Trebius Valens, atrium. Author's photograph (su concessione del Ministero per i Beni e le Attività Culturali).

the impression that this geometrical design may have been intended to imitate First Style masonry (Figure 178). Nowhere, either in the interior or the peristyle was there space accommodated to large entertainments. The

impression was rather one of frugality than of lavishness. All the same the peristyle boasted a D-shaped fountain that may have served also as a piscina. Maiuri believed that the fountain was not functioning in 79; from this

177. House of A. Trebius Valens, Third Style *tablinum*. Author's photograph (su concessione del Ministero per i Beni e le Attività Culturali).

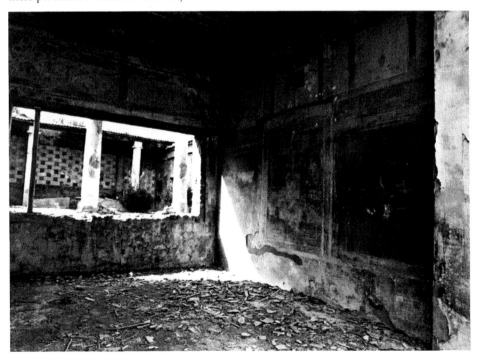

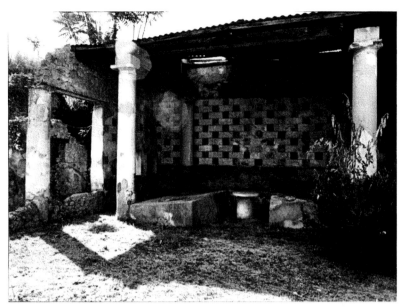

178. House of A. Trebius Valens, fixed garden *triclinium*. Author's photograph (su concessione del Ministero per i Beni e le Attività Culturali).

and from the absence of items for immediate use in certain rooms, Allison has argued that the house itself was not fully functional during the final decade of the city.[159]

INCOMPLETE DECORATIONS

In view of abundant literary attestation to the importance of formal domestic spaces in bolstering political careers, the most surprising revelation is the large number of houses undergoing extensive repairs or renovations either during or after their owner's campaigns for office. Especially this is surprising because the spaces are prominent ones. While the only unfinished room in the Lucretius Valens' Casa della Venere is the large *oecus* facing the peristyle, the majority of redecorations in other houses involve the atrium itself. Two recently active aedilician candidates, L. Albucius Celsus and P. Vedius Nummianus, have atria in a particular state of disarray, the one just beginning a program of redecoration, the other apparently still in the midst of carrying out a long-term program of repair. Additionally the candidate of uncertain status, Trebius Valens, had only rough plaster in the atrium, while Pacquius Proculus was in the process of repairing one atrium wall. Also the prominent C. Julius Polybius had begun the process of replacing the First Style decoration in his vestibulum and inner atrium.

A somewhat different state of renovative disarray characterized the small house of L. Ceius Secundus, who had just completed the Pompeian cursus honorum. Extant decorations show three stages: a coherent

Third Style campaign, attempted repairs of these paintings in the same manner, and a complete set of Fourth Style additions to the peristyle.[160] Because Secundus was a newcomer to the political scene, De Vos suggests that he may even have purchased a house that had been damaged by the earthquake and was in need of repairs. At the least, Secundus may have repaired the house during his candidacy and added the grandiose *venatio* mural to his viridarium after his first political success. At the moment of the eruption, however, he would seem to have been in the process of expanding the house by an upper story. A screen wall in *opus cracticus* still unfinished had been built over the Third Style paintings on the west wall to conceal the stair. This addition of utilitarian space must indeed have been desirable to accommodate the house to social rituals because the ground floor offers scant space for everyday domestic operations, but it had temporarily left one of the major adjoining rooms, that between *viridarium* and atrium, in want of decoration (Figure 179). That storage space was at a premium is indicated by the building of cupboards beneath the atrium stairs. Also a kitchen in a small room off the atrium involved conversion of a space.[161]

How damage might have disrupted the living process can perhaps most readily be perceived in the grand old house on the Via dell'Abbondanza that Epidius Sabinus once shared with his father, Epidius Rufus (Figure 12).[162] Epidius is an Oscan name derived from a divinity of the River Sarno. Epidii were prominent in Campania and the existence of a family cemetery near the Porta Stabiana attests to their presence in the Sabellan city.[163]

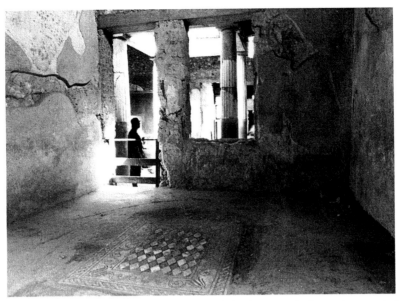

179. House of L. Ceius Secundus, undecorated room behind atrium. Author's photograph (su concessione del Ministero per i Beni e le Attività Culturali).

Thus a history of continuous family habitation seems likely to which long-preserved First Style decorations in the atrium and surrounding rooms will have borne proud witness until the earthquake shook them apart. Repairs unfinished throughout the house show a campaign that was only then in progress with evidence of damage exposed on all sides. Efforts had begun toward refurbishing the atrium and its surrounding members, combining what traces remained of old painting with decorations in a new style.

Grandeur suggests the *dignitas* of early owners. At the height of its glory, this house will have been one of the most elegant in Pompeii. It was one of the few houses distinguished by a *vestibulum*. Set on an embankment that raised it above the sidewalk on the north side of the Via dell'Abbondanza, the facade opens onto a stage-like platform with steps at either end (Figure 180). Entrance was through a double doorway that afforded a second small vestibular space. When the double doors were thrown open to begin the day the scene inside

180. House of Epidius, entrance podium with Corinthian atrium columns. Author's photograph (su concessione del Ministero per i Beni e le Attività Culturali).

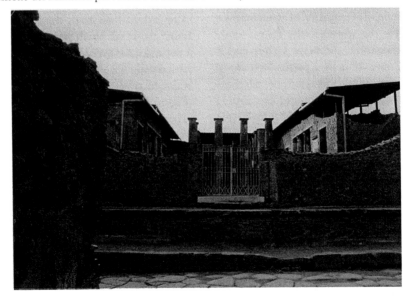

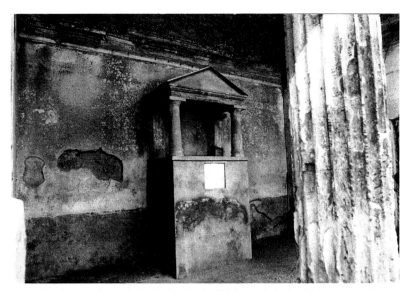

181. House of Epidius, exedra with dedication by the Diadumeni. Author's photograph (su concessione del Ministero per i Beni e le Attività Culturali).

will have been genuinely impressive. With sixteen tall, fluted tufa columns encircling its large *impluvium,* the Corinthian atrium was the largest of its type in Pompeii, but size was only part of the visual effect (Figure 18). The strong verticals of these Doric columns were echoed to the right and left of the *impluvium* by twinned Ionic columns rising, with sharply carved capitals, to an equal height. These marked the entrances of a pair of exedrae. The deeply dentilated cornices that remain within each enclosure show that the original First Style decoration of these spaces will have been preserved as had likewise that of the atrium where traces of heavy cornice molding are still in place. Attached to a lararium in the right-hand exedra is the dedication to the genius of Epidius Rufus, the former master, by two freedmen, the Diadumeni.[164] Its importance is highlighted by its having been the first space to be repainted with illusionistic architecture in a white ground style (Figure 181). Around these exedrae the smaller rooms were in the process of repainting with red and gold panels. The incised outline of a border design without coloration in one room testifies to the ongoing work.

Like many other houses built on irregular terrain, this one adjusted itself by a series of terraces. The atrium and *tablinum* stood on a level. Behind these the ground rose slightly to the walkway and the rise of the garden was another two feet toward an elevated area at the rear where garden rooms will have stood, doubtless a provision for comfortable summer dining. A low retaining wall placed between the walkway and garden separated their levels. Its unfaced rough stone is typical of the inchoate state of repairs throughout the house. The brick columns that

mark the border of the garden are unstuccoed. A piece of old mosaic flooring used for mending shows in the fabric of the retaining wall. Repairs in brick and block mark both the front and back of the *tablinum,* whose interior walls had just been mended without receiving new plaster. Beside it however with a window facing on the garden was a large room found in a surprisingly intact state of decoration with an elegant and harmoniously proportioned version of the *pinacotheca* mode. Centered within its white ground panels, bordered by calyx garlands were a set of three figured panels alternating with iconograpically marked figures of the Muses standing on platforms with backing in the manner of small statues. Within the two facing quadri musicians proclaim their specialities: Apollo Citharoede celebrates his triumph over a (diminutive) python, a second shows an equally self-celebratory Marsyas blowing on his double flute with Olympas as auditor, and the third with Eros supporting a mirror is interpreted as the mime subject of a contest of beauty between Venus and Hesperus. Nor are the Muses distributed at random but chosen with reference to the quadri they accompany with a clear echoing intention.[165] Euterpe, placed close to Marsyas, plays the flute. Terpsichore who, like Apollo, is a lyre player has charmed a small serpent. Urania points to her globe with a proprietary complacency that suggests the superiority of her genuine understanding of celestial matters over "star contests," while Thalia between a faun mask and a comic one and waving a pedum looks with distracted gaze as if uncertain whether she ought to be a pastoral or a comic Muse. Could this indeed be the Thalia of Vergil's Eclogue who sports in the forests?[166]

235

In view of the general condition of the house, one wants to know more precisely the date of this decoration. It would seem unlikely that this one space could have remained undamaged, thus it must have been the first to be repaired. Its calyx garlands look familiar and bespeak the hand of the Vettii painter. Both the theme and location with a prospect of the garden indicate a space for hospitable dining. Although Mau saw these images merely as a declaration of the owner's cultural affinities, Alessandro Gallo gives a much more political interpretation to its subjects perceiving in them a theme of contestation with a bearing on the matter of Epidius' situation as the official actively working with the imperial agent delegated to recover state lands from private possession, yet apparently without losing the approval of his fellow citizens. As he sees it, the rustic Marsyas is appropriate to Epidius' own ancient Sabellan origins, while Venus stands for the colony itself. Thus we see a political tension mediated by the Muses.[167]

In spite of its monumental aspect, the house is not exceptionally spacious; with virtually the totality of its ground floor dedicated to areas of representation, its living quarters will have been on the upstairs floor reached by a staircase at the back of the atrium but a fine prospect overlooking the garden might be imagined from this level.

Comparative Analysis of the Cross-Sections

MONEY, CLASS, AND TASTE This conspectus of decorative survivals in the houses of Pompeian magistrates, along with the efforts made to preserve them through mending, should further reinforce the general principle that redecoration was not the result of a capricious or competitive service to fashion for its own sake, but rather accompanied some manner of architectural restructuring. Naturally what might have been the motivation for restructuring in each and every situation can only be conjectured. For instance, as we saw earlier, on the seaward side of the Villa dei Misteri the division of a large L-shaped room into smaller vaulted spaces had been carried out at the sacrifice of a once-monumental Second Style decoration (Figure 62); this same campaign would seem to have opened the apsidal terrace room whose windows overlooked the sea with a prospect approximating that framed vista of the Stabian Gulf on which Cicero compliments his friend Marius (*Fam.* 7.1.1).[168] Pliny, who frequently mentions the framed shoreline vistas to be seen from his Laurentian villa, takes particular pride in a *triclinium* washed on stormy days by the spray.

One clear example of spatial expansion and amenities financed by a family's increasing prosperity is to be seen in Franklin's tracing the systematic enlargement of the Casa del Marinaio in coordination with the growth of the grain business.[169] In many cases architectural changes may have accompanied change of owner. Elizabeth Rawson commented on the way in which the frequent transfer of properties from one to another Roman aristocrat during the late Republic caused new possessors to want to place a personal stamp on their houses.[170] Damage, however, can never be discounted as a motivating cause at Pompeii. Even without severe shocks, the ongoing strain that a seismic environment placed on walls and support systems bears repeating as a possible cause both for the continuing process of renewal and for the large variety of paintings that characterizes the preearthquake development of the Fourth Style,[171] as well as for the seemingly long-protracted process of postearthquake repairs. What seems paramount is that Pompeian householders did not undertake either restructuring or redecoration on casual whim.

Bringing this principle more specifically to bear upon the lifestyles of candidates themselves may help us to refine Jongman's large-scale observations concerning the absence of direct correlation between wealth and status as based on the prestige rankings of that cross-section of Pompeian society that had witnessed the transactions of Caecilius Jucundus.[172] Despite the fact that these tablets document the previous two decades, and include only a few names associated with the politics of the seventies, their evidence may be considered analogous with that of the final two decades, allowing for certain differences and for the fact that the preearthquake period Jongman discusses will have been more stable than that which followed. Floor space is his index of prosperity, by which measure all of Jucundus' witnesses are relatively comfortable in contrast to their many fellow citizens living in modest quarters. The same is true of our magistrate sampling, yet compounding the evidence of decoration with that of size adds some even surprising ramifications to Jongman's conclusions.

As an overall observation, the evidence for gratuitous remodeling after the earthquake reveals a noticeable difference in the scale of operations between the houses of magistrates who, in general, satisfied themselves with repairing damage, and the houses of wealthy citizens on the Via di Mercurio, engaged primarily in trade, who sponsored extensive decorative campaigns. Mouritsen comments on the manner in which political participation cuts across levels of wealth[173]; his point would seem valid for houses as well. Stereotypical as it may seem, the majority of Pompeian aristocrats observe the very Roman principle of suiting the house to its owner that Cicero articulated in the *de Officiis.*

But to suggest that decurial home owners restricted their expenditures under a given set of conditions, is not *ipso dicto* to equate interior display with gaucherie or social marginality. One must remember that any one of the merchant proprietors might have entered into politics at any time, and conversely that many of the elite owners had commercial enterprises afoot.[174] Furthermore, our speculations concerning nonpolitical persons should allow that their maintenance of business connections across a spectrum of society would motivate a show of prosperity and culture as a means to inspire confidence.

The evidence that Cicero might have found surprising is that which points to merely sporadic coordination between campaigns of decoration and the active conduct of a political career. We have just seen that many persons had either careers in progress or had even gained office while their houses were still undergoing revision or repair. While the new work in Albucius Celsus' house may have anticipated a future move toward the duovirate, it had all the same not been undertaken in time for the aedilician campaign. Epidius Sabinus had gained the duovirate amid conditions of disarray. Insofar as M. Lucretius Fronto might seem to have combined the commemoration of his games with domestic renovations in anticipation of holding quinquennial office, he is one man whose decoration might be considered strategically planned. In general there is remarkably little evidence for such timing and, during the seventies, little evidence for gratuitous redecoration motivated by political causes alone. Even the evidence for restoration so motivated is dubious. Conversely, it might be argued that a candidate's very need for a base of operations at the center of civic activity may have kept some persons from making their houses even more incommodious through large-scale renovation campaigns than any form of seismic damage had already rendered them.

When we consider the possible interrelationship between finances and decoration, we might additionally remember that not all the funds at a political candidate's disposal will have gone into domestic comforts. Expensive gladiatorial contests and *venationes* will often have consumed their share. In this context it seems significant that the ampitheatre was the only one of Pompeii's three public showplaces fully restored.[175] Sabbatini-Tumolesi notes a certain consistency of sponsorship before and after the ban on gladiators.[176] The august politician Cn. Alleius Nigidius Maius makes a strong comeback as *princeps munerariorum* in his capacity of flamen to Vespasian; however, this roster of benefactors did not include the Lucretii, whose original promise of games the earthquake must have aborted. Was it perhaps the money invested in redecoration during the postearthquake years

that held back this politically prominent family from its tradition of sponsoring games? If Zanker is correct in his suggestion that the family of Cuspius Pansa had restored the amphitheater, this public expenditure might account for the unfinished redecoration of their house. Certainly the house belonging to the aristocratic branch of the Popidii who are well-attested as sponsors of games during the decade remained with very incomplete repairs at the time of the eruption.[177] What we do not know is the full number of magistrates who undertook sponsorship, but it seems unlikely that the five benefactors whose announcements of thirteen spectacles from the sixties through 79 remain in place will have provided the populace of an amphitheater city with all the entertainment to which they felt entitled.[178] Rather one may imagine that some of the twenty-six fragmentary *tituli* from which the donors' names are missing might have represented other magistrates.[179] No announcements, for instance, have been found under the name of M. Holconius Priscus, yet a contingent of supporters calling itself "spectacle watchers" posted an endorsement of his duoviral candidacy (*CIL* 7585). Some *munera* include *venationes* as well as combats. Around A.D. 59 Cn. Alleius Nigidius Maius had dedicated his *opus tabularium* with a grand festivity including a procession, a *venatio*, athletes, and *sparsiones*.[180] In all likelihood these *tabellae* comprised that series of megalographies that adorned the parapet of the amphitheater.[181] If we take beast megalographies as a possible indication of sponsorship, then the modest condition of Ceius Secundus' house might seem to be offset by generous games. Of all the houses boasting these amphitheater scenes, his is the smallest with the smallest area oriented toward viewing the spectacle. One may compare the Casa della Caccia Antiqua, complete with its Vespasianic decorations, or the very large Casa del Centenario belonging to the duovir of the sixties A. Rustius Verus, whose amphitheater spectacles are well advertised, and doubtless commemorated within the ambience of his *triclinium cum piscina*.

Discounting, however, the differences in wealth among house owners, the demographic spectrum shows little perceptible differentiation of taste. Tapestries, gilded ornaments and balcony apertures are ubiquitous, regardless of the quality of their execution, but more than one workshop was skillful in rendering exquisitely fine detail.[182] Although new decorations are rarer among the decurial class, when they do occur as in the grand oecus of the lower house of the Vedii, their components are no less colorful and complex. When it comes to a penchant for mythological pictures, the Nigidii, the Popidii, the Vedii, the Lucretii, and the Vettii of both social classes are altogether similar, even if, as with ornamental

motifs, differences in the quality of rendition may reflect differences of expenditure. If I am right in formulating the principle that paratactic compositions were considered more appropriate than mythological panels for the decoration of atrium walls, then both L. Cornelius Primogenes and the owner of the House of the Tragic Poet violate the decorum,[183] but the commercially based Nigidii observe it along with the decurial Lucretii Valentes, Cuspius Pansa, and Pacquius Proculus.

So far as our commonly invoked paradigm for evaluation of Roman taste is concerned, it is one of the regrettable circumstances prejudicing cultural history that our major portrait of a freedman, Trimalchio, is presented through the eyes of the unreliable narrator Encolpius, and even more regrettable that the portrait contains parodic elements directed as much at Nero's foibles as at those of the freedman class.[184] While Trimalchio's manners and material culture may be imitative, this is scarcely a way of life peculiar to freedmen, but only the freedman's version of the large-scale practice of imitation that pervaded Roman society as a whole.[185] So, if Trimalchio does scramble the names and deeds of mythological personalities, his mistakes do not vitiate the demonstration he offers of the importance that mythology had in everyday culture. The commonplace linkage between taste and class that has categorized the social interpretation of paintings is a misleading guide to Pompeii. Just as differences in social background could be minimized by participation in the *ordo decurionis,* so the decorative codes guiding the choice of status programs encompassed the broad spectrum of prosperous society.[186]

Within the more general frame of reference that I suggested in Chapter 5, the kind of painting developed by Pompeian workshops of the fifties and sixties corresponds with the dissemination of material luxury in private furnishings that we find reflected – sometimes censoriously, sometimes benignly – by virtually all writers of the empire. The Roman discourse of luxury always harbors a tension between the ethic regulating individual display and the social factors that encourage it. Through its capacity for representation that approximates luxury, Pompeian decoration participates in this discourse with a positive, affirmative stance, no matter whether it fabricates jeweled columns or fine marble inlay or open vistas of pavilions extending a mastery of space. If postearthquake decoration shows any common tendency, it is toward an intensification of grandeur, as displayed in the *tablinum* of the Casa dei Dioscuri. Spatial openings and substantial architecture over which large tapestries are floated are the hallmarks of the style. The free imaginations of the painters produce endless variations. Hélène Eristov compares these combinations

with the bricolage of the Levi-Straussian mythmaker working with odds and ends of cultural material.[187] Although exact sources for the "odds and ends" of Pompeian ornamentation may elude precise identification, their more general point of reference within the contemporary valuation of material culture is clear. The motivation behind such display, as I have suggested is confidence, whether the confidence of the successful Republican aristocrat at Rome, the municipal benefactor, or the rich merchant trusting in a favorable climate for his enterprise.

STYLE AND IDEOLOGY Whereas the assessment of taste across classes is primarily a synchronic question, the period focus of our investigation invites consideration of another often-debated question involving the influence of political ideology on thematic choices and compositional styles. Although opinion on this subject has changed from the time when Pompeii was regarded as the mere recipient of Roman artistic trends to the effect that the city is now given credit for considerable autonomy of tradition and invention,[188] this has not banished the idea of a Neronian influence on the development of the Fourth Style in Pompeii, an influence often said to be "theatrical" in its analogy with the *scaenae frons* decorations of the Domus Aurea,[189] nor has the genuine difficulty of distinguishing between one and another chronological variation of the style given rest to the often debated question whether a Neronian baroque and a Flavian classicism are appropriate terms for the succession of styles.[190] Given that persons of documented Neronian and Flavian loyalties are included among our small sample of candidates from the seventies, one can conveniently test the ideological question within the context of their decorations. Does any apparent conformity of style and decoration unite the decurial supporters of Nero or does any difference set their domestic programs apart from those of the new Flavian group? As background we might consider that Nero's image and reputation underwent three crises at Pompeii, the first when gladiatorial exhibitions were banned in consequence of the amphitheater riot, the second in consequence of the need for federal funding after the earthquake, and the third, of course, the *damnatio memoriae* that followed on his death. In the face of the first two crises, Franklin has shown us that the Neronians were a group whose members supported each other and entertained imperial visitors, some of them also holding distinctions granted by the emperor. On the basis of a graffito in the House of Polybius, he proposes that Nero had even made a cameo appearance in the city after the earthquake to visit the cult image of Venus

bringing with him a substantial donation in gold.[191] Furthermore, in spite of Poppaea Sabina's family connections with the city and the existence of one Neronian faction called "Neropoppaenses," the death of the empress had apparently no serious effect on political loyalties at Pompeii, nor did the emperor's own discredidation damage careers.[192] Although members of the group understandably ceased to advertise their connection following the *damnatio,* the individuals carried their credentials and their connections over into the Flavian period. This would suggest that Pompeii as a *municipium* had the best of both worlds, enjoying under the most favorable circumstances the benefits of imperial association, but nonetheless possessing the autonomy to preserve political integrity without serious distortion amid upheaval at Rome. The point earlier made about the persistence of the atrium in company with the institution of clientship at Pompeii may apply on a larger scale to the politics of the city.

When specifically we compare the decorative programs in the houses of the most conspicuous Neronians – the Popidii, the Vedii, Lucretius Satrius, and Pacquius Proculus – there is little evidence for the deliberate adoption of any identifiably "Neronian" style in decorations before or after the earthquake. Rather the decorations of Pacquius are pre-Neronian; the Popidii, whose close attachment to Nero's public theatrical demonstrations might make them the most likely candidates for imperial imitation, had portraits in a Julio-Claudian mode, but decorations representing a wide range of periods. While the predominance of Apollo might also stand as a gesture toward the emperor, this is thematic, not stylistic, and the overriding concern of their decorative rational would appear to be a demonstration of cultural sophistication through eclectic selectivity. What survives of preearthquake luxury in the House of Vedius Siricus is shared with the aristocratic Aulii Vettii, M. Lucretius Fronto, and Cuspius Pansa, who have no documented Neronian connections, but also with the financier Jucundus of freedman descent. Such luxury carries the apparent license of translating motifs from the public into the private sphere. In the *tablinum* of the Casa dei Dioscuri, and in two other rooms as well, metallic friezes of heraldic griffins with lyres, cantheri, and other motifs appear above the entablatures or as cornice borders. Similar bordering figures are also to be seen in the ceilings of the Domus Aurea, yet even there the motifs are not innovative but have been common in the iconography of imperial sculpture since the time of Augustus, and before that appeared in aristocratic Republican houses. They are no less Flavian than Julio-Claudian. Although they would seem to be-

long to the decorum of the public world, their sponsors here, the Nigidii, who are bronze merchants, have public profiles only as the donors of their products to the public baths. Perhaps for them the significance of these metallic trimmings lay in the fact that they can be crafted from bronze. If we seek explicitly "theatrical" decorations in the form of the *scaenae frons,* the primary examples appear in the houses of the jeweler Cerealis whose politics were those of a local *rogator,* and Herennuleius Communis, most likely a freedman engaged in business, whose political allegiances are not documented. As I have already argued in my third chapter, the mentality best exemplified by their specific point of reference is the widespread and long-standing inclination toward theatricality in Roman culture.

In the case of the "reformed" Neronians, the Vedii and Lucretius Satrius Valens, the application of redecorations in a commonly distributed new style only goes to confirm the obvious point of the stylistic historians that the final Pompeian style is a Flavian style no matter what might be its patrons' attitudes toward the emperor. The shell-borne Venus in Satrius' peristyle is far more likely to show ideological adherence to the "Colonia Veneria" than to the "ancestress of Rome." By claiming possession of the goddess's origins in this manner, the patron constructs his house as a source of benevolence to radiate into the colony. A similar rationale might also explain the *Aeneid* 12 paintings in the House of Siricus, an almost unique example of genuinely illustrative painting in Pompeii.[193] If any significance attaches to the choice of Venus in this context, it might be the merging of Venus, Pompeii's patron goddess, with Roman high-literary culture. Thus I would again suggest that the chief factors dictating Pompeian decoration are as much economic as ideological, determined by a balance between understood decorum and funding.

Economic considerations also include the sharing of decorative workers, either the teams that applied contextual backgrounds or, in the case of *pinacothecae* with major figurative quadri, the putative specialists whom scholars are currently calling *pictores imaginarii.* In the first instance this distribution does not seem to follow any network of cross-town political affiliations but rather patterns of regional employment with only slight exceptions. According to Bastet and De Vos one and the same Third Style decorators of the middle period worked in the Casa del Centauro and the House of Cuspius Pansa.[194] There is little other evidence for work by the same teams in candidates' houses and this absence is interesting in contrast to such clearly visible marks of sharing on small neighborhood circuits as the cornice ornamentation of the black Third Style *triclinia* in the

House of Trebius Valens and the Casa del Frutteto or the architecturally elaborate compositions to be seen in the *tablinum* of the Dioscuri and garden *oeci* of the Casa di Adone Ferito and the Casa del Naviglio, although it has been argued that the circuit of these painters was a fairly extensive one determined primarily by its comissioners' wealth.[195]

Initially these conclusions might seem negative, especially if the reader expects different answers. Logically speaking there ought to be evidence for similar decorative preferences among persons of like allegiance or opinion. But let us consider this distribution of painting teams in terms of a spatiopolitical anthropology that gives two models for the cohesion of groups with common interests; the one taking its identity from regional proximity and the other creating an identity across regional divisions by conceptual means.[196] In Pompeii the cross-regional (or "transspatial") model operates among members of the decurial class with respect both to alliances and to the posting of programmata. By shared publicity, as Franklin points out, candidates supported each other among their neighborhood constituencies, and also, as pairs, they sought exposure on such busy streets as the Via dell'Abbondanza.[197] Their decorative affiliations, however, are primarily regional so as to suggest a kind of neighborhood bonding. Additionally the circulation of painters within neighborhoods enforces both the concept of municipal autonomy in the development of domestic decoration and the notion of its economic basis.[198]

Naturally the circulation of the *pictores imaginarii* is a different matter that extends beyond the circumscription of neighborhoods. Richardson claims that "the atribution of pictures from the Campanian cities to particular artists has great potential for understanding both the organization and the economics of the decorating industry in antiquity."[199] Recent excavations in the Via dell'Abbondanza of a *pinacotheca* whose decorations were interrupted in progress provide new insights into the relationships between the painters of central quadri and those who executed other parts of the decorative ensemble. Antonio Varone has brought out the great rapidity with which painters will have worked and also suggested that the *pictores imaginarii* did not routinely come to give a finishing touch to an otherwise completed composition but might enter at any point during its progress.[200] This observation is not out of keeping with Richardson's demonstration based on the Casa dei Dioscuri paintings that individual painters of the final period can be distinguished by their stylistic idiosyncrasies from which he concludes that these artists were specialists sought after for their known skills.

Where large *tabellae* are involved, both the scale and quality of painting are overtly related to the possession of wealth. I have earlier mentioned the perfunctory execution of the small mythological quadri in the house of the Lucretii Valentes, which Richardson explains as the early productions of a painter who became better with continuing employment.[201] If we accept his identification of this painter's work in the *pinacothecae* of this house with the quadri of the Casa del Menandro, we would see one painter working for two Neronian supporters. Was he, in fact, a painter for owners of only moderate prosperity? If so, was the other artist to whom Richardson attributes both the Venus megalography here and the panoramic peristyle painting of Venus and Adonis a more expensive artist or simply a specialist in large-scale garden decorations or both? If we follow Richardson's tracking of the most notable large panel painters from the Dioscuri around Pompeii, we find them shared with the owners of other large-scale houses.[202] The finest of all Pompeian painters for his ability to adopt his compositions in scale and atmosphere to the room in which he was working" is, in his opinion, the "Achilles painter" who executed the monumental compositions of the grand *tablinum*, worked also for the Popidii at the Casa del Citarista, and additionally completed three large panels in the very lavishly decorated House of M. Lucretius, whose final owner is unknown.[203] The Meleager painter who supplied the Nigidii with an Endymion, and probably also a Narcissus, now lost, in a room off the atrium, was the author of virtually the entire mythological decoration of the neighboring Cornelius Primogenes' house.[204] Characteristics of the "Dioscuri Painter" who created the large subject paintings in the peristyle of that house mark all three panels of the Vettii gold room.[205] Working also for the Popidii, he supplied one large painting of Io, Argus, and Mercury. His oeuvre also comprehends virtually all the large-scale divinities.[206] The Io Painter, named for his work in the Ekklesiasterion of the Temple of Isis, executed only small commissions within the Dioscuri, but was otherwise an active worker who supplied the mythological gallery of the Macellum.[207] His affiliation with the Dioscuri painter might be partially confirmed by the fact that their Argus and Io paintings are the only two that include the Ovidian detail of Mercury's exhibiting his Syrinx pipe, whose aetiological narrative will soon after bore the vigilant guardian into a neglectful and fatal slumber.

From the general absence of large-scale redecorated *pinacothecae* in known magistrates' houses, it follows unsurprisingly that these owners, with the exception of the Popidii and perhaps the Vedii, had not employed the Dioscuri painters,[208] but I myself want to propose

one other monumental painter who would seem to have executed limited commissions among the more prosperous patrons. The heroic male *contrapposto* figure of Theseus Victor in Balbus' building at Herculaneum that aroused such great admiration among early excavators has a close counterpart in the Mercury of the Ixion painting in the Vettii Red Room.[209] In the pendant Daedalus and Pasiphae, the figure of the craftsman in the equivalent posture, although clad in a workman's exomis and turned with his back to the spectator, shows the same elegant proportions and solid musculature. He is, in fact, far too youthful and masculine a figure for the nonheroic Daedalus. A similarly statuelike *contrapposto* figure seen obliquely is the heroic Hercules of the Nessus and Deianira scene in the *tablinum* of the Casa del Centauro, whose pendant Atalanta would appear to have been painted by the same hand. Although nothing else within the house is on the plane of this showplace, these decurial Vettii clearly found it worthwhile in their redecoration to call on a painter of real consequence. But also this painter's characteristic feminine face, with a long, straight nose; chiseled brow; and the "melon-frisur" of the late Julio-Claudian period characterizes the floating Venus at the center of D. Lucretius Satrius Valens' garden paintings. Adding to this painter's circuit that of the Io painter from the Dioscuri to the Isis Temple and the Macellum that Richardson identifies,[210] we have interesting evidence for sharing of painters between the houses of private citizens and public buildings where repairs would seem to have followed the earthquake. For the continuation of my demographical investigation, I now turn to a few of these public places, raising the question whether the status of the persons who frequented them might influence the status level of their decoration.

HIERARCHY AND ENVIRONMENT

Because many buildings of the public sphere had suffered even greater damage than the private, the problem of redecoration there was more extensive.[211] Thus Pompeii offers a unique opportunity for the observation of simultaneous works in progress on public buildings, while the variety of such buildings allows decorative practices to be traced across a broad spectrum of social usage. The most cursory overview bears out the general principle that the decoration of buildings for public use observes the same code of spatial signification as that which we find in the private world. Corridors and other areas intended for passage make use of a paratactic organization, whereas those areas for stationary activity to which a higher degree of importance can be assigned utilize more complex schemes along with such elements as figured *tabellae* inviting prolonged scrutiny.[212] We saw evidence of this visual distinction in the Third Style period when, for instance, the interior corridors of the Eumachia building are decorated with paratactic bordered panels of a sort very common in their period.[213] With allowance for period variation, the same principle applies in the Stabian Baths where red and yellow panels segment the corridor of the *ambulacrum* in the same manner as those of a domestic peristyle. As we shall see the application of spatial decorum is particularly clear in the fully preserved program of the Temple of Isis where the corridors behind the porticoes are painted with tapestries and small landscape vignettes, and a large room that is certainly for banqueting combines mythological panels with window landscapes showing Isaic shrines (Figure 182). But an interesting variation appears in the Fourth Style Macellum where the corridor at the front of the building adopts the *pinacotheca* mode combining framed mythological paintings with bordered panels and theatrical apertures in a paratactic succession (Figure 183), prompting one scholar to hypothezise that the choice of subjects addressed a particular message to the populace.[214]

The translation of such signifying hierarchies into the public world provokes further questions as to how the level of the decoration might be related to the status level of the users. Such considerations reverse the traditional mode of interpreting decoration as a statement reflecting the preferences of its commissioner in order to take account of the expectations that commissioner or painter sets out to fulfill. No simple answer can be given. While experiences of a profoundly ceremonial nature were signaled by a degree of opulence in the decoration, it belongs to the theatricality of euergetism to raise the experience of the users above their customary level. Marble temples embodied this principle, but its migration into the quotidian world is nowhere more conspicuously embodied than in the appointments of Roman imperial baths with their acres of colored marble. Perhaps because of their direct involvement of the body and its welfare, baths seem always to create a familiar interassociation between patron and user. "No emperor worse than Nero; no baths superior to Nero's baths." Thus we might ask what particular point Statius emphasizes when he declares, in praising the baths of Claudius Etruscus, that there is no plebeian element in their decoration (*Silvae* 1.5.47). Does the significance of this remark pertain to Etruscus' own application of taste at a level of high gentility, or are the bathers themselves the intended beneficiaries of a socially elevated experience? Perhaps the point is specifically political; in as much as the varieties of marble emanating from imperial

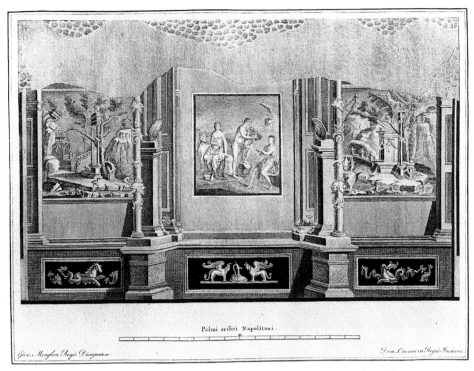

182. Temple of Isis, Ekklesiasteron, wall with Argus and Io. Drawing from Elia, 1941.

quarries may well indicate Etruscus' favored status with the emperor. With a variety of bathing establishments of diverse dates and degrees of elegance in decoration ranging from stucco to colored marble, Pompeii also raises questions concerning patronage and constituency.

In the previous sections of this chapter, I argued that the imitation of costly materials in painting participates in the cultural discourse of luxury with a signifying function comparable to that of their originals. On this same premise it is worth considering a few gathering places that, if not universally public, were accessible to one or another cross-segment of the populace. These buildings can be seen in two categories. The first includes prominently placed civic structures whose plans may obey generic traditions and whose decoration can be considered pertinent to the specific purposes of use. Among such places with Fourth Style decorations or repairs are the Eumachia Building, the Temple of Isis, the Macellum, and the most recent of Pompeii's public bathing facilities. To be observed in the second category are several kinds of establishment whose operations depend on their ability to attract a clientele which may, in some cases, be a function of neighborhood, but in other cases might involve rivalry. Such establishments include trade places such as fullonicae and taverns, as well as more specialized businesses of manufacturing and selling jewelry and garum. In these a wide range of style may be seen with occasional touches of elegance. Because many

establishments in this second category have their seats in renovated buildings where the more elegant decorations might be attributed to a previous functional identity, we must use caution in assessing the status value of their decorations, yet they are scarcely to be discounted; the conditions of reemployment involve often some recognition and respect for a preexisting decorum.

Conspicuous Donations

The Eumachia building and the Temple of Isis are two places of relatively public access that saw extensive restoration after the earthquake. In the first case the work was still in process while the other, as witnessed by epigraphical documentation, was complete. Although no certain date is attached to the work of the Temple, it is generally assumed that it was carried out soon after the cataclysm. Perhaps the private funding involved had permitted this space of a specialized nature to outstrip in restoration such areas of municipal responsibility as the basilica and the Temple of Venus. The materials, however, employed were an inexpensive combination of local tufa and stucco covering with terra-cotta ornaments. These materials were consistent with the original masonry fabric of the temple.[215]

By contrast the still unfinished Eumachia building was intended to display marble finishing in lavish abundance as a replacement for much earlier work in tufa and

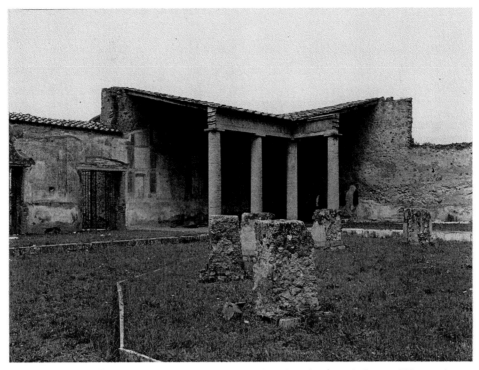

183. Macellum, wall under portico. Fototeca Unione, American Academy in Rome. FU 11663/1966.

paint.[216] It is probably fair to consider it on the way to becoming the most opulent building in Pompeii. One feature surviving from Augustan date, the meticulously articulated acanthus scrolls in its carved door frame, has been often compared with the Ara Pacis in craftsmanship as well as in thematic symbolism.[217] This detailed work formed part of a porch called a Chalcidicum that preempted the area of the sidewalk fronting on the Forum as its exclusive vestibulum. Facing this space, the building facade, exhibiting various statuary of Augustan associations, was, at least in its final incarnation, totally revetted in colored marbles. Although the damage to the interior *porticus* in 79 was extensive, surviving traces of decorative architecture and materials indicate a high level of luxury.

Of the interior wall decoration there survive sufficient identifiably Third Style traces at the back of the building to indicate that this had observed the usual hierarchy of spaces. Paratactic decorations on the stairway leading up from the Via dell'Abbondanza involve bordered panels and candelabra. As de Vos would have it, the form of a twisted ring candelabra that will ultimately become very common occurs for the first time in a corner of the decoration.[218] Referring primarily to the records of Mazois and others, de Vos makes a distinction between areas with paratactic and symmetrical ordering of panels. The symmetrical arrangement occurs in the cryptoporticus which has at its rear the apsidal

area and podium where Eumachia's own statue is positioned. But the level of luxury here is modest and the figured designs are not full-scale quadri but only motifs on bordered panels (Figure 99). That the renewed decoration of other interior portions maintained a similar decorum would be inferred by Dobbins' arguments that the two crypts at the rear had painted plaster in place above marble dados at the time of the eruption.[219]

In contrast the high-status area of the interior courtyard with its exedra boasted marble decorations to match the veneering of the exterior *porticus*. Corinthian columns of white Luna set on a marble sheathed stylobate formed the colonnade (Figure 184). Traces of settings for marble indicate that the eastern wall behind the colonnade was also marble clad.[220] One structural change that had been made in keeping with period stylistics was the alteration of the apsidal niche at the interior rear of the *porticus* from square to hemicyclical. This recess, which was intended for complete marble veneering, held statues of Concordia and Pietas relevant to Eumachia's gesture in imitation of the empress Livia and her son Tiberius.[221]

Given the length of time intervening since the establishment of the building, it seems most likely that its restoration was not in the hands of its original creators, but the pretensions of the new program conformed to those of the old. In its initial construction the building of the edifice must have constituted a major self-assertive

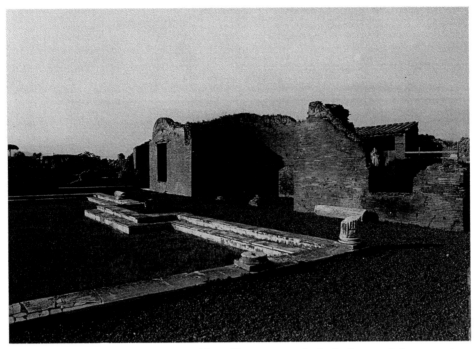

184. Eumachia building, interior space with marble revetment. Author's photograph (su concessione del Ministero per i Beni e le Attività Culturali).

gesture on the part of a primary citizen, and the magnificent rebuilding indicates a high valuation in contemporary civic affairs. All the same the purpose of the structure remains still undetermined, and even the position of the part named Chalcidicum remains vague in spite of Vitruvius' treating them as an optional feature of basilicas. Within the interior colonnade there is no trace of compartments or divisions such as would have suited an establishment continuously dedicated to commerce. It is now generally agreed that the dedication of Eumachia's statue by a group of fullers does not prove that the building was used exclusively, as Mau and Moeller had influentially hypothesized, for the cloth business.[222] Rather than its being fashioned for the requirements of a single specific clientage, Richardson proposes that it served many purposes, including simply "a place to walk and talk and stroll."[223] Manifestly this building is of the type intended to elevate the experience level of the users; paradoxically the aim of sustaining and even surpassing its former elegance stood in the way of its being used at all.

A very different social class and familial situation underlies the restoration of the damaged Temple of Isis (Figure 185). Over the entrance door in the precinct wall is an inscription that testifies to private sponsorship of an unusual kind:

Numerius Popidius Celsinus, son of Numerius restored the Temple of Isis, after its collapse from earthquake from its foundation by means of his personal funds. On account of this generosity, the decurions adlected him with thanks into their order, although he was six years old.

Taken at its face value, this history would appear as one of the best examples of social mobility in Pompeii, indeed in the Roman world, with the influence of a freedman father, N. Popidius Ampliatus, to be understood indirectly from the dedicatory inscription on the grounds that his son, as the alleged donor, could scarcely have been expected to oversee a commission at age six. Stefania Muscettola suggests that the involvement of Ampliatus in the affairs of Isis did not begin ex novo with this restoration because the dedication of a statue of Dionysus within the precinct attests to an earlier association.[224] Furthermore, the names of the entire small family – father, mother, and brother – are recorded in mosaic in the pavement of the Ekklesiasterion.[225]

Aside from the fictions of sponsorship, this enterprise in restoration might also seem remarkable for the apparent speed with which it was carried out,[226] but a recent detailed study of the temple points to another element of fiction in the claim to a complete rebuilding (*restituit a fundamento*). Having discovered a double layering of stucco on the walls of the cella and on the carved tufa capitals, Nicole Blanc and Eristov now argue that the temple building, and likewise the purgatorium, had not been destroyed but remained standing, so that

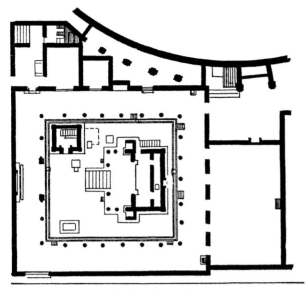

185. Temple of Isis. Plan after Mau, 1904.

restoration in these areas was merely a matter of moderate repairs and reapplication of wall coverings.[227] But the claim *a fundamento* was accurate for the *porticus,* reerected on an earlier stylobate, where the paintings offer an important index of postearthquake styles and motifs.

That the Temple of Isis was considered a municipal institution is attested not only by the status grant made to young Popidius, but also by the herm of Norbanus Sorex for which space had been granted by the decuriate.[228] Norbanus, whose portrait appears to date from the Augustan period, may have been a friend of Sulla, he was an actor who played the second role and the *magister* of a suburban district.[229] According to Blanc and Eristov's new data, the temple itself has its origins in the Augustan period and postdated the outer wall of the theatre, whose curvature determines its own spatial conformation. This dating would bring it within that sphere of Augustan tolerance that sanctioned the operations of the *Iseum Campestre* at Rome. In subsequent years the political alignment of the Temple might seem even stronger. That Isaic priests as a group interested themselves in the political affairs of the town is attested by their endorsement of two aedilician candidates of A.D. 77, C. Cuspius Pansa and Helvius Sabinus.[230] As Muscettola has suggested on the basis of the interweaving of Flavian imperial imagery with that of the cult itself, the choice of this particular temple for restoration might be regarded as a political project astutely motivated by awareness of Vespasians's respect for Egyptian cults and the association of Isis with his victories.[231]

A politics of municipal integration can be seen to characterize the choice of building materials both for the original instantiation and for the restoration work. Mak-

ing no pretension to the luxury of the Eumachia building or the Temple of M. Tullius, two contemporaneous Augustan foundations, the complex is built of commonplace materials: local stone, concrete, and brick, relying on its decoration in paint and stucco relief for its rich appearance. Such choices actually diverge from the custom of building foreign cult places of exotic stone, in the case of Isis either of basalt or granite that would be symbolically Egyptian whatever might have been their actual provenance.[232] Is this simply a matter of small-town economy, or is there a decorum adapted to the level of the patrons or the stature of the cult itself? One may safely speculate that the decoration of the temple in as opulent a manner as decorum permitted intentionally addressed a cross-section of the citizenry, not merely the initiated devotees of the cult but also a variety of persons, some of higher rank, who might be guests of the temple or its benefactors.

Notable in this is the combination of the exotic and the familiar. The cult had its drawing power in the sense of the exotic and its foreignness was by no means concealed. It was evident in the architecture which, although not taking the traditional form of the Isaic temple, is all the same with its peculiar shape of shallow facade on a high podium with projecting wings for chapels different from the standard Greco-Roman form. The stucco ornamentation of the temple building and painted decoration of the precinct have been conceived as an apparent unity with painters and stuccateurs working in probable cooperation. The acanthus frieze of the building is echoed by that in the colorful colonnade, while the patterns on the stucco facades are similar to the designs of candelabra and garlands in the apertures of the painting. One cannot tell which came first. As Croisille has proposed, the various genres of landscape incorporated into every part of the decorative program combined symbols belonging to the cult and its devotees with common images of the period.[233]

Aside from the closed rooms near the theatre reserved as the priests' own quarters, two major spatial divisions make up the temple precinct. The first of these is the deep *porticus* that surrounds three sides of the interior; the other comprises two chambers at the rear of the *porticus* which are decorated in very different styles, the grander of the two being the Ekklesiasterion, without question the ceremonial banqueting space of the temple. Compositions in both spaces observe the general decorum of accommodation to usage with paratactic designs in the corridors and a symmetrically ordered *pinacotheca* in the room at the rear. Between these, however, there pertains a certain balance of distribution, which is to say that the ornamentation of the *pinacotheca* is relatively

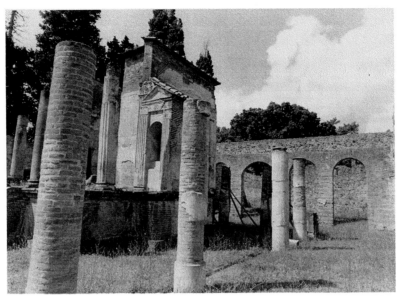

186. Temple of Isis, corridor and entrance into the Ekklasiasteron. Author's photograph (su concessione del Ministero per i Beni e le Attività Culturali).

spare with its major interest concentrated on the paintings themselves, whereas the multiple components of the corridor decoration offer many single details to capture the attention of the person passing through. The variable elements are of two kinds. At the centers of the garlanded red panels that fill the middle zone we see a serial alternation of figures and vignettes. Highlighting the strangeness of the cult, the figures are linen-garbed officials of the temple holding their ceremonial instruments, even to a priest wearing the dog mask of Anubis. The vignettes comprise exotic shrine landscapes of an Egyptian cast in alternation with sacro-idyllic landscapes of the familiar crossroads variety. As Croisille has suggested, this alternation may be understood as an effort to normalize the foreign cult within the milieu of Roman culture.[234] The same might be said for the colorful attic zone in which the typical pattern of a scrolled acanthus frieze is playfully enlivened by a great variety of animals most improbably balanced within the slender tendrils of the rinceaux. Among Isis' many capacities, she is a mother of natural generation.

No apertures mark off the paratactic panels but rather a series of projecting pavilions formed of slender columns in varied perspectival configurations and draped with garlands stand out from the red background. At the base of each we see a black panel framing an acanthus calyx like those in the House of the Vettii. Above each is a figured polychrome panel on which rests a miniature dramatic mask. Several of these frames contain aqueous landscapes, much fuller in composition than those in the bordered tapestries above. Here Roman

and Egyptian appear as two distinct types, the difference suggesting a parallel development of lifestyles as well as worship. The Roman comprises seaside villa scenes with characteristic persons, the Egyptian horned towers and shrines with pygmy staffage figures and Nilotic animals such as crocodiles. Other panels on the south, north, and east walls contain a series of naumachiae, each showing two ships against a background of villa or harbor buildings. Close inspection shows differences between them not only in the positions of the ships, but also in the individuation of the ornaments on their prows.[235] These examples belong to a much larger corpus, of which twenty-seven examples are now extant, situated within a number of buildings that underwent redecoration at the period, largely within the public world.[236] Both the House of the Vettii and Suburban Baths show comparanda. Here their significance might be considered twofold. They are related to Vespasian and to Isis's role as a marine protectress.

On the west wall the paratactic succession was broken by a series of open arches. Five at the right, separated by single piers with landscapes, give access to the Ekklesiasteron, whose ample space will have accommodated priestly banquets (Figure 186). Substantial architecture gives a monumental aspect to this *pinacotheca* room with large-scale panel paintings occupying the middle zones of each wall (Figure 182). Although the upper zones are missing, we can see from the podia that the paintings are framed within deep columniated bays formed by projecting columns and ressauts. Metal-scrolled columns are the one vestige of Fourth Style opulence; similarly

246

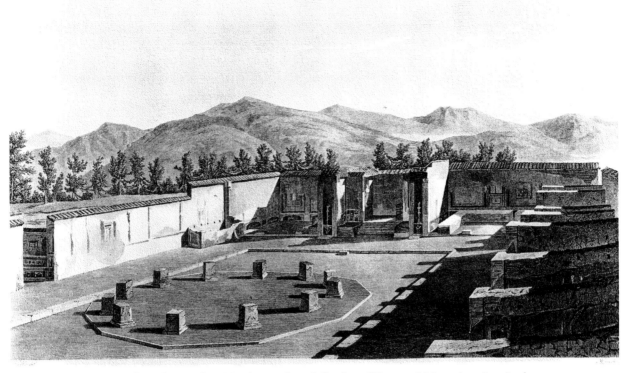

187. Macellum, drawing from Mazois, 32.2, "vue de Pantheon." Fototeca Unione, American Academy in Rome. FU 274617F.

ornamented columns appear in many other contemporary *pinacotheca* ensembles amid settings often more complex and fantastic. In contrast with the fragile pavilion architecture of the corridor walls, these solid piers of the *pinacotheca* framing seem to aim toward an impression of probability. Within the tripartite divisions each middle zone combines a large mythological composition at its center with flanking shrine landscapes seen as through windows: the most exotically foreign aspect of the decoration. Each scene depicts an example of sacred architecture belonging to a deity of the Isaic religion, but, although the deities and their shrines are conspicuously Egyptian, the backgrounds are not. Rather the precincts are situated amid mountainous settings that are wooded and somewhat wild.

The mythological subjects form a pair depicting sequential moments in the history of Io. On the one wall we see the horned maiden guarded by Argus to whom Hermes is showing his seven-reed pipe. The moment of release is thus near and the second panel shows Io's arrival, still horned but now in the care of a sea-deity, at the Canopus where Isis extends a salvational hand as her priestesses shake their sistra. Clearly the themes of these paintings emphasize not only the power of the goddess in offering a hospitable refuge, but also the way in which her compassionate power fosters interchange be-

tween the Egyptian and European worlds. By all these combined elements the Temple of Isis claims a place within the Roman public world.

Civic Buildings: Macellum and the Baths

As indicated by the Forum Frieze in the atrium of the Praedia Juliae Felicis, a large amount of commercial negotiation transpired within the enclosures of the forum colonnade,[237] of which some were garlanded. The essential market for foodstuffs, however, would seem to have been the Macellum at the far end of the Forum, a large, colonnaded enclosure with rows of shop stalls on its south side. Even before the earthquake necessitated its reconstruction, this was not an old building, but a late Julio-Claudian structure situated on the remains of an earlier place. At this time was introduced a central tholos, a feature mentioned by Vitruvius as being characteristic of markets. Originally built of wood, it was being reconstructed more sturdily in stone on the exact same plan and foundations.[238] It had a fountain at its center and its use as a fish market was identifiable by the large number of fish scales found in its vicinity.[239]

Great damage done to the existing structure by the earthquake had necessitated extensive reconstruction (Figure 187). Because the procedures had been drawn

out, the scheduled priorities are clear. The most practical features had been the first to receive service, and plasterers and painters had done their work. All the shops along the south wall had been completed and painted in red, although their marble sills were not yet in place.[240] Likewise the frescoed walls beneath the *porticus* on the west and north walls had been completed. Those on the north formed the rear walls of the external shops, apparently not damaged. In the ceremonial chambers at the rear stuccoed decoration was also completed.

Now work requiring marble and columns was underway in various areas. Although the tholos area was in use, the pavilion structure itself had not been replaced. Old limestone bases for columns stood on the twelve-sided platform, perhaps to be revetted in marble, but neither this material nor the new column shafts had been delivered. Also the ceremonial areas, although architecturally completed, lacked the finishing touches of their decorative revetments. At the rear of the building three separate chambers raised on a podium, all of which had been reconstructed with new grandeur, furnished a theatrical backdrop. The dominant central chamber, structured in the form of a temple *in antis,* was approached by a broad stair covered in *opus sectile.* Its *vestibulum* was stuccoed with figures of heroes. Interior niches housed four statues, of which two, a woman dressed as a priestess and young man, remain in place but cannot be identified for certain. The altar was covered also in *opus sectile.* Because the interior walls remain bare, it can be assumed that this interior chamber was to be revetted as also its two flanking spaces of uncertain function, the one large and empty but screened by columns and containing a podium around the base of the inner walls; the other fitted out with an altar and bench. Since these too, were to be clad in marble, their importance can be assumed. Finally the last operation to be undertaken was the construction of a colonnaded interior portal at the central entrance and this was only just begun.

The corridor on the entrance wall of the building is painted with large-scale, colorful architecture in a paratactic sequence that is all the same both varied and complex (Figure 183). Pavilions, bays, and porticoes form balcony apertures with the features of a tapestried picture gallery.[241] Unlike much of the exiguous architecture of Fourth Style constructions, these are solidly structured on two stories. A solid red-and-gold podium provides the bases for these constructions. From its recessed background the painted architecture reaches forward, but with background extensions in paler colors. The perspective effect thus obtained is not unsimilar to that of viewing the actual columns flanking the facade porticoes through the building's open doorways; this interior

to exterior graduation may have been even more visibly similar with the reconstructed portal in place. A theatrical character is given by the large figures standing in open spaces on the lower balcony. The apertures separate black panels with elaborate acanthus candelabra borders, some with floating deities, others containing a series of mythological quadri by the painter of the Temple of Isis: Io and Argus, Ulysses and Penelope, Phrixos and Helle, Thetis in the workshop of Vulcan, and Medea meditating the murder of her children.[242] While fine, detailed garlands drape the balcony architecture, a frieze of fish and comestibles above the panels and architecture of this public picture gallery keeps the quotidian identity of the market in view.

As a convenience of daily life existing both in the public and in the private spheres, bath buildings are an area wherein the elegance of public decoration routinely surpasses that of private individual. Size is a primary factor in promoting this difference. Vitruvius advises house owners to keep the decorations of their bathing chambers minimal, because the atmospheric conditions are damaging to plaster and paint. Although one can scarcely posit that private baths conform explicitly to this counsel, all the same the decorations in many baths seem perfunctory. Because public bathing establishments offer higher vaults and more capacious chambers that allow the steam more readily to diffuse, their opulence is not impractical. In the Empire durable materials took preference, but as we may conjecture from Pliny's (*NH* 35.26) mention of Agrippa's paintings set into the hottest chambers of his baths, painted baths were the cutting edge of fashion in the Augustan period. As a service provided to the whole community, baths attracted a cross-section of the populace. Even when private houses include them, their owners do not invariably bathe at home. Younger Pliny finds it convenient to visit one of the three "meritorious" bathhouses of the nearby *vicus* whenever his spur-of-the-moment arrival at his Laurentinum precludes his own baths' being heated in time (*Ep.* 2.17.26). Given that only seventeen houses in Pompeii have *balnea,* it is clear that the users of communal *thermae* will have represented a cross-section of society from the decurial to the various ranks of lower classes.

Within the history of thermal architecture, Campania contributed the hypocaust system that enabled large-scale developments, and thus Pompeian establishments are most interesting as they reflect early stages in the development of the bathing plan.[243] Consideration of their places within the social dynamic gives a different slant. Clearly Pompeii has a hierarchy of baths that determines their status within the city. Location might appear

to have made some difference. The Terme Stabianae of the Via dell'Abbondanza, although older than any other public bathing establishment, had already in its history received more care and attention in the way of restoration and rebuilding than the Forum Baths, centrally located and built with public monies during the foundation period of the colony.[244] At the time of their construction these had no doubt represented the cutting edge of elegance but the very fact of their having required and received no attention over the years had left them antiquated. Another small bathing establishment of Republican date located close to the theatre district that contained up-to-date features when built had gone out of use during the Augustan period and been replaced by a private house.[245] In the Stabian Baths, on the other hand, recent damage had caused refurbishing with good painting and elegant stucco, both in the men's quarters and the even more finely decorated women's quarters. All the same, in A.D. 79 the water channels were still not connected, so that the baths cannot have been in use. Possibly the damage was in the aftermath of a smaller earthquake. That these two municipal establishments were not meeting the needs of the city seems indicated by the existence of an ambitious building project, the Terme Centrali, located close to the intersection of the Via di Nola and Via di Stabiae at what was virtually the topographical center of the town.[246] Here on land that had become available in the aftermath of the earthquake the latest developments in heating technology were being incorporated, and the presence of marble building materials indicates that a high degree of luxury had been planned. The lack of double facilities makes it uncertain whether these were intended to serve both sexes or only men.[247]

No separate women's baths are included in the most interesting of Pompeian bathing installations: the large "Suburban Baths" built outside the Porta Marina and decorated with a high level of elegance.[248] In addition to the unusual architecture adapted to uneven terrain of the slope, many technological and decorative refinements distinguished this building: a heated and covered pool, a handsome caldarium built like the black salone of the Insula Occidentalis, with a window-pierced apse to frame shore views, and especially a handsomely decorated pool–a "natatio-nymphaeum" where water descended from a large mosaic fountain down a series of steps to fill basins colorfully decorated with aqueous scenes (Figure 188).[249] Nymphs and floating sea creatures, flooded pygmy landscapes and scenes of marine battles connected the world of the bathers with a sense of the greater sea. One recalls how the Younger Pliny prized the visual connection between his baths and the sea.

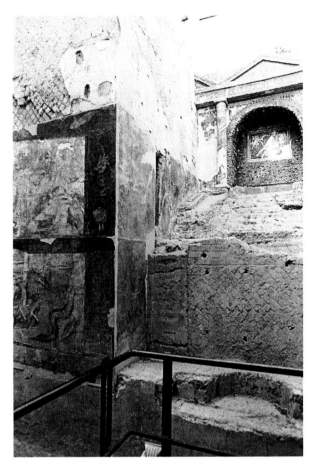

188. Suburban Baths, mosaic fountain with a water stair in *natatio*. Author's photograph (su concessione del Ministero per i Beni e le Attività Culturali).

With the exception of the Sarno Baths, which belonged to their own residential complex, these were the most lavishly equipped. By whom and for what clientele one may ask? Elegant baths outside the walls with sea views exist also in Herculaneum. Jacobelli proposes that they were operated under private ownership for clients willing to pay the additional cost of luxurious surroundings.[250] The presence of a covered walkway leading to the baths from the Porta Marina does argue for frequent traffic between these baths and the city. Like the Terme Centrali, as well as the Terme Suburbane at Herculaneum these lack separate women's facilities. The absence is scarcely surprising in view of the extra-urban location; women of good standing would hardly be likely to journey outside the city walls to bathe. One feature of the Porta Marina Baths in particular raises questions of the clientele for whom they were intended. This is the room termed an apodyterium, a divided room of antechamber and inner chamber with a frieze of graphically erotic pictures around its inner side. These pictures, fourteen in number, are accompanied

by Roman numerals standing above a series of long, empty boxes. The subjects range from fairly standard forms of erotic activity to perversions that beggar even Martial's imagination. It was the first conjecture of the excavators[251] that the images were a kind of index of services available in connection with the bathing establishment and presumably rendered in the honeycomb of small chambers located on the second floor.[252] Staircases just outside the room lead directly to this floor. Whether in fact the provisions are for visitors to the city to discharge their erotic energies before entrance as well as cleaning away the impurities of travel, it makes sense that a space outside the walls should function as a licentious space, where a kind of perverted freedom not even to be sanctioned within the city's established places of sexual license was allowed.[253]

PRIVATE ENTERPRISE

Fullonicae

If Moeller overestimated the importance of woolproduction for external trade in Pompeii, this misjudgment does not vitiate the importance of shops within the economy of the city itself. Laurence corroborates the important contribution made by his identification of three kinds of shops.[254] Of the three kinds the *fullonicae,* which supplied cleaning services, will have seen the most extensive dealings with a general public. Among their most frequent visitors we may imagine the servants of the elite who most likely attached a sense of superior status to themselves. Unlike the dye shops, *fullonicae* are distributed throughout the city. Moeller notes their location on main arteries,[255] but one may also see in this clustering a definite preference for situations close to the direct water route from the *castellum acquae.* Several are installed within the formats of atrium houses; this includes the three largest fulling establishments of the city. One should not consider this a sign of decadence, but even a felicitous adaptation since fulling requires space and in fact the operations of the shop are well adapted to the structure of the house with an atrium for customers and a peristyle for the cleaning operations themselves. As will be seen these three shops take good advantage of the assets of their locations.

The Fullonica attributed to the ownership of L. Varanius Hypsaeus (6.8.20–1), a duovir of the Neronian period who may have occupied the adjoining Casa della Fontana Grande,[256] is developed through modifications in the structure of an old double atrium house (Figure 189). This is a clear case of renovation with a shop installed in the atrium and the peristyle converted into a

work room. The building is located on the Via di Mercurio at the edge of an upscale neighborhood, which seems to be reflected in its combining of two kinds of signifying elements: those pertaining to the status or reception of the client likely to be superior to the proprietors and those that refer to the trade itself.

In the first place there is a clear effort to furnish clients with a dignified showplace by utilizing such elements of surviving decoration such as marble floors. The small chambers surrounding the workroom have several mosaic patterns in black and white of an earlier period including basket weave. To this refinement were added new wall paintings of bordered tapestries with flying figures in the current style. The peristyle preserves its original *porticus* form but with reinforced pier columns.[257] On one side was the fountain, an elaborate marble ornament with double water jets (Figure 126 and 190). But the place was also distinguished by thematic motival paintings illustrating in considerable detail the operations of the fullers' trade. Paintings on a pillar of the east portico show persons engaged in the process of washing, drying and inspecting cloth, presided over by a water deity.[258] One group shows a series of workers treading cloth in small vats. Another combines several activities. Finally there is a clear representation of a fuller's press.[259] These serve several purposes; they celebrate the craft itself in an instructive way for the eyes of practitioners and patrons and they also enforce social hierarchy by setting levels apart.

These furnishings are more elaborate and elegant than another shop on the Via dell'Abbondanza, the Fullonica of Stephanus, identified by its owner's name inscribed by the door.[260] This is a full-scale fulling factory, likewise installed within a former house structure, and which, in the words of Walter Moeller, shows "traces of a rationally planned operation."[261] Although this establishment gestures toward luxury with a show room decorated in fine Fourth Style with garlands and tapestries, it all the same brings the customer into closer contact with the processes of finishing cloth (Figure 191). Near the entrance within the atrium is located a pressing frame, while a large square tub stands in the customary position of an *impluvium.*[262] Ordinarily the customer would have seen the second story loft of this room festooned with material hung to dry. Along with the atrium and exedra, there is a decorated small room that probably served as an administrative office.

In this building there is no sign of habitation and the spaces not clearly intended for public display are not decorated. Facing the work spaces at the back of the garden is an elongated room occupying the traditional position of a *triclinium.* Possibly this is where the workers

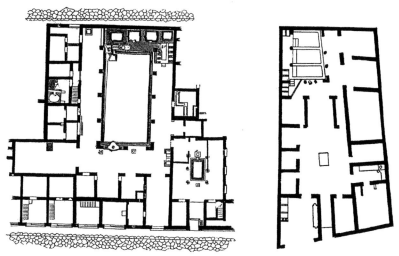

189. Plans of two Fulleries. Left: Via di Mercurio, Region 6.8.21. Plan after Overbeck 1884, 391, fig.
193. Right: Via di Stabiae, Region 6.14.21. Plan after Mau, 1904, 394, fig. 228.

ate the meals provided to them during their working day. That the group was politically active is demonstrated by the large number of electoral programmata clustered about the door, but also on the pilaster of a shop across the street, the representation of Venus Pompeiana drawn by a quadriga of elephants is the work of the felt makers. In the lower register are both names and images of these workers pulling cloth.[263]

Even more extensive decoration of a self-reflexive nature appears in the working peristyle that belongs to the fulling establishment of M. Vesonius Primus on the upper Via di Stabiae in Region 6 (Figure 192). Behind the platform on which the tubs are located is a large panel showing celebrations of the Quinquatrus, the feast of fullers, with groups sacrificing to Minerva, their patron goddess, while a suggestion of narrative content appears in a second panel depicting some form of adjudication.[264] If we compare these three shops, we see, in spite of their differences, that all were decorated on a fairly elevated plane. Being installed in renovated houses they have both utilized previous advantages and added others in kind. All the paintings are in the bordered tapestry styles and of greater opulence than those perfunctory light ground decorations found in the workshops of the Via Castricio. Both the level of decoration and its element of self-reflexivity may indicate the status

190. Via di Mercurio, Fullery, atrium. Author's photograph (su concessione del Ministero per i Beni e le Attività Culturali).

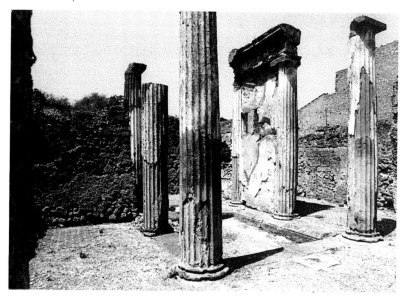

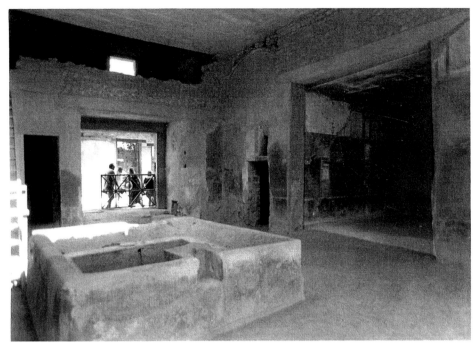

191. Fullonica di Stefano, Region 1.6.7, atrium. Author's photograph (su concessione del Ministero per i Beni e le Attività Culturali).

of *fullones* who were the primary entrepreneurs controlling the woolen cloth industry. In negotiations that concerned the processing of partially finished cloth they were presumably the superior participants.[265] Although the profession was in large parts stocked by successful freedmen, members of the magistrate class did not shrink from association with its business structures. Hypsaeus was the descendent of an old family; he had been active

192. Fullonica of Vesonius Primus, Region 6.14.21, workroom. Author's photograph (su concessione del Ministero per i Beni e le Attività Culturali).

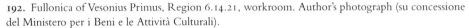

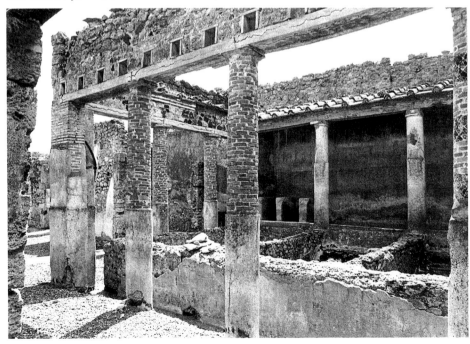

in political life during the fifties and served two terms as duovir during later years. According to Moeller, he was a master fuller.[266]

As a collective entity, fullers had professional needs for water and other commodities that gave them a lively interest in local government, and to all visible effects they did wield political influence at Pompeii. Numerous *programmata* expressing active support for magisterial candidates would seem to indicate that their endorsement, whether individual or collective, was a matter of consequence. Their appropriation of a triumphal Venus Pompeiana on the Via dell'Abbondanza as a locus for self-reflective painting appears to be a strong statement. The decoration of their establishments can easily be taken as an advancement of their own claims to professional prestige, but the decoration may also reflect the status of the household representatives who were concerned with the purchase and the maintenance of cloth. Such details are not mentioned in literary sources, but one assumes that it was not the lowest-placed member of the staff.

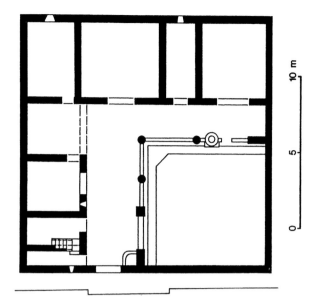

193. Plan 6.11, House of Pinarius Cerealis. After La Rocca, de Vos, and de Vos 1976, 235.

Craft and Commerce

Certainly clients of a high level are signaled by the shop of Pinarius Cerialis where the presence of showcases with examples of the jeweler's craft have made it possible for excavators to distinguish spaces used for reception and for display.[267] Lacking the formal order of atrium and *tablinum,* this small house has an unusual conformation of space. Entering from a side street off the Via dell'Abbondanza, the visitor steps immediately into the broad corridor of a two-sided peristyle that occupies most of the ground floor around which are ranged a series of rooms (Figures 77 and 193). Originally the peristyle may have belonged to an atrium house with its entrance on the Via dell'Abbondanza 3.4.1.[268] This derivation is not to suggest that the layout of the house was incommodious. To the contrary, the peristyle was spacious providing light and air for all the surrounding rooms. A small, second-story space reached by a staircase to the left of the entrance furnished living quarters for the owner and his small staff.

From the objects found in the house and the inscriptions outside, we can learn considerably more about this owner than about many Pompeians. His name, Pinarius Cerialis, has been reconstructed from the graffiti.[269] Whereas the gens name Pinarius indicates clientship with a large, old family represented in Campania, the cognomen Cerialis should represent the bearer's Greek affiliations.

Cerialis' identity as a tradesman is clearly indicated by the other discoveries in the house. At the far corner of

the peristyle was a room that would seem to have contained glass cases or shelves for display. Here Spinazzola found a box containing a cache of 114 gemstones, and a few objects in carved ivory and embossed metalwork along with tools for engraving. The collection of gems included twenty-five intaglios, six cameos in glass paste, along with a large number of unworked stones, glass paste, and shells. Because the designs are executed with varying degrees of skill and finish, it may be assumed that much of the cache represented work in progress.[270] This fact and the presence of the tools certainly indicate that Pinarius was not merely a merchant but actually the craftsman who created the objects he displayed and sold. In fact the nature of incised gems and cameos allows us to infer something about both their makers and buyers. Because they are generally decorated with figures they invite subject recognition and must be intended for persons who have an acquaintance with the fundamentals of literary culture. When famous statues provide the models, they may appeal to a knowledge of artistic culture as well.[271] Some knowledge of this background must be attributed also to the maker of the gems even if patterns are used. This context gives meaning to the decorations of the house which were surely intended to appeal to the persons of elevated taste and knowledge.

Like many Pompeian houses of grander dimensions this one combined the spaces of professional employment and hospitality in keeping with the social status of the owner. With the exception of a large space that Spinazzola designated as a workroom,[272] all rooms on the ground floor were decorated, perhaps initially in

the same period. The details suggest a decoration before the earthquake with later repairs. These repairs were executed with an eye to consistency and coherence. For instance, the dado added in the theatrical room comprises large scale breccia patterns of the Fourth Style repertoire in colors matched precisely to the complex monochrome decorations articulating the theatrical constructions above. From the consistency with which the repairs were executed, we may believe that the house was built and decorated by the same owner and thus that the decorations represent his choice.

The first room of the complex is the small room with theatrical decorations partially visible to the entering visitor through the large window that gave on the peristyle. To enter the room one must go through the small door that opens from an exedral space facing the peristyle (Figure 77). This boasts a conventional, but carefully executed decoration of red-and-yellow-bordered panels with floating Erotes carrying musical instruments. Balcony apertures and a simply structured attic complete the ensemble. Statuary figures were also featured within the bordered panels in the showroom. They were separated by pilaster niches containing candelabra. A large, undecorated room has been designated as the workroom. A vaulted *conclave* with a narrow doorway at the corner opposite the theatrical room had bordered panels separated by large candelabra and cassette decoration in the lunette.[273] De Vos suggests that the decorations in this space are of a less refined quality than those in the more obviously public rooms. Given, however, the absence of an obvious summer *triclinium,* one may imagine that the functions of the rooms were interchangeable at need.

Because Pinarius' trade served the well-to-do classes, it is hardly surprising to find him showing an interest in Pompeian politics as an assiduous rogator. *Programmata* on the space outside his door declare his support for several of his decurial neighbors on the middle Via dell'Abbondanza: Paquius Proculus for duovir and Epidius Sabinus and Trebius Valens as aediles, the last of these programmata bearing not only Cerealis' name but also that of Cassia, his wife.[274] All three notices refer to elections of the early seventies.[275] A later candidacy is that of Lollius for aedile in 77. Given the out-of-the-way location of the house on a side street, one might not consider it a normally advantageous place for displaying programmata. Thus we must think that a lively commerce brought visitors whom Pinarius wished to impress with his political allegiance. Such a trade as his would doubtless yield both social connections and money. Further evidence for money lies

in the fact the house was ransacked after the eruption and many of its paintings destroyed. But Pinarius was not merely a tradesman. Appurtenances of priestly office, a *culter sacralis* and a glazed terra-cotta scyphos with handsome ivy-leaf decorations, were found within the house. From these and the epithet *Cerialis Acratopinion* employed within the notice for Trebius Valens inscribed on a nearby wall (Casa 1.12.4–5), della Corte has proposed an association with the Herculean cult of the Ara Massima. It would be quite normal for a well-off tradesman to hold such a priesthood, but it is perhaps even more indicative of Pinarius' relations with his associates, not to mention probable good nature, that several caricatures of his profile with an outsized nose appear commingled with the programmata outside his door.[276] Painted in the same red as the electoral notices these may well be the product of the same *scriptores.* As della Corte interprets, one of these caricatures is a full-length portrait of the nasal Cerialis in the accouterments of his Herculean priesthood performing a ceremonial dance.[277]

No matter whether they were customers or merely workers, a different segment of society will have frequented the Garum Shop in the Via di Castricio, the southwest quarter of town where many agricultural products were processed. That the shop was actively operating in A.D. 79 is indicated by the dried remains of fish sauce within six storage dolia in the peristyle. One of these contained a pitcher for dipping the sauce. In its rear storeroom piles of amphorae await filling. Curtis, who has studied all aspects of commercial procedures, has argued that the operations taking place here consisted only in the processing of partially prepared fish brought from other sources because the area and storage space are too small for a complete manufacture.[278]

Whatever the nature of its operations, the peristyle had the amenities of a garden with a walk that on one side was colonnaded and faced by an open *oecus.* This portion of the area would seem to have been empty of factory operations because all the storage jars and other equipment stood against the rear wall. The interior was shaded by two large fig trees, one of which will have afforded partial screening for a latrine at the rear. Root cavities for smaller plants have also been found within the garden, possibly herbs used in the garum.[279] Interior plantings will have been echoed on the rear wall by a fairly recent Fourth Style garden painting of the type seen commonly throughout the city. Standing out from a red-bordered background and dado is a dense screen of leafy plants and shrubs with birds among the leaves, and even a peacock in one corner. Additional

ornaments at the corners of the painting contain gold amphorae of a noncommercial type. That this decoration was not random but clearly intended to create an ambience within the working space is the suggestion of Curtis, who notes that its application postdates the building of the latrine.[280]

The question remains whether this decoration was directed toward family members, workers, or clients. The building is not an atrium house. The two parallel rooms fronting the street were bare of decoration. Commenting on their difference from conventional reception areas, perhaps in consequence of remodeling, Curtis argues that these front quarters were private space reserved for owner or workers, and accordingly that the shop included no spatial provisions for selling. All the same the orientation of the rooms is notably utilitarian with a direct line of passage open from the front door into the peristyle, which suggests that this was a main line of march for persons entering the establishment.

If in fact the workers themselves inhabited the various chambers at the front of the shop, then certain side rooms opening off the garden rooms might be thought to be for their use. One is a small room of the Third Style, another a small kitchen room with a hearth, and another, currently undecorated, seems positioned for summer dining. Decorations from different periods appear on the walls; they could be explained in two ways; the one a difference between the living quarters and the industrial quarters of the house, and the other an expansion or redecoration of business quarters. An open room with a window faces the peristyle on the south side. On the west side was the one really decorated room: a small vaulted chamber, painted in the familiar Third Style, with red lateral panels framing a white ground *aedicula* on each of the four walls. The dado was black with a green cornice. All four walls had *aediculae*; two with triangular and two with arched pediments. Thus the door itself is framed as a *aedicula,* while the remaining three walls have small landscape vignettes at their centers. The painting is not without refinement of motif and execution. Above the panels is a floral frieze in black bordered with strips of cornice design. The pediments are edged with light filigree painted in single brush strokes. The acroteria are ship's plumes and the black borders have a delicate palmette design. The decoration contains twelve types of amphorae. Almost certainly these singular topical motifs alluded to the commercial fortunes of the business. Both literary testimony and the presence of stamps in various places attest that Pompeii was celebrated for its garum. The amphorae, especially if, as Curtis argues, they are not of the kind routinely employed by domestic purchasers, would argue that the product was prepared for shipment.

Restaurant Guide

Among the spaces serving the Pompeian public, those generally classed as taverns present some of the thorniest interpretive challenges, yet, in specific cases, their level of decoration may also provide clues to the place of these establishments within the status hierarchy of city life.[281] From Varro and Catullus onward, elite literature treats taverns censoriously or superciliously as places notorious for their lowlife. Horace chaffs the bailiff in charge of his Sabine Farm whom he has promoted from more menial service in Rome (*Ep.* 1.14.21) because honest country life and labor have not erased his longing for the specious allurements of the city: the brothel and fatty cookshop (*uncta popina*). Scorn follows upon social division. Taverns are understood to be the socializing places for those who lack the facilities to gather a compatible peer society at home, but this deprivation, and its consequent difference in the construction of private and public life attaches differences in ideology and outlook. Recently J.P. Toner has analyzed elite censure of tavern society as stemming from fear of the energies released in lower class *otium* especially the "uncontrolled" expression of competitive masculinity that drinking and gaming inspired. He notes that the hostility aimed at taverns was based on the concept of what honorable people might do in public. Especially they should not indulge themselves pleasurably in a public place.[282] Following the precedent of Latin literature, Mau refers to taverns as the haunts of "gamblers and criminals," and the majority of scholars, whether overtly or implicitly, have treated them dismissively from the elite point of view. Richardson gives them no attention in his comprehensive architectural history; only recent work on the sociohistorical side is finding them of interest.[283] As we will see, some taverns through decorative self-reflexivity themselves contribute to impressions of the behavioral indulgences they foster, but their place within the social fabric cannot be summarily relegated to marginality either from the proprietor's point of view or that of their local neighbors.

Establishments generally classifiable as *tavernae* are abundant in Pompeii – 200 according to one reckoning.[284] Even if this figure, as Wallace-Hadrill believes, may be inflated, the number is sufficiently large to suggest that a considerable segment of the population sought either food or sociability away from home.[285] Although these are popularly classified according to their

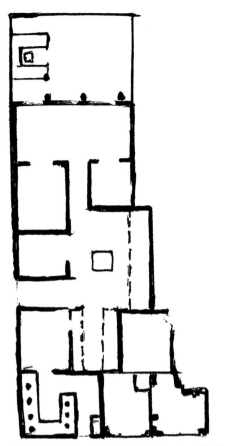

194. Via dell'Abbondanza, Taverna of L. Vetutius Placidus and Ascula. Plan after Eschebach and Müller-Troillus, 1993.

provision of food, drink, or lodging as *cauponae, thermopolia,* or *hospitia,* present-day studies question so absolute a separation of food and drink.[286] Several establishments are apparently connected with bakeries. In taverns where service includes not merely fast meals but also banquets, there are questions of room for stationary occupation. As Jashemsky has pointed out, many also made use of outdoor space. Mapping brings out patterns of distribution, some of which, such as clustering around gateways, are unsurprising, whereas others invite explanations of different kinds. That there are few in the area of major public buildings suggests civic regulations, while their absence from the mansion areas of Region 6 probably indicates that the inhabitants socialized at home. Incidence does not always follow shops; for instance, the highly commercial tract of the upper Via dell'Abbondanza has virtually no taverns, but they cluster at many frequented spaces such as the piazza surrounding the Castellum Aquae and certain crossroads. At the intersection of the Via degli Augustali and Vicolo Storto near the lupanar, Franklin discovers a lively running interchange of graffiti among habitués.[287] Region 1

includes some forty food shops of various dimensions, half of them distributed over the lower part of the Via dell'Abbondanza where the variety of neighboring businesses and clustering of electoral programmata, many of them sponsored by artisans, indicates a lively commercial interchange.

While Pompeian ordinance or custom may have barred these gathering places from areas of civic dignity, such exclusion did not go for the politics of the proprietors who, no less than fullers, found it worth engaging themselves within the network of patronage and support underlying civic activity. Along the lower Via dell'Abbondanza where business establishments alternate with the houses of powerful magistrates, many electoral graffiti declare the clientships of proprietors and their electoral choices. The name of the decurial rogator Trebius Valens is coupled in two programmata with that of one Sotericus owner of two, probably complementary, enterprises: a large and well-equipped bakery at 1.12.1–2, beside a *caupona* (3–4) that takes its identity from the *coponam futui* scratched on a pillar.[288] Faces of Rome and Alexandria posted by the doorway probably declare Sotericus' foreign origins[289]; a painted no-nonsense dog within the serving room looks like a warning to unruly guests. This tawny, sharp-boned guardian chained to a tree might seem lifelike if one is not too fussy about canine anatomy. An air of greater dignity characterizes the establishment at 1.8.8, where a stylish lararium at the end of the central storage counter conspicuously greets the patron's eye.[290] Elegantly molded in stucco, this *tempietto* combines commercial patrons Mercury and Dionysus with their owner's lares and genius (Figures 194 and 195). The names of this owner, L. Vetutius Placidus and his wife Ascala appear in nine programmata. Presumably they lived in a modest but well-appointed atrium house behind the shop, which boasted not only a single-colonnaded *porticus,* but also a covered summer *triclinium* (Figure 196). Placidus, whose name appears in six of the notices, calls himself a *cliens* of C. Julius Polybius and L. Popidius Ampliatus, and recommendations show him sometimes, but not always, supporting the same candidates as these important neighbors.[291] Possibly as a little side source of income, he would seem to have owned a little stomping bin for cloth (*saltus fullonici*) in the space contingent to his tavern.[292] Across town on the lower Via di Mercurio, another respectable tavern couple, Caprasia and Nymphius, supported as rogators the campaign of their down-the-street neighbors the Vettii in the Casa del Centauro. Given that Caprasia's name shows a family affiliation with Vettius's adoptive son Caprasius, the connection draws our attention to the social dynamic of the neighborhood.[293]

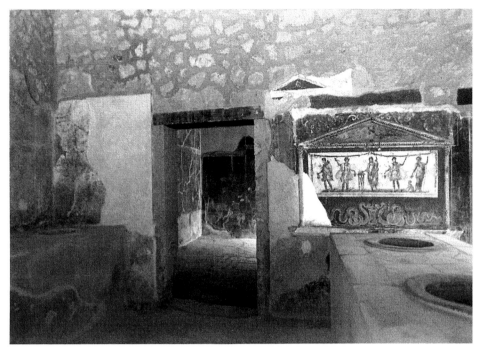

195. Via dell'Abbondanza, Taverna 1.8.8, counter with lararium. Author's photograph (su concessione del Ministero per i Beni e le Attività Culturali).

No comprehensive study of tavern decoration exists; the poor preservation of many stands in the way.[294] All the same it is interesting to apply to some decorations the test of extra-domestic luxury that characterizes other public spaces. If these places offer a social alternative to domestic isolation, do they also provide an alternative ambience? Even very modest establishments may appear to have one touch of luxury in their *opus*

196. Via dell'Abbondanza, Taverna 1.8.8, remains of garden *triclinium*. Author's photograph (su concessione del Ministero per i Beni e le Attività Culturali).

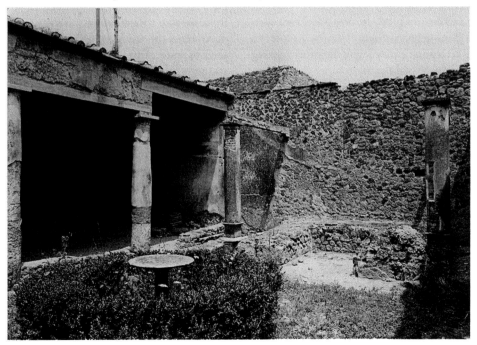

197. Via di Mercurio, Taverna at the crossroads with the Vicolo di Mercurio. Author's photograph (su concessione del Ministero per i Beni e le Attività Culturali).

sectile countertops, but the use of this material may be ascribed to the practical advantages of having a smooth, hard stone. Most interesting, however, at different levels in the status hierarchy is their tendency to employ scenes reflecting their own activity, and the following examples attempt to read the messages carried by some of these.

How trouble arises from masculine competition in taverns is illustrated by a famous set of comic scenes in the Tavern of Salvius (6.14.36). In one panel two men seated before a gaming board dispute the conclusion of a match, the one claiming victory (*exti*); the other arguing that he has the three.[295] In the next panel the dispute has become physical; leaving their seats the two contenders stand belligerently face-to-face, grasping each other's cloaks at the neck. One insists on his three count; the other counters with an obscenity (*fellator*), while the proprietor tugging at his tunic orders them to "do their quarreling outside" (*itis foras rixatis*). In this ambience women also are contentious. As a waiter carrying a pitcher and a glass approaches two seated women, each claims the drink for herself while the servant pacifically assures them that each may drink as she wishes because there is a large supply of wine. One overtly erotic scene completes the spectrum of pastimes. From one point of view these panels can be seen as humorous treatments of stereotypical tavern discourse.[296] As illustrations of disorderly conduct they might also, from the proprietor's standpoint, take on a didactic coloring. Once the quar-

rel has been turned in to the street, it will surely escalate and draw the bystanders in.

More decorous scenes of tavern activity appear within the small taverna (6.10.1) located on the southeast corner of the intersection of the Via di Mercurio with the Vicolo di Mercurio[297] (Figure 197). Its spatial plan, as Mau observed, is clearly designed for the commercial purpose it serves. Behind the small bar enclosure at the front are two rooms for stationary occupation in whose decoration the marks of a single painter's hand can be seen in spite of perceptible differences in composition and style.[298] The outer room on the left has apertures on the street that might, among other things, allow patrons within the tavern to be recognized by passersby. The themes and tone are convivial. Against a plain white background, perfunctory wall divisions marked with heavy red outlines set off a series of quadri bordered simply in red. Eight of thirteen original vignettes survive. Whereas their self-referential subject matter parallels that of the Tavern of Salvius and may well have been produced by the same group of painters, their scenarios are less specifically dramatic, more oriented toward the routine transactions of patronage and service. With information concerning comestibles both written and pictured, they might even function as menus. A string of sausage clusters suspended over the heads of seated customers might advertise the varieties available. Another panel depicted a cart delivering amphoras of

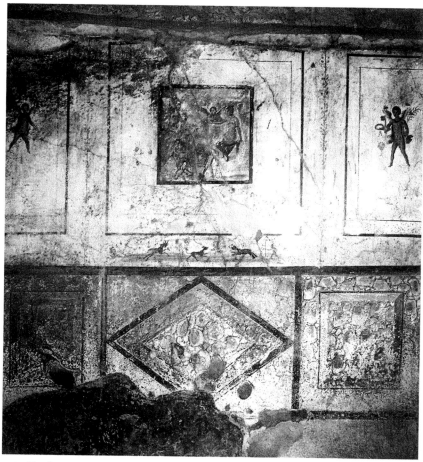

198. Via di Mercurio, Taverna, South Room with Fourth Style decoration. ICCD N56093.

wine.[299] Painted rubrics appear also to refer to service. Customers order wine by name or specify the amount of water to be mixed: "just a little."

The small enclosed room at the right presents an entirely different appearance. In the first place its paintings divide it, in a fashion common to *triclinia,* into an antechamber and an interior room (Figure 198). The background is also white. The room has a high dado painted with false marble. A predella shows hunting scenes. Above this the wall is divided by red lines into panels with alternating decorations of figured quadri and flying Cupids. The subjects of the quadri are a fishing Venus and a Polyphemus and Galatea. Because early excavators gave the establishment a shady reputation as *caupona cum lupanare,* the two rooms have been seen as spaces for wining and couching with their motival content simply contrasted as erotic versus convivial, but I think that a better explanation can be drawn from considering levels of imitation in addition to themes.[300] In the first place the particularly discreet nature of the pastimes shown in the tavern scenes, presenting its transactions, as Mau observed from the proprietor's controlling point of view,

suggests some self-consciousness concerning reputation that accords poorly with a brothel connection. Rather one may take the divided decorative program as an invitation to civility with its streetside chamber designated for the orderly conduct of traditional tavern pursuits, the other with its mythological decorations in imitation of upper-class decoration, invites dining on a level that also imitated social refinement. Thus this establishment at the intersection of the Via di Mercurio stands as a paradigm of the social mixing that characterizes the neighborhood itself.

Self-reflexivity in a different manner appears in the set of three sympotic quadri that Antonio Varone's excavations have brought to light in the insula neighboring that of Polybius (9.12.6) and named the Casa dei Casti Amanti.[301] But "Casa" here may be an overstatement; the residential rooms are small and recessed behind a very large bakery with mills and oven. The large room containing the quadri is decorated with alternating red and black panels with spare divisions and ornamentation that place them within the Third Style, two of the walls having largely escaped seismic damage while the west

wall, according to Varone, was damaged and restored to match. Both the content of the quadri and the size of the room argue for its dedication to convivial pursuits (Color Plate XII), as also the fact that its large south window opens on an enclosed garden. Here on a rough plaster wall, a panoramic view of the Olympians welcoming Hercules, is a lararium painting.[302] In this case, Varone remarks, the work of the *pictor imaginarius* preceded that of the context painters, but one might speculate that, as often in these enclosed garden areas, a full complement of garden paintings might have enhanced the view outward from the enclosed interior room.

Within this supposed triclinium each of the three scenes of the ensemble depicts couples reclining in intimate proximity, two by two on richly upholstered couches and attended by slaves whose services range from producing more drinks on demand to dealing with a female drinker who has visibly overimbibed. No decorous conjugal hospitality here; the carved three-legged tables have no sign of food, and the empty silver cups are being waved in the air. Indeed the couples, garlanded, partially draped and unsurprisingly young, are primarily to be differentiated on the basis of their relative degrees of drunkenness and sobriety. In dubbing the house Casti Amanti, Varone can only be thought to have the absence of actual intercourse in view, but it might even be thought that the male partners, at least, are far too well-soused for sex. Only one pair in the central scene remains sober enough to embrace; the others are concerned mainly with procuring more to drink. In the scene on the east wall that Varone characterizes as a drinking contest, one male has wholly succumbed, while it is difficult to tell whether the female companion of the other is offering a rhyton, removing it, or about to drain it herself. In such a company we can easily imagine Catullus' Septimius and Acme, the preppy Roman youth besotted with drink and desire, the kittenish puella with large and flattering eyes.

Varone finds satirical humor in these, linking the drunken woman on the west wall with a partially visible male splayed out on a couch at the rear and proposing that the figure holding a large stick in the central scene could be taken for a comic father pursuing his rapidly draining finances within a *triclinium* of ill fame.[303] At the same time, by identifying parallels and duplicates, he correctly identifies these images as genre scenes. For one thing, the settings in the vignettes differ, perhaps even to suggest different seasons; the couches on the west side stand within a walled background, the other two beneath outdoor canopies. The soberest of the scenes, that in which two lovers are embracing, is shared item by item with a house in Region 1,[304] while the cou-

ple with the rhyton have a close counterpart in a panel from Herculaneum that the *Antichità* describes as a traditional Roman dining vignette. The drunken woman with a single pair and a servant appear in the House of Cuspius Pansa nearby on the Via dell'Abbondanza.[305] Finally, Varone compares the whole ensemble with a set of three scenes in the Region 5 "House of the Triclinium," which indeed bear out the identification as genre scenes although here a traditional male gathering with nine diners is included even though one is sick.[306]

On the basis of inscriptions, that house has been proposed as the regular gathering place for a collegium of fullers. Although the identification remains merely conjectural, we know of such gatherings and of taverns as their frequently designated venue. Toner mentions their conjunction of recreational freedom with lower-class "labor interests" as one of the causes underlying upper class fear of taverns.[307] The many electoral endorsements in this area of the Via dell'Abbondanza, however, suggest a harmonious symbiosis between the upper-class residents and their baker and mule-driver friends. A programma supporting L. Helvidus Sabinus in the name of *pistores* and *vicini* led Della Corte also to suggest that the upper story of Placidus' taverna at 1.8.8 served as the seat for a "collegium" of bakers convened by the restauranteur,[308] but if such a *collegium* did indeed exist and hold gatherings within its own proper neighborhood venue, its most likely space can now be imagined as this garden-oriented *triclinium* whose spatial connection with the bakery suggests that the room was as much used for eating as for drinking.[309] Rather than mirroring the pastimes of its occupants, or even warning them against overindulgent behavior, these semierotic scenes give a sophisticated and Hellenizing touch, with the kind of fantasy implications that Segal once proposed for the word *pergraecari* in Plautine comedy. They suggest the pleasures that the occupants of the room might imagine themselves enjoying while their real conversation, like that of Trimalchio's freedmen guests, turns on the next gladiatorial contest, the weather, the temperature of the baths, or the fairness of the aediles who set prices for their bread.

Finally we may puzzle over the relationship between the status levels of decoration and clientage in an extraurban complex whose unexpected emergence during the construction of the Autostrada del Sole has given its unusual nature considerable publicity. Located in the area called Agro Morecino, which, in ancient times, was both close to the town's shoreline and near to the mouth of the Sarno, this still incompletely excavated complex seems clearly intended for large-scale use. Surrounding a peristyle is a series of exedralike rooms with fixed

couches and water channels that unambiguously show their accommodation for dining parties. The generous size of a nearby kitchen indicates a capability for serving several rooms simultaneously, while a full bath complex and a stairway to an upper floor would suggest that the establishment offered overnight accommodation. Such operations, however, may still have been suspended at the moment of the eruption because the building was in the process of redecoration. To this condition is owing one of the major resources that the find has offered to scholarship. Apparently stored in one of the *triclinia* and uncovered during the first excavations, were a boat and a wicker basket containing a cache of wax writing tablets that record both lawsuits and loans in the name of the Puteolan house of Sulpicii, whom Andreau associates with imperial slaves or freedmen engaging in commerce.[310] Although it is by no means clear for what reason these records of already long outdated transactions came across the bay to Pompeii, their presence has provoked speculations concerning the identity of the building as either a business headquarters, a seat of some manner of association or simply a very fine public inn favored by visitors of official consequence.

That these five *triclinia* are high-status accommodations seems clearly indicated by their marble-veneered couches and fountain tables with marble tops that resting on vine encircled pedestals. The wall painting also is exceptionally rich in color and refined in detail.[311] In the two matching *triclinia* A and C, scaffolded pavilions project forward from red-ground walls with so great a complexity and perspective depth that they draw the viewer into their interior space. The equally complicated, although more scantily preserved, architectural scaffolding of the central black *triclinium* B is topped by white frieze zones compartmentalized in the *scaenae frons* manner and distinguished by fine details of acroteria, gardens, and flying figures. Figures framed at their centers represent such personages as Ariadne, King Pelias, and Admetus with his lion chariot as well as more common divinities. These figures supply the decoration with a mythological component that is lacking from the large red or black panels of the central zones. Although no mythological *tabellae* are mounted in them, artistic culture is not absent. The thematic decoration of red triclinium A consists of Apollo with a complement of Muses, two floating and the rest positioned on pedestals, but all distinguished more clearly than is often the case by the instruments they hold.[312] Dominating the central space of the end wall, a truly baroque Apollo Citharoede sweeps the strings of his lyre; he is matched at the centers of the side walls by the Muses Calliope and Thalia. Although their postures are station-

ary, a swirl of transparent draperies around them gives a breeze-swept vitality to their presences. Positioned against brilliant red backgrounds on metallic candelabra bases, the smaller Sisters are clearly meant to be seen as replicating statues, but statues of elaborate workmanship with finely articulated draperies. Euterpe deferentially lowers her long flute facing the spectator as Apollo plays; Calliope, touching pen to lips in the characteristic pose of literacy, contemplates a folded tablet at arms length as if deciding what or whether to write. Among the multiple ornaments decking out the pavilions, theatrical masks enforce the performative character of the room.

With a large figure of Sarno filling the central space of its end panel, the thematic keynote of the matching counterpart chamber might seem to carry a more local reference. Stretching from one to another side of his compartment, the reclining deity could be acting as the most prominent guest on the couch were it not for the water reeds that surround him, and call attention to the position of the hostelry at the meeting of river and shore. At the centers of the two lateral walls winged Nikes float into the room, the one holding a large golden tripod. Here the pedestals are occupied by a selection of ritualistic figures, graceful youths bearing offering plates, and one intensely glowering Maenad who executes a dance step, stepping forward with bared leg from the swirl and flutter of her green tunic.

The figures are of a consistently sturdy build; their faces full and fleshy with an idiosyncratic downward slant to the chin and obliquely directed gaze, fortuitously producing effects of anxiety or attentiveness as one may judge. Clio's hair is bound by a fillet, but the majority are garlanded, or crowned one might say, since the jewels and sparkling highlights of their leafy headgear indicate metallic foliage rather than fresh. Richardson identifies their painter as the same who executed the divinities in the atria of the Casa dei Dioscuri and the Casa di Naviglio. Within the casements of the black room one of the Dioscuri horsemen does in fact appear in a statuesque posture, and the face of a flying victory with a tripod and wearing a golden torque has the same uneven alignment of eyes and chin in three-quarter view as do the Dioscuri images. Nonetheless the ripples of her translucent draperies clinging gracefully to her limbs and swirling cloudlike about her feet, as well as the fine feathering of her wings and sheen of the carved tripod are all of an exquisite finish that shows the painter's strength to lie in mastery of material objects. Whatever the clientele that gathered within this space, the decoration invited them to turn their attention toward high culture. Here, as in the Temple of Isis, is an

261

instance of a painter moving between the public and the private spheres, and clearly a painter on the highest level of desirability.[313]

BIG CIRCUITS AND HIGH POWERED CONNECTIONS

With the exceptions of taverns and fulleries, the hiring of painters for public commissions demonstrably aimed toward a high level of quality, but also we see that the best of the taverns could make pretension to elegance. The specific marks of quality, however, are not peculiar to these venues but shared across the spectrum of public and domestic places. Such crossovers lead us back to the question of the link between aesthetics and money. If in fact these paintings were commissioned by the rich merchant class, then what does this tell us about the discrimination of Pompeian patrons?

We may investigate this question a little further by turning attention back to the Temple of Isis, where the decoration would seem to have been a significant commission, involving not only many subject elements but also many groups of painters who specialized in executing them. No less than the *pictores imaginarii* of Richardson's Dioscuri study, these various painters can be identified and traced around the city by their interlocking with the private world. In the first place, the workshop responsible for the fine details of the corridor contexts was the same that decorated the five *pinacotheca* rooms of the Vettii. Their fine floral garlands and especially their acanthus calyxes are unmistakable where they occur. Domenico Esposito sees also their garlands and acanthus borders in the tapestries of the Macellum, where the *aediculae* are large and theatrical,[314] and, provided we can trust the evidence of documentary renderings less detailed than Zahn and Niccolini, they painted the corridors of the Temple of Apollo as well.[315] This decoration, like that of the Temple, also contains a scrolled acanthus frieze, but seemingly without the many animals whose acrobatics enliven the latter. In fact such floral friezes are fairly common; their origin might be attributed to the fine-cut marble decorations on the doorframe of the Eumachia building, and whatever fine features that might have existed within. The one duplication of this zoologically endowed frieze appears in the *oecus* of P. Vedius Siricus' house, which, judging from still unfinished elements of its context, must be one of the last restorations of the city.

These painters did not, it would seem, work only in places where they had a full program to execute. Both the workmanship and the patterns appear in the atrium of the small Casa dell'Ara Massima (6.16.15) lo-

cated on the block of the Amorini Dorati. This is a house of comparatively irregular design, yet furnished with three elegant spaces. At the rear of its small atrium is an alcove that houses a fountain. Candelabra and fine vegetable scrolls against a red ground articulate the forward walls of the alcove, while the mythological quadro on the recessed wall – appropriately one of Narcissus – is mounted on a bordered tapestry framed by balcony apertures. The refinements of these tapestries are closely comparable with those in the House of the Vettii, but a preearthquake date is definitely suggested by the patching of the wall above with a heavy *scaenae frons* whose central landscape and side doors, not at all coordinated with the delicate tapestries of the middle zone, seem to overhang the wall.[316] This tapestry work was the specialty of a fine group of painters, so fine that one may be surprised to see such presumably expensive craftsmanship within a small house. It seems more at home in the luxurious remodeled garden house, the Loreio Tiburtino, in a room on the axis of the euripus.[317]

The acanthus motifs of these painters were often imitated but not equalled.[318] One sees, however, neither trace nor imitation of their characteristic calices or floral garlands on the Via di Mercurio, where an equally refined team of painters produced the spatially elaborate box frames of the largest *aediculae* in several houses. The hallmark of these workers is their finely articulated metallic friezes, almost always involving griffins in various heraldic combinations, with lyres, cantherae, sun heads, and other motifs. This team moved as far from the Via di Mercurio as the Insula Occidentalis where the terraced Casa del Bracciale d'Oro underwent major redecorations in the Fourth Style. In a grandiose vaulted *pinacotheca* on the second descending level, we can recognize their work in a particularly well-articulated version of their metallic griffin-borders, here with unusual winged psyche figures separating the heraldic beasts[319] (Figure 199).

Turning back to the Isis Temple as index, we see that not only fine details but also the naumachia paintings give evidence for the circulation of painters and the interchange of public and private commissions. The great similarity of style and execution among these compositions indicate that one person must have produced them all. While the greater number are in public contexts, the red *pinacotheca* of the Casa dei Vettii also contains examples. Major differences involve the number of ships and the design; in those with three or four the bird's-eye perspective opens more broadly. The panels in the frigidarium of the Suburban Baths are much larger. Positioned on the walls above the *natatio* they are framed with garlands in the manner of tapestries, by which we may

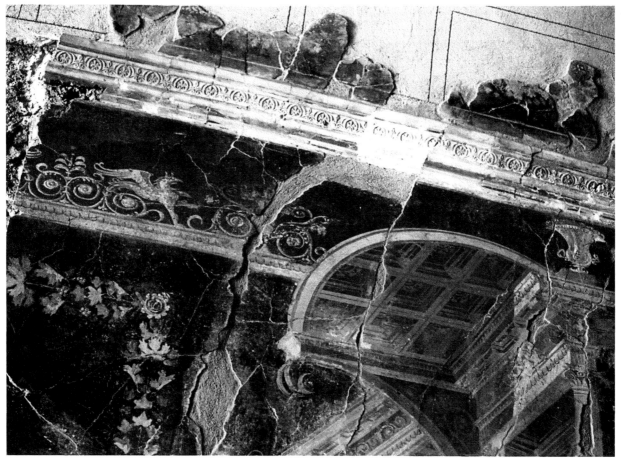

199. Insula Occidentalis, Casa del Bracciale d'Oro. Black *pinacotheca*, second level. Heraldic frieze with acanthus and griffin motifs above a vine-bordered panel in a room featuring Dionysus and Ariadne.

understand that their significance is celebratory rather than illusionistic.[320] Not only the incidental details, but also the panels can be attributed to painters recognizable by their work in other contexts.

Finally, and unsurprisingly, the *pictores imaginarii* who worked in these public places were among the busiest in all Pompeii, and, unlike the context painters, would seem to have crossed from the Via di Mercurio into other areas of the town. Two can be identified to whom Richardson gives the designations Dioscuri and Io painters.[321] In this house he sees them working together, perhaps in a master and disciple relationship, but so closely that their hands are in some cases difficult to distinguish. Generally, however, he grants superiority to the Dioscuri painter who produced the two large peristyle pictures of Perseus and Medea, whose oeuvre comprehends also the floating figures in the red and black *oecus* of the Vettii and also the atrium deities of the Dioscuri, the Naviglio, and the Agro Morecino rooms, not to mention the notorious Priapus of the Vettii entrance space.[322] Although the Dioscuri painter

would seem to have done the houses, it was his colleague the Io painter, who, according to Richardson, produced the mythological panels both in the Isis Temple and the Macellum. The fleshy faces and anxious stares seem typical of both, but by evidence of the Agro Morecino paintings, the Dioscuri painter renders drapery with much greater lightness and transparency. What we then see is the productions of rather versatile master painters who moved from the simulation of standing statuary to more flexible flying figures conceptualized as embroideries on tapestries to large-scale dramatic compositions. In producing their specialties they would seem not always to have been associated with the same context workshop, because some of their most monumental compositions appear framed within the griffin-bordered tapestries of the Casa del Bracciale d'Oro.[323] All the same they worked only with the two best and were productive over a long period of time.

Such conjunctions of refined context painters and *pictores imaginarii* easily confirm the affiliation of wealth with quality, but may also lead us to ask how closely

ancient standards of quality approximated ours. To what extent did the everyday patrons of the Macellum or the devotees of Isis value such refinements as the chiaroscuro modeling of garland flowers and acanthus leaves? We can only answer with reference to visible work. Although marble slabs such as those being installed in the Central Baths and the Eumachia building, as well as the platform exedrae of the Macellum were big, bold, and ostentatious; the painters who worked in these places also considered fine details worth putting before the public eye. Conversely, in the monumental red *oecus* of the Vettii with its naumachia panels and abundance of fine floral garlands, the patrons were content with an imitation of marble panels in the dado.

The circulation of these painters between public and private venues may leave us to bring both questions and observations concerning patronage to our conclusion. Should we conjecture that the patrons who hired these painters to decorate their houses were instrumental in their obtaining the conspicuous commissions of the Macellum and the Temples? Or contrariwise, that these patrons, seeing these artists' work in the public sphere, hired them as soon as possible for their own houses? Perhaps they were not the very summit of the artistic hierarchy; the less frequently represented Achilles painter may have been the greater master, yet the patron who hires a well-known painter must gain a certain distinction by reflection. Finally we may consider that the circulation of painters made it possible for ordinary citizens – those of the Via Castricio, for instance – to experience in their public itineraries repeated viewings of the work of the most valued and presumably the most celebrated painters. Work that might be glimpsed hastily and briefly in the course of a visit to a patron could here be seen repeatedly and everyday. Surely this exposure gave luster to patronage as well as to art.

CONCLUSION

Beyond A.D. 79 in Rome and Campania

Suppose that Vesuvius had remained quiet in A.D. 79. What then might Pompeii have become – aside from being lost to posterity like most other Roman cities and towns? Would it gradually have reconfigured its urban landscape, as one scholar proposes, into the shape of an "imperial city" such as Ostia, where the building of atrium houses literally ceased with the late first century to be substituted, and often physically replaced, by insulae for multiple dwellings?[1] Or even if residential styles had remained relatively stable, what novelties might have entered into painting? Would the Fourth Style have maintained its ascendency, framing mythological *tabellae* with richly ornamented *aediculae* in areas where persons might delay with sufficient time to contemplate their subjects, or might fashions in due course have metamorphosed into something sufficiently consistent in characteristics and widespread in application to merit the appellation of a Fifth Style?

Although these questions are partly recreational, because it is unlikely that any surge of economic centrality might have made an Ostia of Pompeii, they may serve not only to remind us how very accidental is the abrupt terminus that natural forces imposed on the developmental narrative of painting, but also to point us to the places and the conditions to which we must look to pick up the thread.[2] For, in spite of the Elder Pliny's

complaint that the currency of marble and gold had made painting virtually obsolete in his time (*NH*. 35.2–3),[3] the preponderance of scattered evidence from all reaches of the Roman world shows painted plaster to be the most widely employed method of finishing walls. All the same, the evidence is scattered. Turning back from Flavian Campania to Rome we find our curiosity hampered by the fragmentary state of survivals. After walking through such full ensembles as the House of the Vettii or the Lucretii Valentes' Casa della Venere it is difficult to know where or how to place a single isolated room or a disjunctive wall. If we wonder how those new Neronian insulae constructed contemporaneously with the Domus Aurea in the aftermath of the fire of A.D. 64 might have been decorated, only one good example of contemporaneous "Fourth Style" remains for comparison with the Campanian repertoire.

Looking for Roman developments beyond the Campanian terminus, we confront random survivals from two hundred years of painting, all in all making up a substantial corpus, but one so heterogeneous in period and provenance as to defy comprehensive grasp. Attempting to impose some order on this spectrum, Hetty Joyce has organized the examples of Rome and Ostia into three compositional categories in accordance with their approaches to dividing the walls: modular or

paratactic surface decorations, architectural modeling of space, and full-scale figural compositions that treat the entire wall as a canvas – these last being sometimes of the garden variety, but more often marine and underwater scenes to enliven the bath.[4] As she applies these categories to chronological analysis, Joyce's study stresses the formal elements of composition, abstracting categories from context and highlighting continuations of earlier compositional modes over and above conspicuous innovation or change. More recent studies have given attention to the ways in which decoration is adapted to architecture and to the use of space.[5] In this short concluding section of my study, more of an epilogue than a chapter, I attempt to break through the accidental terminus that the abrupt cessation of Campanian painting imposes on our concepts. I do not aim to duplicate Joyce's thoroughgoing, detailed survey, but simply to look at a few examples, some of which Joyce did not have available at the time of writing, and secondly, by consideration of a few representative authors, to sketch some vague sense of the cultural environments in which later painting was displayed.

The first stages of the exploration will take us away from houses, to museums and drawings. As we reach the mid-second century, survivals from a variety of locations whose dates are established with some security by brick stamps, provide something approaching a critical mass for discussion. Among these examples, scholars have remarked certain similarities of composition that make this corpus a touchstone of stylistic identification for the Hadrianic and Antonine periods. Here, if anywhere, we might look for the crystallization of the controversial "Fifth Style," whose autonomy art historians commonly deny.[6] These examples, several of them existing still in context, represent a variety of locations: the greater number exist at Ostia, which is the only place where any manner of coherent historical spectrum might be represented. In Rome are scattered rooms from private houses but also two completely decorated complexes from the Esquiline territory, the Villa Negroni, preserved by drawings from its late-eighteenth-century excavations, and another neighboring installation, the Piazza dei Cinquecento insula, comprising a private dwelling adjoining a full-scale bath.[7] Imperial properties are represented by additions to the old Julio-Claudian villa at Prima Porta, and by a number of chambers in Hadrian's villa at Tivoli whose locations show them lower in status than the opulently decorated marble rooms of that place. Ultimately the route will lead back to a verbal text of this later period, which, if it does not reliably reproduce actual paintings, does provide insight into their social valuation.

LATE FIRST CENTURY: ESQUILINE AND PALATINE

The recent reopening of the Antiquarium Communale, a city museum on the Caelian dedicated to the display of objects serving Roman everyday life, has made available a substantial reassemblage of painting from widely separated areas of the city unquestionably representing different moments of time. Covering the walls of three rooms with a credible approximation of their original appearance in situ, these paintings, all dominated by architectural simulations, supply a backdrop for the exhibition of objects ranging from a hut urn and terra-cotta votives to jewelry, glass, instruments of trade, and surveyors' tools.[8]

In the earliest of the assemblages, the decoration of rooms discovered in the Via Genoa, the architecture forms a light scaffolding to compartmentalize a white ground wall, framing interstitial areas decorated with garlands, floral candelabra, and small landscape panels. A palette of blue, brown, and red creates spatial gradations by darkening the foreground plane while tufts of foliage positioned behind the scaffolding aim also at a sense of depth. The original rooms from which these emanated will, by Pompeian standards, have been lofty. The composition accentuates its height by prolongation of the central zone to a point far above the spectator's line of vision where the vertical rigidity of the aperture columns is broken by pavilion entablatures. Floral bands reaching upward from the podium extend to a level above these pavilions, although not to the cornice. The variety and grace of their forms lends an elegant air to the ambience, although a close view of their calyxes and tendrils shows them painted with broad and irregular strokes. Garlands suspended from their finials loop across the upper reaches of the panels, which all the same continue still higher above them to the cornice line. Although this upper area demands completion by a frieze zone, no indication of one survives.

Some help in adjusting our sights to these paintings is given by evidence for dating based on other than stylistic grounds. Foundation walls of a second-century building cutting into the wall of the Via Genoa house show that its rooms had been sealed off from an earlier date in the first century. Two inscriptions on water pipes give the names of one otherwise unattested T. Flavius Salinator and an Aemilia Paulina Asiatica[9] – an aristocratic couple, one might assume.[10] Although the composition conveys a general impression of refinement, this is by no means a luxury decoration; there are no imitations of marble paneling, and even the scaffolding that forms the apertures seems more akin to wood than to stone.

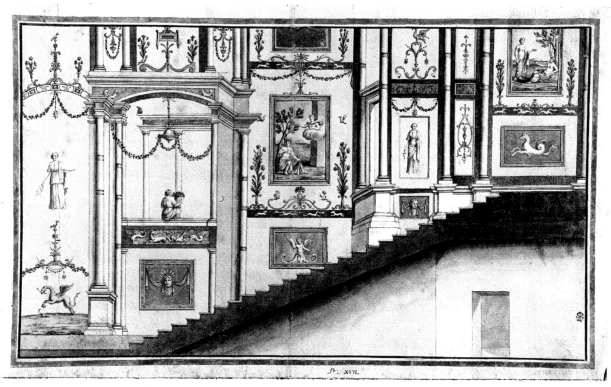

200. Drawing from the 1722 Palatine excavations in the Palace of Domitian, Eton College, Topham Collection. Reprinted by the permission of the Eton College Library Trust.

Both on account of its use of balconies and garlands against a white ground color and its proximity to the Domus Aurea, scholars have wanted to attribute it to the same period, comparing its general appearance to that of minor rooms of the palace.[11]

Because the context of discovery does not indicate whether this room fulfilled a major or minor function within its original context, we can only conjecture its status within a programmatic hierarchy of decoration. Another composition with a possible date in the late first century would appear to emanate from the most opulent edifice of the day. Given the intrinsic interest of the location, one cannot help but be curious about the paintings that surrounded a staircase in the Palatine complex of Domitian, excavated in 1721 or 1730 under the sponsorship of the Farnese Duke of Parma and Piacenza.[12] Like the marble fountain underneath the grand *triclinium,* this decoration was drawn at the time of its discovery and the artist Pier Leone Ghezzi attached his own description characterizing the style as "grotesque" with obvious reference to the motifs of its abundant ornamentation, but otherwise giving little interpretive information except for remarks on the brilliance of the colors he rendered with a full polychrome range (Figure 200).[13] As to where the lost staircase was located and what spaces it joined, we have only indirect hints. Ghezzi alleges that the steps

were of marble and led to one room that was decorated with pavonazzetto columns. His account mentions also the large basalt statues of Hercules and Dionysus discovered in the same campaign of excavations – and still visible at Parma. The decoration extends beyond the area reproduced by the drawing to another story, at least in height; it is also progressively fitted to the rise of the stairs. If his rendition is accurate, the architecture of these paintings has real solidity in its projecting and receding balconies. Clearly the decoration lent dignity to its space by the fabrication of a *pinacotheca.* Its projecting and receding pavilions may remind us of the use of *aediculae* in colored marbles as the interior decoration of the public rooms.[14] The images within the framed panels are somewhat unusual, corresponding to no subject otherwise known. Especially striking is the panel in which one figure apears as an upper torso floating within a cloud: either a divine apparition, or perhaps even an approximation of the strategy by which gods in epic make their favorites invisible at critical moments of their adventures.[15]

THE SECOND CENTURY

A second set of images displayed in the Antiquarium Communale was detached from two walls of a structure

excavated in 1943 beneath the Chiesa di San Criso-gono in Trastevere. Three brick stamps of A.D. 134 give a Hadrianic date.[16] Like the Via Genoa paintings, this composition features areas of white ground transparency, but these are confined areas, made to look like windows by a surrounding surface frame of panels in red and gold that in turn serves as the background for a complex projecting architecture consisting of mixed elements: *aediculae* formed of sturdy columns and pavilions colored in a warm golden tone suggesting marble with crisply articulated carving of capitals, cornices, and entablatures. This architecture, resting on a podium, is double storied and will have given the impression of completely structuring the face of the wall. It is not the accustomed kind of Fourth Style schema that confines its perspective apertures to the sides of the central panels, but rather something of greater complexity in which projecting members, pylons, and the tops of curved porticoes, located behind the *aediculae* on a secondary plane, actually invade the white space at the center, thus rendering it ambiguously transparent and denying the presence of tapestries or other accustomed spatial covers. The visual effect, as Joyce described it, is that of looking through a double range of windows.[17] Spatial indefiniteness lends an unsettling appearance to the flying figures located within the architectural frames at the centers of the panels because these figures cannot, in such a fully open space, be taken for tapestries or for statuary, but rather appear to be winging their way into the interior of the room from outside. Equally disorienting, and, at this point, new within the vocabulary of decoration is the figure of an animal, or rather the figures of animals, posed not where we might expect them, atop the surface of the podium, but rather on the very edges of the panels themselves.[18] Novel as they may be, these creatures are not unique; we see their counterparts, along with a smaller fragment of podium and *aedicula* decoration in the remains of paintings taken from a complex on the Via Merulana.[19]

Several comparable images figure in the partially preserved decorations of a small complex near the underground garden room of the Villa at Prima Porta.[20] As part of the Augustan estates this property remained within the imperial family. During the Empire it saw occasional additions and renovations, the last of which, dating to the Hadrianic period, was a suite of rooms positioned at the edge of the hillside overlooking the Via Flaminia. The fact that the surviving walls rise no higher than the dado and lower middle zones is partially compensated by their large number. The group of three rooms, similarly decorated and opening onto a coordinating corridor, can be regarded as an ensemble

of interconnecting spaces. A continuous line of red porphyry unites the spaces; it is sectioned into panels with floral designs. In one room a large predella of white panels contains marine grotesques. Within the rooms the superstructures are symmetrically designed, their architecture based on columns, while the corridor is paratactic. Aside from their uniformity of color, the schemes show signs of the unitary diversity generally associated with a program even if their partial preservation renders its hierarchy merely speculative. In one room the dado forms a podium to support sturdy columns and candelabra. In the other, each wall has a broad, open central zone flanked by bordered panels. That this room might have been a *pinacotheca* is suggested by the lower part of a picture panel supported on a candelabra. Beneath this quadro we see the figures of two bulls, one facing outward, one sampling the grasses of a sacrificial basket; on a facing wall a pair of antelope is similarly positioned beneath a frame from which rustic baskets are suspended. Comparable in size and position to the horse and the bull standing balanced on the panel frames in the San Crisogono decorations, these miniature figures must be taken for art objects rather than naturalistic illusions. Even at the medium height to which the walls are preserved we can sense the spacious impression once given by the combination of airy white backgrounds and rich framing structures.

The use of repeated colors as the primary means of coordinating an ensemble can now be seen in a more fully preserved Roman structure of a contemporaneous or slightly later date. Recently reassembled after many years' seclusion in storage, the decorated rooms of an insula discovered during excavations for Rome's two central railway stations comprise the ground floor of a complex built during the Hadrianic period upon the remains of structures within the gardens of the Statilii Tauri and the Lollii. Brickstamps and inscriptions date both the beginnings of the complex and its later renovation.[21] While the greater part of the ground floor came finally to be occupied by a well-equipped bathing establishment, a triangular configuration of rooms with a hemicycle forming its apex can be isolated as a house. Within this cluster, the designation of atrium has been given to a central space with a fountain impluvium that serves obviously as the single source of exterior light within an otherwise windowless area. It is a shell of space whose broad doorways face towards an enclosure on either side. The line of vision from north to south comprises the main axis with the hemicycle enclosure to the north filling out the line of the building, and a rectangular exedra opens on the south. The vestibular area to the east also affords an axial view across the atrium to the smaller

hemicycle on its opposite side. By Pompeian standards this unorthodox ground plan disestablishes accustomed spatial interrelationships, yet a hierarchy of decorative complexity and richness gives clear indication of the relative status of the rooms, a principle carried out even when the decorations may not be strictly contemporaneous. Eleven decorated rooms of diverse sizes display patterns that, as Paris puts it, are distinctly different in their approach to the manner of interpreting wall division, in some cases suggesting perspective illusion, in others create pure surface decoration.[22] An important factor in the coordination of this ensemble is the boldly stated black-and-white mosaic patterns extending throughout all the rooms; these are carpet mosaics combining vegetable arabesques and geometric designs interlaced with various motifs such as cantherae and birds. Each pattern appears to be coordinated with its particular decoration in that the richest walls stand above the simplest patterns, but the continuity of the paving gives unity to the spaces, which can be perceived in their contiguity through connecting doorways.

Within these parameters, the architectural layout imposes certain requirements. The disposition of rooms around a centrally located space that serves as a light well made the connecting corridors an essential component of the living space; their decoration is appropriately elegant. Frames solidly articulated in red porphyry color stand out boldly against a white ground color. Although continuous, these constructions are not paratactic in design. Rather, as a series of lintels and apertures in varying sizes, they open doorways and prospects into balconies in light scaffolding. From photographs of this decoration in situ one can see how it functioned to mitigate the spatial confinement of the corridors. A viewer facing from one to another end of the corridor would have her spatial vision prolonged, rather than curtailed, by a complex wall with the illusion of expansive window frames and doorways opening in various directions into a veritable honeycomb of spaces. Glimpsed obliquely with its bold red framing standing out from a recessive white background, these corridors might seem as much like architectural facades as enclosing walls. Of course the actual doorways piercing these corridors do give access to interior chambers, the decoration of which they also, by contrast, serve to enhance.

Through the entire ensemble dark porphyry red is the keynote of the color scheme with complements in lighter hues of gold and red, all conceivably marble colors. White areas accentuating the colors sometimes indicate transparency, but, in certain instances, another species of marble veneer. The relative preeminence of one or another of these colors in each chamber had

clearly been calculated with provision for the amount of light each received. In a series of three interconnecting chambers on the south side of the atrium the two end rooms are illuminated only from the corridors; the darker of the two economizes its illumination by a white background setting forth an airy scaffolding, while its counterpart on the opposite side, having more doorways, varies its spatial boundaries by a highly geometrical arrangement of bordered panels and apertures. The panels designate a firm inner surface for the enclosure, beyond which pencil-slim columns support a shallow exterior porch as if a continuous balcony surrounded the space. Both the panels and their columns have a strong resemblance to those of the Prima Porta decoration.

Between these two spaces stands the exedra, whose position across the corridor from the atrium affords a continuous prospect to the hemicycle on the northern side. This privileged location, illuminated by light from the central source, permitted a much darker color scheme richly combining the two versions of red in a dramatic contrast with the almost white space of the atrium itself as well as the encircling corridors. Broad doorways provided for visual interassociation of these spaces, framing their perspectival effects. Of the two rooms the hemicycle was the more grand; it had boasted a marble revetment of panels and pilasters over two meters in height beneath its painted *aediculae* and pavilions, but excavators found the rectangular exedra in a better state of preservation. Here a low marble dado stood underneath a painted podium. *Aediculae* with fluted columns symetrically partitioned the wall surfaces, two on each side. Their pale color stood out dramatically against flanking panels of red. Between the pairs was an empty central panel above the podium, to which there leads in each case a short set of steps that stops at the top. The interior space of the *aediculae* is painted dark with balcony columns visible outside, and animals stand on their frames. The deliberateness of the animals appears in their statuesque poses. Within the decorations of the hemicycle, however, were representations of large-scale human statues, among which Maenads, Satyrs and Dionysus can be recognized. Both rooms had large swirling vine patterns on their floors.

Whereas these large figures within the domestic hemicycle are obviously statuary representations, those in the large chamber that lies transversely across the insula just south of its domestic quarters might seem more likely to represent live human beings, were it not for their improbable location in a painted gallery high above the floor.[23] This "Basilica of the Baths" as Rita Paris has termed it, is even more sumptuous in decoration than the house it adjoins. On all sides a marble

revetment, its profile sculpted by pilasters and panels, rose well above the heads of patrons to a height of 2.6 meters. From here to the vaulted ceilings an array of columniated *aediculae* painted in the same rich harmony of red and gold tones as the domestic exedra segmented the wall into a series of frames and niches that served as a backdrop for life-sized figures of bathers, all of them women in various states of nudity and dress. With their faces turned inward to the wall, these ladies, generally attended by servants, busied themselves in rituals of cosmetics and ablutions to create a kind of theatrical panoply of bathing. A statue of a Marine Venus, stationed in the apse at the western end of the hall, presided over the activities of the room, which, in view of its programmed access from the frigidarium, would seem to have formed the terminus of the bathing route, but in fact the combination of marble dado and the motif of female bathers was consistent throughout the preliminary chambers of the baths. Coordination between the house and *balnea* indicate that the entire insula complex formed a unit, with the decorated rooms most surely belonging to the proprietor whose affluence their furnishings well attest.[24] In view of the feminine bathers, the Venus statue and one of the Elder Faustina in the frigidarium, an exclusively feminine establishment has been proposed, conforming perhaps to a new Hadrianic move to reinforce or "repristinate" the traditional segregation of sexes in the bath.[25] Regardless of its politics, this was certainly one of the private bathing establishments with which we know that the Esquiline was provided, as exemplified by the baths of Claudius Etruscus.[26] Should we think that some of the splendid marbles that Statius and Martial have ascribed to that ambience were likewise executed in paint?

These painters worked elsewhere in the neighborhood. The few rooms of an adjacent insula uncovered in the excavations show their characteristic overlay of panels and columns. Staircases show that both insulae comprised the multiple storied habitations that the writers Martial and Juvenal in particular have led us to associate especially with the population of imperial Rome, but known to us today primarily through many reconstructed examples at Ostia. Given Rome's proximity to Ostia as well as the economic interrelationship of the two places, Roger Ling considers it only logical that the architecture of the port city should reflect that of the capital, quite probably representing the activity of the same workmen.[27] When speaking of these Ostian *insulae*, Meiggs remarks that they appear far more pleasant than the complaints of Juvenal and Martial would lead us to believe.[28] Many are well-built, spacious, and amply decorated with mosaics and paintings, but he also observes that the partitioning of space into individual units is not at all easy to determine. Only in situations where the buildings contain multiple units with identical ground plans does the division seem clear. Within such houses there is an apparent distribution of spaces with certain distinctly larger rooms.[29] Even so the boundaries and divisions of space scarcely remained constant in this continually changing city,[30] and if many of these innovative houses gave signs of accommodation to a comfortable lifestyle, others are notable for their ability to adapt revisionary architecture to the general expectations of the Roman upper-class house. What happens to the Roman house as represented in these few examples is that it comes to resemble Vitruvius' old plan for the Greek house in its manner of organizing a system of rooms off a corridor encircling a paved central space. In the House of the Muses at Ostia, one of the most elegant survivals of the second century, an encircling file of substantial arches screens the corridor and organizes vistas both from within and without the open courtyard.[31] The hierarchical status of the rooms is clearly designated by the relative complexity of the mosaic patterns. From these we see, as might be expected, that the rooms fronting directly on the corridor are more important than a complex reached by a small extension at the side. This is certainly the property of a single owner.

Within this context painting also reinforces architecture by its visual manipulation of spatial planes. The patterns appear to be deliberately varied. A room that John Clarke refers to as a "Hadrianic reprise of the Fourth Style Manner" procures an impression of light and openness by a gold scaffolding opening windowlike apertures on a white ground. Balcony railings project outward, and Dionysiac images float into the empty space.[32] Certainly the Room of the Muses occupies the keynote position. Although of modest size, it is painted with a finesse equal to any period of Roman painting. Projecting columns articulate the symmetrical tripartition of the walls, which is reinforced by the alternation of red and gold panels. These are braced by stretchers located on a plane equivalent to that of the cornice and creating a protected inner shell of spatial enclosure. On these panels are placed the polychrome images of Apollo and the nine Muses that give the room its name. On the end wall Apollo holds a central position against a gold panel. The nine Muses with clear iconographical attributions are disposed against red panels around the room, but behind the middle plane they occupy, colorations confuse spatial perspective. While narrow apertures give a glimpse of further columns, the vistas become inconsistent because, they, like the panels themselves, are painted in alternating colors: red backing gold and gold backing

red. The consequent effect is a visual closing of the wall that reinforces its interior surface plane by making the exterior perspectives seem unreal.

Similar dispositions of columns and panels constitute the common denominator for all these second-century ensembles we have been discussing. The distribution of these from Prima Porta to central Rome to Ostia does indeed suggest that we are looking at representations characteristic of their time. Should we call this spectrum a new form of painting, a genuine "Fifth Style" or view it as a mere series of variations upon borrowings from the earlier repertoire? To this question Ling has given the essentially negative answer that the Fourth Style constitutes the last burst of creative energy in painting whose exhausted impetus dwindled away as the first century drew to a close. All subsequent developments can be seen as nothing other than pastiches of scattered borrowings from past history.[33] Yet perhaps a "burst of creative energy" is not the only criterion useful for defining a phenomenon, at least in cultural terms. For one thing, there is scarcely any artistic production in Roman tradition, either literary or visual, from which reinscriptions of previous history are absent. In his chronology of painting Mau had seen the Fourth Style as nothing other than an intermingling of elements from the Second and Third. Beyond this, however, the period we are considering was one of extreme self-consciousness as concerned its relationship to the past. Unlike the unhappy nostalgia that Tacitus ascribes to persons of the Julio-Claudian and Domitianic eras when tyrannical excesses of the emperors had made the troubled Roman Republic into a vanished Golden Age, the period of Hadrian and the Antonines could cultivate a more relaxed attitude toward past Roman culture. As will be seen at the end of the chapter, this was the flourishing period of the literary and philosophical movement that we call the Second Sophistic with its heavy emphasis on rhetoric and the structuring capacities of words. So perhaps the important aspect of second-century borrowings is not simply their derivative nature, but their manner of combination and the resultant configuration of space. Naturally we will be disappointed if we are looking for anything resembling the Pantheon or the baths and "Piazza d'Oro" of Hadrian's villa, yet at the same time we must recall that painting always serves architecture as an interior phenomenon, lending its capacity for structural fictions to the visual transformation of predefined space. Thus the "planar puzzles" that Joyce defines in the Ostian House of the Muses,[34] with counterparts now to be seen at Prima Porta and the Piazza dei Cinquecento, are also capable of adumbrating a view of reality, less assertive in its spatial possessiveness than the

pavilion apertures of Fourth Style painting, but posing greater intellectual and visual challenges to the spectator. Thus it would seem that investigation of stylistic coherence must involve not merely compositional lineaments or even programs, but rather cultural contexts and assumptions of viewing.

MYTHOLOGICAL ENSEMBLES

Something beyond the mere identification of second-century paintings as Hadrianic or Antonine seems to be needed to make them appear a little less impersonal and abstract. Familiar mythology engages the spectator more intimately. Amid the collocations of planes and scaffolding that comprise the apparently dominant mode of the period, the *pinacotheca* that foregrounds central *tabellae* has not entirely disappeared. At Ostia the House of the Muses incorporates one room of this format, and the Antonine House of Jupiter and Ganymede another.[35] For more extensive installations, however, we can turn once more to some documentary drawings of lost paintings. Although its collocation of paintings was never publically accessible in antiquity, the Tomb of the Nasonii on the Via Flaminia deserves notice both for the complexity of its assemblage and for the public sensation it caused upon discovery. By far the most extensive repertoire of domestic paintings comprises the series of picture gallery rooms excavated two centuries ago within another house of unusual plan located on the Esquiline not too far from the Piazza dei Cinquecento in the area of the villa Montalto Negroni, from which comes its name of "Villa Negroni." By means of its brick stamps this house can be precisely dated to A.D. 134.[36] This dating shows them roughly contemporaneous with another set of lost paintings recorded at Hadrian's Villa in the series of eight mosaic-paved rooms commonly called the *hospitalia*.

During the spring and early summer of 2000, visitors to the National Museum of the Palazzo Massimo were able to experience the painted interior of the the Tomb of the Nasonii in a scale model reconstruction made possible through the digital enlargements of drawings made at the time of excavation by the antiquarian artist P. S. Bartoli.[37] Like the majority of early archaeological discoveries in Rome, the tomb was found accidentally. Workmen cutting road stone at a division of the Via Flaminia north of Rome uncovered the facade, behind which lay the largest cache of paintings that had yet been exposed to view. Almost overnight Monsignor Suares had written a partial description concluding with his interpretation of the paintings as embodying "hidden meanings of fables that symbolize the human soul." To

this a Monsignor Spado attached a melancholy set of elegiac verses reflecting on the disturbance of sepulchral peace and the triumph of art over human memory, yet praising the "animation of ancient coloring that brought life into a prison-room of death."[38] Rapidly spreading news drew sightseers of all classes to the tomb. Not simply the brilliant colors and good preservation recommended the tomb to curiosity seekers, but also an inscription naming the dedicator as one Q. Ambrosius Nasonius. Although scholars such as Suares acknowledged that the poet P. Ovidius Naso who had died far off in Tomis could not be buried here, still, by virtue of the Roman custom of transferring cognomina, others, including the art historian and antiquarian scholar G. P. Bellori, whose complex commentary accompanied all publications of the paintings, was able to attribute the tomb to a branch of the family desiring to honor its great ancestor. Perhaps, he suggested, on the strength of Ovid's mention in *Ex ponto* 1.8.42–6, of *horti* at the intersection of the Flaminia and Claudia, the tomb might even be located within his one-time property.[39]

Behind the open pedimental entrance which gestured toward the closed pedimental facade of the tomb itself, the contemporary visitor entered an architecturally structured shell of space, painted in glowing cinnabar and pierced at ground level by a series of seven arched apertures which, in the original fabric, framed niches cut deeply into the rock itself to contain burial boxes, and which were stuccoed and ornamented with pageant-like scenes composed of multiple figures. These vaulted niches, originally containing space for two sarcophagus burials, at the time of discovery were piled high with the bones of many layered burials. Between the niches, pilasters segment the interior surface, framing a series of young men or Genii standing like statues with flower baskets. The stucco cornice is ornamented with sea monsters.

Between this zone and the vaulted ceiling the frieze zone is composed of twelve picture panels, each one with a separate painting and screened by high Corinthian pilasters with Amorini in a field of cinnabar (Figure 201, pl. III). The floor is white mosaic with a rhomboid pattern, and the vaulted ceiling is divided into a forechamber and apse with a typical complex coffered design of the kind that Renaissance painters had come to associate with the golden house of Nero (Figure 202). A flying Pegasus occupies the central tondo shaped actually as an octagon surrounded by four figures of termini and an outer ring of garlands. Each of the four corner niches frames a pair of designs. In the upper quadri are a series of hunt scenes, while gendered pairs facing flowered finials in the lower part display seasonal iconography.

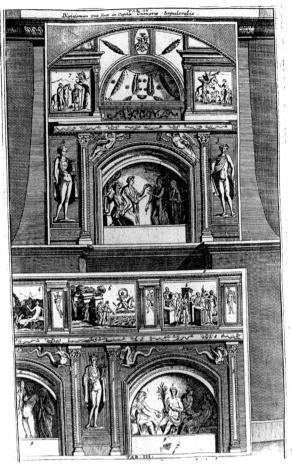

201. Tomb of the Nasonii, end wall. Bartoli and Bellori, 1680, pls. III–IV. Photo kindness of Dottoressa Letizia Abbondanza.

Among the eight of twelve frieze panels recorded, six familiar subjects are clearly identifiable: the Rape of Europa; Hercules and Antaeus (Figure 203, pl. XIII); Hercules bringing Cerberus from the underworld (Figure 204, pl. XVI); the Rape of Persephone (Figure 203, pl. XII); Oedipus and the Sphinx; the Birth of Pegasus among the Nymphs (Figure 204, pl. XX). In the ceiling is the Judgment of Paris. Others are so obscure as to have taxed the ingenuity of scholars over the centuries. The same is true of the scenes within the burial apses, some of which might be explained by mythological allusion and others of which demanded research. All the same, it is not what either seventeenth- or twentieth-century allegorization made of this ensemble that should concern us first, but rather the paintings themselves.

The plane surface of the reconstruction flattens the three-dimensional effect of the vaulted niches; whose deep recession would have indicated the location of their scenes, as opening behind the laid out corpses, in a world beyond the living viewer's reach. These scenes are of presentation and greeting, involving majestic figures

of new family members, these scenes look proleptically into the underworld to allow for anticipatory negotiation with its powers.

Judging the backgrounds of the mythological paintings in the frieze zone is difficult; it appears that Bartoli may have added landscape features as seemed appropriate.[40] Clearly, however, these images positioned over the niches in the flat cornice zone exist in an intermediate space to be understood still as located within the human sphere, but with many of their human and heroic figures representing back and forth commerce with the world of the shades, most obviously Pluto's abduction of Persephone and Hercules' counter abduction of Cerberus. All these scenes are active with many figures in motion whose gestures are even more pronounced and readable than those of the apse pageants. As Hercules with a great show of force begins to raise Antaeus above the ground, Mother Earth turns aside with a gesture of horror, and Athena rushes toward the hero. Europa's companions show startled amazement, while she herself waves cheerfully to them from the sea.

202. Tomb of the Nasonii, vault. Bartoli and Bellori, 1680. Photo kindness of Dottoressa Letizia Abbondanza.

of grave demeanor attentive to each other and often communicating by gestures. Two show Hermes as psychopomp leading veiled figures, in one case before Persephone and Pluto (Figure 205, pl. VIII). The latter touches his chin in a judgmental attitude. Several women, including Persephone, are wrapped in pallae; the men are generally seminude and cloaked in heroic fashion. The location of these scenes on the curved surfaces of the niches would have increased the sense of communicative interaction among the various figures by bringing them more closely face to face. Some of the figures rest on rough stone seats as if the apses themselves incorporated these backgrounds. Marsh reeds in some compositions might suggest that the participants had crossed the Styx (Figure 205, pl. VII). Only in one scene are Pluto and Persephone seated on real furniture (Figure 205, pl. VIII), while the seemingly important rear apse has an architecturally constructed environment (Figure 201, pl. IV). Without forcing any meanings, one might see them as a series of models portraying the various dispositions that might occur to the souls of the dead. Addressed to the viewer who attends for the burial

203. Tomb of the Nasonii. Bartoli and Bellori, 1680, pls. XI–XIII. Photo kindness of Dottoressa Letizia Abbondanza.

204. Tomb of the Nasonii. Bartoli and Bellori, 1680, pls. XIX–XX. Photo kindness of Dottoressa Letizia Abbondanza.

On the basis of these gestures, with aid from his knowledge of classical literature, Bellori went far beyond Suares' remark on hidden meanings concerning the human spirit to construct the paintings into a coherent allegory of the afterlife. For his purposes the keynote of meaning was the assemblage of the rear wall, whose spandrels were distinguished by Victories bearing wreaths; and in whose pageant of figures Bellori saw an image of Ovid as greeted in the Elysian fields by his Muse (Figure 201, pl. III). Flanking panels of the frieze zone that depicted Oedipus answering the Sphinx's riddle, and the winged horse Pegasus carried relevant meanings in that the solution of the Sphinx's riddle highlighted the "frailty of human life" and its inclination toward death, while the winged horse was readied to transport heroes to the Elysian fields (Figures 201; 204). The recurrence of this animal in the center of the vaulted ceiling makes him emblematic of the sun, surrounded by the seasons to whom Bellori assigns a twofold significance in Roman imperial art. Invoking first the numismatic motto of the Empire, *felicitas tem-*

porum, he makes them out to represent the prosperity of the world under good imperial government, but also in funerary art they signify that souls, purged from the world lodge happily in the Elysian fields until through the longest course of the sun they would return again to life.[41] To some panels of less than obvious relevance his classical knowledge provided explanations, as when he finds a rationale for the Judgment of Paris by reference to Tibullus' *Elegies* 1.3 in which Venus welcomes the souls of lovers arrived in Elysium. For the unusual image of Mercury guiding animals he had also an ingenious explanation based on complex and painstaking references to philosophical texts (Figure 206, pl. XIV). But when he came to the hunting scenes, he could not really make them fit his schema and had to content himself with heaping up antiquarian lore (Figure 206, pl. XV). Although the exactitude with which Bellori attempts to rationalize all elements of the Nasonii paintings may stretch credibility, his commentary was among the first of exercises in the interpretation of complex pictorial assemblages from antiquity, and significant

205. Tomb of the Nasonii. Bartoli and Bellori, 1680, pls. VII–VIII. Photo kindness of Dottoressa Letizia Abbondanza.

206. Tomb of the Nasonii. Bartoli and Bellori, 1680, pls. XIX–XX. Photo kindness of Dottoressa Letizia Abbondanza.

for its efforts to arrive at a culturally plausible reconstruction of the mentality behind the assemblage.[42]

No less than the Tomb of the Nasonii paintings, those of the Villa Negroni caused excitement in artistic and historical circles. Discovered in 1777, just within the years when the Pompeian decorations themselves were finally becoming known through the publications of the Royal Herculanean Academy, this structure whose rooms on the ground floor were fully preserved was soon being circulated through a series of drawings made by the architect Camillo Buti. Unlike the Nasonii engravings, these drawings carried no commentary, and indeed their rationale lacked that temptation to reading inherent in the sepulchral ensemble. All the same the sets of drawings in multiple copies found their way into the influential current of decorative sources.[43]

Two steps and a pair of flanking columns comprise the entrance of this house, which dispenses with the extravagance of an atrium and *impluvium* and brings the visitor directly into a small *vestibulum* painted in the manner

of transitional spaces with purely architectural decoration that included a series of three niches housing relief stucco at the rear. Here public and private quarters divided; on the left side was a corridor leading only to the staircase for the upper quarters, and the right-hand route led into two vaulted rooms with narrow doorways. Although these formed the only apparent access to the back quarters, they were not simply passageways but participated fully in the decorative system of the house. Their enclosed nature suggested that they were for winter use. Within the peristyle, a rectangular pool and a two-sided colonnade formed the center for a collocation of variously sized rooms. The two largest, which faced each other across the center of the open area, offered reciprocal vistas across the screen of columns; it is clear that the two columns distinguishing the rear room were placed so as to open a view to its back wall where architectural decorations like those of the *vestibulum* similarly framed a series of three niches with stucco relief. Although Joyce speaks of this space as a *tablinum,* its placement makes it scarcely practical for any of the functions assigned to such a room, suggesting rather that it is intended for use in the warmest season. The two side chambers, covered by barrel and cross-vaults, are interconnecting through narrow doorways.

With the exception of the two paratactically paneled rooms, these decorations were *pinacothecae* with *aediculae* framing large mythological panels. Unlike the small embroidered quadri so frequently seen on the tapestry panels of the Fourth Style, these paintings were on large *tabellae,* some of which filled virtually the whole area of their frames. Aside from acroteria on their gables, subordinate ornaments are sparing and unobtrusive; it is the spatial arrangement that gives character to the walls. The compositions were also unusual in their utilization of lunette space fitted to the area of their cross-vaulted ceilings, as an organic part of their architectural design. The upward projection of the *aedicula* gable into these areas allows for an impression of perspective depth to the spectator viewing as if from beneath. Behind the gables the lunette spaces are open on prospects of rooftops and sky. Thus the screen walls, which are closed and flat in the Third Style manner, appear to stand out against a deeply spacious background. Against this background the *aediculae* project sharply forward toward the interior space of the room, their gables supported in one case by inlaid pilasters and in the other by ornate candelabra style columns (Figure 207). Given the small size of the house, this order can be seen as strategic. Only in the large room is there a difference with an elaborately architectural buildup of projecting pavilions and screen walls that sinks the actual painting and its framing

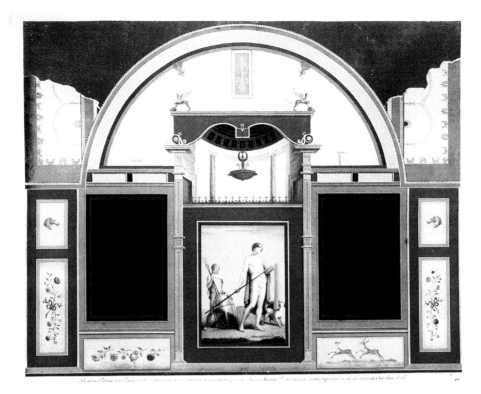

207. Villa Negroni, Room B, Adonis chooses his hunting spear. Buti, 1778–1786 pl. 4. Reprinted by permission of the British Museum.

columns into deep spatial recession (Figure 208). Here in contrast to the other open walls, the architectural structure is closed at its background so that the rear walls terminate the view.

In keeping with the way in which these compositions highlight their subject panels is their thematic concurrence, which relies more heavily on repetition than do the majority of ensembles at Pompeii. Buti found an

208. Villa Negroni, Room D, Dionysiac Room, flute player, Silenus and Maenad. Buti, pl. 12. Reprinted by permission of the British Museum.

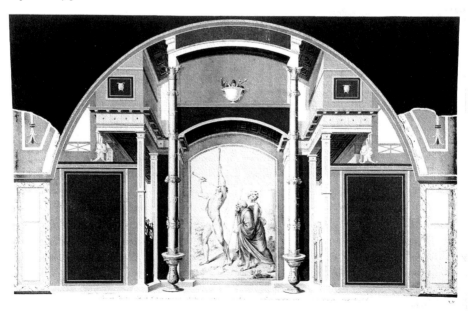

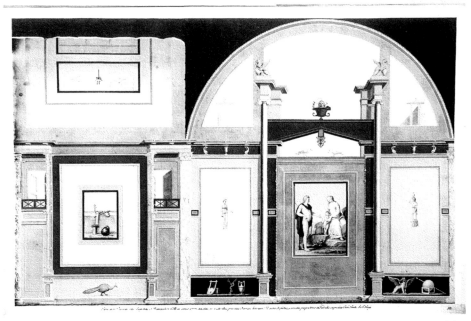

209. Villa Negroni, Room E, Venus, Lover, and Eros. Buti, pl. 9. Reprinted by permission of the British Museum.

ordering principle in the dedication of each room to a particular deity; however, some of these personalities figure more conspicuously than others in their respective chambers. Throughout the house Venus is the dominant personality. In both scenes of Room C she poses by water with swimming Cupids, while the two panels of Room E show her tête-à-tête with a lover and accompanied by a single Eros (Figure 209). The three of Room B refer to her love affair with Adonis. Room G is attributed to Minerva on the basis of a panel in which the goddess stands beside a young man decorating a trophy, but the goddess does not appear in the pendant picture, which shows two women beside an urn placed on a cylindrical base. The large room D, which included three panels, is a Bacchic room bringing together a drunken Hercules with Bacchus and Ariadne and a dancing group of Silenus, flute player, and Maenad.[44] With its leaping satyr and staggering Hercules, the ornate Bacchic room is both visually and thematically the liveliest. Except for the Venus panels with their swarming Erotes, the two or three figure compositions show little dramatic interaction. Especially Venus with her lovers is remarkably passive and quiet. Placing such scenes within a familiar mythological context is difficult. In a sense one might see thematic overlapping as a substitute for interaction within the compositions themselves. The Venus and Adonis triad most closely approximates a narrative sequence since Adonis in one panel is selecting his hunting spear, while in another

he sits with drooping head while the goddess embraces his shoulders. Finally, in the complementary panel, he appears in the guise of an Antinous-like statue (Figure 210). Were it not, however, for the traces of blood in the painting, the seated figure and goddess might be taken for Endymion and Selene. In the Bacchic room the various effects of the wine god give a unitary theme to the paintings. These are festive in the persons of the satyrs, uncontrolled with Hercules, and erotic in Bacchus and Ariadne.

A considerable amount of sculpture was found within the house with evidence that even more pieces, as well as marble floor decorations, had been stripped and looted. Among the pieces remaining were a seated Apollo Citharoedus, now in the Museo Pio Clementino, and a Venus that disappeared into a private collection.[45] There were also marble putti making the statues a reinforcement of the thematic decorations of the walls. From these choices of theme and subject Joyce hypothesizes both a social situation and an owner. As she sees it, a house so consistently decorated with images that betoken a dedication to wine, love, and pleasure must be the pied-à-terre of some cultivated aristocrat, a bachelor and bon vivant, tucked away among the gardens and mansions of the fashionable Esquiline. To which she adds the argument that there is no bath quarter within the plan.

Of course, as both Statius and Martial bear witness and the excavations of the Piazza dei Cinquecento complex corroborate, the Esquiline boasted elegant private bath

establishments in plenty, while the house did have an upper story that could accommodate the practical needs of everyday life. But even if the bachelor and his evenings are a touch of fantasy this is scarcely to deny the cultural associations of the house or the designation of the rooms for hospitality. How fully the paintings belonged within the mainstream of contemporary intellectual life might appear from the similarities between the ensemble and a series of ten mythological panels, long since disappeared, that were discovered at Hadrian's Villa in a series of eight triple-alcove rooms fronting an open peristyle within the residential quarter of the villa, popularly called the guest rooms or hospitality suite.[46] Realistically the function of the rooms is not known, but their importance is signaled by the elaborate central patterns in their mosaic floors,[47] while the tripartite form suggests dining.

Like the Villa Negroni paintings, these are recorded in drawings transmitted through a series of engravings.[48] As their designers show them, they resemble the Villa Negroni paintings in their general outlines, but are unlikely to be the work of the same painters since these figures are actively integrated into full landscape settings of groves, rocks, and other topographical features, while the others position their figures against open backgrounds confining the landscape elements to the lateral borders of each frame. In the absence of any evidence for their actual housings, the paintings can, on the basis of subjects, be seen to belong in thematic clusters of two or three. There are sea-coast encounters between Glaucus, Scylla, and Circe. Minerva appears in two combinations, once with Urania and her globe and again in the mythologically traditional triad with Juno and Venus in a composition that might well be pendant to a seated Paris holding the controversial apple. Venus in one panel appears with Cupid and a sleeping figure in Phrygian dress called Ascanius. If this identification is correct, the situation can only allude to the moment in *Aeneid* 1 when Cupid stands in at Dido's banquet to inflame the passions of the Carthaginian queen. With reference to Roman origins this could be paired with Mars, the Tiber, and Romulus and Remus. Finally a musical pairing occurs in the combination of Apollo and the Muses with a scroll and Orpheus seated with his lyre and charming a triple-headed Cerberus.

What is particularly notable in this series is a visual intimation of conversational interaction among the figures. Wherever characters are grouped or paired, they speak a language of conversational gesture, expressing their interactions by the positions of their hands. Glaucus extends two outspread hands to plead with Scylla, who repulses him by one outwardly turned palm; then,

crouching before Circe, Glaucus holds out one hand to plead on behalf of Scylla, who appears in the distance. Venus extends a protective hand over the sleeping Phrygian shepherd while Mars appears to be giving instructions to the Tiber. Apollo listens and writes at the behest of the Muses. With cupped fingers and an extended index, Minerva engages with Urania in learned debate, but is probably arguing with her sister goddesses. This appearance of signs to clarify interaction, and especially the translation of speech into writing is in a sense paradigmatic of the manner in which the paintings dramatize their encounters. Unlike the typical, theatrically based, heroic painting with which we are familiar wherein a single selected moment points dramatically backward or forward, these panels fix our attention on the single moment depicted as a point of imaginative recreation. What the spectator has to contribute here is not simply information as to what the figures will be doing or what they have done in previous accounts. Instead the spectator uses this knowledge to supply what in the immediate moment they have to say. Thus the moment itself may be prolonged and endlessly embroidered. The emphasis on orality solicits the verbal rather than the visual imagination of the reader.

Nor should this more literary turn surprise us if we think of the intense cultural self-consciousness displayed in the lives and writing of certain persons whom we know well. The many references to literary production and recitation in Pliny's letters show that this form of exchange and entertainment was assuming new proportions within an empire that combined political limitations with an emphasis on sociability. Wallace-Hadrill points out how even his letters of recommendation consistently mention learning as if to make it a major social characteristic of the time.[49] Self-consciousness emerges even more strongly in writers of the Antonine period such as the distinguished lawyer Cornelius Fronto or the antiquarian Aulus Gellius, who was also, in fact, a public servant.

As an active figure in the law courts as well as a correspondent who wrote with an eye to publication, Fronto follows after Pliny, yet many conspicuous differences set apart not only the two men but also their circumstances. In the first place there is the degree of familiarity with the emperor gained through sympathy of common pursuits. Where Pliny's real lack of spiritual companionship with the businesslike Trajan would appear to have limited their correspondence to a series of administrative exchanges, sometimes reflecting policies. Fronto, by contrast, worked with a succession of emperors for whom cultural issues and cultural display were a priority. Although his dealings with Hadrian were for this very

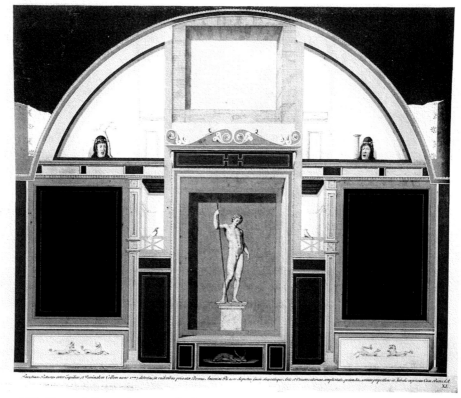

210. Villa Negroni, Room B, statue of Adonis. Buti, pl. 11. Reprinted by permission of the British Museum.

reason precarious, Antoninus provided a more receptive audience, ready with generous praise of the orator's abilities and achievements (Ab AP 2).

Finally, in his capacity as tutor to Marcus Aurelius, he became the literary guide for an intellectually disposed emperor from his youth. Detailed exchanges concerning oratory and history figure heavily in both sides of the correspondence and appear to be the man's primary concern. As Champlin observes of Fronto, "beyond a natural affection for his family it is difficult to find any activity of the orator which does not betray a literary motif. Certain letters are devoted solely to literary matters."[50] They are especially notable in their concern for precision. Fronto favors Cato over Cicero for the meticulousness of his word choice (Ad C. iv.3) Writing advice on Marcus' employment of a simile based on an inland lake within the island Aenarii, he shows particular visual consciousness. He advises his pupil to look at the object as if he were painting it, and then, slipping into Greek, to examine it from multiple points of view. Ultimately this leads to a closer integration of literature and life; the letters are not cut off, but rather one senses literature as a mode of thought. Thus as Champlin remarks, "Rather than gentlemen abdicating the responsibilities of their station in the pursuit of a life of study, we are faced with learned litterateurs of the highest ranks who are deeply involved in the life and conduct of the empire."

Society provides the animating venue for the exercise of such literary exchanges. Pliny always situates literary events within the contemporary social round, making them relevant to his own position as an elder figure on the cultural scene. When he says (Ep. 1.13), "This year has produced a fine crop of poets," he is speaking not merely for himself but a certain level of society among whom poetic productions are shared. Attendance at readings is by invitation. Pliny himself invites friends to hear readings at his own house and also gives readings at other person's houses. He remarks of his friend Titinius Capito how generously he lent his house for readings (Ep. 8.12). Letters about his dinner invitations include the custom of providing entertainment (1.15), and he several times expresses anxiety about the reception of his personal works, both speeches and light lyrics, among members of a discriminating senatorial society. He gives out that the latter were popular and circulated, some of them even set to lyre music by Greeks who learned Latin for that express purpose. All the same, a friend has told him of a conversation in which the propriety of publically exposing his frivolous

persona had been discussed (*Ep.* 7.4). That he treats such levity as a matter of possible cavil, if not genuine censure, makes one wonder just how puritanical the salons of post-Flavian Rome had become. Pliny has two reasons for reading in public, both derived from the salutary effects of interchange. First is the prior anticipation of an audience that can, in itself, put a writer on his mettle, and the second is the actual give and take of criticism and suggestion that follows. Nothing is worse, he remarks, than hearers listening in silence without response (6.17). Although his remark pertains to someone else's performance, one wonders, in view of Pliny's habitual defensiveness, how easy it might have been to criticize him.

Fronto's conversational manner makes correspondence into a form of performance art. He dramatizes not only his content but also the act of writing by admitting his reader to the thought process. Writing a recreational speech intended only to exhibit wit and give pleasure, Fronto speaks of incorporating *fabulae* of gods and men, but, seeking a topic that has not been previously overworked, he chooses to eulogize the divinities of "dust and smoke" essential to the operations of altars, hearths, roads, and paths (Amb. 249.7). His letter frames oratorical performance by commenting on the method and characteristics of its composition and the probable response of its audience as if it were a preface, yet in itself it comprises what it promises.

Even Aulus Gellius who ascribes the composition of his literary miscellany *Noctes Atticae* to solitary rural nights in winter incorporates a sense of occasion and social intercourse into his written interrogations of the past. Although he describes his habit of excerpting from books while reading as a private activity carried on to aid future memory, and his reassembling of the excerpts as a playful mode of self-entertainment, he assigns an outwardly directed purpose to his work (*Praef.* 3–4). Gellius defines an ideal reader whose critical qualifications are ready talents and desire for cultural self-betterment. His own children, he says, are the primary audience for whom he aims to provide relaxation amid their business affairs, but the scope of designated readership extends to all persons busied with duties who are inclined to dedicate their leisure to improved contact with the liberal arts (*Praef.* 4). To this end he highlights the selectivity of his compilation. Having turned his own leisure into labor by scrolling through uncounted *volumina* to amass his storehouse of learning, he has abstracted only what he thinks useful and readily accessible to understanding. Method excuses a lack of rigid structure. The rambling, unsystematic manner that conveys a certain idiosyncrasy on the work can be seen as a structural imitation of

otium, a deliberately created atmosphere of free choice that reaches from writer to reader.

In spite of its proceeding from one man's solitude to that of another, this monologue simulates orality and recaptures dialogue, embedding social intercourse in conversations that spring from a particular occasion or provocation. Recollecting or reenacting Greek *symposia* and *peripateia,* dinners and walks are the most frequently created venues. In the course of a dinner an oil bottle refuses to flow. While the disconcerted serving boy goes out to remedy the failure, the discourse among the diners explores principles of liquidity ranging from oil and wine to fresh- and seawaters. While walking in the courtyard of the baths, the philosopher Favorinus and his disciples tease out possible meanings for Sallust's puzzling statement that avarice fosters effeminacy. In the course of a birthday dinner hosted by a young equestrian at his country villa, the Spanish rhetor Antonius Julianus defends the integrity of Latinate culture by performing in the symposiast manner a series of epigrams written during the early first century B.C. (19.9). By recapturing dialogue, Gellius embodies his own stated purpose of stimulating social intercourse. Many of the dialogues that he conducts on behalf of cultural memory reach back to ancient authors through criticism and correction of their own texts. Even these have a kind of interchange about them, but there are also certain reminiscences of the lecture hall.

The compendiary manner also by its irregularly constructed nature and its moving from one topic to another interweaves the present with the past. Correcting the social debility of ignorance is a major aim; but the various essays have the multifold purpose of recalling the past in order to keep it in memory, to enrich the present, and to recover lost knowledge by which the errors of the present may be corrected. Archaism purely for its own sake is undesirable (1.10). Also the past is not perfect. Both its sentiments and its usages may be criticized, but also the history of interpretation may be criticized for faulty assumptions and applications (2.16). Vergil has not in some cases erred; instead his interpreters have misread him. Especially Gellius' searches to recover meaning engage the present actively with the past. Thus Antonius Julianus, when challenged by his fellow diners to defend Roman literary traditions against the Greek revivals that they consider more sophisticated, makes his recitation of amatory epigrams into a ritual recreation of the past. Reclining, with covered head as befits (he says) the risqué character of the subjects, and softening his vocal tone, he seems to create a sophistication of manners to accompany literary sophistication. Where Fronto addressed a society, Gellius here reanimates one.

Rhetors and the second sophistic thinned the boundaries of cultural past and present in the attempt to create wholeness and continuity, while remaining concomitantly aware of temporal distance as a vantage point affording the opportunity for an overall cultural control.[51] Sophistic mimesis ranged from embedded quotation of lines or phrases intended for recognition to such creative transformations as Lucian's remaking of Polyphemus and Galatea in his *Dialogues of the Gods*. Anderson comments on the self-consciousness of cultural recreation with its opportunity to question past authority, to reinvent, and recombine. This was partly because the works of antiquity were themselves temporally equalized[52]:

a world in which the fifth century has been relocated somewhere in the vicinity of the Trojan War since we still find Homer cheek by jowl with Socrates. The Homeric Olympus is above, the Homeric underworld below, but the Phaedrus charioteer can take the soul at will from one to the other. And at the center of this universe is the rhetor or sophist, depending on how he chooses to style himself, receiving the admiration of all and transporting them wherever they ask to go. Communications are direct; he can ask Homer or Socrates directly to put him right on details; he can expatiate on the situation at Thermopylae or describe the cave of Calypso.

Among the fullest illustrations of a rhetor's intimate verbal and imaginative engagement with the historical-mythological past, and certainly the one most pertinent to such pinacotheca decorations as those in the Villa Negroni or Hadrian's hospitalia, is the collection of sixty-five essays called *Imagines* purporting to describe the actual collection displayed in the picture gallery of a Neapolitan villa written during the early third century by Philostratus, an Athenian educated sophist from Lemnos. While ekphrasis based on works of art is as old as Homer's *Iliad,* still it becomes increasingly common in writings of the second sophistic and frequently figures in novels. As one famous example in Achilles Tatius' *Leucippe and Clitophon,* the elaborate description of a painting, the Rape of Europa serves by a texture of complex parallels and divergences to preview the story line itself, creating space for the reader's critical judgment of the way in which it is interpreted. In the *Eikones,* however, the descriptions are generated from their own narrative context as performances in a manner that highlights their verbal potentialities as a paradigm of articulate response. Given this element of dramatic presence that renders Philostratus' gallery no less representative of a society than the material installations we have been considering, his narrative will serve as an appropriate conclusion,

and one whose Neapolitan setting returns us, if not to Pompeii, at least to the world of Campanian.

PHILOSTRATUS PERFORMS PICTURES

Philostratus enforces the spectatorly quality of his descriptions by adopting a visitor's role. On the occasion of the Neapolitan games, as he tells us, he is lodged in an opulent villa on the Neapolitan sea coast boasting a "*stoa*" built on four or five open terraces turned toward the sea. Although the walls are clad with a rich variety of marbles, they are more rightly distinguished by the sequence of sixty inset pinakes they display. Philostratus praises the judgment of the collector who has assembled the skills of many artists. As the visitor moves back and forth through the galleries the juvenile son of his host asks for his interpretations of the pictures, which he promises to deliver once an anticipated group of young men will have assembled. These preliminaries mark the occasion as rhetorical performance and the sketches as models for formal ekphrasis. The fiction of the visit also enforces the orator's skills in speaking with minimal preparation. Above all the fiction of performance is critical in constructing the reading audience as a stand in for the fictive real audience. In fact Philostratus emphasizes his equation of the real and fictive receivers by focusing on the ten-year-old boy as the theoretical first audience to whom his remarks are addressed while instructing the overhearers, or secondary audience, to follow carefully, to question, or to disagree.

In the introduction Philostratus claims production of truth as a capability of painting. He places particular emphasis on color, which not only brings out distinctions of light and shade but also provides means for the expression of emotions and for the elaboration of ambience. Color, which figures in rhetorical theory as the final articulation for shades of meaning, provides here the tools for perception as reexperiencing. Following the rule of showing not telling, the speaker shows his listeners what they see in a manner that makes seeing into experience.

Reexperiencing takes different forms. In some cases Philostratus deals with his subject in a literary manner by weighing the authority of the painting against that of a presumed source. The very first image where Hephaestus attacks the River Scamander takes rise explicitly from an Homeric scene. Here the rhetor serves as a mediator of the artist's performance, justifying interpretation. Conversely, but not inconsistently, his presentation of Neptune's rape of Amymone accentuates the non-Homeric identity of the scene by initially invoking an Iliadic vignette of the god in all his monarchical splendor,

only to cover it – or erase it – by his actual image of the erotically minded deity pursuing a maiden. In some other cases he creates a wholly new textual presentation. The figure of the fish god, Glaucus Ponticus, is framed within an epic narrative that shows him as an apparition rising before the amazed eyes of the Argonauts (2.15). Readers of Apollonius' *Argonautica* (1.131) might recognize the incident but not the details. At other times the viewers' theatrical recollections come into play, but often with emphasis on what the stage does *not* show. The violent scene in which Agamemnon and many of his followers lie in their blood as Clytemnestra raises her weapon against Cassandra (2.10) show a great tragedy enacted within a brief stage of time, but also, as a painting, "has more in it to be seen than a drama." In giving life to another violent scene, the Madness of Heracles (2.23), the rhetor notes how the painted hero has internalized the Fury, thus rendering invisible that choas of emotion that "you have many times seen on the stage." Allegory enters frequently into interpretations, sometimes depending on extraneous knowledge but often accessible through details themselves. Every detail in a painting of playful Cupids exudes suggestive sensuality. Details also make emotions visible in terms of projected action. Amymone flees the approach of Neptune (1.8), still unaware that she is the object of his love. Trembling she drops her golden pitcher while her pallor betrays fear, an instance of the significance of color. Pasiphae gazes at the white bull in eagerness to embrace it (1.16). These anticipatory explanations solicit knowledge, which in some instances is supplied by additional scenes. Pasiphae's bull pursues his own bovine love, thus baffling any salacious expectations that the voyeuristic reader might harbor, but the affair of Neptune and Amymone looks further ahead. "Let us withdraw, my boy and leave the maiden," says the rhetor while he pictures a bright wave arching above the "marriage" as the clear water takes on a purple hue.

The rhetor also presents rubrics to encourage verbal participation. Amphion moves the Theban stones by singing; after a certain amount of mystification, we are told to imagine a song of the earth. Glaucus utters some unheard oracle, but the kingfishers circling around him are singing of the deeds of men. Face-to-face with Orpheus, their singing exemplifies the music of the sea. When Polyphemus serenades the nymph Galatea, his song, being indirectly borrowed from Theocritus, takes us back to literary sources (2.18). Olympus 1.21 plays flute music to a silent pool, while his mirrored breast may be thought to harbor meditations on music. Water rippling in reflection of his thoughts draws together subject and image. Narcissus, however, remains partly

unfathomable (1.23). Unable to determine whether the panting of his breast remains from the exertion of his hunting or is already the panting of love, the speaker confesses inability to enter into this deluded mind by words. Through such explanations the images are either opened or closed to the spectator. As Anderson says generally of second sophistic discourses, they cross limits of time and enter into intimate familiarity.[53]

Neither in scope nor in inclusivity are the panels uniform. Differences intimating compositional and stylistic diversity lend variety to the discourse. These might easily bear out the rhetor's initial statement that the gallery displays the work of many painters, but, no less plausibly, we might attribute the differences to the varied resources of knowledge and imagination that a spectator can bring to bear on the subjects. While the contents of some panels solicit the imaginations of the audience to engage themselves emotionally with persons experiencing moments of dramatic intensity, others incorporate spatial dimensions that appear to exceed the limits of graphic probability. Some do this by adopting the familiar form of continuous narrative whereby two or three representations of key figures suffice to indicate sequential dramatization of a story within a confined setting. This, for instance is the case with the figures of Chiron and Achilles reduplicated within a landscape that includes both the entrance of the centaur's cave and the plains outside where the young hero practices horsemanship astride the centaur's back (2.1). Within an even more panoramic setting, two stages of the story of Pentheus show the Bacchic sparagmos on Cithaeron and the sobered women lamenting along with Cadmus and Harmonia outside the palace at Thebes (1.8). Such compositions are nonetheless fewer than might be expected while many others deliberately manipulate the attention of the audience in a spatial sense. So there are narratives with apparently multiple settings, such as the story of Hermes (1.26), whose early life unfolds in a linked series of events staged in appropriate places. In what is essentially an epitome of the Homeric Hymn to Hermes, we see the baby god escape his swaddling cloths and descend to the foothills of Olympus where Apollo's cattle are grazing. A bright and colorful landscape reacts to the charismatic presence of the divine actors moving through it.

Although it is marginally believable that one frame could contain the full Olympian topography from summit to base required for the three consecutive actions of this narrative, the contents of many pictures unquestionably exceed what a single panel could show. This is certainly the case in the geographic panels such as "Islands," which constitutes a virtual periplus among

a small cluster of places each one inhabited by active persons engaged in characteristic pursuits (2.17). In his discourse on the Homeric Scamander scene the rhetor asks his spectators to look away from the event, but then summons back their attention to appreciate the realization of a comprehensive landscape of Troy. Sometimes, too, he surprises us by a meticulous attention to probability. Coming to the story of Perseus, he begins with a cryptic denial based on the colors visible in the painting (29.1). "This is not the Red Sea, nor are these persons inhabitants of India." Answers lie in a story line that should be familiar to the viewer; the dark persons are Ethiopians and the water is red with the blood of Andromeda's slain monster. Should the reader be wondering how the painting of Amphion building Thebes can represent as is claimed an actual animation of stones, the perfectly logical answer comes at the end of the description when we hear that the wall is in three stages of building. Naturally such tricks with the reader's vision and imagination accentuate the limitations of the image, placing its credibility at odds with its probability. The resultant paradox of assertion and denial renders naturalism as a construct within the reader's own perception.

Given the way in which Philostratus' commentaries frequently engage literary texts, one may naturally ask whether a similar kind of interaction characterizes their relationship to pictorial traditions. While the gallery itself may be fictive, its contents might conceivably reflect contemporary examples familiar to the rhetor. If indeed this is the case, then we must conclude that traditions have expanded and altered during the century following the burial of Pompeii. Comparing Philostratus' repertoire with extant subjects, one immediately notices how very few close coincidences there are: of the thirty-one images in Book 1, only seven mythological personnages overlap with known paintings: Amymone (8), Ariadne (15), Pasiphae (16), Pentheus (18), Olympus (20 and 21), Narcissus (23), and Perseus, (29) to which may be added the genre images in 1.6 of sportive Cupids engaging in myriad erotically metaphorical activities such as wrestling and hunting. Among the thirty-four images of Book 2, only the Education of Achilles (2), and the Cyclops (18) have counterparts within the known repertoire. Of all these, the brief moment actually described in the Amymone panel in which the confused Danaid drops her golden pitcher is the one instance that might be taken to replicate a known painting, one of three scenes centered on nuptials in the Fourth Style *pinacotheca* of the House of Fabius Rufus (Figures 211 and 212), but even here there is a difference between the seated god of the picture and the more active pursuing lover of the ekphrasis.[54] Among the other overlapping

topics, Theseus and Ariadne has the most details parallel to known Pompeian versions of the myth. Theseus sails away on his ship; Ariadne sleeps in a posture to be seen in several paintings. Her bared breast, bent neck, and raised elbow are features familiar from visual representation. What is unusual is the juxtaposition of the two lovers, Theseus and Dionysus, with the first of these still sufficiently visible on board his vessel that the viewer can see the expression on his face.[55] A gentle Dionysus who has tamed his rout to approach the sleeping woman appears in several Pompeian representations: the House of the Vettii, Casa del Citarista, and House of Caecilius Jucundus, to mention a few, but neither Theseus nor even his sails are to be seen in these. Once again the House of Fabius Rufus presents the closest parallel; the Dionysus and Ariadne that is pendent to the Neptune shows a small image of the departing ship visible on the horizon, but this Dionysus is accompanied only by his leopard and Ariadne is not asleep.

Philostratus' renditions of other myths in the known pictorial corpus present even more singularities of content or composition. Daedalus and the wooden cow made for Pasiphae are shown within the craftsman's workshop, with Cupids aiding the carpentry work still in progress, but Pasiphae roams outside in the cattle yard, desirously eyeing the bull. Philostratus' Galatea floats on the waves making her billowing mantle into a sail, but Polyphemus is not solitary. A veritable community of Cyclopes populates the background of the picture. The education of Achilles (2.2) is not at all modeled on the famous statuary twosome that had seemingly served as a model for the paintings in the Herculaneum basilica and the Casa di Adone Ferito, but is a composite scene involving hunting and horsemanship in an open landscape. Analogously the youthful flautist Olympus, whose musical tutelage by Marsyas (or Pan) was the theme of a second sculptural imitation frequently paired with Chiron and Achilles,[56] appears here in two very different attitudes. In 1.20 he lies sleeping just after Marsyas has gone away from him, whereas his posture in the following description resembles the traditional Narcissus as a solitary figure whose image is reflected in a pool within a woodland setting. The Cassandra shown in this gallery is not prophesying but already caught within the trap of Clytemnestra. Not Perseus, but Eros unfastens Andromeda's chains while the weary hero, sweating and panting lies on the grass receiving the rescued maiden's grateful smile. Rather than riding her accustomed dolphin as she listens to Polyphemus' singing, Philostratus' Galatea here sports on a peaceful sea in a chariot drawn by four dolphins and accompanied by a chorus of nymphs.

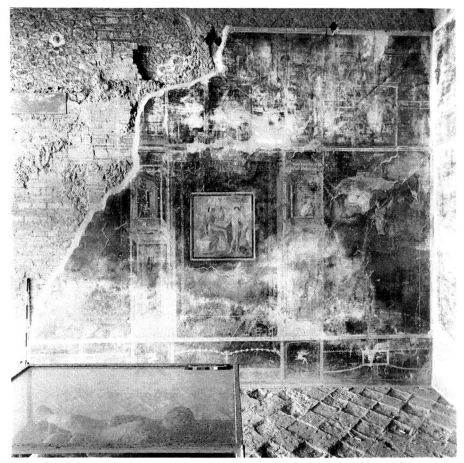

211. Pompeii, Insula Occidentalis, House of Fabius Rufus, Black *Pinacotheca,* north wall, with Neptune and Amymone. ICCD N45100.

Thus while coincidence of images, when it does occur, can suggest the circulation of a standard type of painting, yet its absence is not correspondingly significant because there is no guarantee that paintings like those described did not exist. By this token the substances of the real and the fictive are inseparable, and consequently the credibility of Philostratus' presentations and their reliability as evidence provoked serious scholarly debate during the early part of the twentieth century. While Wickoff took the presence of multiple stages of action in many of his panels as literal testimony to an advanced stage of continuous narrative development on the verge of late antique style, Swindler wholly dismissed his examples as dubious.[57]

More recently the terms of the debate have broadened to encompass the status of the entire gallery as a reflection of contemporary custom. While claiming reliability for his recreation, Philostratus operates to convey an overwhelming impression of plenitude. Within this abundance, some readers and scholars have attempted to grasp a palpable order by one or another contextual

formulation. Goethe approached the challenge thematically by distributing their topics into nine categories that he ranked within a heterogeneously romantic and classical hierarchy in an order of descending semantic status from heroic and tragic subjects chiefly involving death to scenes of courtship and representations of the deeds of Heracles. Trivial xenia occupied the bottom of the scale, while landscapes ranked just above them and real-life or genre scenes formed the middle range. Curiously enough, in view of Goethe's own scale of values, art and music were relegated to seventh position.

Building on this need for category, Karl Lehmann found that Goethe's abstractly thematic classifications failed to satisfy his art historical desire for authenticity. Instead he visualized a more literal thematization in which the paintings would be disposed throughout rooms with four walls. Thus distributed and categorized, a series of primary or noble subjects occupied a center ground, while minor themes were either concentrated in clusters or located in a higher zone in frieze position. As a principle underlying this rearrangement, Lehmann

284

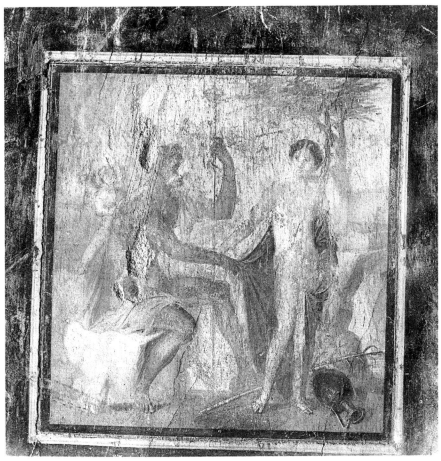

212. Pompeii, Insula Occidentalis, House of Fabius Rufus, Black *Pinacotheca,* north wall panel, Neptune and Amymone. ICCD N45113.

hypothesized a conceptual narrative that would have been clearly accessible to the real ancient viewer and that, as he argued, the rhetor's emphasis on engagement with the subject had concealed. In fact this museum model with its four walled exhibition rooms violates Philostratus' own rubric, which clearly declares that the gallery occupies four or five successive terraces turned toward the sea and open air. No matter whether we consider Philostratus' gallery as authentic or fictional, we should imagine its arrangement as paratactic in the manner of such latter-day peristyle *pinacothecae* as those in the houses of the Vettii, Dioscuri, or Meleagro. Even the sum of sixty may not seem so many if we recall that the peristyle of the Casa di Meleagro displays twenty-seven mythological panels along with minor subjects.[58] All the same we cannot fathom his assumptions concerning the relative sizes of the paintings or their positions on the wall.

Given that these fundamental questions of status remain undecidable, and beyond this our ability to imagine precisely what kind of arrangement, if any, Philostra-

tus may have had in mind, one may conceivably ask whether his ekphraseis are useful in any category of analysis that pertains to the social significance of Roman painting during the middle Empire. The answer must lie in presentation. Lehmann himself had criticized Philostratus' descriptive method because it placed more emphasis on audience response than on composition.[59] Bryson faults Lehmann for the manner in which his construction takes the text of the *Imagines* out of its author's hands, thus disavowing the technique of personal control over subject that is endemic to ekphrasis. Aiming in the manner of Wincklemann to breathe "new life into dead ashes," he converts the Neapolitan gallery into a modernist exhibition space while constructing the anonymous owner as a super-patron or a custodian of culture who preserves a fragile heritage amid a dark century of crisis in the history of ancient painting.[60] While characterizing Lehmann's scholarly hermeneutics as the opposite of interpretation, Bryson regards Philostratus' discursive emphasis as a revelation of "codes of viewing in a remarkably pure form." From his perspective

the positivistic status of the paintings has a bearing on only one aspect of their significance: the question of whether their codes of viewing were in fact anchored within the context of actual Roman art production. Finally, building on this concept, but with a stronger orientation toward cultural than toward aesthetic norms, Elsner characterizes the *Imagines* as a "normative text about how to naturalize the 'other' of art into one's social and ideological context, but one that places its viewer in a position of power."[61] This kind of subject-centered reading suggests a shift from status concern to the kind of personal self-cultivation propounded for the second century by Foucault. Conceivably we may approach most closely to Philostratus' interpretive intervention if we imagine the script on which he elaborates his fullness of setting and interaction of figures to be little different from the gestural communications of persons in the panels from Hadrian's Villa or the enigmatic inactivity of certain mythological scenes in the Villa Negroni.

In spite of these unanswerable questions, it seems appropriate to conclude this study with Philostratus for several reasons. First, the problems he raises are a salubrious reminder of the uncertainty that dogs any attempt at recreation. Second, his rhetorical animation of visual texts as discourse enlarges our own understanding of the potential of mimetic naturalism. Beyond this, however,

is his importance to the history of art itself. As Bryson points out,[62] the books of *Imagines* comprised the preponderance of all that Europeans would know of classical painting until the discovery of Pompeii. Many Renaissance artists followed Philostratus' descriptive outlines in the unquestioning belief of recapturing genuine classical models as, for instance, Galatea with her nymphs and her dolphin chariot. In no known ancient representation has she any such panoply, but transmitted by Renaissance literary traditions, she achieves precisely this triumphal status in the panel Raphael painted for the Villa Farnesina.[63] In the aftermath of subsequent archaeological discoveries, Philostratus was often invoked as a parallel and model against which the sources and history of Campanian subjects might be examined.[64] Not only, however, was it the idea of the antique, but also how to approach it in general that later centuries owed to Philostratus. Along with Pliny's mimetic naturalism, Philostratus' mode of bringing the subject to life though his creation of a vicarious experience for the reader provided a model for the first stages of art historical writing, important to Vasari and his successors in the descriptions of contemporaneous art, especially when its classical affinities stood to be proven. By this technique of reconstructing art as discourse he provides, pace the Elder Pliny, another means by which the painter becomes "the common property of the entire world."

NOTES

INTRODUCTION. THE WORLD'S COMMON PROPERTY

1. Vasari's *Vita di Giovanni da Udine* is the primary source. See Marini 1991, 1104–5, and for discussion Dacos 1969.

2. Mau 1904 (25–39) includes a brief history of early excavation; Corti 1963 provides a more detailed narrative but both are now superseded by Parslow 1995, whose research, centered upon the contributions of the Swiss engineer Karl Weber, brings new documentary evidence to bear upon the procedures and discoveries of the campaigns.

3. Praz 1968, 70–90; McIlwaine 1988, 90. With reference to British country houses, Beard 1978 (10–14) surveys the interior designs of Robert Adam and (23–4) discusses the auxiliary painters Antonio Zucchi and Biagio Rebecca, who executed medallion and panel designs. Parissien 1992 treats especially Adam's ceilings and furniture, tracing his influence from the eighteenth into the nineteenth centuries. For Angelica Kauffman's individual achievement and her influence on the minor arts see Roworth 1992.

4. Allison (1991, 79–84) describes her experience as consultant in the decoration of a house in Sydney, Australia, for which Second Style patterns, many belonging to the Villa Oplontis, were employed.

5. Ashton 1983, 115; 147; 154. Bruno 1993a, 235–55.

6. Goethe 1982, 189. It took a visit to the Royal Museum at Portici where the sculpture, instrumentum domesticum, and detached paintings were being housed to quicken his imagination so that he was "vividly transported into the past when all these objects were part and parcel of their owners' daily life."

7. Grell 1982, 44.

8. Twain 1875 (1996), 329

9. Cited in Reinholt 1984, 276.

10. See, e.g. Ling 1991, 2.

11. Bulwer–Lytton 1834, 34.

12. Bulwer–Lytton 1834, 259.

13. Braudel 1992, 547.

14. Mouritsen (1988, 26–7) criticizes efforts to animate Pompeian society by recovering individuals rather than social structures. It is in fact the structures that painting serves, and it thus is fitting that these should supply our first point of reference.

15. Andreau 1974, 304.

16. Goethe 1982, 189.

17. Gjerstat 1966, Vol. IV.2, 405–7: The stucco is painted in black, red, white, and yellow bands and fields.

18. Carandini 1990c, 97–9, 4.2, reconstructs interior walls of the house that he dates to the sixth century B.C. on the model of the Tomb of the Bulls in Tarquinia.

19. Isager (1992, 118) makes the point that such early Italic art was likely to have been influenced by Greece and Southern Italy.

20. Rouveret, 1987–9, 106–7, reviews evidence for Greek historical painting and particularly the examples from Macedonia that will have appealed to Roman aristocratic victors. She also categorizes the several kinds of triumphal painting that developed over the years.

21. Weigel (1998) has kindly supplied me with this reference as included in his paper "Roman Generals and the Vowing of Temples, 500–100 B.C.: A Prosopographical Study."

22. This is one of the cases of deceptive naturalism where crows descended to perch on tiles.

23. Gruen (1993, 84–130) describes the occasions, the dispositions, and receptions of artistic booty.

24. On the architecture see Strong 1994, 15, but more specifically L. Richardson (1992, 315, s.v. *Porticus Metelli*), who notes that this was the first Roman *porticus* with multiple wings. It enclosed two temples and was later superseded by the *Porticus Octaviae*. Rouveret (1988, 436–8) brings out the theatrical character of the display.

25. For example, Polybius (9.10.1–12) includes paintings in Marcellus's *spolia*; Livy (38.9.13) mentions *tabulae pictae* along with bronze and marble statues in the booty Fulvius Nobilior brought from Aetolia.

26. Gruen 1993, 70–1.

27. Gruen (1993, 85–6) brings out the elements of fictive stereotyping in the general charges of Roman boorishness, and specifically in the case of Mummius, 123–9, who was genuinely an appreciator of Hellenic art.

28. Rouveret 1987, 437–44.

29. Gruen 1993, 84–104.

30. Strong 1994, 14–16.

31. Richardson 1992, 318–9, s.v. *Porticus Pompeii*. Among the paintings were Cadmus and Europa by Polygnotus, a Sacrifice of Oxen by Pausias and Alexander by Nicias.

32. Becatti (1956, 199–210) assumes that all evidence pertains to the library established in the *Atrium Libertatis,* but La Rocca (1998, 203–74) argues that the primary housing for the sculpture collection was in *horti* situated where Caracalla later established his baths.

33. Richardson 1993, 312, s.v. *Porticus Argonautarum*.

34. For detailed reconstructions and complex readings of the politics of Pompey's theater, see Coarelli 1971–1972, and Sauron 1989.

35. Laidlaw 1985, 313–18.

36. Mau 1904, 64–7.

37. De Vos 1979, 50–1.

38. For repairs and building history see Mau 1904, 84–5; for pictures Mazois (3) who misidentifies it as the Temple of Venus.

39. Pagano (1996, 238–43) proposes this identification, while locating the real Basilica, also financed by Balbus, next door. That was the apparent location for a series of statues of Balbus' whole clan: his parents, wife and three daughters, commonly attributed to the so-called basilica. Najbjerg (1997), who also accepts this identification for the Basilica, attributes its construction to the Augustales whose seat was across the street.

40. Martyn and Lettice 1773, xiii; Waldstein and Shoobridge 1908.

41. Richardson 1992, 340–1, s.v. *Saepta Julia.* Pliny (36.30) gives the information that the identities of the artists are disputed, but the statues are so prized that their custodians are considered responsible for their welfare *cum capitali satisdatione*.

42. Little 1964, 390–5, but see explanations by Gury (1991, 97–105), who questions the identity of the building as Balbus' "basilica," but stresses the ways in which the municipal magistrate had alluded to Flavian achievements and subtly likened his own family to the ruling dynasty.

43. Etienne (1993, 345–50) questions this identification, seeing rather an Augustan *sacellum* where *Augustales* also participated in cult; however, Pagano (1993, 233) retains the identification as a *sedes Augustalium* (seat of the Augustales).

44. Moormann 1983b, 175–77; Pappalardo 1993, 91–5, builds a program on these themes, shifting the emphasis to civic virtues and imperial prosperity as represented by the transformation of Achelous' horn into the cornucopia.

45. Barringer 1994, 149–66, and figs. 1–5.

46. Mazois 1824–38, Vol. 1, 60–6: "Once it was thought that the twelve pedestals [of the central tholos] held representations of the twelve gods, but nothing in the decor favored this. Later it was thought that the place must be intended for great public feasts." Gell (1832, Vol 1., 48–9) located the seat of Pompeii's freedman College of Augustales here. This notion was actually fostered by the discovery around the tholos of the fish scales, which finally resulted in its identification as the public market enclosure.

47. Coarelli 1972.

48. Rouveret 1988, 276–8.

49. Pedley 1990, 102–08; Pontrandolpho and Rouveret 1992, 153–62. Tombs from the fourth century onward were sex-differentiated on the basis of grave goods.

50. Pedley 1990, 102; Steingräber 1991, 24–5; Pontrandolpho and Rouveret 1994, 42–51.

51. Pontrandolfo 1996.

52. Denzer 1962; La Rocca, de Vos and de Vos 1976, 279–80; L. Richardson, 1988, 362–3; Whitehead (1993, 305–7) notes the similarity between the some of these painted motifs: tomb gifts, gladiatorial contest, funerary banquet, and the self-promoting imagery of the fictive Trimalchio's planned tomb in *Satiricon* 71; however, Mols and Moormann (1993–4, 40–52) argue that the paintings uniformly represent the lifetime activities of the young aedile as posted by a family wanting to preserve the memory among their fellow citizens of their first distinguished member.

53. Robert 1878; di Mino 1983.

54. La Rocca 1984.

55. Bryson (1990, 35) points out how this happens generally in all modes of painting, and not merely within one or two given periods: "In each style what is actual (the experience of local interior space) is invaded by a principle of irrealisation or fiction."

56. As Lucilius, a satirist of the late second century B.C., remarks concerning superstition, "only pre-verbal children believe that bronze statues are real men" (Frg. Krenkel 492–3: ut pueri infantes credunt signa omnia aena/vivere et esse homines").

57. Perrin 1989, 327.

58. Diogenes Laertius 9.48, gives the reference. Pollitt (1974, 240–5) discusses references to his comments on perspective in *skenographia*.

59. Surveys in Jex-Blake and Sellers 1976, xiii–xciv; Pollitt 1974, 9–111; Rouveret 1989, 303–460.

60. Jex-Blake and Sellers (1976, lxxxii–lxxxiv) propose that Varro's treatment, like Pliny's chapters on art, constituted part of a larger and more general book.

61. Isager 1992, 24–5.

62. Isager 1992, 15–16; Beagon 1992, 26–91; Conte 1994, 67–104.

63. Beagon (1992, 63–91) discusses the moral ambivalence of progress in its liability to corruption.

64. Gombrich 1969, 116–18, 139–45.

65. Rouveret (1987) brings out the important role that the concept of collecting and collections plays in Pliny's writings on art.

66. Appius was also looking at agricultural holdings and debts. As Cicero's predecessor in the governorship of Cilicia, his conduct had been far from impeccable.

67. At the same time Pliny notes that even Agrippa, a personage more disposed to rusticity than luxury, had paid the high price of 1,200,000 sesterces to the people of Cyzicus for pictures of Venus and of Ajax, which he had installed in the hottest area of his baths.

68. Moral censure comes across clearly in his anecdote about Caligula who "lusted" after nude paintings of Helen and Atalanta at Lanuvium, which he would certainly have carted off had not the fragile stucco made it impossible to do so (*NH* 35.17).

69. From this he goes on to remark how many prominent statues are effectually anonymous or of uncertain authorship.

70. Hagstrum (1958, 22–4) characterizes these as a genre of "iconic" poems.

71. Goldhill (1994, 205) points out how the process goes beyond description and dramatizes the process of interpretation in performance.

72. K. Lehmann (1941) attempts a museographical analysis on the basis of thematic interconnections between subjects and treatment. Bryson (1994) has challenged the positivistic conclusions of this study while analyzing both Philostratus' and Lehmann's rhetorical internalizations of the subject

73. For a detailed example of such discovery and restoration emanating from sites in Paris, see Eristov and de Vaugiraud 1985 and 1994, and more generally Barbet 1984, 1997.

74. Dacos 1969, 10.

75. As Vasari recorded in his "Life of Giovanni da Udine": "Both [Raphael and Giovanni] were dumbfounded by the freshness and abundance and beauty of the work, appearing also to them a remarkable thing they they had been preserved for so long a time.... These grotesques created with such skill, with such variegated and bizarre caprice and with such subtle ornamentation of stucco, compartmentalized by diverse fields of color and with little stories so lovely and graceful entered so fully into the heart and mind of Giovanni that from the date of this study he was not content with only one or two times drawing and redrawing them." Egger (1906, 64, Fol. 10) discusses the Volta Dorata, one of the most celebrated of the early discoveries.

76. Corti 1963, 126ff; Allroggen-Bedel 1993, 35–40.

77. The first official comment by the Royal Keeper of Antiquities, Marcello Venuti, is rhapsodic: "We have discovered the most beautiful thing in the world, a wall painted with figures of natural grandeur; magical figures and created with truth, very superior to those of Raphael." To Raphael he later added Titian for coloring, adding that "these paintings must come close to what we have imagined Zeuxis and Apelles to be." Such comparisons become a persistent theme. Writing in 1748 to the Royal Society of London, Charles Blondeau, Esq., quotes the words of the Roman painter Don Francesco de la Vega who had served as his escort through the collection (Blondeau 1749–50, 16): "If Raphael were now alive, he would be very glad to study these drawings and perhaps take lessons from them." One must, of course, not discount Raphael's documented interest in ancient Roman art.

78. Leppmann 1968, 79; Winckelmann 1764; Goethe 1982, 202.

79. Parslow (1995a, 33–44) documents the deliberateness of the policy.

80. Martyn and Lettice 1773, 17, n. 1. Very influential was the comment of Pliny *NH* 35.10 that the great masters painted only on boards or tablets that might be carried about and preserved in case of an accident and that painting on walls was the employment for artists of small estimation. This is, however, to overlook Pliny's chronological separation of the painters of earlier periods from those of his own, but the commentators add (17), "nothing can be more natural than that the best paintings and sculptures, of which the Roman empire at its highest pitch of grandeur possessed the richest treasures, not only in public places but also in the villas of private persons should have been copied in whole or in part by stucco painters. The furnished exemplars, by which the artists of those times had always before their eyes on every side of them,

must needs have suggested, even to inferior performers, the most beautiful ideas and images of adorning, according to the taste and reigning passion of that time, the entire walls of public and private edifices."

81. Winckelmann 1968, 101, 129. Potts (1994) describes and analyses the philosophical and scientific premises structuring Wincklemann's theory of artistic climax and decline in ancient art.

82. The letter, written in 1753, is cited by Martyn and Lettice (1773, xiii) in their preface to the English translation of Vol. I of *Le Antichità di Ercolano esposte*.

83. Paderni 1740. 435–437. Cited by Parslow 1995, 33 and n. 62. The letters were abstracted and translated by their recipient, the Scottish painter Allan Ramsay.

84. Parslow 1995a, 207–8.

85. Goethe 1982, 189; Leppmann (1968, 85) sees his work also in the so-called Villa of Cicero. Chevallier 1977 provides a detailed account of many North European visitors' responses to grotesques and fantasy figures.

86. *Le Antichità di Ercolano esposte con qualche spiegazione:* 1757 Vol. I Naples.

87. Becchi 1826, 2–3, pl. LV.

88. Corti (1963, 142, 171–2) describes the slow progress of the Accademia Reale d'Ercolano toward publication of the seven volume *Le Antichità di Ercolano*; for further discussion of dissemination, see Praz 1969, 70–90.

89. Leppmann 1968, 87–91.

90. Published in Berlin, 1828–52.

91. Zahn 1828: "d'autant plus qu'un connoissance exacte du goût que Les anciens ont deployé dans leur ornemens architectoniques et dans l'interieurs de leurs demeures pourra avoir une influence décidée sur Le goût des moderns."

92. For example, Niccolini 1854–96; D'Amelio 1888.

93. Clay 1976, 105.

94. Mau 1904, 40–4. The difficulty of dating the final two styles is already apparent.

95. Mau 1904, 464–70.

96. Mau 1904, 468–70.

97. Curtius 1929.

98. The pioneering study of stylistic progress in this manner was created by the Dutch scholar H. G. Beyen (1937, 1960). By this token each style advances stage by stage toward a zenith at which its fullest potential is realized; that is to say the Second Style achieves maturity when it displays a full illusionistic opening of the wall from which point the Third Style moves gradually toward reclosing the space. This work, although proleptic in references to later periods, nonetheless gave the preponderance of its attention to the late-Republican Second Style.

The monumental proportions of this study have effectively established the paintings of this particular period as the most frequently discussed, but its methodological influence has permeated scholarship in every area of the field. Most recently Beyen's precise differentiation of chronological phases and subphases in Second-Style painting has served as the model for equally elaborate classifications of the Third Style (Bastet and de Vos 1979; Erhardt 1987), and for tentative essays into classification of the Fourth, for which greater proliferation of examples makes comprehensive ordering more difficult.

The questions that have recently appeared most compelling in this are closely focused. For instance, sufficiently objective evidence exists for the secure attribution of Fourth Style painting to the final decades of the city, but it remains a matter for question which versions of this style preceded and which followed the earthquake of A.D. 62. Strocka (1987), Archer (1990), and Esposito (1999) are among those who have worked most intensively on this question.

99. For example, Ling (1991, 74–82) analyzes the progress of the Fourth Style on this principle, characterizing its embodiment during the Neronian period (A.D. 54–68) as one of delicacy and lightness, while its later phases show no development save for an increasing lack of refinement.

100. Huet 1992, 236.

101. Bryson 1990, 34–46.

102. The idea was first introduced by Scagliarini-Corlaità 1974–6 and has more recently been adopted by Barbet 1985.

103. Scagliarini-Corlaità (1974–6, 17) argues that theme is related to function as an aspect of decorum.

CHAPTER 1. DOMESTIC CONTEXT

1. Hillier and Hanson 1983, 15: "Space was intelligible if it was understood as being determined by two kinds of relations, rather than one: the relations among the occupants and the relations between occupants and outsiders. Both these factors were important determinants of spatial form, but even more so was the relation between these two points of view."

2. Romans, by witness of Cornelius Nepos (*Prologue* 7–8) would seem to have believed in this seclusion. Christ (1998, 521–5) comments on the concern for preserving the boundaries of the private life as symptomatic of the real vulnerability of home, family, and property in a world without organized systems of protection.

3. Jameson 1990, 97–104. Although actual excavation in such cities as Olynthus has shown that the vicarious descriptions of Greek house plans Vitruvius provides have exaggerated the extent to which women's quarters were segregated, or even marked off, on the interior, still the andron does form a recognizable part of the typical plan, even for small houses.

4. Jameson 1990, 98. Of course the general state of preservation offers far less evidence than is the case for Pompeii, but remains of walls with stucco and paint do not reveal elaborate compositions, only some molding and carving of column capitals and entablatures around the doorways of the principal rooms opening off the courtyard.

5. As my colleague Matthew Christ points out (citing Demosthenes 21, 158–9), the Athenian code was rather different: big house = big evil, an offense to democratic values.

6. This practice was no less Greek than Roman. For discussion, see Connor 1985, 79–102.

7. In citing Vitruvius, one must not forget that this basically Republican aristocratic ideology is being written during the political environment of the early principate. Elsner (1996, 56–60) remarks on the architect's "readiness to embrace an Augustan project" that "entailed the continuation of late Republican differentials of social class."

8. Rapoport 1990, 9: "settings cannot be considered singly but only as systems, so that systems of activities actually occur in systems of settings. These are organized in varying and complex ways, not only in space but in time and other ways all related to culture. It follows that what happens in one part of the system greatly influences what happens, or does not happen, elsewhere."

9. Hillier and Hanson 1983, 1–25; Pearson and Richards 1994, 6–8.

10. Wallace-Hadrill 1988, 52 ff.

11. Hillier and Hanson 1983, 15–16.

12. Mau 1904, 247–8; Allison (1993, 1–3) sketches the historical process by which Vitruvius' spatial terms came to be attached to rooms in the Pompeian house and the problems resulting from such identifications.

13. Leach (1997, 50–72) theorizes the shortcomings of this canonical vocabulary in confrontation with literary usage.

14. Hillier and Hanson 1983, 8.

15. Cicero (*de Republica* 2.16) says that he divided the plebs into *clientelia* duly assigned to the *patres*. Dionysus of Halicarnassus 2.10–11 describes the mutual duties and benefits in a detailed manner that seems to reflect the refinements of historical usage. Furthermore, as he notes, the system holds force not only in the city itself but also in all Roman colonies.

16. Coarelli 1989, 183–4.

17. For an account of the indirect evidence for these activities in Cicero and other Republican writers see D'Arms 1981, 41 etc.

18. Varro designates a place to be used by the household in common. *LL* 5.160: "cavum aedium dictum qui locus tectus intra parietes relinquebatur patulus qui esset ad com[m]unem omnium usum." He goes on to say that this space is called *testudinate* when fully covered and, if left open for the sake of light and the collection of rainwater, it is called an *impluvium*.

19. Recent discussions favor different possibilities. L. Richardson (1988, 382–95) proposes either the original Italic hut shape as represented in cinerary urns or else from the central courtyard house. de Albentiis (1990, 26–53) argues for the Etruscan palace model. Carandini has reconstructed the plans of sixth-century foundations on the Palatine slope in Rome around a central space of cruciform shape with a long entrance corridor three exedrae and four corner rooms. Smith 1996, 177–8. Such a plan would accomodate the functions that Roman antiquarians assigned to the atrium.

20. Brown, Richardson, and Richardson 1993, 102–3. Show all six buildings as dominated by full-scale atria with *impluvia* and surrounding members comparable to those of atrium houses. Although Brown et al. suggest that their forms may have been adapted from the already-crystallized design of the house, one cannot overlook the possibility that the line of derivation may have gone in the other direction, from public space to domestic. No certain evidence identifies the function of the sixth-century Roman atrium buildings mentioned in note 18.

21. Parslow (1995, 174–7) recounts how Karl Weber called on Vitruvius, supplemented by the Younger Pliny, for aid in unravelling the puzzles of the unorthodox *Praedia Juliae Felicis,* and the mistakes he made in applying the architect's instructions on the seasonal orientation of *triclinia* to three chambers adjoining the large peristyle. In his catalogue of the Real Museo Borbonico, DeJorio composes what may be the first systematic post-Pompeian plan of the Roman house based on Vitruvius.

22. Mau 1904, 247.

23. Mau 1904, 247.

24. Brown 1961, 21–2, is influential and followed by many (e.g., Clarke 1991, 1–29).

25. Cicero *de Oratore* 1.45.199. Crassus' speech shows the *ianua* and *vestibulum* of Quintus Mucius thronged every day with a great crowd of citizens, many of whom are his equals. Statius (*Silvae* 4.4.42–3) writes to Victorius Marcellus on his life outside of Rome "nec iam tibi turba reorum/vestibulo querulique rogant exire clientes."

26. Wiseman (1982, 1987) has raised questions concerning the nature and function of the Roman *vestibulum* in its differences from the narrower entrance spaces of Pompeii.

27. Ancient descriptions are in Gellius *Noctes Atticae*, 16.5.1–2, and Macrobius *Saturnalia*, 6.8.8, both with reference to Vergil's description in *Aeneid* 6 of the entrances to the underworld, where figures are clustered *vestibulum ante ipsum primisque in faucibus Orci.* The subject has recently been treated by Wiseman 1987 and Leach 1993.

28. Mau 1904, 248–9. For more recent discussion see Laidlaw 1985, 180; and Clarke (1991, 83), who calls these "little temples" proposing that they may have served as the introduction to an imposing loggia decoration in the atrium of the house.

29. *PPM* 4.449.

30. L. Richardson 1988, 111–14. The *fauces* which led inward from the second door were very short.

31. A more extensive discussion appears in Leach 1993.

32. De Franciscis 1990.

33. Franklin 2001.

34. Clarke's dramatization (1991, 4–6) is based on received interpretive tradition rather than any Latin text: "A client emerging from the tunnel-like confines of the fauces directly faced the goal of his or her visit, the paterfamilias, standing or seated at the end of the axis in the *tablinum* and dressed in the toga. A sequence of architecturally framed planes conducted the client's gaze to the paterfamilias in the *tablinum*."

35. Reference to Zahn 1828–52, 5, no. 44.

36. Commonly it has been assumed that the right to display such portraits as limited to certain families formally called *nobiles,* was sanctioned as a particular legal right, but Flower (1996, 53–9) shows instead that, although a particular person's mask might be banned as an item of adverse legal judgment, the so-called *ius gentium* is only a scholarly fabrication.

37. *de Architectura* 6.3.6. The height, he specificies should be the same as the breadth of the *tablinum.* Flower (1996, 185–222) indicates that the preponderance of evidence favors the location of masks in *armaria.* Perhaps Vitruvius' contradictory statement might be reconciled if we think that the *armaria* could have the form of shuttered boxes such as we see hanging in the frieze zones of many Pompeian paintings.

38. The Casa del Menandro does in fact contain an amorphous collection of miniature portrait heads recovered in plaster, not arrayed in the atrium but instead on a shrine in a peristyle alcove. Noting their difference from real *imagines,* Flower (1996 42–3) associates them with family cult. Franklin suggests that peristyle altar had come to be the real family shrine, while that in the atrium honored the Lares of the imperial family (personal conversation with author).

39. So Cicero (*Orator* 31.10) mentions that Brutus has an image of Demosthenes. Wojcik (1986, 219–26) describes the array of "enlightened" Hellenistic potentates that surrounded the atrium of the Villa dei Papiri. In the Casa del Citarista a series of bronze and marble portraits distributed throughout various parts of the house and ranging from the Augustan period through the imperial present illustrations by exception. Only one of these appears near the atrium. Elia (1934, 225) argues, partly from location that several represent imperial figures, but de Franciscis (1951, 45–51) argues that all represent family members rendered in accordance with changing fashions, the later renditions endowed with characteristics of the imperial court.

40. L. Richardson 1988, 387–8, 434.

41. Allison (1993, 5) discovers mention of loom weights in the catalogues of material found in the forecourts of six of the thirty-two houses examined in her study. With the exception of the House of the Ceii, these are small houses and not associated with persons of known influence.

42. *Vita Pop Rom* 28.2. The etymology here, "quod maenianum possumus intellegere tabulis fabricatum," seems to suggest an upper-story room or balcony involving *tabulae* as building components rather than our usual view of them as records.

43. Clarke (1991, 4) notes that "Vitruvius and other writers on the domus are silent on the subject of the fauces-atrium-*tablinum* axis, probably because it was so obvious and invariant a feature." To the contrary one must allow for the possiblity that they did not see the house from this point of view at all.

44. His often-repeated remarks that Vitruvius places family portraits in *alae* appears to be based on an interpolation. What Vitruvius actually says in 6.3.6 is that *imagines* are to be placed at a height measured in proportion to the breadth of other spaces.

45. L. Richardson 1988, 389, but the idea is based on scholarly tradition.

46. For the type see Boethius and Ward Perkins 1970, 132–3.

47. Mau 1904, 309–10; L. Richardson 1988, 112–14.

48. L. Richardson 1988, 112–14.

49. Overbeck, 1884.

50. Under any circumstances the usage is metaphorical. Although frequently employed for an entrance or exit, this is never, Vitruvius excepted, used in an architecturally defined context, but rather in descriptions of natural conformations, mountains, caverns, or rivers where the metaphorical implications of jaws and devouring have their full force. Such a comparison is in vigor when Vergil in three instances places *fauces* at the entrance of the underworld kingdom. The efforts of Aulus Gellius (*Noctes Atticae,* 16.5.1–2) and Macrobius (*Saturnalia* 6.8.8), to explain Vergil's description in *Aeneid* 6 of figures clustered *vestibulum ante ipsum primisque in faucibus Orci* are responsible for our popular identification of the feature as a narrow passage. Thus Gellius seems to contradict his own information when he calls Vergil's *fauces* an "angustum iter per quod ad vestibulum adiretur" ("a narrow route by which one approaches the vestibulum") instead of the reverse. Macrobius (6.8.22) does not correct the error but corroborates it in specifying that the *fauces* leads into the vestibule from the street ("per quod ad vestibulum de via flectitur"). That the entrances to many Pompeian atria were long and narrow cannot be denied, and the same appears true of early houses in Rome, yet the phenomenon also fits with Vitruvius' description of the

Greek *ianua* as a long narrow corridor with a place on one side for the *ostiarius* (doorkeeper) and a stable on the other.

51. Greenough 1890.

52. L. Richardson 1988, 387.

53. Pompeian examples are rare, comprising two principal atria in large houses (L. Richardson 1988, 310: Casa dei Dioscuri; 111–14., House of Epidius Rufus) and two small secondary atria (L. Richardson 118, Casa della Fontana Grande; 160, Casa del Menandro) the latter serving as an entry into the baths.

54. The plan of this room has been speculatively reconstructed in accordance with Carandini's excavations on the site by Coarelli 1989.

55. Allison 1993, 4–7; 1995a, 159–60.

56. Laurence 1994, 122–9. With men at the forum from the second hour, and gathering at the baths in the sixth, the household was in fact left to the women for a half day.

57. L. Richardson 1988, 171–6.

58. Wojcik 1986, 36; Parslow 1995, 78. Oplontis is too extensively remodeled for the interrelationship of spaces in the atrium complex to be clear, but a working peristyle appears to have been located in a second unified complex to the east. See de Franciscis 1975, 1–16 and pls. 1–39, but also L. Richardson 1988, 180–3.

59. L. Richardson 1988, 176–80.

60. Also the two villas at Stabiae, Varanno and San Marco, have formal atria, but these are not agricultural villas.

61. D'Ambra 1993, 31 and n. 64, citing this passage of Pliny, compares the D-shaped porticus in the Forum Transitorium shown on the Marble Plan suggesting that this form was, in fact, au courant in the late first and second centuries A.D.

62. L. Richardson (1988, 309–11) speaks of the peristyle townhouse as a type in which the *tablinum* barrier was suppressed so that spaces seemed to flow into each other. For discussion and contrary views see Dwyer. 1991.

63. L. Richardson 1988, 314–17.

64. In addition to the earlier references, *Dial.* 10.14.4; *Ben.* 3.28.2; *Ep. Mor.* 44.5.1

65. Franklin 1980; Castrén 1975; Mouritsen 1988, 90–9. The account given by D'Arms 1989 of the local distinctions conferred on the family of the Holconii is a case in point. Most recently Franklin (2001, 37–44) traces career and family histories in detail.

66. He uses the word also in the Menippean satire *Taphê Menippou* (Astby 536), which is at least partially concerned with domestic customs and luxury. The rather puzzling reference in an unfortunately corrupt line, concerns the spreading of sand in the large peristyles of houses lacking *cryptae*.

67. McKay 1975, 40–2.

68. L. Richardson 1988, 108–11.

69. De Albentiis 1990, 95–9.

70. L. Richardson 1988, 392–4.

71. Sauron 1980, 73–5.

72. It seems clearly used to signify the enclosed nature of the space, even when it has only three files of columns, and in this respect it is a semitechnical word.

73. Two points should be noted: 1. Peristyle is not the name most commonly employed to designate colonnades in domestic contexts. 2. Not every colonnade is enclosed. Varro uses peristyle with reference to a particular kind of open-air park and aviary, but Cicero does not employ the word at all, save in the passage on

Clodius' building ambitions cited discussed earlier. His practice is typical.

In place of peristyle Cicero's words for domestic colonnades are the Latinate *porticus* signifying the architectural function of the columns and *ambulatio/ambulacrum* signifying the functional purpose of the space. Often it is not possible to determine whether the feature in question is actually enclosed or placed on the exterior. These preferred uses function both as builder's words, to be used when giving orders and also as ways of comprehending the symbolic value of the space with reference to the public life. Closely allied, these words are often found combined in actual usage. Such cases usually involve a distinction between the passage and columns, but in other instances the usages may be interchangeable.

The earliest Latin pairing occurs in the context of Plautus' *Mostellaria* (756) where a house boasting an *ambulacrum* and a *porticus* is presented as a stylish model to be imitated. Whether the style here should be seen as Greek or as Roman is uncertain, but the joke appears to be played on the old Roman father of conservative disposition (817). A clear distinction also is made in Varro's description of his aviary where the *ambulatio* (3.5.10.1) is faced by two colonnaded *porticus* on either side (3.5.11.1). Not in every case, however, is it possible to determine whether these features enclose a space fully or merely border it on one or another side.

74. L. Richardson (1992, 310–11) s.v. *porticus* gives a concise history of the recorded development of these structures from single file walkways to enclosing colonnades within the city of Rome but with notice taken also of domestic peristyles.

75. De Caro 1987, 79–80. Jashemski (1987, 33–64) describes the working peristyle in the vintage area of a recently excavated villa in Boscoreale.

76. For dates of reconstruction and evidence for its form see L. Richardson 1992, 430–1, s.v. "Villa Publica."

77. Vitruvius (5.9.1) attaches colonnades to the areas behind the theatrical stage building to provide shelter for audiences from sudden showers and also for setting up stage machinery. Examples occur throughout the Roman world.

78. Jashemski 1979, 15–54.

79. L. Richardson 1992, s.v. *Porticus Pompeii*, 318–19.

80. Jashemski 1993, 92.

81. LaFon 1981; also Rawson 1976.

82. Shatzman (1975, 380–1) discusses the sources of Lucullus' wealth and its relationship to his acquisition of properties; Jolivet (1987, 874–904) discusses the location of the Campanian villas and argues that their control of a large fish population will have made them profitable as well as pleasurable.

83. Coarelli (1983, 191–217) proposes a direct connection between these Hellenistic features and monumental architecture in the public sphere, especially the colonnades and hemicycles of the Temple of Fortuna at Palestrina, a town in which the Licinii Luculli had connections.

84. Plutarch *Life of Lucullus* 39.4.

85. Carandini (1990b, 12–13) argues that the model of the villa did specifically influence the development of gardens in townhouses.

86. Jolivet 1983, 115–38; L. Richardson 1992, s.v. *Theatrum Pompeii* 385.

87. De Albentiis 1990, 144–51.

88. Carandini 1988, 364–8; De Albentiis (1990, 187) points out the paradox by which Clodius as the greediest of aristocrats was also the leader of the so-called popularists.

89. Q. Asconius Podianus *in Milonianam* 28. Carandini 1988, 366–7; Coarelli 1990, 184–5.

90. Carandini (1990b, 9–15) interprets the phrase "nunc domus suppeditat mihi hortum amoenitatem" ("now the house furnishes me with the pleasurability of a garden") to mean that he did add a garden; however, the rhetoric of the comment is actually that of denial.

91. As Wojcik (1986, 168–70) and others have pointed out, it is the model for the library spaces in the Villa dei Papiri at Herculaneum.

92. Fraser 1972, 325.

93. Ruch 1958, 69–70.

94. Linderski (1989, 105–9) stresses the luxuriousness symbolized by the villa, yet also points out the political status of the participants in the dialogues. In my opinion both the features and the participants emphasize links with the public world.

95. Also the *Brutus* begins when Atticus and Brutus pay a visit to Cicero at leisure *in xysto* (*Brutus* 10).

96. Varro (*Menippeans*, 536.1) speaks of sanding the walkways.

97. Jashemsky (1979, 160–3) notes by the evidence for rows of large plane trees in the palaestrae of Pompeii and Herculaneum bears out Vitruvius' remarks.

98. In *de Oratore* L. Crassus reclines on a couch placed for him in the exedra meditating intently on a speech, as is his customary practice in composition.

99. The use of the diminutive *exhedria* here is singular.

100. Ling 1997, 79–81.

101. Cerulli-Irelli 1971, 29–31.

102. Leen (1991, 229–45) points out that Ciceros judgment is determined much less by what we would call personal taste than by considerations of symbolic appropriateness.

103. Also *Att.* 1.8.2–3. Pliny, no doubt influenced by this example, uses the term frequently with reference to three villas (2.17.16–21, 5.6.15–20, 5.6.23, 9.7.4, 9.36). He does not discuss art works for the *xystus*, but he does associate it with solitary intellectual endeavor.

104. Wocjik (1986, 272) is probably too ready to believe Cicero in changing the attributed ownership to Appius Claudius Pulcher.

105. These, according to Smith 1989, 70–8, were undoubtably acquired by L. Calpurnius Piso during his tour of duty as provincial governor of Macedonia in 57–5 B.C.

106. Pandermalis 1971, pls. 82–89; Sauron 1980, 277–301; Sauron 1983, 69–82; Wojcik 1986, 259–84. This villa, if indeed it was the property of the Pisones and remained in possession of this same family, may have been among the most stable of such properties, although this should not be surprising in view of the Augustan political loyalty of the Younger Piso the Pontifex whom Pandermalis (1971) credits with assembling the sculptural collection of the villa. The traditional attribution to L. Calpurnius Piso Caesonius is based on Cicero's references to his patronage of Philodemus (*Pis.* 68–73) with the implications that the villa will have housed the philosopher's working library. Pandermalis' modified proposal is based on the probable dates of some of the

objects as well as Velleius Paterculus' (2.98.2–3) description of Piso as a person in whom ideals of private and public conduct were harmoniously joined. It might be corroborated by the fact that an identified bust of this Piso was discovered at Herculaneum (Syme 1986, 345).

107. Specifically he lists *cubicula, triclinia,* and *balneae* as well as "cetera quae easdem usus rationes." My omission of baths from this discussion should not be taken for neglect; however, their form is generally unmistakable and their use predetermined.

108. Wallace-Hadrill (1988, 58–69) posits gradations of privacy in accordance with the status of persons entering the rooms.

109. Lehmann (1953, 130–1) explains the decorations of the so-called Boscoreale *cubiculum* as a fantasy world surpassing reality yet blending into it that the owner might contemplate from his couch. To this she adds that Aphrodite, whom she sees represented by fertility symbols, is an appropriate divinity to be honored in a bedroom (121); Holloway (1989–90, 114–19) applies the same principle when he interprets the masks used in decoration as apotropaic protectors of sleep, a precarious state of being in the ancient world.

110. L. Richardson 1988, 397–9.

111. Thus Cornelius Nepos (*Prologue.* 6): "quem enim Romanorum pudet uxorem ducere in convivium?"

112. Dunbabin (1993, 116–41) corroborates the de-emphasis of drinking by a survey of visual iconography that brings out the emphasis placed on food and regularly includes vessels to hold hot water for diluting wine.

113. Gruen 1993, 303–6.

114. Gowers (1993, 109–310) discusses this extensively although with a particular emphasis on the symbolic function of food itself and the recurrent analogy between cooking and satirical writing. The particular aspect of communal dining that she emphasizes (24–32) is its tendency to become Saturnalian through fostering an inversion of social roles.

115. For example, Gellius (6.16.1) attributes to Varro a list of delicacies that nourished gluttony. Among the historically attested impositions of sumptuary laws, Rotondi (1922, 421) gives the sources for Caesar's prohibitions. Gowers (1993, 21, 26, 70–8) cites Macrobius on censorship under sumptuary laws but also points out the ambiguities surrounding many of the items, which may only have been prohibited on working days as opposed to festival days.

116. Inquiring into the origin of triclinear spaces Ruggiu (1995, 139–40) charts the positions of identifiable rooms throughout Region 1, observing a large increase in peristyle locations during the Augustan and Julio-Claudian periods.

117. Dunbabin (1998, 82–9) associates *oeci* especially with dining "in the Greek manner."

118. Maiuri 1952, 1–8.

119. Maiuri 1952, 2–3; Barbet 1985, 85–6; L. Richardson 1988, 156–7.

120. Carettoni 1983, 373–416 and pls. 91–108; 1–16.

121. Maiuri 1952, 5–8; Cerulli-Irelli 1971, 11–15.

122. Maiuri 1952, 5–8; L. Richardson 1988, 165–6.

123. Maiuri 1952, 7–8, n. 20. While excavating in the Praedia Julia Felix, he uncovered a previously excavated room of modest proportions with two large windows, one facing the garden and the other the porticus of the complex. He suggests that a

podium placed on two sides of the room would have accommodated dining couches (in this instance only *biclinia*) with views of the gardens.

124. De Albentiis 1990, 154–5.

125. The third example in the House of Julius Polybius has actual garden views through the windows. Shown in Jashemski 1993, 368–9, figs. 442 and 443.

126. Ruggiu 1995, 139–40.

127. According to Ruggiu (1995, 147) the Romans knew the custom of eating in a reclined posture long before the incorporation of a specific *triclinium* into the house. We see this awareness in Livy's mention of the *lectisternium* where images of the gods were ceremonially situated on dining couches, first in 399 B.C. and again during the Hannibalic Wars. The custom did indeed go back very far if we can believe the information that Cicero *Tusculanae disputationes* 4.2.3, attributes to old Cato that Roman ancestors reclining at banquets used to intone to flute music praises of the virtues of famous men: ("gravissumus auctor in Originibus dixit Cato morem apud maiores hunc epularum fuisse, ut deinceps, qui accubarent, canerent ad tibiam clarorum virorum laudes atque virtutes.")

128. Jashemski 1993, 244.

129. Ruggiu 1995, 139–40.

130. Cicero, *de Oratore* 2.263, that to make appointments *de triclinio* is to distribute patronage to one's cronies or appoint them to offices.

131. I omit *cenaculum* from this discussion because of its apparent transmutation of meaning from an upstairs dining area to an upstairs apartment. Notably, however, it carried an elevator sense during the mid-Republic since Ennius *Annales* 61 has Jupiter call the Gods to assembly in the *caenacula maxima Caeli,* a space with openings on two sides.

132. Ling (1997, 59; 141). Note that it is "among the largest reception rooms in a private house in Pompeii."

133. Riggsby (1997, 36–56) provides a more extensive survey within the large context of public and private spaces and the forms of activity appropriate to their degreee of exposure.

134. Wallace-Hadrill 1988, 78–9.

135. Clarke (1992, 12), but Allison (1995a, 160) noted that the identification of these rooms as bedrooms would not seem to be validated by the distribution of finds from this room type.

136. Allison 1994a, 46–52. Only the House of Julius Polybius had traces of a couch in one of these inner rooms.

137. Cicero *Har* 9.2; *Sal* 21.7; Valerius Maximus 8.1.11; Seneca *Cont.* 1.4.11.5, 2.1.34.3–10, 2.4.5.10, 7.6.48; *Ben.* 9.7.5; Suetonius *Augustus* 69.1.2.

138. Tacitus *Annales* 15.63.18, 16.11.5, 16.35.4. All these instances are suicides ordered by Nero.

139. Seneca, *Cont.* 7.5.pr.4; Quintilian 4.72.3.

140. Riggsby's distinction (1997, 43) between privacy and secrecy is to the point.

141. Even many stories of an unsavory nature imply downstairs *cubicula.* When Scipio in *de Republica* 2.36, tells a story involving the discovery of a corpse buried at the home of L. Sestius, the phrase *in cubiculo effossum* must indicate a room on the ground floor. Also the example that Cicero uses to represent a fraudulent sale in *de Officis* 3.54 of an insalubrious house where snakes crawl out of the *cubicula* seems to imply their position on the ground floor.

142. If in fact Cicero had different rooms in mind when he spoke a moment earlier of those above the baths, then perhaps those would have been upstairs rooms.

143. An anecdote that Seneca (*de Ira* 3.8.5) relates concerning Caelius Rufus has him taking dinner with a client *in cubiculo*, but this venue may be enforcing the point that Caelius' behavior was frequently unorthodox.

144. *Panegyric* 51.4.2, 83.11, but already before this he has remarked how Nerva's adoption of his successor was not done secretly, but ceremonially in view of the Roman people (8.7.1: *non in cubiculo sed in templo*).

145. LaRocca, de Vos, and de Vos 1976, 170.

146. Elia 1934, 217–19.

147. Parslow (1995, 111) notes how rapidly the Spanish excavation teams "unwittingly discovered a characteristic of Roman domestic life by which most household furnishings were kept in storage and brought out only as needed."

148. Allison (1994a, 51–2) comments on the difficulty of identifying *cubicula* on the basis of furnishings, but her study of contents recorded in thirty-two houses also reveals (55, 63–4) that few couches and beds were found in rooms of any description. Mols (1999c) enlists the better preserved remains of a few couches at Herarlanein to reconstruct what he considers the most common type (35–41) the standing couch encased with paneled wooden boards.

149. Sallust (*Cat.* 55.4.1–3) also describes the noisome underground chamber of the Mamertine prison as a *camera* joined to arches of stone.

150. Rizzo (1936. 1–8).

151. *Satyricon* 30.3.1, 40.1.2. Additionally, but not remarkably, the baths have a vaulted ceiling (73.3.2).

152. Here the fact of the room's having only one door is specifically mentioned as it was important to the defense of the young men, found still sleeping when the door was opened ("Tamen, cum planum iudicibus esset factum aperto ostio dormientis eos repertos esse . . . ").

153. Allison 1994.

154. Scagliarini-Corlaità 1974–6, 3.

155. Scagliarini-Corlaità 1974–6.

156. Scagliarini-Corlaità (1974–6) speaks of the "architecture of the painted surface." The principle is also elaborated by Barbet 1985. 57–77; 123–39; 204–14 in her discussions of an "adéquation du décor aux locaux."

157. Scagliarini-Corlaità 1974–6, 8–12, 19–21.

158. Scagliarini-Corlaità 1974–6, 3–44; Barbet 1985, 55–77.

159. I cannot agree with Scagliarini-Corlaità (1974–6, 24–5) that rooms can regularly be identified by functional names.

CHAPTER 2. PANELS AND PORTICOES

1. Ling (1991, 31) suggests that the paintings, although only superficially realistic, have the intentional effect of "transporting the householder."

2. The archeological evidence reviewed in Carandini 1988, 359–87 corroborates the earlier essentially philological study by Royo 1987, 89. Patterson's recent review of topographical scholarship (1992, 200–4) validates their findings.

3. Carandini 1988, 361, citing Cicero's *Comm Pet.*

4. In *Att.* 1.13, he defended himself as having made a good bargain by comparing the consul Messalla's purchase of a house for 13.4 million sesterces. When the senate evaluated Cicero's property for restoration, the worth of the house was set at 2 million sesterces, the remaining 1.5 million being credited to the value of the land.

5. Carandini 1988, 371–2, n. 45.

6. Carandini 1988, 366–9.

7. Carandini 1988, 372.

8. Gnoli 1971, 139.

9. Pietilä-Castrén 1987, 132. L. Richardson (1992, 221, s.v. *Juppiter Metelli (or Metellina) aedes*) also believes that the structure was of solid marble. Dedicated to Jupiter, the temple stood near the Circus Flaminius, preempting triumphal space. Close to it, Metellus created the Porticus Metelli, later the Porticus Octaviae, which enclosed two temples to Jupiter and Juno. The Porticus, built of peperino stone, will not have seemed extravagantly luxurious.

10. In 54 B.C. Cicero (*Att.* 4.16) wryly refers to Caesar's project for rebuilding the district at the heart of Rome, which included constructing marble voting booths at the Saepta.

11. The chronology of importation has received much attention in contemporary studies of the marble trade. Guidobaldi and Salvatini (1988, 173–4) examine the issue with reference to colored marble fragments found in mosaic paving. Although they question the second-century dating advanced in an earlier study of the subject by M. L. Morricone *(Scutulata pavimenta)*, they all the same assign an early-first-century date to a pavement of a house beneath the *Ludus Magnus* containing fragments of alabaster, portosanto, giallo antico, africano, and pavonazzetto. The important question is from where the chips were obtained because the early introduction of mosaic in itself is not in question. Lucilius (K74–75) mentions "vermiculated" tesserae in a passage cited both by Cicero and by Quintilian describing the mosaic worker's art.

12. Carandini 1990a, 163. Calculating with reference to the height of the columns, Coarelli (1989, 180–6) reconstructs a tetrastyle atrium according to the Vitruvian canon of dimensions and concludes that it would have accommodated 2,500 persons.

13. Gnoli (1971, 139–40) thinks that this reference must indicate the exception and prefers the Plinian date of 78; however, Borghini (1998, 214–15) places the first usages as early as the mid–second century B.C.

14. Fant (1988, 149) suggests that this celebrated patronage must indicate that Lucullus had gained control over the quarries.

15. Gnoli (1971, 162) cites this passage as he attributes the use of rosso antico to the late Republic.

16. Carandini 1988, 370–1.

17. Rizzo (1936, 3–5) separates the rooms on the ground floor into two periods.

18. Rizzo (1936, 3–5) believes that they are pre-Sullan.

19. Bartoli, in Rizzo 1936, 3–5.

20. Bartoli, in Rizzo 1936, 7.

21. Rizzo 1936, 7–27, describes the patterns in detail. More recently Anderson 1977, 72–7, provides another detailed description emphasizing primarily the elements of perspective architectonics for which he finds precedent in Greek ceramic painting.

22. Rizzo 1936, 7–12.

23. Rizzo 1936, 20–4.

24. Rizzo 1936, figs. 11–12; Anderson 1977, 74. An alcove close by the entrance of Room II contains a painted door set beneath a projecting gable resting on columns.

25. For the colors, see Rizzo 1936, 25–7, but also Ling 1988, 24–6.

26. Westgate 2000, 256–60, shows an example of the tessellated pattern on Delos and makes the point that the Roman-Italian renditions are uniquely in *opus sectile*. Several pavements in the Casa del Fauno employ local stone for this pattern.

27. Mau 1904, 460–1. The style was Alexandrian in his estimation, with stucco being used compensatorily where marble was not available. He is followed especially by Fittschen (1974, 550–5), who also believes the style to be directly imported from Alexandria.

28. Laidlaw 1985, 118.

29. According to Moormann (1991, 11–17), these are not original decorations but restorations installed after the earthquake of A.D. 62. He bases his conclusion on the degree of illusionism in the atrium and two landscapes of agreed-on later date in the *fauces*.

30. Bruno 1969; Laidlaw 1985, 25. But in fact Mau himself did not deny the intention of giving a masonry appearance to the walls, which were, as he said, "veneered in imitation of ashlar blocks," whereas Bruno (308) implies an unrealistically late date for the prevalence of incrustation by citing as his characteristic example a paneled wall in the fourth-century House of Cupid and Psyche in Ostia.

31. Laidlaw 1985, 25. A more common pattern, as she points out, is continuous around the room.

32. Bruno 1969, 310.

33. Bruno 1969, 317. By this he means that the ascendency of the Masonry Style temporarily displaced any manner of figurative or illusionistic painting from interior walls.

34. Bruno 1969, 317.

35. Bruneau and Ducat 1965, 34–6. On Delos where locally supplied hard stones such as gneiss, granite, and even marble formed the fabric of many walls, there was a certain correspondence with the architectural probability, but even here the stucco coating commonly masked irregularities of rubble masonry.

36. Bruno (1969, 315) doubts that these were ever intended to correspond.

37. Bruno 1969, 314–15.

38. The houses in question were completed before the invasion by Philip in 348.

39. Bruneau and Ducat 1965, 53–9; Bruno 1969; Laidlaw 1985, 34–7.

40. Chamonard 1922–4, 357.

41. Mau 1904, 461.

42. Miller (1993, 85–7) proposes, on the basis of known works and literary testimony, that the beginnings of Macedonian painting long antedated these known examples and that Macedonia had a flourishing tradition, owing in part to the East, before its rise to power.

43. Ginouvres 1993, 136–7; Siganidou and Lilimbaki-Akamati 1996, 27.

44. Bruno (1969), 308 cites the use of carved marble designs created by Polykleitos the Younger in the tholos at Epidaurus.

45. Ginouvres 1993, 136–7.

46. Miller 1993, 41–44.

47. Bruno 1981, 3–11; P. W. Lehmann 1979; Rhomiopoulou 1997, 24–6.

48. Miller 1971–2. 151–62; her analysis (1993, 98–100) of the Tomb of Lyson and Kallikles draws similar conclusions concerning the fortuitous illusions of three dimensionality achieved by elements in the decoration of an interior chamber. They are "suggestive" rather than truly "manipulative" and "likely a more or less-coincidental by-product rather than representing the outcome of any studied, theoretical interest of the artisans involved." On these grounds Miller is reluctant to propose any definite links between Macedonian techniques and the Campanian Second Style.

49. Bruno 1977, 73–87.

50. Bruno 1969, 317.

51. Laidlaw 1985, 37.

52. De Albentiis 1990, 81.

53. Cohen (1997, 187–99) discusses the Samnite affiliation of the House of the Faun speculatively reconstructing variant readings of the Alexander mosaic that the differences between Samnite and Roman perspectives might generate.

54. Chamonard 1922–4, 357.

55. Rauh 1993, 193–250.

56. Laidlaw 1985, 39. The terminus ante quem, 78 B.C., is derived from a graffito, but not particularly revealing because the decoration is obviously much earlier.

57. Laidlaw 1985, 1, but Zevi (1996, 133) observes that these remains are merely survivals from the earthquake, whereas the extent of First Style decoration preserved until A.D. 62 was far greater. A plaster dump discovered by Maiuri outside the north wall of the city contained great amounts of First and some Second Style discards.

58. Laidlaw 1985, 154–7.

59. Laidlaw 1985, 192–4.

60. Laidlaw 1985, 31–2.

61. Scagliarini-Corlaità 1974–6; Barbet 1985, 25–7. These figured insertions generally comprise patterns of leaves and tendrils.

62. Laidlaw 1985, 31–2. House of Sallust. Mau 1904, 43–4, 131–2; Casa Sannitica Laidlaw 304; House of Polibius de Franciscis 1990, 20.

63. Barbet 1985, 31–2; De Franciscis 1990.

64. Laidlaw 1985, 295–300.

65. Laidlaw 1985, 304.

66. Laidlaw 1985, 180; Clarke 1991, 83. Both mention the theory that an interior colonnade surrounded the entire lofty atrium, the evidence for which is a set of Ionic half columns found stored in the second peristyle, the purpose of which is not readily apparent.

67. L. Richardson 1988, 115. PPM 3:650–8. Suadeau (1985, 1–45) posits that the insula was already existing as a unit remote from the city center at a time before the systematization of a city plan, and accordingly places the first stages of this house in the first or second Samnite period prior to the construction of its larger flanking neighbors. Originally as she argues, the atrium was testudinate; in the second century its height was raised and the colonnade introduced in accordance with the Italic practice of adapting features of the "Hellenistic" courtyard to an atrium centered plan. Thus enhanced, she observes, the space conveys an "aura of nobility" in spite of its small size.

68. L. Richardson (1988, 395) observes that houses of the late tufa period "abounded" in such colonnaded loggias fronting on their atria and attributes the fashion to provisions for comfortable summer dining as mentioned by Varro (de Lingya Latina 5.162).

69. Ling 1991, 23–5.

70. Anderson (1977, 75–8) does advance such an argument, but with emphasis on perspective rather than the imitation of particular surface materials. On the basis of perspectival dimension he proposes that the Second Style was synchronically shared by Rome and Pompeii while minor cities like Cosa, or remote ones such as Brescia stayed with an older, nonillusionistic style.

71. Barbet 1985, 29–30; Ling 1991, 23–5.

72. For example, Clarke 1991, 81–4, in terming the decoration in the Casa del Fauno "incrustation" contrary to Laidlaw's analysis.

73. Clay 1976, 39–40.

74. Laidlaw 1985, 172–206.

75. To these might be added the incrustation decoration in the "triclinium" of the so-called House of Gavius Rufus (7.2.16–17) with arches placed above orthostats and garlands. This is a house with decoration of several periods in rooms surrounding the atrium. The atrium itself, badly damaged by the earthquake, was still awaiting restoration (PPM 6, 532–84).

76. De Vos 1976, 37–8.

77. L. Richardson 1988, 155–7.

78. Mouritsen 1987, 56–7.

79. De Vos 1976. Donderer (1982, 231) suggests that such small pieces of marble came into Rome as the detritus from great workshops abroad. Thus the simulation of large-scale veneering by painting might in fact be taken as a species of decoration not actually available in fact.

80. L. Richardson 1988, 158–9.

81. Laidlaw 1985, 31.

82. L. Richardson 1988, 133–4.

83. L. Richardson (1988, 11–13) sees the colonization as a "punishment," whereas Zevi (1996, 125–32) stresses Roman respect for continuities.

84. Berry (1996, 254–6) presents the suggestion that ambulatio did not refer to voting as commonly assumed but rather a piece of material property – a colonnade reserved for the exclusive use of colonists.

85. Zevi 1996, 134.

86. Zevi (1996, 127–8) emphasizes the political semantics of this decoration, pointing out that its closed wall composition, similar in arrangement to the earlier Roman decorations of the Casa dei Griffi, should be understood in relationship to the decorum of a colonnaded temple space, rather than to decorative "trends."

87. Suadeau (1985, 1–45) explains the building history of the Nozze d'Argento insula in its removal for the city center and dates the first stage of the house shortly before the inauguration of the colony. Tilloca (1997, 116–70) shows similar decorations as part of the restructuring of another house in the same southwest quarter, which is of about the same size as the Casa di Cerere.

88. Zanker 1993, 86–7.

89. For the section comprehended by Region 6.17.32–44, see PPM 6.32–44. Zevi (1996, 130) mentions these houses and additionally the clustering of new villa houses on the branch of the Via

dei Sepolchri and the appropriation of that street for primarily Roman citizens' tombs.

90. Taking "Etruscan terraced houses" and terraced villas as their model, Boethius and Ward Perkins (1970, 157) assigned the terraced development of extramural houses to different stages; however, their discussion refers primarily to the segment of housing in Region 8 on the southern side of the city. L. Richardson (1988, 231) is also speaking of this segment when he assigns to constructions to the post-Augustan period citing the Villa Imperiale as their forerunner. Neither scholar was thoroughly familiar with the buildings to the north of the Porta Marina where excavation has made progress only since the 1960s (Reg. 6.17.42–22 and Reg. 7.16). Cerulli Irelli (1981, 23) calls these houses of the Insula Occidentalis atypical and modern. Zanker (1993, 84–6) proposes that the aristocratic villa is their model, pointing to the absence of shops from their facades and to "rooms not strictly oriented to take their departure from the atrium."

91. Their present-day aspect, which is critically important to our reading, combines full reconstruction of the southerly portions of the insula with a virtual recusal of reconstruction on the northern quarters where crumbling of the supporting hillside has halted excavation and endangered the already exposed walls.

92. PPM 6.10–43.

93. PPM 6, fig. 22.

94. PPM (6, 17, figs. 20 and 21) compares the ships' prows in the central oecus of the Casa del Labirinto.

95. Thus (Bryson 1990, 36) observes: "After all, that something can be accurately represented need have no bearing on the status of the original: representation does not *necessarily* produce of itself the idea of competition between the original and the copy, or of the copy's independent power. But when the copy stands adjacent to, or in the place where one would expect, the real thing, something more is involved; the original loses its autonomy, it becomes the first in a series that also includes fictions."

96. Zevi (1996, 134–6) argues from the prevalence of Second Style outside the walls that the majority of the veterans were settled on the farmlands of the *pagus,* whereas the traditional Pompeians remained at the center of the city surrounded by their familiar institutions: the old theater, Stabian Baths, and traditional sanctuaries. Thus, they were, in spite of being disenfranchised by an unequal voting system, able to hold the field against any effort to place Pompeian government in Catiline's hands.

97. Mau 1904, 464–7; 1907, 259–63.

98. Strocka (1991, 66–70) traces the history of building and renovation.

99. Strocka 1991, 29–30. Castrén (1975, 221) suggests that the family were colonists with the exception of P. Sextilius Rufus who came from Nola and returned there after holding the highest Pompeian magistracies; Strocka (1991, 134–6) thinks that a tenant would seem to have occupied the property at some point following the earthquake, when restorative repairs were carried out along with some improvements in the bath and service quarters.

100. Richardson 1988, 174.

101. Richardson 1988, 171–6.

102. The use of the reverse plan in Campania is more common, perhaps, than previously represented. As mentioned earlier, it must also have been the original plan of the elegant Villa

dei Papiri at Herculaneum on its very rich land (Wojcik 1986, 36).

103. Barnabei 1901; P. W. Lehmann 1953.

104. P. W. Lehmann 1953, 3.

105. Lehmann 1953, 4–7. Two names were found, that of a freedman P. Fannius Synistor, on a bronze vessel among the agricultural implements, and also a stamp with L. Herrenius Florus, the name of a well-known Campanian family. Because the status of the paintings appears to her disproportionate to the size of the house, she argues that it was built to be an absentee property that the owner visited only occasionally.

106. De Franciscis 1975, 9, 16–17.

107. De Caro (1987, 80–6) summarizes probable stages of construction. He attributes the placement of the Villa to the improvement in the aftermath of Sullan colonization of the coast road running north from the Herculaneum Gate.

108. Jashemski 1987, 71–3. This raises the possibility of a different attribution from that of Poppaea: the baths of M. Crassus Frugi advertised outside the Herculaneum Gate at Pompeii.

109. Richardson 1988, 182–3.

110. Jashemski 1987, 33–4, 64.

111. Barbet 1985, 27; Bruno 1993b, 223–32, 273, pl. 5.

112. P. W. Lehmann 1953, 152–4.

113. P. W. Lehmann 1953, 150–1.

114. Barbet 1985, 60–1.

115. Barbet 1985, 59.

116. Barbet 1985, 38–9.

117. The third-century rhetor Philostratus, in his book of *eikones,* describes precisely this technique of creating jewels "by light" rather than by color, "putting a radiance in them like the pupil of an eye." (*Imagines* 2.1.340K). Gombrich (1976, 5–18) discusses the artistry of creating form through highlights in ancient painting.

118. Fittschen 1974, 548.

119. Leach 1988, 96–8; Ling 1990, 142–3.

120. Barnabei 1901, 80; P. W. Lehmann 1953, 161–2.

121. Mau 1882, 162.

122. Large monochrome panels appear in the upper zone of a wall in the House of Obellius Firmus (9.10.1–4), a house with Second Style decorations that von Blanckenhagen (1990, 16) dates some years later. Mau (1907, 163) records additional examples in the Casa del Marinaio (7.5.2), the House of Caesius Blandus (7.1.40), and in Reg. 8.5.2, all of which have subsequently disappeared.

123. Moormann 1988, 38–9.

124. Vitruvius 6.7.4. is the first source. P. W. Lehmann 1953, 159; Bryson (1990, 17–33) remarks on the way in which anecdotes about *xenia* emphasize the interplay between art and reality.

125. Bryson (1990, 17–59) discusses these texts in comparison with actual examples.

126. Beyen (1938, 6–20) lists Second Style examples, which, as he notes, are not confined to tablets but directly integrated in their architectural context.

127. The image of the dog, bound with a chain, is painted on the wall with an inscription above him in block letters and thus differs greatly from the ubiquitous renderings of a dog on Pompeian thresholds, which are executed in black-and-white mosaic and scarcely intended to deceive, but more likely to

announce the presence of a dog within the household. One example of a painted dog does, however, exist in the Caupona 1.12.3 on the Via dell'Abbondanza (inter al. Jashemski 1987, fig. 31.)

128. L. Richardson 1988, 174.

129. Peters 1963, 7–9.

130. Barbet 1985, 72–3.

131. Pliny (*NH.* 35.3.12–4.14) attributes their first use to Appius Claudius the decemvir in 495; the tradition seems continuous and the primary associations are military. It was M. Aemilius Lepidus in 78 B.C. who first brought home this heroic mode of depicting family members.

132. Fittschen 1974, 536–57; Lehmann 1953, 130–1.

133. Fittschen (1974, 543–7) cites Strocka to corroborate the principle that different spatial effects are contemporaneous, yet to him it seems surprising that open walls can occur in small rooms.

134. Barbet 1985, 68–9.

135. Barbet (1985, 60–1) describes the structure and architecture framing the vistas, but unaccountably does not mention the grotto, referring instead to the paintings on this rear wall as illegible because of dampness.

136. Barbet (1985, 60–1) includes these in her description but gives only an incomplete account of their imagery as "landscapes" with incomplete architecture. Rather the shrubbery must be seen as part of a garden close at hand. Although Barbet finds these incoherently joined to the rear prospect, the parts are in fact well coordinated.

137. Barbet (1985, 68) remarks how a U-shaped table would be accommodated within the interior space of the tholos room.

138. Barbet 1985, 55–77.

139. The importance of context to the evaluation of content was pointed out by Engemann (1967) and is considered in its practical effects on illusion by Bryson (1990, 39–41) Elsner (1994, 83–4) makes the relevant point that architecture as Vitruvius represents it is no less trompe l'oeil than is painting.

140. Barnabei (1901) saw them simply as simulations of villa architecture, whereas Beyen (1938) made them the pivotal examples of a theory centered about replicas of the Roman stage. Refuting this proposal Lehmann (1953, 90–4) argued that that this quadripartite collocation of panels is not limited to one or another scenic genre as Vitruvius' discussion specifies, but, by Beyen's own admission, must be seen to juxtapose three genres of *scaenae frons*: tragic, comic, and satiric. Lehmann thus reverts to the villa theory but with reference to the extravagant constructions of Ptolemaic luxury, to suggest a fantasy villa opening beyond the compass of the room. The major problem of Lehmann's discussion, however, is her association of the ideas with the consciousness of single house owner to whom she ascribes the intellectual genesis of the decoration.

Although Beyen's theory has never ceased to have credit, the majority of more recent scholars have developed more contextually mediated views. Thus Engemann's (1967) assessment of the illusionistic features of the paintings amplifies Lehmann's notion of the real villa as a point of reference. Studying the remains of their fictive colonnades, he has drawn the conclusion that these are painted in such a way as to indicate probable extensions of actual space within the house. Hellenistic is another strong contender. Lyttelton (1974, 18–25) cited parallel architectural features in the rock-cut tomb facades of Petra to argue that both repertoires were specifically Hellenistic in origin, whereas Fittschen

(1974) builds on Lehmann's reference to Alexandria. He agrees that these decorations are not theatrical but instead considers then Alexandrian in derivation, representing the palaces of Hellenistic kings.

Although Barbet's (1985, 44–5) more eclectic approach is permissive, she does see the combined arguments of Lehmann, Engemann, and Fittschen as "ruining" Beyen's theatrical hypothesis.

141. The point that Eristov (1994, 23–4) explicitly makes concerning the combinatory eclecticism of Fourth Style architecture seems equally applicable to these Second Style compositions. While raising the possibility that a model in contemporary architecture might help in dating the paintings, Barbet (1985, 44–52) concludes with a reference to contemporary *mentalité*. Although observing the presence of persons and cult objects related to daily life, she finally posits that Second Style decoration must be considered as an invocation or synthesis of disparate worlds.

142. Martin (1971) illuminates the contemporary economic thinking represented by this book.

143. *De Re Rustica* 3.17.5–6. Although these *domini* stocked their ponds for their personal gratification, they sent out their servants to provision the table with the harvest of market and shore. Hortensius fed his prize fish, the bearded mullets, with his own hand, and many of his fishermen were employed in supplying minnows for their delectation.

144. Although neither van Buren and Kennedy (1919, 60–6) nor Fuchs (1962, 96–105) had knowledge of the Oplontis paintings, both adduced parallels from known painting, the first with the Insula Occidentalis panel in the Naples Museum, the second with Boscotrecase and the Casa del Labirinto. Fuchs's plan (99) simplifies the more elaborate solution of Van Buren and Kennedy (1919, 61). It is reproduced with updated commentary by de Albentiis 1988, 212–15; Mielsch 1987, 16–17; Coarelli 1983.

145. The choregic Monument of Lysikrates (334 B.C.) in Athens, dedicated in celebration of a dramatic triumph, is a preeminent surviving example, and one whose slender form (barring the enclosing wall) makes it resemble Campanian tholoi; one must imagine many such in antiquity.

146. Lyttelton (1974, 70–83) compares the tholos at Petra primarily with concern for the temporal coincidence between this and Roman paintings as illustrative of a "baroque" tendency in Hellenistic architecture.

147. P. W. Lehmann (1953, 121–3) calls this a temple of Aphrodite on the principle of its appropriateness to a bedroom.

148. Thus van Buren and Kennedy (1919, 63), even before Temple B had been excavated, but more recently Coarelli (1983, 206–11); L. Richardson 1992, 34–5.

149. Pietilla-Castrén 1987, 98–103.

150. Mau 1904, 94–7.

151. Boethius and Ward Perkins 1970, 298.

152. De Ruyt (1983) provides a catalogue of existing remains of *macella*. During the Empire, they were ubiquitous in Africa and frequent in Turkey. Lyttelton (1974, 19–20, fig. 117) mentions that of 8 B.C. in the market of Leptis Magna but distinguishes the painted architecture from that in real markets on account of their narrower compass and what she considers the "sacred" character of their iconography.

153. De Ruyt (1983, 298–9) mentions an image of the Macellum Magnum of Rome that appears on a coin of Nero

154. Cooper and Morris 1990, 38–65.

155. Fuchs (1962, 103) cites the Athenian background. Cooper and Morris 1990, 75–80.

156. Shatzman 1975, 378–81.

157. From his ten years of proconsular campaigns against Mithradates in Pontus, a country rich in metals and productive of luxury goods, Lucullus' appropriations included the royal treasuries of four kingdoms, some of which he distributed among his soldiers, some of which he retained to increase his already ample inherited wealth. Nothing in his record appeared dishonest; he was known for his courteous treatment of the peoples he conquered and generally received the gratitude of the Greeks, whom he rescued and resettled. All the same these policies did not shield him from the inimical rivalries of the late Republic. Finding himself prosecuted back in Rome on charges of prolonging his command for personal profit, he was further humiliated by being made to wait three years for his triumph. Hortensius, Catulus, and a few other senators of Lucullus' own class who opposed Pompey's appointment felt that he had been greatly wronged by this vote of no confidence, but no one was more convinced of this than Lucullus. His gestures of valediction toward public life were theatrical. He deposited large sums in the Roman treasury, feasted the Roman people, and dedicated a tenth of his spoils to Hercules along with an image of the hero enwrapped in the poisoned robe of Nessus.

158. Coarelli 1983, 191–205. This temple dated back into the second century and displayed the contributions of wealthy citizens in a prosperous town.

159. Keaveney (1992, 143–65) dismisses decadent indulgence as the impulse promoting Lucullus's luxurious lifestyle, pointing out the nature of his continuing sideline engagement in the affairs of the late sixties. As he would have it, Lucullus' cultivation of material luxury indulged his aesthetic inclinations long fed on contact with the beautiful objects of the east.

160. Varro *DRR* 3. Lucullus ordered his architect to spend any sum of money required to dig a channel through the mountain separating his villa from the sea so that the tide might circulate daily through his pools.

161. Jolivet 1983, 875–904.

162. LaFon 1981, 151–72; Rawson (1976, 87) had observed how villa properties tended to change hands rapidly following the rise and fall of political fortunes, so that such modifications and additions were the primary means by which owners could place a personal stamp on their property. So Cicero, in writing to his brother Quintus about the latter's newly acquired property at Arpinum, observes that a *piscina*, a palaestra, and a *silva* will go far toward improving habitability (*Q fr.* 3.1.3).

163. Scholars have seen a model for this novelty in the famous game parks of oriental monarchs, but Varro calls the spectacle "Thracian" and compares it with the less violent displays in the Roman arena.

164. In letters of 46 B.C. to L. Papirius Paetus (*Fam.* 9.18.3, 9.20.2). In the latter he remarks that his cook could not accomplish the *ius fervens* (boiling sauce). Punning on the double meaning of *ius* (law) in both passages attaches a certain irony to the accounts because the hosts were Caesarian partisans, Hirtius and Dolabella, both *magistri cenandi* with whom Cicero in the idleness of Caesar's dictatorship was exchanging declamation lessons for gourmet meals, these in the face of Caesar's own sumptuary restrictions on dining.

165. D'Arms 1970, 48–51; Rawson 1976, 85–102. Cicero, as the best documented example, may also have been the most self-consciously active in this area, but his comments give insight into the activities of his contemporaries as well.

166. Wallace-Hadrill 1988, 44–5.

167. Ling 1991, 31.

168. Elsner 1994, 74–85.

169. Strocka 1991, 134–36; followed by Franklin (2001, 189–90) who notes the family's Neronian era comeback in the persons of two aedilician and duoviral candidates. Fufidius Januarius, whose name appears in a later graffito is apparently a local Campanian gens, but with no record of office holding at any time, and may well be a procurator.

170. Zevi 1995, 23–4.

171. Strocka 1991, 39–42.

172. Strocka 1991, 43–4 and pls. 274–85.

173. Wallace-Hadrill (1991, 241–72) builds on Andreau with a full critique of Maiuri's premises and prejudices.

174. The first of the two rooms is the large peristyle oecus from the Villa Boscoreale, segments of which are distributed among National Archaeological Museum in Naples, the Metropolitan Museum of Fine Art in New York, and the Louvre. The second is a similarly square-shaped room recently found in a villa at Terzigno and exhibited this summer at the National Archeological Musseum of Naples in the mostra *Storie da un'eruzione: Pompei, Ercolano, Oplontis.* (For catalogue see D'Ambrosio, Guzzo, Mastroroberto 2003). Andreae 1975 71–92 reconstructs an ensemble from the scattered Boscoreale segments with a convincing argument for their comprising a mimetic gallery of statues. The room, whose end wall includes the figure pair generally taken for Dionysus and Ariadne, is more static than the Villa dei Mistarii, with the majority of its figures seated or standing. I have not yet had the opportunity to study at length or at close range the Terzigno paintings (the surprising emergence of which reminds us how incomplete is our knowledge of any period's repertoire), but on brief inspection I find them to be somewhere in between the Villa dei Misterii and Boscoreale compositions with a seated female in a thronelike chair and surrounded by attendants on the end wall and interactive figures both walking and talking in areas at the sides. These very colorful figures are distributed against a red background within compartments partititioned by scale-pattern and by fluted columns. Since some of them are dressed as slaves in short tunics, a possible dramatic context might be conjectured. The ensemble also includes nude figures, most likely to be statues, and its divided frieze zone contains *pinakes* alongside apertures giving on a colonnaded space, very much in the manner of other partial vistas of the Second Style.

175. L. Richardson 1988, 171–74.

176. Wojcik 1986, 36; Mielsch 1987, 94–5; also Villa of Diomedes (Mielsch 39).

177. Castrén 1975, 71 and 100; Franklin (2001, 203) notes the names of family members or their freedmen in the tablets of Jucundus and also that the final Istacidius Zosimus was a procurator.

178. L. Richardson 1988, 175, citing Maiuri 1931, 59–60.

179. P. W. Lehmann (1953, 5) mentions two owners in the first century. L. Herennius Florus of a well-known Campanian family on a bronze stamp, and the freedman P. Fannius Synistor on a bronze vessel in the agricultural quarters.

180. P. W. Lehmann 1953, 6–7.

181. De Franciscis 1975, 15–16, but arguments against deducing the identity of any owner from a name on an amphora are given by Mouritsen (1988, 16–17).

182. Information from John D'Arms. 1984, unpublished.

183. De Caro (1987, 77–143), seeking to rationalize the diversity, invokes the familiar theme of wild nature to link Centaurs, Pan, and Satyr.

184. D'Arms (1981, 74–6) makes this point.

185. P. W. Lehmann 1953, 166–73; Barbet 1985, 217.

186. Barbet (1985, 68–9) comments on the harmony of proportion between space and design in these two rooms.

187. P. W. Lehmann (1953, 120–1) mentions thematic interrelationships between the rooms but seems reluctant to confront directly the fact of duplication.

CHAPTER 3. THE MODEL OF THE *SCAENAE FRONS*

1. De Franciscis 1975, 14–16, pls. 8, 9, 13. To his mind the difference results from a synthesis of the characteristic Second Style details elsewhere deployed in various rooms. The room, as he sees it, is unified and reveals a taste for variety.

2. Carettoni 1983a, 23–7; 1983b; more recent scholarship is summarized in Cerutti and Richardson 1989, 173.

3. Carettoni 1983b, 26–7.

4. Bieber 1961, 162–3, 172–189, figs. 587, 588.

5. Carettoni 1983a, 38–45; pls. j–k; pls. 5, 5a.

6. Carettoni (1983a, 40) mentions the loss of a panel in the central frame.

7. Spinazzola 1953, 689–709. Because of its vaulted ceilings and interconnected spaces, this complex has commonly gone under the title of bath, yet the absence of visible plumbing argues for a different designation. L. Richardson (1988, 167–8). Schefold (1962, 49–50) who described the ornamentation in some detail saw watery associations among the imagery; however, many of the motifs are common. Moormann (1988, 143–5) describes both the figures and the ensembles.

8. Carettoni 1983a, color pl. J.

9. De Franciscis 1985, 14a, pls. 8, 13.

10. Carettoni 1983a, 26.

11. Picard-Schmitter 1971, 74–81.

12. Carettoni 1983a, 54–5.

13. Bastet and De Vos (1979, 67) comment on the mixture of fantasy and tradition within an image which, in their opinion, is far removed from the "real" *scaenae frons*.

14. Picard 1982; Moormann 1983a.

15. Mau 1907, 248.

16. Picard 1982, 55; von Cube 1906.

17. Beyen 1938.

18. The tragic manner, as Vitruvius 5.5.9 explains it, involved decoration with columns, pediments, statues, and other objects suited to kings. Comic scenes exhibited private dwellings with balconies and views representing rows of windows after the manner of ordinary dwellings. Satiric scenes were composed of "trees, caverns, mountains, and other objects delineated in the satiric style." Along with the masks, the feature of the Boscoreale room, which prompted Beyen to interpret its decorations as theatrical was the grotto design on the rear wall. This was the first dis-

covered instance of such a phenomenon in Pompeian painting. All the same, Beyen was scarcely ready to argue that the entire *cubiculum* was decorated as a stage for satyr drama, but rather he divided it into three units of decoration. The tholos, with its slightly ritualistic character, formed the royal setting, whereas the side panels of the wall with their symmetrical views of loggias and gables flanking a central gateway formed the comedy scene.

19. Among the several scholars who have followed Beyen's theory, Agnes Allrogen-Bedel (1974) has treated the subject in the most detailed manner, first examining the walls with an eye to the specific varieties of masks displayed in them and then as an evolutionary chronology incorporating progressive stages of design. All the same, with reference to the Boscoreale *cubiculum,* she discovers an inappropriate linking between subjects and masks with the satyr mask displayed above the tholos panel (20–30).

20. Among the first to refute the theory was P. W. Lehmann (1953, 90–4), who based her arguments on certain inconsistencies troubling the coordination of Beyen's theory with Vitruvius. Especially she argues that this quadripartite collocation of panels does not contain one or another kind of scene as Vitruvius would have it, but, by Beyen's own interpretation, juxtaposes all three genres of *scaenae frons*: tragic, comic, and satiric. As her alternative proposal, Lehmann (94–131) develops a suggestion advanced at the time when the paintings were discovered: that they constituted the buildings of a villa fictively drawn into the compass of the room. Engemann (1967, 123–34) amplifies this theory with reference to the illusionistic features of the paintings. Studying the remains of their fictive colonnades, he concludes that these are painted in such a way as to indicate probable extensions of actual space within the house.

21. Leach (1981, 158–67) presents the case for independent models in greater detail. A recent tendency, represented by Barbet (1985, 44–52), and Ling (1991, 29–31) is to accept the pluralism of models, but in a kind of "new critical" manner that denies their imitation of any real form and proposes an eclectic, imaginary species of composition that is obedient only to its own rules.

22. Rome is not, in fact, the limit of these installations. Following the interpretive reconstruction of Donati (1987, 149–153) we can see the clear-cut lineaments of a theatrical pattern in the three doors with gabled porches forming the back wall of a large room in the Tuscan Villa Settefinestre. This installation, in Donati's opinion, is closer to those of the Palatine houses than to Campanian examples.

23. As P. W. Lehmann (1953, 114–18) recognized, the grotto in the Boscoreale decoration is not a wild grotto but a feature of a cultivated garden belonging to the conventions of villa landscaping with parallels appearing in actual gardens. The purpose of the decorative segment is to open the room to the fiction of an outdoor ambience. Other paintings of landscape subjects situate their dedicatory monuments within the setting of a sacred grove; neither these monuments nor their settings incorporate the features that Vitruvius attributes to satyr drama.

24. Bieber (1961, 167) reviews the evidence.

25. Allrogen-Bedel (1974, 68–73) raises the issue indirectly by her speculations concerning the significance of the masks. She

rightly observes that any original religious significance would have been lost. Her explanation that the *mimus vitae* is suggested looks in the right direction, yet her limitation to the metaphorical implication of this concept for the individual life bypasses the cultural significance of theatricality.

26. Axer (1991, 221) presents an inclusive definition of Roman theatricality that interconnects its several rituals of presentation: theatre and drama, oratory, circus and amphitheater, triumphs, funerals, and executions. "There is," as he writes, "a level on which they form diachronically a homogeneous entity, absolutely fixed in synchronicity."

27. Veyne (1987, 107–16) discusses the relationship between euergetism, its popular reception, and individual prestige, which is fully as operative in provincial cities as in Rome.

28. Zorzetti 1991.

29. In *Tusculans* 4.3, Cicero, citing Cato as his authority, regrets the loss of the ancient *carmina convivalia* that men sang by turns at banquest in praise of virtues and deeds. Zorzetti (1991, 314–15) locates these within the traditions of praise poetry.

30. Livy 7.2. Also Valerius Maximus 2.4.4.

31. Taylor 1937, 291–6.

32. Taylor 1937, 284–91; votive games, 296–8; funeral games, 299–300.

33. As indicated by the *didascalia*, Terence's *Adelphoi* was performed at the funeral games of L. Aemilius Paulus in 161, and also his *Hecyra* had its second, but unsuccessful, performance on the same occasion.

34. Hanson 1959, 29–30. Boethius and Ward-Perkins (1970, 137–8) briefly summarize the material.

35. Veyne 1976, 375–8.

36. Rawson 1985, 99–100.

37. Gruen (1993, 206–10) reviews the incident.

38. Cicero's contemporary mention of these games, *Pro Sestio* 116, calls them *ludi apparatissimi magnificentissimique* ("the most elaborately furnished, the most magnificent games"). His superlatives underscore the fact that his enemy, P. Clodius Pulcher, had not dared show his face at the games.

39. Gruen (1993, 188–222) questions the efficacy of sponsorship in winning votes but asserts the idea of aristocratic control over culture. He emphasizes the cultural content of plays but tends to play down the *ludi scaenici* as a source of prestige.

40. Frézouls 1983, 207–14.

41. Although the specific citation of Mytilene may be, as argued by Gros (1978, 67; 1987 322–3), unverifiable, the echo of Hellenistic associations can be demonstrated in its own right. Sauron 1989, 457.

42. Coarelli 1972, 104–5; Sauron (1989, 461–4), in keeping with his interpretation of the monument as a metaphorical Elysian Fields, wants to associate the women with the heroines glimpsed by Odysseus in the Underworld.

43. Gros 1987, 325–6.

44. Gros (1987, 327–46) comments on evidence for Augustus' awareness of the value of theaters in Rome. Bejor (1979, 127–8) notes that the majority of municipal theaters were built in the eighty years following the second triumvirate.

45. Pighi 1965, 115, 288. Vitruvius (5.5.7) insists on the good acoustical properties of the "many wooden theaters" built each year in Rome.

46. *Jewish Antiquities* 19, 87–90. The details are important to the enactment of the murder and its aftermath. The theatre had a *porticus* with entrances and exits that guaranteed privacy to those within. The stage building had an inner partition to provide a retreat for actors and performers.

47. D'Arms 1989, 54.

48. Franklin 1997, 442–4. Inscription *CIL* IV.7993 mentions *pompa, venatio, athletae, vela*. Franklin argues that the *opus tabularium* should refer to stage decorations, yet it might seem also logical that they had been deployed in the amphitheater, perhaps as parapet panels. At the same time, the staging of games in the theater was a way of circumventing the ban on contests in the amphitheater.

49. Wiles 1991, 66. Defining Menandrian theatre as having its frame of reference in social reality, with "real-life futures" for its characters, he comments on the interrelationship of dramatic space and reality within the Roman theatre: "reality is not ultimately knowable. There are many competing angles from which stage action can be viewed. Many different frames can be placed around the stage action to make it coherent.... Truth resides not in but beyond the ephemeral casing in which man is housed."

50. Coarelli 1983, 215–16.

51. Pliny *NH.* 36.5–7. Later they found their way back to public display when Augustus installed them within his Theatre of Marcellus.

52. Wiseman (1985, 43–9) reviews evidence with particular reference to Clodia.

53. Zorzetti 1990, 289–307; 1991, 311–13.

54. Franklin 1987, 95–107.

55. L. Richardson (1988, 315) does not agree.

56. Allison 1994, 348. There are several such decorations including four reliefs decorated with theatrical masks embedded within the walls and others standing within the garden area. Marble masks and a head of Dionysus appeared on the walls and masks were hung from intercolumniations.

57. L. Richardson 1988, 175.

58. House of Fabius Rufus (7.16.22). Cerulli-Irelli 1981, 22–32, fig. 2; Barbet 1985. pl. IIa.

59. Bragantini, de Vos, and Badoni 1981, 167, fig. 28A, but also *PPM* 6.37–41.

60. The second figure, whose performance genre seems less certain, is differently dressed (*PPM* 6.40). Wearing a tunic with an *augusticlavis* (sic) and a cloak, he holds in one hand a "knotted bastone" and in the other a *rotulus*.

61. Contra Wesenberg (1991), 67.72 who thinks that these figures, in what he calls an early (Ic/IIa) phase of the Second Style, are precursors of the large Boscoreale figures to come later. I believe that they represent a transitory caprice.

62. In view of Fundanus' profession, the narrative itself may seem to be shaping the ludic dimensions of the event. Gowers (1993, 166–79) enforces the theatrical analysis, noting how theatrical allusions mark scene changes and the drama ends in accordance with Cicero's description of a mime: no conclusion; the guests rush out. All the same she insists that Nasidienus' taste is good – despite the way in which the technology of cooking corrupts the food – and compares his managerial struggles with those of Horace in writing satire.

63. Professional actors shared the social status of other pariahs such as prostitutes and gladiators, being denied citizen rights. Sulla granted equestrian status to Roscius the comic actor; the playwright Laberius felt disgraced and temporarily forfeited his equestrian rank for acting at Caesar's behest in a mime he had authored himself.

64. Aulus Gellius mentions how Hortensius' detractor L. Torquatus mocked his dandified dress and exaggerated gestures (1.5.1–3), going so far as to call him by the name of an infamous dancing girl, "Dionysia." Glamor was manifestly what Hortensius relied on when he answered his critic with a defense of his own superior artistic culture.

65. Edwards 1994, 83–6; Slater 1994 discusses attempts to bend the prohibition and especially the equestrian attraction to pantomime in the early Julio-Claudian period.

66. What Cicero makes L. Antonius say in this context is *vox tragoedorum, gestus paene summorum actorum requirandus est* ("One needs to display the voice of tragic actors and gestures that are virtually those of master stage performers"), the *paene* (virtually) apparently expressing elitist hesitation to identify completely with an actor.

67. Axer (1989, 300–1) notes recent attention to the topic and Cicero's use of special "theatricalizing" devices in specific orations as he goes on to analyze certain instances in which the orator played on his audience's experiences of spectacle in executing a metaphorical or imaginative transformation of the judicial venue into an area of performance.

68. Carettoni 1987, 111–15, is the most recent overview.

69. Carettoni 1983a, 11.

70. Carettoni (1966, 191–2) places the upper limit of the stage decoration at the cornice.

71. Picard-Schmitter 1971, 74–81.

72. Carettoni 1983a, 45–51, color pl. N.

73. Carettoni 1983a, 51.

74. Carettoni 1983a, 52–60.

75. Carettoni 1983a, 54; 1987, 112.

76. Zanker 1988, 101–263, examines the blending of new and old vocabularies in visual imagery, but see also Kellum 1986, 1994b.

77. Bejor 1979, 129, to which might be added Woolf's 1998, 122, testimony to the later spread of theaters among the towns and rural sanctuaries of central and northern Gaul.

78. Bejor 1979, 129–36.

79. King 1994, 228, passim.

80. King 1994, 256–7.

81. Carettoni 1983a, 57.

82. Slater 1994, 122.

83. Within the entire structure of Suetonius' *Lives,* this perception is preliminary to a treatment of the later Empire as an intensification of theatricality which, in its worst scenarios, involved also an intensification of deception or of simulated faith.

84. Slater 1994, 123–8.

85. Two examples are the *tablinum* frieze zone in the Casa di M. Lucretius Fronto and the architectural structures on the rear wall of the grand Salone in the Villa Imperiale.

86. Woodman 1993, 104–28; Edwards 1994, 83–94.

87. Picard 1982, 57–8.

88. Moormann 1983, 73–117.

89. Picard 1982, 55–6. Moormann 1983, 73–5, gives seven clear instances.

90. della Corte 1964, 362–4.

91. Moormann 1983, 76–84.

92. Moormann (1983, 78–9) observes the discrepancy but construes it to indicate that the scene represents the "continuous drama" of pantomime. Fortuitously, his note 25 in which he cites the contrary opinions of Spinazzola (1953 II. 700) and Schefold (1962 144) as to which young man is Orestes and which Pylades re-enacts the confusion that Cicero cites in Pacuvius's drama. Moormann himself (78.n. 29) refers the matter to a pantomime on Orestes mentioned by Lucian.

93. Casa del Citarista (Helbig 1333; MN9111), the Casa dei Vettii, VI.9.6–7 (Helbig 1335), and VII. 2.6 show the figure group.

94. della Corte 1964, 30.

95. Andreau (1974, 270) notes three appearances of his name in the wax tablet, and classifies him among the signers of commercial interests.

96. Moormann 1983, 87–91.

97. Reckford 1972, 405–32.

98. Leach (1991, 106–111), discusses this painting in greater detail.

99. Moormann 1983, 105–11.

100. A somewhat different construction may be given to a few examples of the stage front decorated with figures more closely related to the athletic than the theatrical sphere. Deployment is different. The spaces are larger and face on open areas. The building at 8.2.23, commonly called a palaestra because of its athletic figures, may actually be a dining club.

101. Moormann 1983, 114.

102. MacDonald 1986, 193.

103. MacDonald 1986, 191–8.

104. Boatwright 1994, 189–207.

105. Boatwright 1994, 197–8.

CHAPTER 4. GARDENS AND PICTURE GALLERIES

1. Shatzman 1975, 380, provides evidence for the agricultural function of Lucullus' Tusculan estate, but Varro, in this context, may have been referring to the property on the Pincian hill, which was presumably not agricultural. Lucullus, however, was known for the importation of the cherry tree from Pontus (Pliny, *NH.* 15.102).

2. Rouveret 1987b, 15, cites Huergon's observation in his Commentary that this is the apparent borrowing of an unattested Greek word.

3. In addition to the examples mentioned in Chapter 2, Cicero *Ver.* 2.1.51; speaks of the statues now positioned in the possessor's villa, some between columns and others in the open air. Caesar's gardens also were well populated with statuary which Cicero accuses Antony of carrying off (*Phil.* 2.109). Numerous scholars have also favored the speculation that Asinius Pollio's famous collection of sculpture, which, as the Elder Pliny puts it (*NH.*36.4.33), he wanted people to see, was arranged in a garden (Zanker 1988, 70–1, and for a summary of opinion Henderson 1998, 158, n. 116). Most recently La Rocca 1998, advances the proposal that the *hortus* in question was not a part of the *Atrium*

Libertatis that housed Pollio's library, but rather his extra-urban holdings on the site of the later Baths of Caracalla. Although one cannot agree that the original Punishment of Dirce attributed to the garden was identical with the Baths of Caracalla display piece, certainly La Rocca's proposed location would allow much more space for the sculptural display.

4. Jashemski 1993, 394–404, catalogues, describes, and illustrates nearly forty examples of such plans, most often in the predella zone.

5. Gabriel (1955, 11) seems uncertain whether this effect is accidental ("the changes in the seasons were not taken into consideration") or deliberate ("we have here a fairy garden").

6. Gabriel (1955, 43–53) catalogues the birds but notes that her listing does not include the traces of even more birds whose forms have become indistinguishable. Nor are precise identifications possible in all cases, because some birds do not match the species currently known.

7. Gabriel 1955, 18.

8. Ling 1991, 150. Although he expresses reservations concerning the "deliberate" intentions behind the "paradisiacal effect," he concedes that "such an effect would neatly mirror the new emphasis upon the new golden age and the fertility of Italy in contemporary court poetry." Kellum (1994b, 211–24) much more decisively associates the room with Augustan symbolism, specifically citing the princeps' own "arboreal mythology."

9. Jashemski 1979, 24.

10. Gabriel 1955, 7–8. This border is greatly restored in accordance with conjectural interpretation, but its nature is crucial to our understanding of the representational fiction. Tendrils, distributed at irregular intervals, interlace the outer margin of the border. Some persons have seen the edge as the outer rim of a grotto, but Gabriel suggests a roof composed of stuccoed thatch.

11. Gabriel (1955, 2–5) describes the enclosure from which the paintings were cut. Messineo (1991, 219–51) reports recent reexcavations of the site.

12. Propertius 1.2.10 implies garden ivy when he remarks how spontaneous growth is better (*melius sua sponte*). As an example of growth that is not "self-directed," Richardson (1976 ad loc) mentions how ivy constructions in Pompeian painting are often trimmed into the domed shape of a circus *meta*.

13. Sichtermann 1980, 457–61.

14. Jashemski 1979, 75–7.

15. Insula Occidentalis 6.17.42. Jashemski 1993, 348–58, describes this individual house under the name of the "House of the Wedding of Alexander" from a panel panting recovered on its atrium level; but its more recent and new official name, as used by Moormann 1995 and *PPM* 6.45–145 in the Casa del Bracciale d'oro.

16. Moormann 1995, 214–28.

17. Jashemski 1979, 32–3. Not all houses, even large ones, tapped into the system. Connections were lacking in parts of Region I including the house of Polybius; Jashemski 53.

18. L. Richardson 1988, 62–3.

19. Jashemski 1979, 55–62.

20. Jashemski 1993, 375–79.

21. Jashemski 1979, 69–73.

22. Andreae 1990, 102.

23. To which he adds that even the Roman equivalent *vivaria*

was not used in earlier times. Varro, he notes, talked only of rabbit preserves (*leporaria*) or *roboraria*, tracts bounded by wooden fences. The implication is that neither will have been very large.

24. As the first exhibition on record Andreae (1990, 106) cites that staged in 186 B.C. by M. Fulvius Nobilior as a part of his triumphal celebration.

25. Franklin 2001, 24–5.

26. Andreae 1990, 108–10. *PPM* 7.105–11, pls. 44–54.

27. Andreae 1990, 113–14.

28. Franklin 2001, 123–4, et passim, considers these displays in relationship with the careers of their various sponsors.

29. Kondoleon (1991, 105–15) cites these Campanian instances as background for her discussion of the clear relationship between hunt depictions and patronage in houses of the Greek East, especially Cyprus and Kos.

30. L. Richardson 1988, 126–7.

31. Peters and Moormann 1993, 411–12, review the outlines of Fronto's career, whose dates of office cannot be determined precisely. (Franklin 1980, 67–8, assigns his duovirate to A.D. 73 only by process of elimination.) Some of della Corte's less firmly attested attributions associate other such houses with magistrates: the Casa dei Quadrigi (7.2.25) to a Vettius and the Casa della Caccia Antica (7.4.48) to the family of the Marii.

32. Sabbatini-Tumolesi (1980, 58) who notes that this is the only spectacle known to have been sponsored by an Augustalis.

33. The painting now survives only in the photographic archive of the American Academy, FU 7248. Jashemski 1993, 333–4.

34. De Vos 1976, 280. Andreae 1990, 90–1. Vestorius, who was aedile in 75–6, probably died in office, and acquired his tomb by public decree. Gladiator and animal scenes are juxtaposed here. The animal scenes are fairly extensive with figures placed against a green background.

35. Della Corte 1964, 128–30; Jashemski 1993, 344–5.

36. Jashemski 1976, 69–72. See also Pliny *NH*.

37. Andreae 1990.

38. Coleman (1990, 60–73) questions the reliability of these accounts within a general context of Roman criminal executions and concludes in favor of their probability, noting, on one hand, their specific chronological attribution to the reigns of Nero and Titus and on the other their paradigmatic positioning of "ritual events of ordinary life . . . in a mythological context" for which a "superficial appropriateness was quite adequate; points of detail did not have to correspond."

39. For example, *Ver.* 2.1.45, 50, 61, 2.4.8, 36, 132–3, 2.5.127; *pro Roscio* 133.52.7 (long with vessels and coverlets); *Stoic Paradoxes* 5.36, 6.49.

40. K. Lehmann (1941, 95–105) makes a massive effort to determine positions and thematic connections among the subjects described.

41. van Buren 1938, 78–81.

42. Schefold 1972, 50–2 et passim. His identifications are sporadic; some rooms fit his definition better than others as (141–63) examples of moral severity or rigor under Augustus and Tiberius, apotheosis during the eras of Claudius and Nero, and the power of love in the Fourth Style.

43. James 1975, 117: "After lunch he proposed to Isabel to come into the gallery and look at the pictures; and though she

knew that he had seen the pictures twenty times, she complied without criticizing this pretext." In fact such a specially designated gallery is not the usual custom even of British country houses where collections are customarily distributed throughout all the public rooms. Perhaps the singularity of Gardencourt is owing to the fact that its owners, the Touchetts, are American.

44. Bulwer Lytton (1834, 36–7) took this impression from his sources and placed a single *pinacotheca* at the rear of peristyle beside the large room he called an *oecus* while noting that the position of the picture gallery in the "stately palaces of Rome" was more likely to communicate with the atrium.

45. Presumably he means that they intersperse these within assemblages of less venerable items.

46. Van Buren 1938, 77–8.

47. Carettoni 1983, 60–6.

48. Carettoni (1983, 61–2) suggests that these might be taken for the "guest doors" of a Vitruvian stage set, but this explanation scarcely accounts for the full perspective views seen in these windows or for their unusual placement flanking a closed central space.

49. Rizzo 1936, 11–14, but see now Jacopi 1995, 130–2, who insists, despite Coarelli's positive identification, that the ownership cannot definitely be attributed to Livia. Ehrhardt (1987, 15–16) argues for contemporaneous creation of these rooms on the basis of shared compositional formats and similarities of detail; Jacopi also doubts a "preexisting phase of decoration."

50. Eristov (1994, 59–72), categorizes and illustrates the varieties of construction in Fourth Style *aediculae* with comments on what they owe to earlier manifestations of the form.

51. Similar architectural elements configure a deep and narrow space opening on the rear corridor of the peristyle in the House of Julius Polybius that Barbet (1985, 126–127 and Pl. IV A) calls a *cubiculum*. In this case the large window apertures at the ends of the lateral walls do open, as Vitruvius specifies, upon garden views. Standing out against thick backgrounds of shrubs and trees, we see paired sphinxes facing each other across a fountain basin. The visually discontinuous rear wall is a typical Third Style *pinacotheca* design. de Franciscis 1990, 22; Jashemski 1993, 368–9; Barbet 1985, pl. a.

52. della Corte 1964, 98–9; Sabbatini-Tumolesi 1980, 58.

53. Mau *BdI* 1882.

54. Dilthey (1876, 294–314) describes the paintings fully and provides a text for the epigrams.

55. Moormann (1988, 163) argues against a long-standing opinion that the figure, because of the panther and a cantharus, should be Dionysus. Rather, he thinks that Ariadne appears here in the pose of an exhausted Maenad.

56. Moormann 1988, 163–4. Although puzzled by the wings of the lyre player, he proposes Urania for the second figure.

57. Castrén 1975, 100.

58. Allrogen-Bedel 1974, 28–9; 152–3. She catalogues three comic masks on these side walls, with still another undecipherable.

59. Allrogen-Bedel 1974, 24–5; Ehrhardt 1987, 20–3.

60. Bragantini and de Vos 1982, tav. D. Since this chapter was first written, the complete repertoire of paintings has been moved from its old housing in the Baths of Diocletian Museum to the Palazzo Massimo, where each set of panels has been installed within the space of a chamber fitted to its size, allowing viewers for the first time to encounter the decorations as coherent ensembles.

61. Bragantini and de Vos 1982, 130–1, pl. 36.

62. Bragantini and de Vos 1982, pl. 43.

63. Bragantini and de Vos 136–7, pl. 61, 62.

64. Bragantini and de Vos 1982, pls. 107, 108.

65. Bragantini and de Vos 1982, 284–95, pls. 166–206.

66. Bragantini and de Vos 1982, 284.

67. Bragantini and de Vos 1982, 289, pl. 184.

68. Bragantini and de Vos 1982, 7–94; pls. 6–7.

69. Bragantini and de Vos 1982, 31; Carettoni 1985. Because this decoration has been reassembled from fallen fragments, little is known about its original context save for its location on the upper level. No doubt it belonged to a program, but its fanciful identification as *studiolo* with the cherished retreat that, according to Suetonius (72.2) Augustus called his 'Syracuse' and *technyphion* (Jacopi 1990) has no hard evidence to support it.

70. Carettoni 1983b, 90–1; 1983b, 416.

71. The preface of Book 1, which praises a ruler's concern to erect outstanding public structures within a program of rebuilding, gives little help in refining the actual dates of the treatise.

72. Beyen 1948, 3–21; followed by von Blanckenhagen 1990, 16; Bragantini and De Vos (1982, 23) who include a brief history of the theories concerning ownership.

73. Von Blanckenhagen 1990, 16–17.

74. Bastet and de Vos 1979, 8–9.

75. Bastet and de Vos 1979, 37–9; Pappalardo 1987, 125–9.

76. L. Richardson 1988, 218–20.

77. Bastet and de Vos 1979.

78. Von Blanckenhagen (1990, 3), citing Della Corte's 1922 report of the excavation. On this basis he places the construction of the villa within the "transitional" period from Second to Third Style.

79. L. Richardson 1988, 221–7, 240. Characterizing the domestic architecture of the period as "a style of contradictions," he notes departures from the canonical floor pattern of the formal atrium house. As examples he describes two of the larger houses notable for their Third Style decorations, the Casa di Jasone and the House of Spurius Messor, as being "irregularly cobbled together from bits and pieces of other properties." L. Richardson 1988, 223–4. The House of Spurius Messor, which Richardson terms "small and makeshift," contains few paintings, but the decorations in its large rooms are very fine. Bastet and de Vos 1979.

80. Bastet and de Vos (1979, 85), citing Mau (1882, 418, on the full extent of the decoration; of which only the "grand *triclinium*" of the garden is sufficiently documented for discussion.) DeAlbentiis (1982–83, 245–64, pls. I–V) reconstructs a programmatic significance for the panel paintings that relates to Troy and Rome.

81. Franklin 1980, 62–7. For the family and probable history of ownership see Chapter 6. The earliest Ceius was a magistrate in the Augustan period; the next conspicuous member of the family was elected adile in A.D. 76 and stood for duovir in 78.

82. *PPM* 1.408.

83. Allison 1994, 312.

84. Franklin 1990, 45–50.

85. *BdI* 1873, 205 ff.

86. Franklin 1990, 21–30.

87. Bastet and de Vos (1979, 42) date such examples during the period A.D. 1–25. First example of the style in the Pyramid of Cestius; Barbet 1985.

88. Peters 1993, 149–61. It is interesting that he has chosen to describe these bordering strips with a word *lesene* that may mean either ribbon or pilaster. In fact it is impossible to be certain which alternative the designs imitate.

89. Zevi 1960–61, 20

90. Zevi 1960–61, 13–16.

91. Zevi 1960–61.

92. Leach 1988, 396–7. The more extensive discussion of interconnections among the three paintings by Bergmann (1996, 199–218) brings elements of "spectator response" to a reading in terms of visual attitudes and literary allusion. Ultimately she offers her reader an interpretive choice between censure of the heroines in conformity with Augustan moral and marital legislation or romantic titillation at the "illusion that the women really will kill or die for love."

93. Leach (1988, 397–402) discusses the actions and backgrounds in greater detail.

94. Bastet and de Vos (1979, 89–90) note that these are windows and not *aediculae*.

95. Bastet and de Vos 1979, 89–90.

96. Fragments of cornice and *aedicula* in another black Third Style room of the house of Trebius Valens are similar enough to show that the painter or workshop had been employed again on that street.

97. Della Corte (1964, 314–15) gives the owner's name on the basis of several *programmata* featuring him as a rogator. To what cult his priesthood belonged is not known, but he was presumably the final or quasi-final owner of the house. Other interior graffiti show a lively interest in the contemporary ampitheatre with mention of the conflict between one *Spartac* and *Felix,* as well as a drawing of a gladiatorial contest.

98. Somewhere upstairs, according to della Corte (1964, 316), a maker of wooden tablets had his workshop.

99. One must remember that the Boscotrecase ensemble included at least a third pendant now unknown that could conceivably have been Daedalus. Leach (1988, 364–7) discusses at greater length the visual and thematic interplay of the compositions in both houses.

100. See Peters (1963, 82–5) and Leach (1988, 388–92) for a Third Style version of this subject against a full landscape background that once formed part of an ensemble in Casa 5.2.10.

101. Bastet and de Vos (1979, 8–9) weigh the probabilities of alternative dates before and after the death of Agrippa Postumus. They are inclined to accept the later dating on stylistic grounds.

102. Dawson (1944, 173–9) proposed that many sources were theatrical, referring not only to plays but also to mimes.

103. Leach 1986, 180–2. Differences in manner suggest that the Marinaio painter was the one who copied.

104. Contrast between the extant version in the Casa del Frutteto and a drawing of the lost panel in 9.1.22 appears in Leach 1981, 319–21. To these can be added the Discanno drawing of the version described in the Casa del Marinaio now published in *PPM* 7. Containing only one figure of the goddess but two of Actaeon, this panel is dominated by Diana's woodland shrine, which stands closer to the foreground than any of the three personages of the drama. With this central image and its scattering of goats browsing the cliffs and scarps of the rocky landscape, this Cithaeron is comparable to that of the Dirce and Antiope paintings of the House of Julius Polybius and Casa del Marinaio (Leach

1986, 157–61, 168, 180–2). But the composition, which separates Actaeon from the goddess and locates him on the slope of the mountain, seems to allow for the possibility of his discovery as accidental.

105. Leach 1988, 361–409.

106. Bastet and de Vos (1979, 50–1) note the decorum of paratactic panel painting in the corridor spaces of this building.

107. L. Richardson 1988, (194–8); Dobbins 1995, 600–51. Zanker (1993, 109) speculates that the statue of a richly ornamented Concordia will have displayed Livia's features. A generic image of the goddess still remains on the fountain outside the staircase entrance leading into the back of the building from the Via dell'Abbondanza.

108. L. Richardson 1988, 191, on the temple; 254 and 371 on the tomb. About the affiliations of the priestess, Zanker 1993, 103–105; Franklin 2001, 33–36.

109. D'Arms 1989, 51–68; L. Richardson (1988, 216–17) notes that the stage was not included in the inscription recording the work.

110. That Celer outlived Augustus is clear from his mention as *sacerdos divi Augusti*. On that basis Franklin (2001, 20–1, n. 16) corrects the long-standing assumption that Celer was Rufus's brother.

111. Castrén 1975, 92–103.

112. Franklin 2001, 17–18.

113. Laurence 1994, 40–1.

114. Mau 1904, 465.

115. Brendel 1979, 172.

116. Zanker 1988, 282.

117. Nisbet and Hubbard (1978, 287–9, 293) trace the conflation of materials and rhetoric.

118. Nisbet and Hubbard (1978. 51–54) document the changing loyalties of Dellius' checquered political career. Leach (1997. 111–115) discusses the personalities and properties of *Odes* 2 in greater detail.

119. Pappalardo 1991. 226 summarizes various recent opinions among which he most favors the chronology of Bastet and de Vos.

120. La Rocca 1986. 105–152.

CHAPTER 5. THE STYLE OF LUXURY

1. Elsner and Masters 1994, 1–5.

2. Champlin (1998, 334–5) responds to the general contemporary trend toward enlarging the putative domains of the palace architecture by redrawing its confines. Rationalizing the scraps of literary and archaeological evidence for both houses, he places the greater part of the Domus Transitoria within the area of the Velia and the palace itself on the slope of the Caelian.

3. MacDonald 1982, 20–5; de Vos 1990, 167–86.

4. Dacos (1969, 9–42) provides a descriptive itinerary of the rooms explored by Renaissance artists, who believed them to be the baths that Titus was known to have constructed close to the Colosseum.

5. Weege (1913) summarizes excavation history including the work of Ludovico Mirri, a Roman art dealer, in uncovering eleven buried rooms.

6. L. Richardson (1992, s.v. *Domus Aurea,* 119–20) gives an account of research through the 1980s. Fabbrini (1995, 56–63,

s.v. *Domus Aurea*) summarizes her discoveries (1982) within the context of previous knowledge.

7. Lanciani 1897, 359–60; Ashby 1924. Among the most interesting is a "nymphaeum" with seashells, "enameled" decorations and niches for statuary found accidently in the course of work on the Via dei Serpenti.

8. Although Strocka (1987, 32) has challenged the dating of the complex on the basis of a roughly inscribed *Ti Claud* on an architrave, De Vos (1995, 199–202 and pls. 63–5) defends the traditionally accepted date as based on brick stamps.

9. Fabbrini 1995, 59.

10. Perrin (1990, 211) remarks not only on the difficulty of filling in the spaces, but also on the hesitation scholars have shown to identify places as a context for power.

11. Fabbrini 1995, 59.

12. Peters and Meyboom 1982. 33–74. Moormann (1998) coordinates the numbered plan with a diagram indicating the heights that the marble facings reached in the various rooms.

13. Jacopi (1999) includes up-to-date color photos of many newly cleaned ceilings and their details as well as a few of the archival drawings.

14. Pinot de Villechenon (1998) gives a history of early excavation campaigns and the published engravings that resulted from them in company with full color reproductions of the thirty plates, depicting both full compositions and compositional details in the Louvre volume of Nicholas Ponce's *Bains di Tite*.

15. Ling (1991, 75–82) places the house at the beginning of a stylistic "maturity" that devolves into decadence.

16. Archer (1990, 95–123) lists fourteen examples he considers secure, beginning with the *alae* of the Casa dei Vettii and including both the Villa San Marco and the Casa del Menandro, the owners of which were Poppaei and often though to be kinsmen of Nero's second wife.

17. Peters and Meyboom (1982, 8a) appropriately note that *scaenarum frontes* and other systems were used in Italy a long time before the Domus Aurea, and Fabbrini (1995, 59) remarks that the great paradox of the decoration and Pliny's praise of the painter Fabullus is a failure to recognize any grand imperial vision amid a focus on detail and repetition. These assessments are in keeping with David Hemsoll's realistic 1990 assessment of the architecture of the Domus as an ingenious recombination of elements already well-integrated into Roman building practice.

18. Swindler (1928, 226) notes the parallel but appears to believe the truth of both stories, finding their connection merely "similar."

19. With reference to figured paintings of the Domus Transitoria, de Vos (1990, 182) perceives two styles that she characterizes as a calm classical and a frenetic, but attributes both to the same painter.

20. According to Pliny (*NH.* 35.30) the *colores floridi* were provided to painters at their patrons' expense. *Colores austeri* were their opposite. Rouveret (1989, 255–66) discusses Pliny's technical information concerning these colors, suggesting that the distinction between them involves their degree of luminosity, but also observing that Pliny's division does not concern the painter's skills but rather the amount that his patron is willing to expend. Her discussion does not touch on the person of Fabullus.

All four adjectives can, of course, be found within the vocabulary of rhetoric that frequently overlaps with that of art criticism. Cicero *Brut.* 113 speaks of the "severe" style; as does Quintilian *Inst.* 8.3.14; 9.4.63. Quintilian 12.10.58 defines the style that is *floridus* as a "middle style" aimed to delight. Strictly speaking the rhetorical meanings would create a terminological contradiction, but Cicero also *Orat.* 3.98 uses *floridus* with reference to bright colors in painting, while *vividus* can be found in the vocabulary of art with the meaning of "lifelike" (Prop. 2.31.8 *vivida signa*).

21. Dacos 1968, 224. Peters and Meyboom (1982, 50 ff). distinguish the work of three studios as responsible for the great variety of the first phase paintings. Furthermore, each of these was capable of more than one type of decoration at the same time. Meyboom (1995), who defends Famulus as the proper name of the citizen artist, argues that his art in the actual work of painting was very limited.

22. Suetonius (*Otho* 7) says that Otho voted 50 million sesterces to complete the Domus Aurea, but this does not tell us how much was completed or utilized. According to Cassius Dio (*Hist. Rom.* 64.4) Vitellius found the house small and meanly equipped, and his wife, Galeria, ridiculed the paucity of decorations in its *basilikon*. Dacos (1968, 223) notes evidence of Titus's partial use of the palace in the intermediary floors constructed within some of the loftier vaults and the repainting. Peters and Meyboom (1982) discuss nonimperial restructuring and the decorations that go with it.

23. He is said to have restored the portraits of Nero to their pedestals and to have returned many artefacts to the house.

24. Elsner (1994, 121–4) notes how the discourse of Neronian decadence contingent on the emperor's overthrow colors traditional assumptions concerning the extravagance of the house.

25. Perrin 1983, 78: "le coeur qu'est la *domus aurea* permet à la fiction néronienne de devenir réalité A partir de ce foyer, le néronisme va impulser ses conceptions à l'urbanisme et au 'vécu' de la ville qui l'entoure."

26. This was also the popular saying reported by Suetonius (*Nero* 39) "Roma domus fiet" ("Rome is turning into his house").

27. Perrin 1983, 69–71.

28. Hemsoll 1990, 16.

29. Moormann 1998, 357–8.

30. Cima and La Rocca 1986, 17;45–8.

31. Perrin 1983, 74.

32. Suetonius reports that the ceiling of one banqueting hall was made from movable ivory coffers.

33. Dacos 1969, 7–9; Macdonald (1969, 34–5) anticipates recent discoveries on the ground level on the basis of irregularities in the structuring of rooms, speculating that the octagonal room may have been central to the structure and flanked by identical pentagonal courts. The existence of a real upper story, however, seems to him dubious. Moormann (1998, 347) cites Lugli's opinion of the west wing as a private quarter.

34. Moormann 1998, 348–9; Lavagne (1988, 585) suggests that the specific motif of the Cyclops cave, which had been used sculpturally both in the seaside dining cavern at Sperlonga and in Claudius' dining nymphaeum at Baiae, must have been a Julio-Claudian family joke connected with hospitality. On Sperlonga, Weis (2000, 124–5) mentions the suggestion that Tiberius, who probably first used the motif, had identified with Odysseus, partly

on the basis of the Claudian claim to descent from his son Telegonus.

35. Dacos 1969, 34–6; Perrin 1990, 211–29.

36. Mirri and Carletti 1776, pl. 6; Nicolas Ponce 1786, no. 33.

37. Dacos 1969, 11.

38. Riccotti 1989, 199–231. These were in fact two in number; one pavilion was located on a ship, called the "state barge," that was in itself a complete residence (Athenasius 5.204E).

39. Dacos (1968, 220–1) considers the level of work in these corridors to be compared with that of the chambers surrounding the octagonal room in the "east wing."

40. Mirri and Carletti 1776, pl. 27. Jacopi (1999, 32–9) provides new illustrations, but without discusssion. Lavagne (1988, 580) speaks of this corridor as an antechamber to the grotto of Polyphemus. Although he mentions (578–88) a grotto on Ptolemy's riverboat as a possible model for this feature, he finds that of the Domus Aurea better incorporated into its situation as a whole.

41. The riverboat of the Ptolemies also included a *scaenae frons.*

42. Dacos 1968, 220–1. Although Jacopi (1999, 32–9) adheres to the variant identification of the subject as Bacchus and Ariadne, Capelli 2000 (161–5) correctly places it within the pictorial tradition of Mars and Rhea Silvia including the "Origini di Roma" from the House of Fabius Secundus at Pompeii (5.4.13).

43. Mirri and Carletti 1776, pl. 45.

44. Jacopi 1999.

45. Jacopi (1999, 14–15) summarizes earlier theories of l'Orange and Perrin.

46. MacDonald 1965, 38.

47. As Moormann (1998, 354–6) observes, the most recent trend among interpreters is toward believing this detail on the basis of striations in the masonry fabric and other literary accounts of cosmological representation procured by mechanical apparatus.

48. Hemsoll (1990, 13–14) reminds us of these as well as precedents for the water-step fountain and vaulted nymphaeum.

49. Moormann 1998, 355. The phrase Pliny uses, *in sellariis,* is singular, and although generally construed as "chambers," might even be semantically ironic.

50. Moormann 1998. 352–8.

51. Bastet 1971–2; Strocka (1987, 31–3) considers filigree an important clue to Fourth Style chronology, noting its appearance in the Nemi ships of Caligula. A Claudian coin found by excavators in a channel of the structure confirms his stylistic impression of this as Claudian (late Third Style) work. To the contrary, de Vos (1990, 168–70) refers to a panel painting of Priam's receiving from Hercules the sovereignty of Troy, which she has recently discovered in the Naples Museum as evidence of its Neronian genesis.

52. MacDonald (1982, 20–5) describes another architectural fragment buried beneath Hadrian's Temple of Venus and Rome that is attributed to the Domus Aurea. This is a rotunda placed at the intersection of two corridors screened by columns and paved with marbles and glass.

53. Grimal (1937, 152–64) is responsible for the thematic identification.

54. Eton College Library. Topham Collection Bn7.100a. This description accompanies Bartoli's colored drawing Bn7.100; Ashby 1914, 33.

55. Montfaucon 1721–2, Vol. 3, 340–4. This is not an eyewitness account; the author complains of difficulties in obtaining information, but rather based on Bartoli's drawings of the stage wall and ceilings, also included as illustration. These are in fact the only extant record of the ceiling designs.

56. Gnoli 1971, 14–15.

57. Cima and La Rocca 1986, 24–35, 41–3.

58. Cima and La Rocca 1986, 46–65. For the alabaster, see Gnoli 1971, 172–4, and Borghini 1998, 148.

59. For the boats with their pavements see Gnoli 1971, 103 and pl. 144. The galleys Suetonius describes, *Caligula* 37.2–3, equipped with ten banks of oars, had gem-studded sterns, multicolored sails, baths, porticoes, and dining rooms, as well as a great variety of vine and fruit-bearing trees. Entertained by choral dancing and singing, the emperor sailed in them along the Campanian coastline. Because Liburnian galleys were valued primarily for their speed and maneuverability in naval warfare, Caligula's functional reclassification was perversion intensified. Cima and La Rocca (1986, 30) refer to the Alexandrian constructions as the ideological models also for Caligula.

60. Cima and La Rocca 1986, 105–50.

61. That Vergil's Dido sleeps within a *marmoreus thalamus* (*Aeneid* 4. 392) is in keeping with her foreign identity, but perhaps also foreshadows a tomb or urn.

62. Leach (1991, 106–10) suggests that this ekphrastic passage reflected an actual *scaenae frons* connected with the stage tradition of Euripides' *Phaeton* or else with a pantomime representation of the *fabula.*

63. Van Dam (1984, 249) cites Ovid as the turning point in descriptions of marble. Before him, white is seven times as frequently mentioned as the colored varieties.

64. Bloomer 1992, 16–17.

65. Pavlovskis 1973; Cancik 1968, 62–75; Vessey 1973, 7–54, on the rhetoric of praise; Van Dam (1984, 247) notes that poets were less critical than prose writers, but this follows from their use of descriptions to create contexts.

66. Isager 1994, 204; Beagon 1992.

67. He does briefly note that the Basilica of Aemilius is remarkable for its Phrygian columns. For the colors of the Augustan Forum some of which may be owing to Tiberius' additions in A.D. 19, see Richardson s.v. *Forum* Augustum 162.

68. Croisille (1982, 340–1) raises the question of whether the description is purely fabricated, or, not improbably, drawn from the eyewitness experience of Lucan's uncle. So far as the implications for Roman luxury are concerned, however, the authenticity of Cleopatra's palace is not a critical consideration.

69. Vessey 1983, 215–17.

70. DuPrey (1994, 24) notes the apparent criteria for the success of a villa: "Proper alignment to distant landmarks, to prevailing breezes and to the rising or setting sun," and goes on to note that Pliny professed unawareness of the conceptual difficulty posed to the reader by his meandering itinerary through the rooms.

71. Granted that the *aequare* here (2.2.93: *gaudens fluctus aequare Carystos*) is conjectural (Courtney in his 1990 Oxford Classical Text edition of the *Silvae* (p. 43) from Salmasius), but it makes excellent sense.

72. Hardie 1983, 133–4.

73. Croisille (1982, 367) notices the contradiction.

74. Hardie 1983, 132–3.

75. Vessey (1983, 207–8) highlights Statius' balance between epic antecedent banquets in Vergil and Homer and the new Olympianism of the emperor.

76. According to the reconstruction in Gibson, De Laine, and Claridge 1994, 79–82, this impression is accurate because the lofty ceiling rested above three successive tiers of columns.

77. Coleman 1988, 91–3, citing Gnoli 1971, 18–19. Cancik (1965, 67) believed that Statius describes the *aula regia*, but Gibson et al. (1994, 92) reconcile his details with their reconstructive picture of the *triclinium*. In both cases columns articulate niches. In the *aula* where rectangular niches alternate with apses, these were of pavonazetto. In the so-called *Cenatio Jovis* they were apparently of granite with giallo antico, pavonazetto, and portasanta in the peristyle (Lanciani 1897, 161–2, supplemented by Gibson et al. 1994, 92). Guerrini (1971, f. 111) reproduces Ghezzi's description and sketch of a painted staircase decoration in the pinacotheca mode. (See also Ashby 1907, 60: Topham 16, 17, 18)

78. Gnoli 1971, 18–19.

79. Van Dam (1984, 233) provides extensive contextual references to art collecting in the period. He also argues that Pollius will have installed these statues in the library to provide inspiration for his literary endeavors, citing as precedents Asinius Pollio's library and that of the Villa dei Papiri. The differences, however, are that Pollio's library is (theoretically) a public space while the collection in the Villa is distributed over semi-private internal norms. (Wojcik 1986, 282). By these precedents it seems more likely that at least some of the statues will have stood in a formal reception space as did those of the Diodumenoi in the atrium of the Villa.

80. Bartman (1991, 76–7) regards this claim skeptically. As she points out, Martial (8.6) makes fun of these pedigrees and the hosts who intone them to their guests, but perhaps this is only when the owners are not Martial's particular friends.

81. Gnoli 1971, 5.

82. With reference to the Casa di Arianna, Descoudres (1993, 172–3) argues that the decorations were actually removed during the first stage of the eruption.

83. L. Richardson 1988, 292–8, fig. 44. Parslow (1988, 37–48) discusses the luxury objects found in this unusual establishment. Clayton Fant also points out the presence of a pair of cippolino columns supporting the gabled cover of the nymphaeum *aedicula* in the House of Loreius Tibertinus. But even in the public sphere, marble columns are infrequent. Travertine for the most part became the replacement for tufa in the public sphere. Early exceptions are the Eumachia building with its sculpted door frame and Temple of Venus (L. Richardson 1988, 280). L. Richardson (1988, 373–4) discusses the sources and uses of marble. Had the city survived, however, things would have been different. Remains of decorative materials lying scattered in the unfinished central baths show that these would have become a showplace for colored marbles.

84. Franklin 1980, 20–1.

85. On the grounds that Fronto will have stood for quinquennial in 70, Franklin 2001, 142, n. 41, revises his earlier dating (1968.68) of the joint duoviral candidacy with C. Julius Polybius for A.D.73, noting that the two men must have stood at some undiscoverable year in the previous decade.

86. Franklin 1980, 99; 101–3.

87. L. Richardson 1988, 228–9.

88. L. Richardson 1988, 228. Third Style decorations show that this room belonged to the original house.

89. Andreau 1974, 25–32.

90. Dexter 1974, 101–9.

91. Dexter 1974, 110.

92. Dexter 1974, 130–40.

93. Bastet and De Vos 1979, 64–5.

94. Ling 1991, 59–61.

95. Eristov (1994, 129) shows the genesis of the curvilinear porticus in the very late Second Style and classes it here as a Third Style phenomena that was to be adopted by the Fourth.

96. Barbet 1985. pl. 3c. Against a black ground these alternate mask medallions and quadretti with bird images within a complex frame of rods twined with ivy scrolls.

97. Ling 1991, color pl. vii A.

98. Jashemski 1975, 33–34, mentions the Casa di Meleagro; Eristov 1994, 16, the Casa delle Nozze d'Argento.

99. Curtains have not gone without notice. Warsher 1955, VI viii II. 173–9: "An appendix on curtains represented in Pompeian decoration" calls attention to the increased importance of curtains as a feature of these decorations. Clarke (1991, 166 a) identifies a "tapestry manner" in decorations of the Fourth Style.

100. Bastet and de Vos 1979, 79–80, 213, pl. xvi; Ling 1991, 72, who classes the wall as an example of the "transitional" style.

101. Bastet and de Vos (1979, 128) discuss the introduction of borders into Third Style decoration. As Barbet (1981) and others point out, the painted borders will have been applied by stencil, hence they are mass produced.

102. For the *tapettia* see also *Stichus* 378 and Varro, *Men.* 447 where they are clearly bed coverings.

103. Whitehouse 1998. Vol. 1, 48–151.

104. Varone 1993, 638–9.

105. D'Ambra (1993, 52) suggests that this cloth may originally have been painted to show a design.

106. As in the central panel on the rear wall of the room of the Muses in Pompeii 9.5.11. Ling 1991, 81.

107. Archer 1990.

108. Perrin 1990, 223–9; Riccotti 1989, 221–2.

109. Riccotti 1989, 199–200.

110. Eristov (1994, 71–2) concludes that the forms of most central *aediculae,* for instance, derive primarily from the Second Style.

111. Jongman 1988, 219–20.

112. Franklin 1980, 99–100. Fronto had only four programmata.

113. Seneca *NQ.* 6.1; Tacitus *Annales* 15.22. Notice of destruction wrought by the Campanian earthquake in the context of both writers' remarks. For Seneca Pompeii is a "city" (*urbs*), for Tacitus only a town (*oppidum*).

114. L. Richardson 1988, 310–11.

115. L. Richardson 1988, 314–17.

116. This is not to say that imperial patronage did not affect the internal dynamics of Pompeian politics, but rather that it did so in a manner that would have enforced their sense of importance. Zanker (1993, 96–138) documents from their monuments in the forum the leading roles played by prominent supporters

of Augustus. Franklin (1993) traces the political alliances both among Augustan supporters and among Neronian supporters at Pompeii.

117. For the former, most recently Clarke (1991, 233–5), who takes as his exemplar of freedman's taste "Trimalchio in Petronius' *Satyricon* who clearly broke the codes of tasteful decoration in his effort both to display his wealth conspicuously and to celebrate his favorite myths and anecdotes from his life." But, as Clarke does not recognize, this figure is a caricature rather than an image from life. Advocates for the coherence and artistic quality of the programe include Theo Wirth (1983) who percieves a series thematic interconnection among its mythological subjects, and Ling (1991, 78–80) who observes the elegance of detail in the paintings.

118. Ling 1983, 34–57.

119. Bergmann 1994, 225–56.

CHAPTER 6. THE FINAL DECADE: DEMOGRAPHY AND DECORATION

1. Sabbatini-Tumolesi 1980, 44–50.

2. Seneca's consular dating in *NQ.* 6.1 would actually make it 63, but Tacitus places it in 62. Sabbatini-Tumolesi (1980, 44–55) argues on the basis of one detail in the announcement that the earthquake had already happened, causing the games to be staged either in the forum or Palaestra Grande. Franklin (2001, 137) thinks it likely that they were cancelled.

3. Laurence (1994, 35–6) proposes that the public buildings may have been less resistant to seismic shock.

4. Allison (1994b, 183–90) applies this suggestion specifically to houses and their state of repair.

5. Recent comparisons between the decorative components in the preearthquake paintings of the Marcus Lucretius Fronto and Caecilius Jucundus and those of many verifiable postearthquake paintings emphasize their underlying conceptual continuity. Barbet 1985; Strocka 1987. Archer (1990, 104) uses evidence for the repair of painted walls as his evidence for dating twelve examples to the preearthquake period. This point is in agreement with more general observations of scholars concerning the development of spatial relaxation and ornamentation in Fourth Style walls that have narrowed the distance between the so-called Third and Fourth Styles. Thus Strocka (1987, 33–5) refers the elaborate ornamentation in the white *oecus* of the Casa del Principe di Napoli (6.15.7–8) to pre-Neronian analogies. Another point of comparison is the Villa of San Marco at Stabiae; its entire decorative program is almost entirely composed of bordered red tapestry panels in paratactic and symmetrical arrangements. Archer (1990, 109) cites the evidence of roof tile stamps from the factory of the freedman Narcissus to provide a sound Claudian date for this villa. Narcissus died shortly after his master in A.D. 54 (Tacitus *Annales* 13.1). The tapestry patterns used throughout the Casa del Menandro must surely be attributed to the same workshop. Pappalardo (1991, 226–7), comparing the theories, remarks on the twenty-year discrepancy that separates the beginning and ending dates proposed by various scholars.

6. Mau 1904, 227; also Richardson (1955, 1–5) describes the character of the street.

7. Laurence (1994, 112) points out the regularity of the street pattern within this sector and its well-marked boundaries. He classes the spatial dynamic as "non-distributive" with the movement of people flowing around, rather than through the area."

8. Jongman (1988, 270) discusses land use and the mixture of residential and commercial properties.

9. Lawrence (1995, 72) remarks on the recessed entrances as an indication that the owners wanted to emphasize their distance from the street.

10. Tsujimura 1990, 64–5.

11. Warsher 1951, VI xiii, parts I and II; Eschebach and Müller-Trollius 1993, 180.

12. Mau 1904, 394; Warsher 1951, part I, Nos. 4–5.

13. These in a series of second-floor chambers placed above vaulted rooms on a corridor leading from the secondary street at the rear.

14. Vanderpoel 1961, 181; Packer 1978, 24–30.

15. Richardson 1955, 82–95. The names of probable house owners, Fuscus and Vaccula, appear as rogatores supporting the candidacy of Caprasius Felix located next door. Unworked materials and furniture and furniture parts were found in rooms at the back of the attached house 6.9.9, where a seal with the name of Caetonius Eutychus was found. For the Capuan connection of the Nigidii, see Castrén 1975, 133 and 195.

16. Warsher 1955, VI vii, part II, 9–26, 59. The sign shows three carpenters bearing a *ferculum* that includes a figure of Daedalus and some workmen performing carpenters' tasks. A dead figure lies before Daedalus's feet; this may well be a reference to the nephew Perdix whom the legendary artisan murdered through jealously for his invention of the rake. *PPM* 4, 389–91, however, suggests that the sign indicates a perfumer's shop that deals in spices requisite to funerary rituals.

17. Warsher 1955, reg. VI vii, part I, 167–9, nos. 221–6. This was a shed with a window into a large courtyard. A stair leads to a hayloft and the opening through which the hay was loaded can be seen.

18. Warsher, 1955, reg. VI vii, vol. 1, 4–6; but Richardson (personal correspondence) declares himself "rather doubtful that one can be as positive as she is about the number of house lots the insula was originally divided among. If I am right that the city plan as we know it was a relatively late imposition upon a preexisting urban organization, there were almost certainly irregularities that had to be met at that time."

19. *PPM* 4, 525.

20. Warsher 1957, VI x, part I, 26.

21. Richardson (1955, 9–10) records that the excavators could not decide which figure it imitated.

22. Gell (1832, 190) described it as one of the prettiest things of its kind, demonstrating the ability of the ancients to make water rise in jets, but *MB* 4.9 terms it a "bizarre structure" painted with Apollo and Bacchus.

23. In the Casa del Centauro a First Style *cubiculum* off the atrium is among the best-preserved examples, and other small rooms, both here and in the *viridarium,* show remnants of the style. Laidlaw 1955, 153–9.

24. *PPM* 4.389 cites Mau 1882. 256 on Second and Third Style remnants within the building.

25. L. Richardson 1988, 310–11.

26. L. Richardson 1955, 107–8.

27. Gell 1832, 190.

28. *PPM* 4.851–4.

29. L. Richardson, 1955, 108–9.

30. L. Richardson 1955, 12–13.

31. Naples 27700; *PPM* 4.884–7.

32. *PPM* 4.913.

33. *PPM* 4.974–5.

34. *PPM* 4.941–949 for drawings of the images representing both tragic and comic actors and scenes from drama.

35. Eristov (1994, 210–11, n. 40) analyzes architectural components.

36. He is also a witness on Jucundus's tablets, although Jongman (1988, 356) cautions that his identification from a seal reading Phoebus/L.C. Primog. is not secure.

37. Warsher 1957, VI ix, part I, 1–2.

38. L. Richardson 1955, 144–5.

39. Warsher 1957, VI ix, part II, 58.

40. *PPM* 4.660–1

41. *PPM* 4.663

42. *PPM* 4.667.

43. Warsher 1957, VI ix, part I, 112–16.

44. *PPM* 4.679. The seated figure has two female attendants; one a small slave removing his shoes, but the subject is not identifiable.

45. Warsher 1957, VI ix, part II, 106–11; Vanderpoel 1961, 180–87.

46. L. Richardson (1988, 320) mentions the double-tank arrangement that allowed water to be obtained without great disturbance of the fish-breeding area.

47. Additional subjects recovered in excavation were Narcissus, Venus and Adonis, Apollo with a torch, Thetis bearing arms to Achilles, Apollo with Daphne, and a lyre.

48. *PPM* 4.798–9.

49. Warsher 1957, VI ix, part II, 270.

50. Overbeck (1884, 330–4) believes that all of the original spaces had been retained

51. Franklin (1998, 166–8) gives evidence for dating the candidacy before the Flavian period and for Caprasius' adoption at a mature age.

52. Franklin 1998, 168–70.

53. Caprasius was presumably the elder. On the basis of location, della Corte places him at entry 5 in the larger of the two houses.

54. Overbeck 1884, 332.

55. Overbeck 1884, 332.

56. Bastet and De Vos 1979, 58–9.

57. Overbeck 1884, 333–4.

58. Coralini 2001, 185, p. 060.

59. Gell 1932, 195.

60. *PPM* 4.641, citing Pliny *Ep.* 2.17.12, on the ambiente in his Laurentine villa in which windows open on a series of different landscape segments.

61. Warsher 1951, VI viii, parts I and II.

62. *PPM* 4.611

63. Castrén (1975, 236) documents the offices, correcting previous errors. Franklin (2001, 90–1) notes the early stages of Hypsaeus' career during the Claudian period and his bid for a third

duovirate (quinquennial) in the later Julio-Claudian period (151–2).

64. Warsher 1951, VI viii, part IV, vol. 3, n.p., Nos. 173–205. She gives them a Second Style date. *PPM* 4.621–3 is in virtual agreement, noting that the two were independently built in about 100 B.C. a little apart from each other, the small house, no. 24 having come first.

65. *PPM* 4.621. About 100 B.C.

66. *PPM* 4.621.

67. Warsher 1951, VI viii, vol. 4, n.p., Nos. 277–91.

68. Frölich 1996, 84. The decorations in the atrium and adjoining room, which never have been really legible, precede the mending works of *opus vittatum*.

69. *PPM* 4.636. Frölich (1996, 116) wonders whether its absence betokens simply a lack of interest or whether other motifs, such as the Dionysus in the *ala* of the larger atrium should be seen in substitution.

70. *PPM* 4.

71. Identification rests on a seal found within the house. Andreau (1974, 270–1) notes that the tablets within which Herennuleius' name appears associate him with a group of prosperous businessmen dealing in wine, but perhaps also maritime commerce.

72. *PPM* 4.428–30, but the cozily amorous figures of Pan and his pupil might more appropriately be compared with the late Hellenistic "Pan and Daphnis," with copies both in the Farnese collection in Naples and also the Ludovisi sculptures of the Palazzo Altemps.

73. Warsher 1949, VI x, Casa di Naviglio.

74. Warsher 1949, VI x, 8–12. As she argues, it does not purport to represent such a grand building in the exact sense, but is surely inspired by such. She compares the attic frieze of the House of M. Lucretius Fronto.

75. *PPM* 4.1082–3.

76. *PPM* 4.1090, pl. 35.

77. Following Laidlaw 1985, 45, many social historians have subscribed to this idea (e.g., Zevi 1996, 134–5), but the derived notion that preserved decorations indicate continuous family inhabitation from the precolonial period appears to me unwarranted in view of the general precariousness of family continuity in the Roman world.

78. Franklin 1980, 92–4.

79. For discussion of these establishments and characterization of the district, see Laurence 1994, 70–87. As he explains, the crooked streets of the area suggest organic growth rather than a defined plan. The phenomenon is characteristic of most Roman cities.

80. Della Corte 1964, 346; De Vos 1976, 231.

81. In her coverage of thirty houses, Allison (1994, 46–52) lists sixty-six such spaces as decorated and forty-eight as finished on rough plaster.

82. Jongman 1988, 270.

83. Jongman 1988, 254–68.

84. The overlap between this cast of persons and Jongman's is only partial. Given that the transactions recorded in the tablets took place during the years from A.D. 52–60, Jongman's observations necessarily pertain to Pompeian life before the earthquake. Because the majority of his office holders reached the high

points of their success during the decades of the fifties and six-
ties, his study includes only a few of the magistrates and owners
known from the seventies to be included in the present survey.

85. The house has sometimes been assigned to the elder Epid-
ius and generally carries his name in guidebooks and with ref-
erence to decoration, but Franklin (2001, 149–150) follows della
Corte 1964, 248–9 in this attribution, which is based on three
programmata declaring the support of Cuspius located near the
entrance of nos. 21 and 22. This Via dell'Abbondanza aristocrat
was the third office holder of his line in a family that could trace
its political participation back to the early days of the Roman
colony. The achievements of Pansa's distinguished homonymous
father were commemorated not only by a statue and base in the
forum but also by an unusual shrine at the entrance of the am-
phitheater, which Zanker (1993, 144) proposes to have been set
up as a tribute to his generosity in restoring it. During the period
50–62, he had been four times duovir, and once quinquennial.
During the year 62 he was appointed by the *decuriones* as imperial
prefect under the Lex Petronia to govern the city. Presumably
this was to guide its recovery from the earthquake. As Franklin
points out, a person named to such a post of public responsibility
would need to be beyond factions, and Pansa had no visible links
with any faction, although other distinguished *decuriones* will have
supported his appointment. As a candidate for the aedileship, the
younger Pansa is distinguished as *iuvenem probum dignum rei publicae*
(Jongman 1988, 287).

86. Franklin 2001, 158–9. Sabinus was the first political par-
ticipant from his family for several years. Campaign posters for
his election show a large and somewhat unusual base of sup-
port. Several graffiti show the backing of a well-known imperial
agent, T. Suedius Clemens, who served at Pompeii for Vespasian
recovering private lands that had been usurped for private de-
velopment. Added to this, posters declaring that the entire *ordo*
backed Epidius, might suggest that he was an imperial candidate.

87. Franklin 2001, 115–16.

88. Franklin 2001, 165–9. N. Popidius Rufus, who lived with
his father N. Popidius Priscus at the large house 7.2.20–41, had
completed the Pompeian *cursus honorum* and gained the honorary
appellation *defensor coloniae*. They were among the four families
whose *munera* are advertised conspicuously throughout the city
(Sabbatini-Tumolesi 1980). At the time of the eruption, their
house was still in the process of redecoration.

89. Della Corte (1964, 250) gives the location; Franklin (2001,
115–116) interprets the significance of the writing.

90. While Elia 1934, 224–5 argues that they are genuinely im-
perial, De Franciscis 1951, 45–51, sees here a series of imitations:
portraits of family members rendered with strong Julio-Claudian
affinities. Given the dates of these judgments, political ideology
may be suspected, but de Franciscis's suggestion is in keeping with
the customs of freedperson in the Empire and makes sense in view
of documented family connections with the imperial house.

91. Franklin 2001, 106–9. A large number of graffiti pertaining
to Nero were found in this house. He may also have entertained
an official of the imperial household (*a rationibus*), one Cicuta.
All the same, he appears not to have entered into office until 71,
when he stood for (and obviously was elected to) the aedileship.

92. Jongman 1988, 285, 360–1; Franklin 2001, 142–5. Poly-
bius, a descendent of imperial freedmen, appears as a witness in

the tablets of L. Caecilius Jucundus. He was prominent during
the sixties, and seems to have belonged to a small network of
associates who lived within a few blocks of each other in the area
from the Via dell'Abbondanza to the Via di Nola and who mu-
tually supported each other for office. As Franklin points out, no
member of the group has an old Pompeian name, and the Julii
and Claudii are certainly imperial freedmen. By this token also
they would seem to have had strong connections with Rome. In
view of their probable derivation, their common interests may
well have been commercial. The size of the houses would suggest
that the wealthiest members were Polybius and his self-styled *col-
lega* A. Rustius Verus (*CIL* 7316) who owned the large Casa del
Centenario (9.8.3–6) that occupied the entirety of its block.

93. Jongman (1988, 360–1) notes also the *muliones,* whose oc-
cupations were presumably linked with the operation of the food
shops.

94. Franklin 1980, 78–80.

95. Spinazzola 1953, I, 283 ff.

96. Franklin 1980, 123.

97. Della Corte 1964, 385–6.

98. Mouritsen 1988, 141. The aedilician candidacy is attested
by eleven notices. That Satrius had died before A.D. 79 appears
from the new information De'Spagnolis Conticello (1996, 137–
46) provides in her report of a recently discovered tomb (and villa)
at Scafati. Stelae in addition to that of Satrius give insight into fam-
ily history as an example of the precariousness of child-rearing.
While the distinguished Claudian magistrate, whose honors and
tributes are commemorated by an inscription of the tomb face,
is buried in a more public (but still unknown) locale, the burials
include children previously unknown. Reading these in succes-
sion, Franklin (2001, p. 58. n. 42 and 101, n. 2) concludes that a
homonymous D. Lucretius Valens, son of the Claudian magistrate
had died prematurely, thus motivating the adoption of Satrius,
whose own children, in addition to the aedilician candidate and
his sister Valentina, had included D. Lucretius Valens Iustus, who
had been adopted into the *ordo* before his death at age thirteen
Still another D. Lucretius Valens, dead at two years, may have
belonged to any of these fathers.

99. De' Spagnolis-Conticello 1996, 147–56.

100. *CIL* 4.7755. I owe the reference to Franklin 2001, 104–6.

101. Sabbatini-Tumolesi (1980, 24–34) suggests that he may
have used his privileged position to intercede with Nero for the
reinstatement of gladiatorial games. Franklin (2001, 101. n. 3),
argues contrary to Mouritsen and Gradel (1991) that the younger
Valens needed no such introduction in support of his candidacy,
but rather that the games had taken place when he was still a
child. On the evidence of an inscription on the facade of the
newly discovered tomb (De'Spagnolis-Conticello 1996, 160–62)
we can see these father and son sponsorships as a family tradition.
The Claudian Decimus, in company with his father, had mounted
thirty-five pairs of gladiators and a *venatio legitima*.

102. Franklin 2001, 104–5.

103. Mouritsen (1988, 104) notes that the earliest Ceius was a
magistrate in the Augustan period, but the name disappears from
political records thereafter and as Franklin (2001, 174–7), points
out the new Ceius is apparently the only decurial member of a
family whose name appears otherwise in freedman ranks. Elec-
toral notices in support of men of prominence painted on the

panels of his First Style facade give some indication of the strate-gies by which he sought power while his own bid for office was supported around town by, as Franklin puts it, "a wide collec-tion of hoi polloi," – that is, a bath attendant, a lupine dealer, a cleaner, and so on. Two years after winning the aedileship, he ran for duovir.

104. Franklin (1980, 63–4) gives the evidence for Fuscus' can-didacy in 78. His running mate is unknown.

105. Franklin 1990 traces the history of the business from the architectural modifications and enlargements made to the house.

106. Franklin (2001, 132), who points out all the same that his colleague in the duovirate was otherwise unknown.

107. Della Corte 1964, 181.

108. Sabbatini-Tumolesi 1980, 51–8. The family was of Sam-nite origin, attested in Capua; the branch using the alternative spelling of Sitii had long been active in Pompeian politics.

109. Della Corte 1964, 181; Franklin 2001, 164.

110. *CIL* 4. 1189–91; Sabbatini-Tumolesi 1980, 51–3. One of his posters appeared as far away as the upper Via dell'Abbondanza on the side of the Eumachia buildings.

111. Franklin 1980, 87–91.

112. Overbeck 1884, 290–6.

113. D'Arms 1989, 60–2.

114. Franklin 1981, 122–3.

115. Spinazzola 1953, Vol. ? 281–96.

116. Franklin (1981, 123) concludes from the absence of any notice of Trebius' candidacy that he had not yet stood.

117. Franklin (2001, 147–8); Mouritsen (1988, 122) notes the distinction between these well-connected power figures and the ordinary freedman arguing, contrary to Castrén, that no signifi-cant degree of social mobility characterized the composition of the *ordo* in Pompeii's final years.

118. Elia 1934.

119. Contrary to Elia's chronology, *PPM* 1.117–18 indicates that the atrium on the lower level was the original nucleus of the house. The second peristyle was annexed on the foundations of a building alongside. The atrium on the Via dell'Abbondanza belongs to a later building.

120. Elia 1934, 218–220, noting that portions of the third house opening on the narrow Via dell'Amfiteatro had been demolished to provide space for the third peristyle.

121. Peters and Moormann (1994, 293–327) call part of this interior Fourth Style.

122. Jashemski 1993, 336–7.

123. Jashemski 1979, 69–70, 1993, 315.

124. Andreae 1993, 97.

125. Andreae (1993, 106–14) argues that they are by no means illusionistic and do not extend the space of their enclosures but rather appear as scenes within frames.

126. *PPM* 3.112–13 notes mending in *opus listatum.*

127. De' Spagnolis-Conticello 1996. 147–56.

128. Moormann 1988, 159–60.

129. Richardson (2001, 94–5) considers this the same painter who executed the panorama of Venus and Adonis on the Via di Mercurio.

130. *PPM* 3.172. The pendant of this painting is a single-figured picture of Leda, fingering her himation and taking a stranglehold on the neck of the swan.

131. Richardson 2001. These attributions include virtually the entire Casa del Menandro, granted its curiously graceless figures, and finally, not, I think credibly, two paintings in the Red Room of the Casa dei Vettii.

132. De Franciscis 1990, 24; Jashemski 1993, 249–52.

133. De Franciscis (1990, 21) argues that the condition of the walls with empty quadri indicates incompleteness, but in fact the very precise cuttings and partial fill within the squares suggests something more like replacement.

134. De Franciscis (1990, 23–4) calls this room Third Style, yet the architectural configurations are clearly those of a later date.

135. Although the house appears in most literature as another property of the Epidii, who are in fact the neighbors next door, Franklin (2001, 150) follows della Corte (1965, 495–6), in this attribution, which is based on three programmata declaring the support of Cuspius located near the entrances of nos. 21 and 22.

136. Warsher n. d., IX, n. p., nos. 55–82.

137. Warsher n. d., IX, n. p., nos. 63–8 (called the House of Epidius Sabinus).

138. Franklin, personal conversation, has remarked on the many instances in which a grandiose, three-dimensional *niaskos* type of lararium on a base stands within the atrium, while a less pretentious painted shrine appears within some interior room.

139. Mau 1908, pls. xv and xvi; Bastet and de Vos 1979, 59–60.

140. Originally called the Casa del Principe di Russia, the house was renamed for its owner upon discovery of Vedius's seal; *PPM* 6.228–9.

141. Laurence 1994, 70–84 on the region.

142. *PPM* 6.229, 234–5. The peristyle of the lower house had also retained Second Style decoration.

143. *PPM* 6.255–7.

144. Bastet and de Vos 1979, pl. 58.106.

145. *PPM* 10.378–9; 614–15. Only the latter drawing by La Volpe shows a crown; the other a garland, yet the crown seems correct.

146. Elia 1934, 215–26.

147. Elia 1934, 218–19, refers only to the single large room as a *diaeta,* but this is in keeping with conventional views of the space.

148. Mau 1908, 100–1; Laidlaw 1985, 274–80.

149. Archer (1994, 129–50) and Ehrhardt (1995) agree in call-ing these paintings early; they in fact follow Strocka. None of the new decorations was particularly fine in quality or intricate in detail. Ehrhardt (1995, 140–53) notices work by the same shop in various houses.

150. In the House of Paquius, the space between the *tablinum* recess and the peristyle preserves a complete paratactic Second Style decoration consisting of red background panels with fluted columns, a cornice and isodomes which may have been repainted. It may be somewhat ineptly patched and mended. The House of Trebius Valens, which goes back to the Samnite period, preserves one room to the left of the entrance in Second Style decoration of columns and panels. Its two room bath complex just within the peristyle was also built during this period. *PPM* 3.341.

151. Franklin 1990, 21–30.

152. Elia 1934.

153. *PPM* 1.496.

154. *PPM* 1.486–97.

155. *PPM* 1.

156. Bastet and De Vos (1979, 92–3) note the uniformity of the decoration whose characteristics they assign to the late Third Style.

157. Spinazzola 1953, 283. Much more was to be seen at the time of excavation than remains today, because the area was severely damaged by a bomb dropped during the Second World War.

158. Allison (1994a, 303) mentions a small bronze casket found in this room as an indication that it was in use.

159. Allison 1994a, 308.

160. *PPM* 1.407–8.

161. Allison (1994a, 309–17) reports the opinion of the excavators that the house may have been looted. Objects are in a peculiar state of disarray. She believes it temporarily unoccupied.

162. Franklin (2001, 161–2) calls attention to the paintings flanking the insciption on the lararium, which show a bull being led to sacrifice. Because this is the appropriate offering for a living emperor, the paintings witness the Flavian affiliations of the family.

163. Castrén 1975, 164–5.

164. GENIO. M(arci) N(ostri) ET
LARIBUS
DUO.DIADUMENI.
LIBERTI

"The two freedman Diadumenus to the genius of our Marcus and the Lares" translation from Franklin 2001, 161.

165. Schefold (1962, 135–6) noticed the thematic concinnity, which Moormann (1997, 97) cites as the single instance of a meaningful interassociation among Muses and the subjects of pendant quadri.

166. *PPM* 10.730–5, publishes the drawings made just after excavation.

167. Gallo 2000, 94–6.

168. L. Richardson 1988, 175, 374–5.

169. Franklin 1990.

170. Rawson 1976, 85–102.

171. Thomas 1995, 169–74.

172. Jongman 1988, 239–73.

173. Mouritsen 1988, 112: "*Tabulae ceratae*, sepulchral inscriptions, dedications and not least programmata are quite unaffected by the magistrate's wealth and influence, and we have therefore an extremely reliable picture of the composition of the magistrate body."

174. The Nigidii, especially, are a case in point, because Vaccula's expensive bronze donations would seem to indicate some ambition to be of consequence in the town. As neighbors of Caprasius Vettius they support his candidacy by programmata; there is also some connection with the distinguished Gn. Alleius Nigidius Maius. If Vaccula was in fact the *filius* as Richardson (1955, 188) argues, it would seem to have been merely a matter of time.

175. Zanker 1993, 144.

176. Sabbatini-Tumolesi 1980, 113–16.

177. Franklin 2001, 165–169.

178. Sabbatini-Tumolesi 1980, 113–16 orders the chronology of the spectacles.

179. Sabbatini-Tumolesi 1980, 77–89.

180. *CIL* 4.3883; Sabbatini-Tumolesi 1980, 38–41; Franklin 1997, 442–4.

181. Drawings are now to be seen in *PPM* 10.105–13.

182. The concept of the workship, so frequently considered as a key to style and chronology (for example Stroka 1987; Archer 1990; Esposito 1999 et al.) but wholly based upon the empirical evidence of shared motifs in contemporaneous paintings, is one that must be applied loosely and with caution. The ateliers of later European painting are not a viable model of organization. To the contrary some recent scholars have proposed the circulation of itinerant specialists to be more likely. Thus Blanc (1995) in her examination of stucco applications, such as capitals and friezes, while noting that no two installations duplicate each other exactly, does find it possible to single out an individual specialist on the basis of the placement and shaping of motifs. At the same time she insists that such identifications tell us nothing about the organization of workshops. Along non unsimilar lines Allison (1995b) proposes that rather than "workshops" with consistent membership, "decorators' teams" of an *ad hoc* composition might have been assembled for individual jobs.

183. Bergmann (1994, 231–55) who reconstructs the Casa del Poeta Tragico with computer-simulated illustrations, does note that an atrium is an unusual venue for mythological paintings; nonetheless, she reads the program of the principal rooms "axiomatically" in keeping with Wallace-Hadrill's uniform concept of spatial dynamics.

184. For example, Wallace-Hadrill (1988, 48) assumes the reader's uncritical identification with the short-sighted narrative focalizer: "The whole point about Trimalchio's ostentation is that it is laughable to Petronius' heroes and presumably to the understanding reader.... Trimalchio blunderingly parodies the language of Roman luxury rather than communicating in it."

185. New readings, such as that of Dumont 1990, 959–81 who interprets Trimalchio's decoration and furnishings within the limits of the status imagery available to freedmen, correct the bias of Encolpius' presentation.

186. Mouritsen (1996, 140) makes the point concerning the intermingling of social classes in Pompeii after (but also before) the earthquake.

187. Eristov 1994, 23–4.

188. Ehrhardt 1987; Cerulli-Irelli 1991, 229–34.

189. Picard 1982, 55–9, pls. 1–7.

190. Bardon (1962, 739) was speaking mainly of literature when he characterized "Flavian classicism" as a reaction against "Neronian romanticism," but he calls on stylistic change in Pompeian painting as a corroborating parallel: "In Pompeian painting the accession of the Flavians is marked by a reaction against the excesses of Nero's reign." Picard (1963, 385–6) puts his case in a straightforward and positivistic linkage between Rome and Pompeii: "The Fourth Style did not make its appearance until after the earthquake of 63, and Nero should be considered as its veritable creator. To the mannerism of the last phase of the Third Style there then succeeds a baroque exuberance, expression of the fantastic and marvelous universe that the emperor had wanted to realize in the Domus Aurea."

191. Franklin 2001, 124–5. Citing the *venit ad Venerem* of Giordano 5, he mentions the *millia millionum ponderis auri* (thousands of thousands weight of gold) of the graffito, as a likely donation for

reconstructing the ruined temple, while Poppaea, who had not accompanied her husband, sent a large beryl. On this occasion, Franklin further suggests, Nero relaxed the ban on gladiatorial contests in the amphitheater, "thus earning himself a rapturous welcome."

192. Franklin (2001, 154–87) notes the names of several Neropoppaeenses and their descendants on the electoral slates of the seventies.

193. L. Richardson (2000, 65–6) also categorizes the paintings from the atrium complex of the Casa di Laocoonte 6.14.28–31, now in the Naples Museum, but, although the death of Laocoon may indeed refer to the poem, Aeneas and Polyphemus do not meet in Vergil's text.

194. Bastet and de Vos 1979, 58–60, and comparison tav. XXIV, but the decor of the wall in the House of Cuspius is far more elaborate.

195. Esposito (1999, 28) sees in these decorations the hands of the Casa dei Vettii workshop, by common consensus one of the finest that worked during the later years of Pompeii, and he assigns draws up a list of ten house of which shared details bear witness to their work.

196. Hillier and Hanson (1983, 40–2) construct the category of "transspatial" relationships as a form of conceptual linkage within spatial systems.

197. Franklin 1980, 92–100.

198. De Vos (1981, 119–27) demonstrated this point on a low-economic level with her study grounded in the workshop of the Via di Castricio.

199. Richardson 2000, 7.

200. Varone 1995, 131–4.

201. Richardson 2000, 129–35.

202. The attributions here refer to the more limited repertoire of Richardson 1955, but for convenience I have cited the page numbers in Richardson 2000. This new *catalogue raisonné* may be consulted for a greatly expanded list of attributions, especially including many more minor decorative figures.

203. Richardson 2000, 88–9.

204. *PPM* 4.896.

205. Richardson 2000, 106–14.

206. L. Richardson (2000, 106–107). In Richardson's classification he was formerly individuated as the Perseus painter, but Richardson's most recent estimation is that "these are simply different manners of the same painter, working against different backgrounds and with different kinds of composition."

207. L. Richardson 2000, 122.

208. While noting that these compositions are more complex than is the painter's usual manner, L. Richardson (1955, 143–4) proposed a tentative identification of the Meleagro painter's hand in the three subjects (Thetis and Vulcan; Hercules and Omphale; and Neptune and Apollo at Troy) that decorate the new *oecus* of the House of Vedius Siricus, but Richardson (2000, 159–60) withdraws the suggestion and distributes these attributions among several painters.

209. L. Richardson (2000, 171–5) attributes a quite different oeuvre to this painter, including the heroic paintings of Homeric topics in the House of the Tragic Poet. As he would have it, the two paintings of the Vettii Red Room are the surprisingly finest work of the very secondary Ipigenia painter.

210. L. Richardson 1955, 124–35; 2000, 122–9.

211. Laurence 1994, 34–5.

212. Scagliarini-Corlaità (1974–76, 17–18) observes a close and legible relationship in public buildings between use and decorative code while differentiating private buildings in which decoration is the only key to use.

213. Gell 1832, I, 13–20; Mazois 1824–38 I, pl. 33.

214. Barringer 1994.

215. De Caro 1992, 7–8.

216. Dobbins (1994, 655–61) disagrees with the traditional opinions, including that of Richardson, concerning the state of completion in postearthquake repairs, as well as the extent of the marble introduced.

217. Richardson 1988, 195–6.

218. Bastet and de Vos 1979, 32.

219. Dobbins 1994, 656–58.

220. Dobbins 1994, 659.

221. L. Richardson 1988, 197.

222. Mau (1904, 112–13) believed it a retail area; Moeller (1976, 57–71), while disproving this notion, sees it as the seat of the fullers' guild, with offices inside, while the *Chalcidicum* served as an exchange platform where producers sold their finished products in bulk by auction. L. Richardson (1988, 198), however, argues that the building was one of more various use.

223. L. Richardson 1988, 198.

224. Muscettola 1992, 63.

225. De Caro 1992, 6.

226. De Caro 1992, 7–8.

227. Blanc, Eristov, and Fincker 2000.

228. Muscettola 1992, 8.

229. Mau 1904, 178. A second herm appears within the Eumachia building.

230. Muscettola 1992, 66; Franklin 1980, 120.

231. Muscettola 1992, 64–5.

232. For a summary of the plan and materials of the far more opulent Iseum Campestre, see Beard, North, and Price 1998, 264–5.

233. Croisille 1988, 134.

234. Croisille 1988, 134; Beard, 1998. vol. 1, 282–3) notes the tendency of Isaic excavation reporting to emphasize Egyptianizing elements in the sanctuaries, thus, of course, obscuring such efforts at cultural merging.

235. Avilia and Jacobelli (1989, 131–2) suggest that the positions are meaningful corresponding to recognizable maneuvers in the strategy of naval battles.

236. Avilia and Jacobelli 1989, 135–47; Sampaolo 1992, 36.

237. Nappo (1989, 79–96) publishes an illustrated catalogue and coordinates the images with the forum plan, concluding that they present a "free" rather than an exact representation. Parslow, 1995b.

238. De Ruyt 1983, 138–40.

239. Mau 1904, 95.

240. De Ruyt 1983, 143.

241. Eristov 1994, 219.

242. Barringer (1994, 149–66, figs. 1–5) discusses at length the probable Greek sources of these paintings and concludes that the painter has "Romanized" them by emphasizing moments of

dramatic tension and bringing out a moralistic contrast of "good and bad women."

243. Nielsen 1990, 25–35.

244. Gallo (1991, 30) brings out the double purpose of serving the needs of new colonists but also making a gesture of munificence toward the old Pompeians.

245. Gallo 1991, 40; Nielsen 1990, 32.

246. Gallo 1991, 34–6.

247. L. Richardson (1988, 289) points to the large size of the palaestra and other exercise areas to suggest that the baths were to serve primarily the "young and vigorous," but the central location and the projected decorations might argue to the contrary that it was to be the grandest of all communal baths.

248. Gallo 1991, 37–9; Jacobelli 1991, 147–52.

249. Jacobelli 1995, 18.

250. Jacobelli 1995, 22–3. Possibly, as she suggests, these were the Baths of Piso Frugi advertised on a plaque at the Herculaneum Gate.

251. Jacobelli (1991, 149–151), although she has since expressed doubts concerning a literal point of reference for the paintings

252. Jacobelli 1995, 61–74. Her most recent, more complex, and sophisticated interpretation connects the paintings with the function of the dressing room. As she argues, the numbered boxes will have corresponded to the numbers of drawers in the armadio built into the wall, whose depth they equal in size. As for the exotic pictures, they are in fact to be seen as derived from such books as *Elephantis* even though that contains no homosexual encounters.

253. Jacobelli (1991 149–51; 1995) points out that these images had been painted over at a later period, suggesting a change in the degree of social permissiveness.

254. Laurence 1991, 59–64.

255. Moeller 1976, 80.

256. Moeller 1976, 91–2, but Castrén (1975, 236–7) gives a more judicious account of his political achievements. Franklin (2001, 90–1) considers identification of the residence uncertain, but places the first duovirate in the Claudian period with a second in A.D. 58–9. Finally (150–1), he notes Hypsaeus' campaign for quinquennial office, as documented on an electoral programma.

257. Moeller 1976, 44.

258. Warsher 1951, VI xiii, parts I and II.

259. Mau 1904, 394–5.

260. *PPM* 1.332.

261. Moeller 1976, 41–3.

262. As Moeller (1976, 39–47), observes the vats for the customary processes are ranged in the peristyle and the usefulness of this tub is not clear.

263. Swindler 1923, 302–13, but her study concentrates entirely on the triumphal symbolism of the goddess without attention to the *fullones* as its sponsor.

264. Moeller (1976, 86–7) describes the paintings and discusses interpretations. The scene is apparently a trial, with a group of judges seated on a platform, but its status is rendered problematic by the fact that its judges wear tunics rather than togas. Thus scholars have wondered whether the fuller's guilds possessed their own judicial system independent of civic authority.

265. Moeller 1976, 81–2, 90–7, on the political activities of fullers' guilds.

266. Moeller 1976, 90–1. He also claims that M. Vesonius Primus was a person of influence, possibly associated with an old Samnite family, but he is wrong in making him out to have been a magistrate (Castrén 1975, 238).

267. Pannuti 1975, 178–90

268. *PPM* 3.435 makes this suggestion, noting that two-and three-sided peristyles were common during the second century.

269. Della Corte 1964, 362–4.

270. Pannuti (1975, 187–8) advances several hypothetical explanations for the qualitative differences: possibly the work was unfinished; perhaps different pieces were intended for different ranks of clients or else handled by assistants with varying degrees of skill. Another possibility is that the best stones might be models.

271. Pannuti 1975, 179–187 & figs. 16-31 supplies a detailed catalogue of the gems with compilations of numismatic parallels and other possible sources for the images, noting that Pinarius as craftsman preferred carving carnelian over cameo work. Some of his gemstone subjects with recognizable models include a Maenad, or possible Ariadne (No. 2); Poseidon, resembling a figure on the base of Athena's Parthenon statue (no. 5); flying Pegasus, in agate (no. 10); a full figure Hermes (no. 15) and a head of Hermes wearing the petasus (no 16) both widely diffused as coin images. Among the five cameos are a rustic sacrifice (n. 25) like that on a sarcophagus in Rome; the head of a Nike (no. 26) and an Eros holding a mirror (no. 27).

272. Spinazzola 1953, 690.

273. Spinazzola 1953, 693–4.

274. *Notizie degli Scavi* 1927, 101–2.

275. Franklin 1980, table 6.

276. *Notizie degli Scavi* 1927, 104; Della Corte 1964, 170, also lists a Cerialis as one of the customers who inscribed his name in the lupanar on the Via del Soprastanti.

277. Della Corte 1964.

278. Curtis 1979, 15–23.

279. Jashemski 1979, 195–6; Curtis 1979, 20.

280. Curtis 1979, 21–2.

281. Gulino 1987, 18.

282. Toner 1995, 74–6; Wallace-Hadrill (1995, 43–6) discusses *popinae* as a focus of public concern in the Empire and imperial efforts to control or repress them.

283. Anderson (1997, 326–7) devotes a few pages to their situation in the urban landscape and the verbal status topography, illustrating with some examples primarily from Ostia.

284. La Torre 1988, 77; but Wallace-Hadrill (1995, 46), who calls the number "absurdly large," proposes some confusion between eating establishments and other business places that made use of similar storage equipment.

285. La Torre (1988, 78) disputes Packer's idea that the number represent the extent of middle- and lower-class population who lacked cooking facilities at home, but suggests rather that the disordered state of the postearthquake city and the number of workmen employed in repairing parts of it account for an unusual demand for restaurant food. See also Wallace-Hadrill (1995, 45–6) who accepts La Torre's proposal that kinds of shops other than taverns may have used the same storage arrangements of counter and jars.

286. Addressing these traditional categories, Wallace Hadrill (1995 45–46 and n. 49) seconds the dismissal of the term

thermopolia by T. Kleberg (in *Hôtels, restaurants et cabarets dans l'antiquité romaine: études historiques e philologiques,* Upsala, 1957, 52) on grounds that it is idiosyncratically Plautine, and he also questions the archaeological basis for distinctions among *cauponae, tabernae* and popinae.

287. Franklin 1985–6, 319–28.

288. Eschebach and Müller-Trollius 1993, 62–3.

289. Maiuri (1949, 186) before the interior had been excavated; Della Corte 1964, 345; *PPM* 2.684–5.

290. Della Corte 1964, 325–6. Franklin 1980, 106–9.

291. Franklin 1980, 106–9.

292. Eschebach 1993, I thank my colleague James Franklin for identifying the nature of the object on the basis of Seneca *Ep.* 15.

293. Franklin 1997, 2.

294. Packer (1978, 43–8) briefly surveys general characteristics within the categories he has discussed.

295. Packer 1978, 46–7; Mau 1878. *BdI* (191–93) publish all the texts.

296. Thus Clarke (1998–9, 27–8) distinguishes "popular" from "elite" humor on the basis of its coarseness in a manner that rather overlooks Catullan texts.

297. Mau 1904, 402–4. Clarke 1998–99 includes the paintings of the outer room in his study of humor.

298. *PPM* 4.1005–20. Della Corte (1964, 55) records the traditional designation of this anonymous establishment as caupona/lupanar.

299. *PPM* 6.178.

300. Della Corte (1961, 55) cites the interpretation by a French scholar of the phrase "da [mihi] fridam pusillam" as a double entendre, "such as would be exchanged between soldier and a slave."

301. Varone 1993, 617–40.

302. Varone 1993, 621; Coralini 2001, 60–1, 233.

303. Varone 1993, 627–8; in 1997, 149–152 he provides a detailed study of the figure type and variants.

304. Varone 1993, 629 and Pl.

305. Varone 1993, 624, pl. CLVI 1–2.

306. *PPM* 3.797–823.

307. Toner 1995, 76–81.

308. The patron C. Julius Polybius is also in three electoral graffiti mentioned in connection with bread and bakers (Jongman 1988, 360). The objection posed by De Vos (1976, 220) that there was no bakeshop nearby, is nullified by the past few years' discoveries in the Casa dei Casti Amanti.

309. To the contrary, Varone (1993, 629) distinguishes this installation as one for private conviviality, but this, I think, was written before the bakery had been fully unearthed.

310. Andreau 1999, 71–79.

311. Fragments of the painting from the 1959 excavation campaign in company with the area excavated are described by Elia 1961, 200–11 and Pagano 1983, 325–61, but reassembly of the fragments has followed only upon the reopening of the excavation. For discussion see Nappo 1999, 185–90 and for images of complete walls De Simone and Nappo 2000; Guzzo and Mastroroberto 2002.

312. Guzzo 1997, 134–149; Harris and Schuster 2001, 30–35 as well as De Simone and Nappo 1999 (which I have not had the opportunity to study at length) and Guzzo and Mastroroberto 2002.

313. A visitor of the highest consequence is the proposal of Mastroroberto (2002, 35–87) who argues that the complex received its present decoration in anticipation of the Emperor Nero's post-earthquake visit to Pompeii as one of the elegant little establishments (*deversoriae tabernae*) that Suetonius and Tacitus (*Nero* 27; *Ann.* 14.15) attest to the emperor's having commanded for his amusement. To this end she proposes direct identifications of certain figures in the painting with members of the Julio-Claudian court, most obviously Apollo himself with the emperor, but also Calliope with Agrippina Minor, Nero's mother, Talia as Poppea Sabina, the rhapsodic dancers of the Sarno room as Neronian *Augustiani,* and a even small girl attendant upon Venus as Nero's deceased infant daughter Claudia. Against such identifications, however, must be weighed the fact that Nero's sponsored murder of Agrippina had already taken place before 62, and also that the faces of the various divinities are similar in features and technique to those in the Casa dei Dioscuri and other decorative programs that must post-date A.D. 62 or 63 by several years.

314. See the decorations as reconstructed in 1867 drawings by François-Wilbrod Chabrol in Zevi and Vallet 1981, 138–143.

315. Likewise the large lararium with two facing serpents on the right-hand wall must be attributed to redecoration by a different workshop quite unable to match the style of the earlier work.

316. Another interesting comparison can be made between these complete houses and the Caccia Antica, the decorations of which, on the basis of nonstylistic evidence of coin impressions, can be dated entirely to the Vespasianic period. Allison 1992, 238: For its size, this house shows a great variety of rooms. A key point for comparison is the *tablinum,* in which unusual blue tapestries stand against a white background. The triple-storied balcony structure in the apertures flanking the center is particularly slender and graceful, and the details of rods and garlands as well as the architecture of the *aedicula* and balconies are fine and precise. Other rooms of the house, although relatively small, are boldly stated. Room 13 shows the center of a two-story *scaenae frons* with a dramatic action in progress. Room 14 has a stage-type *aedicula,* and room 8 in the peristyle is a massive *aedicula* construction. Finally the peristyle contains a seemingly incongruous combination of mythological panels on a large scale and the single *venatio* scene in Pompeii including human hunters. The two might be explained as a reference to spectacle sponsored by the house owner, not merely an amphitheater show but also a performance of the Polyphemus and Galatea mime.

317. Ling 1991.

318. For reproductions Guzzo 1997, 131–3, pls. 81–3; Esposito (1999, 36–9) sees an early production of the Vettii workshop here instead and compares the Temple of Isis, but the griffins are the telling evidence.

319. Avilia and Jacobelli (1989) debate the significance of the compositions.

320. L. Richardson 1955, 124.

321. L. Richardson 1955. 120–1.

322. Guzzo (1997, 132); L. Richardson 2001. These are the Wedding of Alexander and Roxanne in the *triclinium,* and in the second-floor *pinacotheca* an unusal representation of Dionysus

and Ariadne featuring a standing heroine, a god whose drunkenly rolled-back eyes might be attributed either to spirits or to passion, and a slightly quizzical Silenus looking on. Save for the appearance of Theseus' ship sailing off in the background, this might seem like simply a Bacchus and Maenad panel. Its pendant was Mars and Venus.

CONCLUSION: BEYOND '79 IN ROME AND CAMPANIA

1. That is to propose not merely that Pompeian atria might have become obsolete, but rather that the very concept of the individual house would have undergone change. Meiggs (1973, 235) noted the increasing use of upper-story space in Pompeii as evidence for an increasing pressure of population, but many other explanations are possible, including either an expansion or even improvement of servants' quarters, or a move to free up additional space on the ground floor by moving family accommodations out of the way. Packer (1967, 80–8) analyzes the evidence for what it does and does not reveal.

It should also be remembered, however, that multiple dwelling structures had long coexisted with individual housing at Rome (de Albentiis 1990, 264). Vitruvius (2.8.17) wrote about the usefulness of brick walls and rubble partitions in tall buildings created to satisfy the pressure for numberless dwellings generated by the imperial dignity and the ever-expanding population of the capital. The postincendiary Neronian rebuilding of the city had featured insulae on broad streets, with certain protective regulations such as fire-resistant stone, limits on height, and facades with porticoes (Tacitus Ann. 15.43). So the insulae of Ostia were not novel, and, moreover, their introduction into the city responded to specific demands created by its particular economy and demography.

2. From a purely architectural point of view this might seem possible, but not from a socioeconomic standpoint. Rather, its continuing architectural history was more likely to have seen an increase in such quasi-suburban villas as the House of Loreius Tiburtinus, and perhaps a closer rapprochement between the rural outskirts and the town.

3. Not to mention the practice, which he deplores, of superimposing new designs on real marble (NH. 35. 2–3) by incising or "vermiculation." In fact, when he speaks of "vermiculating" marble pieces to form figures of objects and animals ("vermiculatisque ad effigies rerum et animalium crustis"), he must be referring to opus sectile, which could certainly be interpreted as a luxurious substitute for painting, and one that was also in common use.

4. Joyce 1981, 21 ff. These large-scale compositions are particularly popular within the context of large baths attached to multiple-unit dwellings where we may assume a degree of elegance in accommodations. Within this range have been found paintings representing a variety of economic backgrounds.

5. Mols (1999a, 255) defends the quality of the decoration, and especially its fine detail, comparing the Villa Adriana which he sees as a Fourth Style simplification comparable to that of Varanno. In 1999b he discusses the relationship between scheme, subject, and space.

6. Ling (1991, 175–6) most emphatically denies its integrity, likewise Moormann (1996, 65), remarking recently on the stylistic

context for paintings from the Piazza dei Cinquecento, observes of the painting from 79 to the conclusion of the first century that "no one has ever formulated a Fifth Style in Mau's traces nor does this seem to be the route to take."

7. Paris 1996. The material, which came to light during excavations for the Stazione Centrale delle Ferrovie in 1862 and for the Stazione Termini in 1946–9, has for the most part been in storage.

8. Sommella and Salvetti (1994) give a history of the collection and describe some of its objects in their catalogue. I have not been able to consult the catalogue of the mostra Affreschi Romani dalle raccolte dell'antiquarium communale (Rome, 1976).

9. di Puolo 1993, 263.

10. di Puolo 1993, 268, n. 4. Records of an 1880 excavation describe a possibly different kind of scheme that contained hunting scenes, rustic scenes, and busts of the seasons in tondi, but these are attributed to the late second or early third centuries A.D. The account gives no sense of their composition.

11. di Puolo 1993, 263–5.

12. Eton College. Topham Collection MB 16, 17, 18. Ashby (1914) briefly describes the paintings under the heading "decorations of a staircase."

13. Guerrini (1971, 20–1) transcribes the text from Ottob lat 108; f.111.

14. For the basilica and the "aula regia," Boethius, Ward-Perkins 1971, 232–3, and on the triclinium and peristyle Gibson, McClaine, and Claridge, 1994, 87–92.

15. Or else, as Dottoressa Silvana Mirandi suggested to me in connection with her paper on Ghezzi at the 1997 Colloquium of Association International pour la peinture murale antique, the representation may be inaccurate.

16. Joyce (1981, 48) upholds the Hadrianic dating implied by these stamps against de Vos's proposal for an Antonine date. She points out that the art historians had initially located the paintings within the Fourth Style category.

17. Joyce 1981.48

18. De Vos (1968–9, 159–60) notes the identical positions of two bulls, and the fact that both have their heads outlined against a tondo disk. Seeing that they are not garlanded as victims, she proposes that they might represent bronze figures of Apis, seeing that the absence of other characteristics that mark this Egyptian divinity might be discounted within a Roman context such as this.

19. De Vos 1968–9, 149–65; Ling 1991, 176.

20. Messineo 1991, 239–48.

21. Paris 1996, 60–2.

22. Paris 1996, 60–3.

23. Paris 1996, 122–30.

24. Because of the name [Vibia Au]relia Sabina on water pipes, as well as the statue of Faustina, Paris (1996, 61–3) proposed that ownership of the complex was a legacy of imperial women. Management of the establishment, however, and with it the perquisite of residing in the house, seems more likely to have been a patronage position to which the imperial statuary paid tribute.

25. Barbera 1996, 120.

26. Barbera (1996, 117) adumbrates its elegance by citing Seneca's derogatory contrast between the dark little bath quarter of Scipio Africanus's villa at Liternum and the modern

establishments of the Neronian era "gleaming with marble, gems and colored glass, where the water flowed from silver faucets and the broad windows afforded sunbaths concomitantly with baths."

27. Ling 1991, 175.

28. Meiggs 1973, 249.

29. Meiggs 1973; DeLaine (1995, 84–5) notes such a distribution in the tripartite "House of the Paintings" built roughly around A.D. 130.

30. DeLaine (1995, 79–106) offers a paradigm of such modifications in tracing from beginnings through the fourth century the architectural revisions of the House of the Paintings. In this case the Hadrianic period construction would seem to have been built on remains of a large commercially oriented complex located close to the center of the grain industry.

31. Clarke (1991, 270–88) describes both wall decorations and mosaics with attention to their visual coordination. He uses alignment of vistas as a principle also for determining the rooms of highest status but seems to find it necessary to identify traditional spaces such as a *tablinum* within this distinctly nontraditional ground plan.

32. Clarke 1991, 283–5.

33. Ling 1991, 175–6, but Mols (1999, 255) defends Ostian painting against imputations of degeneracy, calling attention to its refinements of ornament.

34. Joyce (1981, 47, 64) finds the ambiguity of spatial determination greater at Ostia than at Rome, but this observation precedes discovery of the examples mentioned earlier.

35. DeLaine (1999, 180–1) shows how the interlocked series of rooms creates a perspective frame for this large painting, suggesting that this Antonine house has adopted a Hadrianic plan.

36. Joyce 1983, 425. Paris (1996, 29–31) acknowledges Joyce as the source of her information, but her article is illustrated by reproductions of the drawings in the collection held by the British School in Rome.

37. Andreae 2000 returns to the topic treated in his monograph on Roman sepulchral art (Andreae 1963) 4–5; 38–9. Pace 2000 gives the history of these drawings, which she identified in a volume in the Library of the University of Glasgow. In the form of engravings, these paintings were published in a series of editions during the late seventeenth and early eighteenth centuries.

38. Messineo (2000) gives the fullest account of the discovery yet available and prints Suares's poem in an appendix.

39. Pace (2000) gives a complete history of the fate of the paintings. These historical speculations were as a given for Bellori and his distinguished collaborator, Bartoli one of the foremost artist engravers of the day whose overall replications of archaeological discoveries were very influential in forming ideas of ancient art. Bartoli's engravings were copied many times, and the book in its numerous editions reached many European libraries. As for the paintings, two panels went into the collection of Cardinal Albani, where Bartoli's comments elicited derisive remarks from Winckelmann, while assorted pieces sold to Dr. Richard Mead in England are now in the holding of the British Museum, where Susan Walker considers them too unreliably reworked to be placed on public display. To this day the tomb chamber survives in situ and has recently been published with images of its faded vestiges of painting in Messeneo's 1993 book on the Via Flaminia.

40. Pace 2000.

41. Bellori 1680, 29, but for a full presentation of his allegory, see Leach 2001. 69–77.

42. Leach 2001, 69–77.

43. Buti 1778–1786. In spite of the fact that the collection ipso facto involved decontextualization, Buti professed concern for communicating a sense of each entire ambience as well as for the accuracy of his reproductions. Among the surviving collections several are incomplete and also the colorations differ greatly from one to another. That which was used for the initial research on this chapter was the collection of the British Museum.

44. Paris 1996, 30–1.

45. Joyce 1983, 425–6.

46. MacDonald and Pinto 1995. MacDonald 33–4 prefers the more neutral term Hall of the Cubicles.

47. For description of the mosaics, see MacDonald and Pinto 1995, 161–2.

48. Baldassarri 1989, 207–25.

49. Wallace-Hadrill, 1983, 26.

50. Champlin 1980, 39–44.

51. Anderson 1993, 69: "At the center of the sophist's rhetorical framework is the preservation of a cultural whole of Classical Greece recreated through its literature."

52. Anderson 1993, 83.

53. Anderson 1993, 69–85.

54. Leach 1991, 112.

55. McNally (1985, 152–92) reviews both the visual and literary traditions and makes the suggestion that Philostratus' incorporation of Dionysus may have been drawn from visual art. One can, of course, find an early precedent for conjoining the two moments brought together in ekphrasis of an embroidered tapestry in Catullus 64.

56. Cross-reference Chapter 6. p. 693.

57. Wickoff 1900 pp. 158, 163–164; Swindler 1928, 396 and n. 153.

58. Bryson (1999, 256) includes a conjectural drawing taken from the illustrated edition of Blaise de Vigenères translation of the *Eikones; Les Images ou Tableaux de Platte Peinture des deux Philostrates Sophistes Grecs*. Paris 1614. Notwithstanding the baroque touch of a domed building in the background the U-shaped construction formed by two stacked terraces seems closer to what Philostratus might have been thinking than Lehmann's diagram.

59. As Bryson (1994, 276) quotes: "We shall always regret where formal problems are concerned the limitations of a description which aimed not to describe but to interpret what the audience saw."

60. Bryson 1990, 18–20.

61. Elsner 1995, 30–9.

62. Bryson 1994, 235.

63. Dempsey 1968, 371; Leach 1992, 81.

64. Anderson (1993, 148–49) notes the impossibility of proving that the gallery is real but also comments on the difference between sophistic descriptions and "art criticism" as we take it for granted, with scholarly classifications of paintings in schools and styles and the systematic description of color schemes, ornamental surrounds, architectural vistas, or technicalities of perspective. "He concludes that the literateurs see literary subject matter in the paintings."

ABBREVIATIONS FOR BIBLIOGRAPHY

AdI *Annali dell'Istituto di Corrispondenza Archeologica*

AJA *American Journal of Archaeology*

AJP *American Journal of Philology*

BABesch *Bulletin van de Vereeniging tot Bevordering der Kenntnis van de Antieke Beschaving*

BAR *British Archaeological Reports*

BdA *Bolletino d'Arte*

BullCom *Bulletino della commissione Archeologica Communale di Roma*

CA *Classical Antiquity*

CEFRA *Collection d'archéologie et d'histoire de l'École française de Rome, Antiquité*

CronPomp *Croniche Pompeiani*

CJ *Classical Journal*

DialArch *Dialoghi di archeologia*

HSCPh *Harvard Studies in Classical Philology*

JdI *Jahrbuch des Deutschen Archäologischen Instituts*

JRA *Journal of Roman Archaeology*

JRS *Journal of Roman Studies*

MEFRA *Mélanges d'archéologie et d'histoire de l'École française de Rome, Antiquité*

MAAR *Memoirs of the American Academy in Rome*

MededRom *Mededelingen van het Nederlands Instituut te Rome, Antiquity*

MemPontAcc *Atti della Pontifica Accademia Romana di Archeologia, Memorie*

PBSR *Papers of the British School in Rome*

PCPS *Proceedings of the Cambridge Philological Society*

REL *Revue des Études Latines*

RendPontAcc *Atti della Pontifica Accademia Romana di Archeologia, Rendiconti*

RA *Revue Archéologique*

RivStPomp *Rivista di Studi Pompeiani*

RM *Mitteilungen des Deutschen Archäologischen Instituts (Römische Abteilung)*

TAPA *Transactions of the American Philological Association*

YClS *Yale Classical Studies*

BIBLIOGRAPHY

TEXTS FOR LATIN QUOTATIONS

All translations based on these texts (including those in the Loeb
Classical Library) are my own.

L. Annaei Senecae Dialogorum Libri Duodecim, ed. L. D. Reynolds
(Oxford, Clarendon, OCT, 1977).

*L. Annaei Senecae ad Lucilium Epistulae Morales, Vol. I, Libri I–
XIII; Vol. II, Libri XIV–XX,* ed. L. D. Reynolds, (Oxford,
Clarendon, OCT 1965).

L. Annaei Senecae Tragodiae ed. Otto Zwierlein (Oxford, Claren-
don, OCT, 1986).

Cornelii Taciti Annalium ab Excessu Divi Augusti Libri ed. C. D.
Fisher (Oxford, Clarendon, OCT, 1906).

A. Gellii Noctes Atticae Vols. I and II, ed. P. K. Marshall (Oxford,
Clarendon, OCT, corrected ed. 1990).

Horatius Opera, ed. D. R. Shackleton Bailey (Stuttgart, Aedes B.G.
Teubner, 1985).

P. Ovidii Nasonis Metamorphoses, ed. W. S. Anderson (Leipzig,
BTL, 1982).

P. Papini Stati Silvae, ed. E. Courtney (Oxford, Clarendon, OCT,
1990).

Petronius Satiricon Reliquiae, ed. Konrad Mueller (Stuttgart and
Leipzig, Aedes B. G. Teubner, 1995).

C. Plini Secundi Epistularum Libri Decem, ed. R. A. B. Mynors
(Oxford, Clarendon, OCT, 1963).

Pliny: Natural History in ten Volumes with an English translation by
H. Rackham. M.A. Vol IX, Libri XXXIII–XXXV; Vol X
Libri XXXVI–XXXVII (Cambridge, Mass, Loeb Classical
Library, 1952).

Suetonius Vol. I de Vita Caesarum Libri ed. M. Ihm, Editio minor
(Stuttgart, Aedes B. G. Teubner, 1958).

M. Terentius Varro: Saturarum Menippearum Fragmenta, ed. R. Ast-
bury (Leipzig, BSB B. G. Teubner Verlaggesellschaft, 1985).

*M. Tulli Ciceronis Epistulae, Tomus II, Epistulae ad Atticum, Pars
Prior Libri I-VIII* ed. W. S. Watt (Oxford, Clarendon OCT,
1965).

M. Tullius Cicero Epistulae ad Atticum Vol. II, Libri IX–XVI, ed.
D. R. Shackleton Bailey (Stuttgart, Aedes B. G. Teubner,
1987).

M. Tullius Cicero Epistulae ad Familiares Libri I–XVI, ed. D. R.
Shackleton Bailey (Stuttgart, Aedes B. G. Teubner, 1988).

*M. Tullius Cicero Epistulae ad Quintum Fratrem Epistulae ad M.
Brutum* ed. D. R. Shackleton Bailey (Stuttgart, Aedes B. G.
Teubner, 1988).

M. Tulli Ciceronis de Officiis, ed. M. Winterbottom (Oxford,
Clarendon, OCT, 1994).

M. Tulli Ciceronis Orationes Vol. V ed. William Peterson (Oxford,
Clarendon, OCT 1911).

M. Tulli Ciceronis Rhetorica, Tomus I Libros de Oratore tres continens,
ed. A. S. Wilkins (Oxford, Clarendon, OCT, 1902).

*Servii Grammatici qui feruntur in Vergilii Carmina Commentarii, Vol
1. Aeneidos Librorum I–V Commentarii,* ed. G. Thilo, Lepizig
(repr. Hildesheim, G. Olms, 1961).

Valeri Maximi Facta et Dicta Memorabilia Vols. I and II, ed. John
Briscoe (Stuttgart and Leipzig, Aedes B. G. Teubner, 1998).

P. Vergili Maronis Opera, ed. R. A. B. Mynors (Oxford, Oxford
University Press OCT, 1969).

Vitruvius on Architecture, edited from the Harleian Manuscript
2767 and translated, F. Granger (Cambridge, Mass. Loeb
Classical Library, 1934).

Allison, Penelope M. 1991. "Workshops" and "patternbooks."
In *Kölner Jahrbuch für vor- und Frügeschichte* 24: 79–84.

1992. The relationship between wall-decoration and room type
in Pompeian houses: A case study of the Casa della Caccia
Antica. *JRA* 5:235–49.

1993. How do we identify the use of space in Roman houses?
In *Functional and Spatial Analysis of Ancient Wall Painting,*
ed. E. M. Moormann. Proceedings of the Fifth Interna-
tional Congress on Ancient Wall Painting, Amsterdam, 8–
12 September 1992. Publications of the Dutch Institute in
Rome, *Stichting BABesch* 3:1–8.

1994a. *The Distribution of Pompeian House Contents and its Sig-
nificance.* PhD Thesis. University of Sydney 1992 Vols. I and
II. Ann Arbor.

1994b. On-going seismic activity and its effects on the liv-
ing conditions in Pompeii in the last decades. In *Archäologie
und Seismologie: La regione vesuviana dal 62 al 79 D.C. prob-
lemi archaeologici e seismologici: Colloquium Boscoreale. 26–27.
November 1993,* ed. B. Conticello and K. Varone, 183–94.
Munich.

1995a. House contents in Pompeii: data collection and interpretive procedures for a reappraisal of Roman domestic life and site formation process. *Journal of European Archaeology* 3:145–76.

1995b. "Painter-Workshops" or "Decorators' Teams." *MededRom* 54:98–109.

Allrogen-Bedel, Agnes. 1974. *Maskendarstellungen in der römische-kampanische Wandmalerei.* Munich: Willhelm Fink Verlag.

1977. Die Wandmalereien aus der Villa in Campo Varano. *RM* 84:27–89 and pls.

1993. Gli scavi di Ercolano nella politica cultura dei Borboni. In *Ercolano 1738–1988: 250 anni di ricerca archeologica,* ed. Luisa Franchi dell'Orto, 35–40. Atti del convegno internazionale Ravello-Ercolano-Napoli-Pompei, 30 ottobre–5 novembre 1988. Roma: 'L'Erma' de Bretschneider.

Anderson, F. G. 1977. "Intorno alle origini del secondo stile. *Analecta Romana* 8:71–8.

1985. Pompeian painting: some practical aspects of its creation. *Analecta Romana* 14:114–29.

Anderson, Graham. 1993. *The Second Sophistic: A Cultural Phenomenon in the Roman Empire.* Routledge: London/New York.

Anderson, James. 1997. *Roman Architecture and Society.* Baltimore: Johns Hopkins University Press.

Andreae, Bernard. 1963. Studien zur Romischen Grabkunst. *Mitteilung des Deutschen Archaeologischen Instituts in Rom. Römische Abteilung Heft* 9:88–130.

1975. Reconstruktion des grossen Oecus der Villa des P. Fannius Synistor in Boscoreale. In *Neue Forschungen in Pompeji,* ed. B. Andreae and H. Kyrieleis, 71–92 and pls. 59–71. Verlag Aurel Bongers, Recklinghausen.

2000. La riconstruzione della Tomba dei Nasonii a Palazzo Massimo: una parola mantenuta. In *La Tomba dei Nasonii; Gli Acquerelli a Glasgow,* ed. B. Andreae. *Forma Urbis* 5:4–5; 38–9.

Andreae, Maria Theresa. 1990. Tiermegalographien in pompejanischen Gärten. Die sogenannten Paradeisos Darstellungen. *RivStPomp* 4:45–124.

Andreau, Jean. 1973a. Histoire des séismes et histoire économique. Le tremblement de terre de Pompéi (62 ap. J.C.). *Annales EconSocCiv* 28:369–95.

1973b. Remarques sur la société pompéienne (à propos des tablettes de L. Caecilius Jucundus). *DialArch* 7:213–54.

1974. *Les Affaires de Monsieur Jucundus. CEFRA* 19. Rome.

1999. *Banking and Business in the Roman World.* Trans. Janet Lloyd. Cambridge UK: Cambridge University Press.

Archer, W. C. 1990. The paintings in the alae of the Casa dei Vettii and a definition of the Fourth Pompeian Style. *AJA* 94:95–124.

1994. The maturing of the Fourth Style: the Casa delle Nozze d'Argento at Pompeii. *JRA:* Vol. 7:129–50.

Ashby, Thomas. 1914. Drawings of Ancient Paintings in British Collections I: The Eton Drawings. *Papers of the British School in Rome* VII.: 1ff. and Pls I–XXIV.

Ashby, T. W. 1924. Nero's golden house at Rome. In *Wonders of the Past: The Romance of Antiquity and its Splendors,* ed. J. A. Hammerton, 1037–46. New York: G. P. Putnam's Sons.

Avilia, Filippo, and Jacobelli, Luciana. 1989. Le naumachie nelle pitture pompeiane. *RivStPomp* 3:131–55.

Axer, Jerzy. 1989. Tribunal-stage-arena: modeling of the communication situation in M. Tullius Cicero's judicial speeches. *Rhetorica* 7:299–311.

1991. Spettatori e spettacoli nella Roma antica. *Dionisio* 61:221–9.

Baldassari, Paola. 1989. L'opera grafica di Agostino Penna sulla Villa Adriana. *Rivista dell'istituto nazionale d'archeologia e storia dell'arte.* 11:207–25.

Baldassarre, I. ed. 1990–1999. *Pompei, Pitture e Mosaici.* Vols. I–X. Rome.

Barbera, M. 1996. "I balnea" in Paris, R. 1996, *Antiche Stanze: un Quartiere di Roma Imperiale nella Zone di Termini,* Giorgio Mondadori & Associati Editori S.p.a. Milan: 117–120; 140–69.

Barbet, Alix. 1981. Les bourdures ajourées dans le IVe style de Pompéi. *MEFRA* 93:917–98.

1984. *La peinture murale antique. Restitution et iconographie* Actes du IXe séminaire de l'A.F.P.M.A., 27–28 Paris.

1985. *La peinture Romaine: Les styles décoratifs Pompéiens.* Paris: Picard.

1997. Avec la participation de Claudine Allag. *La peinture romaine du peintre au restaurateur.* Saint-Savin.

Bardon, H. 1962. Le goût à l'époque des Flaviens. *Latomus* 21:732–40.

Barnabei, Felice. 1901. *La villa pompeiana di P. Fannio Sinistore scoperto presso Boscoreale.* Rome: Reale accademia dei Lincei.

Barringer, Judith. 1994. The mythological paintings in the Macellum at Pompeii. *CA* 13:149–66.

Bartman, Elizabeth. 1991. Sculptural collecting and display in the private realm. In *Roman Art in the Private Sphere: New Perspectives on the Architecture and Decor of the Domus, Villa and Insula,* ed. Elaine, Gazda, 71–88. Ann Arbor: University of Michigan Press.

Bastet, F. L. 1971. Domus Transitoria. I. *BABesch* 46:144–72.

1972. Domus Transitoria. II. *BABesch* 47:61–87.

Bastet, F. L., and de Vos, M. 1979. *Proposta per una classificazione del terzo stile pompeiano,* trans. A. de Vos Archaeologische studien van het Nederlands Instituut te Rom, deel IV. 's-Gravenhage.

Bayardi, O. A. 1757. *Le antichità di Ercolano esposte con qualche spiegazione, 1757–1779.* 7 volumes. Naples.

Le pitture antiche d'Ercolano e contorni incise con qualche spiegazione, 1759–1771. 5 volumes. Naples.

Beagon, Mary. 1992. *Roman Nature: The Thought of Pliny the Elder.* Oxford: Oxford University Press.

Beard, Geoffrey. 1978. *The Work of Robert Adam.* New York.

Becatti, G. 1956. Letture Pliniane: le opere d'arte nei monumenti Asinia Pollionis. In *Studi A. Calderini e R. Paribeni III,* 199–210. Milan.

Bejor, G. 1979. L'edificio theatral nell'urbanazzazione Augustea. *Athenaeum* 57:126–38.

Bek, Lise. 1983. *Questiones conviviales:* The idea of the triclinium and the staging of convivial ceremony from Rome to Byzantium, *Analecta Romana Instituti Danici* 12:81–107.

Bellori, G. P. 1680. *Le pitture antiche del sepolcro de'Nasonj nella via Flaminia designate et intagliate da Pietro Santi Bartoli, descritte da Gio. Pietro Bellori.* Rome: publisher unstated.

Bergmann, Bettina. 1994. The Roman house as memory theater: the house of the tragic poet at Pompeii. *Art Bulletin* 76:226–56.

　1996. The pregnant moment: tragic wives in the Roman interior. In *Sexuality in Ancient Art*, ed. Natalie Kampen, 199–218. Cambridge, UK: Cambridge University Press.

Berry, D. H. 1996. *Cicero: **Pro Sulla** oratio* edited with a Commentary. Cambridge: Cambridge University Press.

Beyen, H. G. 1937. *Die pompeijanische Wanddekoration von zweiten bis zum vierten Stil.* Vol. I. The Hague: M. Nijhott.

　1938. *Über Stilleben aus Pompeji und Herculaneum.* The Hague.

　1948. *Les domini de la Villa de la Farnésine. Studia varia Carolo Guilielmo Vollgraf a discipuliis oblata,* 3–21, Amsterdam: North-Holland Pub. Co.

　1960. *Die pompeijanische Wanddekoration von zweiten bis zum vierten Stil.* Vol. II. The Hague: M. Nijhott.

Bieber, Margarete. 1961. *The History of the Greek and Roman Theatre.* 2d ed. Princeton, NJ: Princeton University Press.

Blanc, Nicole. 1995. Hommes et chantiers: à la recherche des stucateurs romains. *MededRom.* Vol. 54. Van Gorcum. Assen. 81–97.

Blanc, Nicole, Hélène Eristov, and Myriam Fincker. 2000. *A fundamento restitut?* Réfections dans le Temple d'Isis à Pompeii. *RA* 227–309.

von Blanckenhagen. P. H. 1990. *The Augustan Villa at Boscotrecase,* with contributions by Joan R Mertens and C. Faltermeier. *The Paintings from Boscotrecase,* 2d ed. *MDAI(R),* suppl. 6. Heidelberg. Mainz: P. von Zabern.

Blondeau, Charles, Esq. 1749–50. Remarks on the principal paintings found in the subterraneous city of Herculaneum. *Philosophical Transactions of the Royal Society* 46:14–21.

Bloomer, M. W. 1992. *Valerius Maximus and the Rhetoric of the New Nobility.* Chapel Hill: University of North Carolina Press.

Boatwright, Mary T. 1994. The city gate of Plancia Magna in Perge. In *Roman Art in Context: An Anthology,* ed. Eve D'Ambra, 189–207. Englewood, NJ: Prentice Hall.

Boethius, Axel, and Ward-Perkins, J. B. 1970. *Etruscan and Roman Architecture.* Harmondsworth: Penguin Books.

Borghini, Gabriele. 1998. *Marmi antichi.* Rome: Edizioni deLuca.

Bragantini, I., and de Vos, M. 1982. *Le decorazione della villa romana della Farnesina,* Museo Nazionale Romano, *Le pitture:* Vol. II.1. Rome: de Luca.

Bragantini, I., M. de Vos, and F. P. Badoni. 1981. La mostra: Schede introduttive e didascalie. In *Pompeii 1748–1980: I tempi della documentazione.* A cura dell'Istituto Centrale per il Catalogo e La Documentazione con la collaborazione della Soprintendenza Archeologia delle Province di Napoli e di Caserta e della Soprintendena Archeologica di Roma. Rome: Multigrafica editrice.

Braudel, Fernand. 1992. *The Limits of the Possible: Vol.1 of Civilization and Capitalism 15th–18th Century. The Structures of Everyday Life: Civilization and Capitalism 15th–18th Century.* Trans rev. by Siân Reynolds. Berkeley: University California Press.

Brendel, O. 1979. *Prolegomena to the Study of Roman Art,* Expanded from "Prologomena to a book on Roman art," with a Foreword by J. J. Pollitt. New Haven: Yale University Press.

Brown, F. E. 1961. *Roman Architecture.* George Braziller: New York.

Brown, F. E., Richardson, Emmeline, and Richardson, Lawrence Jr. 1993. *Cosa III: The Buildings of the Forum. MAAR* 37. Rome.

Bruneau, Philippe, and Jean Ducat. 1965. *Guide de Délos.* Préface de Georges Daux. Paris: E. de Boccard.

Bruno, V. J. 1969. Antecedents of the Pompeian First Style. *AJA* 73:305–15.

　1981. The painted metopes at Lefkadia and the problem of color in decorated sculptural metopes. *AJA* 85:3–11.

　1993a. Mark Rothko and the second style: the art of the color-field in Roman murals. In *Eius Virtutis Studiosi: Classical and Post-classical Studies in Memory of Frank Edward Brown (1908–1988)* ed. H. Millon, 335–255. Washington, DC: National Gallery of Art.

　1993b. The Mariemont Fragments from Boscoreale in Color. In *Functional and Spatial Analysis of Ancient Wall Painting,* ed. E. M. Moormann. Proceedings of the Fifth International Congress on Ancient Wall Painting, Amsterdam, 8–12 September 1992. Publications of the Dutch Institute in Rome, *Stichting BABesch* 3:223–33, 272–76, pls. 4.1–8.4.

Bruno, Vincent. 1977. *Form and Color in Greek Painting.* Norton: New York and London.

Bryson, Norman. 1983. *Vision and Painting: The Logic of the Gaze.* New Haven: Yale University Press.

　1990. *Looking at the Overlooked: Four Essays on Still Life Painting.* London: Reaktion Books.

　1994. Philostratus and the imaginary museum. In *Art and Text in Ancient Greek Culture,* ed. S. Goldhill and R. Osborne, 255–83. Cambridge, UK: Cambridge University Press.

Bulwer-Lytton, Edward. 1834. *The Last Days of Pompeii.* London.

Buti, Camillo. 1778–86. *Picture antiche della Villa Negroni.* Rome: publisher unknown.

Cancik, H. 1965. *Untersuchungen zur lyrischen Kunst des P. Papinius Statius.* Spudasmata XIII. Hildesheim: Georg Olms.

　1968. Eine epikureische Villa, Statius, Silv. II.2 "Villa Surrentina," *AU* 11:62–75.

Capelli, Rosanna. 2000. Questioni di iconografia. In *Roma: Romolo, Remo e la fondazioni della città,* ed. A. Carandini and R. Capelli, 161–5. Milan.

Carandini, Andrea. 1988. *Domus e horrea* in Palatio. In *Schiavi in Italia,* ed. A. Carandini, 359–81. Roma: La Nuova Italia Scientifica.

　1990a. Palatino: Campagne di scavo delle pendici settentrionali. *Bollettino di archeologia* 2:159–65.

　1990b. Il giardino romano nell'età tardo repubblicana e giulio-claudia. In *Gli orti farnesiani sul Palatino,* 9–15. Rome: 'L'Erma' de Bretschneider.

　1990c. Il Palatino e le aree residenziali. In *La Grande Roma dei Tarquinii,* ed. M. Christofani, 97–9, 4.2. Rome: 'L'Erma' de Bretschneider.

Carettoni, Gianfilippo. 1983a. *Das Haus des Augustus auf dem Palatin.* Mainz: P. von Zabern.

　1983b. La decorazione pittorica della Casa di Augusto sul Palatino. *RM* 90:373–416, pls. 1–16, 91–108.

　1985. Gli affreschi della casa di Augusto sul Palatino. In *Restauri a palazzo altemps.* Rome.

Castrén, Paavo. 1975. *Ordo Populusque Pompeianus: Polity and Society in Roman Pompeii.* Rome: Bardi Editore.

Cerulli-Irelli, G. 1971. *Monumenti della Pittura scoperti in Italia.* Vol. III, Ercolano I, *Le pitture della Casa dell'Atrio a Mosaico.* Rome: Libreria dello Stato.

——— 1981. Le case di C. Giulio Polibio e M. Fabio Rufo. In *Pompeii 1748–1980: I Tempi della documentazione.* A cura dell'Istituto Centrale per il Catalogo e La Documentazione con la collaborazione della Soprintendenza Archeologia delle Province di Napoli e di Caserta e della Soprintendenza Archeologica di Roma. Rome: Multigrafica Editrice.

——— 1991. L'ultimo stile pompeiano. In *La Pittura di Pompeii: Testimonianze dell'arte romana nella zona sepolta dal Vesuvio nel 79 A.D.,* 229–34. Milan: Editoriale Jaca Book Sp.A.

Cerutti, Steven, and Richardson, Lawrence Jr. 1989. Vitruvius on stage architecture and some recently discovered *scenae frons* decorations. *Journal of the Society of Architectural Historians* 48:172–9.

Chamonard, J. 1922–24. *Exploration Archaeologiques de Delos* 8, II "Le Quatier du Theatre". Paris.

Champlin, Edward. 1980. *Fronto and Antonine Rome.* Cambridge, MA: Harvard University Press.

——— 198. The *suburbium* of Rome. *American Journal of Ancient History,* 27–118.

——— 1998. God and man in the golden house. In *Horti Romani,* ed. M. Cima and E. La Rocca, *Atti del Convegno Internazionale Roma, 4–6 Maggio 1995,* 333–44. Rome: 'L'Erma' di Bretschneider.

Chevallier, Elizabeth. 1977. Les peintures découvertes à Herculaneum, Pompeii et Stabiae vues par les voyageurs du XIIIe siècle: influence des criteres d'appreciation en vigeur à cette epoque. In *L'influence de la Grèce et de Rome sur l'occident moderne,* ed. R. Chevallier, 173–220. Actes du colloque *Caesarodunum* 12 bis.

Christ, Matthew R. 1998. Legal self-help on private property in classical Athens. *AJP* 119:521–45.

Cima, M. 1986. Il 'prezioso arredo' degli Horti Lamiani. In *Le tranquille dimore degli dei: La residenza imperiale degli **horti** Lamiani,* ed. M. Cima, and E. La Rocca, 105–144. Vicenza: Cataloghi Marsilio.

Cima, M., and La Rocca, E. 1986. *Le tranquille dimore degli dei: La residenza imperiale degli **horti** Lamiani.* Vicenza: Cataloghi Marsilio.

Clarke, J. R. 1991. *The Houses of Roman Italy 100 B.C.–A.D. 200: Ritual, Space and Decoration.* Berkeley: University of California Press.

——— 1998–9. Look who's laughing. Humor in tavern painting as index of class and acculturation. *MAAR* 43–44:27–48.

Clay, Edith, ed., with the collaboration of Martin Frederickson. 1976. *Sir William Gell in Italy: Letters to the Society of Dilettanti, 1831–1835,* 39–40. London.

Coarelli. F. 1972. Il complesso pompeiano del Campo Marzio e la sua decorazione scultorae. *RendPontAcc* 54:99–123

——— 1983. Architettura sacra e architetture privata nella tarda repubblica. In *Architecture et societé de l'archaisme grec à la fin de la république romaine. CEFRA* 66:191–217.

——— 1989. La casa dell'aristocrazia romana secondo Vitruvio. In

*Munus non Ingratum: Proceedings of the International Symposium on Vitruvius' **De Architectura** and the Hellenistic and Republican Architecture,* ed. H. Geertman and J. J. De Jong, 178–87. *BABesch,* suppl. 2. Leiden.

Cohen, Ada. 1997. *The Alexander mosaic: stories of Victory and Defeat.* Cambridge, UK: Cambridge University Press.

Coleman, K. M. 1988. *Statius; Silvae IV.* Edited with an introduction. Oxford: Oxford University Press.

——— 1990. Fatal charades: Roman executions staged as mythological enactments. *JRS* 80:44–73.

Connor, W. R. The Razing of the House in Greek Society, *TAPA* 115:79–102.

Conte, G. B. 1994. The Inventory of the World: Form of Nature and Encyclopedic Project in the Work of Pliny the Elder. In G. B. Conte. *Genres and Readers: Lucretius, Love Elegy, Pliny's Encyclopedia,* trans. by Glenn Most with a foreword by Charles Segal. Baltimore: Johns Hopkins University Press.

Cooper, Frederick, and Sarah Morris. 1990. Dining in round buildings. In *Sympotica: A Symposium on the Symposion,* ed. Oswyn Murray, 66–85. Oxford: Oxford University Press.

Coralini, Antonella. 2001. *Hercules Domesticus: Immagini di Ercole nelle case della regione vesuviana (I sec a.C.-79 d.C),* 246. Studi della Soprintendenza archeologica di Pompei 4. Including illustrated catalogue. Napoli.

Corti, Egon. 1963. *Ercolano e Pompei: Morte e renascità di due città,* 4th ed., with a foreword by Amadeo Maiuri, Rome.

Croisille, J. M. 1982. *Poésie et art figurée de Néron aux Flaviens: Recherches sur l'iconographie et la correspondance des arts à l'époque impériale.* Collection Latomus 179. Brussels.

——— 1988. Paysages et natures mortes au temple d'Isis à Pompeii. *Collection Latomus* 201:124–34.

Curtis, Robert I. 1979. The garum shop of Pompeii (1.12.8). *CronPomp* 5:5–23.

Curtius, Ludvig. 1929. *Die Wandmalerei Pompejis: Eine Einführigung in der Verständnis.* Leipzig: E. A. Seemann.

Dacos, N. 1968. Fabulle e l'autre peintre de la Domus Aurea. *DialArch* 2:210–26.

——— 1969. *La découverte de la Domus Aurea et la Formation des Grotesques à la Renaissance.* Studies of the Warburg Institute 31. London.

D'Ambra, Eve. 1993. *Private Lives, Imperial Virtues: The Frieze of the Forum Transitorium in Rome.* Princeton, NJ: Princeton University Press.

D'Ambrosio, A., Guzzo, P. G., and Mastroroberto M. 2003. *Storie da un'eruzione: Pompei, Ercolano, Oplontis.* Electa, Milan.

D'Amelio, Pasquale. 1888. *Dipinti Murali di Pompei,* with twenty lithographic plates. Naples.

D'Arms, John H. 1970. *Romans on the Bay of Naples.* Cambridge, MA: Harvard University Press.

——— 1981. *Commerce and Social Standing in Ancient Rome.* Cambridge, MA: Harvard University Press.

——— 1989. Pompeii and Rome in the Augustan Age and beyond: the eminence of the *Gens Holconius.* In *Studia Pompeiana and Classica in Honor of Wilhelmina F. Jashemski.* Vol. I. *Pompeiana,* ed. Robert I. Curtis, 51–68 and figs. 1–5. New Rochelle Nk.

Dawson, C. M. 1941. *Romano-Campanian Mythological Landscape Painting.* YClS 9. Reprint, 1965. Rome: 'L'Erma' de Bretschneider.

De Albentiis, Emidio. 1982–3. La pittura della Casa dell'Accademia di Musica, 6.3.7, di Pompeii. *Annales della Facolta di lettere et filosofia, University di Perugia* 20. N.S. 6:247–74.

——— 1990. *La Casa dei Romani.* Milan: Longanesi & Co.

De Caro, Stefano. 1987. The sculptures of the villa of Poppea at Oplontis: a preliminary report. In *Ancient Roman Villa Gardens,* ed. Elizabeth Blair Macdougall, 77–134. Dumbarton Oaks Colloquium on the History of Landscape Architecture X. Washington, DC.

——— 1992. Il tempio di Iside di Pompei: La scoperta, il santuario, la fortuna. In *Alla ricerca di Iside: Analisi studi e restauri dell'Iseo pompeiano nel Museo di Napoli,* 3–22. Naples: ARTI S.p.a.

De Franciscis, Alfonso. 1951. *Il ritratto Romano a Pompei.* Naples.

——— 1975. La villa Romana di Oplontis. In *Neue Forschungen in Pompeji,* ed. B. Andreae and H. Kyrieleis, 1–16 and pls. 1–39. Recklinghausen: Bongers.

——— 1990. La casa di C. Julius Polybius. *RivStPomp* 2:15–33.

DeLaine, Janet. 1995. The insula of the paintings at Ostia 1.4.2–4: paradigm for a city in flux. In *Urban Society in Roman Italy,* ed. T. J. Cornell and K. Lomas, 79–106. London: Routledge.

——— 1999. High status *insula* apartments in early imperial Ostia – a reading. *Meded Rom:* 58:175–90.

Della Corte, Mateo. 1964. *Case ed abitanti di Pompei.* 3d ed. Naples: Fausto Fiorentino, editore.

Dempsey, Charles. 1968. *Et nos cedamus amori:* Observations on the Farnese Gallery, *Art Bulletin* 50: 363–74.

Denzer, J. M. 1962. La tombe de C. Vestorius dans la tradition de la peinture italique. *MEFRA* 74:533–94.

De Ruyt, Claire. 1983. *Macellum: Marché alimentaire des Romains.* Préface de Joseph Mertens. Publications d'histoire de l'art et d'archéologie de l'université catholique de Louvain 35. Louvaine-la-Neuve.

Descoudres, J.-P. 1993. "Did some Pompeians return to the city after the eruption of Mount Vesuvius in AD 79? Observations in the House of the Colored Capitals," in *Ercolano 1738–1988: 250 anni di ricerca archeologica Atti del convegno internazionale Ravello-Ercolano-Napoli-Pompei 30 ottobre–5 novembre 1988* ed. Luisa Franchi dell'Orto, 165–78. Roma: 'L'Erma' de Bretschneider.

De Simone, A., and Nappo, S. C. 2000. *Mitis Sarni Opes: Nuova indagine archeologica in località Murecino.* Denaro Libri: Naples.

De'Spagnolis Conticello, Marisa. 1996. Sul rinvenimento della villa e del monumento funerario dei Lucretii Valentes. *RivStPomp* 7:147–66.

De Vos, Mariette. 1968–9. Due monumenti di pittura postpompeiana a Roma. *BullCom* 81:149–72.

——— 1976. Scavi nuovi sconosciuti (1.9.13): pitture e pavimenti della Casa di Cerere a Pompei. *MededRom* 38:37–75, and pls.

——— 1980. Architectonic decoration. In *Roman Villas in Italy: Recent Excavations and Research,* ed. Kenneth Painter, British Museum Occasional Paper No. 24. London.

——— 1981. La bottega di pittori di Via di Castricio. In *Pompeii 1748–1980: I Tempi della documentazione.* A cura dell'Istituto Centrale per il Catalogo e La Documentazione con la collaborazione della Soprintendenza Archeologia delle Province di Napoli e di Caserta e della Soprintendena Archeologica di Roma. Rome: Multigrafica editrice.

——— 1982. A painted *oecus* from Settefinestre (Tuscany): excavation, conservation and analysis. In *Roman Provincial Wall Painting of the Western Empire,* ed. J. Liversedge, 1–32. B.A.R. Int. Series 140. London.

——— 1983. Funzione e decorazione dell'auditorio di Mecenate. In *Roma Capitale 1870–1911: L'Archeologia tra sterro e scavo,* ed. R. Nicolini, 231–47. Venezia: Marsilio Editore.

——— 1990. Nerone, Seneca, Fabullo e la domus Transitoria al Palatino. In *Gli orti farnesiani sul Palatino,* 167–86. Rome: 'L'Erma' de Bretschneider.

——— 1995. s.v. *Domus Transitoria.* in *Lexicon Topigraphicum Urbis Romae,* ed. E. M. Steinby, 199–202. Vol. II, D–G. Rome: Quasar.

Dexter, Carolyn Elizabeth. 1974. *The Casa di L. Cecilio Giocondo in Pompeii.* Ph.D. dissertation, Duke University. Ann Arbor: MI.

Dilthey, C. 1876. Dipinti pompeiani accompagnati d'epigrammi greci, *AdI* 48:294–317.

Di Mino, R. S. 1983. Fregio pittorico del colombario Esquilino. In *Roma Capitale 1870-1911: L'Archeologia tra sterro e scavo,* ed. R. Nicolini, 163–71, pls. III and IV. Venezia: Marsilio Editore.

Di Puolo, Maddelena Cima. 1993. Affreschi da Via Genoa. In *BullCom* 120:263–9.

Dobbins, John J. 1994. Problems of chronology, decoration and urban design in the Forum at Pompei. *AJA* 98:629–94.

Donati, Fulvia. 1987. Schemi di architetture dipinte dalla villa di Settefenestre: ancora sulla questione degli apporti teatrali. In *Pictores per provincias,* ed. C. Martin, Aventicum V. Cahiers d'Archeologie Romande 43. Avenches.

Donderer, M. 1982. Review of M. L. Morricone. *Scutulata pavimenta. I pavimenti con inserti di marmo o di pietra trovati a Roma e nei dintorni.* Rome, 1980 in *Archeologica Classica* 34:230–34.

Dumont, Jean Christian. 1990. Le décor di Trimalchion. *MEFRA* 102:959–81.

Dunbabin, K. 1978. *The Roman Mosaics of North Africa: Studies in Iconography and Patronage.* Oxford: Oxford University Press.

——— 1993. Wine and water at the Roman *convivium. JRA* 6:116–41.

——— 1998. *Ut Graeco more biberetur:* Greeks and Romans on the dining couch. In *Meals in a Social Context,* ed. Inge Nielsen and H. S. Nielsen, 81–101. Aarhus Studies in Mediterranean Archaeology I. Aarhus: Aarhus University Press.

DuPrey, P. de la Ruffinière. 1994. *The Villas of Pliny from Antiquity to Posterity.* Chicago: University of Chicago Press.

Dwyer, E. J. 1982. *Pompeian Domestic Sculpture: A Study of Five Pompeian Houses and their Contents.* Rome: Giorgio Bretschneider.

——— 1991. The Pompeian atrium house in theory and practice. In *Roman Art in the Private Sphere: New Perspectives on the Architecture and Decor of the Domus, Villa and Insula,* ed. Elaine Gazda, 25–48. Ann Arbor: University of Michigan Press.

Edwards, Catherine. 1994. Beware of imitations: theatre and the subversion of imperial identity. In *Reflections of Nero: Culture, History and Representation,* ed. Jaś Elsner and Jamie Masters, 83–97. Chapel Hill: University of North Carolina Press.

Egger, Herman. With C. Hülson, A. Michaelis. 1905–6. *Codex Escurialensis: ein Skizzenbuch aus der Werkstatt Domenico Ghirlandaios* 2 vols. Reprinted 1975. Vienna: A. Holder.

Elia, Olga. 1934. La casa di un Augustiano a Pompei. *Atti del III Congresso di Studi Romani* 1:215–26.

1937. *Le pitture della Casa del Citarista. Monumenti della pittura antica scoperti in Italia.* Vol. III, Pompeii, fasc. 1. Rome.

1941. *Le pitture dell'Tempio di Iside.* (Monumenti della pittura scoperti in Italia. Pompei III–IV) Libreria dello Stato. Rome.

1961. Il portico dei triclini de pagus maritimus di Pompei. *BdA* 46:200–11.

Elsner J., and Jamie Masters. 1994. *Reflections of Nero: Culture, History & Representation.* Chapel Hill, University of North Carolina Press.

Elsner, Jaś. 1994. Constructing decadence: the representation of Nero as imperial builder. In *Reflections of Nero: Culture, History and Representation,* ed. J. Elsner, and Jamie Masters, 112–30. Chapel Hill: University of North Corolina Press.

1995. *Art and the Roman Viewer: The Transformation of Art from the Pagan World to Christianity.* Cambridge, UK: Cambridge University Press.

Engeman, J. 1967. *Architekturdarstellungen des frühen zweiten stils: Illusionistiche römische Wandmalerei der ersten Phase und ihre Vorbilden in der realen Architekten.* RM, suppl. 12. Heidelberg.

Ehrhardt, Wolfgang. 1987. *Stilgeschictlischliche Untersuchungen an Römichen Wandmalerein von der späten Republik bis zur Zeit Neros.* Mainz: Philip Van Zabern.

1995. Die Malerwerkstatt Casa delle Nozze d'argento/Casa dell'Orso. *MededRom* 54:140–53.

Eristov, Hélène. 1994. *Les éléments architecturaux dans la peinture campanienne du quatrième style.* CEFRA 187. Rome.

Eristov, Hélène, and de Vaugiraud, Solange. 1985. *Peintures Murales de la rue Amyot a Paris.* Cahiers de la rotonde 8. Paris.

1994. Les peintures murales de la cave I. *Cahiers de la rotonde* 15:65–166. Paris.

Eschebach, L., and J. Müller-Trollius. 1993. *Gebäudeverzeichnis und Stadtplan der antiken Stadt Pompeji.* Cologne. Böhlau Verlag

Esposito, Domenico. 1999. La 'Bottega dei Vettii' a Pompei: vecchi data e nuouve acquisizioni. *RivStPomp* 10:23–62.

Etienne, Robert. 1993. A propos du *cosidetto* édifice des *Augustales* d'Herculaneum. In *Ercolano 1738–1988: 250 Anni di ricerca archeologica,* Luisa Franchi dell'Orto, ed. 345–50. Rome: 'L'Erma' de Bretschneider.

Fabbrini, Laura. 1982. *Domus Aurea:* il piano superiore del quartiere orientale. *MemPontAcc* 14:5–24.

1995. s.v. *Domus Aurea:* il Palazzo sull'Esquilino. In *Lexicon Topigraphicum Urbis Romae,* ed. E. M. Steinby, 56–63. Vol. II. D–G. Rome: Quasar.

Fant, Clayton. 1988. The Roman emperors in the marble business: capitalists, middlemen or philanthropists." In *Classical Marble: Geochemistry, Technology, Trade,* ed. Norman Herz and Marc Waelkens. NATO Advanced Science Institute Series, 149. Dordrecht.

Fittschen, K. 1974. Zur Herkunft und Entstehung des 2 Stils. In *Hellenismus in Mittelitalien: Kolloquium in Göttingen,* ed. P. Zanker, 536–57. 2 Vols. Gottingen. Vandenhoeck & Ruprecht in Göttingen.

Flower, Harriet I. 1996. *Ancestor Masks and Aristocratic Power in Roman Culture.* Oxford: Oxford University Press.

Franklin, James L., Jr. 1980. *Pompeii: The Electoral Programmata, Campaigns and Politics, A.D. 71–79.* Rome: Papers and Monographs of the America Academy in Rome 28.

1985–86. Games and a *lupanar:* prosopography of a neighborhood in ancient Pompeii. *CJ* 81:319–28.

1987. Pantomimists at Pompeii: Actius Anicetus and his troupe. *AJP* 108:95–107.

1990. *Pompeii: "The Casa del Marinaio" and its History.* Rome: 'L'Erma' de Bretschneider.

1997. Cn. Alleius Nigidius Maius and the amphitheatre: *Munera* and a distinguished career at ancient Pompeii. *Historia* 46:434–47.

1998. Aulus Vettius Caprasius Felix of Ancient Pompeii. In *Qui miscuit utile dulci: Festschrift Essays for Paul Lachlan MacKendrick,* ed. G. Schmeling and J. D. Mikalson, 165–76. Wauconda, Ill: Bolchazy-Carducci.

2001. *Pompeis difficile est: The Political Life of Imperial Pompeii.* Ann Arbor: University of Michigan Press.

Fraser, P. M. 1972. *Ptolemaic Alexandria.* 2 vols. Oxford: Oxford University Press.

Frézouls, Edmond. 1983. La construction du *theatrum lapideum* et son contexte politique. Actes du Colloque de Strasbourg 5–7 Novembre 1981, 193–214. Strasbourg.

Frölich, Thomas. 1996. *Casa della Fontana Piccola (VI 8.23.24).* Hauser in *Pompeji Band 8.* Munich: Philip van Zabern.

Fuchs, Günter. 1962. Varros Vogelhaus bei Casinum. *RM* 69:96–105.

Gabriel, Mabel M. 1955. *Livia's Garden Room at Prima Porta.* New York: New York University Press.

Gallo, Alessandro. 2000. I quadri perduti del triclinio S della casa di M. Epidio Rufo (IX,1,20). Una lettura politico-sociale. *RivStPomp* 11:87–100.

Gallo, Pasquale. 1991. *Terme e bagni in Pompei antica.* Pompei. T.p. F. sco Sicignano.

Gazda, Elaine, ed. 1991. *Roman Art in the Private Sphere: New Perspectives on the Architecture and Decor of the Domus, Villa and Insula.* Ann Arbor: University of Michigan Press.

Gell, Sir William. 1832. *Pompeiana: The Topography, Edifices and Ornaments of Pompeii, the Result of Excavations since 1819.* 2d series. 2 Vols. London: Jennings and Chaplin.

Gibson, Sheila, Janet De Laine, and Amanda Claridge. 1994. The triclinium of the *Domus Flavia:* a new reconstruction. *PBSR* 62:67–100.

Gjerstad, Einar. 1966. *Synthesis of Archaeological Evidence.* Vol. IV.2, *Early Rome.* Lund.

Gnoli, Raniero. 1971. *Marmora Romana.* Rome. Edizioni dell' Elefante.

Goethe, Johann Wolfgang von. 1982. *Italian Journey (1786–1788)* trans. W. H. Auden and Elizabeth Meyer. San Francisco North Point Press.

Goldhill, Simon. 1994. The naive and knowing eye: ecphrasis and the culture of viewing in the Hellenistic world. In *Art and Text in Ancient Greek Culture,* ed. S. Goldhill and R. Osborne, 197–223. Cambridge, UK: Cambridge University Press.

Gombrich, Ernest. 1969. *Art and Illusion: A Study in the Psychology of Pictorial Representation,* 2d ed. Princeton, NJ: Princeton University Press.

1976. *The Heritage of Apelles: Studies in the Art of the Renaissance.* Ithaca: Cornell University Press.

Gowers, Emily. 1993. *The Loaded Table: Representations of Food in Roman Literature.* Oxford: Oxford University Press.

Greenough, J. B. 1890. The *Fauces* of the Roman House. *HSCPh* 1:1–12.

Grell, Chantal. 1982. *Herculaneum et Pompéi dans les récits des voyageurs français du XVIIIe siècle.* Naples: Centre Jean Bérard.

Griffin, Miriam T. 1995. Philosophical badinage in Cicero's letters to his friends. In *Cicero the Philosopher,* ed. J. G. F. Powell, 325–46. Oxford: Oxford University Press.

Grimal, Pierre. 1937. À propos des "Bains de Livie" au Palatin. *MEFRA* 54:142–64.

Gros, Pierre. 1984. La rôle de la *Scenographia* dans les projets architecturaux du début de l'empire romaine. In *L'architecture dans les sociétiés antiques,* 213–29. (colloq). Strasburg.

1987. La function symbolique des édifices théâtraux dans le paysage urbain de la Rome Augustiene. In *L'Urbs: Espace urbain et historire: Ier siècle avant J.-C. – III sile après J.-C.,* 319–46, CEFRA 98.

Gruen, Erich. 1993. *Culture and National Identity in Republican Rome.* Ithaca, NY: Cornell University Press.

Guerrini, Lucia. 1971. *Marmi Antichi nei Disegni di Pier Leone Ghezzi.* Rome (Vatican).

Guidobaldi, Frederico, and Antonio Salvatini. 1992. The Introduction of Polychrome Marbles in Late Republican Rome. In *Classical Marble: Geochemistry, Technology, Trade,* ed. Norman Herz and Marc Waelkens. NATO Advanced Science Institute Series. Dordrecht.

Gulino, Rosanne. 1987. *Implications of the Spatial Arrangement of Tabernae at Pompeii Region One.* Ph.D. dissertation. University of Minnesota. Ann Arbor.

Gury, Françoise. 1991. La découverte de Télèphe à Herculaneum. In *Kölner Jahrbuch für vor- und Früeschichte* 24:97–105.

Guzzo, P. G. 1997. *Pompei: picta fragmenta, decorazione parietali delle città sepolte,* 134–49. Torino.

Hagstrum, Jean H. 1958. *The Sister Arts: The Tradition of Literary Pictorialism and English Poetry from Dryden to Gray.* Chicago: University of Chicago Press.

Hanson, John Arthur. 1959. *Roman Theatre-Temples.* Princeton Monographs in Art and Archaeology 33. Princeton.

Hardie, Alex. 1983. *Statius and the Silvae: Poets, Patrons and Epideixis in the Graeco-Roman World.* Liverpool: Francis Cairns.

Harris, Judith, and Schuster A. M. H. . 2001. The lap of luxury. *Archaeology* 24:30–5.

Hemsoll, David. 1990. The architecture of Nero's golden house. In *Architecture and Architectural Sculpture in the Roman Empire,* ed. M. Henig, 10–38. Oxford: Oxford University Committee for Archaeology, Oxbow Books.

Henderson, John. 1998. Polishing off the Politics: Horace's Ode to Pollio (*Odes* 2.1). In *Fighting for Rome: Poets & Caesars, History & Civil War,* ed. J. Henderson, 108-164. Cambridge: Cambridge University Press.

Hillier, Bill, and Hanson, Julienne. 1983. *The Social Logic of Space.* Cambridge, UK: Cambridge University Press.

Holloway, R. Ross. 1989–90. Il cubicolo della villa romana di Boscoreale nel Metropolitan Museum of Art in New York. *RendPontAcc.* 52:105–19.

Huét, Valérie. 1992. Review of Roger Ling. *Roman Painting. JRS* 82:235–6.

Isager, Jacob. 1992. *Pliny on Art and Society: The Elder Pliny's Chapters on the History of Art.* London: Routledge.

Jacobelli, Luciana. 1991. Le pitture e gli stucchi delle terme suburbane di Pompei. In *Kölner Jahrbuch für vor- und Früeschichte* 24:147–52.

1995. *Le pitture erotiche delle terme suburbane di Pompei.* Soprintendenza archeologica di Pompei 10. Rome: 'L'Erma' de Bretschneider.

Jacopi, I. 1995. s.v. *Domus: Livia* in ed. E. M. Steinby, *Lexicon Topigraphicum Urbis Romae* Vol. II. D-G. 130–2. Rome: Quasar.

Jacopi, Irene. 1990. Lo studiolo di Augusto: Ricomposizone e ripristinato. *Bolletino di Archeologia* 2:143–8.

1999. *Domus Aurea.* Electa: Milan.

James, Henry. 1975. *Portrait of a Lady. An Authoritative text* 1st Ed. Robert Bamberg. New York: Norton.

Jameson, Michael. 1990. Domestic space in the Greek city-state. In *Domestic Architecture and the Use of Space: An interdisciplinary cross-cultural study,* ed. Susan Kent, 92–113. Cambridge UK: Cambridge University Press.

Jashemski, W. F. 1979. *The Gardens of Pompeii, Herculaneum and the Villas Destroyed by Vesuvius.* Vol. I. New Rochelle, NY: Caratzas.

1987. Recently excavated gardens and cultivated land in the villas at Boscoreale and Oplontis. In *Ancient Roman Villa Gardens,* ed. Elizabeth Blair Macdougall, 31–76. Dumbarton Oaks Colloquium on the History of Landscape Architecture X. Washington, DC.

1993. *The Gardens of Pompeii, Herculaneum and the Villas Destroyed by Vesuvius.* Vol. II. New Rochelle, NY: Caratzas.

Jex-Blake, K., and Sellers, E. 1976. *The Elder Pliny's Chapters on the History of Art.* Trans with Commentary, Introduction, and Preface by R. V. Schroder. Revised. Chicago: Ares Publishers Inc.

Jolivet, Vincent. 1983. Les jardins de Pompeii: nouvelles hypothesis. *MEFRA* 95:115–38.

1987. *Xerxes togatus:* Luculle en Campanie. *MEFRA* 99:875–904.

Jongman, W. M. 1988 *The Economy and Society of Pompeii.* Amsterdam: Giebens.

Joyce, Hetty. 1981. *The Decoration of Walls, Ceilings and Floors in Italy in the Second and Third Centuries.* Rome: Giorgio Bretschneider.

1983. The ancient frescoes from the Villa Negroni and their influence in the eighteenth and nineteenth centuries. *Art Bulletin* 65:423–40.

Keaveney, Arthur. 1992. *Lucullus: A Life.* London/New York: Routledge.

Kellum, Barbara. 1986. Sculptural programs and propaganda in Augustan Rome: The Temple of Apollo on the Palatine. In *the Age of Augustus,* ed. R. Winkes, 169–76. Vol. 5 of *Archeologia Transatlantica.* Reprinted in *Roman Art in Context: An Anthology,* ed. Eve D'Ambra, 75–83. Englewood, NJ.

1994a. What we see and don't see: narrative structure and the *Ara Pacis Augustae. Art History* 17:26–45.

1994b. The construction of landscape in Augustan Rome: the garden room at the Villa *ad Gallinas. Art Bulletin* 76:211–24.

King, Richard Jackson. 1994. *Spatial Form and the Literary Representation of Time in Ovid's Fasti.* Ph.D. Dissertation. Indiana University University of Michigan, Ann Arbor: University of Michigan.

Kondoleon, Christine. 1991. Signs of privilege and pleasure: Roman domestic mosaics. In *Roman Art in the Private Sphere: New Perspectives on the Architecture and Decor of the Domus, Villa and Insula,* ed. Elaine Gazda, 105–16. Ann Arbor: University of Michigan Press.

LaFon, X. 1981. A propos des "villae" républicaines: quelques notes sur les programmes décoratifs et les commanditaires. In *L'art décoratif à Rome à la fin de la republique et au débout du principat,* ed. X. LaFon. CEFRA 55:151–72.

Laidlaw, Laura Anne. 1985. *The First Style in Pompeii: Architecture and Painting.* Rome: Giorgio Bretschneider.

Lanciani, Rodolpho. 1897. *The Ruins and Excavations of Ancient Rome.* Reprinted 1988 Salem, NH: Ayer.

La Rocca, Eugenio, Mariette de Vos, and Arnold de Vos. 1976. *Guida Archeologica di Pompei. Naples:* Arnaldo Mondadori.

La Rocca, Eugenio, 1984. Fabio o Fannio: L'affresco medioreppublicana dell'Esquilino come reflesso dell'arte 'Rappresentativa' e come espressione di mobilità sociale. *Dial Arch* ser. 3. 2:31–53.

With Maddelena Cima. 1986. *Le tranquille dimore degli dei: La residenza imperiale degli horti Lamiani.* Rome: Cataloghi Marsilio.

1998. Artisti Rodi negli *Horti* Romani. In *Horti Romani;* ed. M. Cima and E. La Rocca, 202–74. *Atti del Convegno Internazionale Roma, 4–6 Maggio 1995.* Rome: 'L'Erma' de Bretschneider.

La Torre, G. F. 1988. Gli impianti commerciali ed artigianali nel tessuto urbano di Pompei. In *Pompeii: l'informatica al servizio di una città antica,* ed. A. De Simone 75–102. 2 vols. Rome: 'L'Erma' de Bretschneider.

Lavagne, Henri. 1988. *Operosa Antra: recherches sur la grotte à Rome de Sylla à Hadrien.* Bibliothèque des Écoles françaises d'athènes et de Rome 272. Rome.

Laurence, Ray. 1994. *Roman Pompeii: Space and Society.* London/ New York: Routledge.

1995. The Organization of Space in Pompeii. In *Urban Society in Roman Italy,* ed. T. J. Cornell and K. Lomas, 63–78. London: Routledge.

Leach, E. W. 1981. Metamorphoses of the Acteon myth in Campanian painting. *RM* 88:307–28, pls. 131–41.

1982. Patrons, painters and patterns: the anonymity of Romano-Campanian painting and the transition from the Second to the Third Style. In *Roman Literary and Artistic Patronage,* ed. B. Gold, 158–67. Austin, Texas. Reprinted in D'Ambra, Eve, ed. *Roman Art in Context: An Anthology,* 133–60. Englewood, NJ.

1986. The punishment of Dirce: a newly discovered continuous narrative in the Casa di Giulio Polibio and its significance within the visual tradition. *RM* 93:118–38; color pl. 1; pls. 49–59.

1988. *The Rhetoric of Space: Literary and Artistic Representations of Landscape in Republican and Augustan Rome.* Princeton. Princeton University Press.

1991. The iconography of the Black Salone in the Casa di Fabio Rufo. *Kölner Jahrbuch für vor- und Frügeschichte* 24:105–12.

1993. The Entrance Room in the House of Julius Polibius and the Nature of the Roman Vestibulum. In *Functional and Spatial Analysis of Ancient Wall Painting,* ed. E. M. Moormann. Proceedings of the Fifth International Congress on Ancient Wall Painting, Amsterdam, 8–12 September 1992. Publications of the Dutch Institute in Rome, *Stichting BABesch* 3:23–8.

1997. *Oecus* on Ibycus: investigating the vocabulary of the Roman House. In *Sequence and Space in Pompeii,* ed. Sara Bon and R. Jones, 50–72. Oxford: Oxbow Monographs.

2001. G. P. Bellori and the Sepolchro dei Nasonii: Writing a 'Poet's' Tomb. In *La Peinture Funéraire Antique: IV^e siècle av. J.-C–IV^e siècle apr. J.-C.* ed. Alix Barbet, 69–77 Editions errance. Paris.

Leen, Anne. 1991. Cicero and the Rhetoric of Art. *AJP* 112: 229–46.

Lehmann, Karl. 1941. The *Imagines* of the Elder Philostratus. *Art Bulletin* 23:16–44.

Lehmann, P. W. 1953. *Roman Wall Paintings from Boscoreale in the Metropolitan Museum of Art.* Cambridge, MA.

1979. Lefkadia and the Second Style. In *Studies in Classical Art and Archeology: A Tribute to P. H. von Blanckenhagen,* 225–9. Locust Valley, NY.

Leppmann, Wolfgang. 1968. *Pompeii in Fact and Fiction.* London: Elek.

Linderski, Jersey. 1989. Garden Parlors: Nobles and Birds. In *Studia Pompeiana & Classica in Honor of Wilhelmina F. Jashemski,* ed. Robert I. Curtis, 105–128. Vol. II of *Classica.* New Rochelle, NY: Caratzas.

Ling, Roger. 1977. Studius and the beginnings of Roman landscape painting. *JRS* 67:1–16.

1983. Insula of the Menander at Pompei: a preliminary report. *Antiquaries Journal* 63:34–57.

1991. *Roman Painting.* Cambridge, UK: Cambridge University Press.

1997. *The Insula of the Menander at Pompeii: Volume I: The Structures.* Oxford: Oxford University Press.

Little, A. M. G. 1964. A series of notes in four parts on Campanian megalography. *AJA* 68:390–5.

Lyttleton, Margaret. 1974. *Baroque Architecture in Classical Antiquity* Ithaca, NY: Cornell University Press.

Los, A. Les fils d'affraichis dans l'*Ordo Pompeianus.* In *Les élites municipales de l'"italie péninsulaire des Gracques à Néron* ed. Mirielle Cébeillac-Gervasoni,145–152. Naples/Rome.

MacDonald, W. T and John A. Pinto. 1995. *Hadrian's Villa and its Legacy* New Haven: Yale University Press.

MacDonald, William. 1982. *The Architecture of the Roman Empire I: An Introductory Study.* Rev. ed. New Haven: Yale University Press.

1986. *The Architecture of the Roman Empire II: An Urban Appraisal.* New Haven: Yale University Press.

Maiuri, A. 1931. *La Villa dei Misteri.* Libreria dello Stato. Rome.

Maiuri, Amadeo. 1952. Gli "Oeci" Vitruviani in Palladio

e nella casa pompeiana ed Ercolenese. *Palladio* 2: 1–8.

Martin, Colin. 1987. *Pictores per Provincias Aventicum V* Cahiers d'archéologie romande 43. Avenches.

Martin, René. 1971. *Recherches sur les agronomes latins et leurs conceptions économiques et sociales.* Paris: Les Belles Lettres.

Martyn and Lettice. 1773. *Antiquities of Herculaneum.* Translation of Bayardi. London.

Mastroroberto, Marisa. 2002. Una visita di Nerone a Pompei: le *deversoriae tabernae* de Moregine. In *Pompei: le stanze dipinte,* ed. P. G. Guzzo, and Mastroroberto, M., 35–87. Electa. Milano.

Mau, Auguste. 1882. *Geschichte der dekorativen Wandmalerei in Pompeji.* G. Reimer, Berlin.

Mau, August. 1904. *Pompeii: Its Life and Art.* F. Kelsey, trans. New York.

1882. *Geschichte der dekorativen Wandmalerei in Pompeji.* Berlin: G. Reimer.

Mazois, F. 1824–38. *Les ruines de Pompeii,* Vols. I-IV. Paris.

McIlwaine, I. C. 1988. *Herculaneum: A Guide to Printed Sources* Vols. I and II. Naples: Bibliopolis.

McKay, Alexander. 1975. *Houses, Villas and Palaces in the Roman World.* Ithaca, NY: Cornell University Press.

McKeown, J. C. 1979. Augustan Elegy and Mime. *PCPS* 25:71–84.

McNally, Sheila 1985. Ariadne and others: images of sleep in Greek and early Roman art. *CA* 6:152–92, pls. I–XXVI.

Meiggs, Russell. 1973. *Roman Ostia.* 2d ed. Oxford: Oxford University Press.

Messineo, Gaetano. 1991. *La Via Flaminia da Porta del Popolo a Malborghetto.* Rome: Quasar.

2000. *La Tomba dei Nasonii.* Rome. 'L'Erma' de Bretschneider.

Meyboom, P. G. 1995. Famulus and the Painters' Workshops of the Domus Aurea, *MededRom* 54:229–45.

Mielsch, Harald. 1987. *Die Römische Villa: Architektur und Lebensform* Munich: C. H. Beck.

Miller, Stella G. 1971–2. Macedonian tombs: their architecture and architectural Decoration. In *Macedonia and Greece in Late Classical and Early Hellenistic Times,* National Galllery of Art, Studies in the History of Art 10:151–62.

1993. *The Tomb of Lyson and Kallikles: A Painted Macedonian Tomb.* Mainz: P. von Zabern.

Mirri, Ludovico, and Giuseppe Carletti. 1776. *Le antiche camere delle terme di Tito e le loro pitture restituite al pubblico, delineate, incise e dipinte.* Rome: Per G. Salomoni.

Moeller, Walter O. 1976. *The Wool Trade of Ancient Pompeii.* Leiden: Brill.

Mols, Stephan. T. A. M. 1999a. La vita privata attraverso lo studio delle decorazione parietali. *Meded Rom:* 58:165–74.

Mols, Stephan T. A. M., and Eric Moormann. 1993–4. *Ex parvo crevit:* Proposta per una lettura iconografica della Tomba di Vestorius Priscus fuori Porta Vesuvio a Pompei. *RivStPomp* 15–52.

1999b. Decorazione e uso dello spazio a Ostia. Il caso dell'*Insula* III.x (Caseggiato del Serapide, Terme dei Sette Sapienti a Caseggiato degli Aurighi). *Meded Rom* 58:247–386.

Mols, Stefan. 1999c. *Wooden Furniture in Herculaneum: Form, technique and Function* Gieben: Amsterdam.

Montfaucon, Bernard de. 1721–2. *Antiquity Explained and Represented in Sculptures.* Trans. David Humphreys. 3 Vols. London (Reprinted 1976, New York/London). Garland Press.

Moormann, E. 1996. "Gli affreschi di Piazza dei Cinquecento nell' ambito della pittura romana," in Paris, R. 1996, *Antiche Stanze: un Quartiere di Roma Imperiale nella Zone di Termini* Giorgio Mondadori & Associati Editori S.p.a. Milan: 64–70.

Moormann, E. M. 1983a. Rappresentazioni teatrali su *Scaenae Frontes* di quarto stile a Pompei. *Pompeii, Herculaneum and Stabia* 1:73–117.

1983b. Sulle decorazioni della Herculanensium Augustalium Aedes. *Croniche Ercolanese* 13:175–77.

1988. *La pittura parietale romana come fonte di conoscenza per la scultura antica.* Assen: Van Gorcum.

1991. Zwei landschaft darstellungen in der Casa Sannitica in Herculaneum. In *Kölner Jahrbuch für vor- und Frügeschichte* 24:11–17.

1995. Giardini ed altre pitture nella Casa del frutteto e nella Casa del bracciale d'oro a Pompei. *MededRom* 54:214–28.

1997. Le muse a casa. In *I temi figurativi nella pittura parietale antica (Iv sec. a.C. - Iv sec. d.C.,* ed. D. Scagliarini-Corlàita, 97–102. Atti del VI Convegno Internazionale sulla Pittura Parietale Antica (Bologna, 20–23 settembre 1995). Bologna: University Press Bologana.

1998. Vivere come un uomo. L'uso dello spazio nella *Domus Aurea.* In *Horti Romani: Atti del Convegno Internazionale Roma, 4–6 Maggio 1995,* ed. M. Cima and E. La Rocca, 345–62. Rome: 'L'Erma' de Bretschneider.

Mouritsen, Henrik. 1988. *Elections, Magistrates and Municipal Élite: Studies in Pompeian Epigraphy.* Analecta Romana Instituti Danici. Supp. XV. Rome: 'L'Erma' de Bretschneider.

1996. Order and disorder in late pompeian Politics. In *Les élites municipales de l"italie péninsulaire des Gracques à Néron,* ed. Mirielle Cébeillac-Gervasoni, 139–44. Naples/Rome: CEFRA 215 Centre Jean Bérard.

Murray, Oswyn, ed. 1990. *Sympotica: A Symposium on the Symposion.* Oxford: Oxford University Press.

Muscettola, Stefania Adamo. 1992. Il tempio di Iside di Pompei: La decorazione architettonica e l'arredo. In *Alla ricerca di Iside: Analisi studi e restauri dell'Iseo pompeiano nel Museo di Napoli,* 63–75. Naples: ARTI S.p.a.

Najbjerg, Tina. 1997. *Public Painted and Sculptural Programs of the Early Roman Empire: A Case Study of the So-Called Basilica in Herculaneum.* Doctoral Dissertation Princeton, Ann Arbor.

Nappo, Salvatore Ciro. 1989. Fregio dipinto dal "praedium" di Giulia Felice con rappresentazione del foro di Pompei. *RivStPomp* 3:79–96.

1999. Nuove indagine archeologica in località Moregine a Pompei. *RivStPomp* 10:185–90.

Niccolini, F. 1854–96 *Le case ed i monumenti di Pompei designati e descritti.* 3 Vols. Napoli.

Nielsen, Inge. 1990. *Thermae et Balnea: The Architecture and Cultural History of Roman Public Baths.* 2 vols. Aarhus: Aarhus University Press.

Nisbett, R. G. M. and M. Hubbard. 1978. A *Commentary on Horace **Odes** Book II.* Oxford: Oxford University Press.

Overbeck, J. A. 1884. *Pompeji in seinen gebauden, altertümen und kunstwerken dargestellt von Johannes Overbeck.* Ed. 4 in vereine mit August Mau durchgearb. Leipzig.

Pace, Claire. 2000. Pietro Santi Bartoli's drawings after ancient Roman paintings in the Tomb of the Nasonii: Album MS. Gen. 1496 in Glasgow University Library. In *La Tomba dei Nasonii; Gli Acquerelli a Glasgow. Forma Urbis,* ed. B. Andreae, 5:6–39. Reproduced in part from "Pietro Santo Bartoli: drawings in Glasgow University Library after Roman paintings and mosaics. *PBSR* 47(1979):117–55; pls. XIV–XXVII.

Packer, James. 1967. Housing and population in imperial Ostia and Rome. *JRS* 57:80–9, pls. VI–VIII.

1975. Middle and lower class housing in Pompeii and Herculaneum: a preliminary survey. In *Neue Forschungen in Pompeji,* ed. B. Andreae and H. Kyrieleis, 133–47. Recklinghausen.

1978. Inns at Pompeii: a short survey. *CronPomp* 4:4–53.

Paderni, Camillo. 1740. Extracts of 2 letters from Sig. Camillo Paderni at Rome to Mr. Allan Ramsay, painter, Covent Garden concerning some ancient statues, pictures and other curiousities found in a subterranean town lately discovered near Naples. Dated Rome Nov. 20 1739/Feb. 20 1740, trans. A. Ramsay. *Philosophical Transaction of the Royal Society of London* XLI:735–7.

Pagano, Mario. 1983. L'edificio dell'Agro Murecine a Pompei. *Rendiconti della accademia di archeologia, lettere e belle arti di Napoli,* 325–61.

1996. La nouva pianta della città e di alcuni edifici pubblici di Ercolano. *Chroniche Ercolanesi* 26:229–62.

Pandermalis, D. 1971, Zur Programm der Statuenausstattung in der Villa dei Papiri. *RM* 83:173–209.

Pannuti, Ulrico. 1975. Pinarius Cerealis *Gemmarius Pompeianus. BdA* 40:178–90.

Pappalardo, Umberto. 1987. La Villa Imperiale di Pompei. *DialArch* 3.5:125–34.

1991. Il Terzo Stile. In *La Pittura di Pompeii: Testimonianze dell'arte romana nella zona sepolta dal Vesuvio nel 79* A.D., 221–8. Milan.

1993. Spazio sacro e spazio profano: il Collegio degli Augustali ad Ercolano. In *Functional and Spatial Analysis of Ancient Wall Painting,* ed. E. M. Moormann. Proceedings of the Fifth International Congress on Ancient Wall Painting, Amsterdam (8–12 September 1992). Publications of the Dutch Institute in Rome, *Stichting BABesch* 3:9–95.

Paris, Rita. 1996. *Antiche Stanze: un Quartiere di Roma Imperiale nella Zone di Termini* Giorgio Mondadori & Associati Editori S.p.a. Milan.

Parissien, Steven 1992. *Adam Style.* Washington D.C. Preservation Press. National Trust of Historic Preservation.

Parslow, C. C. 1988. Documents illustrating the excavations of the *Praedia* of Julia Felix in Pompeii. *RivStPomp* 2:37–48.

1995a. *Rediscovering Antiquity: Karl Weber and the Excavation of Herculaneum, Pompeii and Stabiae.* Cambridge, UK: Cambridge University Press.

1995b. The 'Forum Frieze' of Pompei in its archeological context. In *The Shapes of City Life in Rome and Pompeii, Essays in Honor of L Richardson jr. on the Occasion of his Retirement,* ed. H. B. Evans and M. T. Boatwright, Caratzas, New Rochelle, NY.

Patterson, John R. 1992. Review article: the city of Rome from Republic to Empire. *JRS* 82:186–215.

Pavlovskis, Zoja. 1973. *Man in an Artificial Landscape: The Marvels of Civilization in Imperial Roman Literature.* Leiden.

Pearson, Michael P., and Richards, Colin. 1994. *Architecture and Order: Approaches to Social Space.* London.

Pedley, J. G. 1990. *Paestum: Greeks and Roman in Southern Italy.* New York/London: Thames and Hudson.

Perrin, Yves, 1983. Neronisme et urbanisme. *Neronia III: Actes du IIIe Colloque International de Société International d'Études Néroniennes.* Rome.

1987. La *Domus Aurea* et l'idéologie Néronienne. In *Le système palatial en Orient, en Grèce et à Rome,* ed. E. Levy, 359–91. Actes du Colloque de Strasbourg (19–22 Juin 1985). Leiden.

1989. Peinture et société à Rome: questions de sociologie. sociologie de l'art, sociologie de la perception. *Mélanges Pierre Lévêque* 3:313–42.

1990. D'Alexandre à Neron: le motif de la tente d'apparat. La salle 29 de la Domus Aurea. In *Neronia IV Alejandro Magno, modelo de los emperadores romanos,* ed. J. M. Croisille, 211–29, pl. 1–6. Collection Latomus 209.

Peters, W. J. T. 1963. *Landscape in Romano-Campanian Mural Painting.* Assen: von Gorcum.

1982, and P. G. P. Meyboom. The roots of provincial Roman painting: results of current research in Nero's *Domus Aurea.* In *Roman Provincial Wall Painting of the Western Empire,* ed. J. Liversedge, 33–74. B.A.R. Int Series 140. London.

1993. *La Casa di Marcus Lucretius Fronto a Pompei e le sue pitture.* With contributions by E. M. Moormann, T. L. Heres, H. Brunsting, and S. L. Wynia. *Scrinium* 5. Amsterdam.

Phillips, K. M. Jr. 1962. *The Barberini Mosaic: Sunt Hominum Animaliumque Complures Imagines.* Ph.D. dissertation, Princeton University.

1968. Perseus and Andromeda. *AJA* 72:1–24; pls. 1–20.

Picard, Gilbert-Charles. 1963. Bulletin archéologique: La peinture romaine jusqu'a la destruction de Pompéi. *REL* 378–91.

1982. Les peintures theâtrales du IVe style et l'idéologie Néronniene. *Neronia 1977* Adosa, 55–9.

Picard-Schmitter, M.-Th. 1971. Bétyles hellenistiques *Monuments et Mémoires publ. par l'Académie des inscriptions et belles-lettres, Fondation Piot* 57:43–88.

Pietilä-Castrén, Leena. 1987. *Magnificentia publica: The Victory Monuments of the Roman Generals in the Era of the Punic Wars.* Societas Scientiarum Fennica. Commentationes Humanum Litterarum 84. Helsinki.

Pighi, J. B. 1965. *De Saecularibus Populi Romani Quiritium,* Libri Sex, 2nd ed. With additions and corrections. Amsterdam Verlag. P. Schippers.

Pinot de Villechenon, Marie-Noelle. 1998. *Domus Aurea: La decorazione pittorica del Palazzo Neroniano nell'album dette 'Terme di Tito' conservato al Louvre,* with Introduction by Gianni Guadalupi. Milan: Franco Maria Ricci.

Pollitt, J. J. 1974. *The Ancient View of Greek Art: Criticism, History and Terminology.* New Haven: Yale University Press.

Ponce, Nicholas. 1786. *Description des bains de Titus.* Rome.

Pontrandolfo, Angela. 1996. Trasformazioni nella società pestana dell'inoltrato IV secolo. In *I Greci in Occidente: Poseidonia e i Lucani,* ed. Marina Cipriana and Fausto Longo with the collaboration of Monica Viscione, 282–92. Naples.

Pontrandolfo, Angela, and Rouveret, Agnès. 1992. *Le Tombe Dipinte di Paestum.* Modena. Franco Cosimo Panini.

Potts, Alex. 1994. *Flesh and the Ideal: Winkelmann and the origins of art history.* New Haven: Yale University Press.

Praz, Mario. 1969. *On Neoclassicism* Angus Davidson, trans London: Thames and Hudson.

Preziosi, Donald. 1990. *Rethinking Art History.* New Haven: Yale University Press.

Ramage, Nancy. Sir William Hamilton as collector, exporter and dealer: the acquisition and dispersal of his collections. *AJA* 94:469–80.

Rapoport, Amos. 1990. Systems of activities and systems of settings. In *Domestic Architecture and the Use of Space: An interdisciplinary Cross-cultural study,* ed. Susan Kent, New Directions in Archeology. Cambridge, UK: Cambridge University Press.

Rauh, Nicholas. 1993. *The Sacred Bonds of Commerce:Religion, Economy and Trade Society at Hellenistic Roman Delos.* Amsterdam: J. C. Gieben.

Rawson, Elizabeth. 1976. The Ciceronian aristocracy and its properties. In *Studies in Roman Property,* ed. M. I. Finley 85–102. Cambridge, UK: Cambridge University Press.

1985. Theatrical life in Republican Rome and Italy. *PBSR* 53:97–113.

Reckford, Kenneth. 1972. Phaethon, Hippolytus and Aphrodite. *TAPA* 103: 405–32.

Reinach, S. 1922. *Répertoire de peintures Grecques et Romaines.* Paris. Reprinted Rome 1970.

Reinholt, Mayer. 1984. American visitors to Pompeii, Herculaneum, and Paestum in the nineteenth century. *In Classica Americana,* ed. Mayer Reinholt. Detroit: Wayne State University Press.

Rhomiopoulou, Katerina. 1997. *Lefkadia: Ancient Mieza.* Athens: Ministry of Culture.

Riccotti, Eugenia Salza Prina. 1989. Le tende conviviali e la tenda di Tolomeo Filadelfo. In *Studia Pompeiana & Classica in Honor of Wilhelmina F. Jashemski,* ed. Robert I. Curtis, 199–231, figs. 1–12. Vol. II of *Classica.* New Rochelle/New York: Caratzas.

Richardson, E. R. 1979. The Story of Ariadne in Italy, in Kopke, G. and Moore, M. B., ed. *Studies in Classical Art and Archeology: A Tribute to Peter Heinrich von Blanckenhagen.* Locust Valley, New York. J. J. Augustin.

Richardson, Lawrence jr. 1955. *The Casa dei Dioscuri and Its painters.* MAAR 23. Rome.

1976. *Propertius Elegies I–IV* edited with introduction and commentary. Norman, Oklahoma: University of Oklahoma Press.

1988. *Pompeii: An Architectural History.* Baltimore: Johns Hopkins University Press.

1989. Vitruvius on stage architecture and some recently discovered *Scenae Frons* decorations. *Journal for the Society of Architectural Historians* 48:172–9.

1992. *A New Topographical Dictionary of Ancient Rome.* Baltimore: Johns Hopkins University Press.

2000. *A Catalogue of Identifiable Figure Painters of Ancient Pompeii, Herculaneum and Stabiae.* Baltimore: Johns Hopkins University Press.

Richter, Gisela. *Perspective in Greek and Roman Art.* London/New York.

Riggsby, A. M. 1997. 'Public' and 'private' in Roman culture: the case of the *cubiculum. JRA* 10:36–56.

Rizzo, G. E. 1936. *Le pitture della Casa dei Grifi, Monumenti della pittura scoperti in Italia III, Roma I,* descritti con note topigrafiche di A. Bartoli. Rome: Libreria dello Stato.

Robert, Carl. 1878. Fregio di pitture riferabili ai miti di Enea e di Romolo scoperte sull'Esquilino. *AdI* 50:234–74; pls in *Mon. dell. Inst.* 10, Tavv. 60 and 60a.

Rosati, Gianpiero. 1983. Trimalchio in scena. *Maia* 35: 213–27.

Rotondi, G. 1922. *Leges Publicae Populi Romani:* elenco cronologico con una introduzione sull'attività legislativa dei comizi romani, estratto dalla *Enciclopedia Giuridica Italiana* Milan. Rpt. Georg Olms. Hildesheim. 1962.

Rouveret, Agnès. 1987a. Toute la mémoire du monde: La notion de collection dans la *NH* de Pline. In *Pline l'Ancien": Temoin de son temps, Acta Conventus Pliniani Internationalis, Namneti 22–26 Oct. 1985 Habiti,* J. Pigealdus, Namnetensis and J. Orozius Salmanticentsis ed. 431–49. Salamanca/Nantes.

1987b. Remarques sur les peintures de nature morte antiques. In *La nature morte,* ed. Xavier de Villeneuve. Bulletin de la Société des Amis du Musée des Beaux Arts de Rennes. *Numéro Spécial* 5:11–26.

1988. Les langages figuratifs de la peinture funeraire paestane. In *Poseidonia-Paestum: Atti del ventisettisimo convegno di studi sulla Magna Grecia, Taranto-Paestum, 9–15 ottobre 1987,* 267–315, and pls. XLIII–VII. Naples.

1987–89. Les lieux de la mémoire publique: quelques remarques sur la fonction deş tableaux dans la cité. *Opus: International Journal for Social and Economic History of Antiquity* VI–VIII:101–24.

1989. *Histoire et imaginaire de la peinture ancienne: (Ve siècle av. J.-C. - Ier siècle ap. J.-C.).* Bibliothèque des Écoles françaises d'athènes et de Rome 274. Rome.

Roworth. Wendy Wassing. 1992. *Angelica Kauffman: A Continental Artist in Georgian England,* London: Reaktion Books.

Royo, Manuel. 1987. Le quartier républicain du Palatin: nouvelles hypotheses de localization. *REL* 65:89.

Ruch, Michel. 1958. *L'Hortensius de Cicéron: Histoire et Reconstitution.* Paris.

Ruggiu, Anna Paola Zaccaria. 1995. Origine del triclinio nella casa romana. In *Splendida civitas nostra: Studii archaeologici in onore di A. Frova* ed. G. C. Manasse and E. Roffia, 137–54. Rome.

Sabbatini-Tumolesi, Patrizia. 1980. *Gladiatorium Paria: Annunci di spettacoli gladiatorii à Pompeii - (tituli):* Pubblicazioni dell' Instituto di Epigrafia ed Antichità Greche e Romane dell' Università di Roma 1, Rome. Rome.

Sampaolo, Valeria. 1992. Il tempio di Iside di Pompei: La decorazione pittorica. In *Alla ricerca di Iside: Analisi studi e restauri dell'Iseo pompeiano nel Museo di Napoli,* 23–39. Naples. ARTI s.p.a.

Sauron, Gilles. 1980. *Templa serena*: à propos de la 'Villa dei Papiri' d'herculaneum: Contribution à l'étude des comportements aristocratiques romains à la fin de la république. *MEFRA* 92:277–301.

⸻ 1984. Nature et signification de la mégalographie dionysiaque de Pompei. *Académie des inscriptions* 151–76.

⸻ 1989. Le complexe pompéien du Champ de Mars: nouveauté urbanistique à finalité idéologique. In *L'Urbs: Espace urbain et historire: Ier siècle avant J.-C. - III sièle après J.-C.* Vol. 98, CEFRA 457–73.

Scagliarini-Corlaità, D. 1974–6. Spazio e decorazione nella pittura pompeiana. *Palladio* 23–5:3–44.

Schefold, Karl. 1962. *Vergessenes Pompeji: unveröffentlichte Bilder Römischer Wanddekorationen in geschichtlicher Folge herausgegeben.* Bern/Munich. Francke Verlag.

⸻ 1972. *La peinture pompéienne: essai sur l'évolution de sa signification.* Trans. J. M. Croisille. Collection Latomus 108. Brussels.

Shatzman, Israël. 1975. *Senatorial Wealth and Roman Politics.* Collection Latomus 142. Brussels.

Sichtermann, H. 1974. Gemalte Gärten in pompejanischen Zimmern. *Antike Welt* 5:41–51.

⸻ 1980. Zu den Malereien des Tricliniums der Casa del Fruttetto in Pompeji. In *Forschungen und Funde: Festschrift Bernhard Neutsch,* Innsbrucker Beiträge zur Kulturwissenschaft 21, 457–61, pls. 88–9. Innsbruch.

Silberberg-Pierce, Susan. 1980. Politics and private imagery: the sacral-idyllic landscapes. *Art History* 3:1–24.

Slater, W. J. 1994. Pantomime riots. *CA* 13:120–44.

Smith, Christopher J. 1996. *Early Rome and Latium: Economy and Society c. 1000 to 500 B.C.* Oxford: Oxford University Press.

Sommella, A. M and Salvetti, C. 1994. *Antiquarium Comunale: Storia di un museo romano e delle sue raccolte archeologiche* Fratelli Palombi. Rome.

Spinazzola, Vittorio. 1953. *Pompeii alla luce dagli scavi nuovi di Via dell'Abbondanza.* 3 Vols. Rome: Libreria dello Stato.

Steingräber, Stephan. 1991. Zu entstehung, verbreitung und architektonischen kontext der unteritalischen grabmalerei. *JDI* 106:1–36, pls. 1–26.

Strocka, Volker. 1984. Ein misverstandener Terminus des vierten Stils, die Casa del Sacello Iliaco in Pompeji. *RM* 91:125–40.

⸻ 1987. Die römische Wandmalerei von Tiberius bis Nero. In *Pictores per provincias* ed. C. Martin, 29–44. Aventicum V. Cahiers d'Archeologie Romande 43: *Avenches.*

⸻ 1991. *Casa del Labirinto DAI Häuser in Pompeji* 4. Munich; reviewed Franklin *AJA* 96(1992).775 P. Von Zabern.

Strong, Donald. 1994. Roman Museums. In *Roman Museums: Selected Papers on Roman Art and Archeology,* 13–30. London.

Suadeau, J. 1985. *Recherches chronologie sur l'habitat à Pompei: La maison du Cénacle,* Mémoire, Université de Lyon III, unpublished.

Swindler, M. H. 1928. *Ancient Painting.* New Haven: Yale University Press.

⸻ 1923. Venus Pompeiana and the New Pompeian Frescoes. *AJA* 27:303–13.

Syme, Ronald. 1986. *The Augustan Aristocracy.* Oxford: Oxford University Press.

Taylor, L. R. 1937. The opportunities for dramatic performance in the times of Plautus and Terence. *TAPA* 68:284–304.

Thomas, Renate 1994. Zur Bedeutung der Edbebenschäden für eine Untersuchung der stilistischen Entwicklung der neronischen bis flavischen pompejanischen Wandmalerei. In *Archäologie und Seismologie: La regione vesuviana dal 62 al 79 D.C. problemi archaeologici e seismologici: Colloquium Boscoreale,* ed. B. Conticello and A. Varone, 169–74. November 26–7, 1993. Munich: Verleg Biering & Brinkmann.

Thompson, M. L. 1960–1. The monumental and literary evidence for programmatic painting in antiquity. *Marsyas* 9:36–77.

Tilloca, Claudia. 1997. La Casa a schiera I, 11, 14 e le sue fasi costruttive. *Rivista di Studii Pompeiani* 8:105–28.

Toner, J. P. 1995. *Leisure and Ancient Rome.* Padstow, Cornwall. Polity.

Tsujimura, Sumiyo. 1990. Ruts in Pompei: The traffic system in the Roman city. *Opuscula Pompeiana* 1: 58–90.

Twain, Mark. 1996. *The Innocents Abroad,* ed. Shelley F. Fishkin. Oxford/New York: Oxford University Press.

Van Buren, A. W. 1938. *Pinacothecae* with Especial Reference to Pompeii. *MAAR* 15:78–81.

Van Buren, A. W., and R. M. Kennedy. 1919. Varro's aviary at Casinum. *JRS* 9:59–66.

Van Dam, Harm-Jan. 1984. *P. Papinius Statius: Silvae Book II: A Commentary.* Leiden.

Vanderpoel, Halsey. 1961. *Archaeology* 14:180–7.

Varone, A. 1993. Scavi recente a Pompeii lungo via dell'Abbondanza (*Regio IX, ins. 12.6–7*). In *Ercolano 1738–1988: 250 anni di ricerca archeologica,* ed. Luisa Franchi dell'Orto 617–40. Atti del Convegno Internazionale Ravello-Ercolano-Napoli-Pompei 30 ottobre–5 novembre 1988. Rome. 'L'Erma' de Bretschneider.

⸻ 1995. L'Organizzazione del lavoro in una bottega di decoratori: le evidenze dal recent scavo pompeiano longo Via dell'Abbondanza, *Meded Rom* 54:124–39.

⸻ 1997. Pompei: il quadro Helbig 1445, 'Kasperl in Kindertheater' una nuova replica e il problema delle copie e delle varianti. In *I temi figurativi nella pittura parietale antica (Iv sec. a.C. - Iv sec. d.C.;* ed. D. Scagliarini Corlàita, 149–52. Atti del VI Convegno Internazionale sulla Pittura Parietale Antica (Bologna: 20–23 settembre 1995). Bologna. University of Bologna Press.

Vasari, Giorgio. 1991. *Le vite dei più eccellenti pittori, scultori e architettori: edizione integrale,* with an introduction by Maurizio Marini. Roma: Newton.

Vessey, D. W. T. *Statius and the Thebaid.* Cambridge, UK: Cambridge University Press.

⸻ 1983. *Mediis discumbere in astris: Silvae IV.2. Acta Classica* 52:206–20.

Veyne, Paul. 1976. *Le pain e le circque: sociologie historique d'un pluralisme politique.* Paris.

⸻ 1987. Paul Veyne, The Roman Empire, in Paul Veyne, ed. *A History of Private Life I: From Pagan Rome to Byzantium,* trans. Arthur Goldhammer. 5–234. Cambridge/London: Harvard University Press.

Von Cube, G. 1906. *Die römische "Scaenae Frons" in den pompejanischen Wandbildern 4 Stils.* Berlin. Wasmuth.

Waldstein, C. and L. Shoobridge. 1908. *Herculaneum past present and future* London. MacMillan & Co. Ltd.

Wallace-Hadrill, Andrew. 1988. The Social Structure of the Roman House. *PBSR* 56:43–97.

1991. Elites and trade in the Roman town. In *City and Country in the Ancient World,* ed. John Rich and A. Wallace-Hadrill, 241–72. London. Routledge.

1995. Public honor and Private Shame: the urban texture of Pompeii. In *Urban Society in Roman Italy,* ed. T. J. Cornell and K. Lomas, 39–62. London: Routledge.

Warsher, Tatiana. 1949. *Codex Topigraphicus Pompeianus,* VI x.

1951. *Codex Topigraphicus Pompeianus,* VI viii, vols. 1–4.

1955. *Codex Topigraphicus Pompeianus,* VI vii. vols. 1–2.

1957. *Codex Topigraphicus Pompeianus,* VI ix. vols. 1–2.

No date (1940?) *Codex Topigraphicus Pompeianus* IX i.

Weege, F. 1913. Das Goldene Haus des Nero. *JdI* 28:127–244. Berlin.

Weigel, R. D. 1998. Roman Generals and the Vowing of Temples: 500–100 B.C. *Classica & Medievalia* 49:119–42.

Weis, H. Anne. 2000. Odysseus at Sperlonga: Hellenistic hero or Roman heroic foil. In *From Pergamon to Sperlonga: Sculpture and Context,* ed. N. De Grummond and B. Ridgway, 111–65. Berkeley: University of California Press.

Wesenberg, Burkhardt. 1991. Zur Bildvorstellung im grossen Fries der Misterienvilla. *Kölner Jahrbuch für vor- und Frügeschichte* 24:67–72

Westgate, Ruth. 2000. *Pavimenta atque emblemata vermiculata:* regional styles in Hellenistic mosaic and the first mosaics at Pompeii. *AJA* 104:255–76.

Whitehead, Jane. 1993. The 'Cena Trimalchionis' and biographical narration in Roman middle class art. In *Narrative and Event in Ancient Art,* ed. P. J. Holliday, 299–325. Cambridge, UK: Cambridge University Press.

Whitehouse, David. 1998. *Roman Glass in the Corning Museum of Glass.* Vol. 1. Corning, N.Y. Corning Museum of Glass.

Whitehouse, Helen. 1976. *The Dal Pozzo Copies of the Palestrina Mosaic.* BAR Supplementary Series 12. Oxford.

1977. *In praediis Juliae Felicis:* The provenance of some fragments of wall-painting in the Museo Nazionale, Naples. *PSBR* 40:52–68.

Wickhoff, Franz. 1900. *Roman Art: Some of Its Principles and Their Application in Early Christian Painting,* trans. Mrs. Arthur Strong. London: W. Heinemann, New York: Macmillan.

Wiles, David. 1991. *The Masks of Menander: Sign and Meaning in Greek and Roman Performance.* Cambridge, UK: Cambridge University Press.

Winckelmann, J. J. 1968. *History of Ancient Art.* With an essay by Johann Gottfried Herder; trans. Alexander Gode. 4 Vols. New York.

1764. *Lettre de M l'Abbé Winckelmann antiquaire de sa sainteté à monsieur le Comte de Brühl, Chambellon du Roi de Pologne Electeur de Saxe sur les découvertes d'Herculaneum traduit de l'Allemand par M. Huber.* Dresden.

Winkes, R. 1973. Zum Illusionismus Römischen Wandmalerei der Republik. *ANRW* I, Band 4, ed. H. Temporini, 927–44. Berlin.

Wirth, Theo, 1983. Zum Bildprogramm in der Casa dei Vettii. *RM* 90:449–55.

Wiseman, T. P. 1982. *Pete nobiles amicos.* In *Literary and Artistic Patronage in Ancient Rome,* ed. B. Gold, 28–49. Austin, Texas.

1985. *Catullus and His World.* Cambridge, UK: Cambridge University Press.

1987. *Conspicui postes tectaque digna deo:* the public image of Aristocratic and imperial houses in the late Republic and early Empire. In *L'urbs: espace urbain et histoire Ier siècle avant J.-C. - IIIe siècle après j.-C.,* ed. Charles Pietri, 393–413. CEFRA 98.

Wojcik, Maria Rita. 1986. *La villa dei papiri ad Ercolano: Contributo alla riconstruzione dell'ideologia della nobilitas tardorepubblicana,* Soprintendenza archeologica di Pompei, Monografia. 1. Rome: 'L'Erma' de Bretschneider.

Woodman, A. J. 1993. Amateur dramatics at the court of Nero. In *Tacitus and the Tacitean Tradition,* ed. T. J. Luce and A. J. Woodman, 104–28. Princeton, NJ: Princeton University Press.

Woolf, Greg. 1998. *Becoming Roman: The Origins of Provincial Civilization in Gaul.* Cambridge, UK: Cambridge University Press.

Zahn, Wilhelm. 1828–52. *Die Schönsten Ornamente und merkwürdigsten Gemälde aus Pompei, Herculaneum und Stabiae.* 3 Vols. Berlin: D. Reimer.

Zanker, Paul. 1979. Die Villa als Vorbild des späten pompejanischen Wohngeschmacks. *JdI* : 460–523.

1988. *The Power of Images in the Age of Augustus.* Trans. Alan Shapiro. Ann Arbor: University of Michigan Press.

1993. *Pompei: Società, immagini urbane e forme di abitare.* Trans. Andrea Zambribi. Turin: Einaudi.

Zevi, F. and G. Vallet, ed. 1981. *Pompei: gli architetti francesi dell' ottocento.* Naples: Gaetano Macchiaroli.

Zevi, Fausto. 1960–61. *La Casa Reg. IX. 5, 18–21 a Pompei e le sue pitture.* Seminario di Archeologia e storia dell'arte greca e romana dell'università di Roma. Studi miscellanei 5. Rome.

1995. Personaggi della Pompei sillana. *PBSR* 58:1–24.

1996. Pompei dalla città sannitica alla colonia sillana per un'interpretazione dei dati archeologici. In *Les élites municipales de l'italie péninsulaire des Gracques à Néron,* ed. Mirielle Cébeillac-Gervasoni, 125–38. Naples/Rome: Centre Jean Bérard.

Zorzetti, Nevio. 1990. The *carmina convivialia.* In *Sympotica: A symposium on the Symposion,* ed. Oswyn, Murray, 289–307. Oxford: Oxford University Press.

1991. Poetry and ancient city: The case of Rome. *CJ* 86:311–29.

INDEX